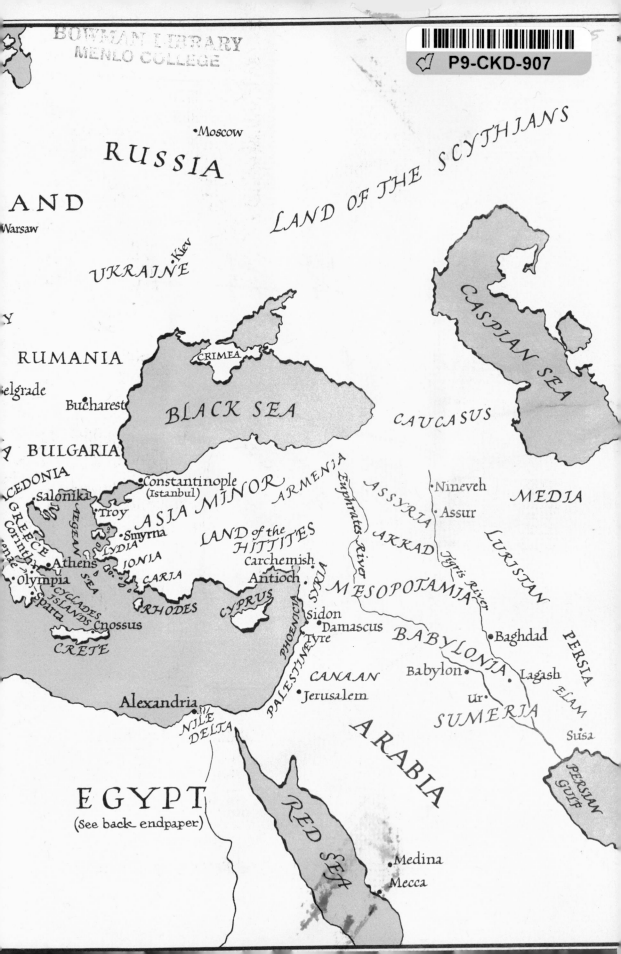

•Moscow

RUSSIA

LAND OF THE SCYTHIANS

AND

Warsaw

UKRAINE

Kiev•

CASPIAN SEA

RUMANIA

CRIMEA

elgrade

Bucharest

BLACK SEA

CAUCASUS

BULGARIA

CEDONIA

Constantinople
(Istanbul)

ASIA MINOR

ARMENIA

Euphrates River

ASSYRIA

Nineveh•

MEDIA

Salonika

•Assur

Troy•

LAND of the
HITTITES

AKKAD

LURISTAN

GREECE

AEGEAN

•Smyrna

Tigris River

Corinth

LYDIA

IONIA

Carchemish

MESOPOTAMIA

Athens•

SEA

Antioch•

SYRIA

Olympia•

CARIA

Baghdad•

PERSIA

CYCLADES

RHODES

CYPRUS

Sidon•

BABYLONIA

Sparta•

ISLANDS

Cnossus

PHOENICIA

Damascus•

Babylon•

Lagash•

ELAM

CRETE

Tyre•

PALESTINE

CANAAN

Ur•

SUMERIA

Alexandria

•Jerusalem

Susa

NILE
DELTA

ARABIA

PERSIAN
GULF

EGYPT

(See back endpaper)

RED SEA

•Medina

Mecca

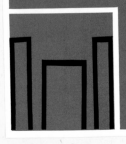

Sculpture

OF THE WORLD:

A History

ALSO BY SHELDON CHENEY:

A New World History of Art
The Story of Modern Art
Expressionism in Art
A Primer of Modern Art
The Theatre
Men Who Have Walked with God

and other books

Sculpture
OF

THE WORLD:

A History BY

SHELDON CHENEY

NEW YORK: THE VIKING PRESS

PHOTOGRAPHS PRECEDING THE TEXT

Title page, left to right:
Oar. Wood. Easter Island. *Museum of Primitive Art, New York.* Text reference on page 25
Bodhisattva. Dried lacquer, gilded. T'ang. *Metropolitan Museum of Art.* Text reference on page 216
Louise Brogniard. Stone. Jean Antoine Houdon. *Louvre. (Bulloz photo).* Text reference on page 463
Yellow Bird. Stone. Constantin Brancusi. 1925. *Philadelphia Museum of Art,*
Louise and Walter Arensberg Collection. Text reference on page 487

Preface heading:
Ostrich Hunt, impression from a seal. Persian, Achaemenid. *Walters Art*
Gallery, Baltimore. Text reference on page 173

Note on Illustrations heading:
Awl with animals. Bronze. Scythian, c. 800 B.C. *National Museum, Stockholm*

Half title:
Lion. Aquamanile. Bronze. Flemish. 14th century. *Victoria and Albert Museum*

Copyright © 1968 by Sheldon Cheney. All rights reserved.
First published in 1968 by The Viking Press, Inc., 625 Madison Avenue, New York, N.Y. 10022.
Published simultaneously in Canada by The Macmillan Company of Canada Limited.
Library of Congress catalog card number: 68–11554.
Set in Centaur and Fairfield types by Westcott & Thomson, Inc.
Plates made and printed in the United States of America by The Murray Printing Company.
Design: M. B. Glick.

Acknowledgments for Text Quotations

The author and the publishers gratefully acknowledge indebtedness for quotations in the text of this book as follows: to Henry Moore for lines from *The Sculptor Speaks,* first published in *The Listener,* London, 1937; to George Rickey for lines from a program note in the catalogue of an exhibition at the Kraushaar Galleries, New York, 1961; to Leonard Baskin for lines from a program note reprinted in *New Images of Man,* by Peter Selz, published by the Museum of Modern Art, New York, 1959; to Small, Maynard & Company for three brief quotations from *Art,* by Auguste Rodin, Boston, 1916; to Raymond B. Blakney for an excerpt from his *Meister Eckhart: A Modern Transla-*tion, published by Harper & Brothers, New York and London, 1941; to Albert Toft for lines from his *Modelling and Sculpture,* published by Seeley, Service & Company, London, 1921; to Pantheon Books for two brief excerpts from translations of Falconet and Maillol in *Artists on Art,* compiled and edited by Robert Goldwater and Marco Treves, New York, 1905; and to Douglas Pepler for an excerpt from *Sculpture: An Essay* by Eric Gill, Ditchling, Sussex, 1918. (The several quotations from Michelangelo and one from Ghiberti have been rewritten from various translations, so frequently quoted and so variously phrased that acknowledgment to the two sculptors seems sufficient.)

Preface

In writing this book I had one objective: to bring within the covers of a single volume a history of all the major phases of the art of sculpture, from the weapons and fetishes of the cave men to the products of our latest generation of carvers, modelers, and welders of metal; and I wanted especially to include the story of Oriental as well as Western mastery.

There exist a score of books in English that carry the title *A History of Sculpture,* or a similar comprehensive designation. But almost uniformly they exclude the magnificent sculptural art of the Orient or compress it into a footnote or an appendix with possibly two or three illustrations; and almost uniformly they ignore the primitive arts of uncivilized peoples. There are 102 illustrations of Chinese subjects in the pages that follow, and more than one hundred devoted to India and the Southeast Asian states. Scythian art is brought into the world story, with a chapter of its own, perhaps for the first time in a history of sculpture. Primitive sculpture, whether that of the troglodytes or that of Oceania or pre-Columbian America or tribal Africa, is similarly represented. It seemed to me that the omission of the rich primitive and Oriental materials argued a cultural arrogance quite intolerable in books purportedly covering the *whole* record of the art.

In rewriting history I bring few credentials

that will pass with conventional educators. I have depended very largely upon my own enjoyment. My aim has been first of all to offer the reader pleasure in sculpture, and imparting knowledge of types, styles, and dates has been a lesser objective. But I did want something more than a picture book. What we have in the text is a sketchy summary of the history behind the creation of each national art, be it Egyptian or Greek, Chinese or Indian. I may mention that I was brought up firmly in the classical tradition. At home the *Venus de Milo, The Dying Gaul,* and the *Boy Extracting a Thorn from His Foot,* in replica, had places of honor on the living-room mantelpiece. My university was devotedly Greek. But at art school, concurrently, the influence of Rodin and Maillol touched us all. Then a disaster occurred, as my advisers and family saw it: I took up with modern art. Lehmbruck was the special instrument of my undoing. Study of modernism, of course, led to appreciation of the sculpture of the primitives and the Orientals.

Many years later, in the mid-nineteen-forties, I planned this book and began to assemble notes and photographs. After ten years of assembling and exploration it became evident that I had collected materials for an encyclopedia of sculpture in three or four volumes. What we all—author, advisers, publishers—wanted was a simple one-volume

work. We emerge finally with our one volume, and we have in it all the illustrations that might be expected in a three-volume encyclopedia.

From the start I had set a goal of one thousand illustrations, and I resisted all suggestions from editors and publishers that I be reasonable. In the end, with over 1100 reproductions in the book, I feel that the illustrations represent the better half of my contribution to the volume. They are mine in a peculiar way: they comprise one man's selection, out of his love for sculpture, from the vast world's store of sacred stones and pieces less sacred. I alone am responsible if an illustration of the *Apollo Belvedere* was omitted, and no one else is to be blamed for inclusion of such unusual pieces as a Tajin stone ax, a very exaggerated Marlik *Stag,* or two Chumash *Whales.* They seem to me to be in the great tradition of sculpture.

I assume that my readers will go along with me in the belief that there is a something that constitutes the essence of sculpture, a spirit and form inseparable, to be comprehended in terms of mass, three-dimensional volume, space around—and always that intangible added by the artist, who relates the creation to the world we know.

I need pause no more than a moment over the peregrinations of my notes and written text. The original wordage, back in the "encyclopedia" days, was double the present count. From this I cut a "final" text, which proved still too large if we were to retain all our pictures. Finally we—author and editors —accomplished the present text. As an instance of our methods, one-half of the Introduction was cut away at a single stroke, as was right because I had elaborated theory —aesthetics—to a degree unnecessary in a factual book. The chapter forewords were in many cases drastically shortened. The running text was trimmed, sometimes to the bone. If the process of compression has involved a loss of smoothness and some disregard for subtle distinctions, I must ask my readers to forgive it for the sake of the greater

convenience of having all the material in one volume.

When the book was planned there was one trouble ahead which we did not foresee: history itself changed, almost epochally, during the period of research and writing. Between 1940 and 1966 sculpture took on increased stature as an art, and its leading practitioners took over leadership in the avant-garde studios. Through the story of Fauvism, futurism, and cubism, painters had been the inventors, the providers of a new and revolutionary art. But, especially under the name expressionism, the sculptors eventually became the more inventive and more celebrated group. It is a sign of the times that no English painter approaches in stature the sculptor Henry Moore; that the radicalism of Lehmbruck and Barlach has been more of a world influence than any other that has come out of Germany; that the most interesting figure in the school of Paris has been, in recent years, the Swiss sculptor Giacometti. No living American painter has started up so many unforeseen eddies of invention, internationally, as the sculptor Alexander Calder. This change, since it is part of history, I have noted. It led to rewriting and enlargement of the final chapter.

Traps are set for survey writers by scholars in such fields as Egyptology and Sinology, especially in the matter of transliteration of names. The Rosetta stone provided a key to the meaning of the Egyptian hieroglyphic language, but no key to its pronunciation. I have adopted here, where consistency is impossible, a system that will bring to the reader names of gods, pharaohs, and men in the most familiar forms. Cheops is the unassailably popular transcription of the name of the pharaoh of the Great Pyramid. The pharaoh of the nearby "second" pyramid (at Giza—or is it Gizeh?) is best known, at least in the literature of art, as Khafre; but he would be transcribed as Chephren if we were following strictly the discipline that gives us Cheops—who in turn would be Khufu if we followed the Khafre formula. The third pyra-

mid builder is named here (and in most histories) Mycerinus, in the Latin form, though some thorough Egyptologists have insisted upon Menkaura. There are many such choices, and we have chosen Rameses where others speak of Ramses; and Akhenaton instead of Ikhnaton. When the museums have put names on the statues they own, we have accepted their spelling in the captions, regardless of anomalies.

Inconsistencies are as common in transcribing Greek names into English, but there is a more commonly accepted pattern. The sculptor Myron is here, as almost universally, given his name in the Greek form; but if in the following paragraph Plato is quoted, few will object that the spelling is not Platon, which is technically correct. Having escaped Myro with the sanction of all parties, it is not so easy to choose among Polykleitos, Polycleitus, and Polyclitus; the last is the Latin form and most favored in English. But to speak of the famous Doryphoros of Polyclitus remains an inconsistency. In all these matters we have tried to settle upon the form that will be least likely to annoy the educated reader. Japanese scholars, with government approval, issued a few years ago a list of changes in spellings of Westernized Japanese words, beginning with such apparent barbarisms as Mount Huzi for Mount Fuji, and the Sinto religion for what we have known as Shinto. The famous temple at Nara that contains so great a treasure of ancient Japanese sculpture, the Horiuji or Hori-uji, became the Horyuzi. Even at risk of being cut off by the Japanese government, I have stuck by the familiar old-fashioned spellings.

In a time such as the present, when sculpture has surged forward, when the operations of invention and experiment are all about, whether in Philadelphia or Turin, London or Seattle, it is particularly difficult for the historian to judge where written history should end, where *mere* experiment begins. I have excluded from my history of sculpture the craftsmen who devise *assemblages*, which

they believe to be sculptural art, and that other most active school, the Pop artists. In one case the assembly of "found objects" is a little too casual; in the other, the underlying theory—that a thing is good because it is commonplace—seems to me at variance with every tenable philosophy of art. History, at present, ends rather with expressionism, in the broad sense, and includes absolute abstraction and near-abstract works whether in built-up boulder-like masses in stone or in the meticulous, almost linear compositions of the welders of metals.

A hundred photographers have contributed to the book. We have put their names into the captions under the illustrations, and the listing there must convey our thanks. I am indebted to as many collectors, directors of museums, and owners of galleries; my obligations to them are listed in a special section at the end of the book.

It remains for me to add here the acknowledgment of a deeper debt to three individuals. Martha Candler Cheney has been a co-conspirator through the entire period of twenty years, in search and research, in travel and adventure. In short, we lived much of the book together.

A very different debt is owing to Bryan Holme at my publishers'. His expertise in art books led him to recall the materials for the book after the project had been dropped —before he became associated with Viking— as impossible of realization at a marketable price. (The Viking Press was repeating only what a dozen of the other most eminent publishers in America, and two or three abroad, had told me—that I had dreamed up a wholly impractical book.) Bryan Holme found a way to overcome the difficulties. I shall always be grateful to him, as will any reader who finds pleasure in the volume, for without his constructive aid there might well have been no book.

The third of my collaborators, Milton Glick, has shown not only great resourcefulness and ability in designing a format that would contain the great number of il-

lustrations, along with the book-length text, but a rare appreciation of the sculptural values in the photographic materials. He is responsible for what seem to me the many happy juxtapositions of related or contrasting pictures.

Space does not permit more than a general "thank you" to Marshall Best, a helpful friend for thirty years and editor of two of my earlier books, and to the other collaborators—editors, copy-editors, production experts—who have become my friends at The Viking Press. Several have helped to make the book what it is, and I am sincerely grateful.

In Paris there is a museum wherein one can stand before an ivory figure of a woman, of the sort known as "Prehistoric Venuses." It is a sculpture that has existed at least 30,000 years. Through this little image the emotion of an artist of the Old Stone Age is projected across 300 centuries. What excite-ment the sculptor felt over his artistic medium, and perhaps over his subject, we cannot know. But the little knot of shaped masses speaks to us today as essential sculpture, stirs us aesthetically. I think that ever since the experience of contemplating that incredibly old bit of carving, I have subconsciously oriented my appreciation to the beginnings in the cave men's art. It is one story, from there through the ages, to the products that grace this book's final chapter: carvings, castings, forged and welded metals, constructions. I have tried to convey the feeling, even something of the excitement of it, in narrative, through the whole progression; and again in illustrations—photographs are particularly kind to sculpture, reconstituting the art, as it were, in a manner quite unique. I end with the hope that the reader may find enjoyment in this well-meaning review of the art.

Contents

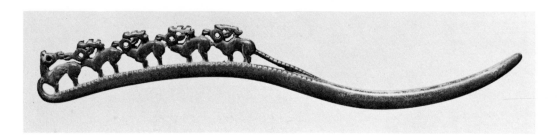

Note on Illustrations

Because a serial list would be useless for reference where so many titles are included,
the list of illustrations sometimes placed at this point is omitted.
Instead, the titles and artists are listed in the Index at the end of the book.
Italic figures, preceded by the letters *ill.,* are employed for illustrations (e.g., *ill., 497*)
to distinguish them from text entries, which are in Roman figures (e.g., 497).

Sculpture

OF THE WORLD

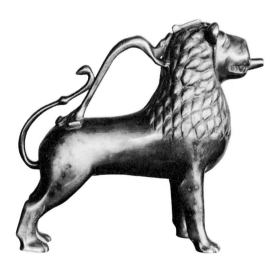

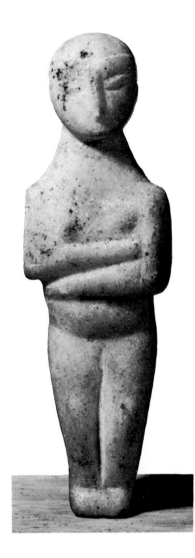

Introduction

The Art of Sculpture

IF you take a block of stone, in its formless condition, and hack and chisel and rub it down to a shape conforming to a vision of order, that is sculpture. In endowing it with a form out of your feeling and vision, you will naturally stick close to the block, respecting the stone.

You cannot go very far toward reproducing the natural scene, nor can you effectively make a commentary on life. The dramatic happening that may stir the painter to creation affords no safe starting-point for a sculptor's imagination. The characters are too many, the background, whether landscape or building, is unsculptural, the narrative element is impossible to sustain. There is some-

Woman. Stone. Cycladic, 3rd millennium B.C. About 5 in. high. (*Courtesy Spink & Son, London*)

thing about this art that is single, silent, and remote.

John Ruskin said that in the disciplined human mind there is no more intense or exalted desire than for evidence of *repose*. He believed that no work of art can be noble without this element, and he added that "all art is great in proportion to the appearance of it." When he searched his memory for examples, he could recall but three artists who illustrated his meaning supremely. Two of them were sculptors. Dante alone, among all the rest of the artists known to history, seemed to Ruskin to be—when tested for the exalted qualities inseparable from repose—the peer of the creator of the Parthenon marbles and the carver of the figures in the Medici Chapel.

Supremely, sculpture is the art of fundamental things, of the stone core of the earth, of the eternal mountains and the silent hills. It is lithic, massive—and serene. Least of all among the arts does it make concession to man's occasional relish for the gay, the trivial, or the fantastic. Without loss of decorum, music may descend from the realm of the symphony to the precinct of the gay song and the merry dance and painting may become lightly decorative or prettily affected. But for the sculptor the path toward fancy, toward the buoyant and the jocund, is a way of peril.

As sculpture is the soberest of the arts, it has known a lesser popularity in recent centuries, during the decline of religions and the spread of materialism and agile intellectualism. But as religion remains the dependable companion of mankind, so the art that is most stable, noble, and nearest to direct revelation, offers to the observer an incomparably profound experience. The *Pietà* of Michelangelo, or any one of a hundred known Heads of the Buddha by anonymous Cambodian sculptors, may remind us, by a mysterious and inexplicable evocation, that the sculptor, beyond all other equipment, requires a clairvoyance, toward the stone, toward his subject. The majestic Chinese statues of the Buddha and

of the Bodhisattvas, breathing amplitude, quietness, and power, mark a peak of achievement in the art that is addressed to the spirit, not just to the senses and intellect of man.

A few sculptors, especially the Hindu and Indonesian masters of relief, the Chinese artisans who designed and cast the Shang vases and jars, and the Mayan decorative stone-carvers, have pushed the art toward the elaborated, the complicated, and the luxurious with wonderful results. There are, moreover, intimate and graceful manifestations, mostly miniature, in which the original massiveness, and the projected feeling of bulkiness and impersonality, are surrendered in favor of lighter, crisper, and more harmonious expression. In this category are amulets, seals, and coins. Few of us, moreover, would willingly forgo enjoyment of the Assyrian hunting scenes in relief, which are like masterly drawings traced on stone, or Ghiberti's panels on the Florentine Baptistry doors, which are bronze approximations of paintings—though we may temper our enthusiasm because both displays are unsculptural in conception.

There are other acceptable compromises and exceptions. The Chinese sculptured landscapes please us in a special way, whether on the hill jars of ancient times or cut into the comparatively recent stone seals. The gracefully attenuated bronze animals of Luristan and the similarly slenderized early worshipers and warriors of the Etruscans are appealing and delightful. But these *are* exceptions; and the basic sculptural "fullness" remains an ideal in the mainstream of Chinese, Etruscan—and even Lur—invention.

In the contemporary period (say, from 1930 to the mid-1960s), when sculpture has expanded in accordance with the scientific advances of the space age, departures from the historic norm have been innumerable and amazing. So unsculptural in the traditional sense are some of the results that they scarcely come within the basic definition of the art. Such are the mobiles, constructivist skeletons, and many of the assemblages so widely exhibited under the label "sculpture." But these

works must of course be considered in our history.

Sculpture in bronze may be considered a less substantial counterpart of stone sculpture, which is basically massive and masculine. Bronze casting is dependent upon a prior art of modeling in clay or wax or plaster. Historically, sculptures in their clay form and bronzes have been created by man since the late Neolithic Age and the dawn of the Bronze Age. Their importance as purveyors of sculptural emotion, their success in harnessing plastic vitality, is not to be lightly discounted, whether in Athens, Ordos, or Ife. Yet carving in stone (or bone or ivory or wood) was antecedent and has remained the core of the art.

When one's appreciation is thoroughly grounded in the basic attributes of sculpture, one can better enjoy the lesser paths and byways. To have lived with the noblest monuments, whether of the Egyptians or the Chinese or the medieval Christian masters, to have absorbed the feeling of silent power and supernatural grandeur in Michelangelo's tomb figures, or in a Nepalese Buddha, equips one to respond spontaneously to the less deep works of a Donatello, a Houdon, or an unnamed Negro carver.

Up to 1930, through a period of at least two centuries, schooling, whether for the artist or for the layman, emphasized a photographic realism and naturalistic perfection as criteria by which to judge the excellence of a statue. The late Greeks and the less robust but more prettily natural of the Renaissance modelers were exalted, while all sculptors who violated any aspect of natural appearance for the sake of aliveness or intensification of emotion were cried down. The observer, the amateur, was led to believe that transcription into stone or bronze of a naturally lovely body or a posed model representing Flora or the Goddess of Liberty was the acme of sculptural art.

Since 1930 there has been a revolt against the easy virtues of realism, and especially against the facile naturalism that reached a zenith in the Victorian era. A great many of the illustrations in school textbooks are still naturalistic, tame, and unsculptural. From the *Apollo Belvedere* and the *Dying Gaul* to Donatello's *David* and the sweet *Saint Cecilia,* and on down to Carpeaux's photographic nymphs and Barye's photographic animals, all the *tours-de-force* of exact copying have been paraded, until the common taste mistakes adroit duplication for creative effort. The casts adorning schoolrooms and public libraries (and still to be encountered in some art museums) lent further authority to the idea of representational realism as the aim and end-all of sculpture.

A perspective upon the history of the art, upon ancient periods as well as modern, upon the Orient as well as the Occident, reveals at a glance that the most glorious cycles of sculptural creation have occurred in times and places not embraced in the history of facsimile realism. Indeed a truth that must be learned (in the West), for the fullest enjoyment of the great pageant of sculpture illustrated in the following pages, is that the representation of the surface aspects of nature is a minor virtue in sculptural art. A person may be looking at a perfect transcription of a pretty or characterful head in marble or bronze, yet not experience one iota of sculptural or aesthetic pleasure. On the other hand, a Chinese monster or a Lur approximated animal may be wholly unlike any beast in the zoological manuals, and an African carved figure or mask may appear as a near-abstract arrangement of the elements of the human body or face; and yet any of these may evoke an immediate aesthetic response.

When we have escaped the habit of looking first for the representational element, we have gone about as far as *knowledge* can take us. No commentator can then help us unless, by suggestion rather than instruction, he can quicken our perceptive senses. No one can knowledgeably say what it is that the artist creatively puts into the statue, what is the form-element, and how it speaks to the aesthetic faculty of the observer. But if he

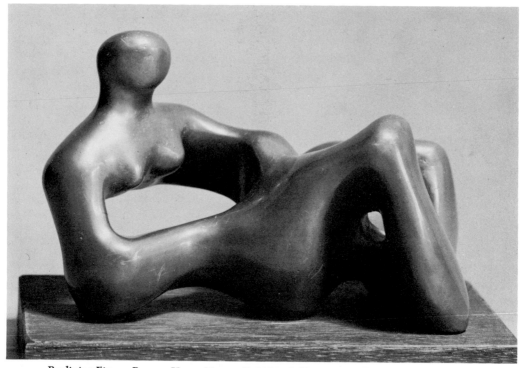

Reclining Figure. Bronze. Henry Moore. C. 1938. *Collection of Billy Wilder, Hollywood*

can get down in words some intimation of the values—of the beauty, if you will—which his more accustomed eyes have experienced, if he can communicate some hint of the serene pleasure, even the glow of the spirit, engendered in contemplation of certain works, he may stir us to live in the presence of great works of sculpture and to enjoy them to the full.

It is generally agreed today that the creative sculptor or painter aims at producing a work endowed with an indescribable, precious, four-dimensional quality that most people call form. It is form that speaks to us first when we contemplate a Stone Age idol, a Greek archaic kouros, or a reclining figure by Henry Moore. Form is the only word that can explain the pleasure afforded us by the abstract sculptures of, say, the ancient Tajin culture of Mexico, or the Amerindians of the middle Eastern states, or the modern Jean Arp.

The art of sculpture had its own perceptive pioneers in the vast and determining move-

ment now seen in perspective as twentieth-century modernism. A sculptor, Elie Nadelman, a true internationalist who spent the latter part of his life in the United States, had already written, before Clive Bell crystallized the theory, that "the subject of any work of art is for me nothing but a pretext for creating significant form, relations of forms which create a new life. . . ." Even earlier the German sculptor Adolf Hildebrand had written a book in the 1890s entitled *The Problem of Form in Painting and Sculpture* which foreshadowed the events and directions of twentieth-century art-progress. Hildebrand pointed out that the true artist's aim is to create a work "with a self-sufficiency apart from nature." The thing created resides, he said, in a unity of form, or an architectonic form, "lacking in objects as they appear in nature." In addition he spoke out for direct cutting as against modeling.

One of the tests now most often applied is: Has the piece a life of its own, or does it

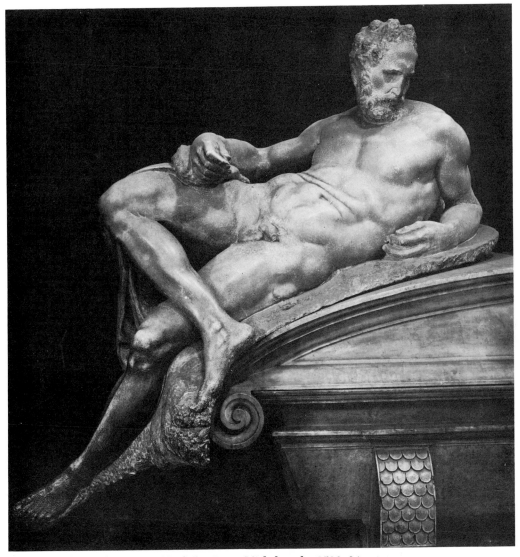

Twilight. Stone. Michelangelo. 1520–34.
Medici Chapel, Church of San Lorenzo, Florence. (Brogi photo)

merely reflect something in objective nature? The life in a Michelangelo piece or in a *Bodhisattva* of the T'ang era leaves no doubt that the intense vitality is that of an independently living creation: the statue is an organism conceived and brought into being by the artist, owing only an impulse and a surface likeness to the model. Though the intensity diminishes as one comes down the scale toward facsimile realism, the works on the great middle ground of sculptural achievement, of the Assyrians and the late Greeks and the Romans, of Ghiberti and Donatello and the della Robbias, of the baroque and neo-classic modelers, of the impressionists—and these are major names and periods of sculptural activity—survive importantly only when the individual sculptor has infused some slight measure of creative formal life into the statue.

If you should ask what schools and names would appear on a guide-map to that part of sculptural achievement wherein form-creation or form-expression is dominant, I would answer: the primitives of all times and places, the early Greeks, the Romanesque masters, the sculptors of the Orient—Scythia, Persia, India, Indonesia, and China—and Jacopo della Quercia and Michelangelo. These schools and masters have left us the works that are most highly charged with life; and in general—except for the Greeks—they are the ones who have been more careless of their models.

After Romanesque expressionism gave way to Gothic realism in France, to Renaissance realism in Italy, the art of sculpture in Europe entered into a slow but lengthy course of deterioration, interrupted only by the talent of a Donatello or a Houdon, and by the startlingly independent genius of Michelangelo. Except for Michelangelo, the aesthetic trend in sculpture ran steadily downward to an intellectual academism and a weak naturalism. When the tide finally turned, at the end of the nineteenth century, there was little in the product of five centuries of European sculpture to afford either precedent or instruction to the young radicals. Since they saw naturalism as a dead end, since all the variations of realism from Ghiberti to the impressionists were being suddenly discredited, they turned to the primitives—which indeed gained for the early moderns a massive strength—and to the Orient, where a rhythmic vitality had always been considered more important than surface representation.

Back in the days when it was axiomatic that the work of art is an imitation of nature, innumerable books were written by sculptors as introductions to the practice or appreciation of the art. Many of these are instructive, for the lover of sculpture, both for what they say and for what they leave unsaid. We may read with respect a book by Albert Toft, a British sculptor eminent in the 1920s, and agree with him that one-half of the artist's preparation is

perception of the marvels of nature. "Above and before all, I repeat, study Nature. None of her works are mean, low, ugly, or vulgar to those who, with the patience born of reverent love, seek out her marvelous and minute beauties." The other half of training, however, is recommended to be study of the Greek and Italian masters, for "inspiration." There is no mention of anything created by the sculptor in the nature of a formal organization or sculptural life. The instance is typical of instruction during the century before the post-Rodin revolt into expressionism.

Rodin himself lent his name to several books. That is, companions and interviewers transcribed his conversations and pieced out his occasional remarks into theories of sculpture. The reported comments, or monologues, are illuminating and provocative; but the modern reader concludes in the end that Rodin was the last giant figure of the realistic schools and only marginally a modern. He was the great, the incomparable impressionist, not properly a post-impressionist.

Rodin speaks for his school when again and again he notes the importance of "the palpitating flesh"; or when he declares that "the principal care of the artist should be to form living muscles. The rest matters little." Of that specialty of the impressionist sculptors, minute modeling of boss and hollow to afford a shimmering effect, he said: "Color is the flower of fine modeling. These two qualities always accompany each other, and it is these qualities which give to every masterpiece of the sculptor the radiant appearance of living flesh."

These interesting observations are likely to sharpen the reader's perception of certain surface beauties in sculpture, but those who believe that a new dimension has been added to sculptural creation since Rodin modeled his naturalistic early works may well prefer his statement about the sculptor's obligation in modeling a portrait: "The resemblance which he ought to obtain is that of the soul; that alone matters." The saying seems to

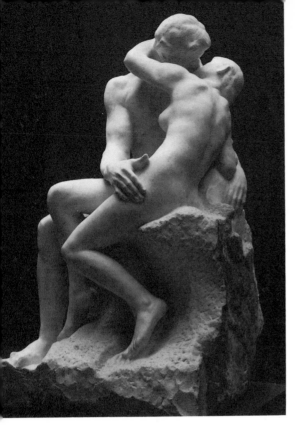

*The Kiss. Marble. Auguste Rodin. C. 1890.
Rodin Museum, Paris*

bring him into the territory of the moderns, where indeed he lingered long enough to design the famous *Balzac*. (See page 472.)

Better known, unfortunately, and frequently quoted by the devotees of realism, is an early saying of Rodin's: "I obey Nature in everything, and I never pretend to command her. My only ambition is to be servilely faithful to her." This well caps a progression of sayings explanatory of the naturalism that had gained steadily in Europe over a period of five centuries.

Lorenzo Ghiberti had written concerning the baptistry doors which he completed in Florence in 1452: "I tried to imitate nature as closely as possible, with all the correct proportions, and by using perspective I was able to produce excellent compositions graced with many figures. . . ." But perhaps the most eloquent of all the exponents of the natural had been Etienne Falconet of the eighteenth century, whose nude nymphs are still coldly charming. "Nature alive, breathing, and pas-

sionate—that is what the sculptor must express in stone or marble," he wrote. "The grandest, the noblest, the most striking product of the sculptor's genius should express only relationships possible in nature—its effects, its fantasies, its singularities."

At the beginning of the twentieth century Aristide Maillol pointed out an inevitable weakness in the realist's case: having only nature's effects as his material, he exaggerates nature's movements and locutions: "Donatello's art does not really come out of nature; it belongs to the studio. He exaggerates to make it lifelike. His weeping children grimace frightfully. One can express sorrow by calm features, not by a twisted face and distended mouth."

If addiction to naturalism was cause enough for the decline of sculpture in the nineteenth century, there was a companion evil in the failure to comprehend the differences between stone-cutting and modeling. Michelangelo wrote the most-quoted statement about the differences between true sculptural art and clay modeling: "By sculpture I mean the thing that is executed by cutting away from the block; the sort executed by building up tends toward painting."

Three hundred years later practically no sculptor in Europe was capable of cutting a stone block, and no school taught the process. The most honored sculptors were claymodelers. They, the "artists," made clay sketches, and sometimes plaster models. Then, if the final statue was to be in stone, "workmen," or *praticiens*, made the replica, using a pointing machine to assure perfect copying. As the so-called sculptor never touched the block, the sense of the stone, of lithic grandeur and heavy monumentality, totally disappeared.

One of the results was that sculptures became light, complicated, spiky, and sketchy. The easy thumbing of wet clay often brought sculpture into the estate of a second-rate and strained sort of painting. Subjects not suitable to the stone abounded; goddesses holding aloft

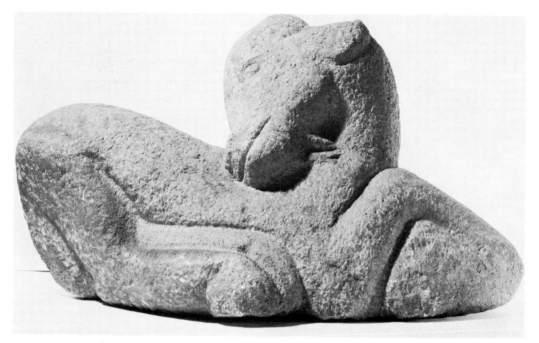

Goat. Stone. John B. Flannagan. 1930–31. *Baltimore Museum of Art*

torches of learning, soldiers bearing guns and bayonets, winged creatures naturalistically portrayed in flight. This was the heyday of pictorial sculpture.

Eric Gill, Gaudier, Meštrovic, and Lachaise were leaders among post-impressionist revolutionaries who insisted upon a return to the sculptural process, and upon the importance of the "stone feeling" in the finished statue. Eric Gill wrote a famous essay entitled "Sculpture," and the opening lines are an echo of Michelangelo: "I shall assume that the word sculpture is the name given to that craft and art by which things are cut out of a solid material, whether in relief or in the round. . . . I oppose the word 'cut' to the word 'model.'" And again: "The sculptor's job is making out of stone things seen in the mind."

The law that applies to basic sculpture, to the statue cut in stone, applies to all the more refined or lesser varieties of the art. That is, the finished work in wood or ivory or clay will be true to the character of the material and will bear the stamp of the sculptor's skill.

Two American sculptors, John Flannagan

and the Greek-born Polygnotos Vagis, have said that their approach was to wait until the stone or wooden block in hand created its own subject; until subconscious memory yielded up an image that somehow belonged to the shape and texture and "feel" of the rock mass. Flannagan wrote that an image exists within every rock and that "the creative act of realization merely frees it." Vagis, when looking at a field stone or boulder, let his sculptural "feeling" play over it until the hidden subject took over his mind. Then he was ready to begin cutting.

This idea is not new. Shortly after the year 1300, Meister Eckhart, the great preacher and mystic, wrote: "When an artist shapes a statue in wood or stone, it is not his subject that he puts into the wood; rather he cuts away the covering material that has been hiding an image. It is less what he imparts; it is rather the stripping away of an obscuring envelope so that what was hidden in the rough may shine out." Johannes Tauler, another leader in that crowning century of mystical perception, reported the incident of

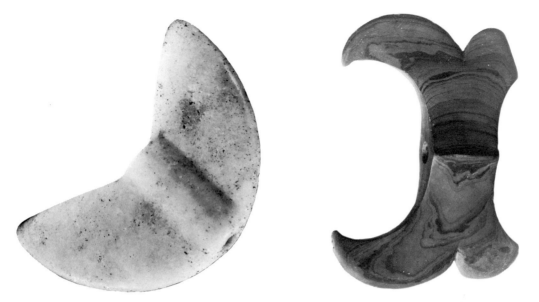

Banner stones. Amerindian, Mound Builders culture, 100–500 A.D. *Left:* Ohio.
André Emmerich Gallery, New York. Right: Illinois. *Museum of the American Indian, New York*

a sculptor who regarded a huge block of marble and exclaimed, "What Godlike beauty is here hidden away!"

Regarding the materials used in sculpture, granite is the favorite hard stone, some artists insisting that this lends itself best in the creation of "sculptural feeling." Basalt dictates a severe simplification. Both of these intractable stones were used from the very start of recorded history: the Egyptians, who consciously aimed to create images for eternity, used them for their tomb statues.

Marble, the favorite stone for the middle ground of sculpture, is not very hard; neither is it soft like the limestones which are its closest relations. Greek and Roman sculptors favored marble, and even today marble remains the chosen material for portrait busts and monumental compositions.

The non-crystalline limestones have been freely used throughout the centuries, but they cannot be polished and are not durable if exposed to weather. The small sculptures in alabaster have a translucent glow, but the material is one of the softest and needs protection. Another soft medium is steatite (soapstone). Lending itself to facile carving or abrasion, it sometimes appears where more difficult sculptural work was scarcely attempted; though it may be said that primitive peoples did not let the intractability of materials check the native impulse toward artistic expression. Flint and basalt are typical Stone Age materials.

The oldest shaped stones uncovered at prehistoric campsites and caves are weapons, and it is a moot question whether these can be considered sculpture. Certainly the desire to render the shapes pleasing entered at some stage of weapon design, and there came a day when ceremonial hatchets and axes evolved out of the purely functional kinds, often with an animal form approximated in the general design or as an added feature. But it may be that the first independent statuette was of bone or horn. One of the commonest early materials was ivory, from mammoth tusks. Of these three materials, ivory is the only one extensively used throughout history, from the age of the Cro-Magnons until our own time. Curiously, the era of its greatest glory began in the so-called "Dark Ages."

Apart from stone and stonelike materials, only one other material lends itself to the true sculptural process: wood. Impermanent by nature, subject to breakage and rot, the wooden statue has seldom survived the oldest cultures, though its presence can be surmised from the time when sculpture first became sculpture. Superbly right for carving, lending itself to effects of fluent cutting and of agreeable texture impossible to any other material, wood has become in the twentieth century, as it has been so often in history, a prime vehicle of creative sculptural expression.

The rest of the story of materials is in clay, but with it we turn away from basic sculpture. The word "sculpture" is descended from the Latin word meaning to cut or carve, and with clay we enter the field of modeling. A composition imprisoned in a block is no longer released by cutting away. Instead the "sculptor" builds up the image, by pressing onto a central mass or core innumerable lumps of wet clay, thumbing and streaking them into final place. The piece as it appears in the museum case may be labeled burnt mud, clay, or terra cotta, but the process is much the same. It has been daubed together by hand while the mud or clay was wet, then fired, possibly in hot sunshine or in ashes, most often in an oven.

The apparent hostility of the moderns toward modeling arose when it was recognized that whole generations of modelers had been falsifying monumental work by creating in clay, in typical softened modeling technique, then mechanically enlarging and copying the effects in marble or bronze. They thus lost the characteristic virtues that inhere in clay or stone or metal expression as such.

Since there are legitimate uses for modeling, and indeed some kind of original is inevitable for statues to be cast in metal, the moderns laid down a rule which seems likely to govern creative sculptural effort for a considerable time to come: The clay shall be manipulated by the artist always in accordance with a vision of the completed work *as it will appear to the beholder in the material of the final piece.* That is, if the sculptor envisages a bronze statue as the end-product, he is constrained to think metallically while producing the clay model, smoothing the surfaces and otherwise capitalizing upon the effects characteristic of metal. If he has in mind a painted and refined product such as colored porcelain (in the tradition of Sèvres or Meissen ware), his clay original will have yet another sort of smoothness and composition. Whereas if the clay statuette is the whole aim of his endeavor, he may proceed in a self-proclaiming technique of chunk-upon-chunk, thumb-marked modeling; or he may pursue naturalism with a detailing and a finesse of approach impossible to reproduce in any transfer beyond the clay or plaster or wax.

There are marvelous examples of clay (or mud) statuettes among the Chinese tomb figurines, and again among the Mexican Stone Age relics. These are apt to be expressionist in the best sense: sculpturally alive, true to the inner character of the subject, and typically claylike. Among the moderns, several sculptors have specialized in capitalizing upon the capabilities inherent in clay; and the Swiss Herman Haller especially has served to prove that the terra-cotta figure can have distinctive and engaging virtues. Some of the Lehmbruck terra-cotta pieces are among the masterpieces of modern sculpture, partly by reason of the artist's scrupulous loyalty to the clay as such.

On the other hand, a study of contemporary bronzes should convince the observer that the great recent sculptors (where they have not insisted upon working exclusively in stone and wood, by direct cutting) have followed the rule of visualizing the final metal effect during the period of producing the model. Archipenko, Lachaise, Arp, and Moore provided excellent examples of the cast bronze

Man Drawing a Sword.
Wood. Ernst Barlach. 1911.
Museum of the Cranbrook Academy of Art,
Bloomfield Hills, Michigan

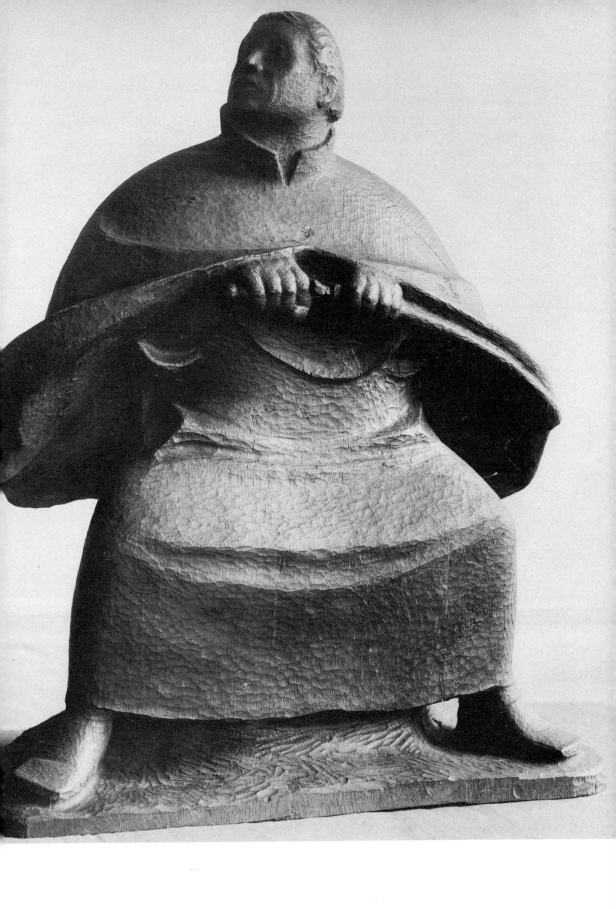

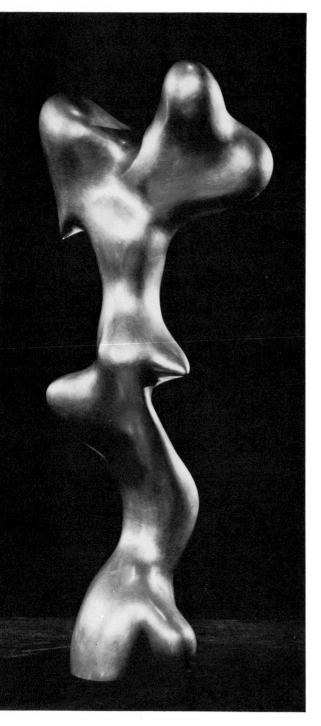

Growth. Bronze. Jean Arp. 1938.
Philadelphia Museum of Art, Arensberg Collection

figure endowed with sheer and glistening effects natural to metal but not to clay.

It must be added that very often, when a terra-cotta piece has won an appreciative audience, the sculptor's desire to perpetuate it in more durable form has led to casting in bronze, without modification. (Or after his death eager executors duplicate clay sketches in metals, as has happened with Degas, Rodin, and Renoir.) Thus in museum halls there are many so-called modern statues that seem to belie the modern passion for truth to materials.

Worse still, one of the greatest of the twentieth-century progressives, Jacob Epstein, in later years went back to the practice of reproducing in cast bronze his sketchy, lumpy clay portraits. Without wanting to detract in any way from Epstein's genius and his early service to the modern movement, one may call attention to the illogical duplication in bronze of his streaky and muddy-surfaced modelings as the most instructive example extant of a denial of the values of material.

No one can see what formal sculptural values may be hidden in the materials now entering into the manufacturing field of industrial design. There are new materials such as chromium and magnesium to challenge the sculptor. Archipenko, Brancusi, and Gonzalez have experimented with direct cutting in metals (as against casting), and Lehmbruck produced many of his outstanding statues in an artificial stone. As a stone and cement agglomerate, the material led the artist to express himself in a fairly smooth, stonelike idiom, yet with a variation of surface not far from that possible to clay. Most recently a new generation (after Gonzalez) has developed every phase of sculpture assembled by welding, and the names of Armitage, Jacobsen, and David Smith have become familiar at the great international showplaces.

There are scores of "new" theories about the art of sculpture. These range from a frank neo-primitivism, as in the few sculptures of Modigliani and an early phase of Epstein's work, through various profound and weighty

works, to the most complicated "light" constructions, as in the airy "mobiles" of Alexander Calder—who was originally a sculptor but is hardly to be contained now in any historical definition of the word.

It may be that it is only because we are still so close to the triumphant days of realism that a large group of innovators and settled moderns remain near the neo-primitive, heavy or simplified types of sculpture. In any case, there is sufficient reason for the contemporary sculptor's concern with ovoid, cubic, and spherical forms, if their reiteration helps stir in the collective public mind a long-dormant love of reposeful, elemental things, of hard, simple, solemn things. It may be that the immediate art of appreciating sculpture hinges upon some deep-down clairvoyance in this regard, upon subconscious perception of elemental form.

Henry Moore, speaking of shape-consciousness, and of his own early devotion to bones, shells, and pebbles, observes that "there are universal shapes to which everybody is subconsciously conditioned and to which they can respond if their conscious control does not shut them off."

Subject-values are, of course, inseparable from the others; but the proper order of recognition is an intuitive response to elemental sculptural beauty, then intellectual pleasure in the descriptive truth and the literary associations. Any alert mind is pleasantly engaged by a cleverly exact transcription or by a show of unusual virtuosity in smooth technique. But the mental delight thus awakened is a poor substitute for the profoundly moving and felicitous response to innate massive rhythms, whether encountered in the form-symphonies of Michelangelo or in the "universal shapes" of Henry Moore.

Montserrat. Sheet iron. Julio Gonzalez. 1936–37.
Stedelijk Museum, Amsterdam

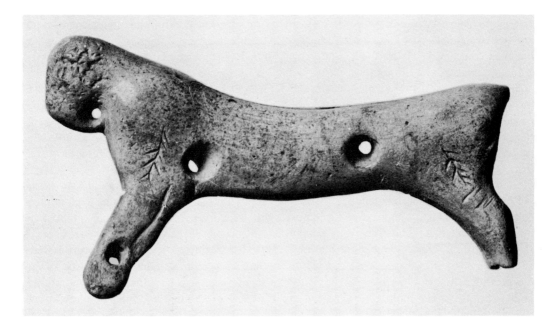

1: Primitive Sculpture:

From the Cave Men
to Our Stone Age Contemporaries

I

W E cannot know exactly when man began to shape tools or weapons artistically, with regard to the pleasure afforded by contrived looks or "feel." Even more obscured is the event of his first cutting an independent statuette. It is probable that sculpture as an art preceded drawing or painting. It goes back to the very beginnings—as does dance, which precedes music and poetry. Incomparably old among figurative arts, sculpture is also incomparably represented among the relics of prehistoric cultures. By its nature heavy and durable, it survives earthquakes and vandalism, sudden injuries from wars, and the gradual silting over of ancient living-sites. Primitive sculpture, though long obscured and only recently known in art museums, is properly the foundation for all study of the art.

The primitives are the world's basic sculptors, and from them each line of civilized development has branched. Their creations are fundamentally vigorous, innocent of reasoned purpose, studied detail, and elaborate ornament. Whether a rough prehistoric "Venus"

Baton or symbol of authority. Reindeer horn. Aurignacian, c. 30,000 B.C. Isturitz, Basses-Pyrénées. *St. Germain Museum. (Photo Charles Hurault, St. Germain)*

of the Aurignacians from the Old Stone Age (of perhaps 30,000 B.C.) or a rhythmically designed stone horse of the New Stone Age (of possibly 2000 B.C.) in Europe, or an idol of a South Sea island tribe living today under Stone Age conditions, the sculpture of the primitive mind, a mind not yet developed to the point of possessing a written language, is simple, strong, and true to the spirit rather than to the external and detailed reality of the model.

Primitive art cannot be delimited within dates. In some areas the Stone Age has lasted into our own time. The American Indian cultures north of Mexico were all at the level of the Stone Age until they gave way before the pressures of the white man. Some Melanesian and Polynesian cultures and others in Africa, Australia, and the Arctic lands remain at the primitive level, and their arts are technically prehistoric.

In the twentieth century we are at something of a loss to know how early man felt about life or art and to fathom his reasons for fashioning a javelin-thrower into an approximation of a stag or a lion, or to explain why, in much later times, he carved a duck or an otter or a hawk upon his tobacco pipe. Archaeologists have evolved a number of theories to explain the earliest works of art, but there seems little doubt that many representations grew from religious impulses and filled devotional or ritualistic needs. Instinctively men wanted to placate the spirits or to please their God or gods; certain objects either contained a spirit or evoked it. They had "magic."

Other manifestations of this art were merely utilitarian. To begin with, early man did only what was necessary. But after a while he polished down the tool or other object he had made and found it more pleasing visually than the first crude product. At some point he playfully added ornament.

The instinct for ornamentation has been claimed by some students as the true origin of all visual arts. To them it seems that art, instead of originating independently, might have evolved from such practices as body-painting and tattooing and the later tribal fashion of wearing ornamental headdresses, necklaces, and the like. But to interpret man's invention of art according to any one theory seems unnecessarily limiting.

In the simplest terms we see the prehistoric artist as a man who was extraordinarily limited mentally, who understood some things and met many others in the natural world that he was unable to explain. Swayed by instincts and emotions, he did not think about

Horse. Stone. Neolithic, 3rd or 2nd millennium B.C. Woldenberg, Germany. *State Museum, Berlin.*
(*Courtesy Archiv für Kunst und Geschichte, Berlin*)

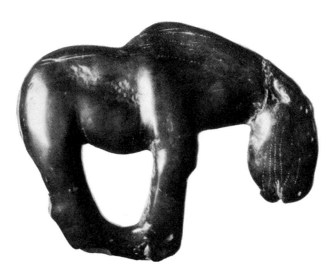

PERIOD	DATE	TYPE OF MAN	SCULPTURAL ART
Eolithic	c. 2,000,000 years ago	*Homo habilis* (?)	Eoliths: crude weapons only slightly shaped
Paleolithic (Old Stone Age):			
Pre-Chellean	c. 100,000 B.C.	Java man	Rudely chipped weapons, axes, scrapers, etc.
Chellean		Peking man	
Acheulean			Tools improved. Bone implements.
Mousterian	from	Neanderthal man	Wildemannlisloch Venus (?)
Aurignacian	c. 75,000 B.C.	(*Homo sapiens*)	
	c. 25,000 B.C.	Cro-Magnon man	Wider range of shaped tools. Some engraving; sculpture in the round.
Solutrean	c. 20,000 B.C.		Flint points greatly improved; other sculpture almost lacking.
Magdalenian	from c. 16,000 B.C.	Cro-Magnon man	Culmination of cave-dwellers' art. (Painted murals.) Wide range of sculpture in the round and in relief.
Mesolithic Age (Middle Stone Age)	from possibly 15,000 B.C. in Europe, earlier elsewhere	Uncertain tribal elements: hunters and fishers	Weapons and tools crude. No figurative sculpture. Rude beginnings of pottery.
Neolithic Age (New Stone Age)	Begins possibly 15,000 B.C. in Asia, 8000 B.C. in Europe	Confused racial patterns. Man initiates primitive agriculture, housing, animal culture, weaving.	Peak of shapely stone weapons and tools, whence alternate name "Polished Stone Age." Dolmens, menhirs and other megalithic monuments. Extensive development of pottery; then clay statuettes. Slow resumption of figurative sculpture in stone. Rare design in copper.
Bronze Age	Begins c. 4000 B.C. in Orient, c. 2000 B.C. in Europe	Man invents a metal harder than copper.	Continuing Stone Age arts; but from c. 2500 B.C., widespread use of bronze for weapons, tools, bracelets, brooches, etc., and finally statuettes.
Iron Age	Possibly c. 1800 B.C. in Asia, c. 1000 B.C. in Europe	Man a worker in iron.	No epochal change in the sculptural arts, which had vastly expanded in the preceding period.

the desirability of art as such. He merely had the impulse to create. The process differs little from that which takes place among intuitive artists today: first contemplation, then the manipulation of materials until the image takes life in a new embodiment. Afterward come all the associative values and uses. In the case of primitive man, if he created a piece that really pleased him he might dedicate it to his gods or God. A likeness in sculpture, something brought mysteriously out of the other world, had an element of magic in it. If I use or wear it, it makes me fine; I am set apart from other men, I am grander or more powerful, or I am more attractive to the opposite sex. Or again, if the piece is an ax head or javelin-thrower, not only am I a greater natural hunter than the others, but I am set apart by this display of hunter symbols.

But there is nothing that transcends the truth that art at its genesis exists to please

some deep-rooted faculty in us, to satisfy an aesthetic hunger. The attraction an agreeable shape holds for us is as basic as our impulse to create rhythmic forms in dance or music. The immediate response to a formal creation is elementary and profound; later may come the realization and the delight of seeing something familiar reproduced.

What is at present known about earliest man and his sculptural art is shown in the chart on page 17. *The Old Stone* or *Paleolithic Age* covers roughly the vast period from the rise of man in the Pleistocene epoch to the culture of the Cro-Magnons, an undetermined time from about 1,000,000 to 30,000 years ago. During the first four of the seven periods of the Old Stone Age there was a slow development from the crudest sort of implement to hand-axes and symmetrically shaped scrapers and points. The fifth period, the Aurignacian, witnessed the rise of the Cro-Magnon race and the appearance of improved weapons such as harpoons and javelin-throwers, numerous sculptures in the round, and engravings on bone. The following period, the Solutrean, named after a people who moved across to what is now France from the East, is remarkable only for the flint blades and points, made by the pressure flaking process. The culmination of Cro-Magnon art, and therefore of all Paleolithic art, occurred in the Magdalenian period (or Reindeer Age) with the paintings of its cave-dwellers, then using not only caves but some rude outside shelters. The sculptors of the period worked in stone, mammoth ivory, reindeer horn, bone, and clay. No pottery is known, but animal figures were modeled in the round and drawings of figures were incised upon the wet walls of the cave. The only claim of transitional Mesolithic art upon the attention of the art-lover is the invention of a rude sort of pottery. The deterioration of other art forms may be attributable to the drastic changes of climate due to glacial shiftings.

The New Stone Age, or Neolithic era, known also as the Polished Stone Age, possibly dates from as early as 15,000 B.C. It lasted until the dawn of the Bronze Age. Some authorities believe the latter to have started in some parts of the world as early as 4000 B.C., others say 2500 B.C. This great era of prehistoric art lasted until the dawn of civilized art in Sumer, Egypt, and China, and included the bulk of Amerindian, African, and South Sea island art.

At the beginning of the New Stone Age, the skills of the preceding ages were not transmitted, except in the field of weapon- and tool-making. Pottery was substantially a Neolithic art, and stone sculpture in the monumental sense was resumed only here and there at varying and generally untraceable dates. Men, no longer dependent wholly upon hunting, turned their attention to agriculture and the domestication of animals. The manufacture of stone weapons reached a refined stage, as indicated in the name Polished Stone Age. It was the age also of the dolmens and menhirs and cromlechs, the megalithic or "large-stone" art, which appeared as at Stonehenge and in the French prehistoric tombs, sometimes as architectural or arranged monuments, sometimes as monoliths. The stones are usually not sufficiently shaped to be classed as sculpture, though occasionally a menhir is traced over with engraved designs and some of the carefully fashioned stones do, in fact, evoke an aesthetic response hardly to be distinguished from our response to basic sculpture.

At the beginning of the *Bronze Age* there was little change in sculpture, but a major advance toward industrialization. Neolithic man had used copper for ornaments and occasionally for representational sculpture, but the era of metals really opened with the invention of alloys, notably bronze. From about 2500 B.C. bronze was used increasingly for weapons and for such ornaments as brooches and bracelets, and for statuettes. The Stone Age arts, especially flint-chipping and pottery-making, continued through the Bronze Age; typically Bronze Age arts persisted in some regions long after others started using iron.

In most regions of Europe, the Iron Age,

dating from about 1300 B.C., was not prehistoric, but the Hallstatt and La Tène cultures, pertaining to peoples known to the Greek-Roman civilization as barbarians, were technically primitive. Most of the sculpture is small and incidental to manufacture, as on urns, pins, and swords.

The plates which illustrate this chapter suggest how basic and universal is man's impulse to create, how instinctive his urge to improve. From the start man seems to have had an interior sensibility, a sense of form, an aesthetic impulse. Primitive sculpture is evocative of contemplative pleasure, of a sculptural emotion, as is all great plastic art.

In the 1960s, new discoveries by anthropologists in East Africa have given rise to articles appearing under such startling headlines as "Scientists add a million years to the span of man's existence on earth." Equally startling was the still-debated opinion that man is descended physically from the Australopithecines, the so-called man-apes of South Africa who walked erect and supposedly used stone, bone, and wooden weapons to overcome their prey. However, many anthropologists today believe that despite their upright posture and tool-using capability the Australopithecines were not directly ancestral to men, but instead represent an offshoot of the evolutionary line that led to man. It is possible that these hominids lived concurrently with the earliest known true man, *Homo habilis*.

As to dating, the lay reader does well to allow, near the dawn of art, a hundred centuries here and there. The dates in this book are perhaps as near right as is possible in a period of scientific guessing and scholarly controversy.

Feline. Petroglyph. Solutrean, c. 20,000 B.C.
Les Combarelles, Dordogne. (*Archives Photographiques, Paris*)

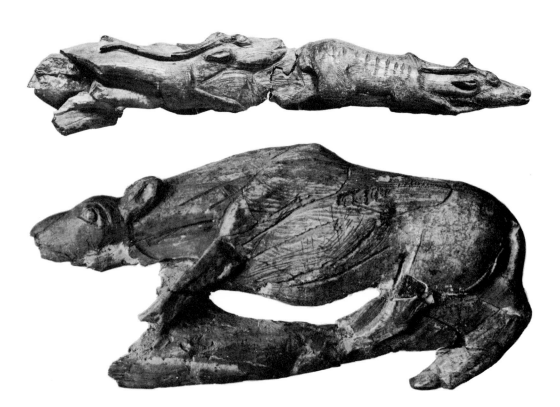

II

THERE is a marginal theory that the first pieces of sculpture treasured by men were bits of stone or bone which had been worn down by the elements into shapes resembling animals or human beings. Early man would value such nature-formed figures as luck pieces. A pebble approximating the mass of a bison or a human head would appeal to him as a token bestowed by the spirits, as a precious link with them. It might itself seem to be instilled with magic.

Through rude efforts to improve and then to duplicate the nature-formed luck pieces, the theory goes on, there arose the whole complex of activities known as the figurative arts. It is supposed that from such a beginning, perhaps 100,000 years ago, the activity was carried forward by the Neanderthal hunter-savage, then by Cro-Magnon man. After possibly seven hundred centuries, in the late Old Stone Age, artists achieved the sort of animal image shown in the illustration of the reindeer-horn sculpture from Isturitz, which is supposed to be an ornament or a baton of authority of the Aurignacian epoch. It is pleasing but hardly more than rudely resemblant. (Illustrated on page 15.)

There is only one figurative sculpture that

Reindeer; Bison. Javelin-throwers. Ivory. Magdalenian, c. 15,000 B.C.
Bruniquel, Tarn et Garonne; La Madeleine, Dordogne. *British Museum;*
Les Eyziès Museum (Hurault photo)

is considered by archaeologists to belong to an earlier period than this baton. Its subject is Woman. The piece from the Wildenmannlisloch Cave, an Alpine site in eastern Switzerland, is not only the oldest example of sculpture known but a unique specimen dated to Mousterian times, and thus presumably at least 40,000 years earlier than the Aurignacian finds. Some archaeologists refuse to believe that this graceful knot of sculptural masses was shaped by men, for prior to 1926, when the unique piece was discovered, it had been assumed that Neanderthal man possessed no aesthetic sense at all. He had rough stone weapons and tools, but no art. Authorities therefore suggested that the stone had more or less automatically developed into its present human shape while being used as a utilitarian scraper. Then when some sensitive observer saw in it an image of a woman he mounted it in a segment of a cave bear's jawbone. This mounting has lasted through possibly 70,000 years. Not only the general shape of the statue but the suggestion of details such as the eyes and nose seem to other scholars to indicate human artifice.

The *Reindeer* and *Bison* represent animal figures carved on useful objects such as javelin-throwers. They are characteristic of a stage attained by the sculptors of the Magdalenian epoch, when the images had become vigorously lifelike and there was a maturer feeling for rhythmic design.

These are examples of the art of the Cro-Magnons, successors in Europe of the Neanderthalers. The Cro-Magnons painted the walls and ceilings of their sanctuary cave-rooms with amazingly truthful pictures of the animals they hunted. In addition to this, archaeologists have found such objects as broken javelin-throwers, flint points, and stone skull-crushers, which have helped them to piece together a rudimentary picture of how these early men lived. It seems safe to assume that they were exclusively a hunting people. In their ivory or bone sculptures (they did not use metal) they caught the observed character, the alertness and the stance, the typical bulk and the typical movement of a stag or doe, of a wild horse, bison, or panther. And to the look of the animal they expressively added the *feeling* of it. Their little "statues" form a worthy parallel to the virile and sometimes superb paintings on the walls of their rock shelters.

The Cro-Magnon people believed that possession of an image of the hunted bison or stag would afford the hunter mastery in the chase, and so the sculptors concentrated upon quarry animals. There is nevertheless a considerable range of material, stone and clay and horn, and of method, from full-round to incised drawings and figures in low relief. See the illustration of a petroglyph of a feline from Les Combarelles on page 19.

To return to the human figure, the unique *Venus of Wildenmannlisloch,* which is now widely accepted as man's handiwork, seems to be a forerunner of the figures known as Venuses of Aurignacian times. Scores of

Woman. Bone. Neanderthal, c. 70,000 B.C. Wildenmannlisloch Cave, Switzerland. *Heimatmuseum, St. Gallen*

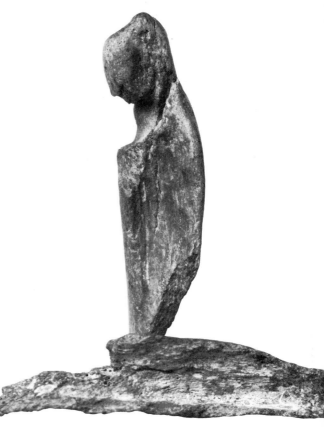

examples have been recovered from European and Asian caves and campsites. For illustration here I have selected the so-called *Venus of Lespugue* and *Venus of Willendorf*. These miniature Venuses are generally heavy and bulgy, with emphasis on the womanly parts. The faces are mostly without features. Fertility rites were among the earliest religious or conjuring activities of primitive peoples, and the Venuses are presumed to have been ritualistic objects or fetishes, designed to induce fecundity.

The figures indicate a long apprenticeship in the use of chipping and cutting instruments. They are of interest to theorists of art as revealing a bent, at so early a time, toward fluent outlining and rhythmic ordering of sculptural masses. They interest ethnologists because the bulginess of certain body parts seems to link the Cro-Magnon goddesses with the similarly steatopygous women of the present-day Bushmen tribes of Africa.

This type of art disappeared from Europe soon after the last glacial age, possibly about 10,000 or 12,000 B.C., and figurative sculpture is then wholly absent. The date when the practice of carving figures in stone was resumed in Europe and Asia is unknown, though it would seem to be in the New Stone or Polished Stone Age. Neolithic cultures appeared at widely separated dates in different parts of the world, and some survive today. For that reason the word "primitive," like the word "Neolithic," has come to designate art of a certain type or spirit, rather than art of a measured time-period.

The resumption of a typical primitive practice in the Neolithic Age is illustrated in the early Cycladic figure shown beside the *Venus of Willendorf*. The subject is rare (but not unique) among Cycladic pieces in that it seems to be directly in

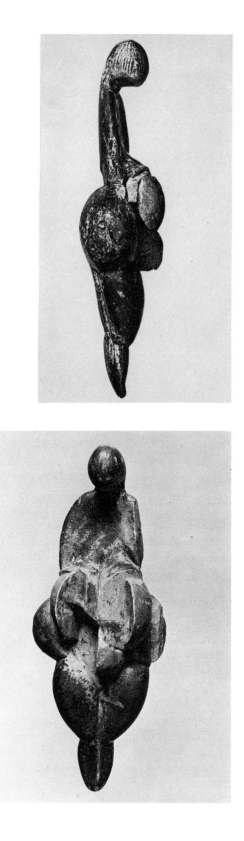

Venus of Lespugue. Ivory. Magdalenian, c. 15,000 B.C. Grotte des Rideaux, Lespugue, Basses-Pyrénées. *Musée de l'Homme, Paris.* (*Photo Giraudon, Paris*)

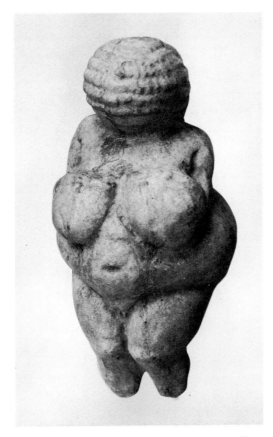

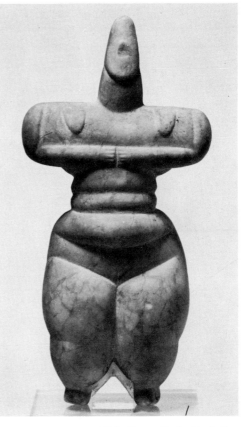

Venus of Willendorf. Stone. Aurignacian. Willendorf, Austria. *Naturhistorisches Museum, Vienna*

Idol. Stone. Early Cycladic, 3rd millennium B.C. *André Emmerich Gallery, New York*

line of descent from the Aurignacian Venuses. It has the featureless face and, in the body, the steatopygous fatness of the earlier figures. It is at the same time more advanced as a design, clearly a step toward the schematized Cycladic figures. The piece was found in Malta but is thought to be of Pentelic marble.

The Cycladic marbles from the Greek isles in the Aegean were mostly of human figures, ranging from practically abstract pieces, like fat fiddles, to statuettes slightly more detailed than the one shown on page 1. Primitive simplicity and vigor are inherent, along with a captivating rhythmic expressiveness. The sculptors escaped the pitfalls of intricacy of design, over-ornamentation, and naturalistic detailing.

Mention of the Polished Stone Age suggests a second line of sculptural development, and one that bridges the gap between Paleolithic and Neolithic cultures. In both ages weapons and tools were fashioned with notable feeling for abstract form. The art of shaping volumes beautifully is illustrated in the evolution of ax head and javelin point. The handsome skull-crushers and the attractive hatchets of the New Stone Age indicate a conscious delight in the tactile appeal of the sleek worked stone, as well as an intuitive feeling for volume organization.

The most ancient artifacts were rudely chipped scrapers or points, but an increase in sensitivity of design can be traced through the Paleolithic epochs. The thin, almost elegant laurel-leaf blades of the Solutrean

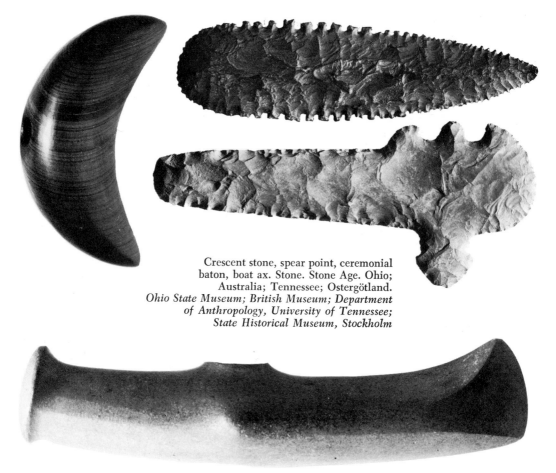

Crescent stone, spear point, ceremonial baton, boat ax. Stone. Stone Age. Ohio; Australia; Tennessee; Östergötland. *Ohio State Museum; British Museum; Department of Anthropology, University of Tennessee; State Historical Museum, Stockholm*

epoch marked a high point of Cro-Magnon artisanship and were surpassed only by the polished knives and points of Neolithic times.

In part of Asia the semi-civilization of the New Stone Age came perhaps as early as 15,000 B.C., and in Europe as early as 8000 B.C. Through hundreds of generations thereafter the changes in weapons and other tools most clearly indicate an awareness of sculptural beauty.

This obviously originated less from man's desire to imitate nature than out of an instinct to create rhythmically and to shape things into aesthetically pleasing forms. Tools bear out this theory, as do the menhirs or "long stones" set up on primitive sites, which survive today as impressively grand, if non-figurative, monuments; and a store of small,

non-utilitarian sculpture that is abstract, in the absolute meaning of the word, innocent of suggestion of natural objects. The immediate followers of early man had begun to treasure polychrome pebbles and bright crystals, as well as shells and teeth, and the cultures of later prehistoric men yield numerous types of abstract ornament and fetish. But it is the stone weapons that are central to the exhibit.

From the useful axes and points and clubs the series goes on to ceremonial weapons, patently elaborated for display. Often in the ritual axes there was evidence of the grasp of the finer nuances of plastic order, of balanced weight and related mass, and of pleasingly adjusted outline. The advance from simpler contour and casual form to such

elaborated clubs as those of the Maoris and to the rhythmic oars or paddles of the Easter Islanders was accompanied by growing appreciation of woods and stones. These materials were valued for their texture or their markings. Eventually, in this line, there appeared the exquisitely fashioned ceremonial objects of the Chinese, in precious jades.

The Bronze Age, marked by the epochal introduction of a metal harder than copper, dawned in some Near Eastern regions as early as 2700 B.C. As always when an art enters upon a new phase, the idioms and methods of the past survive for a while. The knives and axes were at first modeled after the examples created in the Stone Age, but, as the Bronze Age progressed, refinements appeared. For instance, the axes and adzes of the people of Luristan, while preserving a primitive vitality, began to take on a fluency and elegance seldom seen in the weapons of the Stone Age. Even though the artists worked animal compositions into their weapon or tool designs, the whole retained a virile simplicity. This is transitional sculpture, between prehistoric and civilized art. And indeed there is no dividing line between the superbly right semi-primitive sculpture of the Lurs and the early art of the civilized Persians.

If the growth of sculptural awareness can thus be traced in the weapons or tools of early man, there is also confirmation of his growing feeling for sculptural form in nonutilitarian objects. The shaped stones of the North American Indians, sometimes apparently treasured for ornamental values alone, sometimes symbolic, and sometimes being used as fetishes, are among the most lovingly fashioned sculptures to survive from primitive times. Though thousands of banner stones of the North Central Indians have been found, there is no evidence that they served any purpose beyond pleasing the senses. Variations of the type, known as lunar stones, winged stones, double-crescent stones, and so on, are commonly met with in the museums; but the banner stone is, sculpturally speaking at least, the most engaging exhibit. It is typical primitive art with vigorous simplicity, forceful thrust, and direct decorative expressiveness. Two banner stones are illustrated in the Introduction on page 9.

A second line of Amerindian sculptures approaches the abstract in forms abstracted from nature or poetically summarizing it.

The "long stone" art. Pre-Celtic. Part of temple remains, Stonehenge, England.
(*Kean Archives, Philadelphia*)

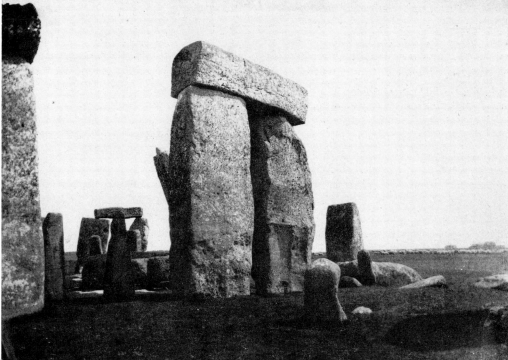

Adze head. Bronze.
1000–800 B.C. Luristan, Persia.
Museum of Fine Arts, Boston

Club. Wood. Maori. New Zealand.
University Museum, Philadelphia

Although the banner stones are wholly nonrepresentational, the bird stones of the same tribes are abstractions in this second sense. While these forms are very far from realistic, they are nevertheless endowed with bird feeling. The beauty is at once that of the bird-subject and that of the artist's creation.

The lovingly polished miniature whales and other animals found on sites of Amerindian communities along the coast of California (chiefly on the islands of the Channel Archipelago) are close to realistic representation. Yet they never lose the simplicity of statement common to untutored peoples. The whales, especially, are highly attractive. The fishhook is from the same culture.

Primitive man, certain pragmatists assert, had no other purpose in life than to obtain food, protect and propagate his kind, and develop skills that would serve practical ends. Imitational sculpture, they say, originated as a side issue of manufacture. Only when practical demands had been satisfied did art come into being as a playful or pretty addition to the plain tool, weapon, or vessel.

The stone pestles made by the Marquesans and by the Amerindians of the Antilles probably passed through a long metamorphosis before they approached the type pictured, with a head or heads terminating the neck of the pestle. The usefulness of the objects continued unimpaired, but art had been added. The sculptors who carved the bird and human figures on the stone pipes of the American Mound Builders may have done so for ritualistic occasions. Non-ceremonial objects would call for less elaboration.

The evolution of pottery is another factor to be considered in any study of the origins of art. The craft of making vessels in sunbaked or fired clay came fairly late in the rise of primitive man; meanwhile shells, gourds, and hollowed stones served his need for a dish or a jar. No pottery has been found among the relics of unsettled, exclusively hunting or migratory peoples. But, once invented, the baked clay vessel became almost the commonest expression of man's skill, from the epoch of primal agriculture to a period just short of civilization. The line of sculptural development, from abstract shaping to elaborated

figurative design, can be traced once more in ceramic pot and storage jar and in rudimentary statuettes.

At first the abstract elements of composition were more important than the art of copying from nature. But very soon the baked clay vessels began to be embellished with representational elements; and, at some undetermined point in prehistory, the common manufacture of clay figurines began.

The feeling for good proportion, pleasing outlines, and massing was instinctive with primitive pot-makers; and when ornamentation was added, it rarely became excessive or ran counter to functional laws, except, perhaps, in ceremonial or libation vases. The most ancient vessels are forerunners, on a primitive level, of the exquisite Chinese Sung bowls and the sixth-century vases of the Greeks.

The art historian usually considers as sculptural only those vessels that have representational forms in the modeling. At first the primitive potters seem to have experimented with faintly or crudely imitational details in handles or on the rim, neck, or shoulder of a vessel. Prehistoric Italian dishes of the Picene culture afford eloquent if crude testimony about the beginnings of rim figures, and innumerable early Middle American and South American earthenware vases have incidental sculpture on their sides. Peruvian wares are endlessly interesting for the ingenuity with which the sculptors integrated illustrational features with the design of the pot or bottle, without impairing its function or disturbing the decorative unity of the vessel.

Another line of evolution is shown in vessels designed in the shape of a head or a body. In the beginning, face urns were modeled with hardly more than a representation of eyes and a mouth, or eyes and a nose; sometimes they are found with utilitarian ears pierced for handles. The vase with breast forms is not an uncommon type. Indeed any shapely or symmetrical part of the body might suggest variations of the contours of the clay vessel. This progression leads on to dishes and jars completely composed to approximate the appearance of a man or a woman, an animal, and sometimes a fruit.

The primitive artist was likely to geome-

Fishhook; *Whale.* Stone. Amerindian, Chumash. Channel Islands, California. *American Museum of Natural History; Museum of Science, Buffalo*

Bird stones. Amerindian. Michigan; Illinois. *American Museum of Natural History; Museum of the American Indian, New York*

Pestles. Stone. *Left:* Amerindian. West Indies. *Museum für Völkerkunde, Berlin.* (*Photo courtesy Archiv für Kunst und Geschichte, Berlin.*) *Right:* Polynesian. Marquesas Islands.
Musée de l'Homme, Paris

Bird; Man. Effigy pipes. Amerindian, Mound Builders culture, pre-Columbian. South central United States. *American Museum of Natural History; Brooklyn Museum*

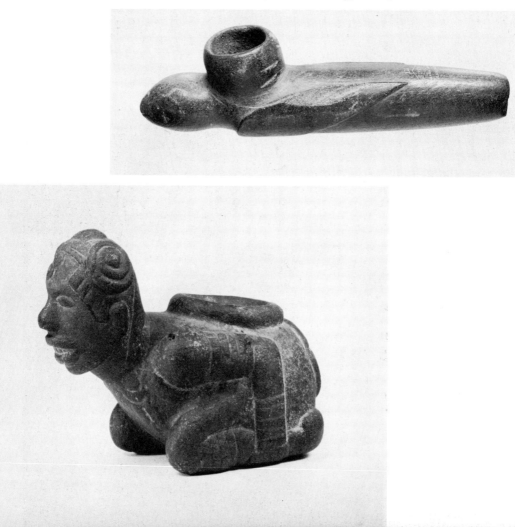

trize or conventionalize the natural forms in clay as he did in his stone effigies. The gift for formalization and for subordinating the representational features to the formal needs of the craft is illustrated in thousands of early American vessels such as the human-effigy vase from Chihuahua, Mexico, with its extreme simplifications, or distortions of nature. The two Tarascan effigy jars, simulating realistically a child and a dog, are essentially primitive with their simple massiveness and rhythmic modeling. These were executed by sculptors living under Neolithic conditions and they mark a final point in the progress of prehistoric artists toward naturalism.

Realism cannot, however, be considered a primary aim of the primitive artist. In spite of evidences of his keen observation, the unlettered sculptor usually remained true to the spirit rather than the visual fact of his subject-

Jars with effigy added. Clay.
Above and left: Mexico.
American Museum of Natural History.
Below: Peru. *University Museum, Philadelphia*

Effigy vessels. Clay. Amerindian, Stone Age.
University of Tennessee; American Museum of Natural History

Effigy Jars. Clay. Tarascan, pre-Columbian. Mexico. *American Museum of Natural History*

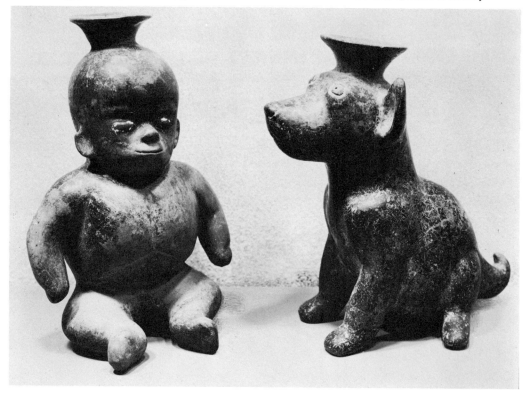

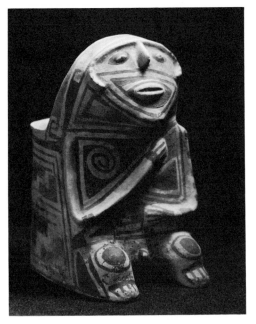

Human-effigy vessel. Clay. Chihuahua, Mexico.
Laboratory of Anthropology, Santa Fe

matter. The last two clay sculptures shown in this chapter are of the type of idol or fetish found at the dawn of civilization. They are simple, directly expressive, and generally formalized. The representational element—so highly praised by archaeologists and historians in an earlier generation—now seems less significant than the artist's intuitive mastery of sculptural method. The figure of a woman with stubby arms is from the culture called Amlash, recently discovered in northern Persia on the border of the Caspian Sea. The black clay *Mother Goddess* figure with a suggestion of outstretched arms, in the University Museum, Philadelphia, is more clearly a fetish, a descendant of the fertility goddess commonly found in the Middle East. This example also comes from a northern Persian culture, centered to the eastward of the

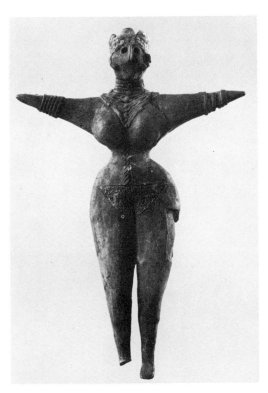

Mother Goddess. Clay. Bronze Age. Asterabad,
Persia. *University Museum, Philadelphia*

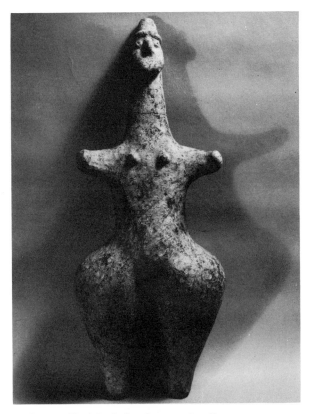

Woman. Clay. Amlash culture, 2nd millennium
B.C. Persia. *Bertha Schaefer Gallery, New York*

Amlash finds. The *Dancing Girl* in wood (from a Chinese tomb) was made a half-millennium later and, though very different in mood, is still an example of primitive simplicity, vigor, and directness of statement.

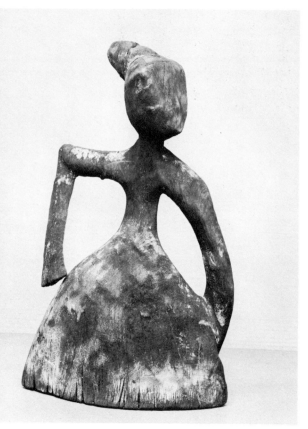

Dancing Girl. Tomb figure, wood.
4th–3rd century B.C. Chang-Sha, Hunan, China.
Fuller Collection,
Seattle Art Museum

The chapter concludes with a Neolithic *Jaguar* in stone, from Panama, which is so stylized that it might have been carved by a neoprimitive modern of this century. It illustrates a common sort of geometrization evident also in the effigy vase from Chihuahua. Squared or rounded forms, graceful elliptical contours, and massive simplification add up to a primitive style replete with plastic life.

For rhythmic massing and pleasing finish, the *Jaguar* might be compared with the *Horse* shown on page 16. It is obviously of the Stone Age, found at Woldenberg in Germany and attributed to a prehistoric culture two or three millennia earlier than that which produced the jaguar. This demonstrates a common generic likeness existing in prehistoric sculpture, whether dated at 10,000 or 5000 B.C. in Asia, or 2000 B.C. in Middle Europe, or A.D. 1000 in America. The combination, in this horse, of the profoundest sculptural qualities with such crudities as the faltering lines of dots on head and mane remind us that the Neolithic artists, distributed over all the continents, and tenants of Asia through perhaps one hundred and twenty centuries, worked in societies at the level of hunting or rudimentary agriculture and long before the invention of the art of writing. And yet, intuitively, the Neolithic artist grasped the values of monumental massing, melodious proportioning, and vigorous statement of the essential character of his subject.

Jaguar. Mortar, stone. Neolithic. Panama.
University Museum, Philadelphia

2: Egypt:

The Eternal in Sculpture

I

HERODOTUS said that "the Egyptians were the first to erect to the gods altars and temples; and they carved in stone the figures of animals." This Greek historian, writing in the fifth century B.C., was one of the first to circulate the untruth that the Egyptians invented the arts of architecture and sculpture. Coming himself from a country young and not too firmly established, Herodotus must have found the relics of three thousand years of Egyptian culture an overwhelming token of age. In the statues of the gods and pharaohs—and animals—he would find the element of timelessness, of eternity, as nowhere else on earth.

Although the people of Egypt had not invented representative sculpture, they had made the art their own as had no other nation. Neither Babylonia nor Persia nor the Cretan and Mycenaean forebears of the Greeks had formed a style so primary, so single, and so national. A piece of Nilotic sculpture is recognizably so, whether of the Old Kingdom of 2600 B.C. or of the Middle Kingdom of 1900 B.C. or of the Saitic period thirteen centuries later, just before Herodotus visited the cities of the Nile. The massiveness and expressive monumentality combined with a plastic sensitivity place Egyptian accomplishment far ahead of that of any other people of pre-Classic times.

The distinguishing trait of Egyptian sculpture was the persistence of the note of eternity, of durability, of timelessness. Plato recorded that in the land of the Nile it was unlawful to introduce novelty, and as life went on unchanged, century after century, the artist too, perhaps, was forced to hold to

Hippopotamus. Stone. C. 3200 B.C. *Ny-Carlsberg Glyptothek, Copenhagen*

an unyielding tradition. Only once, in the immensely fruitful interlude associated with the mystic and heretic king Akhenaton, did the sculptor step out of the role of disciplined servant of a tradition.

So many generations of historians had portrayed the valley of the Nile as the cradle of civilization that when, in the nineteenth century, explorers on the Tigris proved Sumer to be the original home of laws, writing, and culture, the Egyptologists fought tenaciously, but in vain, to retain priority for their chosen land. Today, though it is clear that the Mesopotamian city-states became civilized earlier, Egypt emerges as the nation with the more stable institutions, the more distinctive culture, and the first great, consistent sculptural art.

Perhaps no other national art, excepting the Chinese, is so outstanding for dignity and grandeur as Egyptian sculpture. It has been called cold and tomblike by critics to whom emotional representation seemed more desirable than the contemplative pleasures arising from peace of spirit. But the peace and sense of eternity of the great statues have endured and been admired throughout the centuries.

The convention of frontality was adopted by the Egyptian sculptors and observed in a large majority of their monumental works. The face usually was made to stare straight forward, and the body was so disposed that a plumbline dropped from the forehead would bisect the bulk of the figure perfectly. A leg may be advanced or an arm lifted, but the two halves of the body have the appearance of equal weight. Few of the asymmetrical arrangements and angular posturings that enliven late Greek art are to be found. The Egyptians were obsessed with the fundamental order or system of the human body, while the Greeks played upon its every variation and chance singularity.

Most Egyptian sculpture was destined for tombs. The owner's double was placed in the tomb as a housing for the soul—or, it may be, to act for the mummified one—and servants and beloved companions and familiars were placed close by to prolong the pleasures of living that were dearest to him. The Egyptian accepted the fact of the afterlife and, sensibly, he set about to prepare for it as best he could. Far from being a symbol of sorrow, uncertainty, and gloom, his tomb was looked upon as his happy home for eternity.

If the sculptures we know best are likenesses of the tomb-builders (or likenesses of the gods), this is because the artists put their profoundest love and exertion into the portraits, as being central to a man's happiness. There are, in addition, innumerable minor sculptures and uncounted relief murals in which have been fixed the familiar life, the joys and the ceremonies, the human and animal companions, the musicians, and the dancing girls; but obviously the sculptors did not give their best efforts to these secondary themes. The unending rows of little models of houses and granaries and bakeries, and people and animals, though fascinating as illustrations of a mode of life in an ancient land, hardly warrant being lifted into the category of great art.

The simple magnitude and the eternal note belong, then, to the serious works, the images that had to do with religion, those that were designed for survival in an unending afterlife. But with the formalism appropriate to so high a purpose, the sculptor was obliged to develop a degree of realism suitable to portraiture. It would be disastrous if the man or woman portrayed were mistaken, for in the afterlife no correction could be made. Thus the sculptors took particular pains in modeling the faces of their subjects and allowed themselves a mere routine treatment of the bodies; in these we find an unashamed repetition of standard poses. A study of the heads preserved in the world's museums would seem to prove the Egyptians to be among the foremost masters of portraiture; they succeeded in revealing the individual, even to the point of psychological disclosure, but for the reason just noted the bodies often seem dull and routine.

The land, too, has its influence on the

sculptural expression. The unchanging seasonal cycle, the regular habits of the River Nile and the consequent repetitive agricultural cycle, the deserts and the cliffs: all this no doubt was related to the thinking of the sculptors, and of the priests who determined the sculptors' way of service. Incidentally the architecture—plain, massive, enduring—grew out of the topography, out of flat lands and emergent cliffs; and the sculpture, to fit the architecture, was heavy, dignified, squared.

Only once did the Egyptian sculptors depart radically from the norm established by the artists and priests of the Old Kingdom. Under the encouragement of Akhenaton, the pharaoh who introduced a new monotheistic religion, they made excursions into the realm of psychologic portraiture and stylistic expressionism. By the lucky chance of uncovering the studio of Thutmose, a sculptor at El Amarna (the capital established by Akhenaton), modern archaeologists have discovered an extraordinary collection of heads in stone and wood, and of plaster casts apparently made by the sculptor as a record of his important works. The masks go beyond mere naturalism; they are portraits not of facial aspects alone, marvelously copied, but revelations of nuances of character, of inner illumination.

The famous bust of Nefertiti, Akhenaton's queen, is on the naturalistic side, yet the inner being is marvelously suggested; the control of the physical woman by the spirit within, the shadowing forth of a soul and a mind in perfect poise, is as complete as in anything achieved in thirty-three centuries of sculptural history.

Although the portrait heads of the Eighteenth Dynasty are commonly reviewed under the rubric "realism," it is notable how character and feeling are brought to the surface. Few of the heads are without distortion: the narrowing of the face and elongation of the skull led scientists to mark the royal family as sufferers from macrocephaly or as sharing in the strange African custom of skull deformation. The escape of Akhenaton's sculptors was not into realism as commonly defined, but into a mode where reality was heightened by spiritual revelation and by the creative manipulation of sculptural materials.

After the heretic's brief reign, art returned to the old standards. However, the statues copied from ancient models show some of the influence of the Amarna sculptors, the faces being modeled with more sympathy and regard for character. The most notable later change of style came after eight centuries, in the Saitic period, with a high polish and crisp stylization of the sculptural figures. From 600 B.C. until the Romans lost the country to the Moslems in A.D. 640, the Egyptians were sometimes in bondage (to Persians, Greeks, and Romans) and sometimes in a nominal independence; but the arts never again touched the high standards set in the time of Khafre, the Twelfth Dynasty Kings, Thutmose III, Akhenaton, and the Saitic rulers. Saddest of all was the decline in the Ptolemaic era, when native sculptors tried to marry their art to that of the Greeks. The end came in the time of Cleopatra, an era of Egyptian art marked by a weak, softly conventionalized pictorialism. The early masterpieces were then sleeping underground, in a peace and security not to be disturbed until the nineteenth-century archaeologists put their spades to work.

The chronology of Egyptian civilization can be summarized as follows:

Prehistoric Period: from an undetermined date in the fifth millennium to about 3400 B.C. (Some historians prefer 3200 B.C.)

Protodynastic Period: Dynasties I and II, c. 3400 B.C. to 2780 B.C.

Old Kingdom: Dynasties III to VI, 2780 B.C. to 2280 B.C.

Middle Kingdom: Dynasties VII to XVII, 2280 B.C. to c. 1570 B.C.

New Kingdom: Dynasties XVIII to XXX, c. 1570 B.C. to 332 B.C.

Ptolemaic Period: 332 B.C. to 30 B.C. Egypt under Greek rule.

Roman Period: 30 B.C. to A.D. 364. Next, Coptic art; then, in A.D. 640, Islamic.

II

THE Stone Age flint blades of Egypt are unsurpassed, but the pottery of prehistoric and of early historic Egypt is less remarkable for its forms than for its painted decorations. There is also little sculptural feeling in the polished alabaster and porphyry vessels of the fourth millennium B.C. and only an average sensitivity is displayed in the burnt-mud, stone, and ivory figurines of the predynastic period. Occasionally the clay pieces were modeled with great vividness.

But Egyptian sculpture at the very dawn of history shows a mastery of fundamental volume-relationship and a pleasing technical finish. The alabaster *Baboon of King Narmer* is one of a few surviving pieces from Dynasty I that appear to have no sculptural antecedents. The dog-faced baboon was an animal sacred to the God of Wisdom, and this ex-

ample, the first datable Egyptian religious relic, is a work of extraordinarily fine sensibility.

The earliest relief carvings of Egypt show probable Mesopotamian or Elamite influence before 3400 B.C. A fragment of the so-called *Bull Palette* is in a technique not paralleled in known Egyptian art; and the ivory knife-handle from Gebel-el-Arak illustrated, also predynastic, is alien except for the Nilotic subject matter. On one side it vividly shows a battle scene, with apparently Asian and African fighters; on the other side a god is represented between two lions, with other animals below.

A succession of slate palettes follows the typical Egyptian pattern of low-relief sculpture with crisp outlines, the figures only slightly rounded at the edges, and the total

The Sphinx and the Great Pyramids. Dynasty IV. Gizeh. (*Archives Roget-Viollet, Paris*)

area divided into "fields." Most notable is the *Palette of King Narmer,* first king of Dynasty I, with relief compositions on the front and back. The curious Egyptian compromise of realism with convention is thus early illustrated. The faces have individual character, and all the documentation is detailed. Displayed is the artistic convention of the full-front figure fitted with head and feet in profile, and rudimentary hieroglyphs are incorporated into the design.

How far the sculptors had then gone toward realism, even naturalism, is illustrated in many of the miniature statuettes to be seen in the museums; and particularly in the ivory figurine of a king at the British Museum. There is a feeling of monumentality even in these small pieces where subtleties of pose and temperament are fixed. In the "king" even the pattern of the quilted cloak is detailed, without loss of massiveness. Yet it is less than four inches high.

There are gaps of centuries in the 3000-year span of Egyptian art, gaps in achieve-

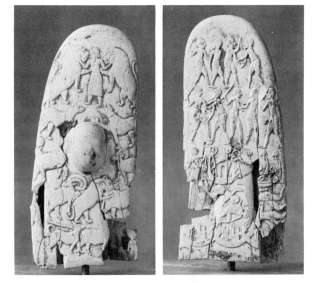

Relief on knife handle. Ivory. Pre-Dynastic. Gebel-el-Arak. *Louvre.* (*Giraudon photo*)

Figure of a man. Stone. C. 3200 B.C. *Ashmolean Museum, Oxford*

Baboon of King Narmer. Alabaster. Before 3200 B.C. *Dahlem Museum, Berlin*

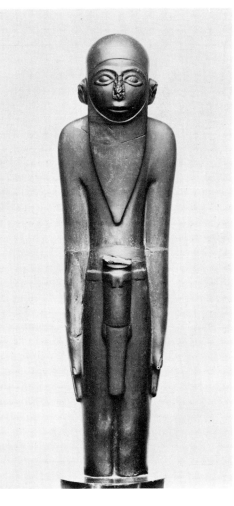

ment rather than in data. Between Narmer and the Pyramid of King Cheops (Khufu) at Gizeh little notable sculpture survives, and the stone *Hippopotamus,* shown on page 33, alone may serve to illustrate three hundred years of effort. About 2900 B.C., however, the story was resumed, and the qualities found in the sculptures of Narmer's era appear again on a larger scale and in greater magnificence. The kings of the Fourth Dynasty were the builders of the great pyramids, which represent colossal pieces of abstract sculpture rather than the designs of an architect. Cheops and Khafre (probable King of the Sphinx) and Mycerinus, who are known to sculptural history through imposing portraits, were rulers during the 120 years of the dynasty.

Sculpture was already massive and fairly realistic, as indicated in the limestone portrait heads discovered in tombs at the extensive "Cheops Cemetery" at Gizeh beyond the pyramids. (The portrait head of a princess shown, unlike most museum heads from Egypt, was designed without a body.) As for the Sphinx, the monument, 66 feet high, has been mutilated by the ravages of time and

Figurine of a king. Ivory.
Dynasty I, before 3200 B.C.
British Museum

Palette of King Narmer. Stone.
Before 3200 B.C. Hierakonpolis. *Cairo Museum*

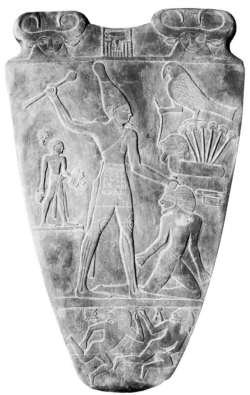

Portrait head of a princess. Stone.
Dynasty IV, c. 2640 B.C. Gizeh.
Museum of Fine Arts, Boston

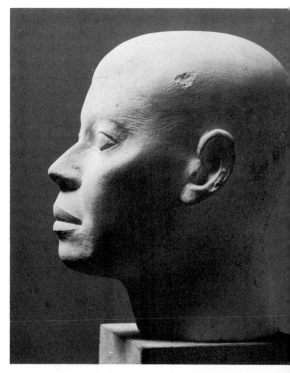

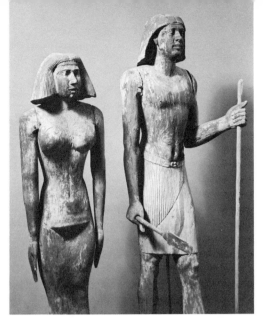

Mitry and His Wife. Wood. Dynasty V.
Metropolitan Museum of Art, Rogers Fund

Mycerinus and His Queen. Stone.
Dynasty IV, c. 2580 B.C. Gizeh.
Museum of Fine Arts, Boston

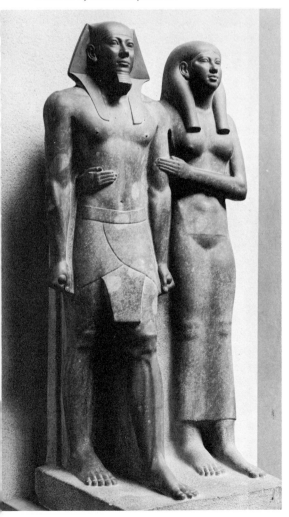

by misguided restorers, yet it still retains something of the sculptor's intention. The monarch, ennobled, looks out over mankind thoughtfully and benevolently. Not only the imposing size but a sculptural calm lends majesty and remoteness to the figure.

There is one perfectly preserved work which exhibits majesty and remoteness without recourse to oversize dimensions. The seated *King Khafre,* in hardest diorite, is a magnificent portrait statue. Beautifully conceived and sensitively modeled and finished, this monument is essentially Egyptian in its solidity and simplification. Originally there were twenty-three other large statues of King Khafre in the funerary chamber, cut in varying types of stone, but only nine survive.

King Mycerinus is often depicted in sculpture with the gods; but never is he shown more appealingly than in the double portrait of *Mycerinus and His Queen,* an almost life-size monument. As portrait and as sculpture the composition is less vital than the seated Khafre; and indeed the trend of sculpture was downward after Khafre's reign. But in comparison with similar double portraits of the Eighteenth and other late Dynasties, it is definitely superior.

Usually only the face is lifelike in Egyptian portraiture, but in the torso of the *Woman* at the Worcester Art Museum the loveliness of the feminine body has been interpreted, not with the naturalism of the Greeks but with reticent formalization. The figure is almost column-like in its slimness, but it loses nothing of the melodic curves of the model. There are examples of a more forced and lighter type of expression in swimming girls that appear as spoon-handles. The stylization is deliberate and sophisticated, and the slender figures are in strong contrast to the heavier sculptures made to appear in or near tombs.

The famous statue known as *The Village Magistrate* demonstrates a peak of naturalistic art reached in the Fourth and Fifth Dynasties. Egyptian diggers who uncovered the statue at Sakkara recognized the likeness, so true to the type of petty functionary known

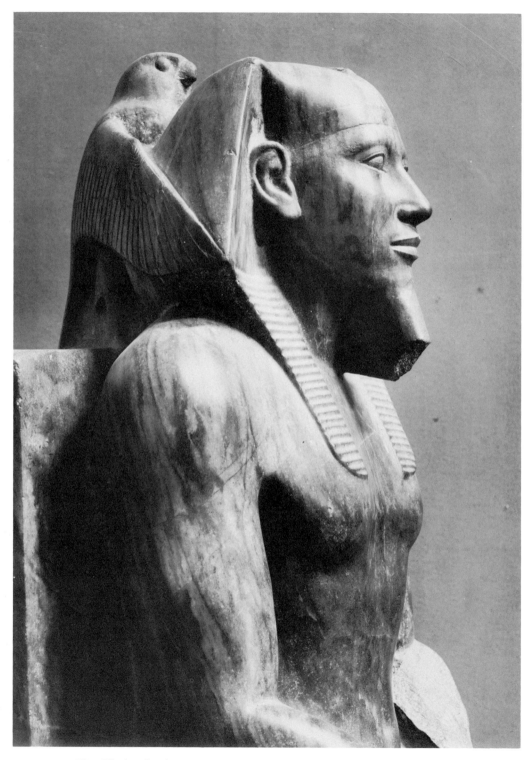

King Khafre, detail. Stone. Dynasty IV, c. 2620 B.C. Gizeh. *Cairo Museum*

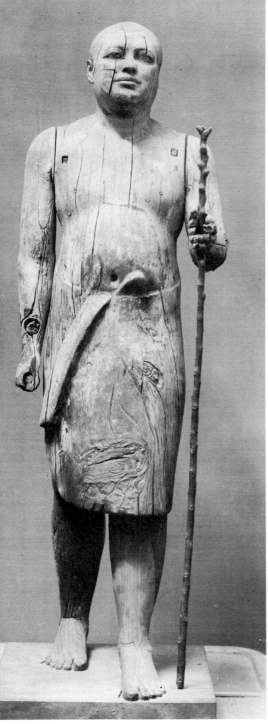

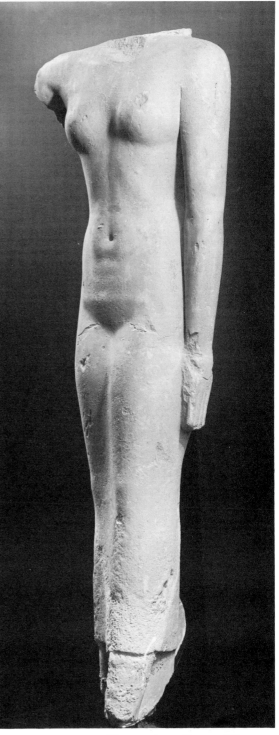

The Village Magistrate. Wood.
Dynasty IV. *Cairo Museum*

Woman. Stone. Dynasty IV.
Worcester Art Museum

in Egypt even today. When the statue was found, the face still had part of its coating of stucco and color.

Painting, in a few conventional tints, was common both in stone sculpture and in wood. However, stones susceptible to high polish, such as diorite or basalt, were left unpainted. On the other hand, practically every limestone figure had its heightening envelope of color. The *Nude Walking Figure*, of the Fifth Dynasty, often singled out as one of the outstanding masterpieces of Egyptian sculpture, is a conventionalized type in a standard pose and as such lacks something of the sheer plastic beauty of the masterpieces produced under the Fourth Dynasty. Hundreds of figures were similarly disposed, with face and eyes straight forward, the two halves of the body symmetrically balanced except for the advanced left leg. This stance was copied by the Greeks eighteen centuries later for their Apollos or kouroi.

Another standard type is that of the scribe, seated cross-legged with a papyrus roll spread on his lap. The pose affords opportunity for the rhythmic massing of volumes, and particularly in the examples from the Fourth and

Fifth Dynasties, as in the two *Seated Scribes* illustrated, there is notable play and counterplay without disturbance of the rather heavy main rhythm.

The scribes, again tomb figures, are to be seen in most of the larger art museums. The example from the Louvre is more than usually naturalistic, with hardly a trace of the conventions that so often lead scholars to criticize Egyptian sculpture as rigid and unnatural. It is exact realistic portraiture, heightened by insets of quartz, rock cystal, and copper in the eyes.

The nude *Ha-Shet-Ef,* a young noble, is exceptionally animated. The sleek stylization does not detract at all from naturalness. The sculptor has not been hampered by the conventional runner pose, used so woodenly in innumerable routine portraits. So much realism and free action in this type of sculpture were not to be achieved again until the seventh and sixth centuries in Greece.

The mutilated *Senedem-ib-Mehy* bears such a likeness in technique that it might be from the same hand. The figure is ascribed to the Sixth Dynasty, a full thousand years after

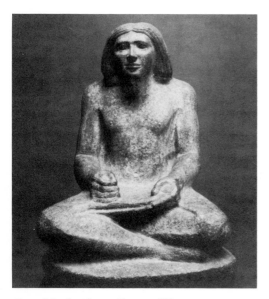

Seated Scribe. Stone. Dynasty IV. Gizeh. *Dahlem Museum, Berlin*

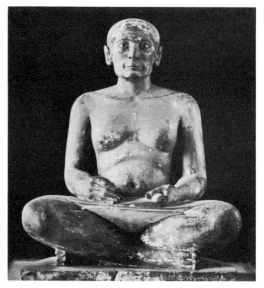

Seated Scribe. Stone, painted. Dynasty V. Sakkara. *Louvre.* (*Giraudon photo*)

King Narmer; roughly, from the thirty-fifth to the twenty-fifth century B.C. The period from Dynasty I to Dynasty VI was known as the Old Kingdom, ending in 2280 B.C.

The Old Kingdom was a golden age of relief sculpture. From Dynasty III there exists a series of three portrait reliefs of Hesire, on wooden panels. These were found in his tomb. The one illustrated, showing the accessories of his office, includes a scepter and writing materials. The usual conventions of relief depiction are observed, the head, the knees and the feet occurring in profile, the upper body full front. There is a liveliness in the figure, and a special linear grace. The modeling is exceptionally varied and complete for the period.

Nude Walking Figure. Stone.
Dynasty V. Sakkara. *Cairo Museum*

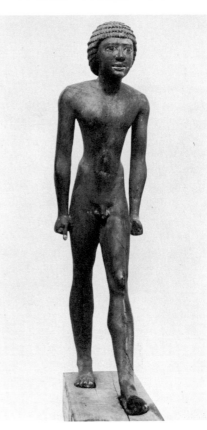

Ha-Shet-Ef. Wood. Dynasty VI.
British Museum

Senedem-ib-Mehy. Wood. Dynasty VI.
Gizeh. *Museum of Fine Arts, Boston*

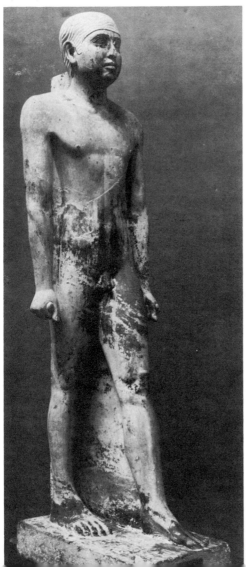

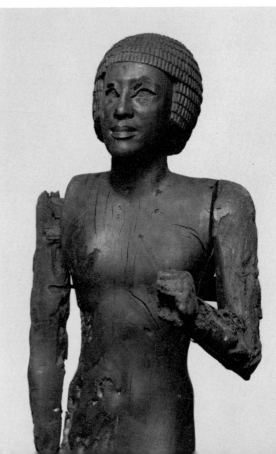

It was not until the Fifth Dynasty that interior tomb walls were covered, like the pages of a vast stone picture book, with representations of every activity dear to the owner. Hunting and boating and wrestling, plowing and harvesting, herding and milking, carpentering and accounting, marketing and cooking, wildcats and birds, pet donkeys and calves and ducks, musicians and dancing girls, the offering of gifts and sacrifices to the gods, the mourners and the priests, the funeral procession and the feast; all this and whatever else was important to the man during his lifetime formed the subject-matter of the low-relief sculpture on the walls of his tomb.

Today the reliefs afford a valuable record for the fact-seeker, and there is much in the display besides to delight the art-lover. The reliefs on stone were usually painted, and on the bare spaces between figures or groups of figures there is often a running commentary in hieroglyphics.

At the end of the era of the Old Kingdom there was a period, roughly from the Sixth to the Eleventh Dynasty, early in the Middle Kingdom, when there were no kings of united Upper and Lower Egypt. This feudal age was less important for its sculpture. A statuette, *Woman*, in wood, now in the University Museum at Philadelphia, indicates how few changes occurred between the Fourth and

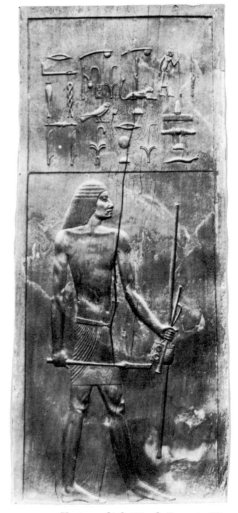

Hesire, relief. Wood. Dynasty III. Sakkara. *Cairo Museum*

Interior wall of tomb, bas-relief. Stone. Dynasty V. Sakkara. *Museum of Fine Arts, Boston*

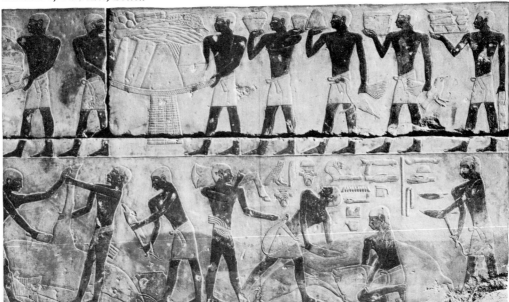

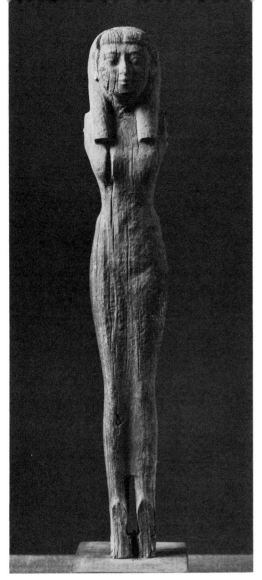

Twelfth Dynasties. Also introduced here are examples of minor sculptural arts, a pottery perfume spoon from the Toledo Museum and two glazed animals (without regard to date). The miniature hippopotamuses, often blue-glazed and traced over with conventionalized drawings, are especially engaging.

During the Twelfth Dynasty a renaissance occurred and some of the old magnificence of sculpture was recaptured. Although the artist's touch is not so sure or so sensitive as it was during the Old Kingdom period, there are portrait statues of Amenemhet III that could hardly survive from any but a great sculptural era. A solid art of stylization, at once massive and crisp, returns, too, in the lesser statues.

Perfume spoon. Faïence. C. 12th century B.C.
Toledo Museum of Art

Woman. Wood. Dynasty XII.
University Museum, Philadelphia

Interior wall of tomb, bas-relief. Stone.
Dynasty VI. Sakkara. *Cairo Museum*

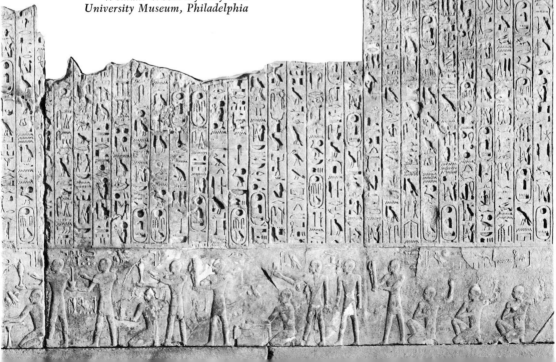

The stone statuette, *Man*, from the Louvre is strikingly simple and alive.

Most notable, however, is the return to large, essentially stonelike effects, especially in the sphinxes. These may seem a little dull compared to the king portraits of a millennium earlier, but they are imposing nevertheless. There is dispute among the archaeologists as to the dating of the smaller obsidian head of a king (now in Lisbon) shown here. Sometimes it is identified as a portrait of Amenemhet III, and, though it is certainly very much in the tradition of the time, a few authorities would place it in the Saitic period, more than a thousand years later. This points up the fact that the changes of style and method in Egyptian sculpture are slight, even over periods embracing millennia. The changelessness is due largely, no doubt, to the domination of the art by the priesthood. But whether of the Twelfth Dynasty or the Twenty-sixth, the head is a superb piece of portraiture.

The fine *Bellowing Hippopotamus* in the British Museum is a massive clay piece which once was glazed. It is the sole illustration from a period of two centuries when the country was again disunited or held under foreign domination and when art expression was largely stifled.

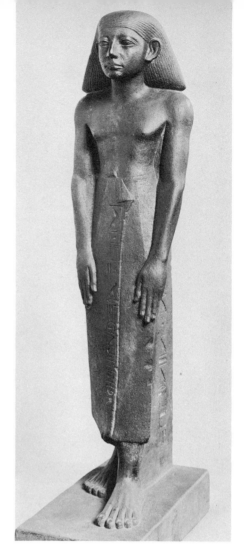

Man. Stone. Dynasty XII. *Louvre*

Hippopotamus. Faïence. C. 2000 B.C.
Collection of Mr. and Mrs. A. Bradley Martin, courtesy Brooklyn Museum

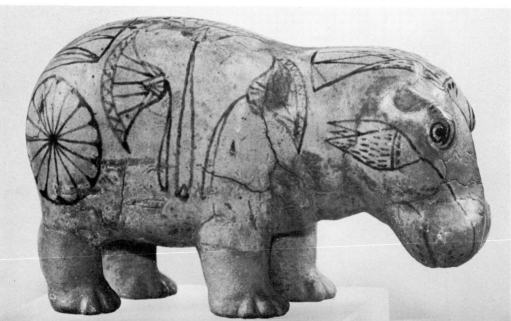

About 1580 B.C. the Eighteenth Egyptian Dynasty came into power, and at the opening of this New Kingdom period, sculpture began one of its cyclic upswings. The over-life-size statue of Queen Hatshepsut, who reigned in the early fifteenth century B.C., exhibits a sleek delicacy new to monumental sculpture. A fresh convention, the banded eyebrow with parallel extension of the line of the eyelid, adds to the alert expression of the face.

A great many statues of the period indicate that some of the sculptors had developed a mechanical routine. A smooth mechanical effectiveness replaced the virility of earlier work. However, the statue of Thutmose III, nephew of Queen Hatshepsut and her successor on the throne from 1468 B.C., is an exception. The massive sculptural beauty that had characterized the best Old Kingdom portraits appears here, especially in the head, without loss of surface sensibility.

The Eighteenth Dynasty covered one of the great periods of luxurious living at court, and new lavish standards of sculptural embellishment were established in connection

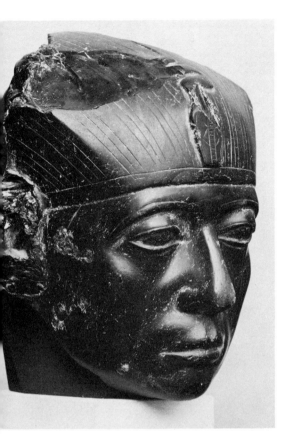

Head of a King. Stone. Dynasty XII, c. 1820 B.C. *Calouste Gulbenkian Foundation, Lisbon*

Bellowing Hippopotamus. Clay, glazed. Dynasty XVII. *British Museum*

Monkey. Faïence. C. 1400 B.C. *Brooklyn Museum*

Headrest simulating a hare. Wood.
C. 1400 B.C. *British Museum*

Queen Hatshepsut. Stone. Dynasty XVIII.
Over life size. Deir el Bahri.
Metropolitan Museum of Art

with the temples. Quality gave way to quantity as figures, imposing in size, were duplicated along corridors and avenues. But the stone *Lion* from Nubia, created in the fourteenth century—a little before the peak of ostentatious building—retains its sculptural vitality.

Equally fine, in a minor way, is the headrest simulating a hare. The exaggerated stylization seems quite un-Egyptian. It is known that from the time of Thutmose III—named the Egyptian Napoleon for his imperial triumphs—to the reign of Amenhotep III, three generations later, art-objects from Crete and from Mesopotamia appeared in the markets of Thebes; but there is no evidence that the headrest is of other than Egyptian workmanship.

By the time of Amenhotep III, that is, in the first half of the fourteenth century, mural sculpture had gone through many changes and had arrived at the rich, almost baroque decorativeness displayed in the fragment of a stele illustrated as *Amenhotep III in His Chariot.* The double portrait—a left half of the relief repeats in reverse the right half shown—is a glorification of the king as a military hero. The small figures represent captives.

That some of the more engaging qualities of the ancient style persisted at this time is sufficiently illustrated in the simple statuettes of two brothers, in silver and wood, in the Metropolitan Museum of Art. Made as portraits when the boys died, and later placed in their mother's grave, the images are factual and lifelike. Most statues in ancient times portrayed boys as little old men, but here the characteristics of the childish face and figure were well observed and executed.

In the whole course of civilization there is no stranger transformation of a national art than that which occurred in Egypt in the reign of Amenhotep IV, or, as he renamed

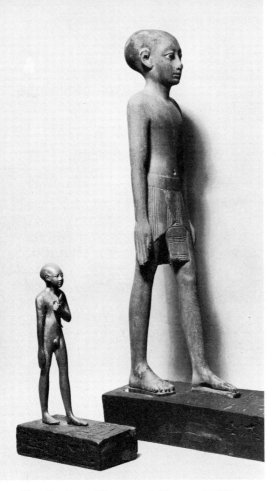

Two Brothers. Silver; wood. Dynasty XVIII,
c. 1500 B.C. *Metropolitan Museum of Art.*
(*Photo by Charles Sheeler*)

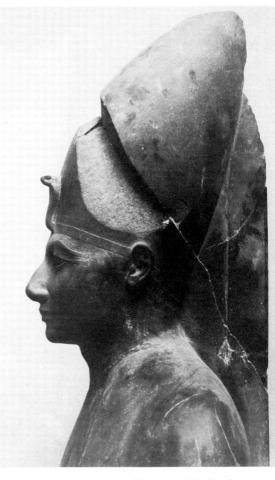

Thutmose III, detail.
Stone. Dynasty XVIII.
Cairo Museum

Lion. Stone. Dynasty XVIII.
Soleb, Nubia. *British Museum*

himself, Akhenaton. He introduced a reform religion, Egypt's first monotheistic faith, and, while suppressing the old gods and the powerful priesthood, he undertook vast works of public building. As part of the new order, Akhenaton freed artists from traditional restrictions and encouraged individual expression. The Amarna school of sculptors—so named from the new capital city—aimed at realistic portraiture, while expressing the inner character of the sitters. The plaster heads or masks of the fourteenth century B.C. unearthed in the studio of Thutmose, such as those of Akhenaton and Nefertiti, may have been in the nature of artist's trial pieces, but there is no mistaking the touch of a master artist striving toward realism.

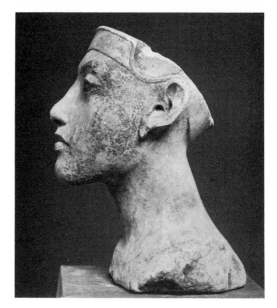

Head of Nefertiti. Plaster. Dynasty XVIII. El Amarna. *Dahlem Museum, Berlin*

Amenhotep III in His Chariot, detail of stele. Stone. Dynasty XVIII. Thebes. *Cairo Museum*

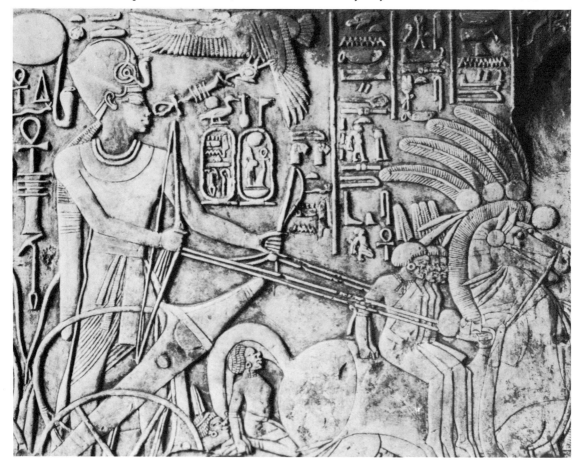

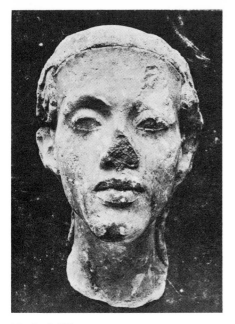

Head of Akhenaton. Stone. Dynasty XVIII.
El Amarna. *Dahlem Museum, Berlin*

Queen Nefertiti. Stone, painted.
El Amarna. *Dahlem Museum, Berlin*

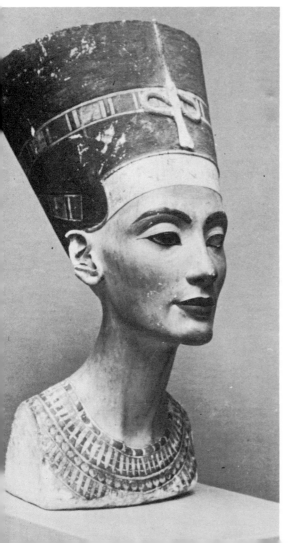

The lovely painted limestone portrait of Akhenaton's queen, Nefertiti, is the most celebrated of the finds at El Amarna. A perfect example of its kind, this head can fairly be analyzed as a realistic presentation of both the external and the inner beauty of the model. Nothing so lifelike had been known up to this time. But the sculptor departed from nature sufficiently to make the head more than a surface copy; he emphasized the clear-cut outlines, exaggerated the slimness of the neck and shoulders, and underlined the tilt of the head. The full coloring has survived, perhaps unfortunately, for while color was doubtless thought of as a naturalistic innovation, the ancients were not masters of this particular art. Many art-lovers who have enjoyed the bust of Nefertiti in black-and-white photographic illustration have been disappointed to find the original fully and uncompromisingly painted in bright colors.

In the brown sandstone and plaster heads of Nefertiti and of her daughters in the same collection, there is less of the subtle charm of the model, but certainly attainment of creative sculptural form.

The artists at El Amarna did not pursue their naturalistic course for long. A new sort of conventionalization soon appeared, marked especially by an enlargement of the eyes, nose, and lips, and insistence upon the egg-shaped form of the head. The elongation of the skull, which scientists have attributed to advanced cases of macrocephaly in the royal family, occurs so frequently that it may be a compositional convention. In the reliefs of the period the servants and, one fancies occasionally, even the animals have it. In extreme cases, as in the royal family heads shown, there are abstract sculptural values gained in the arbitrary manipulation of the oval.

With the passing of Akhenaton the reforms he had introduced and the innovations he had fostered in the arts disappeared, and the old gods and the priesthood were reinstated. Only faint influences from the Amarna school lingered on in sculpture. Yet here *Tutankhamen as the Moon God*, in the massive old

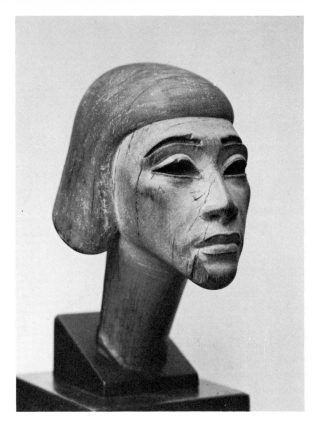

Royal family head. Wood. Dynasty XVIII. El Amarna. *Louvre*

Royal family head. Stone. Dynasty XVIII. El Amarna. *Dahlem Museum, Berlin*

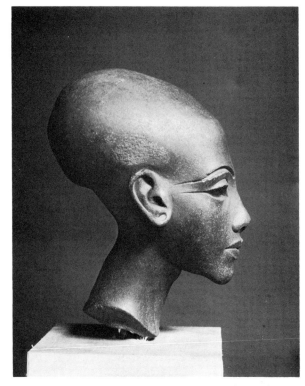

style, suggests that the statue may well be of the time of Tutankhamen but from the hand of one of the surviving sculptors of Akhenaton's group.

It was the Pharaoh Tutankhamen, son-in-law of Akhenaton, who restored the old gods and returned art to the traditional path. At the same time he revived old ideals of luxurious living and ostentation which led to a florid exuberance in the arts and crafts. Most of the furniture and statuary that was so widely publicized at the time of the discovery and stripping of Tutankhamen's tomb is decadent in taste and meretricious as art. The pharaohs of the Eighteenth Dynasty left some beautiful and craftsmanlike relics, but degeneration had set in, and there were to be only two notable revivals before the coming of the Greeks: the Ramesseid of the Nineteenth and

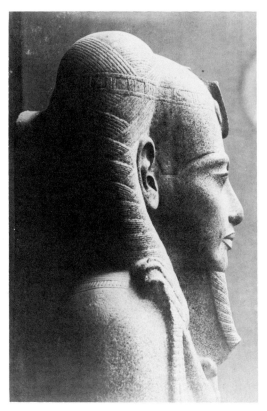

Tutankhamen as the Moon God. Stone. Dynasty XVIII, c. 1350 B.C. Karnak. *Cairo Museum*

Twentieth Dynasties, and the Saitic of the Twenty-sixth.

The Eighteenth Dynasty failed to restore the best ideals of relief sculpture, and the wall carvings of the Amarna interlude did not reach the standard of the sculpture in the round. As so often in the tombs, the incised or carved murals were endlessly interesting as reports on contemporary life but in general were inferior as art expression. During the Nineteenth Dynasty a certain elegance of design was attained in exquisitely carved but generally overcrowded panels. One of the panels illustrated is at Abydos, from the era immediately following Akhenaton.

In the Ramesseid period, the time of the glories of Karnak, the sculptors recaptured something of the dignity of monumental sculpture. The bodies were mass-produced and, more often than not, lifeless and dull, but the faces were occasionally lit up by the sculptor's success in capturing the spirit of his

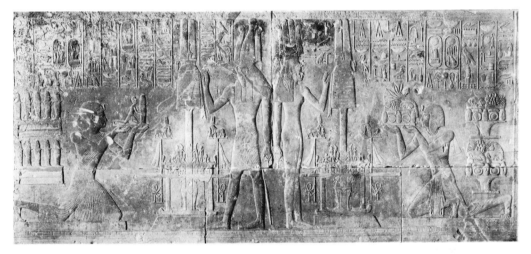

Offerings of Gifts, relief, detail. Dynasty XIX,
c. 1315 B.C. *Metropolitan Museum of Art*

Relief, detail. Temple of Seti I, Abydos.
(*Sebah photo courtesy Giraudon*)

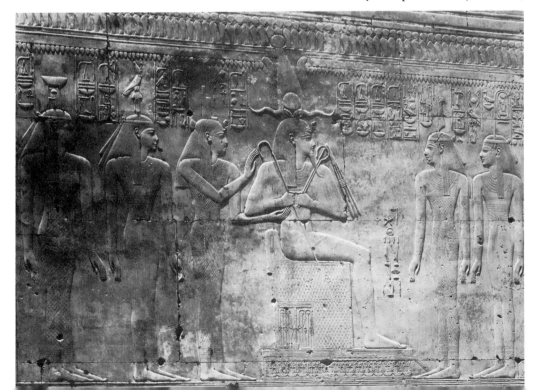

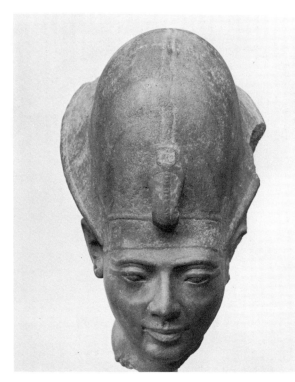

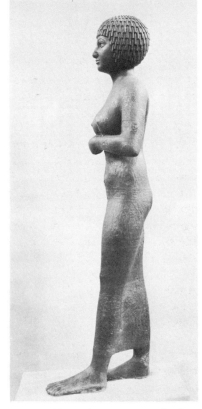

Head of Rameses II. Stone. Dynasty XIX,
c. 1290 B.C. *Metropolitan Museum of Art*

Statuette of Takushet. Bronze with silver
inlay. Dynasty XXV, c. 700 B.C. Bubastis.
National Museum, Athens

Rock-cut Temple of Amon at Abu Simbel. Dynasty XIX, c. 1250 B.C.

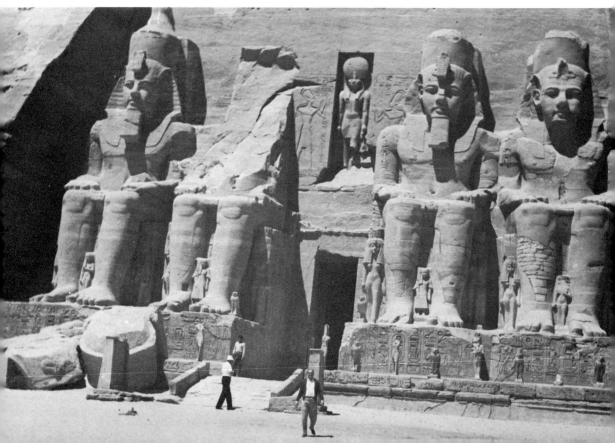

model. The head of Rameses II in the Metropolitan Museum is one of the finest relics of the era and reminiscent of the best work done at the time of Thutmose III.

What the sculptors of the reigns of Rameses II and Rameses III lost in creative sensibility they tried to make up for in volume. The temple at Karnak and the rock temple at Abu Simbel are embellished by an almost incredible number of colossal stone figures. At Karnak these were transported to the site. At Abu Simbel the figures (seen in the illustration) are 80 feet high and carved in the face of the cliff. Behind them the temple halls are hewn out of the solid stone to a depth of 120 feet, with two rows of similar colossi in the great hall. Some of these relics have been saved from the flood waters caused by the construction of the high dam across the Nile. Many of the monuments are impressive from sheer magnitude and repetition, but subtlety at that time was no longer the companion of monumentality.

Five dynasties and as many centuries passed before another memorable renaissance occurred. As an empire Egypt crumbled; then toward the end of the dark age, in the so-called Ethiopian period, there was a fresh outlook, and new activity in small sculpture. In the past, Egyptian sculpture, while paying minimum attention to the human body, produced the most beautifully sculptured heads. Now the feminine body began to be studied and its volumes and curves were sympathetically interpreted, as seen in the statuette of Takushet. Artists delighted in showing the soft modulations of the flesh under drapery, as the Greeks were to learn to do later.

During the Twenty-sixth Dynasty (in the seventh and sixth centuries B.C.) Egyptian art flowered for the last time. Artists of the Saitic period revived the dignity of large portraiture; the integrity of the stone block was again respected, and craftsmanship again attained a high level. Typical of this period is the polished surface of both large and small sculptures. There is something essentially Egyptian about the portrait of Prince Wa-ab-Ra, a quality felt in the *Baboon of King Narmer,* created twenty-five centuries earlier, and in many examples through the centuries. Now the block figure is realized with the least possible interference from detailing of arms and legs, and the squared mass is burnished.

Although Saitic art is notable for its craftsmanship and an almost silky stylization, there is a series of pieces in which heavy patterning is added in the arbitrary folds of the drapery. The stone *Woman* in the Louvre shows more than usual vigor in the modeling, and a nice feeling for the effects that arise from a slight asymmetry. The innumerable sleek statuettes of Neit, the warlike sky-goddess in the Saitic pantheon, are perhaps more in character. By this time even the religious figures had become very human, with carefully sculptured bodies.

Prince Wa-ab-Ra. Stone. Dynasty XXVI, c. 570 B.C. *Louvre.* (*Alinari photo*)

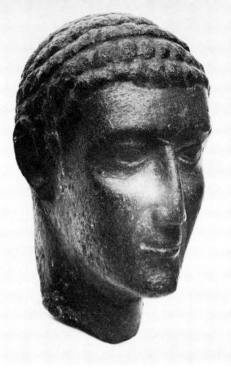

Head of a Man. Stone. Egyptian, 1st century A.D. Lowie Museum of Anthropology, University of California, Berkeley. (Photo by Ron Chamberlain, courtesy University Art Museum)

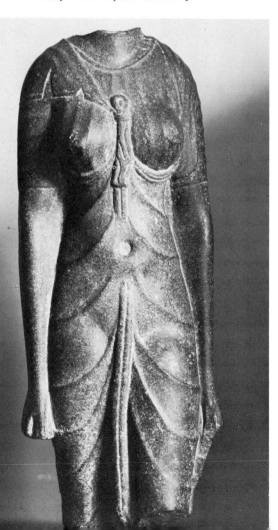

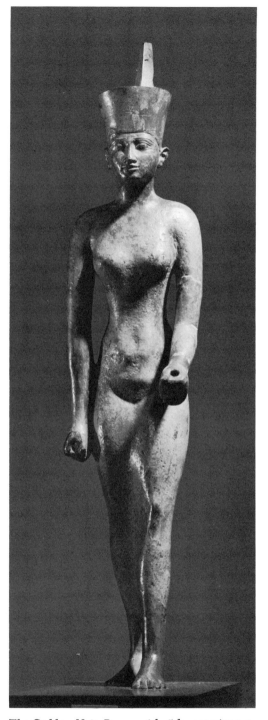

The Goddess Neit. Bronze. 6th–5th centuries B.C. University Museum, Philadelphia

Woman. Stone. 7th–6th centuries B.C. Louvre. (Giraudon photo)

The cat, about which a cult centered in late Egyptian history, was a frequent sculptural subject from the Twelfth Dynasty on. Among the thousands of known bronzes, the best are likely to date from the Twenty-sixth Dynasty, when the trend toward simplification and formalization was still strong. However, the cat-lover will find many statuettes to please him from all periods down to the Egypto-Greek Ptolemaic.

The falcon too was sacred and the subject of widely varying interpretations. Probably none is finer than the illustrated black basalt example in the Louvre, handled with typical Saitic formalization. Here again the late Egyptian perfection of craftsmanship is demonstrated.

The Thirtieth is the last truly Egyptian dynasty of kings. Of the mid-fourth century B.C., it preceded the second Persian conquest of Egypt, a decade before the coming of Alexander the Great. The only illustration from this Sebennytic period, *Prince Nechthorheb*, shows, appropriately, an uncompromisingly stonelike statue with something of the true Nilotic feeling of the eternal in it. It is dignified, majestic, serene.

Perhaps the finest of the relief sculpture of the Saitic epoch appeared on the granite and basalt sarcophagi. The smaller space to be covered led to a crisp, shorthand type of stylization. A good deal of earlier idiomatic method, even of rigid conventionalization, remained, coupled with late-period sophistication. The reliefs shown possess the old granite feeling with a subtle, new, almost decadent grace. These reliefs, covering the sarcophagus of the priest Taho, son of Petemonkh, are now in the Louvre.

A fragment of a relief created two centuries later shows an undulating, ribbon-like composition with stylized and somewhat distorted forms. The piece is in the museum at Providence, Rhode Island.

The Ptolemaic period followed generations of cultural interchange with Greece, yet the Egyptians were still able to produce such typically national monuments as the temple

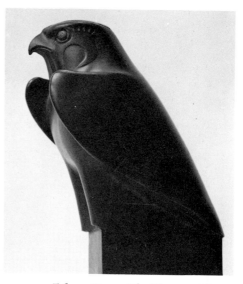

Falcon. Stone. 7th–6th centuries B.C. *Louvre.* (*Archives Photographiques*)

Prince Nechthorheb. Stone. Dynasty XXX, c. 350 B.C. *Louvre*

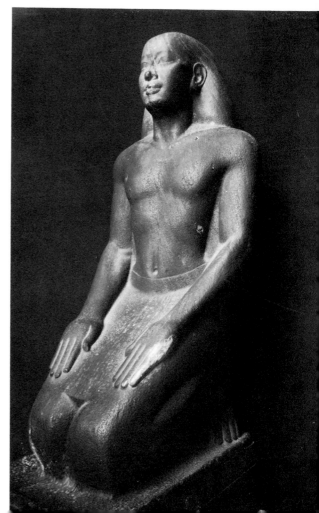

Facing page: Details from Sarcophagus of Taho. Stone. Dynasty XXVI.
Above: Journey of the Sun through the Underworld of Night.
Center: Osiris Enthroned. Louvre. (Alinari photos)

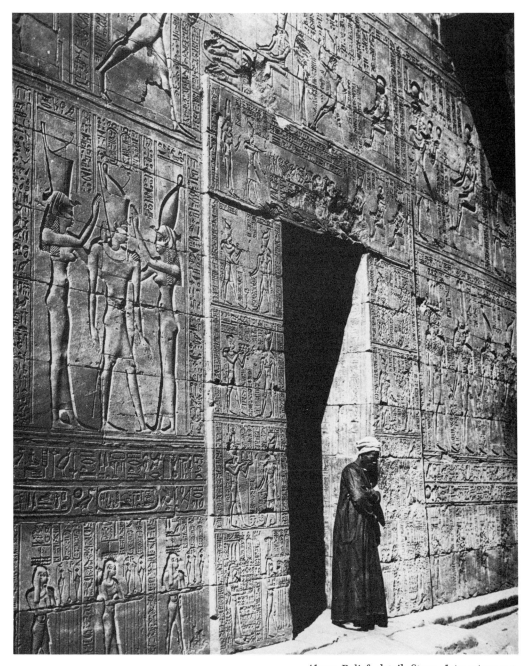

Above: Relief, detail. Stone. 1st century B.C.
Temple of Horus, Edfou. (Archives Roget-Viollet)

Foot of facing page: Offering Scene, relief.
Stone. 3rd–1st centuries B.C.
Temple of Horus, Edfou

of Isis at Philae and the temple of Horus at Edfou. However, by now portraiture in the round was measurably inferior and the portrait heads in relief (made specifically for mummy-cases) were generally dull and negligible as works of art. By comparison the picturing on temple walls was still characteristic and interesting, but the bulginess of the bodies and the relaxing of the geometrical idiom made the figures sit less well in their architectural settings.

Mural and relief art on a small scale carry the story of typically Egyptian sculpture into a period when statues in the round reflected complete decadence. Thirty centuries had now passed since an unknown sculptor fashioned the *Baboon of King Narmer*.

The most interesting late relic is the fine portrait head in the Lowie Museum (illustrated on page 56). It shows a new influence, that of candid Roman portraiture. It is carved in Egyptian stone, and the way of statement has the old Egyptian integrity. But the curls are in an idiom not to be found in earlier native sculpture, and there is a freshness of aspect that may be considered classic. Clearly the Egyptian and the Greco-Roman traditions have met.

King, fragment of relief. Stone.
C. 300 B.C. *Museum of Art, Rhode Island School of Design, Providence*

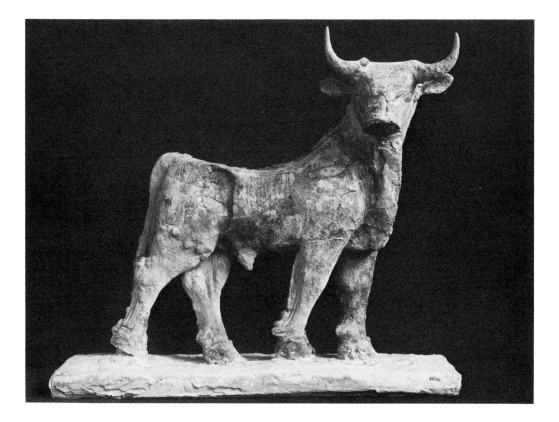

3: The Mesopotamian Pageant:

Sumer, Babylonia, Assyria

I

THE images that Rachel stole from her father were in all likelihood examples of the clay figurines portraying gods or goddesses that are known to have existed in abundance in ancient Mesopotamia and other Near Eastern lands. These figures, originally designed as fertility fetishes, are found at Stone Age levels and at succeeding stages in Mesopotamian, Syrian, and Palestinian history. Before the Flood, the making of clay gods had become an industry, originating possibly in Susa (the biblical Shushan), in Shinar (Sumer), or in the Babylonian centers of the north. Mesopotamia, the original Garden of Eden, was the cradle of commerce; it was here that systematized manufacturing first developed. The Sumerians even evolved a method of mass-production, using molds for casting the "abominable idols" so often referred to in Old Testament history.

Bull. Copper over wood. Before 3000 B.C. Al-Ubaid. *University Museum, Philadelphia*

From beginning to end, the Sumerian-Babylonian-Assyrian achievement in the figurative arts must be considered as second-rate. But in other directions the Eurasian world owed these peoples an immense debt; theirs was the first written language, the first stable state government, and the first practical numbering system. Decisive strides were also made in law, astronomy, agriculture, architecture (including the development of the arch), mechanics (the first wide use of the wheel), medicine, and literature. Sculptural art, however, is represented by only two noteworthy achievements: one, the art of seal-cutting, which reached a proficiency hardly matched elsewhere at the time; and the other, large bas-relief in stone, to which the Assyrians brought an incomparable realistic precision.

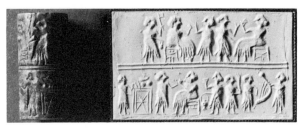

Cylinder seal, stone, and impression.
Sumerian, c. 3000 B.C. Ur.
University Museum, Philadelphia

In the realm of monumental sculpture, the Mesopotamian artists were greatly inferior to their Egyptian contemporaries. Their larger pieces contain no mystery and little grandeur. The artists were sensitive only to natural shadings; they were masters only of realistic interpretation. This is engagingly demonstrated in the animals they hammered out of copper (dating as early as the *Baboon of King Narmer* in Egypt), and in their war and hunting scenes carved in bas-relief on stone in the ninth, eighth, and seventh centuries B.C.

Herodotus noted that every Babylonian carried a seal and a cane. Perhaps the scarcity of stone in the Valley of the Two Rivers dictated the small-scale stonecutting practiced there. In any event the cylinder seals best show the development of the national artistic talent, from rude expression to a masterly style, through fluctuations of flowering and decline and reflowering, in the vicissitudes of Sumerian, Babylonian, and Assyrian dominance. There is no book on Mesopotamian sculpture as a whole that exerts the fascination of any one of several books reproducing collections of seals.

The examples illustrated are, of course, *impressions* from the seals, not the seals themselves. For display purposes, museums roll the sculptured or engraved cylinder (a negative) over tablets of wax or plaster of Paris to produce positive images. Originally the owners of the seals rolled them over clay stoppers or on tablet-markers, to signify ownership. In a dozen examples of this most personal of the sculptural arts, I have tried to present uninvolved ornamental designs: simple, readable compositions where the figures are clear and sharp against an unbroken background, as befits a miniature art. In their seals, the Sumerians and Babylonians produced a distinguished, graceful stylization.

By comparison, the monumental sculptures are usually schematic and stiff; exceptions are to be found in the marvelous series of reliefs beginning with the ninth-century battle scenes from the palace of Assurnasirpal and progressing, over two centuries, to the days of Assurbanipal. During the latter period a series of spirited documents was carved in stone. As realistic reporting, these have hardly been rivaled in the entire history of art. The subjects that the Assyrian bas-relief sculptor excelled at were animals, particularly bulls, lions, horses, and dogs. These he seemed to enjoy portraying more that he did the human figure. In carrying out a royal commission, the artist was probably more self-conscious in the way he depicted his king-master. While plunging his royal lance into the throat of a lion, the king appears stiff and wooden, but the movement and the agony of the animal are represented realistically and without restraint.

The sculptured records of life in Mesopo-

tamia, after the Sumerian decline, tell us that the kings were brave, mighty, cruel, and sadistic. The background, century after century, suggests a combination of luxurious living, hunting, and a quest for military glory. The artists, like their patrons, had to be materialists; the one exception was in the delineations on the seals.

Impression from seal. Babylonian.
Babylonian Collection, Yale University Library

*Contest of Heroes with Lions and
Water Buffalo.* Impression from stone seal.
Akkadian, c. 2400 B.C.
Walters Art Gallery, Baltimore

For easy reference, the periods of Mesopotamian history are listed below:

Prehistoric or Predynastic Period: From a time well before the Flood (sometimes dated 4000 B.C., sometimes several millennia earlier) to c. 3100 B.C.

Early Dynastic or Sumerian Period: From c. 3100 B.C. City-states of Kish, Uruk, Ur, etc.

Sargonid Period: From c. 2340 B.C. Sumer ruled by Semitic invaders led by Sargon of Akkad. Sometimes known as Period of Sumer-Akkad.

Neo-Sumerian Period: From c. 2125 B.C.

Babylonian Period: From 2000 B.C. The Semitic Amorites invaded Sumer, founded Babylon, and, under Hammurabi, sixth king of the dynasty, formed the country Babylonia out of Sumer and Akkad.

Period of the Assyrian Empire: From c. 1270 B.C. From Assur, a city or city-state in the far North, the Assyrians spread southward and over several centuries conquered Babylonia. Under their king, Assurnasirpal (884–860 B.C.), they subdued Babylon itself and set up the greatest empire so far known in western Asia.

Chaldean or Neo-Babylonian Empire: From 606 B.C. The resurgent Babylonians under Nebuchadnezzar displaced the Assyrians. Babylon became the world's greatest and showiest capital, with temples, the palace, the Hanging Gardens, the king's library, etc. In 539 or 538 B.C. Babylon was taken by the Persian Cyrus the Great, and Mesopotamia became a part of the Persian Empire.

Running Animals. Impression from stone seal. Sumerian, before 3000 B.C. Uruk.
Walters Art Gallery, Baltimore

II

THE origins of Mesopotamian art are obscure. Some books begin with examples from Susa, in Elam, over the border of the Iranian highland, and the earliest Sumerian sculpture may well be related to Elamite or Persian art. The ruins of the Sumerian cities of Ur and Lagash and Kish have yielded relics older than the Susan statuettes, including fragments dating to 4000 B.C. These pieces are, however, cruder and patently less likely to have been in the line of a developing regional tradition than a figure such as the Susan stone *Curly-Horned Ram* illustrated. It stands as one of the earliest attractive expressions in sculpture from western Asia.

The alabaster *Kneeling Woman* shown is also from Susa, though of later date, and is likewise superior to most of the statuettes found in Sumer. The piece in its simplifica-

tions, its fitness of technique to materials, and its rhythmic orderliness, retains certain virtues of primitive art. The subject, a woman with hands upholding her breasts, symbolizing the Mother Goddess, or perhaps representing a woman in the Mother Goddess attitude, is common to fertility fetishes in Persia, Mesopotamia, and Syria. The figure possesses a sculptural sensitivity seldom manifest either in the contemporary Sumerian or in the later Babylonian statuettes of idols and adorers.

Among the Sumerian clay figurines there is, however, one strangely diverting group of serpent-headed women that is superior to any other sculptures of so early a date. Though presumably representing a demon, the figure illustrated, in the University Museum, Philadelphia, is likely to suggest the decadent civilization of today, with its lounge

Stag Hunt, relief. Stone. Hittite, c. 12th century B.C. Malatya. *Louvre. (Tel photo)*

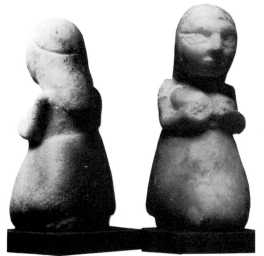

Kneeling Woman. Alabaster.
C. 3000 B.C. Susa.
Louvre. (*Tel photo*)

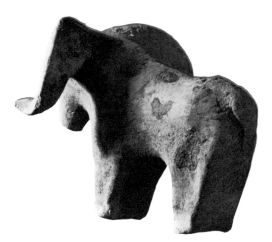

Curly-Horned Ram. Clay.
C. 3000 B.C. Susa.
Louvre. (*Tel photo*)

lizards and its exhibitionist ladies with skin-tight skirts.

Some animals devised in copper were found by the excavators at Ur. The appealing copper *Ass,* which had served as mascot on the rein-guide of the chariot of Queen Shubad, was recovered from a royal cemetery of possibly 3300 B.C. As yet this piece is an isolated find, without known antecedents in its own territory. The character of the model has been sympathetically conveyed, with even a touch of humor in the cocked ear and the jaunty pose of the head. Thus the naturalism that was to become the most notable trait of late Mesopotamian art is exhibited in one of the oldest relics of Sumerian civilization.

It is found again in two free-standing bulls, shaped in sheet copper over wood. These formed embellishments on a temple façade at al-Ubaid, of about 3100 B.C. One is shown on page 61. An almost startling lifelikeness is achieved here, twenty-five centuries before Greek realism. More typical of Sumerian work at this period are the two skirted *Adorers,* in which the exaggeration of features such as the nose, eyes, and beard almost reaches the point of caricature. The expression on the faces of these male figures, one of intent worshipfulness, was doubtless the sculptor's main preoccupation.

After the *Adorers* there were portraits of king and officials. A keeper of a temple granary named Kur-lil from al-Ubaid is the subject of a blocky sculptural portrait of an official, in which the feeling for the stone is well preserved, the area of the face alone tending toward naturalism. This forthright statue marks one of the peaks of achievement in the monumental type of art in Sumer. Nevertheless a more conventionalized art, practiced with full respect for the nature of the medium, existed side by side with the realistic main effort; but the surviving relics are too battered for easy enjoyment.

There was a feeling of confinement in much of the stone sculpture of the eight centuries between the Sumer of the First Dynasty of Ur and the Neo-Sumer of the Third

Ass. Figure on rein guide. Copper.
C. 3300 B.C. Ur. *British Museum*

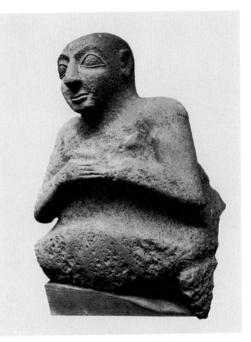

Kur-lil, Keeper of the Temple Granary. Stone.
C. 3000 B.C. Al-Ubaid. *British Museum*

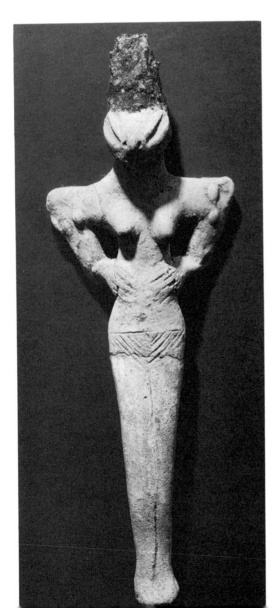

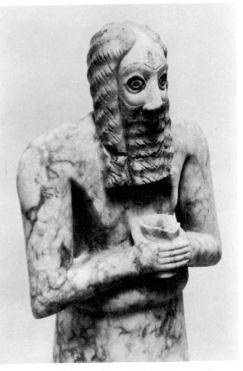

Adorer. Stone. C. 3000 B.C. Sumer.
Oriental Institute, University of Chicago

Demon Woman. Clay. Before 3000 B.C. Al-Ubaid.
University Museum, Philadelphia

Dynasty. It is illustrated in the typically squat statue, *King Gudea Seated*. Despite the dumpy figure, the portrait is nearer to the contemporary Egyptian style than is any other surviving Mesopotamian statue. King Gudea, though not one of the great conquerors, is the best known of the rulers of the Sumerian city-states, through his patronage of sculpture. A score of statues of him survive, whole or as fragments, and usually in a conventional pose such as the attitude of worship, or as architect. The stiff bodies with wide shoulders give the impression of being that way not because the sculptor willed it, but because he had an incomplete mastery of his medium. The heads are more lifelike, at times even catching a spontaneous expression. The enlarged eyes and ears, and the feathered eyebrows, were

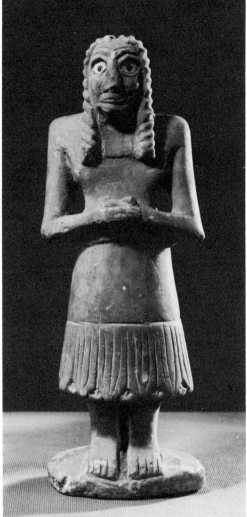

Adorer. Stone. C. 3000 B.C. Sumer.
University Museum, Philadelphia

King Gudea Seated. Stone.
Neo-Sumerian, c. 2100 B.C.
Metropolitan Museum of Art

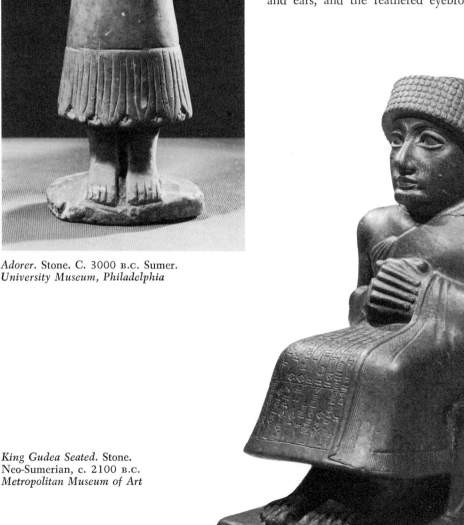

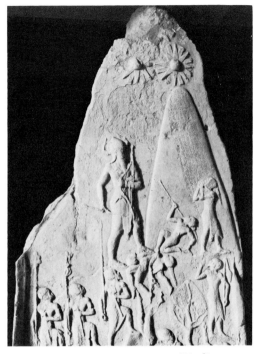

Victory Stele of Naram-Sin. Stone. Akkadian, c. 2300 B.C. *Louvre.* (*Giraudon photo*)

Bull's head ornament; lion's head seal; duck weights. Copper; stone. Sumerian; Babylonian. *Metropolitan Museum of Art; Louvre; University Museum, Philadelphia*

local conventions. Almost Egyptian in style is the headless stone statue, *Gudea Standing*, in the Louvre. It is smoothly sculptural, in a set attitude, and it marks the point at which Mesopotamian sculpture is most profound.

But the best is now past in the story of Mesopotamian sculpture in the round. During the following two thousand years the major sculptors produced masterpieces only in the medium of bas-relief, in tiny seals or great stone murals. The seals and weights had been exceptionally fine from earliest times, and indeed there is no more attractive run of miniature sculptured stones than the one comprised in the duck and frog weights of Mesopotamia. Examples are shown above, with a lion-head seal and a bull's head in copper that once decorated a lyre.

The museums contain innumerable stone reliefs, memorial tablets, boundary markers, vase decorations, and the like. Among the early pieces, the most famous is the *Victory Stele of Naram-Sin* of Akkad, of about 2300 B.C. This vividly represents the conqueror-king trampling cohorts of his victims as he leads his warriors up a mountain, above which the favorable sun is shown. The con-

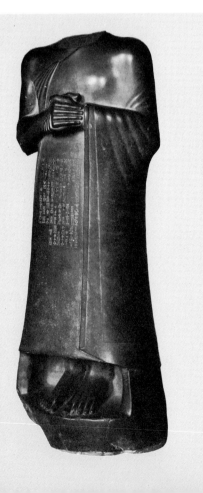

Gudea Standing. Stone. Neo-Sumerian, c. 2100 B.C. *Louvre.* (*Bulloz photo*)

Standard. Bronze. Pre-Hittite, c. 2100 B.C. *Metropolitan Museum of Art, Joseph Pulitzer Bequest*

Head of a Dragon. Bronze. Possibly Elamite. *Louvre.* (*Tel photo*)

ventionalization of the mountain and the sun is simple, and the relief sculpturing has a roundness, even a flowing grace, unusual in Sumerian art.

A great quantity of sculptured work must have been imported from the north and west. Most of the identified relics, however, are in bronze and are therefore to be assigned to later dates. Sometimes a scepter-cap was labeled Mesopotamian, though the provenance must have been Iranian; and there are harness rings and statuettes that are Cappadocian or Hittite though exhibited beside Babylonian relics.

The *Head of a Dragon* in the Louvre is an exceptional bronze sculpture, doubtless of a late period. It is supposed to be a cap from a scepter or staff and, if not imported from the Iranian countries, was made by an artist influenced by the art of Elam or Luristan. A second animal piece, the bronze standard with two long-horned beasts skillfully entwined, is labeled by the archaeologists merely "pre-Hittite (about 2100 B.C.)." Its affinities, stylistically, would seem to be northern Persian.

In Sumerian relief art the best examples are the work of the seal-cutters. As early as

3300 B.C. cylinder seals had gained popularity and relief impressions were appearing on clay stoppers and markers. (The illustrations show modern impressions made from originals in the museums. See pages 62–63 and 70.)

The art of the seal-cutters flowered and declined many times during the thirty centuries of Mesopotamian history. The experts stress differences of subject-matter, technique, and aesthetic value in such periods as Uruk, Ur I, the Sargonid age, Ur III, and in Babylonian and Assyrian examples. There were also incursions of style from Susa and influences from the confused complex of cultures that existed in the general direction of the West, from the Egyptians, the Syrians, and the Hittites. From earliest times the seals took on a clarity and a crispness of technique fitting to their purpose and to the materials and methods of the art. In many periods the subjects were religious: heroes protecting sacred flocks, scenes of judgment, divinities, priests, and demons; and of course the familiar worshiper, adoring or being introduced to the god or priest, or protecting divine property. Occasionally there were hunting scenes, heraldic motives, and geometric or floral patterning.

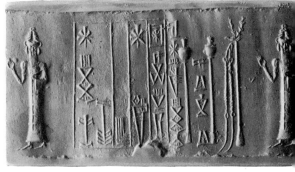

Impressions from stone seals: hunting scene
and physician's charm. Akkadian.
Museum of Fine Arts, Boston; Louvre

Of the seals illustrated, the earliest examples (from before 3000 B.C.) are notable for the freedom of movement and the vitality of the designs. The artists were already masters of the sort of decorative design in which the Orientals have always excelled. The seal with running deer (the design, as is the case with others, was repeated in the impression by rolling the spool through two revolutions) is especially successful in fitting the heavy animals into the field. A second crisply stylized seal including cattle illustrates the more conventionalized type and, after five thousand years, it seems engagingly "modern." With the compositions of the Sargonid era (approximately 2340 B.C.) a strain of realistic detailing entered, but the better seals are still characteristically decorative.

Some authorities believe that the art of seal-cutting preceded bas-relief sculpture in the large and that the famous stone murals of the Assyrian palaces grew out of the smaller art. But influences also came from abroad, and particularly from the Hittites, who emigrated southeastward from the neighborhood of Anatolia and upper Syria. These people seem to have been the first to develop bas-relief on a monumental scale. Extensive ruins exist with outdoor reliefs cut in rock at Yazilikaya near the modern village Bogazköy, and lesser monuments are to be found elsewhere. The best-known relics are from the walls of a palace at Carchemish (or Kargamish), a later capital. The Hittite style is typified in very flat figures on almost unbroken flat fields, and by highly conventionalized objects and patterning within precise outlines. Hittite sculpture, from the twelfth to the ninth centuries, is more alive

and graceful than similar Babylonian work in the large. (See *Stag Hunt*, page 64.)

The ninth-century stone statue of Assurnasirpal II of Assyria is the first really monumental work surviving from the sixteen centuries following Gudea's reign. It is solid and dignified, but the hair and beard are rather coarsely conventionalized, as are the fringes of the skirt. The amber statuette of Assurnasirpal in the Boston Museum is more clearly defined and more column-like. An ornamented gold breastplate is set into the amber.

Less subtlety is evident in the sculptured monsters which guarded the Assyrian palaces. These are not so much reliefs as engaged figures in the round, viewable from three sides. The sculptors gave each monster five legs so that the observer, looking at it directly from the side, would see a required four legs, and, looking from the front, a required two legs. The human-headed winged lions and bulls are more impressive for their size and

Lions. Column base. Stone. Hittite, c. 12th
century B.C. Tel Tainat, northern Syria.
(Courtesy Oriental Institute, Chicago)

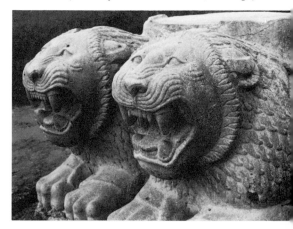

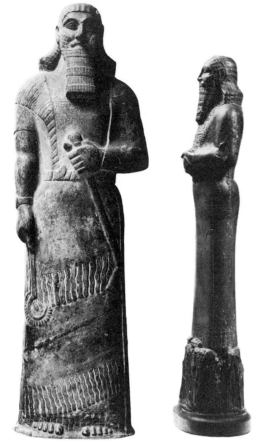

Assurnasirpal II. Assyrian, 9th century B.C.
Left: Stone. Height about 43 in. *British Museum.*
Right: Amber. Height about 10 inches.
Museum of Fine Arts, Boston

massiveness than for any other quality. Sculpturally speaking, the volumes are haphazardly related, the rhythmic lines broken, and the patterning of feathers, hair, and beard too insistent. Perhaps the best of the massive monsters is the stone *Lion* in the British Museum, from the palace-temple of Assurnasirpal II at Nimrud. The largeness and nobility of the animal have not been destroyed by sculptural niggling or ostentatious patterning.

The low reliefs on immense slabs of stone in the palace of Assurnasirpal established a mode of mural decoration that became more or less standard throughout the Assyrian epoch and the succeeding neo-Babylonian period. A series of stones depicted giant figures of protecting deities, or showed the king and his attendants. In these stiff compositions

the sculptors' main interest would seem to have been in depicting details such as feathers, fringes, tassels, imposing beards, elegant hairdos, bracelets, and dagger-handles. A boastful inscription, standard for all the king's monuments, is written across the face of the design.

The war and hunting scenes in the palace murals are less outstanding, but there was competent practice of a style which was to reach its culmination two centuries later in the realistic reliefs at Nineveh. In the *Hunting Scene*, a stone relief from the palace of Assurnasirpal II, although the woodenness persists (the King's beard is still a characterless, stereotyped convention), one finds a growing naturalness in the animals and a more competent sense of pictorial composition.

After the reign of Assurnasirpal, mural art declined. The artist conceived each incident episodically and the panels constituted a series of illustrations which were neither sculpturally related nor integral to an architectural scheme. Some banded scenes from the gates of the palace of Shalmaneser III at Balawat are of technical interest because they were worked in bronze. They are architecturally controlled and flatly ornamental, but lack something of the liveliness of the stone reliefs. The illustrated panels, *Siege Scenes*, from the palace of Shalmaneser III, show Assyrian war chariots and the slaughter of prisoners.

Lion. Stone. Assyrian, 884–859 B.C. Palace of Assurnasirpal II, Nimrud. *British Museum*

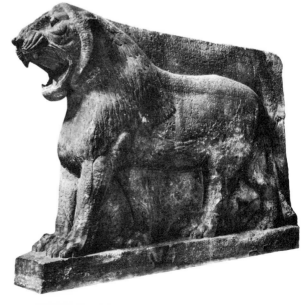

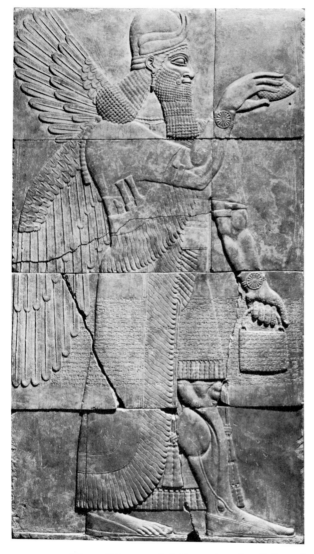

Winged Figure, relief. Stone. Assyrian. Palace of Assurnasirpal II. *Walters Art Gallery, Baltimore*

Hunting Scene, relief. Stone. Assyrian. Palace of Assurnasirpal II. *British Museum*

A century later the trend toward vivid naturalism returned. From the palace of Tiglath-Pileser III at Nimrud stones have been recovered that represent a transition in style between the art of Assurnasirpal's palace and that found in the palace of Assurbanipal at Nineveh. The artists recorded war and hunting scenes with increasing exactitude. The two panels shown, *Siege Scenes,* are interesting historically, for what they tell of the capture of a city. One illustration depicts Assyrian scribes listing the spoils taken from the city's inhabitants. Here the wool of the sheep is nicely differentiated from the sleek hides of the oxen. Another illustration shows a wheeled, fortified tank with a battering ram, followed by infantry. Bows, arrows, spears, and shields are shown in detail. The style is typically Oriental, with no attempt at scientific perspective; but few observers today would find the design less satisfying or the record less telling because the figures fail to diminish in depth.

Since a single Assyrian palace might contain bas-relief murals totaling a mile and a half in length, it is not surprising to find in it work of uneven quality. A high mark was reached, however, in a series of well-composed and vivid *Hunting Scenes* and *Battle Scenes* executed in low-rounded relief, for the palace of Assurbanipal at Nineveh. This Mesopotamian ruler was the last notable figure of the Assyrian line—the Sardanapalus of romance and legend. (See page 74.)

The ultimate point of precise delineation was attained in depictions of animals such as horses, asses, camels, dogs, deer, and lions. These were cannily observed and superbly

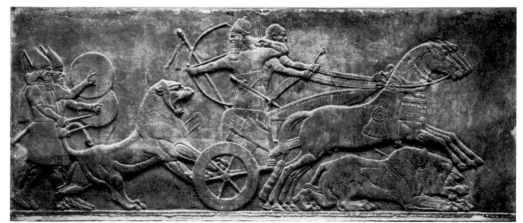

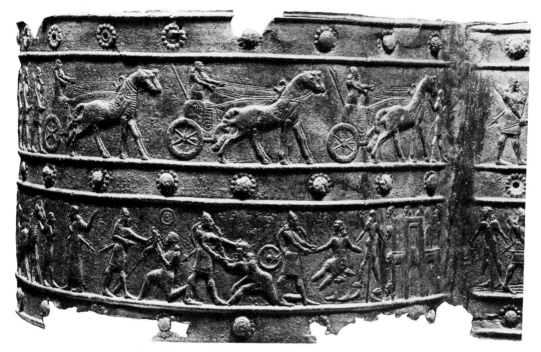

Siege Scenes, relief. Bronze. Assyrian, 9th century B.C.
Palace of Shalmaneser III, Balawat. *British Museum*

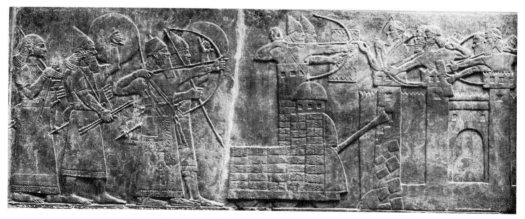

Siege Scenes, reliefs. Stone. Assyrian, 8th century B.C.
Palace of Tiglath-Pileser III, Nimrud. *British Museum*

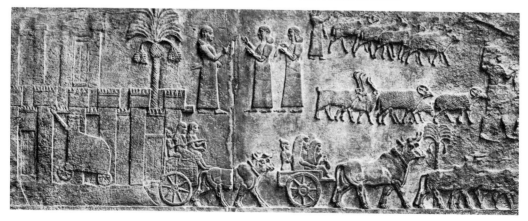

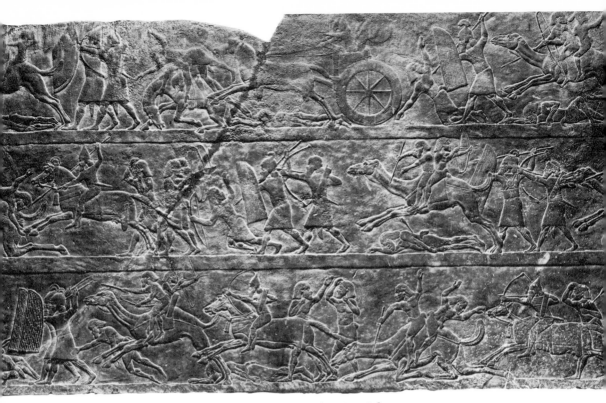

Battle Scenes, relief. Stone. Assyrian, 7th century B.C.
Palace of Assurbanipal, Nineveh. *British Museum*

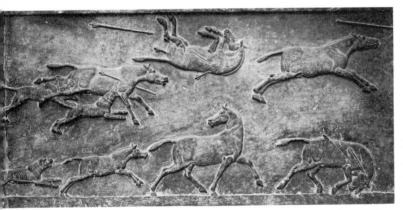

Hunting Scene, relief, detail.
Stone. Assyrian. Palace of
Assurbanipal, Nineveh.
British Museum

Wounded Lioness,
detail of *Hunting Scene.*
Stone. Assyrian.
Palace of Assurbanipal,
Nineveh. *British Museum*
(*Hachette photo*)

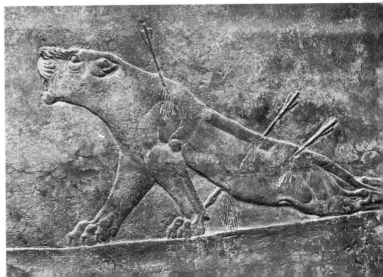

drawn. The typical *Hunting Scene* illustrated, showing the hunting of wild horses, is one of the finest of the mural slabs.

A similar panel of deer is so true to observation that one cannot doubt that the king's artists rode beside him on his hunting or warring expeditions—just as newsmen and photographers have recorded front-line battles in our century. Reporting could hardly seem more immediate, more objective than in the sculptured *Wounded Lioness* shown, in a detail, from a panel at Nineveh.

When the Babylonians regained control of Mesopotamia, the new kings, especially Nebuchadnezzar, set out to surpass the Assyrian achievement in luxury and elegance. However, sculpture suffered a decline except in a type of relief work on bricks. Small sections of animals were molded on bricks with colored-glaze facing in such a way that the animal forms took shape as the bricks were fitted together in the building of a wall. The method of modeling, making molds, then mass-producing clay figurines and small reliefs, had been practiced by the early Sumerians, then by the Babylonians. Now, in this larger-scale application of the technique, the Neo-Babylonians achieved fuller use of color.

The exceptionally fine glazed-brick *Lion* illustrated appeared sixty or more times on the walls of the Street of Processions leading to the Ishtar Gate. Only the colors varied. The lion was sacred to the goddess Ishtar or Astarte. Other animals were represented on the high gateway towers: rows of bulls and long-legged dragons were created in similar glazed-brick relief, with a few in flat enamel. When the Persians conquered Babylonia in 539 B.C. they brought the story of Mesopotamian art to an end, but they utilized the glazed-brick technique and created their own reliefs with greater finesse.

Meanwhile, among the marginal developments of Mesopotamian art was the continuation of seal-cutting, examples of which are illustrated. During the final centuries of Assyrian and Babylonian rule, in Syria and Palestine especially, the cultural lines became very confused and art influences were intermingled. The Hittites sometimes provided models; but as far away as Cyprus unmistakable Assyrian idioms appeared freely in monumental sculpture. In Cyprus and Phoenicia and Cappadocia small bronzes might be influenced from any one of several cultures or from two or three at once. The examples shown illustrate a wide variety of methods and motives. The most Egyptian of the pieces is *The God Hadad.* Probably older is the sinuous *Snake Goddess,* whose affinities are northern, possibly Cretan or from the Anatolian countries.

Lion, relief. Glazed brick. Babylonian, 604–562 B.C. Street of Processions, Babylon.
Museum of Art, Rhode Island School of Design, Providence

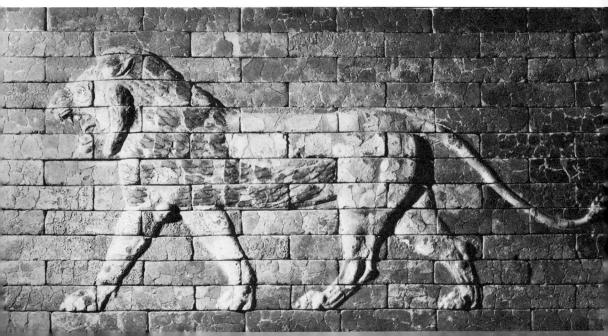

Impressions of seals. Assyrian and Babylonian. C. 1500–550 B.C.
British Museum; Oriental Institute, University of Chicago

Cow and Calf, high relief. Ivory. 9th century B.C. North Syria. *Louvre. (Tel photo)*

Left: Snake-Goddess; center: The God Hadad; right: Man Walking. Bronze. Phoenician,
1st millennium B.C. *Brooklyn Museum; Louvre (Alinari photo); Walters Art Gallery, Baltimore*

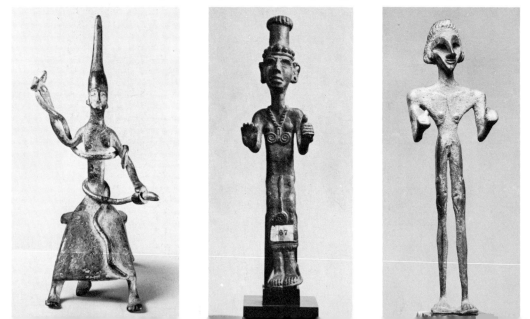

These figures, and the *Man Walking,* all thought to have originated in what was ancient Phoenicia, or in other parts of Syria or Canaan, might as well have been found in Cappadocia, Cilicia, Malta, Carthage, or even farther afield. Thousands more or less like them are known to have been produced by the Phoenicians for export.

Only one other marginal development might be suggested: the rather slight but sometimes evident influence of the Scythians, the sculptors who developed the superb "animal art" of the steppes. Their special style seems reflected, for instance, in the spiritedness and rhythmic arrangement of the horses in *relievo* on the Phoenician silver platter illustrated. It was the Scyths who helped to sack Nineveh, weakened the Assyrians, and opened the way to the final Babylonian hegemony, the last phase of Mesopotamian independence. But for the most part it seems unlikely that Assyrian and Babylonian art was essentially influenced by the people of the steppe. The one true contribution of the Mesopotamians to world sculpture was an engaging realism, whereas Scythian art is highly conventionalized and decorative. The contrast is interesting between the *Lion* of the Ishtar Gate and the more virile sculpture of the Scyths, which is illustrated in the next chapter.

The relief from North Syria, opposite, part of a group of ivory reliefs from furniture, is added here merely to emphasize the mixed influences that the Syrians and other Near Eastern craftsmen absorbed. Some details on the ivories are unmistakably Egyptian, but the whole set might be Cretan, or possibly Mesopotamian. The plaque shown, with cow and calf, is perhaps too rhythmic and too graceful to be either. It was preserved for us by a king of Assyria, Adad-Nirari III, who stole it from King Hazael of Damascus. In such ways the arts were widely interchanged in the centuries of the Babylonian wars.

Platter with reliefs. Silver. Phoenician, 1st millennium B.C. *Walters Art Gallery, Baltimore*

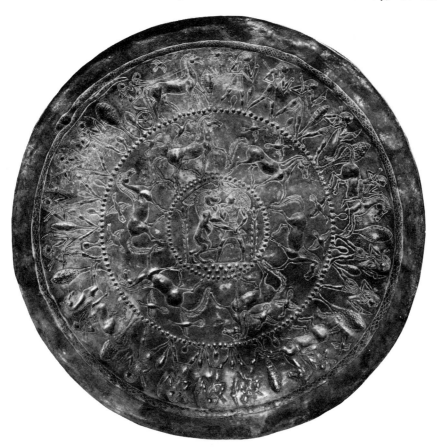

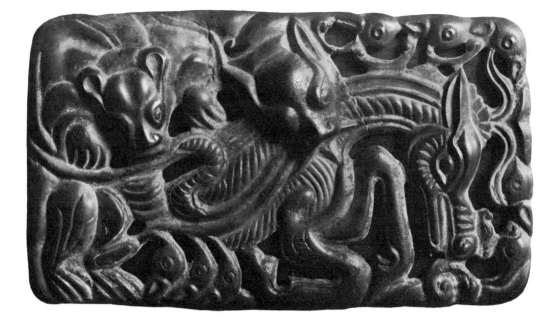

4: The Animal Art
of the Eurasian Steppes

I

ON the maps of the classical world Scythia appears as a variable and unbounded country to the north and northeast of the Black Sea, and the nomadic people who roamed it were horsemen of the forests and the pastures. The Scyths seldom built cities, and moved on to more favorable lands when climatic conditions and opportunities to conquer weaker peoples prompted a change.

Before the flowering of Greek civilization, the Scyths had helped to destroy the Assyrian state, and after the seventh century B.C. they were frequently at war with the Greeks themselves.

They had no written language, and to learn about them historians have had to rely upon foreign reporters such as Herodotus. The Greek writers knew only the borderland Scyths, however, and what they have transmitted is a fragmentary, half-mythical account of the vast hordes in the real Scythia of the steppes.

The surviving art, which consists mostly of small sculpture in gold and bronze, with some antecedent Stone Age bone and horn carvings, also tells something of the Scyths' ways of life and of their culture. Studies of the diffusion of Scythian and related sculpture leave no doubt that this nomadic people roamed a territory larger than all Europe, a

Plaque with fighting animals. Bronze. Scythian. Russia. *Art Association of Montreal*

territory extending from the Danube Basin to the eastern borders of Mongolia, including what is the Ukraine in modern Russia, the steppes about the Caspian Sea, and most of Siberia. So wide is the range that some historians refer to the findings as Scytho-Siberian art. Others, despairing of ever fixing even vague territorial limits, write merely of "the animal style," or "the art of the steppe."

Certainly "the animal style" is perfectly descriptive of Scythian art, for its sculptors seldom chose human beings as subject-matter. The sculptural forms of animals are formalized, vigorous, and decorative, as opposed to the naturalistic work of the Mesopotamians and the late Greeks; they are also more virile than the idealized sculptures of the classic Greeks and are Oriental in feeling.

Ethnically the Scythian peoples, although doubtless intermixed with Mongolian strains, were substantially of the Indo-European stock. They were Aryan-speaking, and thus closer in spirit to their Persian neighbors in Iran (another form of "Aryan") than they were to the Assyrians, Babylonians, or Arabs. It is logical therefore that Persia, especially, continued the Scythian way of art, refining it and perpetuating it not only at home but at the courts of Constantinople (Byzantium) and other cities of the Eastern Christian world where Sassanian culture and products were later welcomed. As the designation of a distinctive artistic style, "Scythian" serves to cover the activities of the Cimmerians, who were the predecessors of the Scyths in certain western parts of Scythia, and of the Sarmatians, who later took over those lands.

The earliest known gold and bronze sculptures left by the Scyths seem not to antedate 1200 B.C. The golden age dawned in the ninth century B.C., and some of the most accomplished Scythian artists were therefore contemporary with the Dorian Greeks, the Assyrians, and the Persians of the pre-Achaemenid period.

The best way to approach Scythian or Scytho-Siberian sculpture is to study the three or four main types of stylization and craftsmanship in relation to a few centers of discovery. The Siberian finds are numerous, and Minusinsk, near the border of Mongolia, was important as a center. The mid-Siberian phase, as we may call it, is distinguishable from the Ural or East Russian phase and from the Western phase, which centered in the Dnieper and Don basins. There is great simplicity, almost primitive, in even the smallest renderings of stags, tigers, elk, and other beasts by the Siberian craftsmen. Later a special way of formalizing wings, manes, and even tigers' stripes, in flowing linear patterns, enriched the style; more involved compositions, usually of savage beasts in conflict, were beautifully executed.

Generally speaking, these characteristics may be said to apply to the Scytho-Siberian style of art as a whole. The representation, though stylized, was intensely true to the nature—or better, the spirit—of the animal, but the formalization of certain parts remained rigid, even extreme. Usually the sculptor's purpose was to be decorative rather than realistic, and he did not hesitate to distort parts of the body, or to terminate a lion's legs, for instance, with approximations of bird's feet, if the resulting forms fitted more beautifully within the limits dictated by the intended use of the sculptured object.

It was in the South Russian steppe area, especially along the lower Dnieper River and the upper shores of the Black Sea, that the Scyths came into trade and cultural relationship with the Greeks. Eventually they even

Double Animal. Bronze. Scythian. Russia.
Museum of Science, Buffalo

accepted and helped spread classical standards toward Altai and eastern Asia. Before that time, the Scythian style had maintained its Oriental characteristics and flourished as an independent, highly individualized way of design. The chief finds have been in the Kuban district, almost at the western terminus of the Caucasian Mountains. The amount of gold discovered there adds evidence to the belief that the art was that of an originally Eastern people who pushed westward from the gold-producing Altai and Urals.

The political organization, about the sixth century B.C., seems to have been a federation of tribes or tribal groups under a number of minor kings and princes, each of whom established a regal standard of art. Finally, in perhaps the second century B.C., the Sarmatians overcame the original Scyths, and it may have been they who formed a connecting link between the Scytho-Siberian animal art and the medieval art of Europe.

Scholars speak of a separate art development in the Caucasus, a development marked by all the characteristic vigor of the Scythians, but with its own unmistakable type of styli-

zation. It is here especially that geometrically patterned borders were developed. There is a special beauty in the bulbous animals within the Caucasian plaques. The spirited stags especially achieve a remarkable illusion of sculptural roundness, within the relief technique, enriched with insets and borders patterned with double spirals.

Despite the confusion regarding their origins, and the many alien or at times sympathetic influences borne in upon the steppe peoples, the Scythian small sculptures remain a distinctive and magnificent contribution to the world's art. They are especially significant in the Western art world because the basic principles are similar to those animating the form-seeking or expressionist schools of the twentieth century.

It should be added that the Scytho-Siberian has been called "the world's oldest style of art." A similarity was noted between the lively animals of the metal-workers of the steppes and the sculptures and drawings of the cave men of Magdalenian times. Through pottery as well as sculpture, the proponents of the theory trace a tenuous line from late Stone Age effort in Europe to Bronze Age achievement in Scythia. Both styles are primitive, vigorous, and affirmative, and both are dedicated to the depiction of animals.

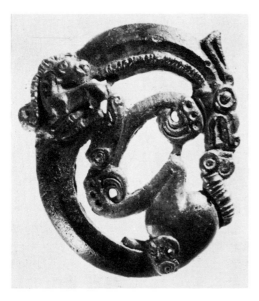

Horse and Wild Goat. Bronze. Scythian, 1st millennium B.C. Crimea. *Hermitage, Leningrad.* (*Courtesy Iranian Institute, New York*)

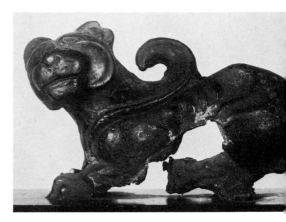

Winged Lion. Bronze. Scythian, 1st millennium B.C. Semirechye, U.S.S.R. *Hermitage, Leningrad.* (*Courtesy Iranian Institute, New York*)

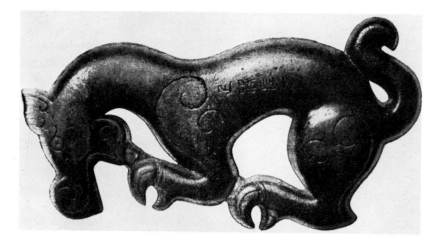

II

THE dating of most Scythian art-objects cannot be other than conjectural, but historians have drawn up a table of periods for them, beginning with "archaic Scythian" and "classic Scythian." The early examples display an extraordinary power and forthrightness, two characteristics which persisted even in later periods when ornamentation became elaborated, and again toward the end when the Greeks had taught the Scyths to be more realistic.

In the three examples here, the virile curves are typical. The spirited swing of the *Winged Lion* is no less compelling than that of the *Feline Animal* and the *Wild Goat* on an elongated horse. All three designs are vigorous in contour, but the sculptors also paid attention to secondary elements of design such as the recurrence of the undulating curve in nose, jowl, wing, and rump in the first example; the arbitrary patterning of the paws in the second; and the ornamentation of the

goat's horns and the horse's mane (misplaced below the neck) in the third example. The chief traits of Scythian art are reflected in these objects, which, despite their small size, have a feeling of largeness, strength, and movement, as well as richness of detail.

In the golden *Crouching Stag*, the strength of the main motive—the body of the design kept free, clear, uninvolved—is contrasted with the decorative treatment of the horns. This plaque, from a warrior's shield, must have been designed with heraldic or talismanic intent, and apparently it was made by hammering gold over a "pattern" carved in wood. The crouching-stag motive is often found among early relics from the Russian shores of the Black Sea to Minusinsk in far Siberia.

Another type of contrast or variation (still within the unity of a single main sculptural movement) is demonstrated in the patterning of the band about the *Panther* by means of

Feline Animal. Bronze. 1st millennium B.C. Manchuria or China.
Formerly Eumorphopoulos Collection. (Courtesy Musée Guimet, Paris)

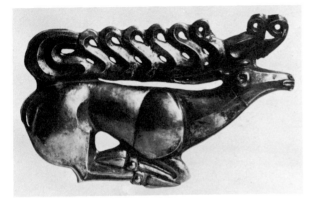

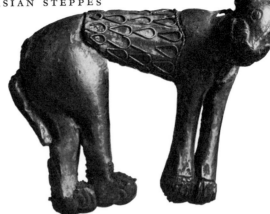

Crouching Stag. Gold. Scythian, 1st millennium B.C. Kuban Steppe, Caucasus, U.S.S.R. *Hermitage, Leningrad.* (*Courtesy Iranian Institute, New York*)

Panther. Bronze. Scythian, 7th–6th centuries B.C. Crimea. *Hermitage, Leningrad.* (*Courtesy Iranian Institute, New York*)

fences; probably the enclosed spaces once were filled with color pastes. The piece is of an early period, when polychrome effects were introduced but only briefly employed. Again there is the extraordinary sense of aliveness in the total figure, not at all impaired by the conventionalization.

The profile piece is standard in Scythian art. When the design is to be seen from the back as well as from the front (as in the case of pole-top standards, mirrors, and the handles of knives) the object is flattened and appears as two slightly convex relief pieces placed back to back in the form of a closed bivalve shell.

Besides woodcarving there was the older Scythian tradition of bone- and horn-carving. The limitations imposed by the harder materials may have established the compactness and directness of expression seen in the later phases of Scythian art. Wooden figures are fairly rare among surviving relics, but there are many objects in bone or horn, all of which follow the same rigid type of formalization.

The Western Scythian bronzes sometimes lack the sturdy simplicity of the Siberian examples; but the harness ornament, at left in the illustration below, has its own primitive largeness and vigor. It is notable that the designer has turned the head backward to bring the figure into a more compact decorative organism. Even the very heavy stylization has not robbed the animal of truthfulness. The head with enlarged jaws is more exaggerated, almost a caricature. The third piece, though heavily stylized, has a lighter sort of rhythm. The final example shown, a deer, has antlers made up of repeats of the bird's beak-and-eye motive, and the feet end in approximations of birds' heads. This common and fantastic motive is also seen in the heads and beaks which terminate the legs of the horse in the third illustration of this section. Occasionally the bird-head motive appears at the end of an animal's tail, as may be seen in the golden plaque at the foot of page 84.

There are numerous separate birds' heads in museum collections. The motive became so conventionalized that at last representation

Ornaments. Bronze. Scythian. Caucasus; Siberia. *Cernuschi Museum, Paris; University Museum, Philadelphia; Museum of Science, Buffalo*

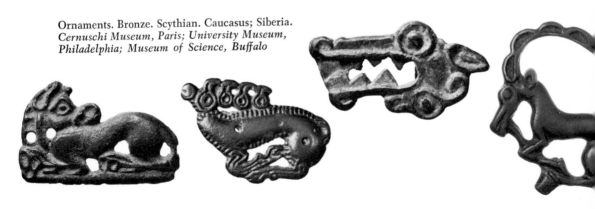

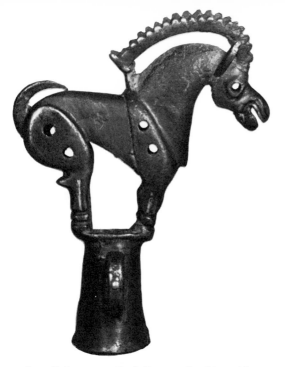

was abandoned almost entirely in favor of ornament. Abstract designs resulted also when compositions were based upon an animal's hoof or hindquarters.

Occasionally the Siberian sculptors would restrain their tendency to formalize their subjects. Decorative but more realistic are the pole-top figures, *Wild Goats*. Examples range from this semi-realism to the near-abstract approximations of animals that decorate handles on bowl-edges or mirrors, or form terminal figures on knife-handles.

The horse, like the elk and the goat, afforded endless opportunity for decorative interpretation. The lead-bronze horse from Leningrad (if, indeed, it be a horse) is a decorative *tour de force*. Note the bird's-head feet, and, above, the extra animal heads which add contrapuntal movement. The little bronze running *Horse* is simpler, but hardly

Stag. Pole-top standard. Bronze. Scythian, 5th century B.C. Caucasus. *Art Association of Montreal*

Wild Goats. Pole-top standards. Bronze. Siberia.
Buckingham Collection, Art Institute of Chicago

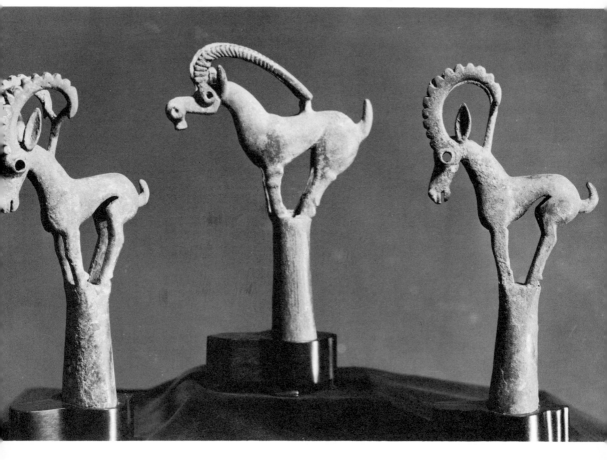

less appealing in its fluent way. The piece represents the southeastern extension of the Scytho-Siberian style, best known under the name "Ordos bronzes." This type of work comes from the Ordos Desert in Mongolia, which adjoins the Chinese provinces of Shan-si and Shen-si.

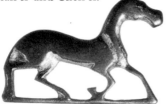

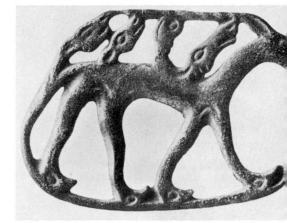

Horse. Bronze. Ordos Region, China.
Museum of Science, Buffalo

Horse. Lead-bronze alloy. Perm District, U.S.S.R.
Hermitage, Leningrad

Animals Fighting. Plaques. Bronze. Ordos Region.
Collection of Dagny Carter; Detroit Institute of Arts

Antlered Bear Fighting a Tiger. Gold. 1st century A.D. Siberia. *Hermitage, Leningrad*

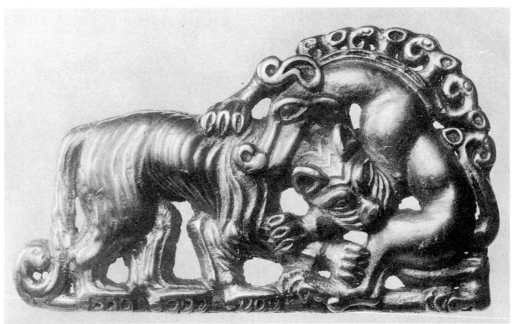

A series of plaques, mostly worked in gold and each with one end larger than the other, depicts animals in conflict. This series is so fine sculpturally that it places the Siberian artists ahead of the Western Scyths in the skillful handling of involved animal forms. The *Antlered Bear Fighting a Tiger* is a richly rhythmic creation. Sometimes as many as four fighting beasts (some unidentifiable) appear in a single design. Rarely is a man's figure incorporated. The animal-conflict plaques are almost invariably found in pairs with the design reversed, and they are supposed to have served as girdle-clasps or quiver-clasps. The persistence of the conflict motive would seem to indicate some religious or totemic significance, but archaeologists have been unable to explain the true meaning.

It is easy to see how the bars along the lower edges of these plaques, together with elaboration of the antler motive, might evolve into an encircling patterned border. It will be noted on the page opposite that, for the first time, bordered Scythian designs are shown.

In late examples the purely ornamental elements were increasingly stressed, but there is no intricate geometrical fretwork and arabesque. Only in the special Caucasian phase did the artist use border areas with all-over patterning. (In the other direction both the vigor and the decorative richness of Scythian sculpture entered into Chinese art, especially during the Han period.)

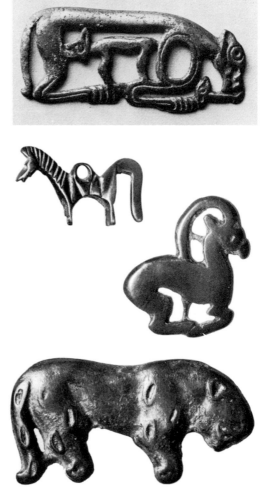

Animals. Bronze. Scythian; Chinese. Russia; Siberia; Ordos Region. *Cernuschi Museum, Paris; Collection of Dagny Carter; C. T. Loo Collection*

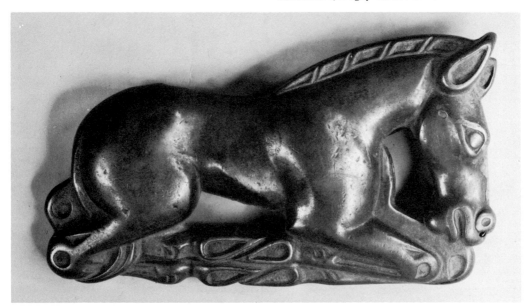

A culture related to that of the Scyths, possibly antecedent to it, is known to scholars merely by the term "animal art of the Caucasus." The most important type of sculpture was a square plaque with a wide ornamental border, within which appeared an openwork animal design. The figures were especially spirited, and an idiomatic use of swelling or bulbous forms in the forequarters and flanks added weight to the design. The effect of largeness was increased by slenderizing the lesser forms and by curving these into sinuous, echoing rhythms. Antlers and tails were often made to end in spirals as geometric as those in the patterned borders. Some, perhaps early examples, exhibit single animals in silhouette. Others were rendered more elaborate by the addition of decorative areas of engraving on the main forms and by an increase in the number of figures. In the example at the Chicago Art Institute (left, below) the stag is accompanied by two dogs and a bird. It is believed that the Caucasian or geometrical phase

of the Eurasian animal art led directly into the barbarian sculpture of Central and Western Europe.

A complete survey of Scythian art would end with degenerate examples, illustrating the decline that resulted when Hellenizing influences became too strong for the native tradition to withstand. There are many late objects ascribed to Greek workmen living within or upon the borders of Scythia, and certainly for centuries there had been a trading of influences at the Black Sea settlements. The culture crossed not only with the Greek but also with the Persian, and there is reason to believe that the Persians, unlike the Greeks, derived lasting influences from it. Certainly in Persia, even down to Sassanian times, there were animal ornaments in the true steppe-art tradition, and in Luristan, within the Persian territory (discussed in Chapter 8), a phase of small sculpture unmistakably related to the Scythian, equally strong, affirmative, and decorative.

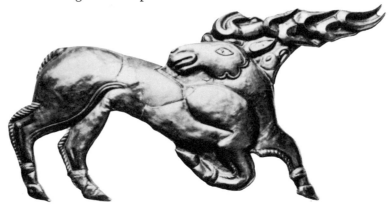

Stag. Gold. Greco-Scythian, c. 500 B.C. Found in Hungary. *Museum of Fine Arts, Budapest.*
(*Courtesy Archiv für Kunst und Geschichte, Berlin*)

Plaques with animals. Bronze. 1st millennium B.C. Caucasus.
Left: Art Institute of Chicago; center and right: Metropolitan Museum of Art

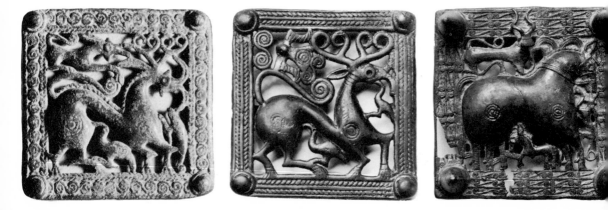

5: The Greeks:

Archaism, Classicism, Realism

I

GREECE was the first civilized European state. The beginnings of its arts were epoch-making and the later influence overwhelming in European and American culture from the fifteenth to the twentieth centuries. Greek art avoids mystery and complication and through most of its course is distinguished for its crystal-clear realism and its grace. The Greeks discarded Oriental conventions; they idolized nature, and, from the time of the building and decoration of the Parthenon to the end of the decline in Greco-Roman naturalism, lucidity and simple representation prevailed in their art.

The Parthenon marbles alone afford material for a glorious chapter in the history of world sculpture. But the supremacy of Greek art over all other expressions is not as freely conceded today as it was forty or four hundred years ago. Nevertheless the classic ideal is respected and recognized as having shaped European thought and art practice more profoundly than any other.

Sculpture took first place in Greece among the figurative arts, and its development is richly documented. An acute factual interest is evident in the few "monuments" surviving from the pre-Hellenic periods: the athletes

Ilissos. Stone. Parthenon, Athens. British Museum

Statuettes. Bronze. Sardinia. *Prehistoric Museum, Rome.* (*Alinari photo*)

Statuettes. Clay.
Cyprus. *Metropolitan
Museum of Art*

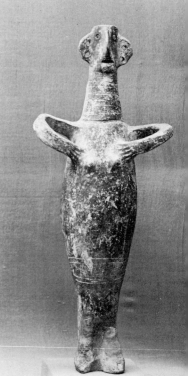

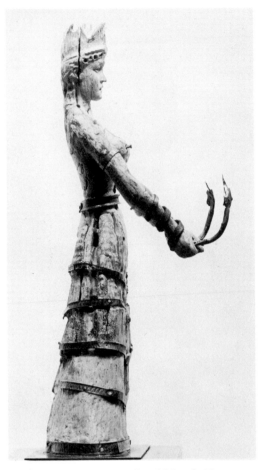

Snake-Priestess. Ivory with gold band. Minoan, c. 1500 B.C. Crete. *Museum of Fine Arts, Boston*

Rhyton (the *Boxer Vase*). Stone. Cretan, c. 1600 B.C. Hagia Triada. *Museum of Heraclion, Crete.* (*Photo of replica, Metropolitan Museum of Art*)

and snake-goddesses of Crete, the *Boxer Vase* and the Vaphio Cups with their exact limning in gold, to cite a few famous examples. Before the "true Greeks" emerged, there was a wide dispersal of the geometric style (in miniature expressions), which marks the point where Greek art came nearest to the formalized and unrealistic expressions of Asia. With the later phases of the Dorian invasion the consolidation of the Hellenic nation was accomplished, and a new freedom and realism prevailed in what we now refer to as the classic art of Greece.

The most typical Greek artistic expression, the superb achievement, is Classical sculpture. By general acceptance, Classical art is noble, reasonably like nature, clear, harmonious, reposeful. The lovers of Greek art, one might almost say the worshipers of Greek art, from Roman days onward, esteemed the Hellenic masters above all others. Perhaps the only service of the twentieth-century critic in this regard should be to broaden the term "Classical" to enlarge its meaning to cover not only the Greek achievement of the Periclean decades but also the transitional period from the archaic. There was already the classic devotion to the idealized human being, to everything that was rational, nobly ordered, and both inwardly and outwardly harmonious. The grand period in Greece can be placed between the perfecting of the stone kouroi and korai of the late sixth century and the completion of the Parthenon.

The response we feel when viewing the pre-Classical statuettes, especially the spirited miniature figures of the geometric age, is very different from that evoked by the soberer expressions of the Classical spirit. But our instinctive appreciation of the little bronze horses or the fiddle-figured Cycladic marbles should be a tribute to an *added* phase of Greek art, to an early and a minor period when the Greeks were still influenced by the East. The fragmentary *Dionysus, Goddesses,* and *Ilissos* of the Parthenon pediment are in a higher category. They display a lithic grandeur, integrity, and amplitude that mark the sixth- and fifth-century work as the first peak of European achievement.

The years following the Periclean Age were marked by an increased realism in sculpture which paralleled a decline in the expression of Classical ideals. During the fourth century, new interest in the individual and in depicting the actual world was reflected in the rise of portraiture and pictorial sculpture, while monumental works suffered a loss of vigor from the overemphasis on naturalistic detail. As Greek culture spread to territories beyond the Aegean during the Hellenistic period, after the conquests of Alexander, its original creative spark became diffused and finally died out.

It should be added that recently, in the 1960s, the ties between the pre-Hellenic civilizations and Greece proper have been stressed by archaeologists and historians. Excavations have brought to light the extent of commerce between the Mycenaean civilization and the Athenian territory that later became the nursery of Greek culture. The Mycenaean-Minoan languages, too, have been more fully identified as early forms of Greek. Whereas a separate Aegean culture was given independence in earlier histories, the story of Crete, Mycenae, and Classical Greece is oftener told in one unfolding history in today's accounts. Despite the sequence of stylistic changes in the sculpture pictured on the following pages, a rather remarkable overall unity will be noted.

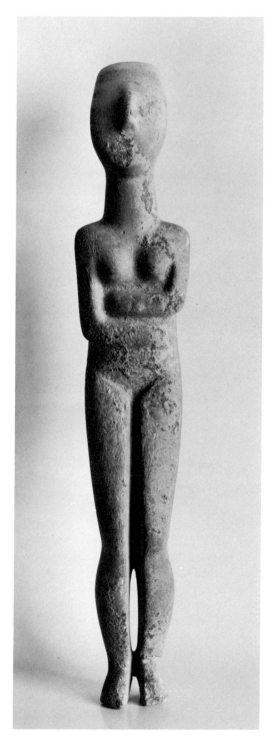

Above and at left and right on facing page: Figures. Stone. Cycladic, 3rd or 2nd millennium B.C. *Metropolitan Museum of Art; British Museum; Museum of Art, Providence*

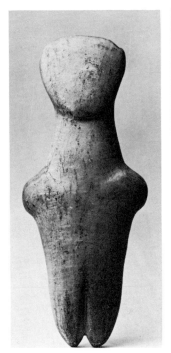
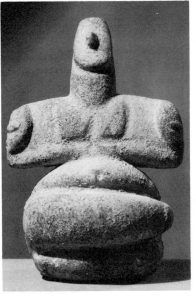
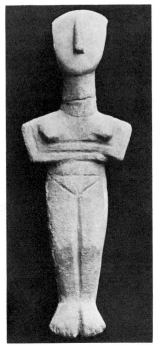

II

THE end of the Stone Age occurred late in most parts of Europe. Long after Egypt and the Near Asian nations had arrived at such basic civilized attainments as systematic agriculture, systematic writing, and stabilized law, the lands of Greece, Italy, and Iberia were still primitive and untamed, and northern and central Europe formed little more than an uncharted wilderness. Even after 1500 B.C., when islands of culture and commerce had risen along the Mediterranean, from Sidon to Iberia, central and western Europe remained subject to waves of wandering peoples for another two thousand years. The lines of migration are confused, and

knowledge of the "original peoples" of Europe, and of their art, is vague, to say the least.

The seaways of Egyptian, Mesopotamian, and Phoenician traders can be traced in early ages, and the pre-Greek arts of the Mediterranean basin most often bear the stamp of Nilotic or Near Asian cultures. Iberia and Malta both have notable relics of the Stone Age, especially dolmens and menhirs, and many Bronze Age figurines have been found. These are of problematic date, as are the clay figurines of the region, which could be assigned to almost any century from prehistoric times to the eighth century B.C. Shown on

Center: Seated figure. Stone. Cycladic. Melos. *Metropolitan Museum of Art*

Figured cups. Gold. C. 1500 B.C. Vaphio.

page 88 are three bronze votive figures from Sardinia, where the influences might be those of Etruria or an earlier culture imported from the East. In Sardinia the culture is known as Nuraghian, after a unique type of Stone Age tower of fortification.

Crete and Cyprus were outstanding sites of pre-Greek artistic development, and the early Cretan achievement is pre-eminent in the Aegean area. However, to stress the fact that there were areas of sculptural activity in other regions of Europe and in nearby Cyprus at the time, illustrations of Sardinian bronzes, Cyprian clay figurines (see page 88), and Cycladic marbles have been placed before the Cretan relics.

The Cycladic statuettes, originating in the Aegean islands southeastward from Attica, are considered to be the first stone sculptures produced in Greek territory. They are seldom more finished than the examples shown. These works, like those of Sardinia, constitute a distinctive minor development. Many of the pieces are intuitively rhythmic and very engaging. Especially prized today are the early schematized figures, almost abstract—amulet-like bits of marble in the shape of spatulas or fat fiddles.

A great commercial civilization prospered in Crete as early as 1500 B.C. This is indicated by discoveries in the ruined palace of King Minos at Cnossus, where fine vases and colorful mural paintings abounded. However,

sculpture was not foremost among the arts practiced by the Cretans. Indeed the surviving body of sculptural art from the Cretan city-states and from Mycenae in the Peloponnesus is small, and, though some of the semi-primitive statuettes and groups in clay are effective as genre pieces, the quality is seldom more than routine.

The *Snake-Priestess* (at the Boston Museum; see page 89) belongs to the highest period of Cretan accomplishment. In general, Cretan art is light, worldly, even gay, running to capricious elaboration and to surprising representations of athletic feats and violent body movements.

The ivories, especially the group of goddesses or priestesses, of which the one at Boston is the most subtly realistic, are more appealing than any other local type of sculpture. There are painted faïence statuettes of the same subject, but these incline to be elaborate and garish. The priestesses with their small waists, bared breasts, and aproned loins, together with the snakes they usually hold, figured in Minoan religious rites. The Cretan culture was neither overwhelmingly centered in religion nor dedicated, as were Assyria and Babylonia, to glorification of a king-god. There are no portrait statues; rather the athlete, the warrior, and the entertainer are commonly depicted.

The *Boxer Vase* (page 89), with its spirited reliefs, is a typical piece. It is carved in steatite

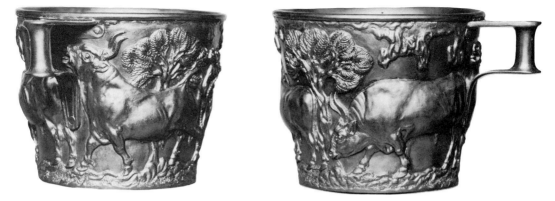

National Museum, Athens. (Giraudon photos of replicas in Louvre)

and was probably gilded. Crete also produced ivory and bronze figurines of athletes and worshipers, and many gems and seals, interesting but not quite so skillfully made as the Sumerian and Babylonian examples. There are a few realistic colored faïence reliefs, as well as double axes and ceremonial pillars which might be classed as abstract designs.

Also of Minoan workmanship, though found at Vaphio in the Peloponnesus, are the two Vaphio cups of gold, bearing designs on the outer shells. The modeling was accomplished by the repoussé process, the metal being hammered up from the reverse side and the detailing probably finished by surface tooling. The designs, one of bull-hunting and the other of bulls in a wooded pasture, are vigorous and marvelously realistic. As sculptural goldsmithing they were not surpassed by the artists of the golden age a millennium later.

In the few notable relics of sculpture from Mycenae, the city-state that succeeded Cnossus as the dominating power of the Aegean world about 1400 B.C., we find, as in Crete, a growing tendency toward naturalism. The best-known example is the famous pair of sculptured lions carved in stone over a gate at Mycenae. There are also grave stelae with rather crude low-relief work which suggests a possible Hittite influence.

The other most treasured examples of Mycenaean sculpture are in metal. Golden cups recovered from graves at Mycenae, like the Vaphio cups and perhaps also Minoan, are beautifully designed in abstract shapes; others are boldly figured in relief. Aside from these cups, the most interesting relics in metal from the Mycenaean civilization are daggers and swords with inlaid designs upon the blades. Many of these show superlative workmanship.

Impressions of seals. Cretan and Mycenaean. *National Museum, Athens*

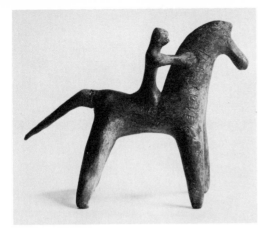

Horse and Rider. Clay. Greek, early 1st millennium
B.C. Attica. *Museum of Fine Arts, Boston*

In summary we can say that the Cretan
civilization had advanced furthest within the
Aegean complex of cultures before 1500 B.C.
Then about 1400 B.C. Mycenae took the
leadership. Mycenaean culture, however, was
soon to be absorbed into that of the Dorians,
the Indo-European invaders from the north,
and for centuries thereafter the figurative arts
were all but obscured. The tenth and ninth
centuries are often referred to as the Greek
dark ages. Animals in clay are the best sculp-
tures surviving from the period before the
eighth century. At that time the islands nearest
Asia were the most progressive, particularly
Cyprus.

The Cypriote clay figurines are especially
noteworthy. Four statuettes of the Mother
Goddess, or of worshipers, favorite subjects in
Cyprus as in Syria and Mesopotamia, are
illustrated at the bottom of page 88.
From the sixteenth century on, Cypriote
sculpture borrowed freely from the Cretans
and Mycenaeans and also from the Egyptians;
and, late in the eighth century, from the
Assyrians when the country became vassal to
Sargon. In many of the remaining works there
is evidence of diverse influences, including
the Egyptian, the Assyrian and the already
mixed Phoenician styles.

Early in the seventh century Cyprus was
already a part of the Hellenic world, and
there is no clear dividing line from then on
between the native style and the sculptural

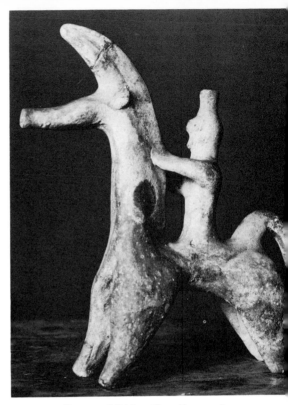

Horse and Rider. Clay. Cyprus. *Louvre.*
(Giraudon photo)

Head of a Man. Stone. 7th century B.C. Cyprus.
Fuller Collection, Seattle Art Museum

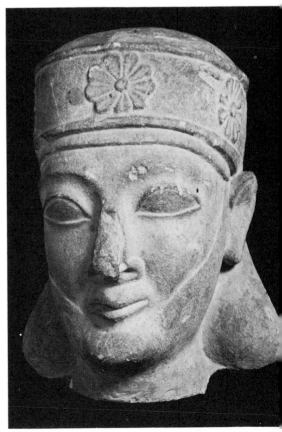

developments that took place on the Greek mainland or in Ionia. The *Head of a Man* (at Seattle) cannot be exactly dated but it would seem to represent Cypriote sculpture at the moment when artists arrived at a pleasing realism. It should be noted that part of the Cypriote stylistic idiom was derived from the nature of the limestone or soft sandstone in which the sculptors commonly worked, which permitted fluent cutting and the tooling of sharp edges, characteristics better illustrated in the head on page 148.

Before the artists achieved this fairly realistic standard, the geometric style (known in art histories as one of the most widely diffused of European-Asiatic modes of stylization) had been in vogue in Cyprus as well as in the neighboring cultures. In the Cycladic Islands human figures had been produced in the geometric style, and Greek pottery was often decorated with highly conventionalized human forms. Popular subjects in the round were horses with riders, and in the later phases of the geometric style animals were the essential subject-matter for bronzes and for many painted decorations. Some scholars plausibly infer a connection with the animal art of the steppe country, and imposing charts have been compiled showing the diffusion of the geometric style within the barbarian

cultures of Europe and its later incorporation into Romanesque sculpture.

Students of Greek vase-painting recognize similarities in form between the bronze horses and the engaging beasts found on Athenian pottery of the eighth century. There is the same tendency to elongate the masses and to model graceful, rhythmic silhouettes. The compositions are most often based on triangles. The depth of the figure from front to back is narrowed, and ribbon forms are played against sudden excrescent curves.

It would be an oversimplification of history to assume that, after the eclipse of the Minoan and Mycenaean cultures, the Hellenes from the north brought in the geometric style; but the typical combinations of zigzags, meanders, and checks, and of virile geometrized figures, do seem to have spread with the Dorian invaders. The geometric style filled the gap between the Cretan-Mycenaean art of

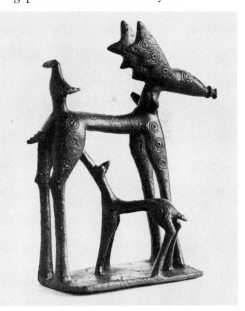

Deer and Fawn. Bronze. Greek, geometric period, 9th-7th centuries B.C. *Museum of Fine Arts, Boston*

Horses. Bronze. 9th–7th centuries B.C. Greek, early and late geometric. *Art Museum, Princeton University*

the Heroic Age and archaic Greek art—that is, the oldest recognizably Greek development. The stylization of animals deriving from the northern countries has no connection with the more naturalistic approach of the Cretans and Mycenaeans; eventually the Greeks too became obsessed with realism.

The early monuments of Hellenic art came largely from Asian provinces, especially from Ionia. Certain ivory figurines from Ephesus are typical of Oriental ideals (if not workmanship), but are unmistakably related to the first Greek mainland sculpture. Of this sort is the bronze figure of a man standing erect and column-like with arms held

Kouros. Bronze. Greek, 7th–6th centuries B.C. *National Museum, Stockholm*

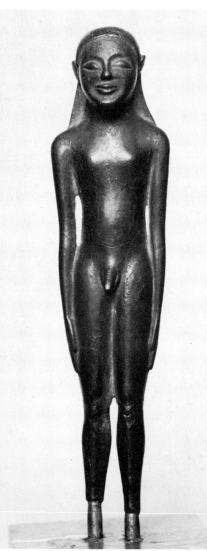

Hera of Samos. Stone. C. 590 B.C. *Louvre*

stiffly to his sides and spread locks widening the neck so that the single-block effect is not disturbed. This type of figure was the forerunner of the two commonest kinds of sculpture practiced in the sixth century: the kouros or hero-athlete, and the kore or maiden. The bronze kouros now in Stockholm is one of the finest surviving examples of the period. It is noteworthy that while male figures were commonly presented in the nude, the undraped female figure was not seen for another century or more and did not become a common subject until the middle of the fourth century.

The *Hera of Samos,* one of the earliest large monuments of Hellenic sculpture, definitely shows Oriental influence. Some scholars attribute the stiff effect to a slavish copying of prototypes in wood, where the tree-trunk dictated the mode of carving. However, a change from the former, Oriental tradition is seen in the arm, which is raised

Kouroi. Stone. 6th century B.C. Tenea; Melos. *Glyptothek, Munich; National Museum, Athens.* (*Alinari photo*)

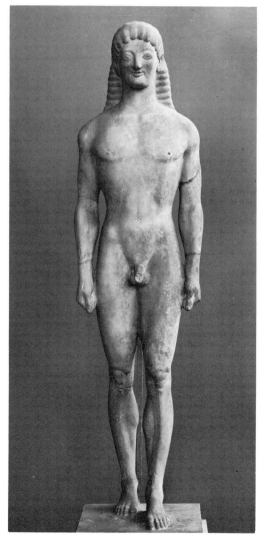
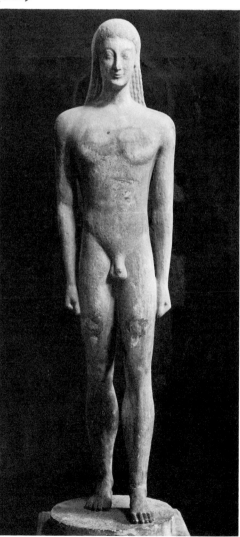

to the breast. A further attempt at naturalism is seen in the treatment of the toes, which are separately if somewhat awkwardly characterized.

By the late seventh century the peoples of Greece had their own language and literature and a common but strangely elastic hierarchy of gods and minor divinities. They also had established religious and athletic festivals which periodically drew the leaders together. But the tendency of the Greeks toward the centralization of their empire was balanced by a fanatic loyalty to the individual city-states that collectively formed the Hellenic nation. Sculpture progressed in much the same way. While the art followed a common national ideal, the work of different regions such as Attica, Ionia, Arcadia, Corinth, Epirus, and Crete was still recognizable. It would be wrong, for instance, to overlook the variations in the kouroi and korai just because the types had become standardized.

The kouros type of figure, long known erroneously as the archaic Apollo, had a prototype in Egyptian sculpture. The body pose, with hands at sides and left foot slightly advanced, is so similar to the Egyptian convention that there can be little doubt that the Greeks worked from Egyptian models. From this point on, however, Greek sculpture began to change quite radically. Despite the set pose and such schematized details as the treatment of the hair and eyes in the two stone figures illustrated, from Tenea and Melos, the natural rendering of the body definitely shows a step in a new direction.

The Greeks began to crystallize a philosophy that made man the measure of all things. The gods, as revealed in the myths, were human, and fidelity to the ideal physical standard soon became the prime test of visual art. The figures long known as Apollos were probably hero-statues of youths (generalized as to features but true to the common athletic ideal), depicting athletic heroes and probably used as votive figures.

For some time the anatomy of the body, though more realistically rendered, re-

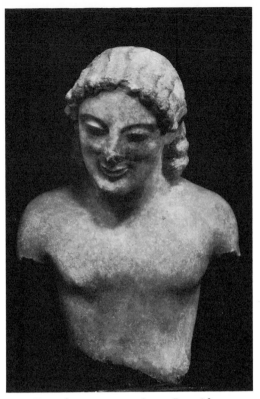

Bust of a young man. Stone. Late 6th century B.C. Athens. *Acropolis Museum.* (*Alinari photo*)

Kouros. Stone. Boeotia. Late 6th century B.C. *National Museum, Athens.* (*Alinari photo*)

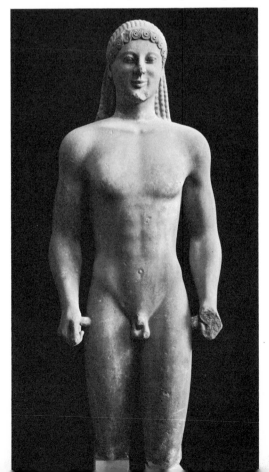

tained a certain schematized symmetrical patterning. This is seen in the stiffly frontal attitude and the balancing of such stressed parts as breast muscles, shoulder contours, the outline of the abdomen and of the kneecaps—all of which are evident in the example from Tenea. Originally these statues were colored, painted or tinted stone sculpture being standard throughout Greek history.

In the latter half of the sixth century, to which the latest kouroi are ascribed, a greater understanding of anatomy is evident. Even so, we still see little deviation from the careful balancing and stressing of symmetrical parts. The face too remained a "type," the eyes rather less protruding, perhaps, but the lips still fixed in the "archaic" smile. Nevertheless, the third of the illustrated kouroi in stone, at left, is more natural and believable, more human and active. The statue may remind us that the Greeks had now established the free-standing human figure as central in the art of sculpture, in accordance with their man-centered philosophy, a gain revolutionary and historic, and a gain destined to be passed on as standard for Rome, Renaissance Italy, and eventually all of Europe.

In the battered bust of a young man in the Acropolis Museum, the stereotype smile persists but there is increased freedom in the modeling of the head. This is slightly turned —and a very long tradition was thus broken.

Probably not since the era of Minos, a thousand years earlier, had a staute on Greek soil possessed a head that did not face directly toward the front.

Few known sculptures of the first half of the sixth century escape the basic rules pertaining to the kouroi and the korai. The well-known seated figures, mostly battered, from Branchidae in Greek Asia seem to hold to the rigid frontal scheme. But fragments of a *Winged Victory* from Delos follow this tradition only from the waist up; the lower limbs are sculptured in profile to suggest motion. The one notable relic that survives in fair condition, illustrating a variant type, is the *Moschophorus* or *Calf-Bearer*, a votive offering to Athena. Possibly this was a portrait of the donor, Rhombos. Stripped to essentials and formalized only in certain details—the man's garment is indicated only by faint lining over the modulations of the body—the whole exhibits an entirely new sculptural mastery.

The famous *Lions of Delos*, which stand

Moschophorus. Stone. Mid-6th century B.C. Athens. *Acropolis Museum*. (*Alinari photo*)

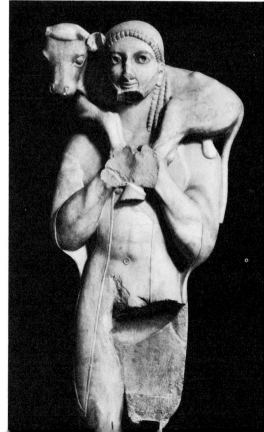

Lions of Delos. Stone. Archaic.
Palace Terrace, Island of Delos

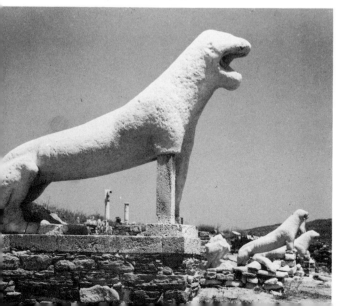

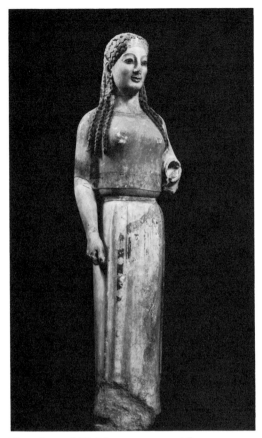

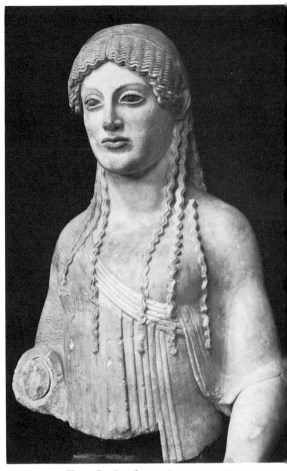

Kore: La Boudeuse. Stone. c. 490 B.C.
Athens. *Acropolis Museum.*
(Alinari photo)

Kore. Stone. Mid-6th century B.C. Athens.
Acropolis Museum. (Alinari photo)

Sphinx. Stone. Mid-6th century B.C. Athens.
Acropolis Museum. (Alinari photo)

Kore. Stone. Mid-6th century B.C. Athens.
Acropolis Museum

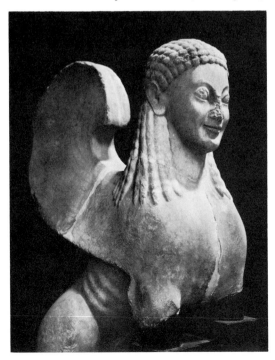

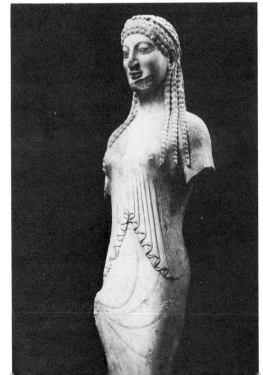

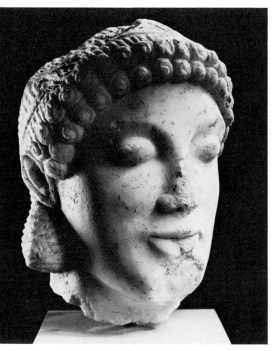

Head. Stone. Greek. C. 500 B.C.
Nelson Gallery–Atkins Museum, Kansas City

in a row on a ruined terrace, are somewhat weathered but remain monumentally impressive nevertheless. These mark a peak of the archaic style as developed in the Cycladic Isles.

A common tendency among the sixth-century sculptors was their failure to differentiate fully the male from the female figure. The *Calf-Bearer* and many of the kouroi have an almost androgynous air. The waist is narrowed, the hipline rounded. Conversely the korai, or maidens, often have a masculine look.

The early korai statues are not as aesthetically satisfying as the kouroi, nor do they demonstrate so well the transition from rude convention to realistic statement. Nevertheless there are finely statuesque figures among the Athenian "maidens" discovered in the ruins of the Acropolis. The figure of a maiden in antique dress is solid and sculptural, except for the unfortunate way in which the sculptor has broken the figure at the waist. The head is particularly accomplished, and the dress

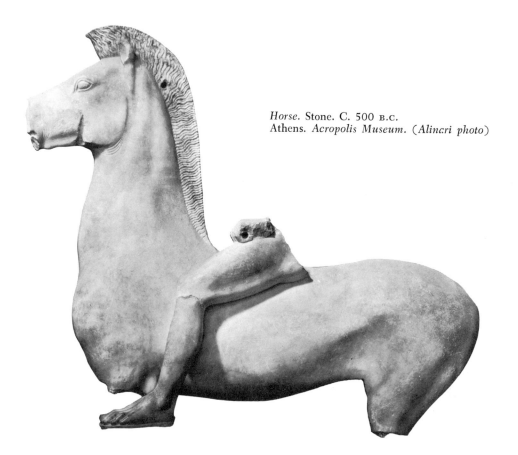

Horse. Stone. C. 500 B.C.
Athens. *Acropolis Museum.* (*Alincri photo*)

notably simple for a time when draped folds and painted ornamentation were strongly exploited.

The most majestic of the korai is the example known as of the Oriental type. Extreme formalization persists in the treatment of the hair and drapery, and the rigid pose adds to the air of dignity and reserve. The statue is of approximately the date of the preceding piece, but the conventions are less marked, the eyes are inset better, and the full lips modify the archaic smile. Another step toward the classic profile is seen in the way in which the slope of the subject's nose follows the slope of the forehead.

The pensive maiden, sometimes known as *La Boudeuse,* is shown here (slightly out of chronological order) to demonstrate the naturalism for which the Greek sculptors were striving. The hair and garment are hardly less conventionalized than before, but the carving of the face and the ear is closer to true anatomical form. This is indeed one of the great moments in Greek sculpture, when stylization still obtains but is controlled by knowledge and the desire to present the natural nobility and dignity of the model. The same tendencies are illustrated in the lovely *Head* now at Kansas City.

The monumental quality which is so typical of Egyptian sculpture was never more nearly attained in Greek work than in the sixth-century *Sphinx* shown. It represents a brief period before the Hellenes became completely absorbed in their quest for realistic expression.

The masterpieces of mid-sixth-century archaism preceded the Parthenon sculptures by hardly more than a century. But here is a largeness and an animation derived less from observed form and movement than from a feeling for sculptural masses and the rhythms of formal creation.

After Phidias, Greek artists were to prove strangely indifferent to animals as subject-matter, but in the archaic period they were still proficient in representing the character of the animal model. No complete equestrian statues with riders survive, but in the fragment of a *Horse* shown, from Athens, there is a direct statement of the essentials in sculptural terms, without undue insistence on anatomical fidelity. The superb lines of the head, neck, and back are fixed perfectly, then reinforced by the simple and effective formalization of the mane.

In the bronze *Charioteer* at Delphi, the best known of the monumental bronze sculptures of the early fifth century, only the main figure survives from a lost group. Some of the archaic stiffness is evident here, and the rather awkwardly treated drapery nullifies the character of the body; but the head, set firmly upon the column-like neck, is both simple and believable.

In this last period before Greece achieved unity after its victories over Persia, the Hellenic settlements were scattered around the coasts of the Mediterranean and Aegean Seas. At the opening of the fifth century, although Cyprus was already thoroughly Hellenized, the work of her sculptors was so distinctive that it could not be mistaken for that of any other people. Certain archaic conventions persisted, but the total aspect of the sculptured figure or face was becoming more lifelike, as in Athens and Olympia. The limestone *Head of a Priest* shown (probably done a quarter-century before the *Charioteer*), despite its schematized hair, mustache, and beard, and the unnatural eyes, is graphic and factual.

Among the Cypriote pieces there is a type of head which has achieved fame as representing the "eternal critic." Readers who know the human type can appreciate the skill with which these sculptors caught in light caricature a characteristic mixture of eagerness and superiority, of alertness and scorn. In the colossal stone *Head* shown, from the seventh century B.C., note how the wide-open masculine brow and beard contrast with the rather precious and feminine mouth.

In Greek relief sculpture the conventions of the archaic style disappeared sooner than they did in statues that were carved in the

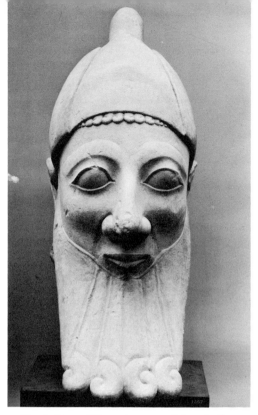

Head. Stone. 7th century B.C. Colossal. Cyprus.
Cesnola Collection, Metropolitan Museum of Art

round. One reason was that the rigid rule of frontality was less logical where figures were inserted serially on a flat panel. Moreover, relief figures were particularly suitable for the depiction of scenes that called for pronounced action. Almost as early as the action reliefs, compositions of figures in the round were placed in the pediments of temples.

There are existing reliefs on pediments that illustrate every step from the archaic style, as seen in a famous panel showing Perseus and the Gorgon (from an early sixth-century temple at Selinus, a Greek colonial city in Sicily), to the free action panels showing *Youths at Games* on a statue base found at Athens. Here, despite the archaistic treatment of the heads, free bodily movement in a wide variety of poses is achieved, perhaps for the first time. The athletic ideal which was to blossom during the next century is already evident.

Charioteer. Bronze. 470 B.C. Delphi.
Delphi Museum. (Alinari photo)

Head of a Priest. Stone. C. 500 B.C. Cyprus.
Cesnola Collection, Metropolitan Museum of Art

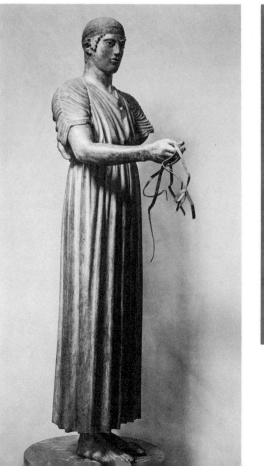

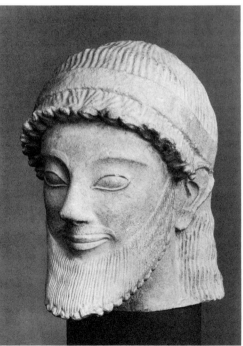

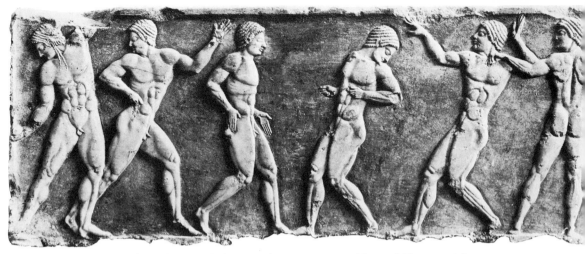

Youths at Games, relief. Stone. Attic, c. 510 B.C. *National Museum, Athens*
(*Photo by Clarence Kennedy*)

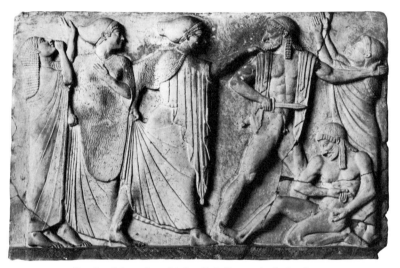

Death of Aegisthos, high relief. Stone. Archaic. Argos.
Ny-Carlsberg Glyptothek, Copenhagen

One of the finest of the transitional pieces is the panel depicting the *Death of Aegisthos,* now at Copenhagen. The relief displays the major archaic conventions in the treatment of hair and drapery, but there is a rhythmic, flowing movement about the whole. This work is of the Argive school, which flourished before the one at Athens, where Hagelaidas of Argos is reputed to have taught Polyclitus, Phidias, and Myron.

Another accomplished school was that of Aegina, and the sculptures recovered from ruins of the temple there are, in fact, the first to suggest the dawning of the new classic realism. The relics are part of great decorative groupings of statues once designed integrally with the architecture. The figures from the two pediments which formed the gable ends of the temple vary greatly in lifelikeness. In the nineteenth century they were subjected to a process of enthusiastic restoration at the hands of the neo-classic sculptor Thorwaldsen, who added heads, legs, and weapons as he thought they would originally have looked. The least battered (and least restored) pieces remain of great interest as examples of Greece's progression toward her classic ideal. The restorations of the total pediment com-

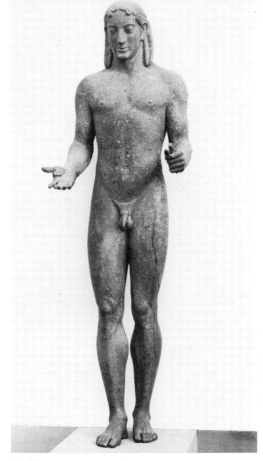

Apollo. Bronze. Late 6th century B.C. Attica. *National Museum, Athens*

Hercules. Stone. C. 485 B.C. Temple of Aegina. *Glyptothek, Munich. (Giraudon photo)*

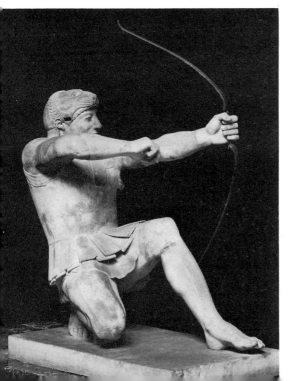

positions, though doubtless inaccurate in details, are instructive as suggestions of the aspect afforded by monumental temples a half-century before the building of the Parthenon.

The *Hercules* from the Temple of Aegina and a similar *Dying Warrior* are important examples of the new, factual representation. While hidden restorations have been made, the sculptors' increased mastery and their grasp of free action are plainly to be seen.

Many years before, the workers in bronze had produced the superb *Apollo* shown at left. This was excavated as recently as 1959, at Piraeus, the port of Athens. The figure is life-size. It is dated by some scholars as early as 520 B.C. It might fairly be termed the first monument fully in the Classical Greek style.

It was about 460 B.C. that architectural sculpture reached a new height in the decoration of the temple of Zeus at Olympia. The remains of the pediment groups, which were destroyed by an earthquake, are unfortunately more scant than those recovered at Aegina, but the fragments point toward a culmination in the pediments and friezes of the Parthenon. Perhaps the finest of the Olympian figures, though not the most realistic, is the *Apollo*. The strength portrayed here is of more than a merely physical kind. The head of a river god, known as *Kladeos,* is particularly successful, and the modeling of the face is even superior to that in the *Apollo*.

There were technical advances in relief sculpture too, particularly in gravestones and other commemorative stelae. More appealing than any surviving examples, however, are the panels of the so-called *Ludovisi Throne.* These are obviously of a period when sculptors still found decorative value in the old conventions, while they strove for more realistic means of expression. In the *Birth of Aphrodite* the veil-like garments create an artificial yet most pleasing effect, while the rounding of the figures produced a feminine charm not earlier encountered. Three compositions, including one not visible in the

illustration here, were carved on one block of marble.

The athletic ideal came into full flower at about this time, and the *Discobolus* or *Discus-Thrower,* by the most renowned of early Greek sculptors, Myron, is a pleasing example of the classical figure in action. The original *Discobolus* of Myron, in bronze, does not survive, but many Greek and Roman copies exist, all of which are more or less imperfect. The illustration here is the restoration known as the Castel Porziano copy. The Romans of Nero's time wrote of the *Discobolus* as a triumph of reproductive art, and this opinion is echoed in schoolbooks to this day. There are, however, many moderns who agree with Pliny that the artist was overconcerned with the physical body.

Equally accomplished was Myron's *Marsyas,* which probably formed part of a larger composition including the goddess Athena. The original work is lost, but if the copy in the British Museum is accurate and without benefit of later knowledge by the copier, Myron achieved a comprehension of anatomy and an all-around lifelikeness unknown before his time.

The recently discovered bronze *Zeus*—or, according to some scholars, *Poseidon*—marks a further gain in exact copying. Interesting though the statue is in its own way, the integrity of the mass has been sacrificed for the privilege of presenting a detailed imitation of life and action. The whole conception of the figure can be considered anatomical rather than sculptural.

Ludovisi Throne: Birth of Aphrodite. Stone. 5th century B.C.
National Museum, Rome. (*Alinari photo*)

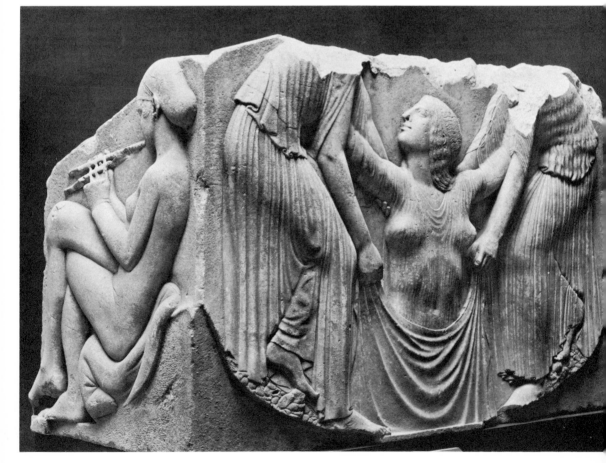

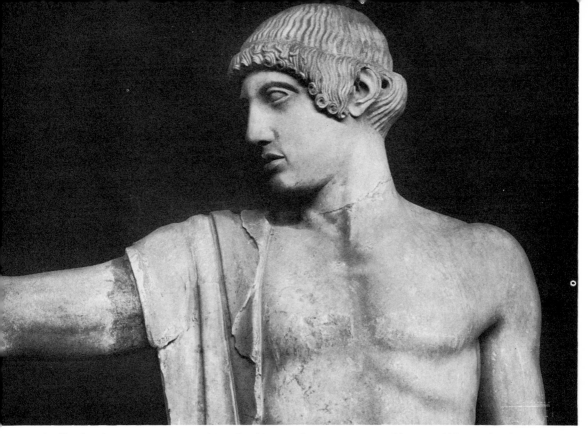

Apollo, detail. Stone. C. 460 B.C. Temple of Zeus, Olympia. *Museum, Olympia.* (*Alinari photo*)

Kladeos, detail. Stone. Temple of Zeus, Olympia. *Museum, Olympia.* (*Alinari photo*)

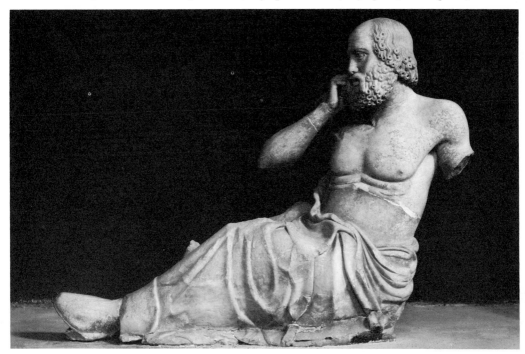

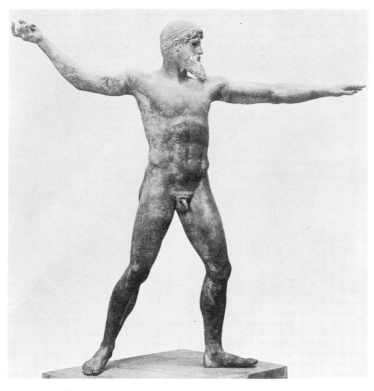

Zeus. Bronze. C. 460 B.C. National Museum, Athens

Discus-Thrower. Bronze. Copy of original by Myron. C. 450 B.C. *National Museum, Rome.* (*Alinari photo*)

Marsyas. Bronze. Myron. *British Museum*

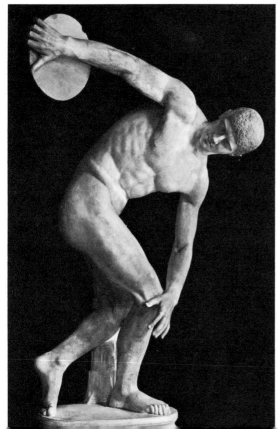

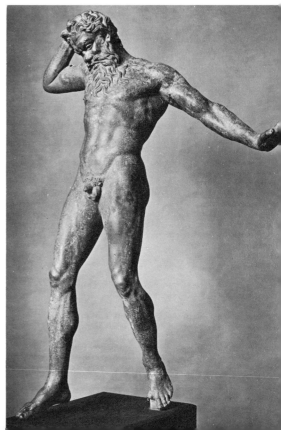

Gem-cutting continued to be an outstanding minor art, as can be seen from these typical compositions. During the fifth and fourth centuries they were often amazingly true to the model. The original was a cutting or engraving on stone, sometimes the stone of a finger-ring. The impression, taken usually in wax or plaster of Paris, appears as a miniature bas-relief sculpture. The examples illustrated show how the jewel-like imprints follow the main lines of Greek sculptural development, even while possessing the precision and crispness that are required in a miniature.

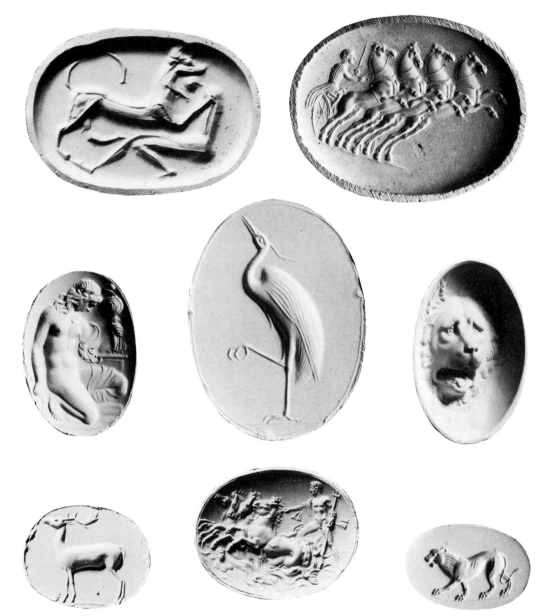

Impressions from stone gems. Greek, 8th–1st centuries B.C.
Museum of Fine Arts, Boston; Metropolitan Museum of Art

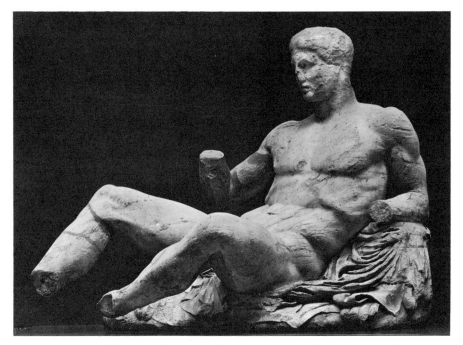

Dionysus. Stone. C. 433 B.C. Parthenon, Athens. *British Museum*

When the free-standing sculptures of Myron were being produced, the Parthenon, the temple at Athens dedicated to Athena Parthenos, was being adorned with pediment groups and friezes. The completion of this great edifice marked the culmination of heroic architectural sculpture. The subjects, processions and battles long since standardized, varied only in the devotional scenes centering around the lives of the gods. The Athens of Pericles had drawn sculptors from all parts of Greece. Though Phidias has been named as the directing genius of the Parthenon, no sculpture survives which can be identified for certain as his. From descriptions and a small replica of his colossal statue of Athena which stood within the Parthenon, it would seem that it was a pretentious and florid "showpiece"; in fact, the figure was encrusted with plates of gold and ivory. It was approximately forty feet in height.

Among the extraordinary single figures of the pediments, the *Dionysus* perhaps represents the highest achievement of Greek genius. There is a similar grandeur in the *Three God-*

desses. These minor divinities are human yet godlike, familiar but remote. The triangular space occupied by *Dionysus,* and by the *Three Goddesses* as a group, was determined, of course, by the architectural form of the pediment. The entire composition within the pediment was known as *The Birth of Athena.* Unfortunately the central standing figures, presumably the commanding ones, are lost.

The so-called *Ilissos,* symbolizing a river, is from a group in the western pediment depicting the contest between Athena and Poseidon for the land. It has been possible to reconstruct the scheme of the western pediment group of figures more plausibly than that of the ones occupying the eastern pediment, but again the dominating figures have perished. The *Ilissos* suggests that the genius of the artists was hardly less brilliant in one pediment than in the other. Certainly the Athenian sculptors achieved a richness of design and a show of power in repose unequaled in the pediments at Olympia and Aegina. (The *Ilissos* is illustrated on page 87.)

One of the few details that have escaped

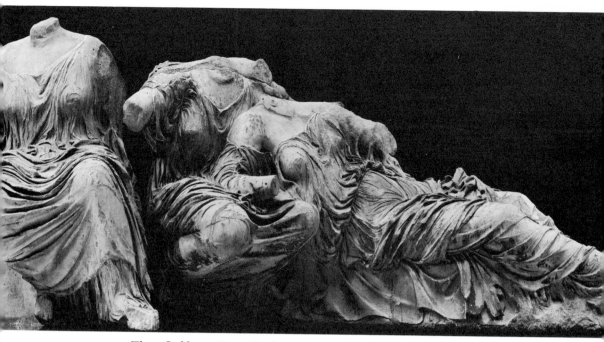

Three Goddesses. Stone. Parthenon, Athens. *British Museum*

serious damage in the twenty-four centuries since the Parthenon sculptures were lifted into place is the *Horse of Selene.* At the extreme right of the eastern pediment, filling the angle of the gable, the head rested, with the muzzle protruding outside and below the pediment floor much as it now protrudes over the edge of the museum base. It marks perfectly the advance from archaic stylization into the full Classical style. There is a simple grandeur about the piece, which is at once an interpretation and an enlargement of nature.

The designs in high and low relief are

Horse of Selene. Stone. Parthenon, Athens. *British Museum*

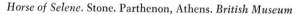

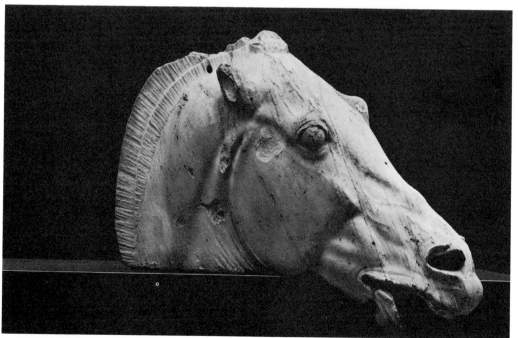

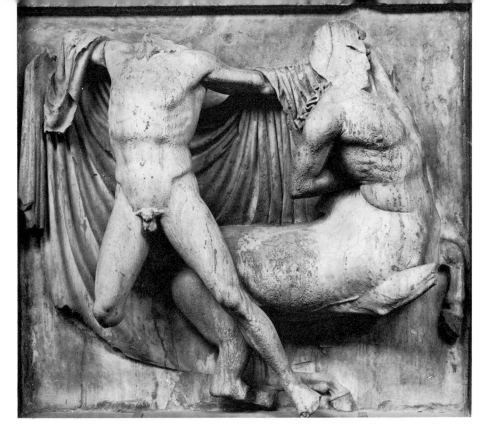

Metopes. Stone. C. 440 B.C. Parthenon, Athens. *British Museum*

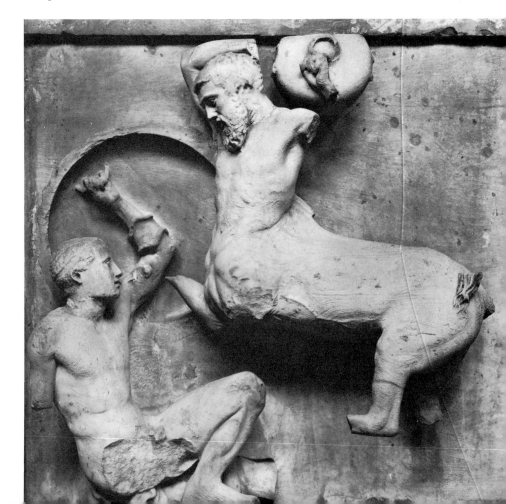

only slightly less impressive than the figures in the round that decorated the pediments. A series of ninety-two sculptured compositions originally formed the metopes, the panels between the triglyphs in the Doric frieze. The surviving examples, carved in very high relief, deal chiefly with contests between the Lapiths and the Centaurs. The two panels shown are indicative of the skill of the best sculptors in adapting their designs to architectural space. The natural expression in the faces is greater here than in any earlier Greek work.

Originally a frieze 525 feet long decorated the inner porticoes of the Parthenon. As many as 335 figures are still to be seen, *in situ* or in museums. The subject was the Panathenaic Procession, picturing a group of gods and with them the horsemen, marshals, sacrifice-bearers, musicians, maidens, and citizens who marched to the temple every fourth year during the Panathenaic Festival. The free action and flowing rhythm of the compositions reached a new peak, especially in the sculptures of the horsemen. The slab illustrated has been studied endlessly by artists seeking to comprehend the mystery of "classical perfection." The low relief miraculously creates the effect of rounded forms and of action in space, yet the average depth of the figures is only about 1½ inches, and the highest projection is 2¼ inches.

Phidias is the first important name after Myron in the history of Greek sculpture, and his figure of Zeus at Olympia was one of the Seven Wonders of the Ancient World. It was more than forty feet high, and like his *Athena Parthenos* it was cased in plates of gold and ivory. In the throne upon which the god sat were inlays also of ebony and precious stones. Many minor statues were set into the composition, and there was a profusion of panels with narrative scenes in relief and others with painted scenes. It was doubtless a wonderful and glittering example of bravura sculpture, and to the Greeks it was a holy symbol of the Olympian religion.

In the nineteenth century classicist scholars, accepting a series of "brilliant conjectures," praised Phidias as the greatest of Greek artists and as creator of the Parthenon marbles. They accepted as "in the style of Phidias"

Horsemen. Stone. C. 440 B.C. *Frieze of the Parthenon, Athens*

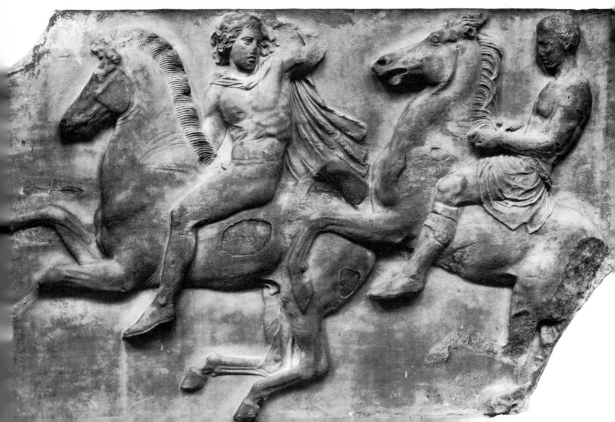

the incomparable *Dionysus* and the *Three Goddesses* of the east pediment. In the twentieth century scholars reassessed these judgments, pointing out the fundamental differences between the monumentally solid pediment figures and the two showpieces as described by ancient writers and as known in incomplete replicas. It became clear that Phidias had been a showman and a director of other artists rather than the foremost genius of Greek sculpture. He died in disgrace, having been accused, according to Plutarch, of inserting portraits of himself and Pericles in the elaborate reliefs on the shield of *Athena Parthenos*.

The names of a number of Phidias's contemporaries are known, but only two or three can be connected with surviving works. The *Head of an Athlete* (possibly a Roman copy) is ascribed to Cresilas, who also sculptured a famous bust of Pericles. The athlete's head

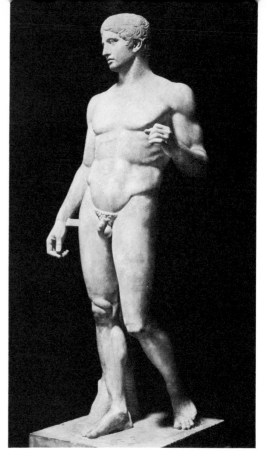

Doryphoros. Stone. Roman copy of original by Polyclitus. Argive, 450–440 B.C. *National Museum, Naples. (Alinari photo)*

Boy Athlete, or *Idolino.* Bronze. Roman copy. Argive, c. 440 B.C. *Archaeological Museum, Florence. (Alinari photo)*

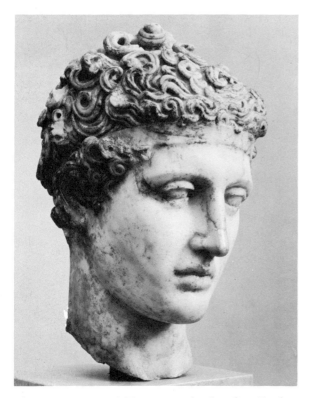

Head of an Athlete. Stone. Attributed to Cresilas. 440–420 B.C. *Metropolitan Museum of Art*

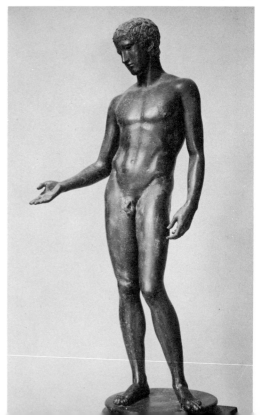

illustrates the smooth, harmonious perfection at which Athenian artists had now arrived. In it we find the most prized attributes of the Classical school: idealization, dignity, nobility, firmness, repose.

Polyclitus reached the athletic ideal in his *Doryphorus*, or *Spear-Bearer*. The sculptor wrote a treatise on proportion in art, the theme being proportion in presenting the human model rather than in compositional division or adjustment. Some authorities believe the *Doryphorus* to be the statue known of old as "the Canon," a demonstration piece by which Polyclitus sought to illustrate the ideal measurements of head, shoulders, arms, and legs. Taking the palm of the hand as a basic measurement, he constructed all his statues with thighs six palms wide, feet three palms long, and so on. The head measured one-seventh of the total height.

The new interest in man as a physical type is illustrated again in the *Boy Athlete*, sometimes known as the *Idolino*. The face is handsome, the body slight, rhythmic, and typical of youth. Pausanias considered that Polyclitus in his time "had brought the art of bronze-casting to perfection."

The several figures from a lost pediment group illustrating the story of Niobe are supposed to have been the work of sculptors in one of the Asian or Peloponnesian cities. The *Wounded Niobid* shows practically no facial contortion, though she has an arrow in her back. The dignity of the figure, its firm modeling, and the rhythm of the masses, raise it above most of the work of the period, except for the Parthenon marbles. Especially noticeable is the avoidance of line and gesture that would carry the observer's eye away from the center, a common fault in the routinely sculptured athletes, Amazons, and goddesses of the Polyclitan and later schools.

About this time (after 435 B.C.) there developed in Arcadia a school largely devoted to the depiction of violent action. In *Greeks and Amazons Battling* on the frieze from a temple at Bassae near Phigaleia, Arcadia, we

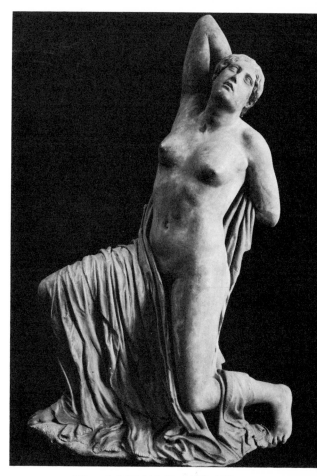

Wounded Niobid. Stone. C. 435 B.C. *National Museum, Rome.* (Anderson photo)

Greeks and Amazons Battling. Stone. Arcadian, c. 420 B.C. Bassae. *British Museum*

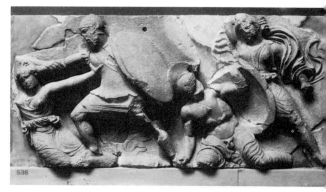

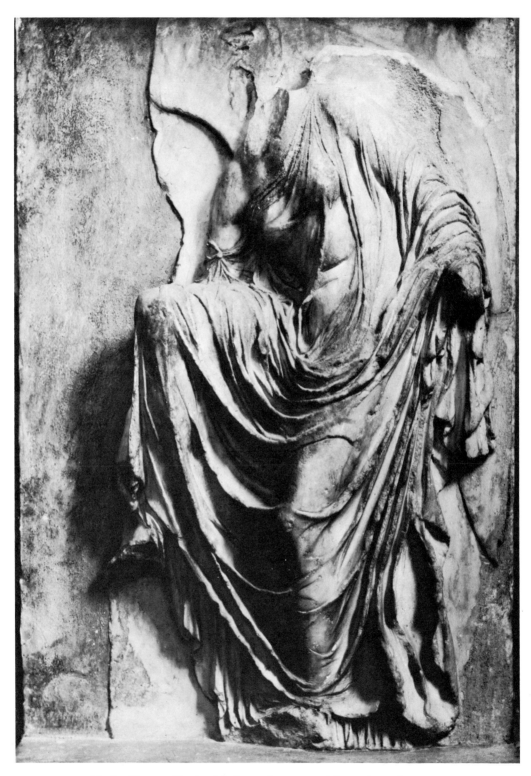

Maiden Untying Her Sandal. Stone. C. 410 B.C. Athens. *Acropolis Museum*

see warriors thrown into confusion and horses rearing and stumbling. Even garments are arranged so that they appear to be blown this way and that, to increase the impression of movement. The designing is effective in the large, and only a lack of subtlety in the actual carving prevents the frieze from taking its place with the great works.

The Athenian sculptors seldom carved a more graceful and ingratiating figure than the *Maiden Untying Her Sandal*. This is one of the slabs from a frieze that adorned the

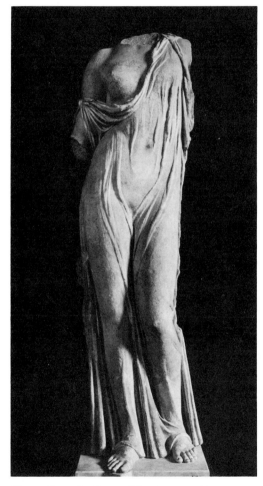

Venus Genetrix. Stone. Athenian, c. 400 B.C. *National Museum, Rome.* (*Brogi photo*)

Gravestone of Hegeso. Stone. Athenian, c. 400 B.C. *Keramikos, Athens.* (*Alinari photo*)

balustrade of the Temple of Athena Victor on the Acropolis. The draperies are rhythmically handled, and the way in which the fabric clings to the curves of the maiden's body brings to mind Aristophanes' famous lines about the girl who "had had a bath, and wore a transparent little tunic."

Something of the same lightness, charm, and liveliness characterizes the *Venus Genetrix*, although the work is known to us only through copies. The original statue may have been the *Aphrodite of the Gardens* by Alcamenes. As yet there were few female nudes in Greek sculpture, but here, certainly, the underlying graces of the body are more revealed than veiled by the effectively arranged garments.

As in the *Venus Genetrix*, so in many of the reliefs found on gravestones of the period, the effect the sculptors sought was more pretty than profound. The example illustrated, the gravestone of Hegeso, is perhaps the best known of its type and a masterpiece in its particular field.

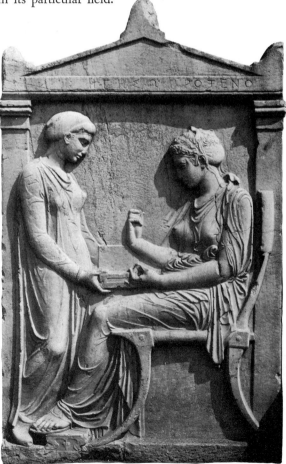

According to the Greek writers, coinage had been invented by the Lydians in the eighth century B.C. Designed and identifiable disks of electrum, gold, and silver were used for barter instead of cattle, axes, bullion, or whatever else had previously been used as standard measures of value in different regions. It was Croesus of Lydia who first regularized minting and values.

By the early fifth century many cities of Greece proper and of the Asian, African, Sicilian, and Italian colony-states were issuing coins. Perhaps the most beautiful ancient Greek designs in the average coin collection are the Syracusan examples. Most of these show the head of Arethusa, or Persephone, on the obverse, and on the reverse side the favorite motive of a chariot.

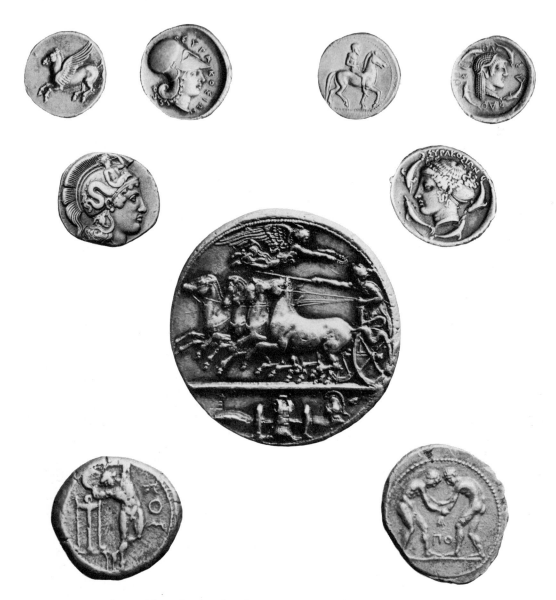

Coins. Silver. Greek, 5th–4th centuries B.C. *Bibliothèque Nationale, Paris; Museum of Art, Rhode Island School of Design; Museum of Fine Arts, Boston*

It used to be said that the second great period of Greek sculptural art opened with the appearance of Praxiteles. Generations of art-lovers who looked for faithful transcriptions of attractive models in graceful poses praised the statues of Praxiteles and Lysippus as examples of supreme lithic art. In our own time, critics who have reawakened to the values of primitive art and of expressive rather than representational sculpture have to some extent undermined the reputations of the fourth-century Classical masters. But to dismiss such works as the *Hermes with the Infant Dionysus* as merely pretty and affecting would not be fair. The statue of Hermes is typical in its handsome face and substantial body. Its soft modulations and pleasing finish are a great deal more expert than the work of copiers in later centuries.

The *Aphrodite of Cnidos* by Praxiteles was one of the outstanding statues of the fourth century. The model, reported to have been Phryne, a famous beauty, was obviously shapely, and the sculptor has portrayed her

Hermes with Infant Dionysus. Stone. Praxiteles. C. 350 B.C. *Museum, Olympia.* (*Alinari photo*)

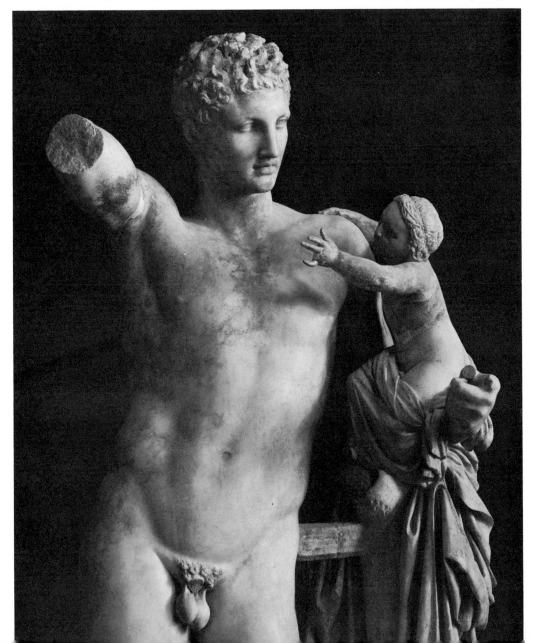

prettily and acceptably—although we have only Roman replicas of the statue as evidence. Ancient writers were eloquent in their praise of the original marble composition. Pliny declared in his *Natural History* that "the finest statue, not only of Praxiteles but of the entire world, is the *Aphrodite*. Many have traveled to Cnidos just to see it."

Several heads exist which are considered to be from ancient copies of the Cnidian *Aphrodite* or of other of Praxiteles' female figures. The *Head of a Girl,* from a draped statue, now at Toledo, is typical of the Praxitelean grace, charm, and tenderness; it is characteristic too of the regular-featured face with dreamy eyes then fashionable.

In the fourth century the sculptor Scopas was among those who opposed the current

Aphrodite of Cnidos. Stone. Attributed to Praxiteles. C. 340 B.C. *Louvre*

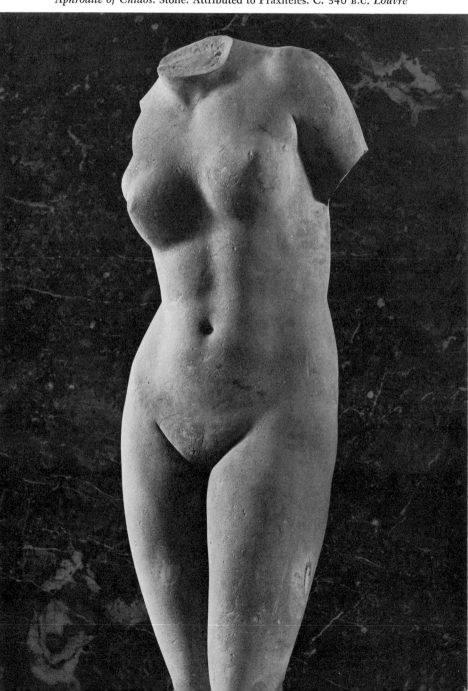

tendency to soften and sentimentalize the human figure, especially the face. His modeling appears to have been vigorous and firm while that of most of his contemporaries was weak. Unfortunately the only uncontested originals of Scopas that survive are fragmentary or in poor condition.

Also of the fourth century was Lysippus, who has generally been named with Praxiteles and Scopas as one of the foremost Greek masters. He tried to perpetuate the natural idealism of Praxiteles and invented his own canon of proportion, just as Polyclitus had done. No surviving works are known to be from his hand, and the one outstanding Roman copy, the *Apoxyomenos*, suffers in comparison with copies from Praxiteles. The typically naturalistic figure of *Hermes Resting* is commonly attributed to Lysippus, but this cannot be verified.

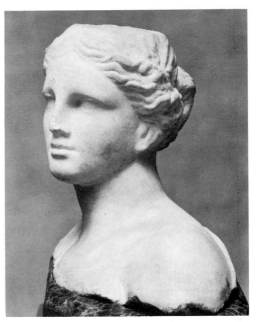

Head of a Girl. **Stone. School of Praxiteles. Late 4th century** B.C. *Toledo Museum of Art*

Hermes Resting. Bronze. Attributed to Lysippus. 4th century B.C. *National Museum, Naples*

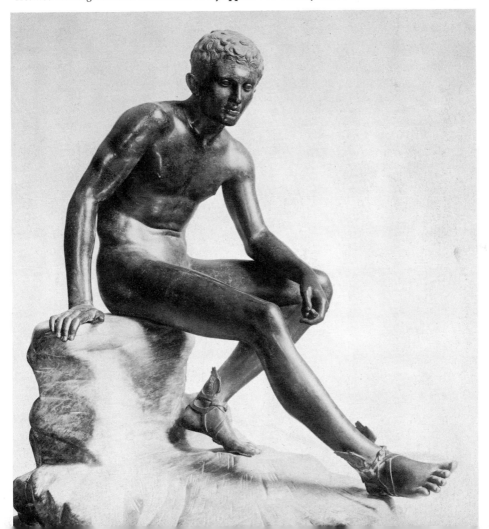

✶ The relief panels on the so-called sarcophagus of Alexander are characterized by vigor and lively action. Though they may be on the melodramatic side, there is no denying that the presentations of Alexander in battle against the Persians, and Alexander in a lion hunt, are visually exciting. In small reproductions the composition seems crowded, but in reality the figures are well spaced and rhythmic.

Among the characteristic reliefs of the mid-fourth century, the most famous was the frieze decorating the tomb of Mausolus, ruler of Caria, *The Mausoleum* at Halicarnassus. The panels are superior to the designs on the Sarcophagus of Alexander (produced several decades later) in their simpler composition and the firmer handling of the individual figures. Scopas is believed to have

been one of the sculptors involved in the making of these vigorous reliefs, but no specific part of the frieze can be convincingly ascribed to him.

In the fourth century the decline of monumental sculpture into naturalism was matched by the rise of lifelike portraiture. The statuette *Socrates* was not a study from the life (the philosopher had been put to death in 399 B.C.) but was a later sculptor's version, expressing alertness, inquisitiveness, and kindliness. As sculpture it achieves a sense of controlled organization.

Aristotle had said that the purpose of portraiture was to represent a man's features, "and, without losing the likeness, to render him handsomer than he is." Alexander the Great objected to being portrayed realistically and appointed Lysippus sole imperial por-

Battle Scene. Stone. 4th century B.C. Mausoleum, Halicarnassus. *British Museum*

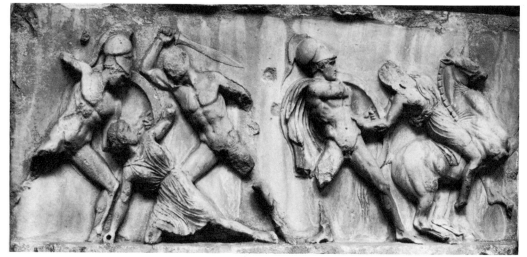

So-called sarcophagus of Alexander. Stone. 4th century B.C. *Istanbul Museum*

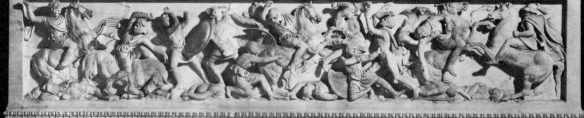

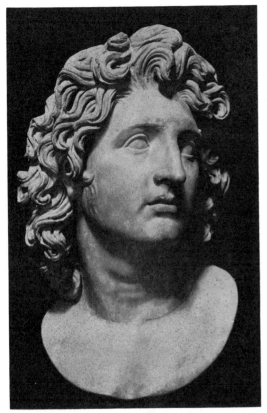

traitist because, according to Plutarch, all others had "failed to convey his masculine and leonine look." Lysippus made many busts of Alexander, picturing him as a heroic conqueror rather than a plausible individual. The bust here is probably a copy of one of them. This sort of heavy idealization ran parallel with the realistic Hellenistic sculpture. Comparison with the bust of Pericles by Cresilas may suggest that little progress had been made in the intervening years.

The fourth century was also notable for the charming terra-cotta statuettes generally known as Tanagra figurines. The name indicates the provenance of the first large finds in modern times and also one of the important sites of manufacture. Less well known are the Myrina figurines made by the artisans

Socrates. Stone. Roman copy. After 350 B.C. *British Museum*

Alexander. Stone. Lysippus. 4th century B.C. *Capitoline Museum, Rome.* (*Alinari photo*)

Pericles. Stone. Cresilas. 5th century B.C. *British Museum*

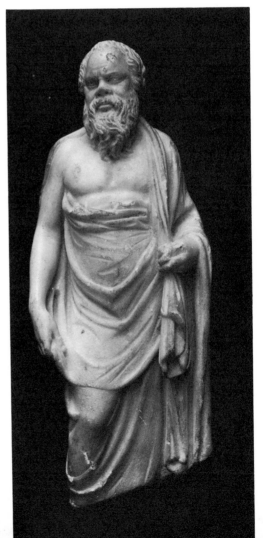

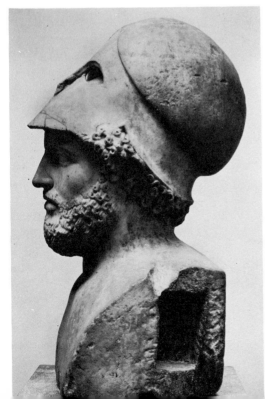

of Myrina in Asia Minor. In addition, there were schools of sculptors devoted to the miniature clay compositions in Smyrna, in Rhodes, and, in a smaller way, in many cities, including Athens and the Greek communities in Italy.

Terra-cotta statuettes had been common from earliest times, but in the fourth century the sculptors abandoned the subjects that had been popular earlier—notably the gods—and specialized in intimate portraits of women, girls, and eccentric characters. Women, gracefully dressed, conversing, walking, reclining, dancing, were the commonest and the most successfully treated subjects. Many of the figures are attractive and engaging, and all are illuminating as social documents. The examples shown, *Dancing Girl* and *Standing Woman*, are typical of the many hundreds to be seen in the world's museums.

The sculptors of Myrina were more ambitious, and they often returned to the gods and legends for their subjects. Four exceptional little statuettes from Myrina and other provincial centers are illustrated. The *Crouching Eros* and the *Venus Rising from the Sea*, at the Royal Ontario Museum, are examples which combine exquisite sensibility with a superior feeling for plastic rhythm. The *Horseman*, at the Louvre, is another exceptional piece.

After the conquests of Alexander, when vast territories outside Greece were Hellenized and leadership slipped from Athens and the original Greek territories, eccentric portraits, caricatures, and occasionally pornographic

Dancing Girl; Standing Woman. Clay. Hellenistic. Tanagra.
Walters Art Gallery, Baltimore; Louvre. (*Giraudon photo*)

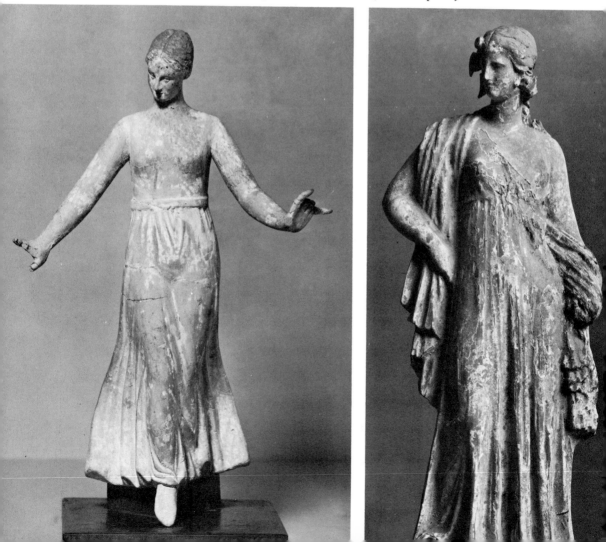

genre compositions became a "leading line" among the statuette-makers. At Smyrna especially, the artisans delighted in oddities and exaggeration. Favorite subjects were Eros, old people, actors, slaves, and the like; and there was an extraordinary run of miniature caricature heads. The bent *Slave* (the bundle now lost from his back) gains sculpturally from the clever exaggeration of natural features, and the *Comic Actor,* a Boeotian piece, is also extraordinarily alive and expressive. The two caricature heads, which might be titled "Loud-Mouth" and "Thick-Head," are typical of the combined alert observation, satirical intention, and intuitive feeling for the medium that went into the artisans' equipment. They are from a large collection of caricature heads at the Louvre.

Caricature heads. Clay. Hellenistic. Smyrna. *Louvre.* (*Tel photo*)

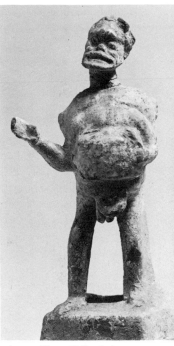

Slave. Clay. Hellenistic. Smyrna. *Louvre*

Comic Actor. Clay. Hellenistic. Boeotia. *Museum of Fine Arts, Boston*

Venus Rising from the Sea; Crouching Eros; Horseman; Cupbearer. Clay. Hellenistic. Tanagra; Myrina. *Royal Ontario Museum; Louvre.* (*Alinari photo*)

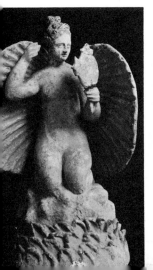
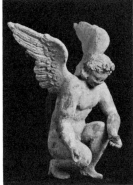

Whatever Greek sculpture may have lost in the later centuries, dignity remained to the very end. One of the grander monuments after the Hellenistic dispersion is the majestic and spirited *Victory of Samothrace* or *Winged Victory*, in the Louvre, which for many observers still ranks among the greatest statues in the world.

Almost the only equestrian monument surviving from late Greek times is the imposing group of horses surmounting the porch of St. Mark's Cathedral in Venice. Once an adornment of a Roman arch in Byzantium, the *Horses of St. Mark's* were for long considered to be of Roman origin, but their provenance is now generally accepted as Grecian. Whatever their date, there is a breath of grandeur and monumentality about them.

What remained of Greek originality and freshness in the Hellenistic era went into the devoted re-creation of human beauty. No god was so glorified as Aphrodite, and in the artists' hands she became a very womanly woman. Some of the most famous life-size nude figures are shown on pages 128 and 129. One can realize what study and loving care went into the conception and carving of the *Cyrenian Aphrodite* and the *Syracusan Aphrodite*. Insofar as sculpture is a reproductive art, and observation of and feeling for natural beauty a source, these are examples of high accomplishment.

In this realistic sculpture the comeliness of the model counts for a great deal. Some observers find the *Capitoline Venus* (and the similar *Venus de Medici*) less attractive because the clean-cut, athletic ideal seems to have given place to a preference for amplitude and softness. These were among the universally admired statues only a few decades ago. The *Apollo Belvedere* has similarly fallen in popularity, on account of the feminine head and the almost painfully naturalistic treatment of the body.

The *Aphrodite of Melos*, or *Venus de Milo*, is a refreshing figure after a century or more of facsimile realism. Here womanhood is at

least generalized and it is possible to feel that the statue stands for generic woman rather than a naked model. The head is better preserved than most ancient examples and shows the persistence of the ideal classic face.

During the latter and more degenerate phases of Greek culture, one of the largest monuments of architecture and sculpture, the *Altar of Pergamon*, was erected in Asia Minor. This had an enormous frieze on which the battle between the gods and the giants was pictured in high relief. The work here is too vigorous and melodramatic to be counted among the masterpieces of sculpture, but it is important as marking the culmination of a tendency to which it gave the name "the Pergamene style." This style had already begun to form in the days of Scopas. Technically it is distinguished by a special boldness of handling, with vigorous ridging and undercutting.

The method is nowhere better illustrated than in the portrait of Homer. The strength and verve here are typical of the handling of a series of type portraits of famous poets, philosophers, and statesmen, which do not pretend to be personal portraits but rather crystallizations of the popular idea of Homer, Socrates, or Epicurus. Paradoxically they are conventionalized in the Pergamene manner yet remain naturalistic in the sculptor's observation and intention. Even the head of Anytos, an extreme example of the Pergamene type of carving, with turbulent modeling, has a lifelike aspect.

The Dying Gladiator, so well known through replicas, is another example of this style. The head is not especially noteworthy, but the anatomical truthfulness, together with the sentimental subject-matter, has made the work famous. This was the Dacian "butchered to make a Roman holiday," whom Byron wrote about in *Childe Harold's Pilgrimage*. The Capitoline example is a copy of the bronze original from the Pergamene Acropolis. Recent authorities prefer the name *Dying Gaul* and reject the gladiatorial inference.

Athens was not without sculptors to vie

Victory of Samothrace.
Stone. Rhodian, c. 250 B.C.
Louvre. (Roget-Viollet photo)

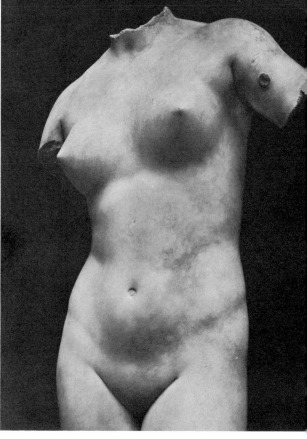

Syracusan Aphrodite. Stone. 3rd century
B.C. *Syracuse Museum.* (*Alinari photo*)

Cyrenian Aphrodite, detail. Stone. 3rd century
B.C. *National Museum, Rome.* (*Anderson photo*)

Horses of St. Mark's. Bronze. 4th century B.C. *San Marco Cathedral, Venice.* (*Alinari photo*)

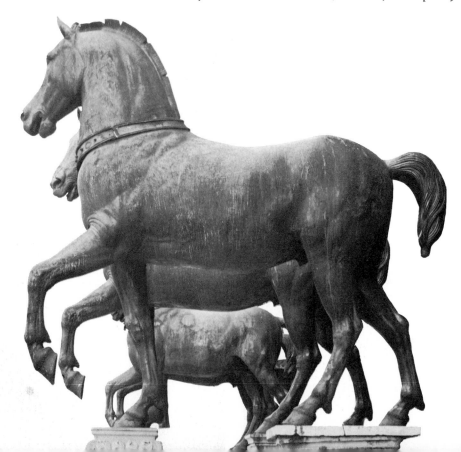

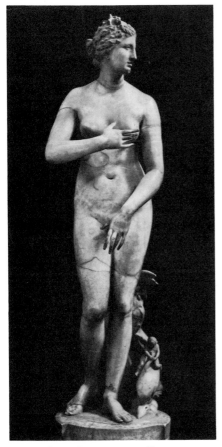

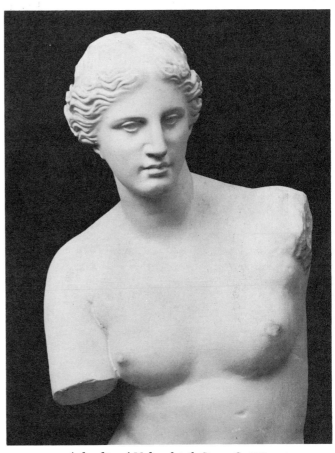

Venus de Medici. Stone. Hellenistic.
Uffizi Gallery, Florence. (*Brogi photo*)

Aphrodite of Melos, detail. Stone. C. 150 B.C.
Louvre. (*Fiorillo photo*)

Homer. Stone. Greco-Roman.
British Museum

The Titan Anytos. Stone. 2nd century B.C.
National Museum, Athens

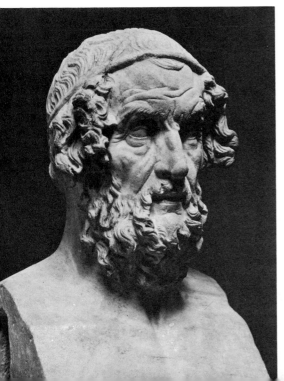

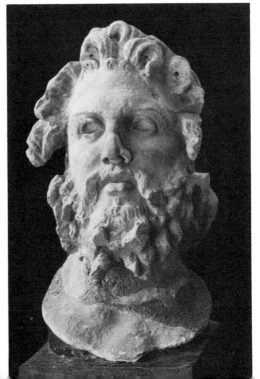

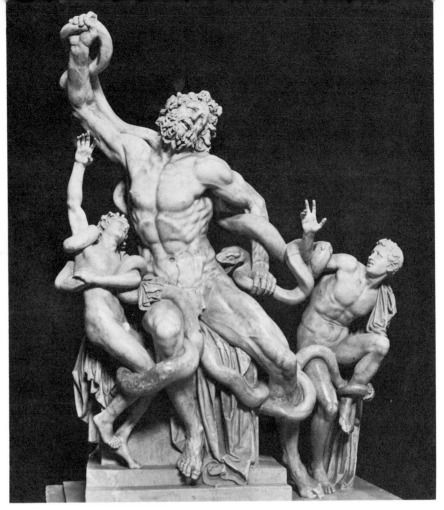

Laocoön. Stone. Rhodian, 1st century B.C. *Vatican Museum*

The Dying Gladiator. Stone, after bronze original.
Pergamene, 2nd century B.C. *Capitoline Museum, Rome*

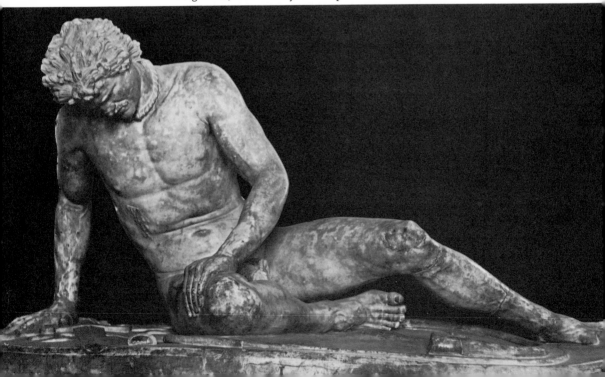

The Farnese Hercules. Stone. Glycon. Athenian, 1st century B.C. *National Museum, Naples.* (*Anderson photo*)

with those of the Pergamene and Rhodian Schools. As seen in the work of Glycon, who carved *The Farnese Hercules,* the Hellenistic Athenian style was hardly less forced than that practiced in the provincial schools. Although Glycon is credited with the *Hercules,* it is sometimes considered to be after an earlier model by Lysippus.

After Greece succumbed politically to the Roman armies, Greek restraint in matters of art also came under pressure from the Romans, and the style that evolved became known as Greco-Roman. The artists, however, were still Greeks.

We see the degeneration of vigor into physical violence and even sculptural anarchy in the *Laocoön,* a group of figures by the Rhodian sculptors Agesander, Polydorus, and Athenodorus. The work would hardly be worth reproducing, had it not precipitated one of the most protracted debates in the later history of aesthetics, a debate revolving around the question of emotion's place in art, and especially around the humbug of the pathetic appeal. The *Laocoön* was extensively restored after its discovery in 1506 in Rome, and a new restoration or "correction" was initiated in 1960.

As often happens at the end of a long period of decline, the artists of Greece made a final effort to upgrade their sculpture by returning to older masters for their inspiration. They copied the surface virtues of the sculpture of the fourth century and even ventured into the territory of fifth-century archaism. Occasionally they managed to achieve the old grace and naturalness, but the creative fire had long since burned out.

Five hundred years after the carving of the archaic korai and kouroi, the story of Greek sculpture came to an end with graceful but weak and conventional work. The Western world was waiting for a new impetus in art. There was an air of expectancy, as if heralding the birth of Christ.

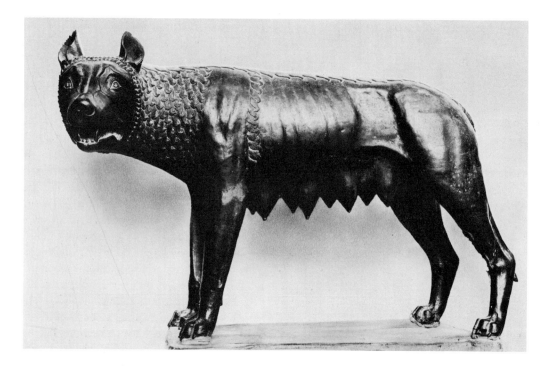

6: Etruscan and Roman Sculpture

I

IN Augustan Rome there was a vogue for Etruscan literature and for Etruscan bronze sculpture. While the Imperial Romans reverenced Greek art, they recognized that an antecedent native art had existed and that this had served as a foundation for their own artistic achievement. Especially admired were the statues brought to Rome from the conquered mid-Italian cities. Later, and over long periods, Etruscan art was forgotten. During the eighteenth century the sculpture was rediscovered and Italian and German scholars contributed to the literature about it. However, only after the beginning of the

twentieth century did English-speaking people begin to appreciate Etruscan art, the Victorians having dismissed the Etruscans as "rude sculptors" who attempted unsuccessfully to imitate the Greek style.

The range of Etruscan sculpture is remarkable. As well as the primitive, simple work, realistic pieces existed at an early date. The most interesting examples to the twentieth-century eye are the spirited and frankly unnatural statuettes of warriors, maidens, and votive figures, and the magnificent bronzes of animals which might well have been inspired by Scythian art. There are not

She-Wolf or *Capitoline Wolf*. Bronze. Etruscan, early 5th century B.C.
Museo dei Conservatori, Rome. (*Alinari photo*)

only stylistic resemblances but exactly repeated idioms.

At one time Roman art was universally considered a reflection of Greek art (accomplished on Roman soil by imported or captured Greeks), and the outstanding achievements of Roman sculptural artistry, in portraiture and in decorative relief-cutting, were regarded as extensions of the Greek or classic style.

If one can judge by the sculpture exhumed at Pompeii, Herculaneum, and other sites, what counted most to the art-loving Roman of the Empire was Greek statuary of the realistic Hellenistic period—especially goddesses, nymphs, and legendary heroes—and the late terra-cotta figurines of Tanagra, Myrina, and Rhodes. The conquering Roman armies brought back to their capital city marvels of Greek sculptural achievement. From Delphi alone the Emperor Nero is reported to have carried away five hundred statues. The Etruscan sculptors, who were already proficient at portraiture, possibly were then influenced by Hellenistic naturalism.

What Rome is best known for artistically are the immense structures decorated with bas-reliefs, and also, toward the end of its great era, the impressive carved tombs—and always the portraits. In portraiture there were occasional variations in the form of full-length figures and equestrian statues.

A wealth of human interest is to be found in the faithful imaging of emperors, generals, senators, actors, courtesans, and wives as they appeared to the uninhibited portraitists of the time. In the Augustan era, which was the age of Virgil, Horace, Ovid, and Livy, realism in sculpture reached a peak. The *quantity* of sculpture produced by and for the Romans would seem to have exceeded that known to any other Western civilization.

A few historical guideposts may help one to appreciate the work illustrated in this chapter. First there was a pre-Etruscan period, from which sculptural fragments are rare. These are artifacts of the Villanovans, Bronze Age Indo-Germanic people who had pushed

down into Tuscany from the north. Then the Etruscans—presumably invading by sea—overcame the "native" people, probably in the tenth or ninth century B.C. The flowering of Etruscan art occurred from the seventh century to the late fifth century. By the mid-fourth century Greek influence and Roman pressure modified the native Etruscan style, although superb manufactures in bronze were still produced. There followed the indeterminate Etrusco-Roman period, and even after the Romans became masters of a vast empire that included all of Etruria, certain typical Etruscan minor arts were fostered by the emperors.

Roman history can be divided roughly as: 1. Period of consolidation and expansion, from the earliest settlement in Latium, perhaps as early as 1000 B.C., through the period of the city-states and local kings to the expulsion of the last Etruscan king of Rome in about 509 B.C. 2. Republican period, 509 B.C. to 27 B.C. 3. Imperial period, from the Augustan age through the great era of conquest and building to the death of Marcus Aurelius in A.D. 180. 4. Degeneration and break-up of the empire, ending with the final occupation by the barbarians in A.D. 476. Before that date the Byzantine style had been born in Eastern Christendom, destined to sweep all but the last vestiges of the Roman style from large areas of Europe.

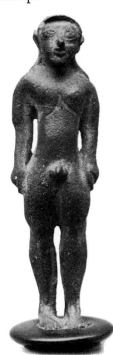

Kouros. Bronze. Etruscan, 7th–6th centuries B.C. *Metropolitan Museum of Art*

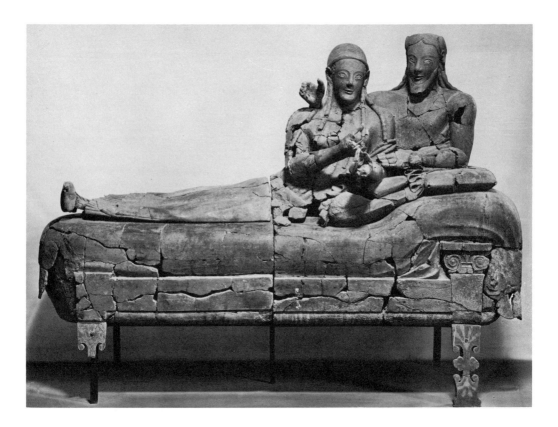

II

MANY of the early Etruscan bronzes are in an attenuated idiom, as illustrated here in the bronze *Warriors*. There are figures of priestesses and gods (or athletes) belonging to the same period, similarly stylized, thinned and rhythmic. Some seventh-century bronzes, and a few figures in the native *bucchero* or black-clay ware, seem closer to the Phoenician or the Greek style. If the examples shown in the museums are not misdated by the authorities, sculpture in Etruria was more subtle and expressive than that in Greece at the time. This was at the very beginning of the development of the Greek kouroi, and at the main Hellenic centers of the art there was hardly an example to be compared artistically with a host of Etruscan "Apollos," athletes, and female worshipers.

Despite the tendency to depart from nature and render the total figure rhythmically and decoratively, in an Oriental manner, the Etruscans soon began a course of individualized representation. This was at a time when Greek sculpture was still concerned with type faces and standardized figures. The clay *Woman* illustrated, from the British

Portrait figures on a sarcophagus. Clay. Early 6th century B.C.
Cerveteri. *Villa Giulia, Rome. (Anderson photo)*

Museum, is patently an individual portrait. It is one of a series in clay in which the features, the contours, and the expression vary widely.

The Etruscans could, however, yield to a vogue and meet foreign rivals on their own ground. The kouros figure finds treatment with all its limitations recognizably if liberally observed, as many bronze athletes and the so-called *Apollo of Veii* in clay witness. Even the "archaic smile," which conditioned Greek representation of the human face for a considerable period longer, appeared in the products of Etruscan studios.

The portraits on the lids of sarcophagi yielded temporarily to the vogue, as in the double-portrait arrangement on the sarcophagus from Cerveteri. The intent of personal identification is plain, despite the smile and a likeness in the two faces arising out of a

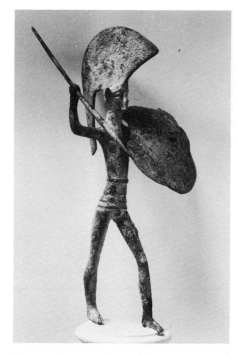

Warriors. Bronze. Etruscan. 7th century B.C. *University Museum, Philadelphia; Metropolitan Museum of Art*

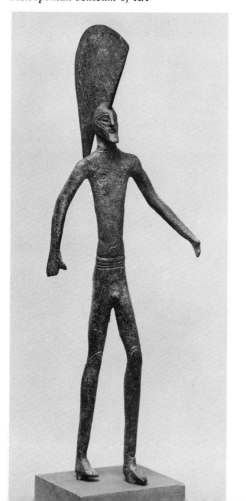

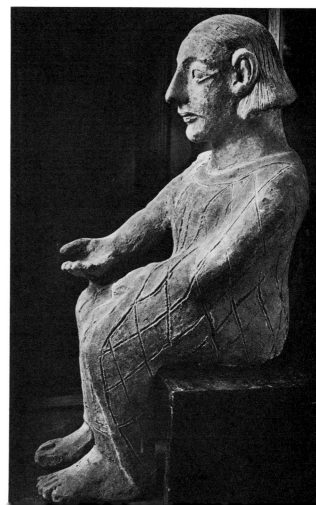

Woman. Clay. C. 600 B.C. *British Museum. (From Etruscan Sculpture, courtesy Phaidon Press, London)*

conventional method. The statues on coffin slabs, in likeness of the man entombed, or the man and his wife, are among the commonest and most distinctive relics from pre-Roman Italy. The portraits became progressively more realistic, until that pitch of exact delineation was attained which led on to Roman portraiture of the Republican era. Many of the sarcophagus groups are "light," even satiric, in general aspect. Authorities used to teach that Etruscan art was funereal and somber, but it is possible that these people, like the Egyptians, enjoyed planning and contemplating their charming tombs.

The so-called *Apollo of Veii*, in terra cotta, is related to Greek work of the time, more obviously than is any other important statue. The treatment of the hair, the brows, the eyes, and the smiling lips is clearly Hellenic, and the treatment of the draperies closely parallels that seen in the korai of about 500 B.C. But there is unusual boldness in the thrust and stride of the figure, and the face is lifelike and individual.

The *Worshiper* in bronze, probably of earlier date, is a marvel of sculptural expressionism, distorted anatomically for both decorative purpose and increase of meaning. A twentieth-century Lehmbruck could hardly have slenderized and manipulated a body with happier sculptural effect. The face is not a variation of a type but is the artist's interpretation of an individual. Though the idiom or mannerism of thinning the figure persisted through four centuries, one of the surprising things about Etruscan bronzes is the wide variation of types and methods.

Vigor and animation distinguished Etruscan sculpture, and in the animal pieces these qualities attained perfection. Some of the smaller bronze figures, which appear as decorative accessories on vases, carriages, and furniture, suggest a relationship to the spirited animal sculpture of the Scyths. The two early pieces shown here, probably eighth-century, are somewhat characteristic of the "steppe art."

In the *Chimera* at Florence the animal's strength has been expressed in a frankly

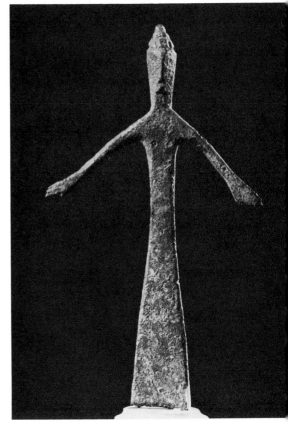

Votive Figure. Bronze. Etruscan, 7th–6th centuries B.C. *University Museum, Philadelphia*

Head of a Warrior. Stone. Etruscan, 6th century B.C. *Archaeological Museum, Florence.* (*Brogi photo*)

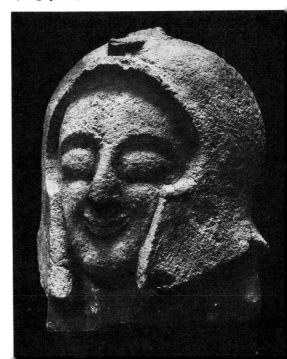

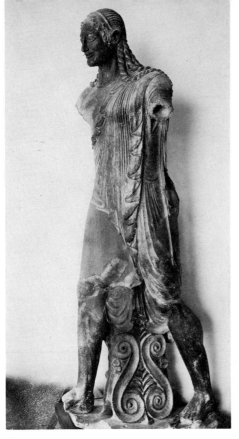

Apollo of Veii. Clay. Late 6th century B.C.
Villa Giulia, Rome. (Alinari photo)

Warrior. Bronze. Late 6th century B.C.
Louvre. (Giraudon photo)

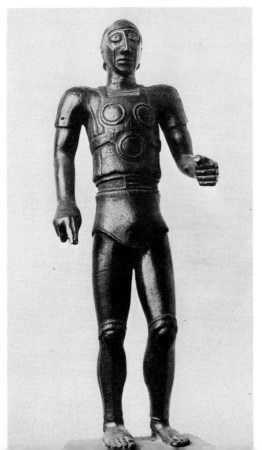

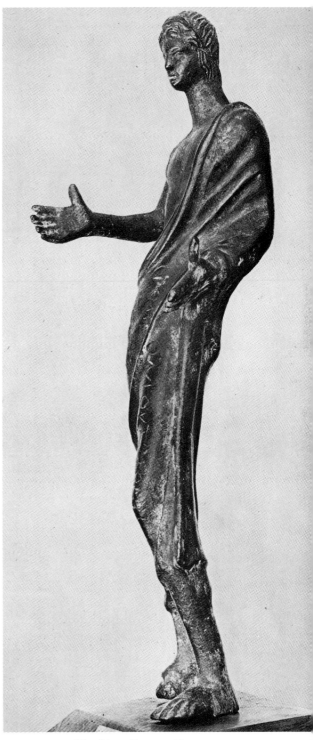

Worshiper. Bronze. 6th century B.C.
Villa Giulia, Rome. (From Etruscan Sculpture,
courtesy Phaidon Press, London)

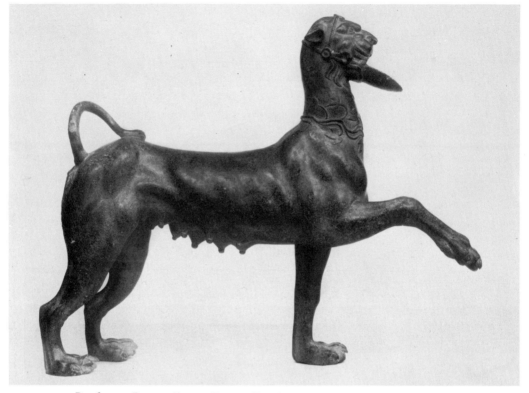

Pantheress. Bronze. Etrusco-Roman. *Dumbarton Oaks Collection, Washington*

Chimera. Bronze. 5th century B.C. Arezzo. *Archaeological Museum, Florence.* (*Alinari photo*)

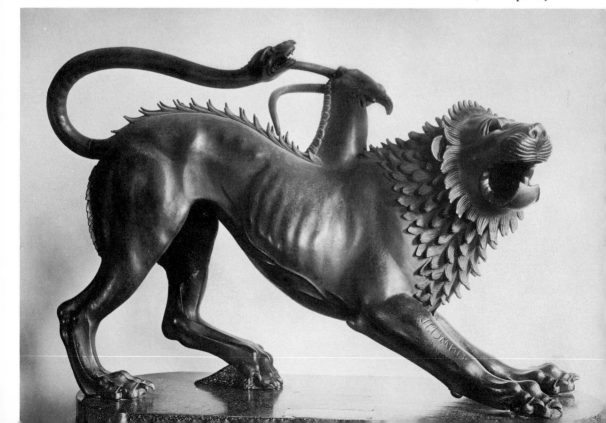

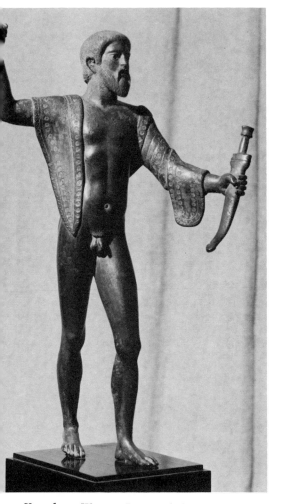

Hercules or *Warrior*. Bronze. Early 5th century B.C. *Nelson Gallery–Atkins Museum, Kansas City*

decorative creation. It is the Scythian formula brought to a new refinement. Other animal forms are added, such as the head terminating the chimera's tail, and the ibex head and neck stemming unaccountably from the animal's back.

The *Pantheress*, described by some authorities as Etrusco-Roman, exhibits the typical litheness and verve hardly known in the later Roman product. Again ornamentation is superimposed, on the throat.

The *She-Wolf*, sometimes known as the *Capitoline Wolf* and famous as a symbol of the founding of Rome, is another example of superb limning with both decorative and realistic intent. Nothing could be truer to wolfish nature, to strength and alertness. The ornamental treatment of the fur, in arbitrarily chosen areas only, indicates that the intention is non-naturalistic. The presence of Romulus and Remus in the statue today distracts attention from the animal and destroys sculptural unity. The child figures were added at the time of the Renaissance. (The illustration is on page 132.)

The Etruscan workers in bronze sometimes achieved an equal elegance and suavity in sculpturing the human figure. The bronze *Hercules* body is clean-cut, smoothed, even satiny, while the characteristic contrast is gained by ornamental enrichment of the scant draperies and texturing of hair and beard.

Bull, aquamanile; wheeled censer. Bronze. 8th–7th centuries B.C. *Tarquinia Museum*. (*Anderson photo*)

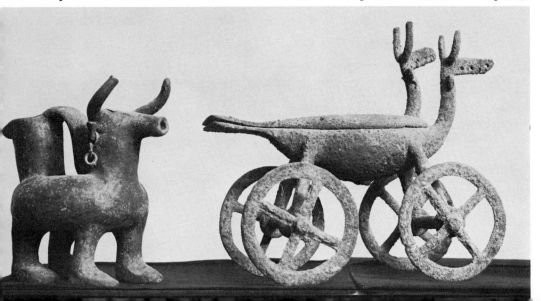

Like the Chinese, the Etruscans frequently combined reliefs and free-standing figures to embellish metal vessels. The legs, clasps, and handles were adapted from objective nature, and pictorial scenes in relief either circled the vessel, as here, or filled four side panels. The elaborate composition on top of the cist is a device often encountered.

Scores of statuettes in our museums once adorned the lids of urns. The more usual subjects were acrobats, or satyrs and nymphs, or warriors: a single acrobat arched his body to form a handle, or two wrestlers formed a loop; a satyr and a nymph stood with arms locked, or two warriors carried a mate crosswise. Great inventiveness was used to vary the formula, and the technique of the casting and finishing was extraordinarily refined. Such figures are found on incense-burners, candelabra, mirrors, and other small furniture, as well as on vessels.

There was a special division of Etruscan sculpture in terra cotta in which naturalism was pursued for its own sake. Some oversize

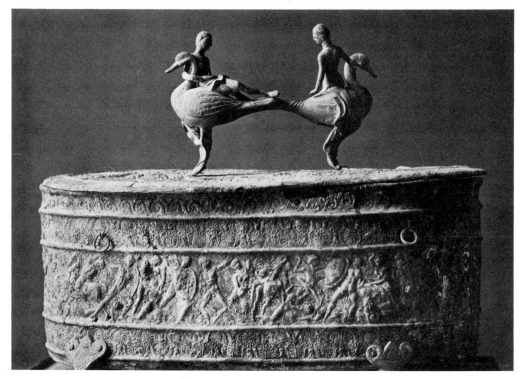

Bronze cist with relief of Amazons in battle. *Vatican Museum*

Etruscan Dining. Portrait on sarcophagus cover. 3rd century B.C. *Archaeological Museum, Florence. (Brogi photo)*

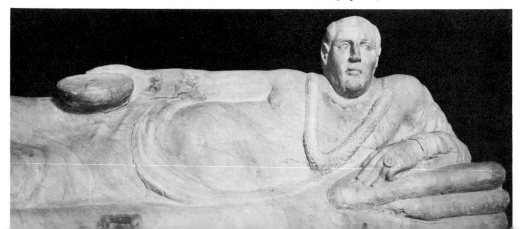

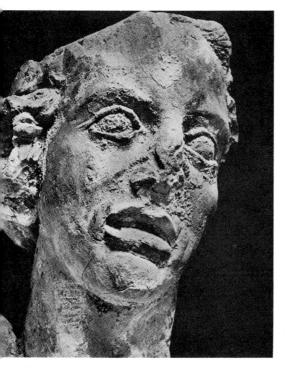

Head of a Woman. Clay. 3rd century B.C.
Civic Museum, Chiusi. (*From* Etruscan Sculpture,
courtesy Phaidon Press, London)

warriors, with every detail of dress and ac-
couterment meticulously shown, are notable.
But the more engaging examples are the por-
trait slabs adorning sarcophagi and cinerary
urns. The deceased was usually shown reclin-
ing, often as if dining in the Roman manner.
The faces were minutely representational and
cruelly candid.

The *Head of a Woman* at Chiusi is a strik-
ing example of the progress of portraiture. It
suggests modeling from life and shows psy-
chological understanding, recalling the Egyp-
tian realism of the sculpture at El Amarna in
the time of Akhenaton.

Even when the portrait on the cover is
naturalistic, the sarcophagus or urn is likely
to bear examples of more standard decorative
or formalized sculpture in the relief panels on
the sides of the casket. Etruscan portraiture
led into the literal and precise sculptural por-
traiture of the Romans, and the relief panels
of the Etruscans partly afforded the inspira-

tion for the rich pictorial reliefs in which
Roman sculptors were to make their second
most distinctive contribution to sculpture.

After Greek influence had been assimilated
in the Etrurian cities, local sculptors created
panels and even temple friezes in which each
figure was obviously studied from life. They
reached a degree of truthfulness unsurpassed
even by the melodramatic works at Hali-
carnassus and Pergamon. The relief design
in the scene of warriors on a stone sarcopha-
gus at Boston is simple and stylized. The
cutting suffers somewhat from crudeness, but
the sculptural effect carries well to a distance.
This was preparatory to the famous *Warriors'
Dance* of the Roman collection at the Vatican
Museum.

During the fourth century Etruria began
to lose important cities and territories to the
Romans; but as the art of the vanquished
merged into the art of the victors, Etruscans
became the most accomplished of Roman
artists. There were, too, increasing waves of
influence from Greece, so that the fine work-
manship ceased to be identified nationally.
The brilliant *Head of a Horse* at Florence
would seem to be in direct line from the
Chimera and the *Pantheress* illustrated previ-
ously. Elsewhere the styles are so mixed that
while one scholar credits the piece to the
Greeks, another gives it to the Etruscans.

The *Head of an Athlete* in the British
Museum is another masterpiece, dated by
experts as late as 200 B.C. In its firmness and
its clean-cut, subtly formalized expression it
could hardly be mistaken as Hellenic. The
modeling is vigorous but restrained. Every
edge is clearly, even forcefully marked, yet
the details comprise a whole that is massive
and sculpturally compelling.

The life-size bronze portrait of Aule Meteli,
known as the *Orator* or the *Arringatore,* is a
fitting final example of Etruscan invention,
because it leads directly into the following
Roman developments. Again the portraiture is
exact and uncompromising. Neither decora-
tive nor rhythmic intention is important com-
pared with presentation of an image true to

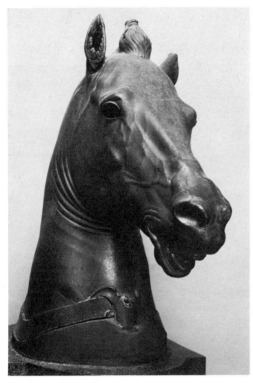

Head of a Horse. Bronze. Etruscan.
Archaeological Museum, Florence. (*Brogi photo*)

every wrinkle, hair, and mole of the original. The apotheosis of this naturalistic method appears in the illustrations on pages 144 and 145. Perhaps the excellent forthright portrait, *The Actor C. Norbanus Sorix,* is the best surviving example of a transitional type, in which sculptural nobility is discernible, along with painstaking fidelity.

The typical Roman portrait soon lost the Etruscan characteristics, except the lifelikeness, as in the marble portrait bust at the Metropolitan Museum of Art, illustrated, which would seem to be marvelously exact, but hard and cruel. Henceforward there is only a determination to present the individual as he is, neither improved (in the Greek manner) nor at any point falsified for fancied aesthetic requirements.

The Roman gallery is the most telling record of the men of an era as they outwardly looked, stripped of dignity, pride, and inner light. The artists' aim was to reveal character, not in the noble sense, by portraying essential humanity or divinity, but by imaging the individuals with their defenses down. As

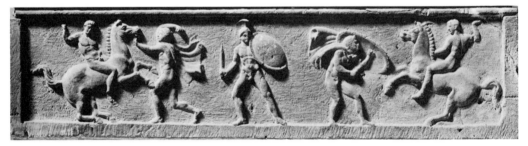

Relief on a stone sarcophagus. 3rd century B.C. *Museum of Fine Arts, Boston*

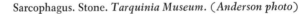

Sarcophagus. Stone. *Tarquinia Museum.* (*Anderson photo*)

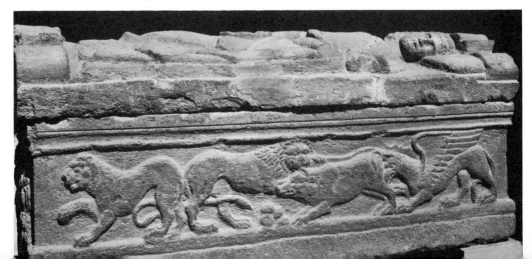

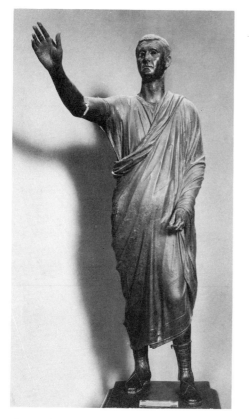

Orator. Bronze. 3rd or 2nd century B.C.
Archaeological Museum, Florence. (*Brogi photo*)

Head of an Athlete. Bronze. Etruscan,
c. 200 B.C. *British Museum*

The Actor C. Norbanus Sorix.
Bronze. Etrusco-Roman, 1st century
B.C. *National Museum, Naples.* (*Alinari photo*)

Portrait bust. Marble. Roman, 1st
century B.C. *Metropolitan Museum of Art*

often as not, evidences of physical degenera-
tion are added to those of decadent character,
as seen in the clay portrait bust in the Boston
Museum.

The rather battered first-century B.C. stone
head in the Metropolitan Museum might be
entitled "The Pugilist," so brutal is the im-
pression. The head in the British Museum is
of a less menacing subject, and the workman-
ship is notable for the subtle, flowing model-
ing, although the material is hardest marble.
The portrait bust of *Seneca* is of a different
sort. It follows closely the late Greek or
Greco-Roman style known as Pergamene,
with rough exaggeration of the features and a
vigorous, sketchy technique. Lifelikeness,
however, is not sacrificed.

Sometimes historical interest is added in the
bust of a man who was a military genius or
despot. In general the rulers and emperors of
Rome were shown more sympathetically, with
some softening if not idealization. This is true
of the head reputed to be that of Julius

Portrait busts. Stone. 1st century B.C.
Metropolitan Museum of Art; British Museum

Portrait bust. Clay. Roman.
Museum of Fine Arts, Boston

Seneca. Stone. 1st century A.D. *Uffizi Gallery, Florence.* (*Brogi photo*)

Supposed bust of Julius Caesar. Stone.
Louvre. (*Giraudon photo*)

Pompey. Stone. *National Museum, Naples.*
(*Anderson photo*)

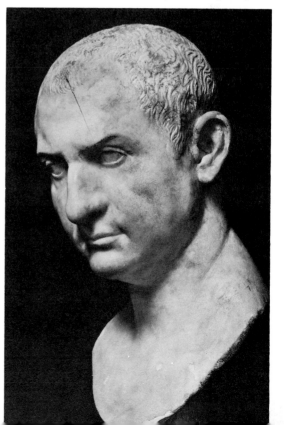

Caesar which is illustrated, and of the bust of Pompey. By the time of Augustus the sculptors, possibly Greek, frankly improved upon nature.

The famous full-length figure of Augustus in the Vatican is a showpiece, enriched with excellent mythological and historical scenes in relief upon the breastplate, and with a Cupid riding a dolphin at the emperor's feet. It is the best full-length figure in the whole range of Roman effort, appropriately opulent and imperial, though lacking in sculptural integrity. The most interesting part of it is shown in the illustration, from which some disturbing elements—the outstretched oratorical arm, the lance, the wooden, overlabored draperies, and the Cupid—have been sheared.

Of the studies of children, one of the most appealing is the portrait *A Youthful Roman.* Mastery of child portraiture followed long after that of reproduction of the adult face and figure. As we know from ancient and medieval art, the child was often limned as a small man. So rare are realistic children in classical sculpture that many standard books on the subject yield no more than an occasional Cupid or a bevy of babes used decoratively. Here, however, the artist has realized the special anatomical character of the youthful head.

In the symbolic statue *The Nile,* the children (there are sixteen of them, representing the cubits of the river's annual rise) are among the best. There is some question as to whether the statue may be Greek rather than Roman.

The *Nero* on a horse is one of the curiosities of Roman sculpture. The masses have been related with some competence; there is even a certain nobility in the stance of the horse. But the sculptor, whose intention was realistic, failed in some of the requirements of correct reporting. Other equestrian statues, notably a marble one portraying Lucius Cornelius Balbus and a bronze one of the Emperor Marcus Aurelius, suffer from the same fault. The animals are out of drawing. The compositional relationship of horse and rider has not been solved.

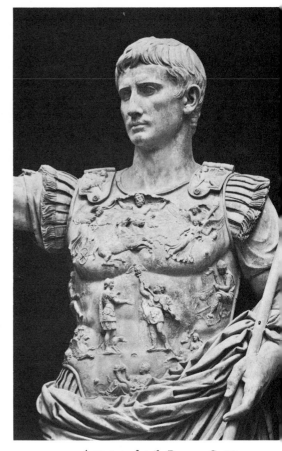

Augustus, detail. Bronze. C. 20 B.C. Vatican Museum. (Anderson photo)

A Youthful Roman. Stone. Barracco Museum, Rome. (Alinari photo)

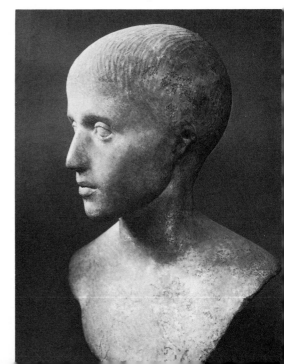

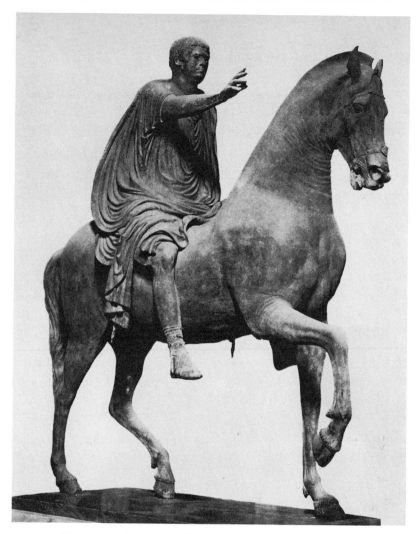

Nero, equestrian statue. Bronze. 1st century A.D. Pompeii.
National Museum, Naples. (*Brogi photo*)

The Nile. Stone. Greco-Roman. *Vatican Museum.* (*Anderson photo*)

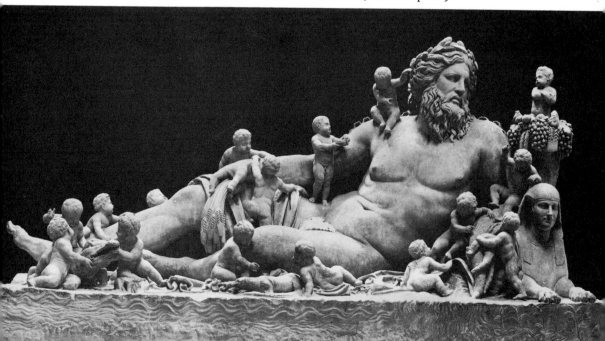

The tradition of naturalistic delineation continues long after the Augustan age. The portrait of L. Caecilius Jucundus, a banker, belongs to the reign of Nero, in the second half of the first century of the Christian era. It is a prime example of camera exactitude, a mercilessly candid image of the man.

In the portrait of a lady in the Museo Chiaramonti, of about the same time, the self-assuredness of the subject has been admirably caught. Certainly no attempt is made to hide the signs of advancing age, the protuberant eyes and the sagging cheek muscles. In the bust of Marcus Aurelius, attempted naturalism in treatment of eyes, eyebrows, beard, and draperies has ended in a rather unnatural fuzzy and plushy effect. This is a link with a type of over-ornate bust which later became popular. As contrast, an admirable bronze head of an African, provincial Roman or possibly provincial Greek, of the third century B.C. is illustrated. It suggests affinity with the Etruscan style and points to the truth that plastically the earlier works were the best of Roman sculpture.

The Romans seldom excelled in animal sculpture. The *Young Deer* found at Herculaneum is a lone piece, hardly approached in

Portrait of a lady. Stone. 1st century A.D. *Museo Chiaramonti, Rome.*
(*From* Roman Portraits, *courtesy Phaidon Press, London*)

L. Caecilius Jucundus. Bronze. 1st century A.D. *National Museum, Naples.* (*Brogi photo*)

Bust of Marcus Aurelius. Bronze. 2nd century A.D.
Private Collection. (*Giraudon photo*)

Head of an African. Bronze.
3rd century B.C. *British Museum*

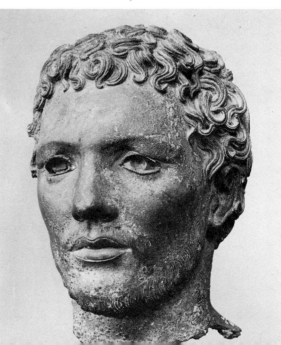

attractiveness by any similar statue from Roman hands. Experts have surmised that it is a copy of a Greek original. It is a fair deduction, if the work is of the early fifth century B.C. Otherwise it could be accepted as Etrusco-Roman.

The Romans achieved mastery of relief picturing in stone, which they extended into the field of free decorative carving. Their inheritance was double: from the Greeks, whose grave monuments especially had been in the bas-relief mode; and from the Etruscans, who had embellished stone sarcophagi and bronze urns with lively and striking compositions. The panel here, *Air, Earth, and Water,* an ingratiating if superficial masterpiece, is from the famous Ara Pacis or Altar of Peace, a commemorative monument erected by Augustus about 13–9 B.C. Inner and outer walls were sheathed with sculptured slabs. The three admirably placed female figures symbolize Air, the fecund Earth, and Water. Without calling into play the principles of mechanical perspective, the sculptor achieved a sense of objects receding in space and thus added an illusionary feature not previously notable in sculpture.

A reversion to simple, rhythmic composition is to be seen in the *Warriors' Dance,* in the Vatican Museum, where the effect is gained by a related series of isolated figures, creating strong shadows, against an unbroken background. This panel, however, is ascribed by some historians to a period two or three centuries earlier, and may, indeed, be Etrusco-Roman.

The love of the Romans for landscape is evident again and again in their bas-relief sculpture. There is a sentimental note in the treatment of the *Peasant Taking a Cow to Market,* and considerable skill in the realistic shaping of the foreground group. But the all-inclusiveness of the picture is disconcerting. The shrine and statue on the ledge at the top, the circular building at the center, opened to show a pillar with offerings to Diana, the tree growing incongruously through an archway at right, the basket carried by the peasant, and the rabbit on a pole-end—this might not tax a painter's power of integration, but the burden all but breaks the sculptor's back.

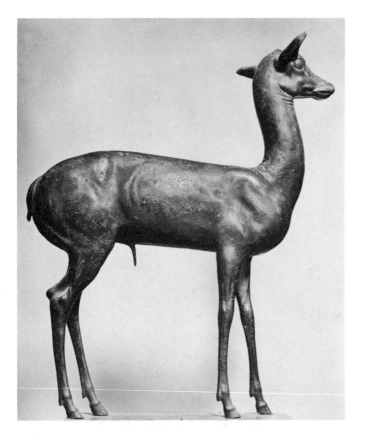

Young Deer. Bronze.
1st century A.D. Herculaneum.
National Museum, Naples.
(Anderson photo)

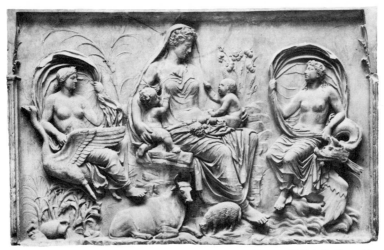

Air, Earth, and Water. Stone. C. 13–9 B.C. Ara Pacis, Rome. *Uffizi Gallery, Florence*

Warriors' Dance, high relief. Stone. *Vatican Museum.* (*Anderson photo*)

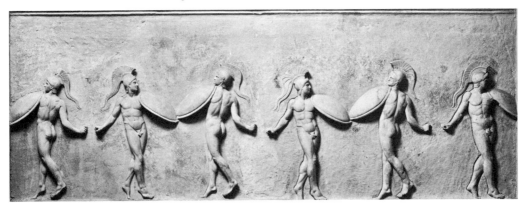

Peasant Taking Cow to Market. C. A.D. 50. *Glyptothek, Munich*

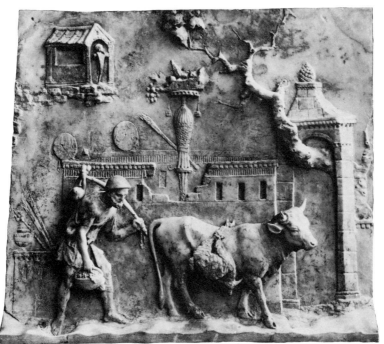

In the wave of building and decoration that increased consistently during the reign of Trajan, sculpture became grander and more opulent than ever before. Typical of the period is Trajan's Column in the Trajan Forum in Rome, constructed between A.D. 106 and 113. Around a stone shaft 11 feet in diameter, rising 100 feet in the air, sculptors carved a pictorial record of the emperor's military expeditions against the Dacians. The armies in preparation, the river crossings, the fortified towns, the victorious battles, the pacified land were all shown in vivid if overcrowded and generally undistinguished reliefs, flowing spirally round and round the column. The monument was copied often in later times but never surpassed. Because each of the 155 episodes flows into the next, the picturing is said to be in the "continuous" style. Trajan himself appears 70 times in the 650 feet of picturing.

The triumphal arch was another type of monument frequently erected by the Romans to commemorate personages and events. Some of the structures survive in more or less ruined condition, as in Rome, in Benevento, and in Orange in France, and sculptural panels from others are preserved in the museums. The sculptors worked in high relief and aspired to effects of pictorial depth formerly considered beyond sculptural attainment. The panels from a destroyed Arch of Marcus Aurelius in Rome, now in the Capitoline Museum, are thoroughly characteristic. The foreground figures appear almost in the round, heads on hidden bodies

Preparation for War with the Dacians. Stone. C. A.D. 113.
Base of Trajan's Column, Rome. (*Alinari photo*)

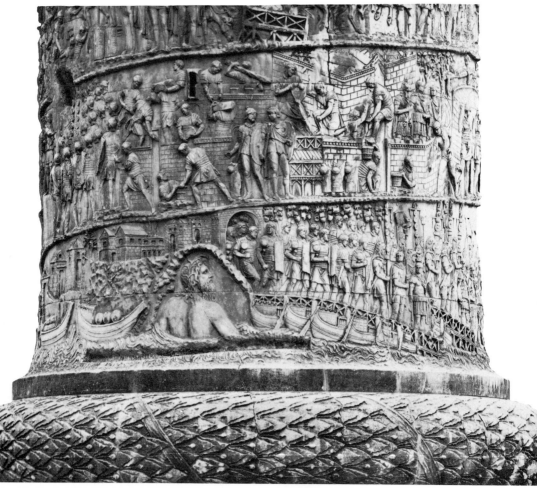

suggesting depth, and the background is made to appear as if it were at a considerable distance.

As well as this rather wooden, if ambitious style, graceful designing in very low relief continued. It is reflected in the exquisite reliefs on Arretine pottery (which was now in a decline artistically, after a history dating back to 100 B.C.). Sculptors attained their most unequivocal success in ornamental panels, instituting floral wall decoration and decoration for furniture, destined to be revived with enthusiasm at the time of the Renaissance and even at the beginning of the twentieth century. The transformation of garlands, wreaths, and sprays of common flowers into exquisite all-over patterns was superbly accomplished.

The use to which this decorative style is put is almost sumptuous in such compositions as the stone table support in the Metropolitan Museum. The low-relief tracery flows into high relief and into the round sculpture of the winged animals. In other examples certain standard motives, including cornucopias and symbolic females and winged beasts, carry the style into a mixture of methods and to a distressing decadence.

The most distinctive and masterly work in late Roman sculpture is the sarcophagus adorned with pictorial relief panels. Examples survive illustrating the transition from pagan to Christian symbolism and purpose. The compositions carry on the stylistic tradition of the high-relief panels of the commemorative arches (while recalling, of course, the Etruscan sarcophagi). It was from study of these Roman reliefs that the Italian sculptors of the late Middle Ages and dawning Renaissance were to draw inspiration for their pulpit panels, as seen especially in the work of the Pisanos. The two panels first

Reliefs from Arch of Marcus Aurelius. Stone. C. A.D. 130. *Capitoline Museum, Rome.* (*Brogi photo*)

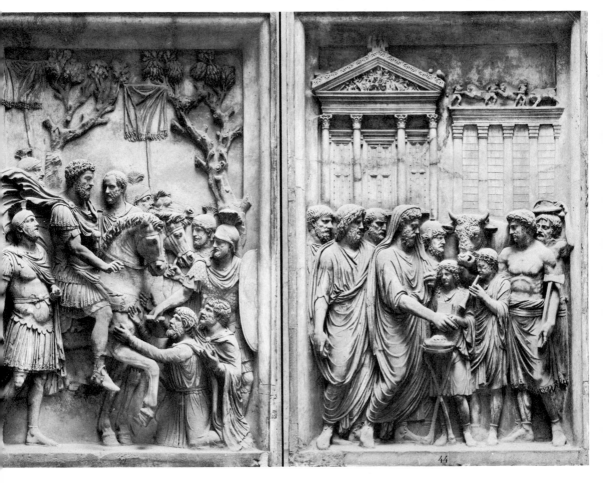

Table support with reliefs. Stone. *Metropolitan Museum of Art*

shown, in the Metropolitan Museum of Art, both illustrating the story of Endymion and Selene, are of the continuous-composition type.

The friezelike panels usually appeared on the two sides of the coffin, and smaller, more formalized reliefs upon the ends. Often the edges of the slab forming the coffin lid were adorned with a second frieze, in smaller scale, adding to the sense of rich elaboration. Sometimes curved ends permitted a continuous relief around the whole coffin, as seen in the second illustration.

To intensify sculptural values, the shadows were deepened. The sarcophagi showing a Bacchanalian scene and the story of Orestes illustrate the contrast of low-relief and high-relief methods.

Elaboration could hardly go further than in the panel depicting *Romans and Barbarians Battling,* on a sarcophagus in the National Museum, Rome.

There are hundreds of the carved stone coffins in the museums, and the standard is

in general low, for their production became commercialized. Boxes were put on sale with the sculptural decorations completed; only a figure on the top slab, usually a portrait of the owner, was left unfinished to the day of sale. Nevertheless there were many reliefs beautifully designed and competently carved.

The coming of Christianity marked a change from secular and pagan mythological subjects (such as the *Circus Races* illustrated, with Cupids acting as horsemen and as charioteers) to Christian themes. At first Roman mythology was drawn upon for episodes that might suggest the immortality of the soul or the resurrection. Then Christian motives and scenes from the Gospels were openly introduced. As soon as Christian worship was legalized, depiction of Christ and the Apostles became common, as well as the Judeo-Christian figures of the Old Testament. The sarcophagus of Junius Bassus, of the niched type, includes scenes such as *Adam and Eve, Daniel in the Lions' Den,* and *Christ before Pilate.*

Endymion, panel on sarcophagus. Stone. 2nd century A.D.
Metropolitan Museum of Art, Rogers Fund

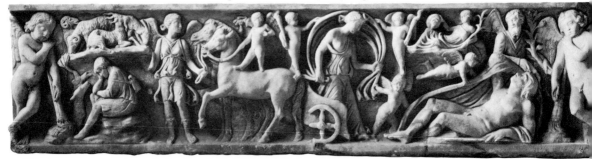

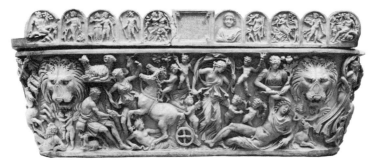

Sarcophagus with Endymion story. Stone. C. A.D. 200. *Metropolitan Museum of Art, Rogers Fund*

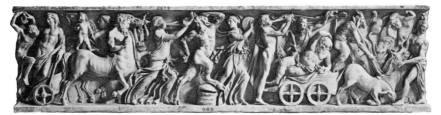

Sarcophagus with Bacchanalian scene. Stone. *National Museum, Naples.* (*Brogi photo*)

Sarcophagus with story of Orestes. Stone. *Lateran Museum, Rome.* (*Alinari photo*)

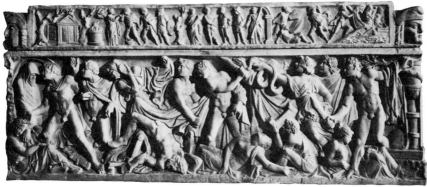

Romans and Barbarians Battling. Stone. *National Museum, Rome.* (*Brogi photo*)

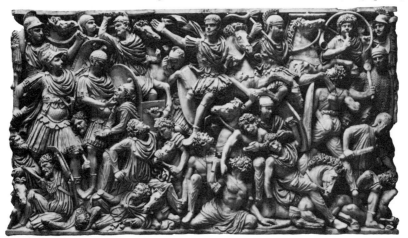

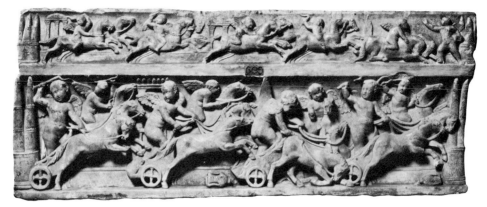

Circus Races with Cupids. Stone. Vatican Museum. (Anderson photo)

Sarcophagus of Junius Bassus. Stone. A.D. 359. *Vatican Grottoes, Rome. (Anderson photo)*

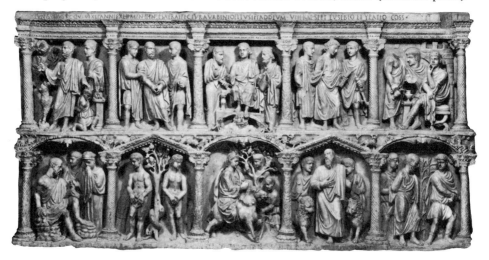

Feats of Hercules. Stone. Borghese Museum, Rome. (Anderson photo)

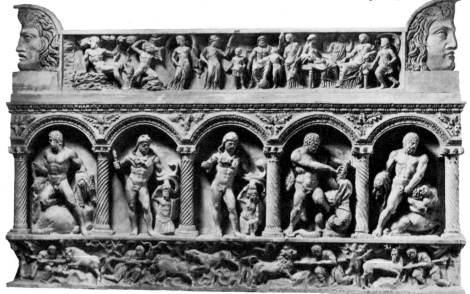

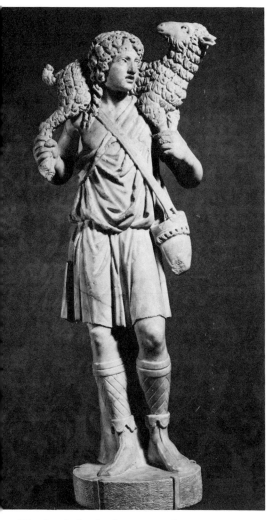

The Good Shepherd. Stone. 3rd century A.D. *Lateran Museum, Rome.*

The niched type commonly shows five or seven scenes on each side, or five or seven figures, separated by classical columns. The variations are many: tree trunks and foliage for columns and arches; Apostles and saints where Roman gods or the seasons used to be; austere single figures or detailed group scenes; and frequent efforts to break up the too mechanical niche effect by the thrust of an arm or a drapery-end across a column. A curious fact is that in a time when Roman portraiture had degenerated, so that there is hardly a competent bust extant of any of the emperors from Commodus to Constantine the Great, the heads and figures in the relief compositions are often natural and believable as well as sculpturally sound.

The shepherd or cowherd carrying a lamb or a calf on his shoulders was not a new figure in classical art. But when the Christians were being persecuted by official Rome, in the days of the catacombs and the casting of martyrs into the arenas, an old, recognized subject could be repeated with new significance for the persecuted followers of Christ. *The Good Shepherd* became a standard figure in art. It was generally interpreted rather woodenly, as in the famous statue—famous for sentimental reasons—illustrated. A characteristic setting of the symbolic figure into a richly sculptured panel is illustrated in the sarcophagus *Vintage Scene,* an example of third-century Roman decorative work almost Oriental in its opulence.

Vintage Scene with the Good Shepherds, panel from sarcophagus. Stone. *Lateran Museum, Rome. (Anderson photo)*

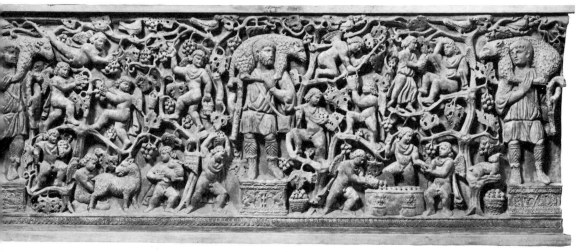

The removal of the capital of the Christian Roman state to Constantinople in A.D. 330 was a turning point and presaged the converging of East and West. How much longer Roman art remained intrinsically Roman is debatable. On stylistic grounds one might mark as Roman those last story-telling monuments in which classic naturalism and extravagant grouping of figures persisted.

When a recognizably Byzantine style emerged—that is, an Oriental Christian style —marks that distinguished it from the sculp-

tural practice of the Western Christian realm were a pronounced rounding of all forms and the return to design with separate figures against bare backgrounds. One might choose contrasted coffin panels that exhibit the difference between the late Roman and the dawning Byzantine style. But the ivory plaque showing the *Ascension* and the *Women at the Tomb* is even more eloquent of the new ideal. Its serenity of design and harmonious grace, and the distinctive Byzantine rounding of the figures, mark it as post-

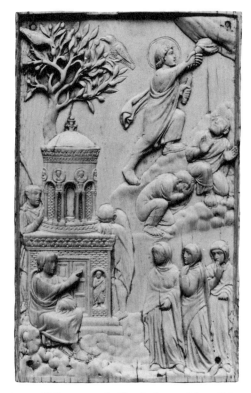

The Ascension and *Women at the Tomb*. Ivory. 4th or 5th century A.D.
Bavarian National Museum, Munich. (Giraudon photo)

Story of Jonah, panel from sarcophagus. Stone. *Lateran Museum, Rome. (Alinari photo)*

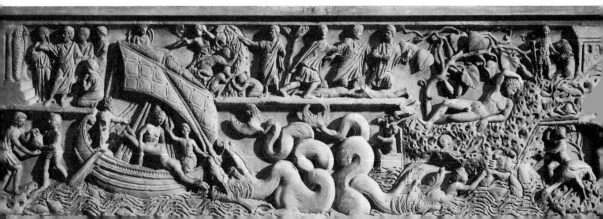

Roman in style. A new way of art was displacing the Roman, even before Rome itself succumbed to the assaults of Northern Barbarians.

Cameo-cutting was a minor sculptural art that reached its apogee among the Romans. The cameo is a gem cut in agate, sardonyx, or other layered stone in such a way that a composition stands out in one color on a background of another—commonly white on some reddish hue. Unlike the seals of the ancient world, which were engraved in intaglio, the designs on cameos, whether mythological, genre, or portrait, were cut in re-

lief. Endless ingenuity was exhibited by the Roman cameo-cutters to obtain natural illustrational effects. The *Gemma Augustae,* showing Augustus enthroned with Roma among attendant gods and mortals, over a scene of soldiers and captives, is the most famous elaborate example. But many art-lovers prefer the sharper-cut, more decorative designs, such as the neat *Venus Bathing,* in the Bibliothèque Nationale in Paris, because they escape the compositional laxness and the naturalistic appeal which, here and elsewhere, vitiate so much of the general run of Roman art products.

Cameo. Stone. Roman. *Kunsthistorisches Museum, Vienna.* (*Giraudon photo*)

Cameo. Stone. Roman. *Bibliothèque Nationale, Paris.* (*Giraudon photo*)

7: The Opulent Sculpture of Persia;

The Legacy to Islam

I

IF there is such a thing as a characteristic Oriental style in art, ancient Persia was at the heart of it. The large sculptural monuments that survive in Iran are not many, nor are they all in the full current of Orientalism. There is at times obvious borrowing of method from the Babylonian, with evidences of a naturalism that has affinities with the West. It was rather in some types of sculpture in lesser size and marked by Eastern formalism and richness that the early artists working on Iranian soil achieved supremacy.

Their sculpture, mostly in bronze and clay, is a product of cultures outside the main historical path of Persian civilization. The peoples or tribes were similarly Aryan but they were of Outer Iran as distinguished from the Inner Iran of the vast Iranian plateau. The peripheral cultures included those of Luristan, several in Azerbaijan, one known as Caspian (in the present-day territory of Mazanderan), and an Eastern phase centered at Asterabad. During the 1960s an Amlash or Marlik Culture was identified, though some authorities sought to classify it as part of the Caspian. Of all the bodies of sculpture

Crouching Panther. Silver. Parthian. 3rd–2nd century B.C.
Museum of Art, Princeton University. (Enlarged)

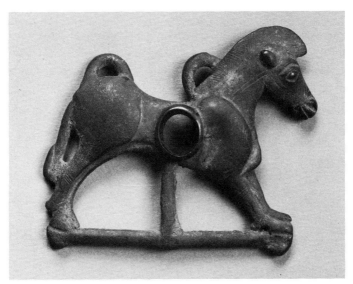

Horse. Bridle bit. Bronze. Luristan.
Franklin Mott Gunther Collection, Washington. (*Photo courtesy Iranian Institute, New York*)

from the outer states, however, that of Luristan is the largest and most distinctive.

As yet no calendar of the Luristan achievement has been worked out on archaeological evidence. No individual piece can be placed, except provisionally, but it may be assumed that the earliest typical works were produced before 1000 B.C. and that production continued down to the fifth century B.C. and sporadically, no doubt, later. It is remarkable that a highland people known to the "civilized" Assyrians and Babylonians of the era as rude provincial horse-traders should have created such sensitive and refined products.

It was the Achaemenian kings (Cyrus the Great, Darius, and Xerxes) who, despite the barriers to unification of the country, brought together all the Persian and Median lands into one national entity and expanded the empire to include Mesopotamia and Armenia, Asia Minor and parts of Greece, Macedonia and Thrace, Egypt and Libya, and a segment of India. It was the greatest empire known to history in 500 B.C., but it had no cohesive force and certainly no single style of art.

The far-traveled emperors commissioned palaces and gateways of honor and sculptured murals worthy of conquerors and reminiscent of the glories of Babylon and Nineveh. At Susa and Persepolis they built palaces to rival those of Nebuchadnezzar and Assurbanipal and called in artists and craftsmen from near and far. Achaemenid sculpture varied from friezes showing Babylonian influence, to small animals in metal in the Outer Iran tradition, and fully Orientalized jewel-like trinkets. (See illustrations on pages 172–73.)

The empire's process of disintegration continued for over two hundred years. Persian art was not much changed by the conquest of Alexander the Great in 323–330 B.C., but Greek grace and Greek realism sometimes crossed with Oriental elements to produce hybrid forms, as witnessed in Gandhara (in Afghanistan and India) at a later time.

After Alexander's death the Seleucids (named after Seleucus, one of the Greek generals) consolidated Persia and its eastern territories so that the empire stretched from the Aegean to the Indus. After a period of rule by the Parthians, who were eastern Iranians, in 224 A.D. the Sassanian kings, the true Persians, brought back earlier tra-

ditions and inspired a new flowering of the arts. The peak of Persian sculpture was reached in the four centuries of the Sassanian period. Sculptural compositions ranged in size from cliff carvings to coins and jewelry. Persian influence in the arts extended to all the civilized countries of Asia and Europe.

Islamic sculpture was a development of the Persian and extended, with slight variation, into India and Egypt, but was recreated as purest Persian in Iraq and Arabia and in Spain in the west and Turkistan in the east. The Moslem restriction against the use of figures contributed to light arabesque-like art in metal, stucco, and wood, though animals and flower motives, as well as some human figures, appeared in the compositions. Mohammedans introduced the written word, and stucco or stone panels were overlaid with calligraphy. The beautiful Arabic script was inset in bands of tile ornament circling rooms, and was interwoven with the relief ornamentation on bronze ewers, silver platters, and wooden sarcophagi.

Though the last great invasion of Persia, that of the Mongols in the thirteenth century, brought in a new art of painting, it had little effect upon sculpture. By the end of the fourteenth century the sculpture of the Islamic nations began to deteriorate, and from the eighteenth to the twentieth centuries its eclipse was complete.

The following reference list is offered as a fairly accurate guide, although it is sometimes impossible to determine exactly in what year a king took over the majority of the Persian states.

550–330 B.C.	Achaemenid Dynasty
323–250 B.C.	Seleucid Dynasty
250 B.C.–A.D. 226	Parthian Rule
226–641	Sassanian Dynasty
641–1037	Early Islamic
1037–1194	Seljuk Dynasty (and successors)
1256–1501	Mongol Dynasties
1499–1736	Safavid Dynasty
1736–1786	Afghan and other rule
1794–1925	Kajar Dynasty
1925 to date	Pahlevi Dynasty

Tribute-Bearers, detail. Stone. Palace of Darius I, Persepolis.
(*Courtesy Oriental Institute, Chicago*)

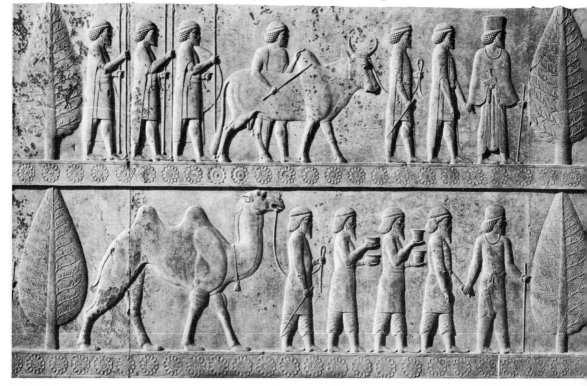

II

THE *Standing Stag* shown in the illustration is attributed to some indeterminate date in the second millennium B.C and is one of the earliest known bronze pieces from Outer Iran. It represents one of the several cultures found in Luristan, Azerbaijan, and the area along the south coast of the Caspian Sea.

In Luristan, later, the most famous of the outer cultures developed. Animals were the usual subjects, with every line and feature of the beast noted and recorded. Though conventionalized, movement was intensified. In many examples a strict symmetry was maintained, with animals confronting each other in heraldic fashion. The grace, vigor, and elegance of the Luristan bronzes were to be attributes of Persian art through the following twelve centuries. The subjects may have been almost wholly symbolic or religious; each represented an animal related to an astral deity, whether a lion, a goat, or a horse. The exclusively talismanic pieces were less common than usable objects such as bridle bits and harness rings, axes and knives, vases and personal ornaments. Apparently a certain reverence attached to everything pertaining to the horse, and axes and vases had divine significance. The first four examples are finials.

Center: Standing Stag. Bronze. 2nd millennium B.C. Pusht-I-Kuh Mountains, Persia.
Metropolitan Museum of Art, gift of Mrs. Khalil Rabenou, 1959

Left and right: Finials. Bronze. 1000–800 B.C. Luristan.
Tyler Collection (Giraudon photo); City Art Museum, St. Louis

Confronted Animals. Finials. Bronze. 1000–800 B.C. Luristan. *Museum of Fine Arts, Boston*

It is not the symbolic or magic significance, or the notable functional fitness, however, that attracts the attention of art-lovers more than twenty-five centuries later, but the inherent beauty of the designs. As if to prove that their success proceeded from no trick of elegant attenuation, the Lurs proceeded from slender conventionalization to sturdy, even heavy effects, as in the bronze *Horse* illustrated on page 161.

Practically all known Luristan sculpture has been dug from graves, and plaques for horse bits, in pairs, are among the commonest grave-finds. Horses were buried with human beings. Today zoologists are able to identify the breeds of horse from the characteristics conveyed in the plaques.

Yet more remarkable is the range of sculptural effects. The stags, lions, and ibexes were often given wings, but others remained true to outward nature. From the *Winged Rams* on the bridle bit opposite to the meticulously documented *Rams* below is

a flight from fantasy to the best sort of realism. The Lurs might have been surpassing realists in art (as were the sculptors of the Assyrian reliefs in the same era) if their culture had been a scientific or materialistic one, for there is ample evidence of camera-like observation and a sound knowledge of anatomy.

The bronze vase with ibexes as handles has something of the delicacy and richness which were to characterize Persian pottery twenty centuries later. The spouted clay pitcher is of a culture centered in northern Persia, of about 1000 B.C. The bronze spouted libation ewer is patently a lineal descendant, sculpturally refined. Whether there was intent to suggest bird form in the pieces is questionable. A series of such products could be assembled to prove that the basic elegance, the feeling for a rich but simple refinement of forms, was a gift of the mountain peoples, and that, when the empire was formed, the Persian style emerged with characteristics

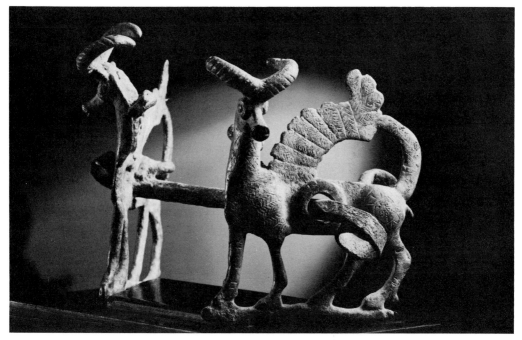

Winged Rams. Bridle bit. Bronze. C. 1000 B.C. Luristan. *Nelson Gallery–Atkins Museum, Kansas City*

Vase with ibexes as handles. Bronze. Luristan.
M. and R. Stora Collection.
(*Courtesy Iranian Institute, New York*)

Rams. Bit plaques. Bronze. Luristan.
University Museum, Philadelphia

Spouted libation ewer. Bronze. Luristan.
(*Courtesy Iranian Institute, New York*)

Spouted pitcher. Clay. C. 1000 B.C. Sialk, Persia.
Museum of Science, Buffalo

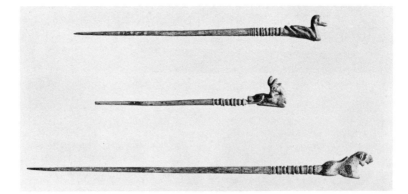

Above: Pins; *below:* pinhead; *right:* finial.
Bronze. Luristan. *Museum of Fine Arts,
Boston; Metropolitan Museum of Art*

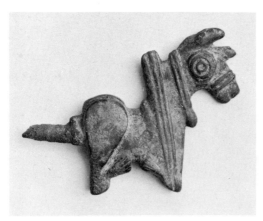

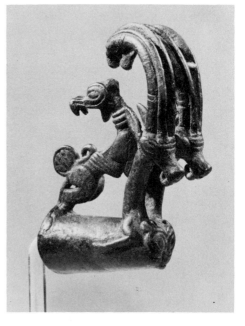

native to Iran rather than borrowed from the artists of Mesopotamia, as some scholars had previously believed.

Animal motives were predominant in personal ornament, on vases and mirrors, on tools and weapons. Necklaces were closed with animal clasps, bracelets were plain or braided bands ending in matched animal heads, and pins often had animals as terminal ornaments. Note especially how well fitted the natural object is to its placing, in relation to the actual pin, and how completely stylized. The awls, too, are examples of the object designed to function, then embellished by a talismanic decorative animal. There are rare exceptions when human beings (or gods) have been represented, just as an occasional Luristan stone relief or clay figure has turned up among the very numerous metal finds.

As among the Scythians—and other primitive Asian peoples—the Lurs had a special feeling for the abstract values of proportion, silhouette, and balance in the design of axes. Perhaps more ceremonial than utilitarian, the bronze ax heads have notable rhythmic flow. For pulsing surge of line, they are unsurpassed; and there is a wealth of counterplay in edgings and patterned bits and, occasionally, superimposed animal forms.

The beauty of the Luristan miniature lion, goat, or unicorn is formal, aesthetically realized, rather than lifelike. The *Camel* shown, which looks quite unlike the graceful and elegant products of the Lurs, is from the adjoining province of Azerbaijan, and is from a different (though still Persian) culture. Its fixed expression of disdain can be seen on the head of any present-day camel. No less decorative but even more "distorted," and indeed a superb example of expressionistic design, is the *Leaping Lion* of the Warburg Collection.

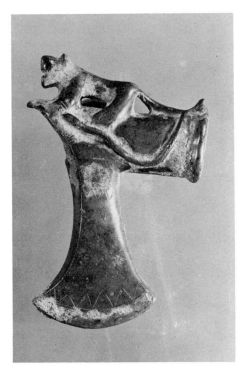

Ax head with lion. Bronze. Luristan.
(*Courtesy Iranian Institute*)

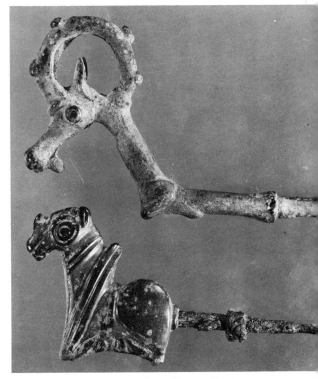

Pins. Bronze. Luristan.
University Museum, Philadelphia

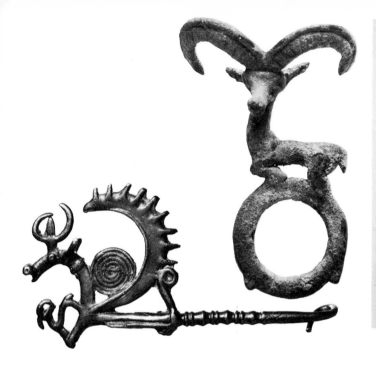

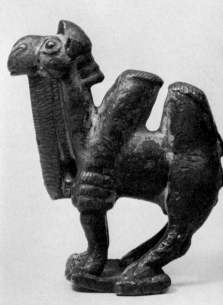

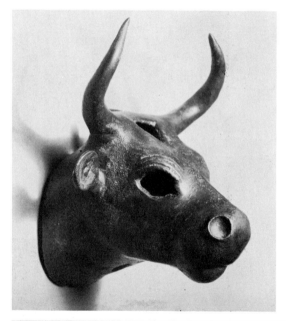

Left: Pin. Bronze. Caucasus.
Museum of Science, Buffalo.
Center: Ibex. Harness ring. Bronze.
Metropolitan Museum of Art.
Right: Camel. Bronze. Metropolitan
Museum of Art, Rogers Fund

Bull's Head. Bronze.
C. 1200 B.C. Azerbaijan.
Collection Mrs. Otto Kahn.
(Courtesy Iranian Institute)

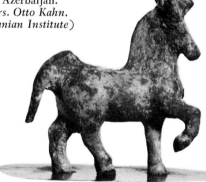

Leaping Lion. Bronze. C. 1000 B.C. Luristan.
Collection Mr. and Mrs. E. M. M. Warburg

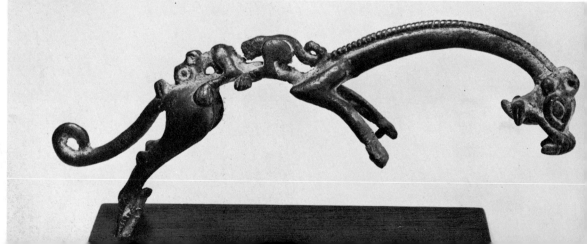

The *Bull's Head* from Azerbaijan, of about 1200 B.C., has the elegant simplification which later marked the best Persian sculpture. Again animals predominated as subjects, and there were pieces with close affinity to the Luristan bronzes. Others have no discoverable prototypes and are labeled by archaeologists merely "pre-Achaemenid Persian." The *Prancing Unicorn* is representative of a heavier decorative type. A second *Bull's Head*, in the Cleveland Museum, illustrates interesting variations from the one just shown. It is a little less refined but still is marked by bullish character and plastic vigor.

The province of Azerbaijan also yielded the rare copper head of a bearded man, which, like the bronze *Bull's Head* from the same area, might be a link in the true Persian tradition, of the indeterminate pre-Achaemenid period. It is lifelike but nonnaturalistic, giving us the individual man within a conventionalized sculptural conception. A limestone head, probably from the early Achaemenid period, now at Brussels, is nearer to the true Persian type, Orientally formalized (as in the patterned beard), and escaping the influence of Chaldea and Babylon, which was to intrude at the very moment when Persia's political power was at its greatest.

On facing page:
Prancing Unicorn.
C. 1000 B.C. Kuh-I-Dasht.
Museum of Science, Buffalo

Bull's Head. Bronze. Persian, pre-Achaemenid, 6th century B.C. *Cleveland Museum of Art*

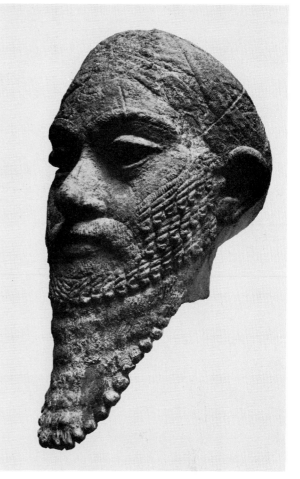

Head. Copper. Before 1000 B.C. Azerbaijan. *Metropolitan Museum of Art, Rogers Fund*

Head. Stone. Achaemenid. *Adolphe Stoclet Collection, Brussels. (Courtesy Iranian Institute)*

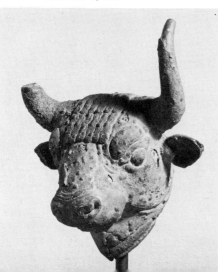

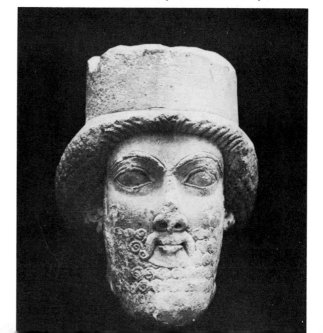

Great parts of the stone mural reliefs of the palace of Darius at Persepolis still survive and are typically Persian, but the glazed-brick relief figures of the palace at Susa reverted to Mesopotamian models. In the latter the technique of neo-Babylon was taken over by the Persian builders, and only a little of the typical Iranian formalization was added. The animals are spirited and decorative, but there is a Babylonian shallowness. The frieze of the *Spearmen* at Susa, without subject-precedent in Babylon, is also in glazed brick, and here Persian rhythmic feeling and luxurious Persian ornament prevailed.

In the sculptured capitals of the palace of Artaxerxes II, at Susa also, the Babylonian models were forgotten, and work of essentially Persian beauty was revealed. The main forms, of bull or unicorn, are monumentally preserved, the parts are disposed with sculptural compactness, and the detail enhances the rich effect without appearing obvious. They have the special Persian elegance to be seen in the refined architectural columns.

Tribute-Bearers, relief. Stone. Palace of Darius I, Persepolis. *Courtesy Oriental Institute, Chicago*

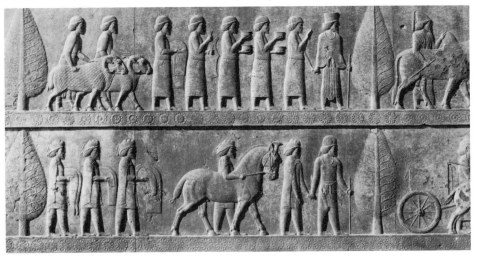

Lions. Glazed brick. Achaemenid. Palace of Darius I, Susa. *Louvre. (Giraudon photo)*

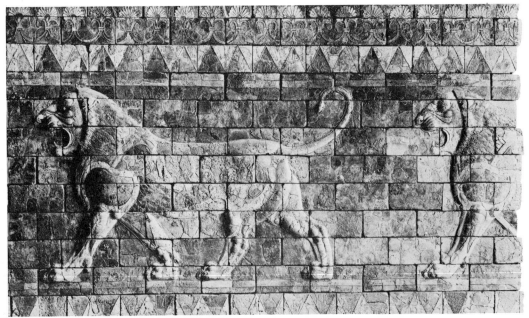

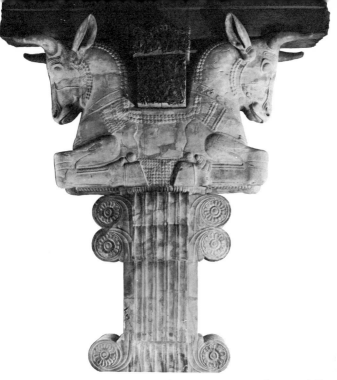

Capital with bulls. Stone. 521–485 B.C. Palace of Artaxerxes, Susa. *Louvre.* (*Alinari photo*)

Spearmen. Glazed brick. Achaemenid. Palace of Darius I, Susa. *Louvre.* (*Giraudon photo*)

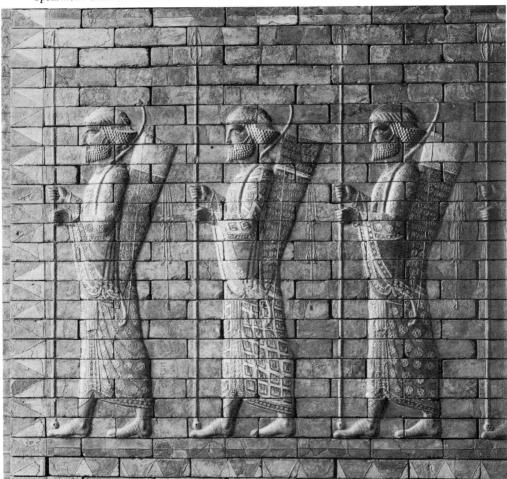

The same slender, rounded elegance is found, without the luxurious note, in the stone friezes at Persepolis, which are of slightly earlier date, about 500 B.C. They show Darius the Great, attended by his son Xerxes, giving audience to a petitioner and tribute-bearers. They appear as murals flanking a great stairway of the palace. As sculpture and as architectural embellishment they are more dignified and architectonic than the Mesopotamian murals from which they distantly derive. (See pages 162 and 170.)

On the platform above, the Persians set a gateway or doorway of honor, derived from the winged-animal or sphinx gateways of the Assyrians (who had taken the idiom in turn from the Hittites); and aside from such changes as substituting an Aryan for the Semitic head, the Persians formalized and improved the type. But these "set pieces" are not important artistically in the history of sculpture, though illustrated widely because of their imposing size. Almost any piece from the mural series, such as the *Ahura Mazda* in the Fogg Museum, tells more of the sculptural competence and reticent taste of the Persian craftsmen. In the murals at Persepolis the single figures of tribute-bearers, even of camel or horse or goat, have a character suitable to the stone, a sculptural dignity.

The set of golden appliqués, supposed to be Scythian in origin, nevertheless seems to fit perfectly within the characteristic Achaemenid art-craftsmanship. They were part of a hoard of two hundred and five gold ornaments found together, some figurative and some not, all supposed to have decorated a single garment. The stamped animal figures are less fantastically treated, less distorted than is usual in the products of the Scyths, and may have been designed in Scythian

Ahura Mazda, relief. Stone. Achaemenid. Persepolis. *Fogg Museum of Art*

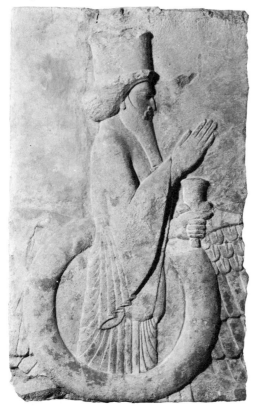

Appliqués. Gold. Scytho-Persian, Achaemenid. Kuban Region, U.S.S.R. *University Museum, Philadelphia*

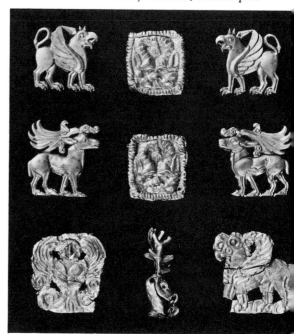

workshops for Persian taste. The golden armlet from the Treasure of the Oxus, one of two surviving as a pair, is a rich ornamental entity even without the colored enamels once embedded upon its surface. It is an indication that the vigor and originality of the Indo-European or Iranian line continued uncurtailed in the Achaemenid period, with only an added luxurious refinement.

In so small a craft as seal-making, the achievement is repeated. The Persian seals have a wider range of subject, though obviously deriving in part from the Mesopotamian. The stylization is oftener graceful and fluent, with clear outlines against plain backgrounds.

In the Seleucid and Parthian periods, following the Achaemenid, there was growing influence from outside cultures, especially the Greek, after 330 B.C. Nevertheless examples of small sculpture exist that continued the traditional vitality, as illustrated in the *Crouching Panther*, enlarged to show its character, shown at the beginning of this chapter, on page 160.

Impressions of seals. Assyrian (*top*); Persian, Achaemenid. *Walters Art Gallery, Baltimore; Bibliothèque Nationale, Paris; British Museum; Museum of Fine Arts, Boston*

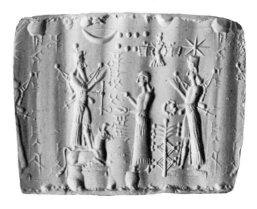

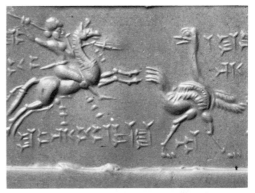

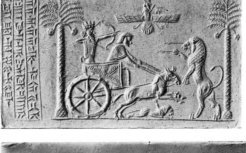

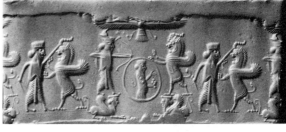

Armlet. Gold with depressions for inlays. Achaemenid. From Treasure of the Oxus. *Victoria and Albert Museum*

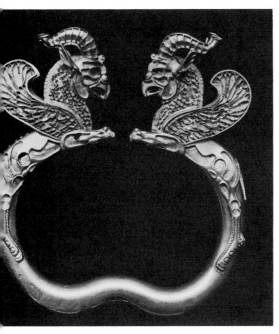

The glazed-clay head in the Metropolitan Museum of Art was actually a waterspout or gargoyle. The glaze has all but disappeared, but the earthenware color beneath is pleasing and the total effect singularly sculptural. The creative composition indicates the mastery to which the Persian artists had attained just before the great period known as Sassanian.

The silver plate with *Amazons Hunting Lions,* of the Parthian period and probably from Asia Minor, is a composition more decoratively disposed than traditional Greek design would have made it, with a more rhythmic treatment of the animals than any found among the Greeks. Note the *spirit* of the lions and of the horse's head, in relation to the Sassanian silver plates immediately following. But the lightness of touch and a breath of naturalism in detail are Hellenic. Throughout the Near East at this time there was a confusion of the elements which eventually formed the Byzantine style.

Head, downspout. Clay, glazed. Parthian.
Metropolitan Museum of Art,
gift of Walter Hauser, 1956

The famous rock-cut tombs of the kings, some celebrating the defeat of Roman emperors and generals by the Persians, are imposing and quite ornamental for the narrative type of sculpture. Though somewhat derivative they are not naturalistic, and in the finest examples—as at Naksh-I-Rustum and Taq-I-Bustan—the rhythmic repetition of forms and enrichment of patterning were typically Oriental. But cliff art was unsuited to the Persian genius and is better seen in India or China.

The small sculptures, especially the surviving figured silver dishes, were lavishly ornamental and sensuously full. The method is not far different from that of the Scythians and the Lurs, and it indicates a direct line of descent through Achaemenid and Parthian silver. But the Sassanians added a wealth of figures, an abundance of patterning, and a variation of surface appeal fitting to art at the world's most sumptuous court. It is aristocratic, regal sculpture at its best. For some art-lovers it may seem ostentatious, but there can be no doubt that the Sassanian craftsmen here touched a high mark of *relievo.* Comparatively restrained is the graceful bronze ewer shown, with an abstract all-over design on the vessel itself and a sinuous, undecorated feline animal attached as handle.

The extraordinarily spirited design of the silver wine bowl with an eagle at the center is typically Iranian, but the emphatic narrative treatment and the melodramatic poses indicate late Greek influence.

Ewer. Bronze.
Sassanian.
6th century A.D.
Metropolitan Museum
of Art, Fletcher Fund

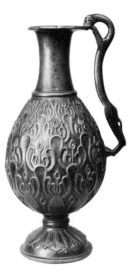

Amazons Hunting Lions. Silver, repoussé.
Parthian. Asia Minor.
Brummer Collection, New York

Shapur II Hunting Lions. Silver dish.
Sassanian. *Hermitage, Leningrad.*
(*Courtesy Iranian Institute, New York*)

Shapur II Hunting. Silver dish. Sassanian.
Collection of Mrs. Cora Timken Burnett.
(*Courtesy Iranian Institute*)

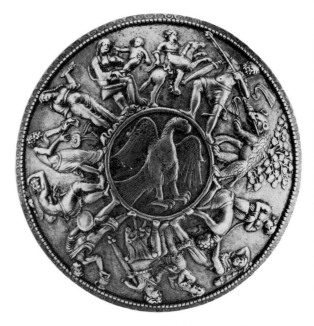

Wine bowl. Silver, repoussé,
partly gilded. Seleucid. Bactria.
Freer Gallery of Art, Washington

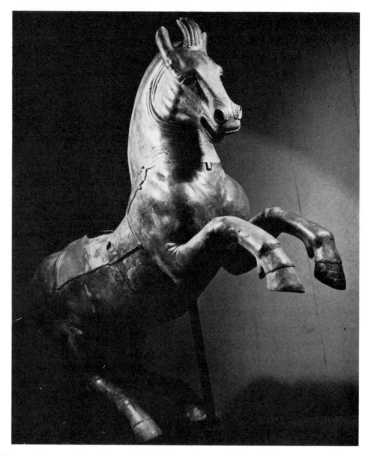

Horse. Bronze. Sassanian. Arabia. *Dumbarton Oaks Collection, Washington*

The monumental *Horse* in bronze, characteristically Persian but of a less extravagant phase, comes from Arabia of the Sassanian Period, a reminder that Persian art had conquered great parts of Asia beyond the borders of the Iranian plateau. A second example of Persian-Arabian craftsmanship is the small bronze *Bull,* identified by authorities as Sabean —from Sabea, the biblical Sheba. (Recently the *Horse* has been relabeled "late Roman" by some scholars, despite its Oriental style marks.)

Although from the seventh century onward Persian accomplishment is oftener known as Islamic art, there are some minor manifestations—seals, coins, the crafts necessary to dress, and miniature metal sculptures —that seem to belong to the Persian community rather than to Islam. Technically, figurative art was henceforward forbidden in Moslem communities; but many Persians took the prohibition lightly and continued to make small figures of animals, such as the *Lion* shown. There are beautiful little sculptural compositions, too, in the coins, rings, medals, and seals of Sassanian times.

The decorative gold medal in the Freer Collection, Washington, marvelously illustrates Bahram Gur hunting with a falcon. A completely contrasting style of posteresque decoration occurs in the coin showing a lion and a peacock on obverse and reverse. The decorative script here adds to the ornamental fullness. In the abstract ornament of gold on steel some of the possibilities of nonobjective design are realized. The beauty of Persian calligraphy as seen in later manuscripts is proverbial. The lovely writing is embedded, too, in the floriation of engraved bronze ewers and jugs, and even in the elaborate fields of ornament on carved wooden doors and screens.

Finally, there was a great deal of stucco

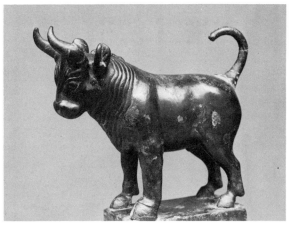

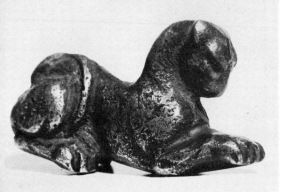

Bull. Bronze. Sabean, 6th century B.C. South Arabia. *Metropolitan Museum of Art*

Horse; Lion; coins; ornaments. Silver; bronze; gold; other metals. *Private Collection; Ackerman-Pope Collection; Freer Gallery of Art.* (*Courtesy Iranian Institute*)

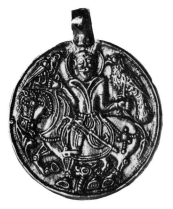

Hunting Scene; Boars, panels in relief. Stucco. Sassanian. *Philadelphia Museum of Art*

sculpture to embellish houses and palaces, and profuse stucco decoration spread later to all Mohammedan lands and can be seen today in Granada and Cairo, Samarkand and Agra. The arabesque was considered a distinctive creation of Arabian-Islamic craftsmen, although foreshadowed in Sassanian compositions. Abstract ornamentalism unfolded in lacelike profusion, in flatly sculptured panels or in tracery over the whole architectural composition.

When the Moslems revert to figurative art, it is likely to be reminiscent of Sassanian craftsmanship. The repetition of motives, geometrical yet with variation, as seen in the *Hunting Scene* and *Boars,* and the weaving of main outlines and repeated details into an all-over effect, were echoed in all Mohammedan lands from the seventh to the twelfth century. Thus typical Persian sculpture continued as Islamic sculpture in Asia, Africa, and a fringe of Europe.

The peak of Mohammedan building and sculpture occurred in the thirteenth and fourteenth centuries. The mural reliefs of that golden age were unrivaled in decorative opulence and almost incredibly profuse on the inner walls of mosques and palaces. The stone or stucco reliefs vibrate with life, as in the Mihrab wall at Hamadan. Both the loveliness and the "lightness" of this type of sculptural design are here supremely illustrated. The absence of figuring is in accordance with the Mohammedan commandments; but if no animals or plant-forms appear, there is ample suggestion of them, especially where the modeling is most vigorous. Indeed, despite the prohibition, the spirit of Scythian, Luristan, and Sassanian sculpture was revived in Persia and in all Mohammedan lands. One might put side by side the latest of Sassanian wall plaques and the earliest of Luristan heraldically balanced animals to indicate the two prime sources of Islamic wall decoration, the one typical of the over-all ornamentalism, the other illustrating the virility of the main motive.

In the sculptured frieze at Mshatta the

Sculptured frieze. Stone. 4th–7th centuries. Omayyad Palace, Mshatta, Syria. *State Museum, Berlin*

Mihrab of Oljeitu, Friday Mosque, Isfahan. Stucco. 1310. (*Photo by Arthur Upham Pope*)

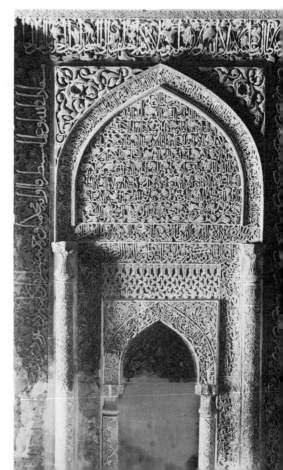

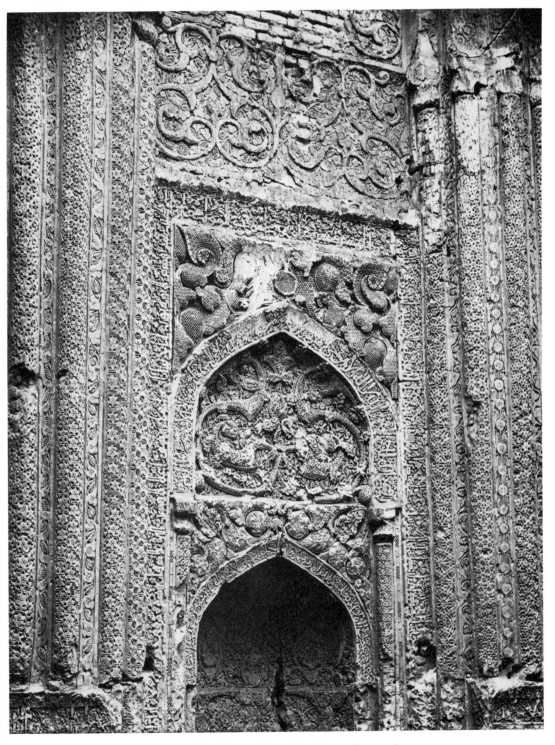

Detail of the Mihrab, Alaviyan, Hamadan, Persia. Late 12th century.
(*Photo by Arthur Upham Pope, Iranian Institute*)

familiar animals, still rhythmic and formalized, are surrounded by areas of lacelike ornament. Authorities differ as to the probable date, and some scholars insist on classing the Omayyad Palace as Byzantine rather than Islamic. It was perhaps a product of Christian craftsmen working under Moslem rulers.

In Moslem-ruled Spain the abstract sculptural decoration spread over great areas of courtyard wall and inner partition, especially at the Alhambra, built in the thirteenth and fourteenth centuries. In the Court of Lions here, the fountain's lions (imported from old Persia, the scholars say) and their geometrical disposition are Oriental, as is their unrealistic appearance. But the carved screens set into

the walls, and the light foliation traced over every structural member, are more truly Islamic. In Spain the style is called Moorish.

Even when the prohibition of imaging was no longer observed except by the most puritanical followers of the Prophet, the human figure was seldom depicted. Animals, as so often in the Near East, were the prime inspiration. Ewers, jugs, and incense-burners were designed as birds or beasts, free or even fantastic in detail, and pierced, abridged, or hollowed for functional purposes.

In Venice, the Treasury of St. Mark's owns the Persian silver casket with conventional *repoussé* designs in panels on top and sides, but set on a base showing a continuous com-

Court of the Lions, Alhambra Palace, Granada. 13th–14th centuries. (*Archives Roget-Viollet*)

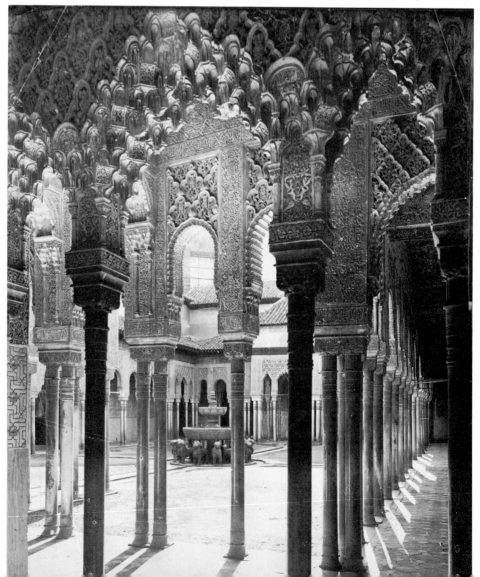

position of intertwined animals of a sculptural excellence not common in Islam at this period. The little frieze is directly in line from Scythia and Luristan. It is spirited, decorative, fanciful, yet virile.

The Moslem artists displayed their skill as carvers also on such craft objects as book-bindings and wooden and ivory chests. Their cutting of relief compositions, whether in wood or in ivory, was intricate and exquisitely rich. The Moorish chests of Spain bear inlaid panels that are masterpieces in the style, and in India large pierced screens and small ivory inlays are marvels of delicately opulent workmanship.

Animal figures in Islam were often de-signed primarily to provide convenient areas to be engraved or chased. The *Lion* incense-burner from Kariz is shamelessly falsified, from the naturalist's point of view, but pos-sesses unmistakable leonine character. The arbitrary simplification of forms allowed the worker in *repoussé* and engraving to practice his art freely. Even today Oriental craftsmen fill the bazaars with debased representations of such beasts.

In the West, clay-molded and glazed sculpture has generally seemed a lesser art: porce-lain figures and groups are likely to be trivial and frivolous, and the common over-bright coloring is essentially unsculptural. But in Persia, where the potter's art was

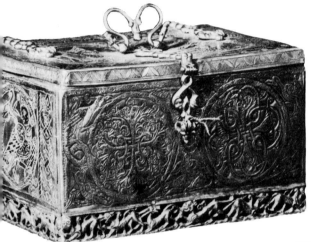

Casket. Silver. Persian, 12th century. *Treasury of Saint Mark's Cathedral, Venice.* (*Courtesy Iranian Institute*)

Lion. Incense-burner. Pierced bronze. 12th century. *Hermitage, Leningrad*

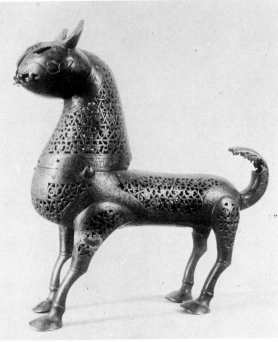

Lion. Incense-burner. Pierced bronze. 12th century. *Metropolitan Museum of Art*

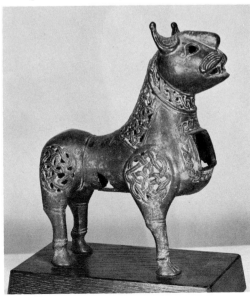

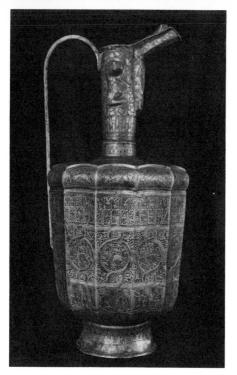

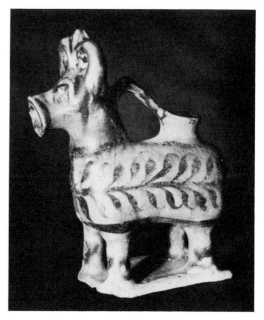

Ewer. Bronze with silver inlay. Mosul period, 13th century. *University Museum, Philadelphia*

Aquamanile. Clay, glazed. Persia. (*Courtesy Iranian Institute*)

Vase. Clay, glazed. Persian, 13th century. Kashan. *Freer Gallery of Art, Washington*

Lion, detail. Incense-burner. Bronze. Seljuk period, 1181–82. Kariz, Khurasan, Persia. *Metropolitan Museum of Art, Rogers Fund*

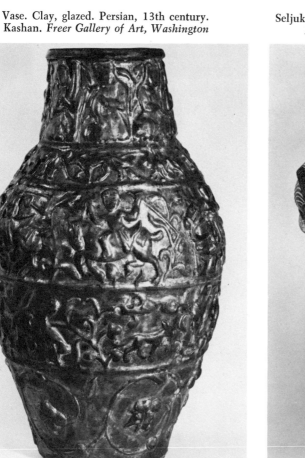

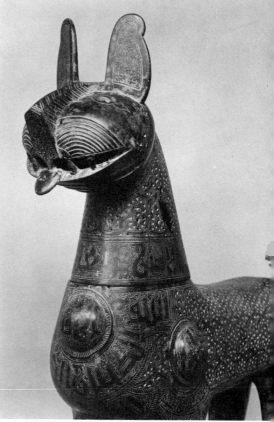

carried to a glorious achievement surpassed nowhere except in China, the sculptor joined with the potter to produce serious (and sometimes half-serious) works. There are sumptuous designs with animals in the round added to vases and jugs already rich with intricate molded and painted patterns. The aquamanile shown, very different in method, as regards both total design and surface decoration, seems like a playful work in comparison; but it is nonetheless a typical example of Islamic craftsmanship, vital as sculpture and ornamentally alive. It is probably late in date.

The Persian vases, plates, and jugs were proportioned as beautifully as the Greek, and when figurative reliefs were employed to enrich the surfaces the modeled composition was completely appropriate. The illustrative designs were usually kept to proportioned bands within a controlled all-over pattern. The glazed-clay vase at the Freer Gallery, Washington, is characteristically graceful in form and lively in decoration.

Persian sculpture declined when Europe advanced into the period of the Renaissance, but examples can be found which indicate native feeling for the fundamentals of the art, particularly for fitness of subject and method to material. Islam invaded India, which possessed a great body of sculpture of its own. The eighteenth-century pierced-ivory plaque from Madura, *Indian Prince and Attendants,* inherits from Indian art and from the richness of Persian-Islamic artisanship.

Indian Prince and Attendants. Pierced-ivory plaque. 18th century. South India.
Victoria and Albert Museum

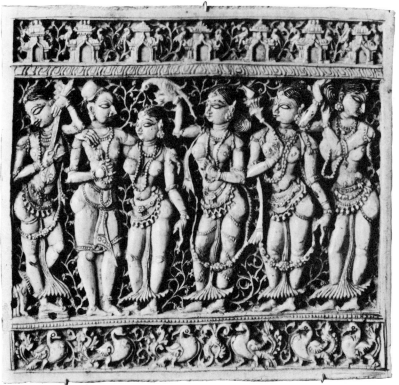

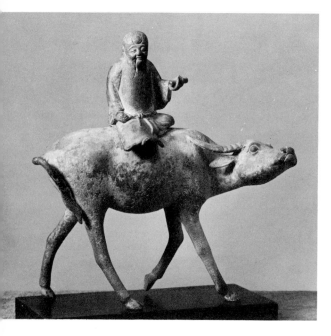
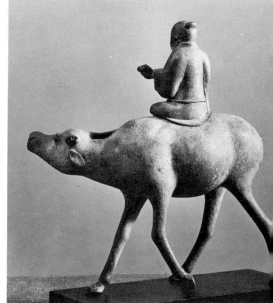

8 : China :

The World's Supreme Sculptural Achievement

I

CHINA is the oldest civilized nation on earth, and the Chinese people have persisted in one recognized national culture longer than any other. Incursions from outside amounted at times to conquering invasions, but the native populace so far outnumbered the invaders and was so fixed in its social life that the conquering newcomers were absorbed in the typically Chinese way of life and culture. A new method or intention in art, even a new religion, might be introduced but did not alter the mainstream of Chinese tradition.

The life of the Chinese ruling class has been colorful and picturesque, from the entry of the Shang emperors in possibly 1523 B.C. to the exit of the last Manchu empress in 1908. Court life in the many periods was enriched through devotion to the arts, and there was an upper class (including the scholars, who are especially honored) that cherished art works and kept alive the records of outstanding artists.

The magnificence of decor at the courts was attested in the writings of Marco Polo, and the books of China's own historians reflect the vigor and opulence of the nation's artistic life. The Chinese have seldom de-

Lao-Tse on a Water Buffalo. Bronze. Sung. Worcester Art Museum

veloped archaeological exploration in any systematic way, and it is likely that a wealth of sculptural material still lies underground. A few Stone Age finds are related easily to the more pronounced idioms in a profusion of small sculptures and calligraphic scratchings found at Anyang, dated between 1900 and 1200 B.C. These display the squared ornamental ribbons in relief and serrated edges which appear on the bronze ritual vessels of the early Dynasties, vessels constituting the first great Chinese sculptural achievement as now known.

The ritual vessels, dated by most authorities to the Shang era (1523–c. 1028 B.C.) and the Chou era (c. 1028–222 B.C.)—all early dates are debatable—give evidence of the existence of widespread spirit-worship and ancestor-worship. These bronze ceremonial jugs and jars, cups and caldrons, beakers and basins, were generally altar furnishings, used for sacrificial rites. They were designed over a considerable number of centuries. In the Ming Dynasty,

which corresponds to the period of the Renaissance in Europe, vessels very similar to the Chou ritual masterpieces were produced, but they were copies in the historic style rather than newly imagined works.

Carving in jade in China has a history longer than that of bronze-casting. This is one of the branches of sculpture in which the nation leads the world. The most flourishing period of sculpture in jade began (so far as we know) in the era of the Chou emperors. Jade as a material was highly prized and possessed a very intimate appeal. A piece such as the disk on page 194, may even have been venerated. Others served as emblems and "luck" tokens. The dead were buried with symbolic jades placed in or upon the ears, eyes, and tongue. Various jade animals were found in the graves of the Chou Era, especially those symbolizing immortality or resurrection, of which the cicada was the most favored.

Many respected historians claim that every

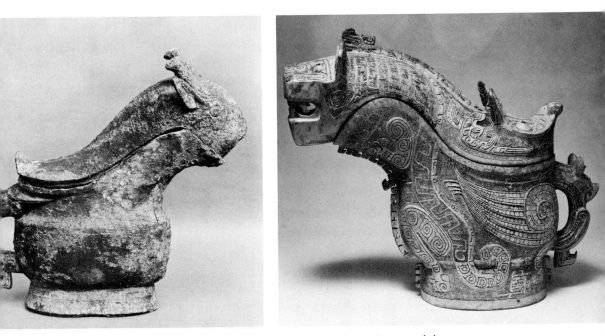

Left: Wine vessel. Bronze. Shang. *Metropolitan Museum of Art*

Right: Ritual wine vessel. Bronze. Early Chou. *Fogg Museum of Art*

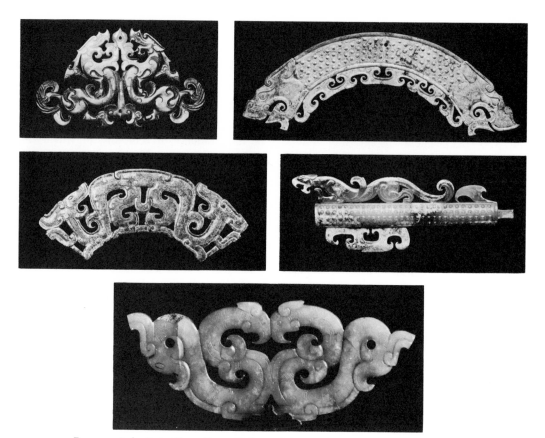

Dragons. Jade. Late Chou. *Freer Gallery of Art; Nelson Gallery–Atkins Museum, Kansas City.* (Bottom figure enlarged)

motive found in Chinese art originated in the West or the North. Scholars have uncovered prototypes of the animals, masks, and figures that appeared as subject-matter in the Chinese repertory. Rostovtzeff, in his book *The Animal Style in South Russia and China,* even questions whether the dragon is an invention of the Chinese and prefers to accept as its ancestor the "wolf-dragon" of the Mesopotamians.

It was the Chinese sculptors, however, whether invaders or long-resident natives, who gave magnificence to the dragon idea. In every particular the sculptural carving on the ritual vessels of the Shang and Chou eras seems to prove a long antecedent period of practice in this one highly original style. As to the craft of bronze-casting, the masterly

technique of the earliest known Shang bronzes suggests that invasions from the bordering steppe countries, where metal-working was carried on, had occurred long before authenticated Chinese history begins.

The Shang Dynasty lasted more than five hundred years and gave way gradually before invaders who founded the Chou Dynasty in 1028 B.C. Among the disorders of warring feudal states lived the great sages Lao-Tse and Confucius. The philosophy of Lao-Tse, called Taoism, had profound effect on the arts later, after the introduction of Buddhism. In the second half of the third century the Ch'in Dynasty conquered and united the country and gave the name China to the nation. In the time of Ch'in there were only the relics called the Ch'u bronzes, from the

state of Ch'u, to indicate radical departure from the Shang and Chou style as typified in the richly adorned ceremonial vessels. Best known of the Ch'u or Ch'in works are the bronze mirrors discovered in the Huai River Valley; the backs were worked with an intricate but subdued all-over patterning, upon which appear low reliefs of fantastic dragons or birds. They are essentially Chinese, even while differing markedly from the Shang and early Chou heavily decorative style.

Another invasion from the northwest at about this time, apparently direct from the Scytho-Siberian steppe country, was even more important. In Suiyuan in Inner Mongolia and especially in the Ordos Desert— along the border of Shensi in China proper —thousands of small animal compositions in bronze have been turned up, with the spirited rhythmic qualities of the "animal style" as known in Scythia and the steppes of Turkistan and parts of Siberia. Besides purely ornamental items, there were harness rings, buckles, etc. Some were formed of single animals, and others composed into plaques with repeated animals or with a scene of conflict between a tiger and a horse: all are patently an extension from the steppe art.

With the next dynastic change, which brought in the Han emperors, familiar Chinese history begins. Sculpture had progressed from the magnificent ornamentalism of the earliest ritual vessels to an inspired simplicity, especially in the animals of Han. Much of the sculpture of the Han era, as it now appears in the museums, is suggestive of the link with the art of the steppes. The sculptors of Han invented a sort of low-relief picturing on stone unique in the annals of the art.

They also began manufacture of clay tomb figures, which led on to the familiar decorated ladies, caparisoned horses, dancers and lute-players, dogs and camels. These figures vary in size from the common six- or eight-inch height to more than twenty-four inches. They may be unpainted, painted, or glazed. A great many that are now terra-cotta in color

Bears. Bronze, gilded. Han. *City Art Museum, St. Louis; Adolphe Stoclet Collection, Brussels (Courtesy Madame Feron-Stoclet)*

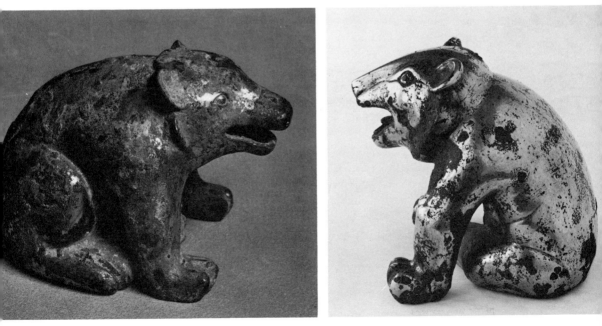

have traces of brighter pigment in deep cracks or folds. In the women's figures the faces were often left unglazed. The golden age of the tomb figures is sometimes placed in the T'ang era, which ended about ten centuries after the probable introduction of the clay figures and objects into the graves of Han. The first clay statuettes are supposed to have been introduced as an improvement to replace the straw figures used during the era of Chou; those in turn had been substituted for the living retainers who had been entombed with the corpse of emperor or noble in earliest times.

A new invasion, encouraged by the emperors and sages, produced a totally different flowering of sculpture in China during the centuries immediately after the Han period. Buddhism as a religion was brought from India, and Buddhist statues and probably Buddhist sculptors were imported. Knowledge of Buddhism and devotion to the Buddha had been pushed eastward to the border of China before the birth of Christ. The actual introduction of the faith into the Far East is generally dated from A.D. 65, when the Chinese Emperor Ming Ti saw the shining figure of a savior in a dream, and sent a mission to India to investigate the new religion. By the second century it had claimed a considerable following, though it was not until the third century, when the Han Dynasty had come to an end, that Buddhist art began to penetrate into China proper. The fifth and sixth centuries witnessed a flowering of Buddhist sculptural art comparable to the Gupta achievement in India.

A great deal of the iconography was taken direct from the Indian statues, in such monuments as the statue-filled caves at Yun K'ang in Shansi province. Doubtless Indian missionary-artists (many missionaries are known by name), and sculptors from invader groups trained in the animal art of the steppes, at first gave direction to their Chinese fellow artists. Among the distinguishing marks of the Indian sculptural idiom were schematic arrangements of the draperies, usually dis-posed in low-relief folds, and a treatment of the face that is Greco-Indian rather than typical Indian. Shortly thereafter the foremost sculptural art of China was that of the native Buddhist monks. And indeed, through the most glorious period of national expansion, through the Wei Dynasty and the Six Dynasties period, culminating in the T'ang Dynasty, the images of the Buddha and the Bodhisattvas were the inspiration for Chinese sculpture. At last the human figure became central to the art, and the Chinese came to use the basic sculptural material, stone. The period of magnificent achievement opened in the fifth century and continued until the decline of the T'ang Dynasty in the ninth and tenth centuries.

There had been many sects of Buddhism—a schism in India had divided the faithful into a southern school, strict in its interpretation of the Master's injunctions, and a more relaxed and tolerant northern school—and Chinese sculpture mirrored many of the variations in belief.

Ch'an Buddhism came as a cult within Buddhism, but it was the Taoism of Lao-Tse and of his disciple Chuang-Tse, two centuries later, that gave new direction to the religion and in turn influenced sculpture. Chinese art had been magnificent, full, rhythmically active. Now it was quietened. The sculptors relied upon simplicity. The statue itself spoke of withdrawal, contemplation, and an inward peace attained. The unassertive art of Ch'an (later Zen) intimated the peace of Lao-Tze as also the Buddha's vision of Nirvana.

During the famous Sung Dynasty and the following Yuan Dynasty sculpture was plentiful but its quality began to deteriorate. Sung painting and porcelain were of the finest, but the sculpture began to be generally over-ornamented, or merely reflective of the masterpieces of the great periods from Chou to T'ang.

Another type of sculpture was introduced in oversize guardians of tombs or palaces (illustrated on page 204). The colossal figures of men or animals were set like

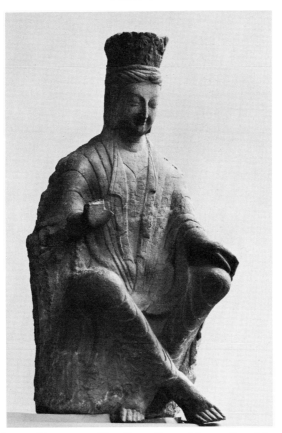

Buddha. Stone. 5th century. Yun Kang Caves. *Metropolitan Museum of Art*

sentries along the avenues leading to the tomb entrances. Sculpturally the surviving examples in stone are magnificent, whether in museums abroad or still at their original sites.

The successive Chinese dynasties gave rise to more than a proportionate share of the world's degenerate dictators. A nation that could snub and obscure "the perfect sage" Confucius during his lifetime was obviously inhospitable to the arts at certain periods. Although the legacy of Chinese sculpture is so great that examples can be found in market places the world round, the loss of monuments was perhaps greater than any other nation's. Again and again the edict went out from an incompetent emperor's court than all bronze or copper vessels or statues in the land must be delivered for melting down. The losses of monuments in stone were fewer, but the colossal animal guardians of the tombs were neglected for centuries, and in the caves of Buddhist carv-ings the signs of vandalism are often apparent. Even so, in amount as in quality, the surviving Chinese products constitute the most magnificent body of sculpture in the world.

A table of the historic periods or dynasties as now usually accepted follows:

Hsia (largely legendary)	ending about 1523 B.C.
Shang (sometimes Yin)	approximately 1523–c. 1028 B.C.
Chou	c. 1028–222 B.C.
Ch'in	221–207 B.C.
Han	206 B.C.–A.D. 220
Wei & the Six Dynasties	220–618
T'ang	618–907
The Five Dynasties	907–960
Sung	960–1280
Yuan (Mongol)	1280–1368
Ming	1368–1644
Ch'ing (Manchu)	1644–1912

After 1912, the Republic, then Communism

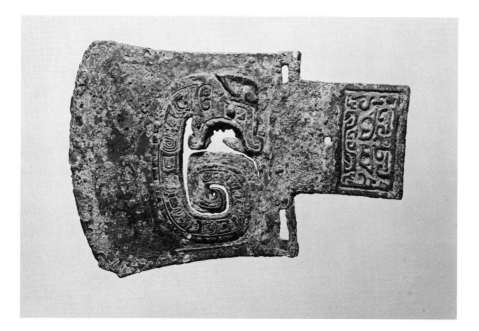

II

IN the earliest relics that have come down to us from the Shang period, the evidences of a formal style are implicit. The decorative, talismanic jades cannot confidently be dated to the early Shang era, but the oldest known bronzes seem clearly to be early Shang, and they present a fully formed majestic Chinese style. The apparently abstract ornamentation on tools and weapons usually proves to be conventionalizations of animal forms, oftenest the *tao-tieh*, the "dragon" or imaginary monster, or other traditional beast.

The ritual vessels form a magnificent group of sculptures in bronze. The geometrized relief figures can be identified as fantastic dragons and parts of dragons, or less often, and later, as owls, pheasants, and tigers, or beast and bird fragments combined. The

grain jar of the Freer Gallery, Washington, is especially instructive because each unit of the relief ornament can be read as an animal form imaginatively paraphrased. The vigor and the ornamentalism of these reliefs are superb.

In the bronze wine vessel at the Metropolitan Museum of Art (page 185), where the incidental encrustations and tracings have been lost in the wear and tear of thirty centuries, the contours of the vessel still stand out with controlled power and a rhythmic massiveness.

The combination of creative sculptural design with sumptuous elaboration of the surface reliefs is better seen in the "horned monster" vessel. It is a functional libation vessel, vaguely suggesting a monster, with panels containing other monsters. Heads,

Ax. Bronze. Shang, 1523–c. 1028 B.C. *Whittemore Collection, Cleveland Museum of Art*

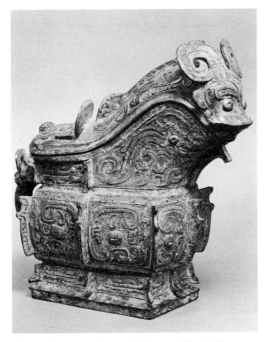

"Horned monster" vessel. Bronze. Early Chou.
Metropolitan Museum of Art

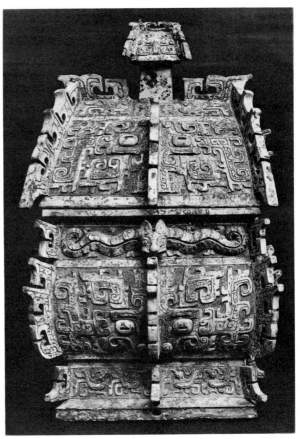

Grain jar. Bronze. Early Chou, 11th century B.C.
Freer Gallery of Art, Washington

eyes, or tails cover wide areas to convey the mystery of animal-power, in a technique which is uniquely Chinese.

The libation vessel suggesting two pheasants, in the Freer Gallery, is a pleasing variation. Symmetric form has been achieved by placing the birds back to back or "addorsed." The pheasants, which have been very summarily presented, are conventionalized almost beyond recognition and endowed with rams' horns.

The ritual bronzes were limited to a few traditionally determined types. The differences are those of use, choice of subject-matter, and abundance of detail. Today some of them seem overloaded with ornament, though there is a certain magnificence in the very opulence of the wine vessel from the Fogg Museum, which illustrates the interlocking of animal motives and suggests a

link with the Scythians. It is not clear where the tiger-headed beast ends and the birdlike forms begin. Sometimes the outline of a wing resolves into a coiled dragon; tails or feet may terminate in birds' beaks, in the Scythian fashion. (See page 185.)

After the Shang Dynasty gave way to the Chou, there was a weakening of the art. The bronze vessels became less imposing in massiveness of design and wealth of decoration. The *Pheasant* in the Dumbarton Oaks collection is shown quite realistically, though traced over with patterning and calligraphic relief. The owl-shaped jar at Yale returns to a severer style but is equally readable.

In the early Chou period design was at times exuberant and even florid. Though the maker lost the rectilinear crispness of the style, as well as accustomed reserve and dignity, the *Elephant* libation jar, for ex-

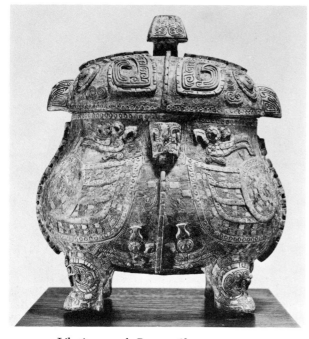

Libation vessel. Bronze. Shang.
Freer Gallery of Art

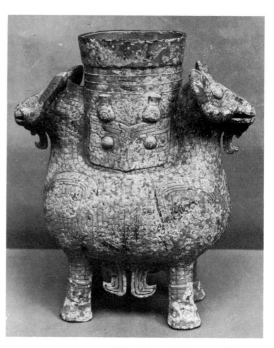

Ritual vessel. Bronze. Chou.
Victoria and Albert Museum

Pheasant. Libation jar. Bronze.
Shang or Early Chou.
Dumbarton Oaks Collection, Washington

Owl. Jar. Bronze. *Yale University Art Gallery,
Hobart and Edward Small Moore
Memorial Collection*

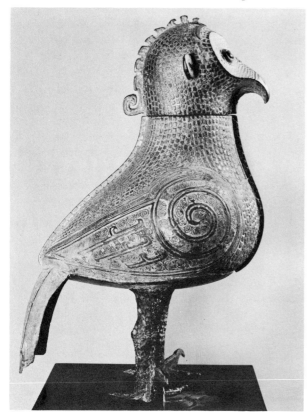

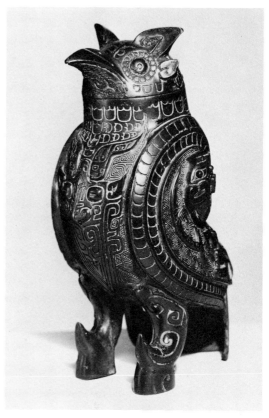

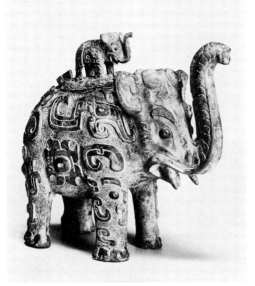

Elephant. Libation jar. Bronze. Early Chou.
Freer Gallery of Art, Washington

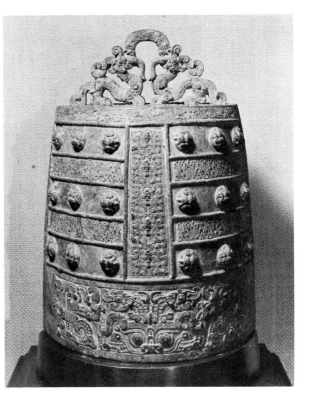

Ritual bell. Bronze. Late Chou,
5th–4th centuries B.C.
Winthrop Collection, Fogg Museum of Art

ample, is a masterpiece of its type. Many bronze gongs and bells have survived from the Chou era and are among the finest products of the time. The reliefs on the bodies of the bells vary widely in elaboration and in aesthetic validity. A common accessory is a pierced, flattened composition, with perhaps two dragons face to face, forming a handle or hook for hanging. The motive is one of the most beautifully handled in the whole range of Chinese conventionalized animals.

In both the late Shang and the Chou periods the carvers of jade produced gemlike compositions such as amulets, emblems, and ornaments and minor figurative pieces. The astronomical disk or symbol of Heaven shown is an example of the ritual objects basic to the religion of the times.

It is notable that jade figurative designs were generally kept as simple as the bronze vessels were elaborate. Since the pieces were treasured as amulets or charms, they were as replete with symbolism as the designs of the

ritual bronzes. The subtle aesthetic perception to be inferred in the maker of the astronomical ring is not easily matched in sculptural history elsewhere. But the owners of the emblem doubtless regarded it less as compelling art than as a link with the immanent Power. The design is intimately associated with the early Chinese myths of Heaven. It also has been interpreted as symbolic of the *yin* principle of the *yang-yin* masculine-feminine dualism recognized as basic to world order. The plaque with dragons shown is one of the most elaborate compositions in jade surviving from an early period. Intensity of feeling, even the ferocity, of the monsters in bronze is lacking, on account of the softer quality of the medium. The animals, however, are still superbly alive. The formalized little *Bird* is exceptional in being in marble. The *Stags* are simply set out but with each animal's characteristic form and feeling recognized and expressed.

The figure of a man in the group of small

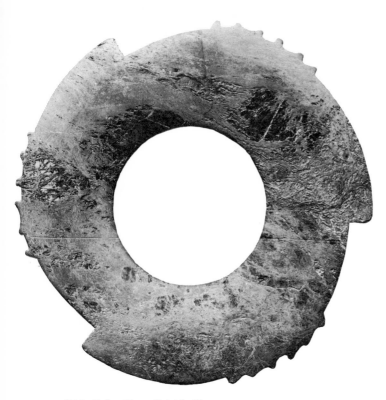

Disk. Jade. Chou. *British Museum*

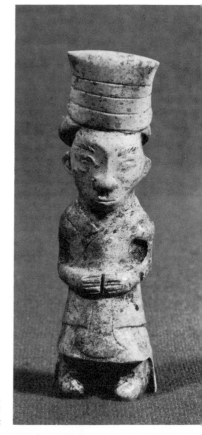

Man; Stags; Bird. Jade; Stone. Chou; Shang.
Fogg *Museum of Art; Metropolitan Museum
of Art; Freer Gallery of Art*

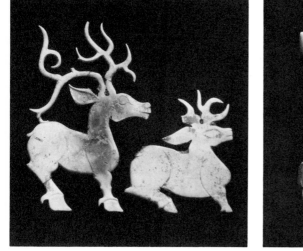

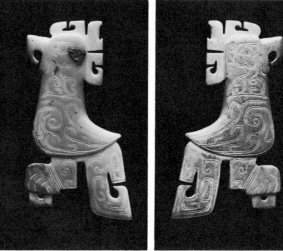

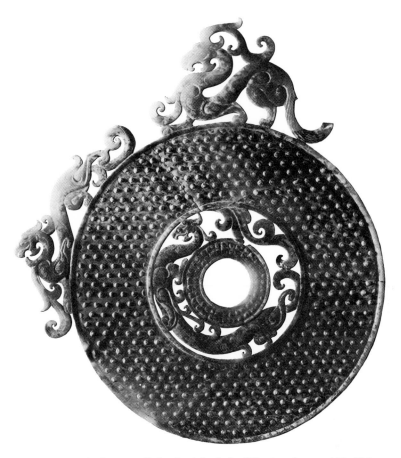

Plaque with dragons. Jade. Period of the Warring States, 481–221 B.C.
Nelson Gallery–Atkins Museum, Kansas City

jades is the only human being to appear in the first twenty-two illustrations of early Chinese sculpture. This is a fair index to the rarity of the anthropomorphic image during the Shang and Chou periods.

The Chinese objects form a treasury of jade carvings that is unsurpassed. They range from rare realistic pieces through every type of conventionalization to abstract compositions. The animals such as dragons, bulls, deer, tigers, pheasants, and cicadas had religious significance. Where jade was the standard "luck stone," the pieces included many poorly designed and executed examples. The stone's texture and color appealed rather than the artistic value. But an extraordinary number of exquisitely carved ornaments have

survived to delight the lover of near-abstract art. This may be seen in the five jewel-like examples on page 186.

As one turns again to the bronzes, it appears that these ancient Chinese statuettes also portrayed the tiger and the dragon. The pieces are rendered ornamental by the all-over patterning, which is, of course, in itself a language of symbols. How far the artist sometimes went in the addition of *relievo* is indicated in the *Tigers* shown, though the characteristic strength and litheness of the beasts seem not to have been impaired.

As against the simplified ornamentalism of the tigers, there is the fantastically ornate *Head of a Dragon* at the Freer Gallery. Each curve was made the excuse for a flourish. But

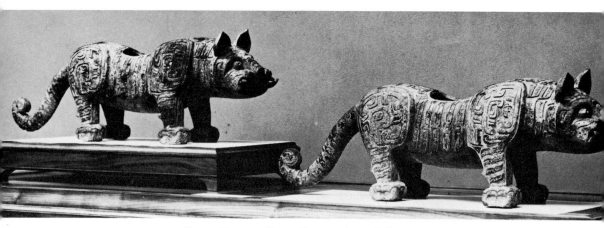

Tigers. Bronze. Chou. Shen-si. *Freer Gallery of Art*

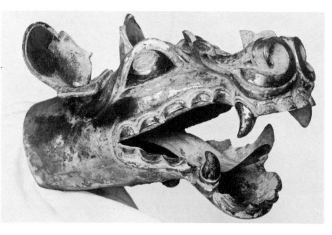

Head of a Dragon. Bronze.
Late Chou. *Freer Gallery of Art*

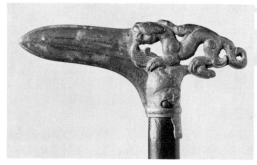

Ax head with dragon. Bronze. Chou.
Metropolitan Museum of Art

in spite of this redundance the intrinsic dragon seems realized and expressed in an unmistakably Chinese work.

The two little bronze *Winged Dragons* of the Pillsbury Collection are masterpieces of the late Chou ornate style. This type of sophisticated design came to its perfection when the Greeks were still developing their archaic style and when Europe beyond Greece was largely an unknown wasteland. The ax-head design of a dragon shows how far the Chinese artists had progressed from primitive rudeness and mere literalism.

Between naturalism and a frank decorativeness there are bronzes such as the *Water Buffalo,* where the animal seems to represent its species perfectly. The formalized composition on the back—technically the lid—seems to be a direct descendant of the heraldically conventionalized animal art of the steppes.

The group of illustrations dealing with Scythian sculpture ended with examples of Ordos bronzes found in China and upon its border. Again a selection of the Ordos products (or as some insist, truly Chinese counterparts) is introduced: a *Horse,* a *Tiger,* and a *Stag.* In the first millennium B.C. China was repeatedly overrun by invaders from the West, who in general adopted Chinese customs and the Chinese style of art. But it would be foolish to believe that conquerors from Mongolia and the steppe country

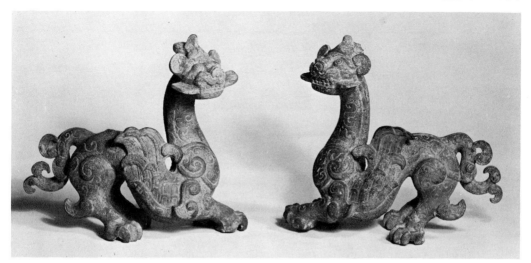

Winged Dragons. Bronze. Late Chou. *Pillsbury Collection, Minneapolis Institute of Art*

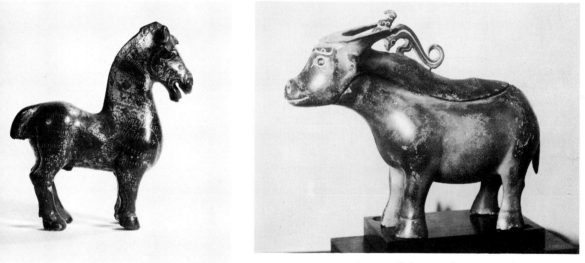

Water Buffalo. Vessel. Bronze. Chou.
Fogg Museum of Art

Horse; Tiger; Stag. Bronze.
Han Period. Ordos Region; Siberia.
Hanna Collection, Cleveland Museum of Art;
C. T. Loo Collection; *Mrs. Jess Bryan Bennett*
Collection (*Courtesy Philadelphia Museum of Art*)

Deer. Bronze. Ordos. Adolphe Stoclet Collection, Brussels. (Courtesy Madame Feron-Stoclet)

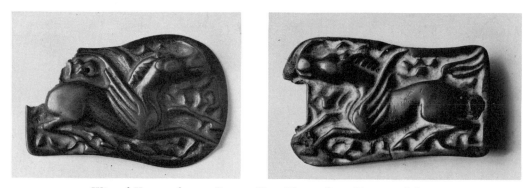

Winged Horses, plaques. Bronze. Han. *Metropolitan Museum of Art*

beyond, owning a distinctive and vital style of art, contributed nothing to the subsequent Chinese tradition. As the invaders at one time revolutionized the military science of the Chinese, so they seem to have contributed much of their art vitality to the country they overran. The influence can hardly be marked down as of the Ch'in or the Han period, though the simplification and directness of statement in Han sculptures may owe some debt to the steppe art.

At the time when Buddhism came to China, generations later, there was an admixture of Greek in Indian art. Some authorities believe that it was the Wei artists who learned directly from Western sculpture. The two winged-horse plaques, ascribed to the Han Dynasty, suggest that a Greco-Scythian influence may have arrived with some earlier nomadic invaders.

Truer indications of influence through the concise, rhythmic Ordos style are found in the two *Deer* shown. Identified by some scholars as products of the Ordos region, they

are claimed by others to be strictly Chinese. Without being unnatural, they escape detailed naturalism.

If some of the pieces are more realistic than is usual in early Chinese sculpture, the period, which is not far from the time of Christ's birth though a thousand years after late Shang art, yields many fantastic designs. The *Chimera* is surprisingly rugged and massive, considering its small size. It is a variation of the dragon of earlier plates, but lacks all serpentine character. Above it is a vigorous *Lion*, profusely decorated and of similar stylistic character.

The horned, yet partly feline, partly equine *Fantastic Animal* is clean-cut, rhythmic, and powerful. In spite of the stripped style of this animal and the simplicity and un-

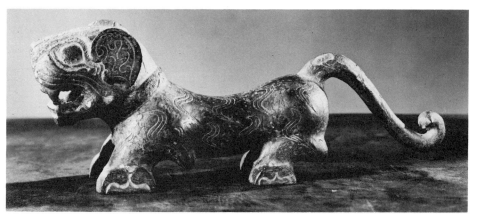

Lion. Bronze. Han.
Collection of Mrs. John F. Lewis, Jr., Philadelphia. (Photo courtesy University Museum)

Fantastic Animal. Bronze. Han.
Cleveland Museum of Art

Chimera. Bronze. Han.
Nelson Gallery–Atkins Museum, Kansas City

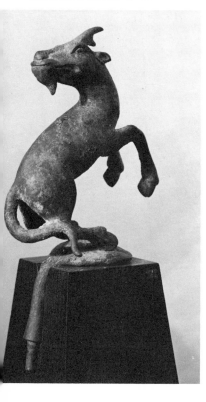

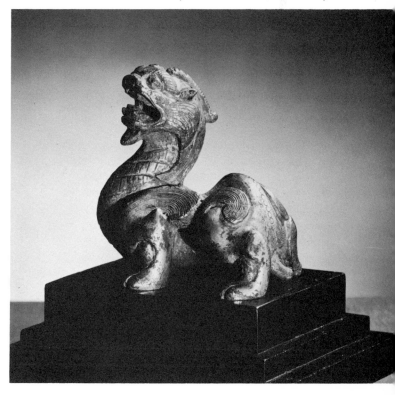

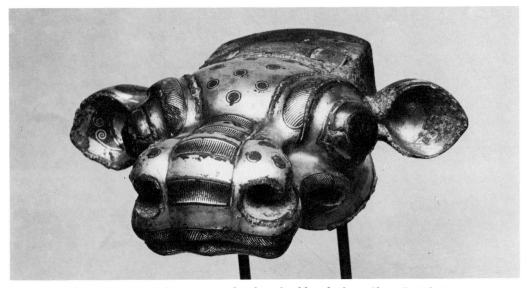

Head of a Water Buffalo. Bronze with inlay of gold and silver. Chou. *British Museum*

decorated appearance of the *Bears* (page 187), the liking for profusely decorated sculpture was to continue through many centuries. The art that began in the legendary Shang times with display of added ornament at last reached this simplicity and directness of representation—though what is represented might still be imaginary or mythical.

Bronzes with inlays of gold and silver were especially prized in the late Chou and the Han eras. The inlaid pieces were usually vases, fibulae, and mirror-backs; but the *Head of a Water Buffalo* shown is sculpture in the round, made to serve as an axle cap and presumably one item in an array of ornamental chariot hardware. From such relics in our museums it has been possible to gain added insight into the sumptuous and brilliant life at the Han courts.

The Han jades continued the double tradition of abstract or near-abstract emblems and highly formalized figurative carvings. A stylization that reverted to the animal art of the steppes marks the ceremonial ax head surmounted by a dragon. The reversed head is a familiar Scythian motif and the addition of a second animal, the hare in this instance, is also characteristic.

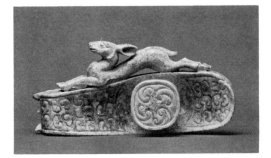

Buckle with antelope. Jade. Han.
Winthrop Collection, Fogg Museum of Art

Ceremonial ax head. Jade. Han.
British Museum

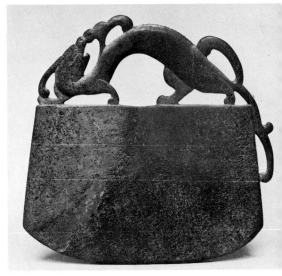

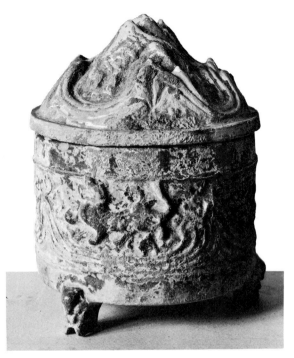

Hill jar. Clay, glazed. Han. *City Art Museum, St. Louis*

The jades offer occasional realism, for example the engaging little antelope, clean-cut and sheer, on the buckle, which is richly patterned for contrast. The repeated curves and the svelte elongations of the animal are far removed from the fantastic treatment of the beaked, winged *Dragon* in the group on page 202, or the lush ornamentalism of countless dragon charms and buckles in the museums.

Seemingly there was nothing the sculptors of Han would not attempt. Portrayal of landscape would seem to be the province of painters and poets, but one of the most distinctive products of the time is the hill jar. The vessel itself is round with a bas-relief panel circling it. But the lid is a composition in which the mountains rise up out of a perianth of waves. The subject-matter is drawn from the Taoist legend of the Blessed Isles. The elements of mountainous island and surrounding waves are manipulated for rhythmic sculptural beauty, and the effect as abstract composition is definite and compelling. The bas-reliefs molded on the pottery vessels demonstrate the liveliness and strength so usual in Chinese *relievo*.

The first conspicuous output of the famous tomb statuettes occurred at this time. Human beings were portrayed, often in groups. Especially ingratiating are some perky figures of dogs, and the many horses are impressive. Already sculptors were producing models of houses, courtyards, garden pavilions, and household paraphernalia, which are valuable as clues to the life of the Chinese people rather than as sculpture. Despite such masterly Han pieces as the *Head of a Horse,* the high periods of production were to occur in the Wei and the T'ang Dynasties.

The Chinese had been masters of bas-relief carving, and the very shallow relief-cutting illustrated by the *Scenes of Chinese Life* from the tomb of one Wu Liang Tzu, who died A.D. 147, is a typically Chinese development. Here the design has been reduced in effect almost to the status of black-and-white drawings; but it is stone-cutting and therefore technically sculpture, although the figures are only slightly raised from their background. As practiced, the art has unrivaled vivacity and contrast. The voluminous horses and men and the accented contours mark the artists as sculptors at heart,

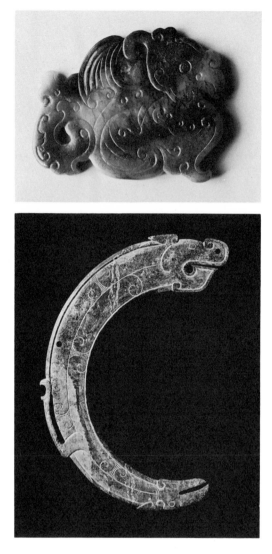

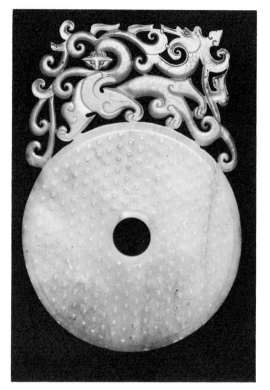

Dragons. Jade. Han. *Metropolitan Museum of Art; Freer Gallery of Art*

Head of a Horse. Clay. Han. *Royal Ontario Museum*

Dog. Clay. Han. *Royal Ontario Museum*

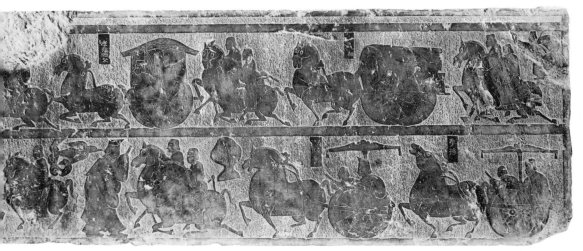

Scenes of Chinese Life, reliefs. Stone. Han. Shantung.
C. T. Loo Collection; Musée Guimet, Paris. (*Lower photo, Giraudon*)

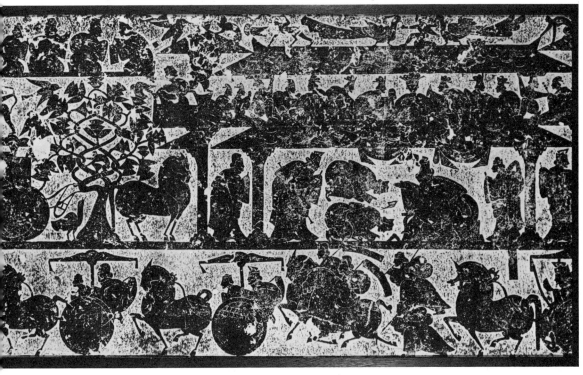

rather than mere draftsmen. The illustrations usually seen (including one of those here) are from rubbings or "squeezes" brought out of China by archaeologists. Throughout the stones, which depict military and other earthly scenes and life in fantastic realms of air, wind, and water, the sense of movement is extraordinary and there is a mood of impending drama. From this kind of shallowly incised design, depending so largely upon linear exactitude, one can go on to the study of normal bas-relief, and high relief, and so back to cutting in full volume.

There is a series of colossal stone animals,

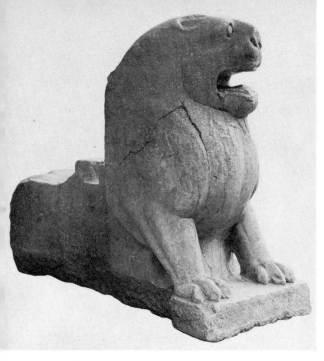

Lion. Stone. Han.

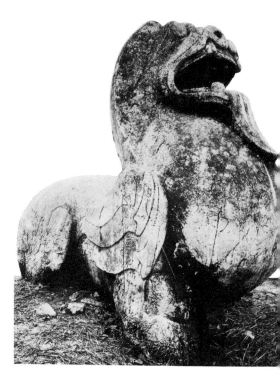

Chimera. Stone. C. A.D. 518. Near Nanking.
(*Photo by Osvald Siren*)

Animal. Stone. C. A.D. 1400. Near Nanking. (*Photo by Claude Arthaud and François Hébert-Stevens*)

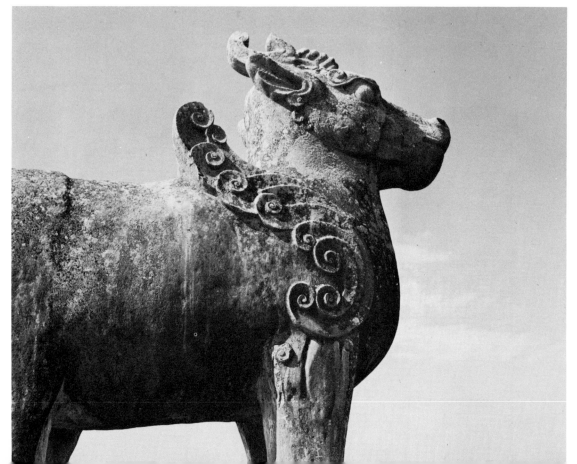

incorporating the fullest resources of sculptural art, which date from the Han into the Wei period. The oversize beasts seem to breathe forth power and magnificence. Whether it is the *Lion* shown, fragmentary but no less lion-like, or an overwhelming sixth-century *Chimera,* the sense of a ferocious guardian animal is as fully conveyed as is the impact of sculptural energy and grandeur. The statues have magnitude and nobility and may mark one of the zeniths of art in stone.

In the third example, *Animal,* a series of bold and masterly decorative additions, typically Chinese, modify a little the appearance of overwhelming grandeur. Such figures protected the "spirit paths" leading to the tombs of great men. Approaches to palaces also might be lined with the animals or with colossal stone soldier-guardians.

One thousand years after the coming of China's two supreme sages, Lao-Tse and Confucius, the influence of a third sage, the Buddha Gautama, whose religion already had inspired great works of art in India, brought about a revolution among Chinese artists. Sculpture became essentially the medium of this religion, and the human figure, long neglected as subject-matter, became central, owing to Buddhist concentration upon the human mind and its development toward enlightenment.

There can be no doubt that Hindu models had effect upon the Chinese sculptors; and through the type of Hindu figure that had inherited from the Greeks, via Gandhara, some slight influence from Greece lingered on. There is an unmistakable aura of classic grace. A figure such as the *Bodhisattva* from the Boston Museum exhibits idioms easily identified as taken from Indian masters, and the mixture of Greek and Eastern feeling is faintly evident in the face.

The Buddhists of India had fashioned extraordinary cave-temples, and these were filled with rock-cut representations of the Buddha and his attendants, and of incidents in his life. The Chinese, with only a little

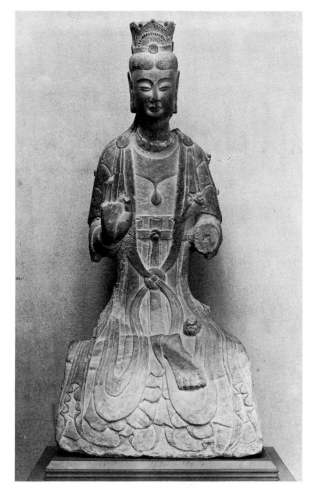

Bodhisattva. Stone. North Wei.
Museum of Fine Arts, Boston

more restraint, hollowed out shrines quite as amazing and exuberantly decorated. Perhaps the most satisfying examples date from the late fifth and sixth centuries. In general, the photographs of the caves in their present condition fail to do justice to the individual statues, though one of the Lung Men Caves in Honan indicates something of the majestic effect of the major figures.

One rather angular and slenderized style stands out distinctively and unmistakably in semidetached figures from, and in, the Lung Men Caves. The seated *Bodhisattva* of the Loo collection is a beautiful example and has been referred to as Gothic on account of the tendency to play with the flowing contours,

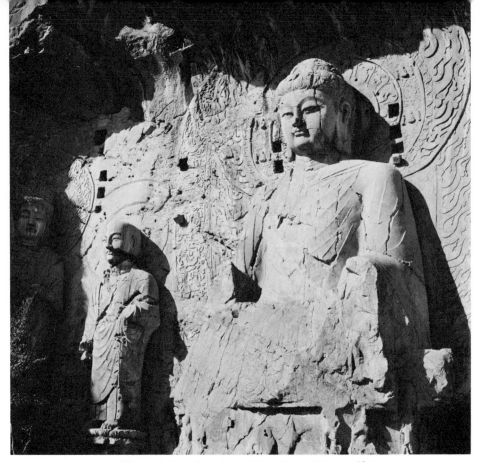

Buddha and Attendant. Lung Men Caves, Honan, China.
(*Photo by Claude Arthaud and François Hébert-Stevens*)

and the abstract, almost geometrical design.

Another stylistic development, characteristic of the earlier painted sculpture of the Yun Kang Caves in Shansi, resulted in rounder figures more in harmony with the serenity of Buddhism. Many of the cave Buddhas *in situ* demonstrate the quiet nobility of the style, and the example from the Metropolitan Museum of Art makes clear the sculptural idioms by which the workers at Yun Kang achieved their effects. (See page 189.)

In the early sixth century shrines were built in incredible numbers in China. During only two reigns the emperors erected thirteen thousand Buddhist temples. The shrines, except the caves, have disappeared but considerable numbers of stelae and independent statues have survived. A common kind of stele is a stone slab carved in combined low and high relief. There are wonderfully graphic pictorial scenes and exceptionally

fine ornamental panels carved upon the face of the monument, and usually there is a deep-cut niche (sometimes more than one) in which full-rounded or engaged figures are placed. The Buddhist votive stelae shown illustrate two types of decorative flattened relief-carving much practiced in China through several centuries.

The small sculptural arts as well as the monumental blossomed in the Wei Dynasty. Sculpture in bronze developed in two directions. One was the utter simplicity of such concise expressions as the *Buddhist Monk.* Though small in size, the figure affords an impression of solidity, power, even magnitude. Every unnecessary feature, every complicating detail has been sheared away. The *Buddha* at the University Museum, Philadelphia, from an altar group, though simple, has been decoratively enriched. Some pieces were almost baroque.

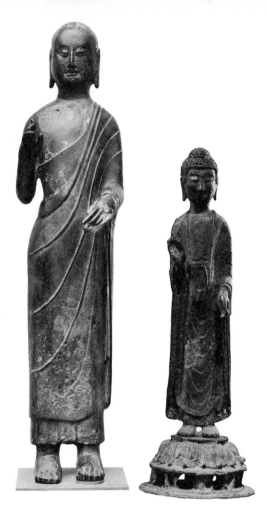

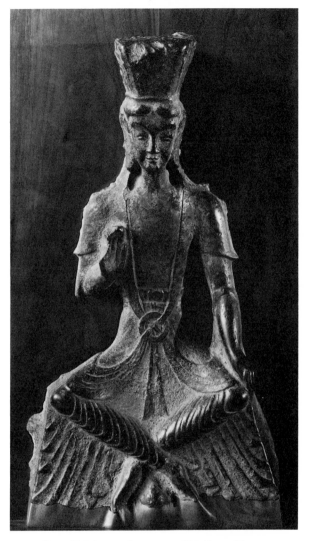

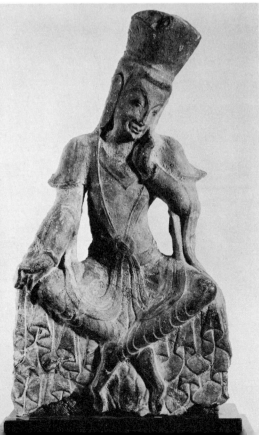

Seated Maitreya. Stone. A.D. 512. Lung Men
Caves. *University Museum, Philadelphia*

Top left: Buddhist Monk. Bronze. Wei.
Metropolitan Museum of Art

Center: Buddha. Bronze. Sui.
University Museum, Philadelphia

Left:
Seated Bodhisattva. Stone. Early 6th century.
Lung Men Caves. *C. T. Loo Collection*

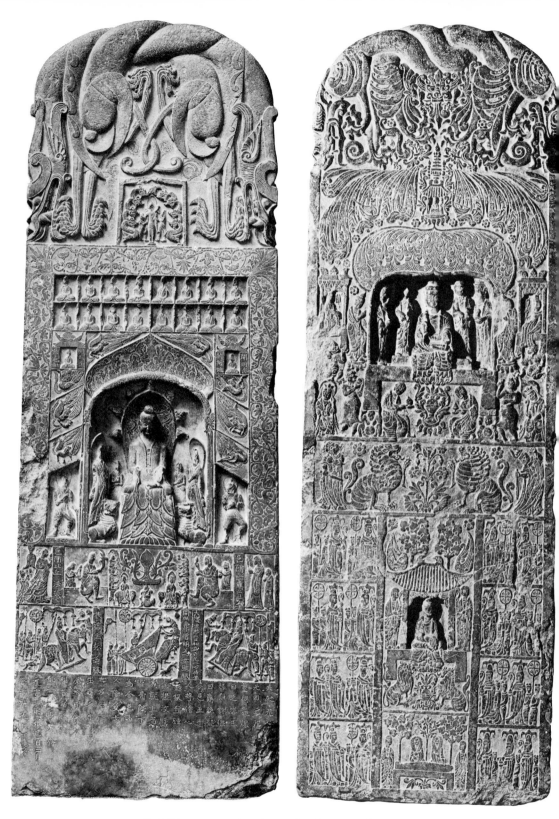

Buddhist votive stelae. Stone. North Wei. 6th century.
Museum of Fine Arts, Boston; Nelson Gallery–Atkins Museum, Kansas City

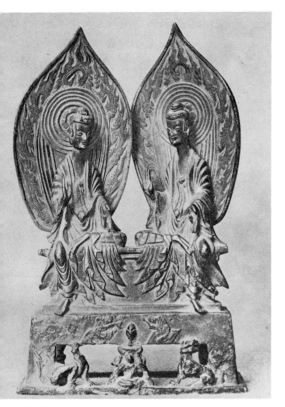

Buddhist altar. Bronze, gilded.
A.D. 518. *Musée Guimet*

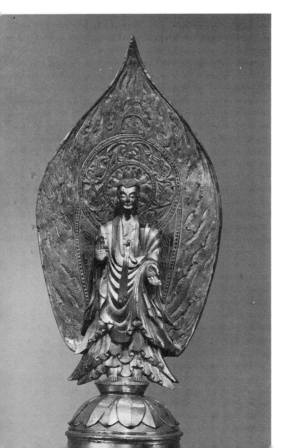

Buddha. Bronze, gilded. Wei. A.D. 536.
University Museum, Philadelphia

The bronzes were mostly devotional figures or groups of figures. Unmistakable influence from India is evident in the Buddhist altar, though the animal figures at the base seem to have come down direct in the Chinese line, and the lean, angular sculpturing is suggestive of the Lung Men stone figures.

The leaf-form nimbus filled with flames was characteristic of the earliest dated Chinese Buddhist sculptures, bronzes of 437 and 444. The exquisite little gilded bronze *Buddha* at the University Museum shows a nimbus. This was adapted in later sculptures to appear as a decorative canopy, along a line of development that is more often encountered in Japan.

The wide diversity of techniques can be noted also in the surviving monuments of carved sculpture. The *Bodhisattva* of the Freer Gallery, essentially Chinese, is at the farthest remove from the austere treatment of the *Monk* shown previously, though it too is unmistakably a product of Chinese Buddhist art.

The "feel of the stone" is inherent in the *Head of a Buddha* at Minneapolis, which is typical of many detached heads taken from China into the museums of the Western world. The colossal *Head of a Bodhisattva* at the University Museum, though decorative, has impressive and silent grandeur.

As if to prove their independence of any stylistic limitations, cave artists, at about the same time, produced mural reliefs with the light, almost frivolous touch evident in the *Apsara* in the Fogg Museum. Seldom has linear grace been woven more charmingly into stone patterns than in the series of cave decorations at T'ien Lung Shan from which this fragment was taken. The differences of style in the statues and reliefs of a single cave shrine are attributable to the fact that sculptors came to a few working centers from many distant points, even from India. There

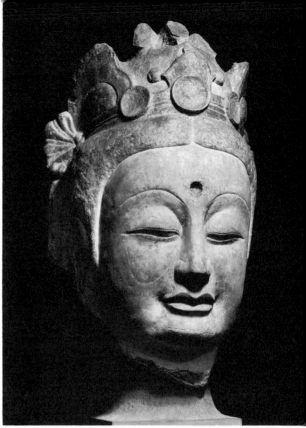

Head of a Bodhisattva.
Stone, colossal. 6th century.
University Museum, Philadelphia

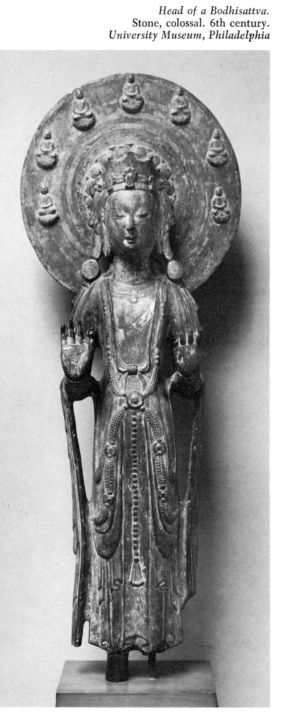

Bodhisattva. Stone.
Period of the Six Dynasties.
Freer Gallery of Art

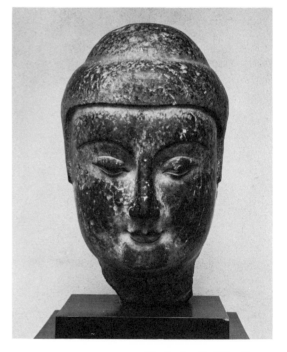

Head of a Buddha. Stone.
Northern Ch'i. Honan.
Minneapolis Institute of Arts

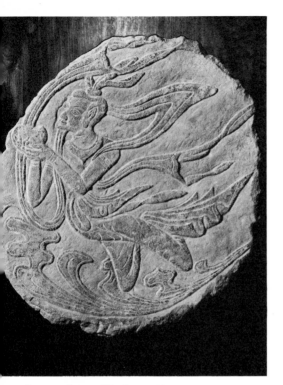

Apsara. Stone. Northern Ch'i.
T'ien Lung Shan Caves.
Fogg Museum of Art

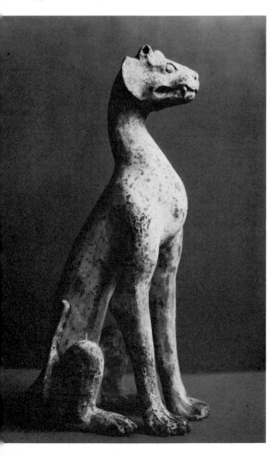

are differences, too, between the art of the Eastern Wei regime and the Western.

It was during the Wei Dynasty that the art of making pottery figurines came to a climax. In accordance with men's belief that it was good to be surrounded in the tomb with what had been interesting and agreeable in life, the statuettes represented court ladies, dancing girls, pet dogs, pigs, horses, and so on—though anything and everything both actual and legendary seems to have been depicted sooner or later.

Among the most intriguing objects are the more or less imaginary beasts, such as the catlike *Tiger* (or dog) from the Loo collection. The most spirited of the figures were often the dragons or chimeras, as the *Dragon* at Providence. The ancestors of this beast can be found, of course, in the bronzes and jades of the Chou era of a thousand years earlier.

Most of the terra-cotta or earthenware statuettes were at one time painted, and those that have survived bear traces or patches of coloring, often white, and only very rarely a full coating of pigment. Already glazed or partly glazed figures appeared among the earthenware pieces.

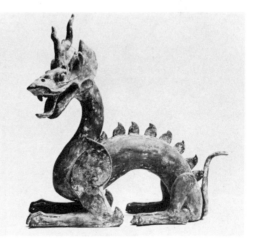

Dragon. Clay. Wei. *Museum of Art, Rhode Island School of Design, Providence.*

Tiger. Clay. Wei. *C. T. Loo Collection*

Fragmentary horses' heads in clay, and horses with heavy trappings and unusual ornamental additions remain as perfect examples of the Wei and T'ang mastery. The pieces illustrated, at Cleveland and Oxford, are at once massive, beautifully rhythmic, and reposeful. The essential sculptural largeness suffers no diminution from the profuse adornments. The Wei Period and the following T'ang give to the world its largest treasure of sculpture in clay.

The human figure in the time of Wei was treated, in the statuettes, with something less than the finesse shown in the T'ang Era. But the kimonoed ladies, generally modeled solidly into pillar-like compositions, with skirts flaring at the feet, are engaging and sculpturally correct. The faces of the examples at the Royal Ontario Museum are typical and full of character.

The *Bodhisattva* in stone shown is attributed to the Ch'i (which displaced Eastern Wei in 550). The figure, holding a lotus bud, is carved with a remarkable simplicity. A dignified material solidity and a sense of remoteness from the world have been

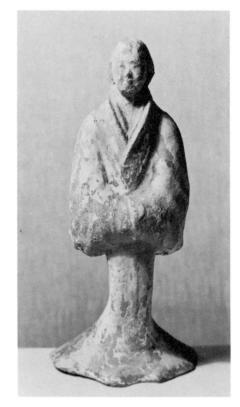

Women. Clay. Wei.
Royal Ontario Museum

Horse. Clay. Wei. Charles W. Harkness
Collection, Cleveland Museum of Art

Horse. Clay. T'ang.
Ashmolean Museum, Oxford

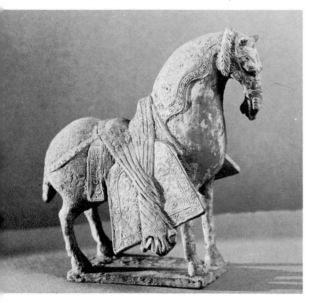

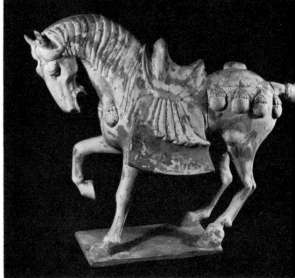

achieved. Captured in stone is the stillness, the awareness of an interior life, which is at the heart of Buddhist devotion.

The following Sui Dynasty, in power from 581 to 618, brought in no stylistic innovations but fostered the arts as known under the Six Dynasties emperors. A high point of elaboration was reached in the portion of a shrine now at the Nelson Gallery, which epitomizes the colorful and vigorous Oriental mode. It commands attention for the skill in marshaling mass and movement, and in stressing a main line of direction through a writhing pattern of virile bodies and thrusting ornament. It marks a peak in the sculptural design that parallels to some extent the unrivaled Chinese silk embroideries.

Elaboration is more restrained and graceful in the limestone *Kuan-Yin* at Boston. From this time forward the god of mercy, known as Kuan-Yin, and later as a goddess, the Merciful Mother, was a favorite figure in the enlarged pantheon of Buddhist and Taoist divinities.

The suavely decorative *Kuan-Yin* at the Metropolitan Museum is a counterpart in

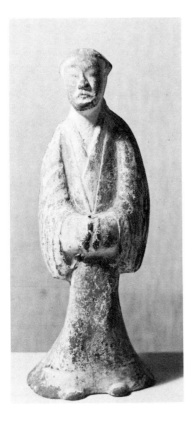

Bodhisattva. Stone. Northern Ch'i.
University Museum, Philadelphia

Portion of Shrine. Stone. Sui.
Nelson Gallery–Atkins Museum, Kansas City

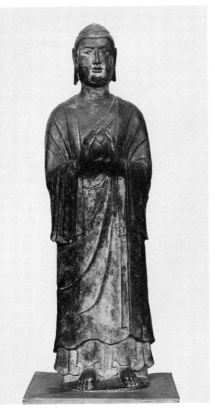

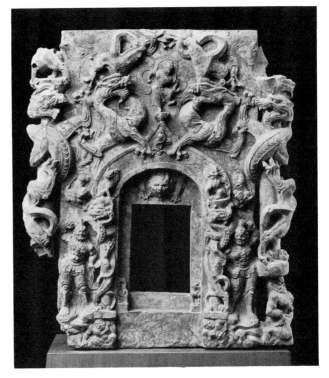

bronze. At this time the repeated forms in the elaborate draperies of the Buddhist bronzes began to be more fluent: a step toward the type characteristic of the T'ang era. Especially notable here are the ribbon-like accessories and edgings.

The seated *Kuan-Yin* of the Freer Gallery was produced at a time when many of the bronze figures were being dressed up in elaborate garments and garlands. This one achieved sculptural solidity and even remarkable plastic integrity.

The T'ang is by reputation the most magnificent, the most gorgeous period of Chinese history. The lesser techniques of sculpture, in clay and bronze and wood, were practiced with surpassing mastery, but above all it was the stone statue that was carried to new heights of achievement. The dignity and monumentalism of the pieces are undisturbed by the counterpoint of line and minor mass and surface variation. These Buddhas and Bodhisattvas are subtly expressive even while retaining the quality of rocklike solidity.

The *Bodhisattva* from a private collection in New York is one of the sublime expressions of aesthetic and religious feeling in a great era and is more lyric and more graceful than most of the stone sculpture of the time. The same combination of graceful and massive qualities is to be seen in a *Bodhisattva* of the T'ien Lung Shan caves. The large mass of the statue is not unusual for that time, but the subtle shaping of the body and the delicacy of feeling in the treatment of the draperies suggest an exceptional refinement of the art.

Kuan-Yin. Bronze. Sui.
Metropolitan Museum of Art

Kuan-Yin. Stone. Sui,
6th–7th centuries. *Museum of Fine Arts, Boston*

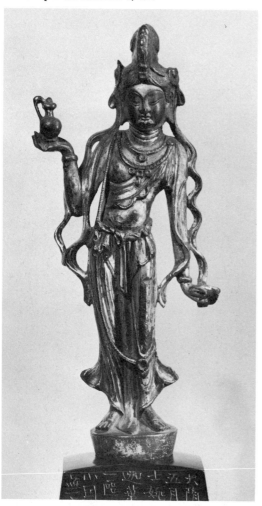

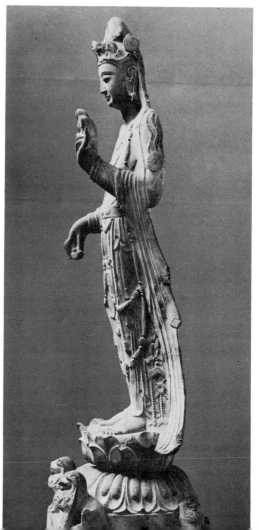

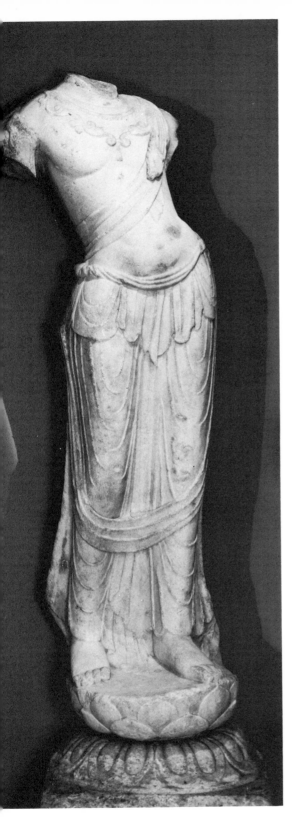

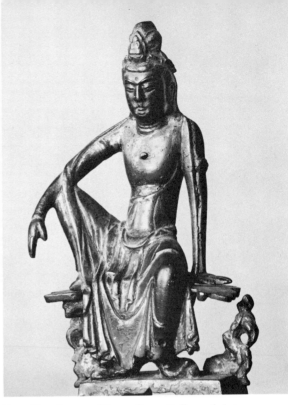

Kuan-Yin. Bronze. T'ang. *Freer Gallery of Art*

Bodhisattva. Stone, with gilt and color. T'ang,
8th–9th centuries. *Freer Gallery of Art*

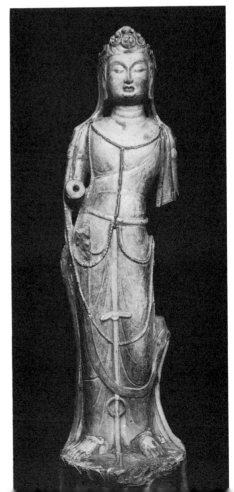

Bodhisattva. Stone. T'ang. 8th–9th centuries.
Private Collection, New York

The *Bodhisattva* of the Metropolitan Museum on the title page of this volume is in dried lacquer. The quiet expressiveness, which is a central aim of Buddhist art, is supremely felt. The sculptural character is increased by surface harmonies, particularly in the treatment of draperies.

The technique of dried lacquer results in different effects from those of stone carving and clay modeling. Over an armature of wood or a removable clay core the figure is roughly modeled with cloths soaked in lacquer. Successive layers of lacquer-wet cloth or of lacquer paste are added until the surface has been built out to its final shape, when a coating of lacquer paint is applied. Smooth surfaces, banded draperies, and sharpened area-edges are natural to the method. The *Bodhisattva* of the Metropolitan Museum, with facial features and drapery edges cleanly accented, is typical.

The *Kneeling Bodhisattva* in stone is very much smaller in size but hardly less powerful than the life-size and colossal figures. It is worth noting how simply and harmoniously the garment is suggested. Again the treatment is a reminder of the debt of Chinese sculptors to the Buddhist sculptors of India.

The technical expedient of sharply marked edges is not, of course, unknown in carved stone statues. The device might have been noted in some of the earliest heads of the Buddha carved in China, and it persisted through the following centuries, as in the *Head of Buddha* in the Victoria and Albert Museum.

That the medium of wood also could be

Bodhisattva. Stone. T'ang. T'ien Lung Shan Caves, Shansi. (*Courtesy Osvald Siren*)

Kneeling Bodhisattva. Stone. T'ang.
Fogg Museum of Art

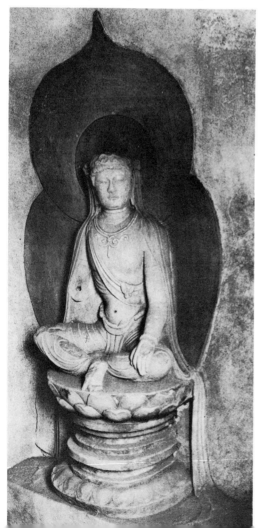

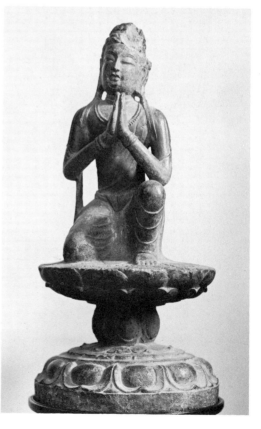

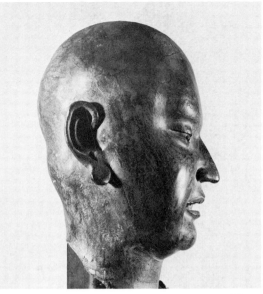

Head. Dried lacquer. T'ang.
Art Institute of Chicago

used for the noblest purposes, with amplitude and impersonal grandeur, is sufficiently proved in the life-size *Kuan-Yin* shown, from the Metropolitan Museum of Art. The softness of the wood is properly revealed in the deeper cutting and the freer play of ribboned forms.

When they worked with wood, Chinese sculptors sometimes copied nature exactly, as they did also in later lacquer figures. The lacquer *Head* at Chicago is obviously imitative of a model and marks the farthest point attained by the Chinese in their excursion into naturalism—at a far distance from their normal Oriental formalism.

All the collections of Oriental art include figures of tomb or temple guardians in stone

Kuan-Yin. Wood. T'ang or Sung.
Metropolitan Museum of Art

Head of Buddha. Stone. T'ang.
Victoria and Albert Museum

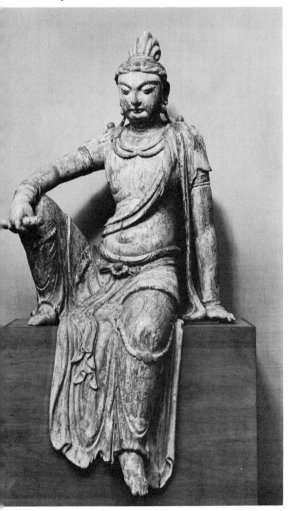

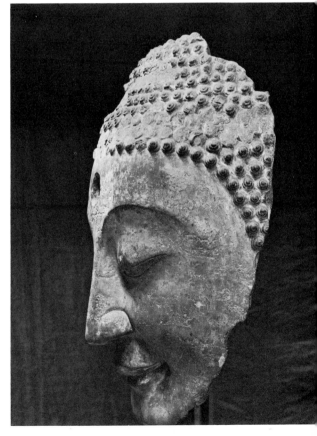

and wood. The bulky bodies and brutal faces considered appropriate to the purpose lent themselves well to heavy sculptural effects. The example in the Hoyt Collection is unusual, being of dried lacquer. Somewhat less horrendous than some, it has an unusual subtlety of expression. The amount of minor modeling is extraordinary, considering the effect of solidity, not to say concentrated power, conveyed by the figure. A related example is the *Head of a Lion,* exceptionally in cast iron.

In small clay sculpture the T'ang era is fully as rich as the Wei. Primitive expressionism and simplicity give way a little to a more realistic mastery and to elaboration, but there is direct expression too, as in the *Camel* shown.

The *Horse in Combat* of the Eumorfopoulos Collection at the British Museum indicates that the spiritedness common to the treatment of animals in the Chou, Han, and Wei eras has been maintained. An endless study could be made of the caparisoned animals and the ways in which their trappings are represented. The saddle robe here, in its form and the direction of its edges, provides an instructive example of creative composing.

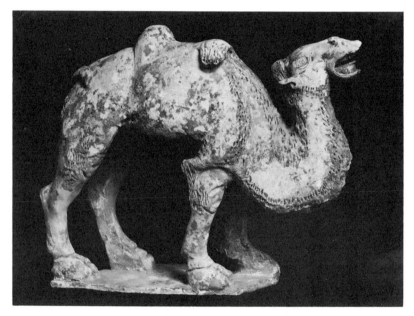

Camel. Clay. T'ang. *Fuller Collection, Seattle Art Museum*

Horse in Combat. Clay. T'ang. *British Museum*

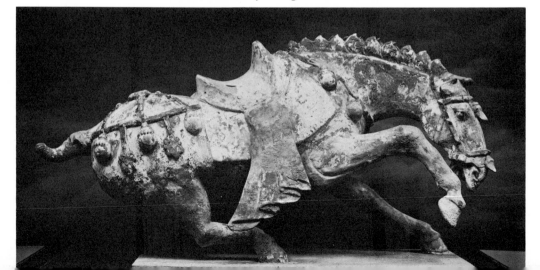

The unusual rounding of the forms and the smoothing of the surfaces of the *Polo Player* at Stockholm make a more ingratiating appeal, though perhaps a less profound one as compared with the *Camel* or the *Horse*. It is an extraordinarily accomplished and fluent design, hardly rivaled in its particular field outside the body of Chinese work.

The tomb statuettes of the T'ang era can be masterpieces of realistic reporting. The *Equestrienne Dismounting,* and the group of posed *Ladies* are typical treatments of themes from everyday life. They illustrate the application of solid sculptural artisanship to the slightest subjects.

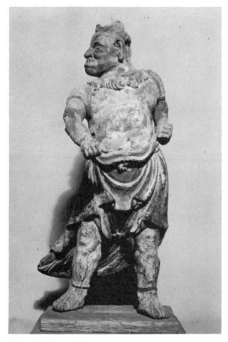

Temple Guardian. Dried lacquer. T'ang.
Collection of Charles B. Hoyt.
(*Courtesy Fogg Museum of Art*)

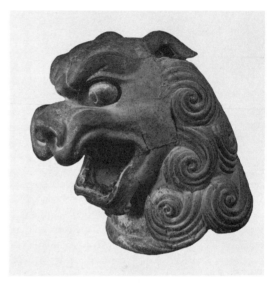

Head of a Lion. Cast iron. T'ang.
Detroit Institute of Arts

Equestrienne Dismounting. Clay. T'ang.
Detroit Institute of Arts

Polo Player. Clay. T'ang.
Museum of Far Eastern Antiquities, Stockholm

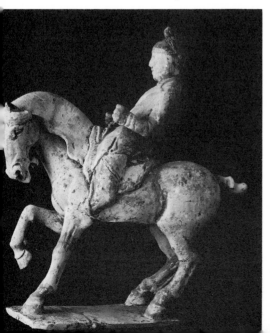

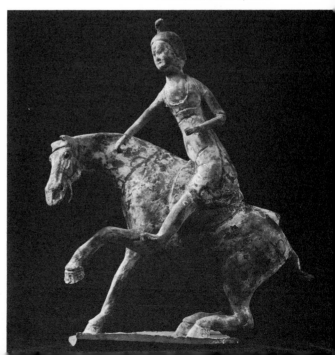

Both the Wei and the T'ang statuettes on these pages are executed in clay and they vary from plain terra-cotta to examples painted in white or varied colors, and glazed examples. In general the sculptural values seem not to have been harmed by the loss of color.

One especially attractive and sophisticated type is the *Lady* with festooned sleeves and flaring shoulder patches. Her headdress and skirts are fitted with flaring ruffles to match, but the pointed effect is relieved by the collar that repeats the oval of the face, and by a rounding of the statuette at the base.

After the T'ang Dynasty came to an end A.D. 907, five minor dynasties rose and fell before the powerful Sung Dynasty came into being A.D. 960. This was a turning point in Chinese history; but the more than three hundred years of Sung yielded little superlative sculpture.

The most distinctive contribution was made in painted wooden statues. They were generally large and captured the combination of magnificence and quiet feeling which had characterized T'ang religious sculpture. The *Kuan-Yin* at Boston is both massive and rich in detail. It is utterly reposeful yet sculpturally alive, a masterpiece of the style.

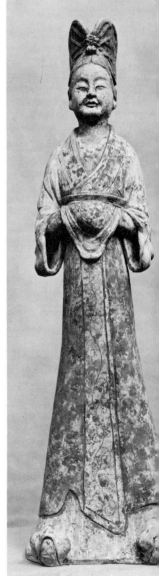

Flute-Player; Lute-Player; Lady. Clay. T'ang. *Victoria and Albert Museum; British Museum; Royall Tyler Collection*

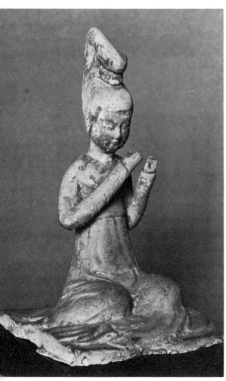

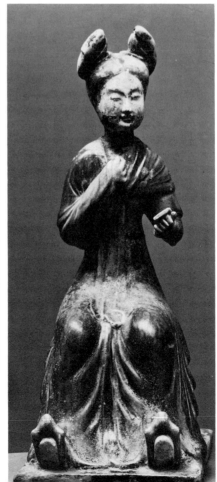

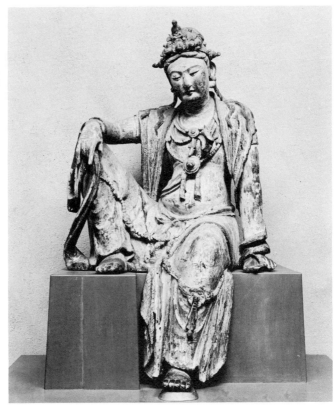

Kuan-Yin. Wood. Sung, 12th century.
Museum of Fine Arts, Boston

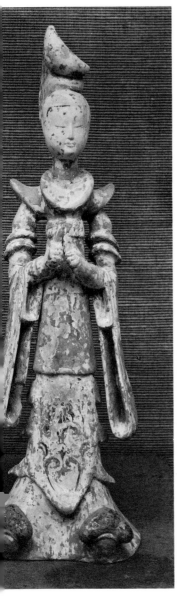

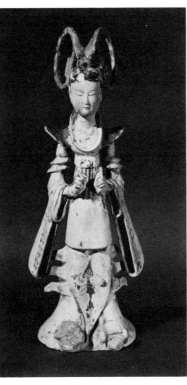

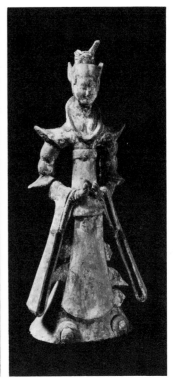

Ladies. Clay. T'ang. *Seattle Art Museum;*
Toledo Art Museum; Philadelphia Museum of Art

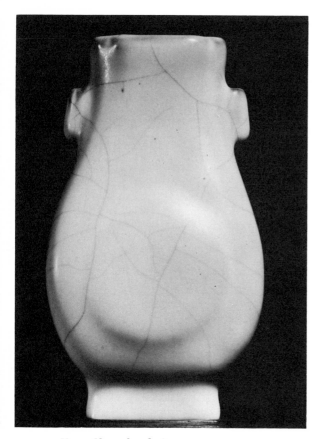

Vase. Clay, glazed. Sung.
Freer Gallery of Art

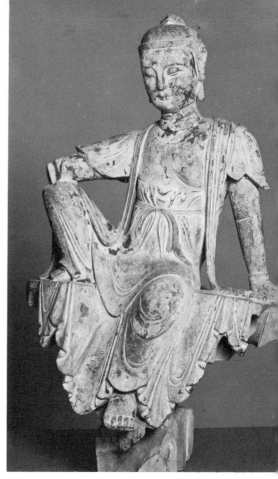

Bodhisattva. Wood. Sung, 12th–13th centuries.
Collection of Charles B. Hoyt.
(Courtesy Fogg Museum of Art)

The *Bodhisattva* of the Hoyt Collection retains more dignity and reserve than most of the wooden figures of the period. The technique of cutting, too, is crisper, and the graceful draperies resemble the T'ang. This piece is exceptional for the expression of both spiritual discernment and sculptural sensibility.

The bronze statuette of *Lao-Tse on a Water Buffalo* is exact and subtly expressive, yet it avoids the over-detailing of a too observant realism. The sage of non-resistant action, who put his trust in mystic understanding and a serene power derived from nature, is shown at ease upon one of the most refractory of beasts. But one need not know the significance of this Taoist theme to recognize the superlative values of the treatment. (See page 184.)

It is generally believed that at no other time or place did the art of the potter reach the heights achieved in China in the Sung era. The vases, bowls, and dishes were unsurpassed for form, glaze, and texture, and at its best the ceramic vessel had abstract sculptural beauty. The architecture of the bowl is properly adjusted, with feeling for ordered mass and svelte contour. The vase shown, from the Freer Gallery, abstractly designed, is hardly less sculptural than the infrequent ones with representational touches in high relief.

A set of six *Lohans,* or disciples of Buddha (of an original probable eighteen), forms one of the curiosities of the late period of Chinese sculpture. These life-size figures are of clay, glazed and fired in the manner of the pottery that we call chinaware. Because

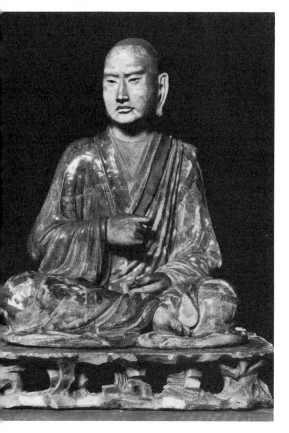

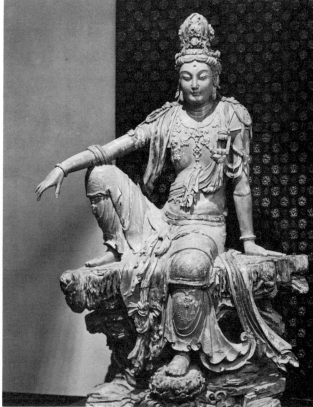

Lohan. Clay, glazed. Sung or Ming.
University Museum, Philadelphia

Kuan-Yin. Wood. Yuan.
Nelson Gallery–Atkins Museum, Kansas City

of the size, each piece constitutes a marvel of ceramic achievement. The one at the University Museum is particularly interesting for the fine head and expressive face. The virtues of the series, however, are comparative. It is obvious, from the laxness of sculptural expression in the figure, that the standards of the art had already seriously deteriorated. The colors, unfortunately, are overbright and inharmonious.

In the Orient a replica of a masterpiece was valued as highly as the original, if it was as fine, and copying the great works of the past now became a recognized industry. Works dated to the Sung and Yuan and Ming Dynasties but "in the style of Han" or "Chou" or "Wei" are numerous. Yet only rarely does a *Kuan-Yin* or a tomb guardian or a *Lohan* substantially reflect the glories

of the earlier achievements. The heavily decorated *Kuan-Yin* of the Nelson Gallery, which is ascribed to the Yuan Era, is, however, a welcome exception.

The Yuan Dynasty, of the Mongols, succeeded the Sung and in 1368 gave way to the Ming, which lasted to 1644. Century after century passed, and no fresh inspiration came into the art. The ivory carvings are among the best works from the Ming period.

Objects in ivory had been treasured immemorially but had been overshadowed by the popular and exquisite carvings in jade. Most distinctive of the Chinese ivories in Western museums are figures, often of old men, shaped to preserve substantially the outline of the tusk; that is, with the indentations but slightly cut. The effectiveness of the pieces arises from the resulting slender styli-

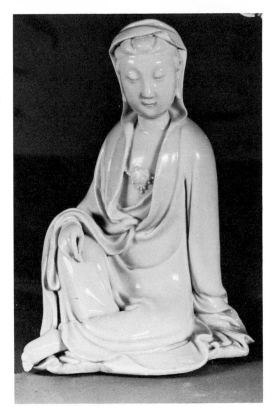

Seated Kuan-Yin. Porcelain. Early Ch'ing.
Buckingham Collection,
Art Institute of Chicago

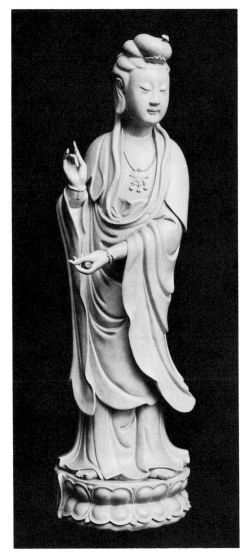

Kuan-Yin. Porcelain. Late Ming.
Seattle Art Museum

Old Men. Ivory. Ming. *Metropolitan*
Museum of Art; Royal Ontario Museum

zation and fluent channeling. The standardized old man of these pieces, representing the dignity and serenity of the aged, is sometimes called the god of longevity.

Porcelain figures became a standard product, and the hundreds of known examples are pleasing and distinctive. The virtues here are grace and the fitness of the creamy white ware to its sentimental-symbolic subject matter. The figure is most often the Kuan-Yin, now become a feminine deity, and as commonly idolized in the Far East as the Madonna is in the West. The examples at Chicago and Seattle are typical.

The objects shown in the facing illustrations are pretty and have sentimental appeal but cannot compare with the profound works produced in the twenty-five centuries between Shang and Ming. Some of the most ingenious

and intricate ivory carvings in relief—marvelously cut fans and screens and box panels —arouse our wonder more for their workmanship than for artistic originality. Woodcarving, too, was carried on, both in the round and in relief, and the spread and the ornateness of the fretwork screens and panels, the high-relief carvings on beam and balustrade, and the melodramatic figures in the temples, pagodas, and palaces of Peking are known throughout the world.

The account may best end with the truth that artisans were still occasionally, in objects such as stone seal-handles and jade figures, capturing a little of the magic of early Chinese animal sculpture. A composition such as the appealing *Horse* in white jade affords us something of the old delight in rhythmic massing and exquisite finish.

Horse. Jade. Ch'ing. Kang Hsi period, 1662–1722.
Metropolitan Museum of Art, gift of Heber R. Bishop, 1902

9:Korea and Japan:
The Spread of Buddhist Sculpture

I

KOREA'S location on a peninsula pointing southward from the Manchurian mainland toward the westernmost islands of Japan was a factor in the spread of sculptural art in the Far East. In the period of the Han Dynasty the Chinese Empire had expanded to embrace both lower Manchuria and Korea. Korean art was destined, in the centuries immediately following, to be a brilliant reflection of Chinese art. Korean artists in turn took

actual models of Buddhist sculpture into Japan, and from this beginning the whole monumental art of the Japanese was to flower.

Racially the Koreans were Siberians who had settled in the peninsula as refugees from the war-torn states of upper China. They persisted physically as a distinctive people, differing both from the Chinese and from the Japanese. Their social and cultural customs and institutions were those of China (includ-

Wine vessel, tomb figure. Clay. Possibly 4th century A.D.
Kyungju, South Korea. *National Museum, Seoul*

ing ancestor-worship and spirit-worship, educational system, *cash* money, etc.). In the fifth and sixth centuries they were full in the tide of Buddhist ardor that was then sweeping the Chinese Empire. The Korean statues of the Buddha and Bodhisattvas made at that time and in the T'ang era are hardly distinguishable from the mainland figures. The Koreans were harried by the nearby Japanese, were sometimes conquered and had their land annexed. But in the sixth century, in one of the quieter periods, they passed on to the island kingdom both the knowledge of Buddhism and the tradition of Buddhist sculpture.

Korean art is competent, craftsmanlike, and pleasing, but most of it is derivative. While sculpture is noticeable among their arts, pottery is the field in which the Koreans more particularly please discriminating collectors. The porcelains were developed with originality and rivaled the Chinese products.

There were three phases in Korean sculptural art. The first, a local type of mortuary sculpture, is illustrated in a terra-cotta piece from a tomb, and indicates an inventive imagination. The second phase, as instanced in a *Bodhisattva* in bronze, illustrates the dependence upon China for both subject and method. In this there still persist vaguely some traits inherited from the Greeks through the Romans, developed idiomatically by the sculptors of Gandhara, absorbed into the main body of Indian Buddhist art, carried to the Chinese, and handed on by them to the Koreans. The third phase is illustrated in the relief panels from the Temple of Sok-kul-am in South Korea, where the Korean sculptors departed somewhat from the models as known in the Lung Men Caves and other Chinese shrines and endowed their work with a serenity and lifelikeness not encountered before.

Owing to their geographic position, the island people of Japan sometimes withdrew for long periods from contacts with the mainland and from contamination by the world currents of commerce. Between periods of withdrawal, however, there were times when interchange with the nearby continental nations introduced new philosophies, religions, and arts. The real story of the art of Japan begins with the introduction of Buddhism from Korea in A.D. 552, and the cultural ideals derived through Korea from the Buddhist sculptors of China determined Japanese practice for centuries.

Although the tide of Buddhism swept over Japan from outside, transforming worship and art, it is clear that the Japanese had previously trained artisans who were able to work with and understand the immigrant Korean sculptors, and in time to make the traditional Buddhist sculpture their own in a personal and national way. There is a primitive Japanese sculpture which goes back to the later Neolithic era. In a period known as Jomon a special sort of pottery and anthropomorphic figures in potter's techniques were made in considerable numbers. Later, in the fourth and fifth centuries, the Japanese had developed a form of sculpture in clay, known as Haniwa. It is in appearance a primitive or folk art, and it has been widely celebrated recently for its simple virtues and a naïve individuality.

The Haniwa compositions were generally tomb figures; again China is paralleled, though there is no stylistic connection with the Chinese. The Haniwa figures, seldom more than three feet high, were set *outside* the burial mounds, usually on cylinders built as reinforcement of the mounds, whereas the Chinese clay ladies, dancers, and musicians were interred inside with their owner. The origin may have been the same: to relieve the loneliness of the afterlife by providing loved or amusing companions at the tomb, mercifully manufactured in clay so that the originals might stay alive—though once servants, entertainers, and horses had been buried with their masters.

The new Buddhist religion was not immediately established; political factions fought for and against it until Prince Shotoku Taishi

Triad with Buddha. By Tori. A.D. 613. *Horiuji Temple, Nara*

became Regent to the Empress Suiko and gave official encouragement to the building of monasteries and temples. However uncertain and delayed official acceptance may have been, the Buddhist art style was established by the importation of Korean images and by the arrival in Japan of sculptor-monks. The period was known as Suiko from the name of the Empress (reigning from 593 to 628), or Asuka, from the name of the district in which the culture formed, in Yamato.

Shinto had been the distinctive religion of the Japanese. It was a mosaic of beliefs which included nature-worship and ancestor-worship and taught with special emphasis that a spirit inhabited every person, phenomenon, or object. While not a particularly exacting religion, Shinto had its ritual and reached into every home, since every piece of furniture and cooking or washing utensil was endowed with a spirit.

There also developed an unquestioning patriotism and obedience to an emperor whose spirit was the sun-goddess. A caste system, dating from feudal times, led to dominance by the samurai or military class. Shinto nurtured only a few of the arts, most notably the formalized no drama and the minor sculp-

tural art that provided masks for the no actors.

Shinto remained the official religion of Japan until 1945, even though the showier religious monuments of the country had been for more than thirteen centuries the Buddhist monasteries, and the Buddhist priests the most active workers in sculpture. Buddhism opened new vistas of universal spirituality, self-giving, and compassion. But the individual was still surrounded by those thousands of minor spirits, and he had no reason to give up the main beliefs and observances of Shinto.

The art horizon was widened as was religious perception, and the Japanese went on to creation of the *Buddhas* and *Bodhisattvas* in wood or bronze to celebrate the Buddha Sakyamuni. They learned to provide the vehicle by which the devotee might be stimulated to spiritual contemplation or be led into the mood of quiet peace, the token on earth of *nirvana*.

Because the islands lacked workable stone, the sculptors turned to wood, of which there was a plentiful supply, and they learned to work bronze. In Japan too, as in China, statues of life size or over were built up in lacquer. The lacquer or lac tree, a species of sumac, was native to both countries. But the Japanese genius found noblest expression in the medium of wood.

For thirteen centuries the Japanese have treasured and protected the early wooden masterpieces and the wooden temples and monasteries in which many of them are housed. While a few centuries of wars or a few decades of religious intolerance have obliterated most of the images in wood in the rest of the civilized world, the Japanese have succeeded in preserving a major heritage. Their wooden figures form the world's most successful achievement of sculpture in the medium. The African body of sculptures in wood, which is equally craftsmanlike and aesthetically as appealing, is also a ritual form of creation, but the Japanese figures rose to a monumentality seldom attained by Africans.

Langdon Warner, a pioneer scholar-writer who did much to increase appreciation of Japanese sculpture in America and England, wrote in *The Enduring Art of Japan* that "possession of the mysteries of a craft means nothing less than a power over nature gods and creates a priest out of the man who controls it." Japan's sculpture is evidence of an extraordinary power to understand nature and to transmit the spirit of inner man along with an image sufficiently true to nature. It is priest's business. Throughout the Buddhist world the priest-sculptor is found, and Buddhist sculpture attains spiritual quietude and repose more fully than any other.

One of the waves of influence from China, in the period of the T'ang emperors (A.D. 618–907), brought a modification of the impersonality or aloofness which is implicit in early Japanese monumental sculpture. Ch'an Buddhism had turned the Chinese product toward humanism and simplification, and temporarily at least toward realism. Ch'an or Zen Buddhism in Japan brought in a gradual drift toward lifelikeness in portraiture, and (from the Taoist element especially) an ease in both pose of subject and methods of cutting or modeling. In later centuries, as sculpture entered fields other than the religious, some of the stiffer poses came back into fashion. At the same time the craftsmanship began a centuries-long decline, ending in a rather slick sort of stylization.

The earliest two historic periods, the Suiko and the Nara, were comprised in slightly less than two hundred and fifty years and produced the best of which Japanese artists were capable. The Suiko period ended within a century, in A.D. 646. In the late seventh century art flowered anew, in what is known as the Nara period, which was to last to 794. The following period is known as the Heian, from a word meaning "Capital of Peace," referring to the new capital, Kyoto. Despite successful repetitions of traditional types, the time is somehow an unexciting one. New circumstances should have given rise to fresh modes of expression. Buddhism ex-

panded with the rise of mystical sects, and the court and nobles strove to lift the arts to new creative levels. But the golden age was past. Sculpture lost its simplicity and something of its dignity, although it acquired a liveliness and outward decorative grace.

The latter part of the Heian period (or Heian II, as it is sometimes referred to) was also called the Fujiwara period. The Kamakura period (from 1186 to 1392) brought about a return to older standards. Curiously enough, the destruction of some of the great Buddhist temples at Nara occasioned the renaissance. Leading sculptors were brought together and were set the task of producing images "as fine as the ones destroyed." It turned out that they did not possess the genius necessary to the conception and execution of statues as magnificent as the *Buddhas* and *Bodhisattvas* of the eighth century, but they did develop a school of woodcarving that excelled in realistic portraiture.

After the Kamakura period came the Muromachi, from 1392 to 1568, then the Momoyama to 1615, and the Yedo to 1867. But by any profound standard the history of Japanese sculpture had all but ended in the thirteenth or at latest the fourteenth century. The late Kamakura portraits are interesting and sometimes illustrate an extraordinary combination of realism and schematization. Zen Buddhism retained none of the early tendency to suppress personality, and encouraged the production of images of saints and priests. From portraying religious characters the sculptors began to commemorate noblemen and warriors.

From the seventeenth to the early twentieth century monumental sculpture is scarcely mentioned in serious books about the art, and Japanese sculpture is known to most Western collectors and students in such small objects as masks, netsuke, and sword guards, and in tiny ivory carvings. The larger masterpieces, with rare exceptions, are to be seen only in the Buddhist monasteries, or occasionally at one of the three national museums at Nara, Kyoto, or Tokyo. Government-approved publications compile the list and dates of the historical periods thus:

Asuka period (or Suiko)	552–646
Nara period	646–794
Heian period I	794–897
Heian period II (sometimes Fujiwara)	897–1186
Kamakura period	1186–1392
Muromachi period	1392–1568
Momoyama period	1568–1615
Yedo period	1615–1867
Modern period	1867–to date

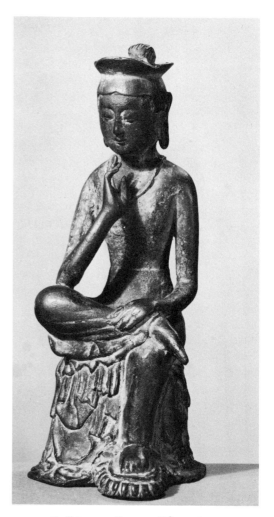

Bodhisattva. Bronze. 7th century. Sankoku, Korea. *Fogg Museum of Art*

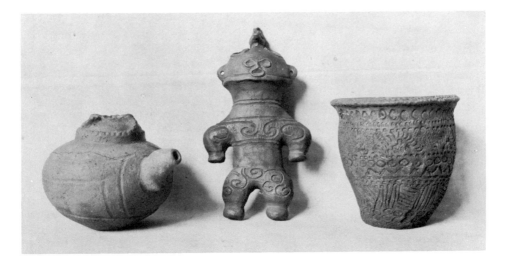

II

THE Korea of the sixth century was successful in art in all the fields cultivated by the Chinese of the era of the Six Dynasties. There are some clay pieces from the fourth or fifth century, of which the wine vessel in the form of a warrior on horseback, at the head of this chapter, is an amusing example. But the commoner type of early Korean sculpture is so similar to the Chinese, as in the case of the bronze *Bodhisattva* opposite, that only specialists are able to name the origin immediately.

All the types of statue common to the Buddhist centers of China under the Wei emperors are duplicated in the products of the Korean states. The Buddha and his disciples are found in every size and form, from colossal stone figures to diminutive bronzes. The tomb guardians, both human and animal, abound, and relief sculpture is varied and spirited.

The design of pagodas in Korea was original and might be considered as a sort of abstract sculpture. A native development occurred also in the memorial lanterns and tombstones, which take simple form, then blossom in incidental ornament as distinctive as that found on the Celtic crosses of Ireland. Most worthy of attention, however, is a series of large figures cut on stone slabs for wall coverings. Those at the Temple of Sok-kul-am, near Kyungju in South Korea, which is part cave-shrine and part architectural structure, form one of the noblest of the many Buddhist art meccas in the Far East. Like the Chinese models (and similarly influenced by Greco-Indian sculpture), these half-round figures, ascribed to A.D. 752, have dignity, amplitude, and serenity. They have also a special rounded grace which is innately Korean.

Of the Neolithic Jomon culture in Japan, the figure at the Musée Guimet, Paris, shown between primitively decorated jars, is simpler than most and is one of the more pleasing pre-Buddhist Jomon products.

Teapot; figure; vase. Clay. Japanese, Jomon culture. *Musée Guimet.* (*Photo Giraudon*)

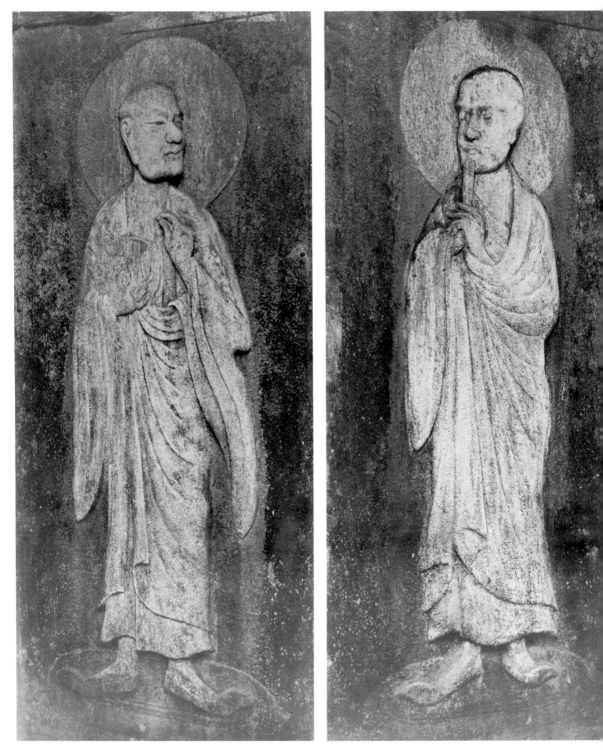

Buddhist figures. Stone. A.D. 752. Temple of Sok-kul-am, South Korea.
(*Photos courtesy National Museum, Seoul*)

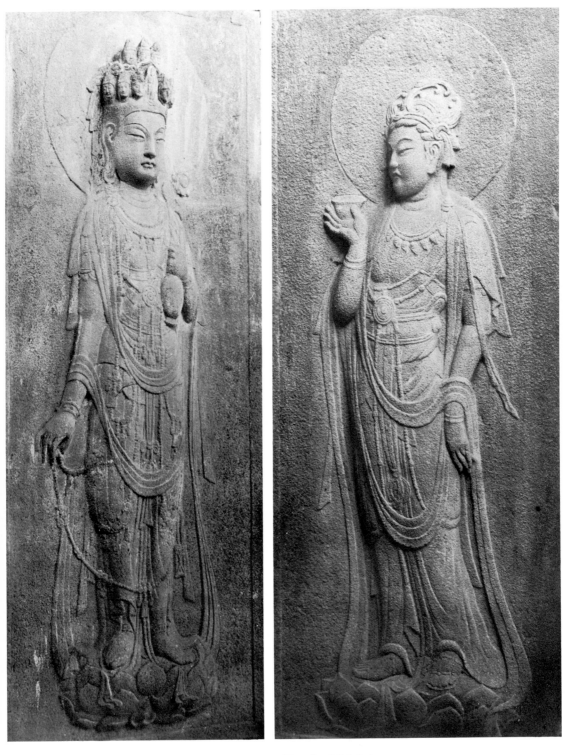

Bodhisattvas. Stone. Temple of Sok-kul-am.
(*Photos courtesy National Museum, Seoul*)

The *Horse* of the Haniwa primitive or folk art shows surprising intuitional graces and an amusing mixture of formal short-cutting and realistic detailing.

The bronze *Buddha* from Seoul, a Korean image, is in an idiom reminiscent of the Wei carvings of the Lung Men Caves of the sixth century and of the Chinese bronze statuettes of the sixth and seventh centuries. But with the wooden *Buddha* of the early seventh century from the Chuguji Temple there is a suggestion of a native Japanese modification of the imported style. Simplification and clarity were to characterize Japanese work for several centuries following. And, indeed, the native sculptors were already setting out upon a course that would lead them to a distinctive and magnificent national achievement. The very fine *Buddha* in wood, shown

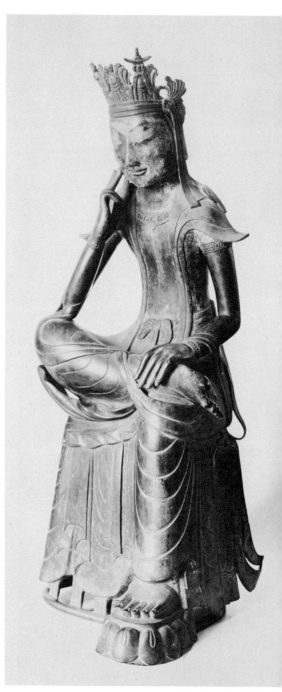

Buddha. Bronze, gilded. Korean, Period of the Three Kingdoms, 7th century. *National Museum, Seoul*

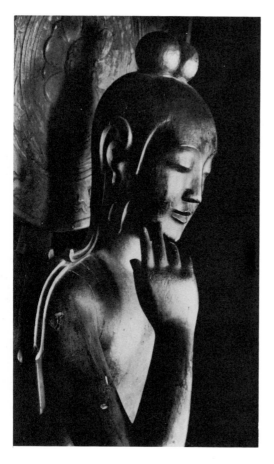

Buddha, detail. Wood. 7th century. *Chuguji Temple, Nara*

here only in detail, is said to have been carved in Japan by Korean sculptors. It was one of the images produced under the patronage of Prince Shotoku, in whose private chapel it stood. The *Buddha* in bronze, below, indicates the direct descent of methods (most notably the scalloped draperies) which are to be seen, less regularized, in the Chinese *Buddhas* of the Northern Wei period. It is also associated with the memory of Prince Shotoku. It bears a date, 625, and is the work of the priest-sculptor Tori, a native artist in the second generation from an immigrant Korean carver.

As early as the first half of the seventh century a national genius different from the Chinese was indicated especially in sculpture in wood. The Japanese craftsmen valued the grain of the wood and the marks of the knife. The *Buddha* at Kyoto is cut with the directness and smoothness of stylization proper to the native cypress used. Not only the technique of the carving but the facial type and a way of slenderizing the figure, fashionable

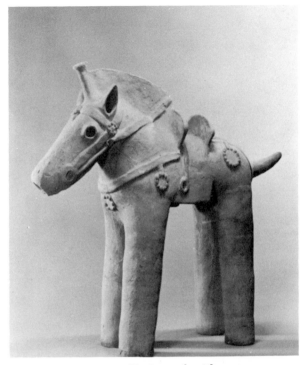

Horse. Clay. Japanese, Haniwa style, 6th century. (*Courtesy Society for International Cultural Relations, Tokyo*)

Buddha. Bronze. Japanese, early 7th century. *Horiuji Temple, Nara*

Buddha, detail. Wood. 7th century. *Koryuji Temple, Kyoto*

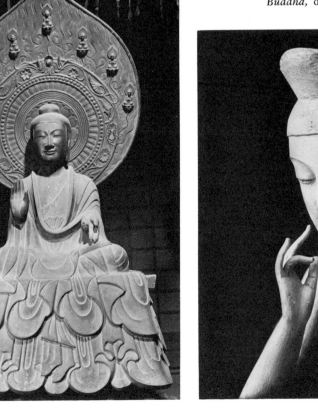

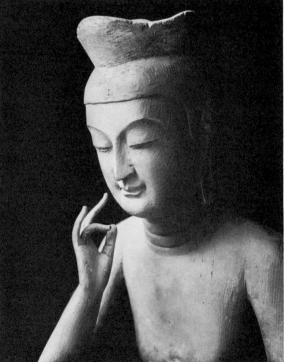

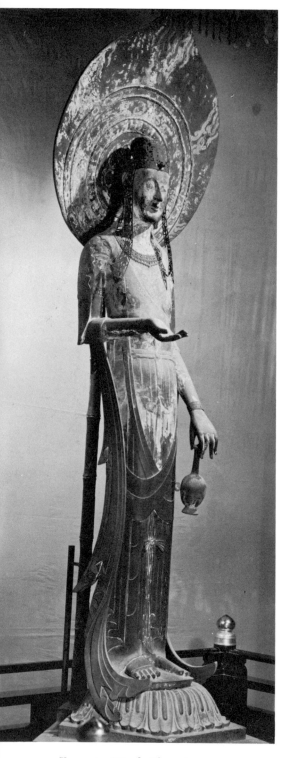

Kwannon. Wood. 7th century.
Horiuji Temple, Nara

for a considerable period after, proclaim that the statue belongs to a national expression different from any other.

The *Kwannon* from the Horiuji Temple (corresponding to the Chinese Kuan-Yin) is a more extreme example of the slenderized style. Except for the nimbus, there is adherence to the reticent carving and exquisite formalization that best represent the Japanese achievement. The flattened detail and the repeated curvilinear rhythms are beautifully manipulated, without detracting from the sculptural "set" of the piece.

There are also seventh-century masterpieces in bronze which range in size from statuettes to the colossal. The Buddhist statuettes are comparable with the Korean and Chinese bronzes of the same period; but in oversize metal figures the Japanese achieved a distinctive variation. The detail shown, of Yakushi, the god of healing (or the healing Buddha), central figure of a bronze triad about twice life-size, is modeled with perfect mastery of the bronze medium.

God of Healing, detail. Bronze, colossal.
Early Nara period. *Yakushiji Temple, Nara*

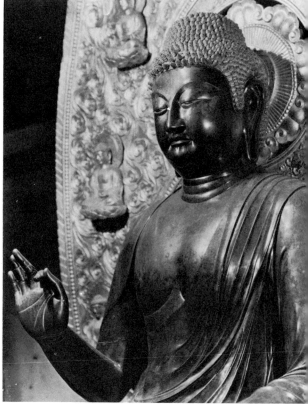

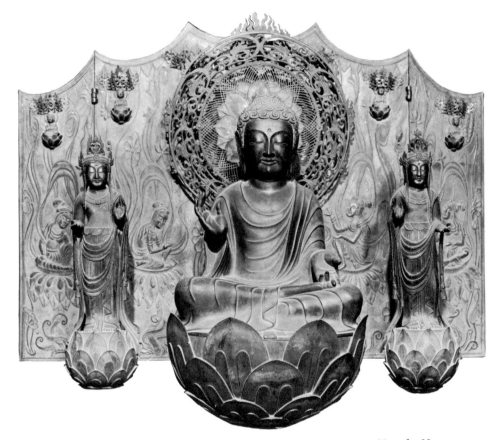

Amida Triad. Buddhist shrine. Bronze. Late 7th century. *Horiuji Temple, Nara*

(The mastery is so evident that some authorities assert that the craftsmen involved must have come from China or Korea, countries owning a longer tradition of metal casting.) The massing, the smoothness of surface, the avoidance of undercutting, all indicate comprehension of the special possibilities of bronze-casting as a sculptural method. It is a work of the late seventh century.

By comparison a miniature work, the head of the central figure in the *Amida Triad* next shown is equally a masterwork of simplicity and subtlety. The whole piece, whether the trinity of free-standing figures or the exquisitely graceful complex of reliefs on the shield at the back, is a miracle of metalwork and a prime example of Oriental mastery of abundant design.

After the late seventh century China was under the influence of the T'ang emperors, and again there was interchange of ideas between China and Japan. The *God Protector* in unbaked clay (page 238) may conceivably indicate renewed discipleship to the Chinese masters. As written language, education, manners, and dress were changed, so the Chinese style in sculpture was re-embraced.

The clay medium has seldom been employed so skillfully in large images as in the case of this over-life-size figure. The crisp treatment of the draperies is especially notable. The body is built up on a framework of wood, and there is an admixture of very small amounts of other substances: straw fiber, paper fiber, and mica, with the clay.

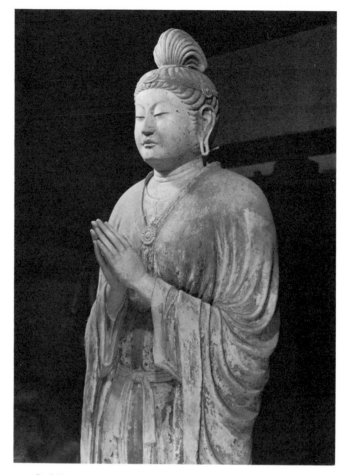

God Protector. Clay. 8th century. *Todaiji Temple, Nara*

Guardian King, detail. Clay. 8th century.
Todaiji Temple, Nara

Guardian, detail. Clay. 8th century.
Shinya-Kushiji Temple, Nara

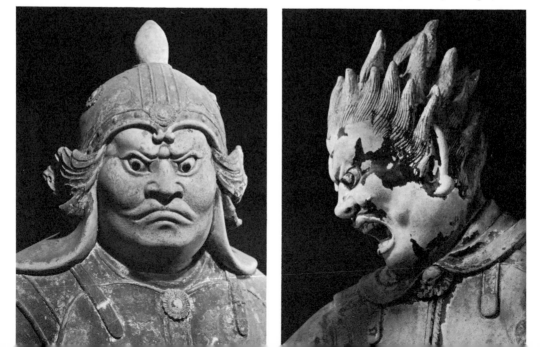

The seated clay *Bodhisattva* (at the right) is even more obviously a reflective work, inspired by the Chinese artists of T'ang. Yet the Japanese at this time, after three or four generations of practice, had as patently developed their own methods. Nowhere is modeling in clay in near-life-size and over-life-size, and in dignified mien, more beautifully exemplified than in this and the illustration facing it. Originally the second statue was finished in porcelain clay and painted, but the colors have worn off in the more than a thousand years since its creation.

The Japanese originality of statement is seen too in the many series of guardians set up in temples. The Japanese guardian, unlike the common tomb guardian of the Chinese, is usually an image of one of the Protectors of the Buddhist Faith or Kings of Heaven. The same frightening aspect is characteristic of both groups. The Japanese were perhaps the greater masters in this ogreish mode. Seldom has the human visage been sculptured into so many fearsome but engaging variations. There is a breath of realism here, too, that is seldom felt in the *Buddhas* and *Bodhisattvas*.

Naturalism is also seen in the delineations of the legendary disciples, as in the eighth-century lacquer *Disciple of Buddha* shown.

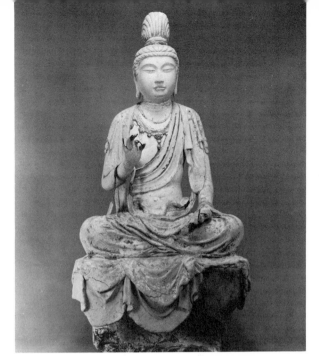

Bodhisattva. Clay. Early 8th century.
Horiuji Temple, Nara

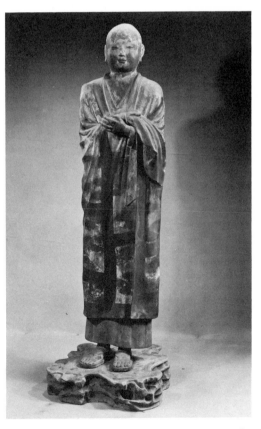

Disciple of Buddha. Lacquer. Late Nara period,
8th century. *Kofukuji Temple, Nara*

Left: The Priest Ganjin, detail. Lacquer. Nara
period, 8th century. *Toshodaiji Temple, Nara*

There are many of these disciples, the face of each so individualized that they would appear to be portraits from life. And indeed portrait statues of the greatest Japanese teachers of the Buddhist faith survive, from this and from later periods (though sometimes they were carved a century or two after the subject had died).

But it is the dignity, the solemnity, the quiet power—and some unexplainable sculptural revelation of inner majesty and other-worldliness—that lifts the statues of the divinities above all other categories. Something of the majesty and remoteness can be seen in the lacquer *Kwannon* from the Shorinji Temple at Nara. Perhaps a little more artificial, in the repeated circlings of the draperies, than the comparable works of the Chinese,

the statue can nevertheless rank with the masterpieces of T'ang. It is known, on account of the headdress, as the *Eleven-headed Kwannon*. (A miniature head at the very top is cut off in the photograph shown, without loss to the composition as a whole.)

Although the golden age of Japanese sculpture may be said to have ended by the opening of the ninth century, there were enough repetitions of the masterpieces of the seventh and eighth centuries to leaven the mass of reflective and "light" works. The lacquer *Buddha* at the Metropolitan Museum, New York, is one of the exceptional monuments—majestic, remote, serene.

Buddha. Lacquer.
Metropolitan Museum of Art

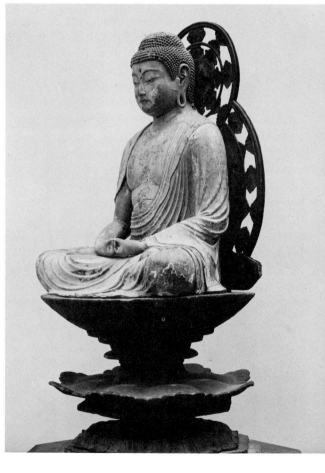

Kwannon. Lacquer, over life size.
8th century.
Shorinji Temple, Nara

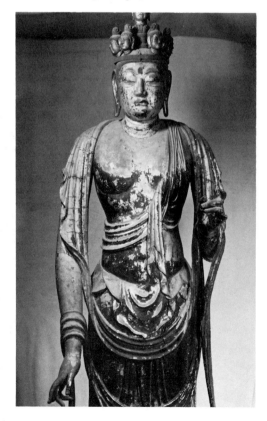

A truer expression of the taste of the time is in a famous series of apsaras or heavenly maidens and flying angels; in the decorative reliefs adorning architecture; and in elaboration of headdress or aureoles; not to speak of the semi-sculptural picturing on lacquer boxes and the engraving on mirrors. In the Byodo-in Temple at Uji in Kyoto there are fifty of the apsaras and angels, figures with flowing draperies, clouds, etc., apparently floating before the walls, enclosing a colossal gilded Buddha or entwined in the decorative aureole. They are, in a small way, charming and agreeable, but far from profound. A good deal of the art of the Heian period has, in fact, an aspect reminiscent of baroque. The *Heavenly Musician* illustrated is instead a relief, from a panel in a famous octagonal bronze lantern that still stands before the Great Buddha Hall at Todaiji. The detail shows one of the six heavenly musicians as they are wrought on pierced bronze insets.

The sculptors Unkei and Kaikei are especially known for portraiture. The portraits illustrated demonstrate the naturalness of aspect that was an ideal in the Kamakura period, which opened in the late twelfth century. The study of *An Old Ascetic* is an exceptional character piece, painstakingly realistic and full of the feeling of old age and asceticism. It may be as late as midcentury and it is ascribed to a follower of Unkei, possibly Tankei. Unkei himself,

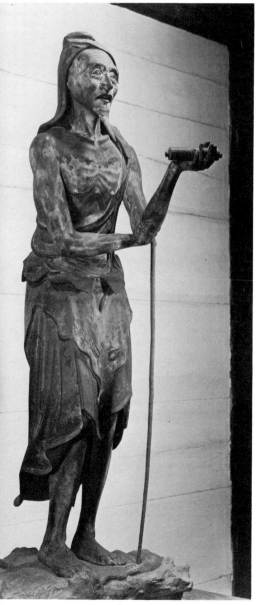

An Old Ascetic. Wood. Early 13th century.
Sanjusangendo Temple, Kyoto

Heavenly Musician, detail of lantern panel.
Bronze. 8th century. *Todaiji Temple, Nara.*
(*Photo Asuka-en, Nara*)

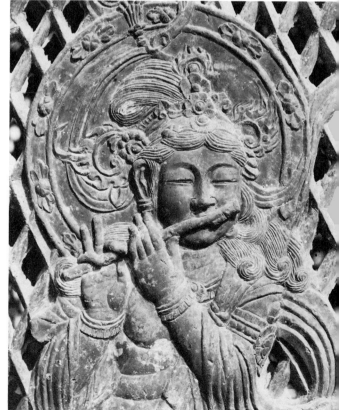

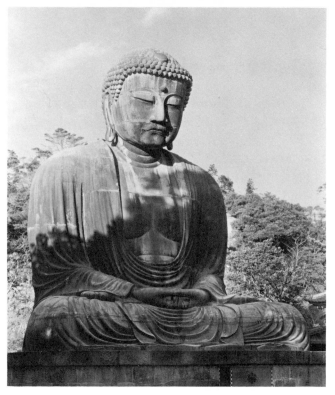

The Great Buddha. Bronze. 13th century. Kamakura

Shigefusa. Wood. 14th century.
Meigetsuin Temple, Kamakura

Guardian with Lantern. Wood. By Koben. A.D. 1215.
Kofukuji Temple, Nara

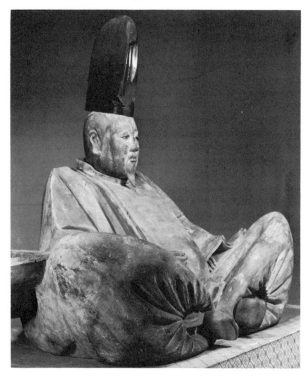

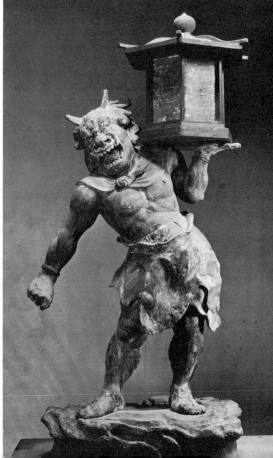

whom the Japanese revere almost as a Michelangelo, carved the portrait statue of the Buddhist disciple shown at right, the great Indian Asanga, whose writings did much to spread the gospel of Buddha in Japan. Exact portraiture was then an aim, and Unkei achieved a living, believable figure despite the lapse of centuries since Asanga's time.

It was a son of Unkei, named Koben, who carved two *Guardians with Lanterns* for the temple in which the statue of Asanga stands. The one shown is typical of religious figuring of the time: more human, more natural and understandable than the older images had been—even where the subject was mythical. There is great vigor here, and complete knowledge of human anatomy and posture. Whether such a natural demon equals the more restrained and majestic ones of the eighth century is open to question.

The Great Buddha of Kamakura was erected in the thirteenth century. The colossal figure, almost fifty feet in height, has long since been deprived by the elements of its protecting temple; it stands silent and majestic, a lasting reminder of the solemnity, peace, and illumination of the Buddhist faith. Conceived as a monument honoring the Buddha but at the same time to the glory of the community of Kamakura, *The Great Buddha* recaptures the largeness and the spiritual remoteness of sculpture of an earlier time.

The portrait of Shigefusa, a feudal lord who lived in the thirteenth century, was carved after his death. Sculpturally the representation of the stiff brocaded robes is awkward—this was the carver's counterpart of the ceremonial portrait-painting of the time —but the face is a marvel of character disclosure. The sheer cutting of the upper body makes an excellent foil to the subtle facial play; but this sort of simplification was to lead to a rather slick schematization, as illustrated in many later portraits.

The *Amida Buddha* from the fifteenth century is inserted as evidence that religious sculpture was continuously produced, and

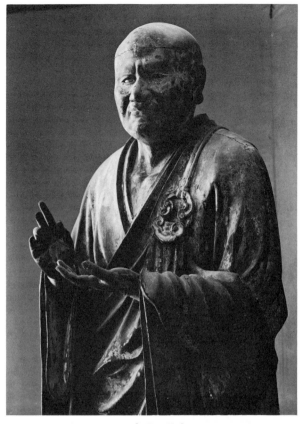

Asanga. Wood. By Unkei. A.D. 1208.
Kofukuji Temple, Nara

Amida Buddha. Bronze. 15th century.
Detroit Institute of Arts

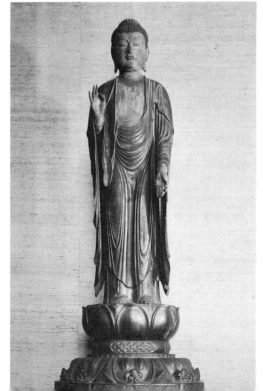

that occasionally the old ideals of an impersonal, formalized, and spiritually compelling art persisted. Nevertheless Japanese sculpture had retrogressed—as did the Chinese and Hindu from the fifteenth to the nineteenth century—so that shallowly appealing works, such as cleverly streamlined portraits, are the outstanding exhibits from five hundred years of production.

For the rest, the story is chiefly of small objects: the masks made for use in the no dramas, often characterful and carved with charming fluency and finish; the sword guards bearing decorative patterns or anecdotal bits of relief, even landscapes; and the netsuke, little carved images in wood or ivory that terminated the cords closing bags or pouches, cleverly reproducing animals, flowers, human beings, and other objects in daily life or legend.

In ivory the adroit Japanese craftsmen made innumerable miniature statues and reliefs, often exquisitely carved but almost never important *objets d'art*. A great deal of their best sculptural effort, in recent centuries, has gone into decorative wood carving in connection with architecture. But nothing has served to revive the creative spirit that flourished in the Suiko, Nara, and Kamakura eras.

Masks; sword guards; ornaments. Wood; metal; metal with inlays.
16th-18th centuries; recent. *Victoria and Albert Museum*

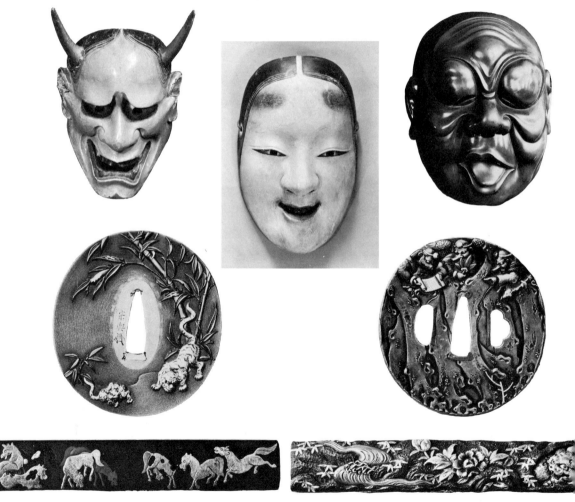

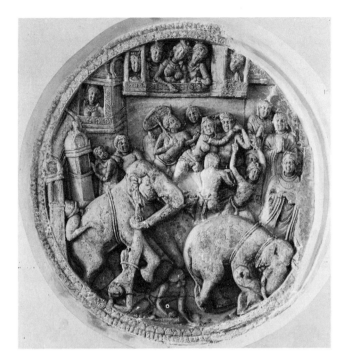

10: India:

The Maturing of the Opulent Oriental Style

I

SCULPTURE in India is one of the media for story-telling, and its theme is overwhelmingly religious. The densely populated land teems with temples and shrines, and the buildings are encrusted with sculptural works, which form a vast picturebook of popular religious tales. The Hindus were old in spiritual wisdom when the Buddha Gautama came in the sixth century B.C., but it was the Buddhist faith that was destined to inspire mankind's noblest achievement in the realm of devotional art in stone.

Technically the story begins nearly two thousand years earlier, for excavations at Mohenjo-Daro and Chanhu-Daro in the Sind district of the valley of the Indus and at Harappa in the Punjab have uncovered clay figurines and seals which are important in that they indicate an advanced independent culture of the Indus Valley by the year 2500 B.C. Because of the profusion of seals, it would seem possible that the Sumerians who pushed into Mesopotamia possessed a common ancestry with the people of the Indus.

Miracle of the Drunken Elephant. Medallion. Stone. 2nd century A.D. Amaravati.
Government Museum, Madras

India includes minorities of half a dozen ethnic strains, from Negroid and Mongoloid to Dravidian and Aryan types, but the central ruling element is commonly accepted as Aryo-Dravidian. The Dravidians were dominant when the Indo-European Aryans, related to Persians and Greeks, poured down through the northwestern passes and pressed the Dravidians into the south. The Aryans established themselves as the governing power, shaped the common religion, and made their Brahmins the only priests; they developed a basically Aryan language—in its literary form, Sanskrit—as first among the tongues of India. To protect their superiority, as they saw it, the invaders established the caste system that persisted down to the twentieth century. Neither upheavals caused by the Hun invasions of the fifth and sixth centuries and the Moslem invasions that lasted over many centuries, especially the eleventh and twelfth, nor again the conquests by the Moguls in the fifteenth and sixteenth centuries, were able to destroy the caste system. In a country with a loose confederation of principalities—a mosaic of near-independent states—invasions and conquests before the British administration seldom involved more than a segment of the land and a fraction of the people.

Aside from the Indus Valley culture, the earliest history of sculpture in India tells of outside influences. When Alexander invaded in the fourth century B.C. he left part of his army as settlers and administrators in the Ghandaran section of the country. Three or four centuries later a development of classic sculpture occurred where Buddhism met surviving Greek influence or, as is now believed, encountered new influences from Rome. Reflections of Greek realism and clean Greek cutting are notable, especially in the free-standing figures of the Buddha, already known in several parts of India and in Ceylon by A.D. 200.

In the third century B.C. Asoka proclaimed Buddhism as the state religion of India and commemorated the occasion by erecting a great number of stone columns upon which his edicts were inscribed. These are the first monuments that can be dated. The crowning sculpture would appear to have had the simplicity and elegance of Persian work, although the pillars had native modifications.

During the first half of the second century B.C., however, the indigenous idioms began to reappear, and from then on a truly Indian art flourished. An exuberant type of art developed within the Hindu religion. One of the noblest faiths, it encourages asceticism and mystic contemplation and promises rewards of harmony and peace to those wise ones who progress beyond the dance of the senses, and at the same time it recognizes the naturalness of indulgence in the sensual world. Much of the sculpture on the walls of the Temple of the Sun at Konarak in the district of Orissa is erotic and would not be tolerated by religious or civic authorities in the West, and such scenes are occasionally encountered elsewhere in India on religious shrines and temples. This decorative style is thought to have a Dravidian source. The supposition is that these early inhabitants had developed a "people's art" and that when Aryan officials of a master caste initiated large sculptural projects as at Barhut and Sanchi, they had no choice but to call in people's sculptors. Thus a lush and tropical element came to be incorporated in the first stupas or architectural mounds enshrining relics of the Buddha.

The gateways at Sanchi especially seem to be in the style of an art for the masses. Thenceforward the innumerable temples were embellished with figures, panel groups, and festoons of foliation. A particular art form in ancient India was cliff sculpture, a rocky outcrop carved into a thousand figures, or the rock-cut temple, with rooms and passages carved out and architectural pillars and walls shaped from the monolithic mass.

When the stupa at Barhut and the great stupa at Sanchi were built and decorated, though the illustrated stories were Buddhist, no image of the Buddha appeared. A sym-

Sculptured gateway. Stone. C. 150 B.C. Sanchi.
(*Photo Goloubev, courtesy Musée Guimet*)

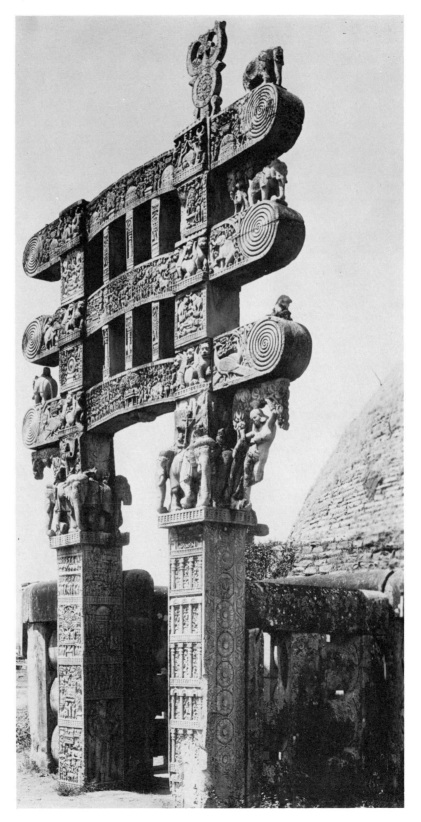

bol sufficed: the tree appeared, instead of the Master, in the episode of the enlightenment; the wheel in the account of the first sermon; or a lotus blossom; or footprints; or a stupa. But gradually the Buddha's injunction against the worship of images was forgotten, and his own likeness became the central motive. Whether the image was introduced first by the artists of Mathura or Sarnath, or of some other center but faintly touched by Hellenism, or by the sculptors of Gandhara, seems still undetermined, though the date probably was the first century of the Christian era.

Elie Faure eloquently described the Indian temples and the sculptural style that derived from the tropical South in his book *Histoire de l'Art*: "Everything may serve to carry a statue, everything may swell into a figure—the capitals, the pediments, the columns, the upper stages of the pyramids, the steps, the balustrades, the banisters of stairways. Formidable groups rise and fall—rearing horses, warriors, human beings in clusters like grapes, eruptions of bodies piled one over the other, trunks and branches that are alive, crowds sculptured by a single movement as if spouting from one matrix. . . ."

Thus the perceptive French historian summarized "the orgy of ornament" that is one part of the Indian heritage in sculpture. He knew but did not so tellingly dwell upon the soberer part, which drew some of its clarity and simplicity from the sculptors of the Gandharan school.

Because of sectional differences, and frequent dynastic changes, a complete chronology would be more confusing than helpful.

The following is therefore a shortened and not quite complete table of periods of Indian history.

Prehistoric period: Down to c. 3000 B.C. Pre-Dravidian and Dravidian peoples.

Indus Valley Culture: Possibly as early as Sumerian and Egyptian beginnings, but more conservatively dated 2500–1500 B.C. Excavations at Mohenjo-Daro, Harappa, and recently at Kalibangan.

Aryans entered India, probably between 2000 and 1500 B.C., to become the dominating element of the population.

Pre-Maurya period: 642–322 B.C. Most notable date is 327–323 B.C., when Alexander the Great settled his Macedonian and Greek countrymen in Gandhara (which is mostly in Afghanistan) and the northwest area of India.

Maurya period: 320–185 B.C.

Andhra and Indo-Parthian period: Approximately 185 B.C. to A.D. 320.

Gupta period: A.D. 320–600.

Medieval period and Decline: A.D. 600 to the seventeenth century.

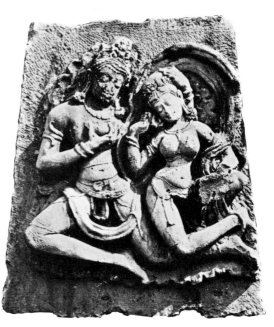

Flying Figures. Stone. 6th century. *Aihole*

II

INDIAN sculpture is nowhere surpassed in sensuous charm and opulence. There are diverse major styles, but the oldest relics are of a civilization scantily represented by works of art. The Indus Valley culture yields hardly more than a store of well-designed seals, a very few battered statuettes in stone, and the usual commonplace figurines in clay. The seals, of which hundreds have been found, are carved in ivory or stone, or (more rarely) modeled in terra-cotta. The examples illustrated, from the excavations at Mohenjo-Daro, are in steatite, a soft stone. The commonest type of design shows an animal on a more or less squared field, with a line of hieroglyphs above. In general the seals indicate an admirable sense of style and a competent craftsmanship.

It is likely that many significant relics of the time—late in the third millennium before Christ—still lie buried in the Indus Valley cities. The torso of a *Dancing God* is the best known of the few stone statuettes so far dis-

covered. It is distinguished by great sculptural vigor, along with subtle feeling for mass and contour. Drilled holes are believed to be sockets for affixing of the now missing head and limbs.

The first datable monuments are the Buddhist commemorative pillars of the third century B.C., bearing the edicts of the Emperor Asoka. The beautifully formalized animals, clear and bold, are perfectly fitted to their decorative purpose. The six surviving Asokan columns are monoliths, forty to fifty feet in height, each with a decorated capital and abacus surmounted by a single animal figure, or, as in the first of the illustrations, a "multiple animal." The multiple lion is from the pillar at Sarnath, where the Buddha first preached. The bull is from a pillar originally at Rampurva in Bihar.

The details of relief medallions illustrated, from the Buddhist stupa or shrine at Barhut, show the voluminous figures, the abundant detail, and the crowded composition which,

Seals. Stone. Indus Valley culture, 2500–1500 B.C. Mohenjo-Daro.
National Museum, New Delhi

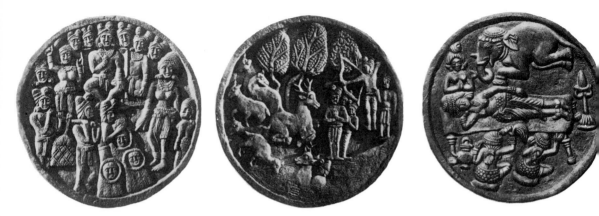

Relief medallions. Stone. C. 150 B.C. Stupa, Barhut. *Indian Museum, Calcutta.*
(*Photo Goloubev, courtesy Musée Guimet*)

Dancing God, statuette. Stone. 2400–2000 B.C. Harappa, Punjab. *National Museum, New Delhi*

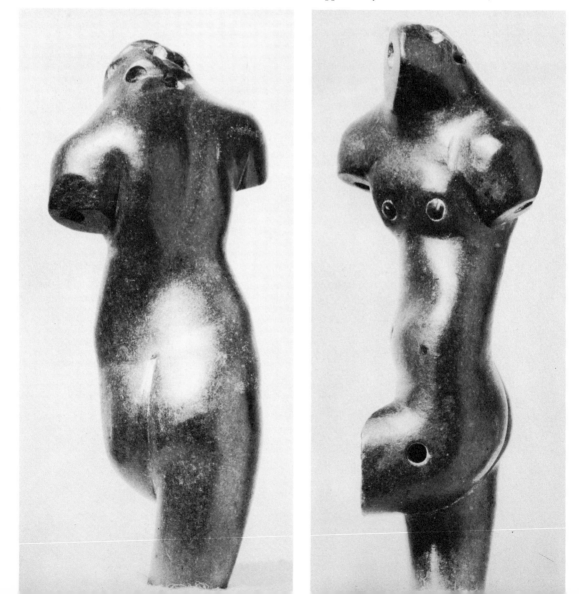

for centuries, were to characterize Indian relief sculpture. Other decorated structures indicate that the opulent mode had then been established over a wide area. The next outstanding exhibit, the gates and pillars at Sanchi, generally credited to the first century B.C., show the style matured and exuberantly manifested.

The vigor, the richness, the very volume of this outpouring of sculpture usually appears overpowering to Westerners. Almost any chosen panel illustrates a remarkable mastery of plastic design and extraordinary craftsmanship in cutting. This ornamental sculpture is more important than the structure it adorns. Supremely showy, at times extravagant and gaudy, it nevertheless maintains a standard of splendor and opulence

Asokan column and capital figures. Stone. 3rd century B.C. Sarnath (*above*); Rampurva (*below, right*); Lauriya Nandangarh. *Sarnath Museum; National Museum, New Delhi; in situ.* (*Photos by Archaeological Survey of India*)

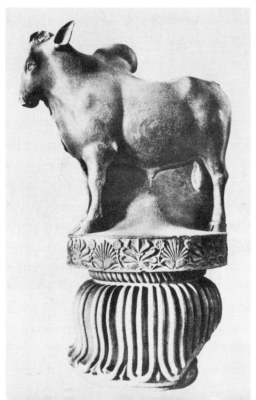

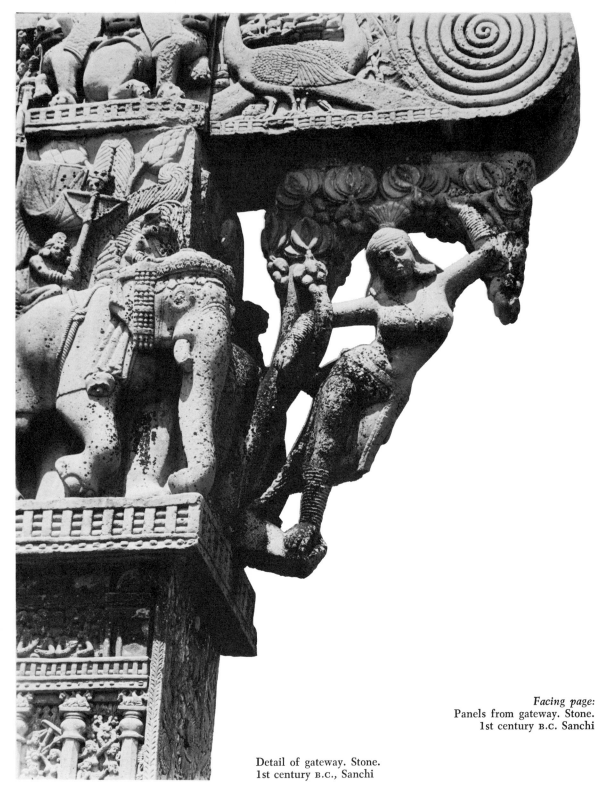

Facing page:
Panels from gateway. Stone.
1st century B.C. Sanchi

Detail of gateway. Stone.
1st century B.C., Sanchi

which is most characteristic of the Indian and Indonesian contribution to sculpture. In the nineteenth century Ruskin and, indeed, most authorities considered it so barbaric and so physical that it was relegated to the ethnological rather than the fine-arts museums. Now, when tastes are less rigidly Hellenic, the sensuous Oriental style is recognized as one of the major achievements within the history of creative sculpture. There are innumerable figures in the panel groups, or on pillars, that show how the female body became standardized in early Indian art, small of waist, generously full in breast and thigh. The fine torso at the Museum of Fine Arts in Boston, though somewhat battered, may illustrate the point better than the more commonly reproduced pillar nymphs from Mathura.

The Indian style may have been fully formed in the Maurya period but the flood of typical products came only in the Andhra period, to which belong the masterpieces of Sanchi and the relief from Amaravati shown at the beginning of this chapter (though the sculpture of the Barhut stupa and some parts at Sanchi are of earlier date).

The *Head* from Mathura, with its formalized curls and heavy features, is of the late Andhra or the succeeding Gupta period. It is in line with the voluminous composition and heavy richness of earlier native monuments. The chapter-opening illustration, a medallion from the stupa at Amaravati, illustrates the legend of the drunken elephant and is a relief that could not be mistaken as other than Indian. The railing of the stupa, and its gates, supported nearly 17,000 square feet of reliefs.

The stone figure of the Buddha now at Kansas City obviously departs from the style illustrated in the four preceding illustrations. It signals arrival at India's "second style," a style nobly serene and almost austere. It is Indian, with a suggestion of Western classicism in the handling of the draperies, and there is a general air of classic purity and restraint.

Torso of a Yaksi. Stone. 100–50 B.C. Sanchi.
Museum of Fine Arts, Boston

Head. Stone. 2nd–5th centuries. Mathura.
Victoria and Albert Museum

Similarly, the fourth-century *Head of Buddha* (at right) is different from anything so far illustrated from Middle Indian art. For three hundred years nothing had been produced in Europe as solidly sculptural and as subtly beautiful as this. But in the Buddhist East, whether in India or in Afghanistan, the Greek manner had been preserved, and continued from the time of Christ's birth to the tenth century. The serenity and calm, though classic, appear to be a Buddhist influence rather than Greek.

The two heads next shown are of types commonly found in the Gandharan country. They are so numerous in smaller size that it is inferred that molds were sometimes used for duplication. Sculptor-monks believed that merit was earned when images of the Buddha were multiplied. The great number of detached heads in the museums is partly ex-

Buddha. Stone. Gupta, 5th century.
Nelson Gallery–Atkins Museum, Kansas City

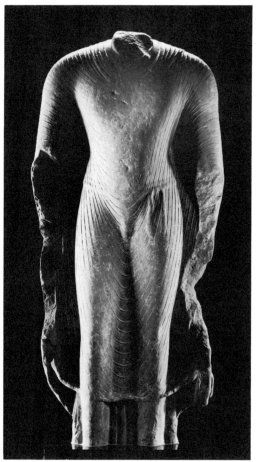

Head of Buddha. Stucco. Gandharan, 4th century. *City Art Museum, St. Louis*

Head of Buddha. Clay with gesso. 7th–10th centuries. Gandharan. *Metropolitan Museum of Art*

Head of Buddha. Stucco. 5th century. Hadda. *Victoria and Albert Museum*

Buddha. Stone. Gupta, 5th century.
Mathura Museum. (Courtesy Musée Guimet)

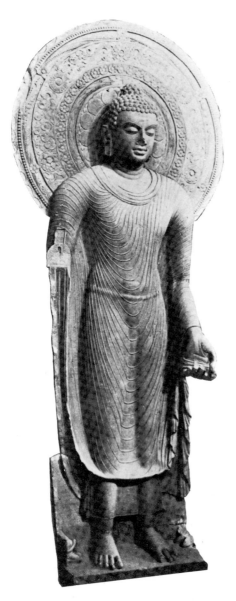

plained by the fact that bodies often were hastily modeled in impermanent materials and collapsed during the following centuries. (But some heads were obviously made for mounting on walls.)

There is a range of Gandharan heads that may be described as the Apollo type spiritualized and endowed with the serenity of the Buddha. Occasional pieces, such as the smiling *Head of a Devata*, indicate less serious intention.

The full-length *Buddha* in stone (at left) is unmistakably Indian, a representative work of the fifth century, in the Gupta period. The Western influence has been absorbed. A type of Buddha figure has been established, with incidental Hellenic features, which in its Cambodian, Javanese, Chinese, and Japanese interpretations provides the largest treasury of exalted statues devoted to a single subject. In India, at many centers, the parallel art of luxuriously abundant sculpture, of swelling forms and sinuous line, was being practiced; but the emergence of the solemn, awe-compelling Buddha was the main feature of the period. The figure, as it was absorbed into Indian iconography in the fifth century, has little left of the naturalistic Greek Apollo, though some of the minor sculptural idioms are marked by experts as Greco-Roman.

The early sculpture from India is almost entirely in stone, with the Gandharan exhibits exceptionally (but rarely) in stucco. But from the fifth century there were masterpieces in metal. The *Buddha* at Birmingham shows the simplification and calm dignity of the stone *Buddhas* of Sarnath translated into metal. This over-life-size figure is of copper, not bronze, and it is cast in two layers over a core of clay, sand, cinders, etc. Bronze figures in smaller size became more common.

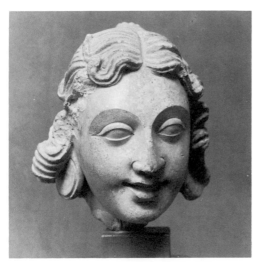

Head of a Devata. Stucco. 4th century. Tash Kurgan, Turkestan. *Museum of Fine Arts, Boston*

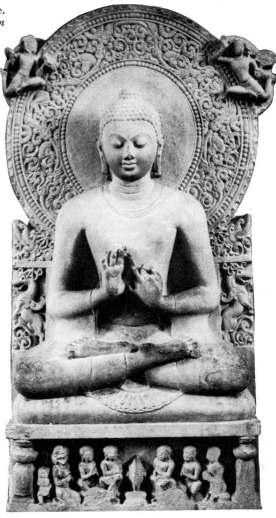

Buddha Delivering His First Sermon. Stone.
5th century. Sarnath. *Sarnath Museum*

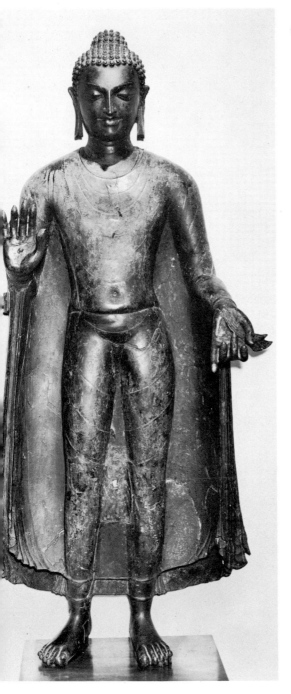

Buddha. Copper. 5th century. Bengal.
Birmingham Museum and Art Gallery, England

Asoka had established Buddhism as the national religion in India and sent missions to introduce the cult in neighboring and allied countries. His son visited Ceylon, and the island adopted Buddhism and has continued, unlike India, to be overwhelmingly Buddhist. The remains of the ancient capital, Anuradhapura, include many remarkable specimens of the several diverse styles of Indian sculpture. Among them a Sinhalese version of the austere Buddha type is most notable. The dignity and clarity of the standing figures are qualities transmitted in course of time to Cambodia and Java also.

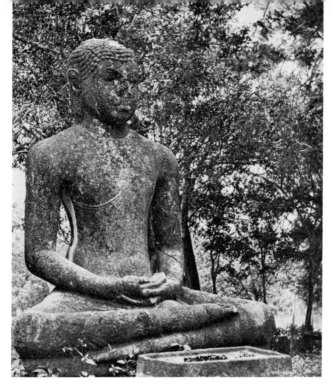

Buddha. Stone, colossal.
3rd or 4th century. Anuradhapura

The colossal seated *Buddha* of Anuradhapura is one of the most impressive monuments in the East. The simplicity, the bulk, and the plastic rhythms reinforce the human serenity and the cosmic stillness which the statue is designed to evoke in the worshiper. There are companion figures less well preserved at Anuradhapura; and many of the treasures of that ancient city have counterparts at the later capital, Polonnaruva.

Ceylon also developed the ample, decorated style, as is seen in such a fragment as the voluptuous *Couple* on a guardstone ending a balustrade at Anuradhapura. On page 248 is a relief of *Flying Figures* from a temple at Aihole in southern India, where similar figures illustrate the mature Gupta style. The sensuous note was dominant for many centuries in temple sculpture, whether Buddhist, Jainist, or Hindu.

Buddhist Figures. Stone, over life size. C. 200. Anuradhapura, Ceylon.
(*Photo courtesy Musée Guimet*)

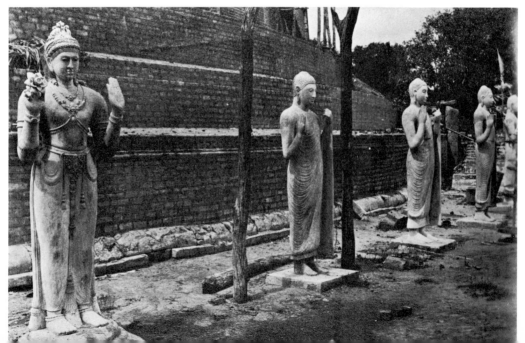

At Ellora in the Deccan the outstanding temple, the Kailasa, was hewn complete from a rock mass. The Hindu sculptures were carved in a mixed fashion, with dominating figures in the round, and some engaged figures and areas in low relief. The scene illustrated, *Siva and Parvati on the Mountain, with Ravana the Earth-Shaker Below*, is typical of the intensely vigorous and prodigally abundant compositions. There are both Buddhist and Jainist rock-cut shrines at Ellora, profusely sculptured, and at Badami there are cave temples with similarly sumptuous rupestrian art.

The Siva Temple at Elephanta is a cave shrine famous for its splendid reliefs and for the *Three-Headed Mahadeva*. The cave temple as an entity can be studied as early as the third century B.C., but in the earliest examples the display of sculpture is comparatively meager.

At the edge of a lake near Anuradhapura the sculptors of Ceylon transformed a huge mass of rock into a devotional sculptured composition. But the most amazing example of such carving is on a cliff, or rather an upthrust rock wall, in the complex of monolithic temples and cave shrines at Mamallapuram in eastern South India. The rock mass, some thirty feet high and one hundred feet long, was carved with hundreds of figures of gods, men, nymphs, and animals, to illustrate the Hindu legend of the Descent of the Ganges. (See following page.)

The life-size elephants afford some focus in the confusion of figures, but the effect is disordered. However, many of the separate groups in relief, and certain processions of figures, are effective and even masterly. The animals are especially charming, more naturalistic than is usual in India, but sheerly carved, with perfect understanding of the

Couple. Stone. 5th–8th centuries. Anuradhapura. (*Photo Goloubev, courtesy Musée Guimet*)

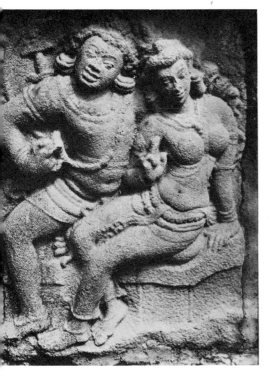

Siva and Parvati on the Mountain, with Ravana the Earth-Shaker. Mid-eighth century. Rock-cut Kailasa Temple, Ellora

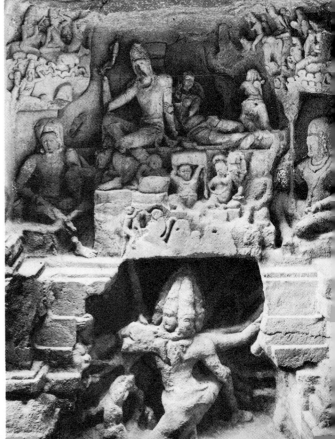

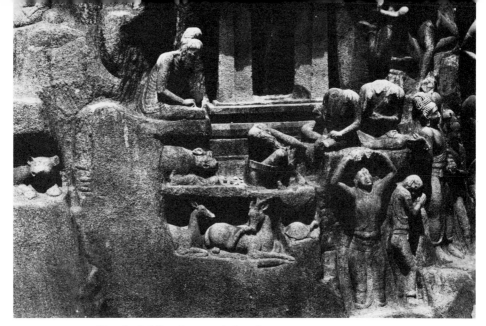

Detail of cliff sculpture. Early 7th century. Mamallapuram

The Descent of the Ganges, detail, cliff sculpture.
Early 7th century. Mamallapuram. (*Courtesy Musée Guimet*)

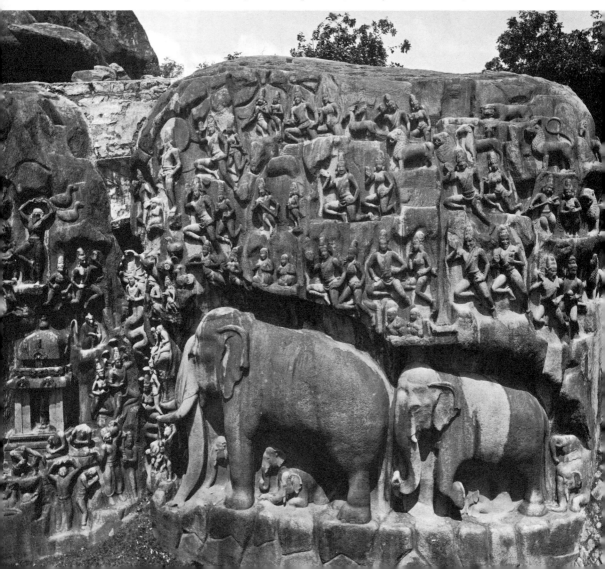

lithic medium—as may be seen in the detail of the two deer and the tortoise.

The detailed picture of the Kandarya Mahadeva Temple at Khajuraho serves to illustrate how the unruly elements in the sculpture could be brought into subjection to architecture. Building logic had almost disappeared, but the inset traceried panels and the half-contained figures are unusually interesting. (See following page.)

Back in the fifth century, the beautifully simplified, rather severe style of Buddha image had become fairly common among bronze statuettes. The example at Boston (page 263, lower illustration) is typical. The larger *Buddha* beside it was found in Indo-China but is identified by scholars as a fifth- or sixth-century product of Indian

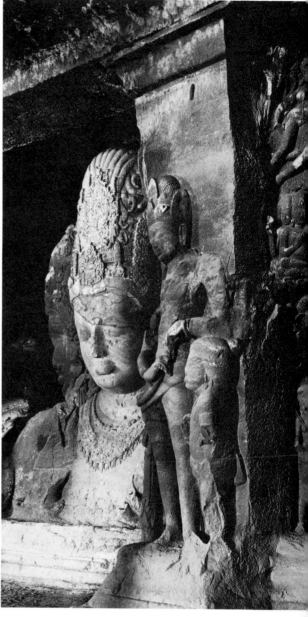

Three-Headed Mahadeva. 8th century.
Rock-cut temple at Elephanta.
(*Courtesy Musée Guimet*)

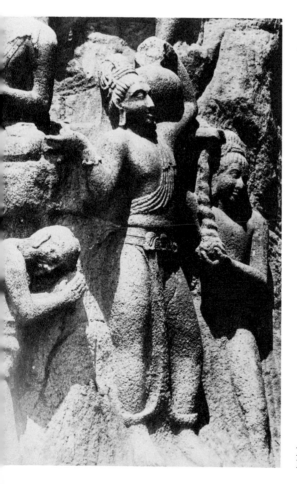

Detail of cliff sculpture.
Mamallapuram

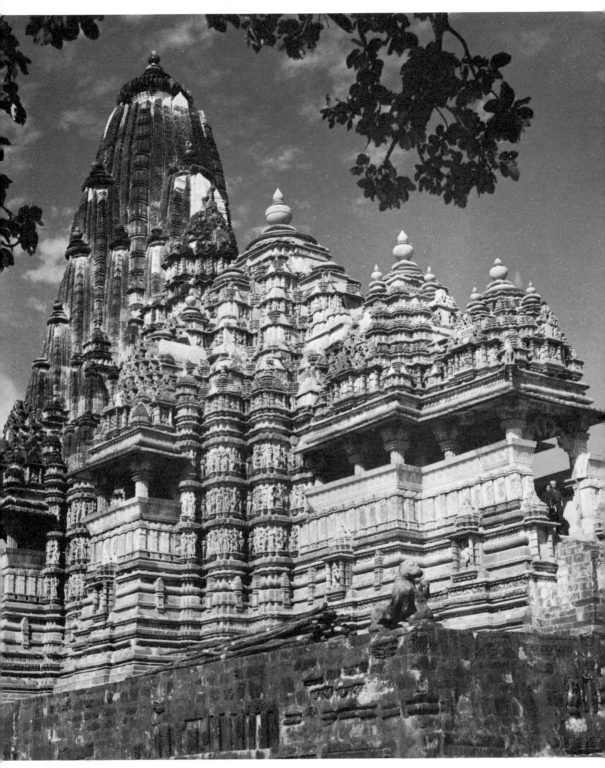

Kandarya Mahadeva Temple, Khajuraho. C. 1000

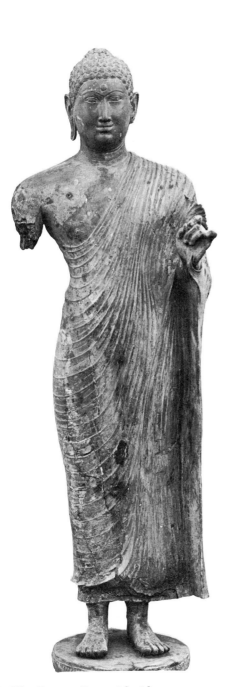

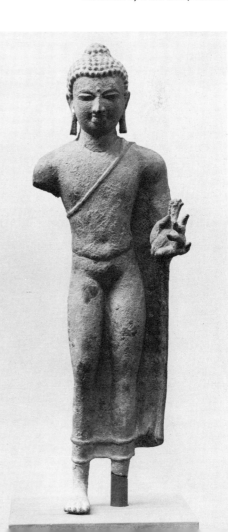

Bodhisattva. Bronze. 8th century. Ceylon.
Museum of Fine Arts, Boston

Buddha. Bronze. Gupta, 5th–6th
centuries. Found in Annam.
(*Courtesy Musée Guimet*)

Buddha. Bronze. Gupta, 5th–6th centuries.
Museum of Fine Arts, Boston

craftsmen, and is thus an example of Gupta workmanship.

The tradition was continued in medieval times. The fluidity of pose of the little eighth-century Sinhalese *Bodhisattva* is indicative of the way in which the sculptors of Ceylon matched or foreshadowed the developments of mainland art. It is in line with the early medieval style known as Pallava. The *Parvati* shows traces of the classic treatment of drapery, but the general aspect is of a late medieval piece, foreshadowing the coming decadence. (Below, at right.)

There are great numbers of the bronze (or copper) figures in the museums, with a certain purity of feeling from the early medieval style. Much of the sculpture at the famous Rajrani Temple at Orissa is in voluptuous style, as the stone figures of nymphs from the British Museum and the Metropolitan Museum clearly demonstrate.

Despite the spirituality and austere idealism of true Hinduism, the popular deities are dualistic, and occasionally they express an understandable wantonness. In popular imagery they become less and less remote,

Panel figures. Stone.
11th–12th centuries. Orissa.
British Museum; Metropolitan Museum of Art

Parvati. Bronze. C. 900. South India.
Cora Timken Burnett Collection,
Metropolitan Museum of Art

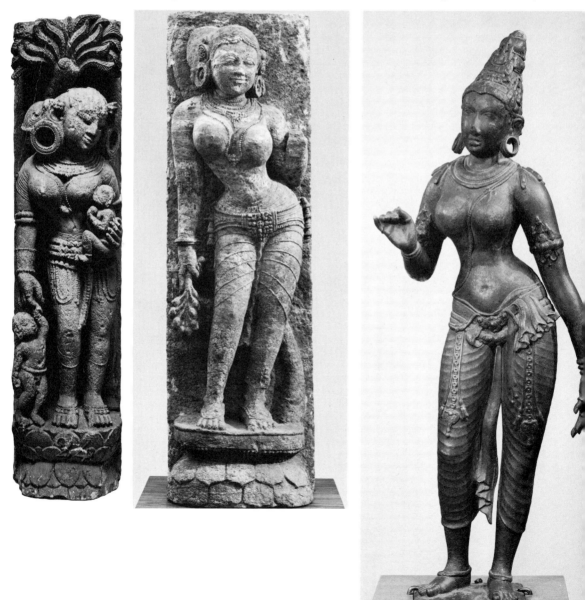

less and less symbolic. In the end they appear superbly virile and sculptural, as in the *Rama with a Bow* illustrated. But they are a great distance from any divinity that could be imagined by a Christian or a Moslem or a Buddhist of the strict sect.

By this time Buddhism in India had been in a centuries-long decline. It is largely the Hindu deities that illustrate the rest of the story of Indian sculpture. Ceylon continued to reflect mainland tendencies in sculpture, and the *Youthful Saint* shown is reminiscent of South Indian or Dravidian expression, if

a little more obviously decorative. The precision of pose in the bronze here, as in the preceding piece, is notable.

The later Hindu sculptors were more interested in precise adjustment of attitude and in symbolic appurtenances than in a massive sculptural entity. In the late Medieval period and in the decadent period to follow, the lithic element virtually disappeared; and in the bronzes that represent the best in Indian achievement after the twelfth century, refinements assume importance rather than largeness and dignity. Even so satisfying

Rama with a Bow. Copper.
12th century. South India.
Victoria and Albert Museum

Youthful Saint. Bronze.
Ceylon. 12th–13th centuries.
Colombo Museum

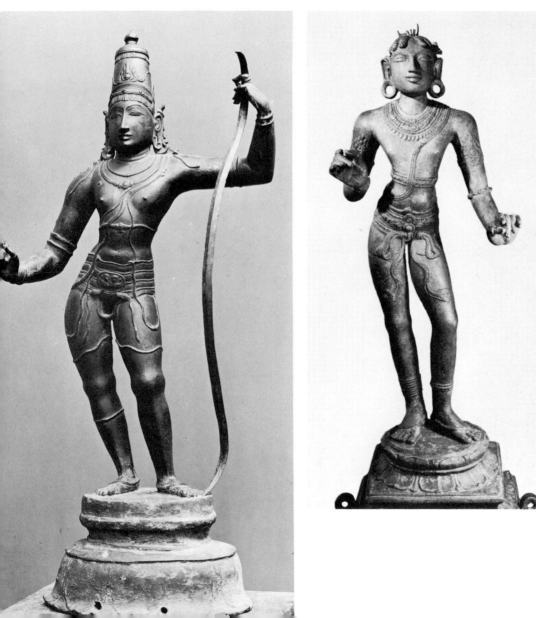

a statuette as the seated *Uma,* which reverts a little toward classic repose, gains part of its effectiveness from the piling up of decorative accessories, and lacks the quiet dignity of the bronzes of the golden age.

In the North, especially in Bihar and Bengal, a different kind of ornateness was cultivated at this time, demonstrated in a long series of high-relief plaques or stelae dedicated to the sun-god Surya, or occasionally to Siva. The plastic unity often suffered, as in the *Siva-Sakti* and *Surya* shown. They are typically crowded, perhaps typically overloaded. The style of cutting is hardened, as if the carvers of stone had attempted to approximate the properties of sculpture in metal. Often the crowded-in masks, flowers, scrolls, and minor figures are marvelous, both compositionally and as skillful carving. The *Siva-Sakti* is, of course, profoundly symbolic, each detail contributing to the meaning.

The sculptors of Nepal, the country to the northwest of Bihar and Bengal, with a

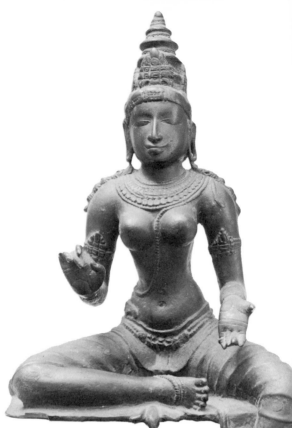

Uma. Copper. 12th–14th centuries. South India. *Museum of Fine Arts, Boston*

Left: **Siva-Sakti.** Stone. 10th century. Bengal. *British Museum*
Right: **Surya, the Sun-God.** Stone. 12th century. Bengal. *Victoria and Albert Museum*

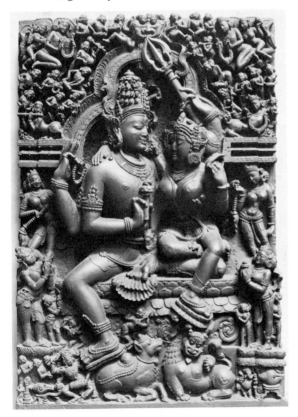

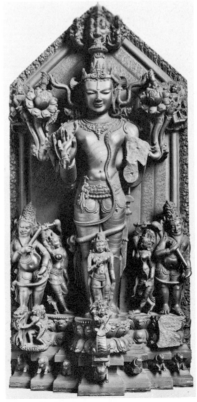

history and a people inextricably bound up with those of India, but generally independent, developed an attractive variation of the Hindu or Buddhist-Hindu art. The statuettes of bronze and copper often combined sheer, prettily modeled masses and elaborated decorative accessories. The decorators' instinct sometimes led to the insetting of jewels in the bronze floriation. The copper *Lokesvara* illustrated is typical. Traces remain of a gold covering. The six-armed figure is a manifestation of the beneficent Dhyani Bodhisattva worshiped in Nepal.

A second copper figure, very similar in idiom though later in date, is the image of Tara, a goddess in both the Hindu and the Buddhist pantheons—in the latter as mother of mystic wisdom and therefore, by association, Mother of Buddha. Statuettes of similar nature, but generally less accomplished, have been brought from Tibet, where sculpture was strongly influenced by the Nepalese, if not produced by immigrant craftsmen and their descendants. Nepalese art, in turn, was influenced by contact with both Tibet and China.

The deities Parvati, Uma, and Kali (all manifestations of the Spouse of Siva) reflect the three responsibilities of the Hindu divine triad: creation, preservation, and de-

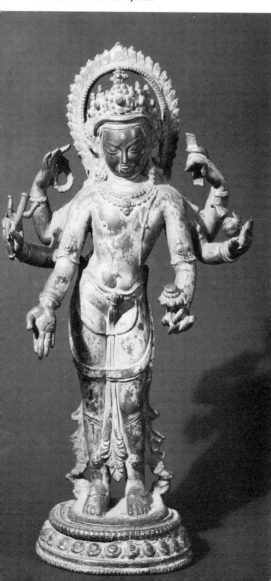

Lokesvara. Copper, gilded. C. 12th century. Nepal. *Whittemore Collection, Cleveland Museum of Art*

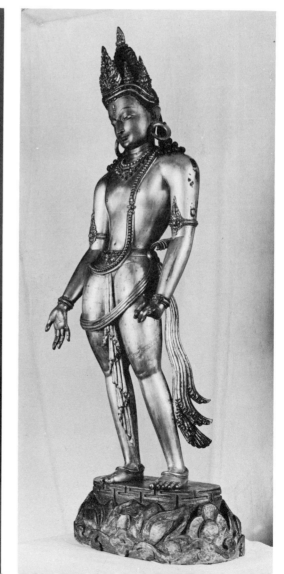

Avalokita. Cast copper, gilded, inset with jewels. C. 16th century. Tibet or Nepal. *Victoria and Albert Museum*

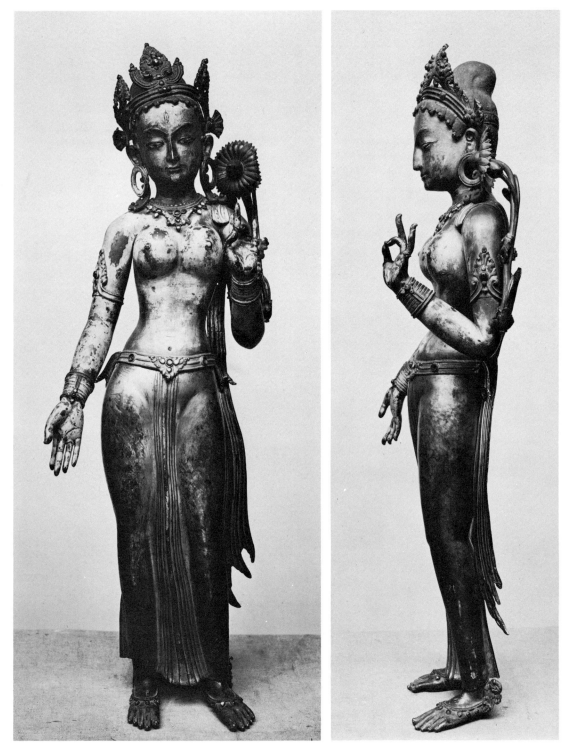

Tara. Copper, gilded, inset with jewels.
Nepalese-Tibetan, probably 16th century. *Victoria and Albert Museum*

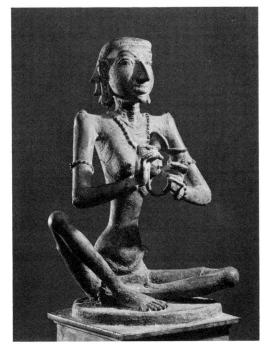

struction. Kali is the goddess-manifestation of evil, destruction, and bloody horrors. The example here, *Kali with Cymbals,* despite the scarecrow face and the haglike skinniness of limb, achieves a truly rhythmic sculptural movement.

A favorite subject among late South Indian bronzes is Siva represented as Nataraja or Lord of the Dance, one of the thousand manifestations of the supreme Hindu deity. Usually the dancing figure is four-armed, surrounded by a circle of fire, and standing on a dwarf. Often the halo of flame, attached to two of the hands, to the hair, and to the headdress, is missing from surviving examples; however, the precise movement and balance of the figures are remarkable.

Kali with Cymbals.
Bronze. 14th century.
Nelson Gallery–Atkins Museum,
Kansas City

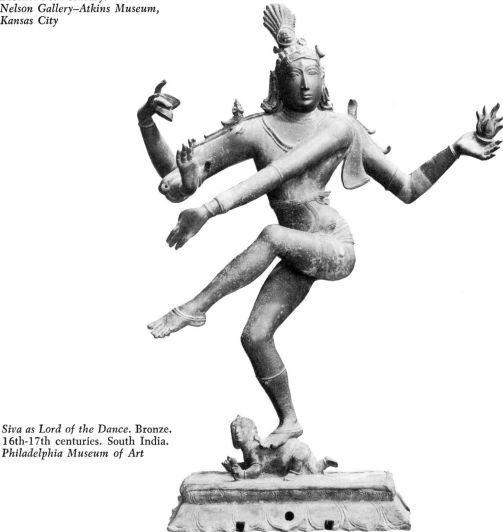

Siva as Lord of the Dance. Bronze.
16th-17th centuries. South India.
Philadelphia Museum of Art

The second example illustrated of Siva as Lord of the Dance is a richer decorative unity, and it illustrates almost scientifically a frequently forgotten truth about sculptural composition—that although basically an art of related masses, sculpture implies space carved out, and an ordered relationship of solids and surrounding space. Here the artist has outlined a circular space, and implied a spherical space, and he has brought alive both solids and spaces in a composition full of equilibrated movement. The significance of the figure is that this is Siva dancing joyously, to set in motion the pulse of life in everything spiritual and physical.

Great numbers of bronze statuettes were produced after 1600, but the best were copies of earlier styles; the mass comprised crude trade pieces. The museum pieces of later date, such as the Lakshmi illustrated, are notable

Siva as Lord of the Dance. Bronze. South India. *Royal Ontario Museum*

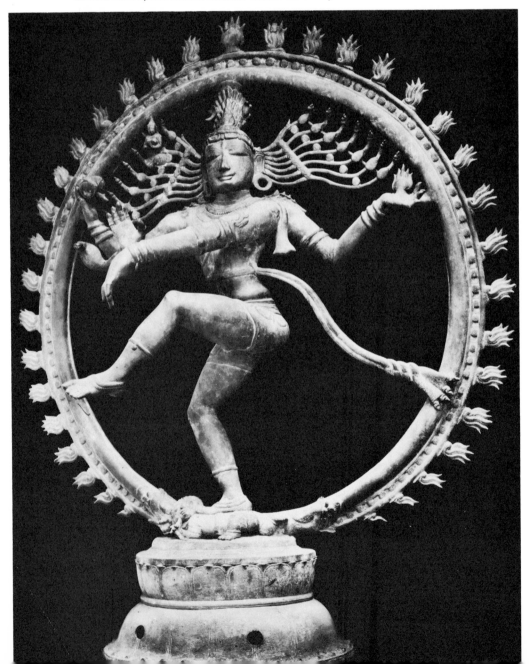

as reflecting merits more enjoyably conveyed five hundred or a thousand years earlier.

In the Western world, appreciation of Indian sculpture has been delayed almost as if it were as strange as the arts of the South Seas. The classically trained European, holding to Greek standards of a simple, clear, idealistic art, and puritanically reticent where the human figure was concerned, simply closed his eyes to the gorgeous if sometimes sensual display existent in the lithic and metal arts of India. Fortunately, in the mid-twentieth century appreciation has widened as the Greek influence has weakened. Even in architecture, Western ideals of logic and discipline have been relaxed and the temples and shrines have been widely enjoyed. The buildings, of which the frames often seem to be obscured under cascades and torrents of sculpture, are seen to be consistent and in the spirit of the national culture. The final illustration is of two gopurams, the temple

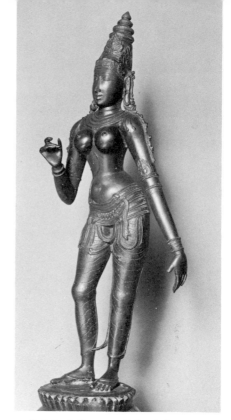

Lakshmi. Bronze. 16th–17th centuries. South India. *Musée Guimet*. (*Giraudon photo*)

Aiyanar. Bronze. *Victoria and Albert Museum*

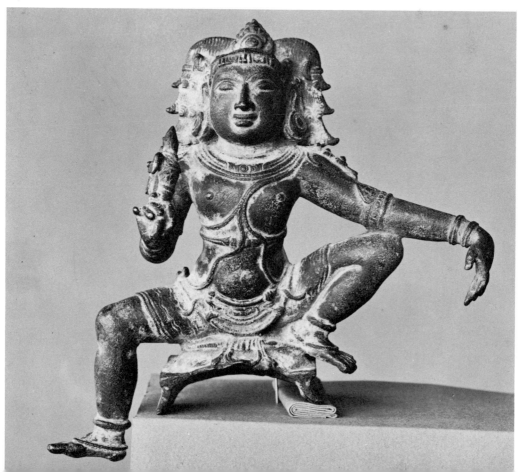

gateways that are characteristic features of so many of the sacred cities of South India. Hardly buildings or shelters in the orthodox sense, they are signs and expressions of a national ethos, of a distinctive religious fulfillment.

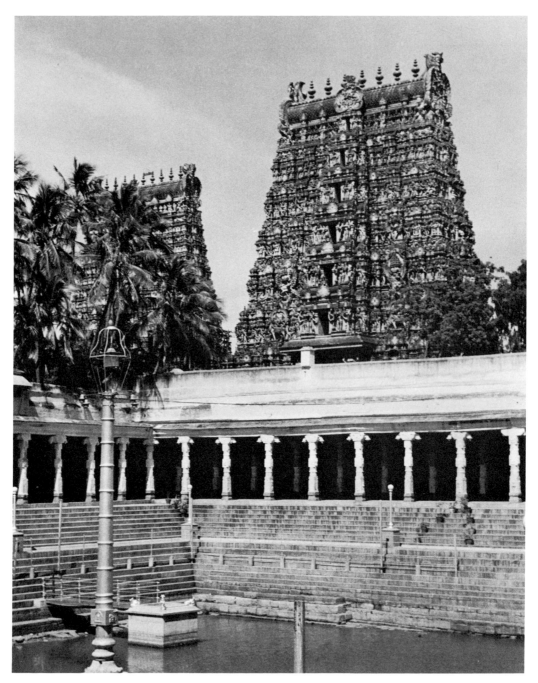

Gopurams at Meenakshi Temple, Madura. (*Government of India official photo*)

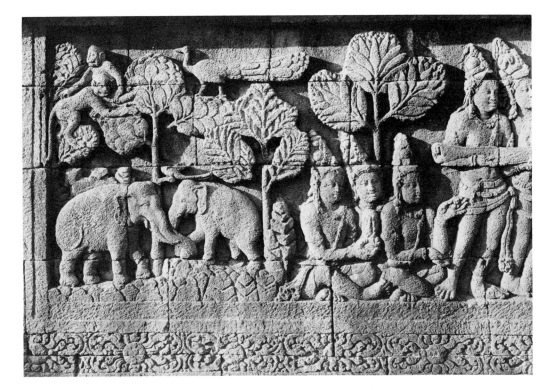

11: The Flowering in Southeast Asia:

Cambodia, Siam, Java

I

THE history of art in Southeast Asia goes back to the fifth century A.D., but it was rather in the seventh and eighth centuries, the time of the achievements at Mamallapuram, Ellora, and Elephanta, that the Indian style of art was fully embraced. When the Emperor Asoka had consolidated his empire he grew tired of war and turned to religion. He was personally converted to Buddhism and sent missionaries abroad. Eventually Buddhism became the dominant religion in Burma, Siam, Cambodia, Laos, Champa, Sumatra, and Java, and art which was predominantly religious and Buddhist was practiced widely. The Hindu culture also sent out its missionaries and flourished for a time in Cambodia and especially in western and middle Java before the eighth century. The artists were evangelists and created figures to glorify gods and saints.

The Khmers, people of Cambodia, who then ruled also in Siam (Thailand), created a

The Buddha Receives the Robe of the Monks, relief. Stone.
Buddhist, 8th–9th centuries. Borobudur Temple, Java. (*Musée Guimet photo*)

distinctive style of East Asian art as early as the seventh century, a style that culminated in a classic period lasting from A.D. 900 to 1200. They developed both a Buddhist and a Hindu art. The superbly sculptured heads brought to distant art museums have become identified especially as examples of the Khmer style. They afford a revelation of a basic Buddhist principle concerning peace of mind on earth and eventual rest in the bliss of Nirvana. As the classic period came to its end there were, of course, variations and influences owing to dynastic changes and pressure of successful invaders.

Siamese art began as early as the Cambodian and the development was at first identical. The Thais had affinities with Chinese art, but, in the period of assimilation and Thai subservience, the Indian and Cambodian influence prevailed. It is not easy to identify early Siamese works. What may be called the Mon style, after the people who settled in part of Burma and, by infiltration southeast, in Siam, prevailed until the tenth century.

After their invasions of the eleventh and twelfth centuries, the Thais, Mongolians from the north who became the true Siamese, made their concerted stand in the thirteenth century against the Khmers who ruled over southern Siam. In the fourteenth and fifteenth centuries the Thais conquered Cambodia and destroyed the Khmer civilization. The city of Angkor Thom, built about the end of the ninth century, and the temple of Angkor Vat became lost in the jungle and the ruins were discovered only in the late nineteenth century. The mature Siamese style is especially the product of the thirteenth to fifteenth centuries, though many appealing works were to be produced also in the sixteenth and seventeenth centuries. Siamese, Cambodian, and Javanese art products are suffused with the spirit of Hinduism, and the craftsmanship of the Indo-Chinese people is an extension of Indian skills.

After Cambodia, the Siamese went on to conquer Champa, along the coast of present-day Vietnam. The Champans had developed a style in the Indian tradition, but it was modified by contacts with the Chinese and the Polynesians. It is more primitive, with a heavy stonelike quality. It is of special interest for archaeologists because many pieces suggest a link between further Indian art and the art of the Mayans in Central America.

The Hindu culture of western and central Java before the eighth century, allied especially with the Pallava culture of South India, is represented by few surviving monuments. The greatest existing Javanese monument is the temple-complex of Borobudur, which is Buddhist. It consists of terraces, stupas, balustrades, and niches with statues.

The two religions imported from India are often strangely mixed in Southeast Asia. In many cases the two faiths persisted at the same court. The ruling classes in the several kingdoms were often Hindu. But the Hindus, even in India, incorporated the Buddha and the Bodhisattva Avalokitesvara into their pantheon.

Late in the ninth century the Javanese wrested central Java from the Sailendra rulers who had come from Sumatra. Buddhism then gave way to Hinduism and the next group of temples celebrated Siva, Vishnu, and Brahma. The center of cultural activity passed to east Java before A.D. 1000, and Chandi Kidal, Chandi Djago near Malang, and the mausoleum temple of King Erlanga at Belahan were built. In the fifteenth century Java was taken over by the Moslems, and figurative sculpture has never been importantly revived, only woodcarving as a folk art surviving.

II

THE recognizable Cambodian style appeared in the sixth or seventh century A.D. The relics from those centuries include such proficient sculpture as the pre-Khmer *Head of Buddha* and the two standing figures, *Harihara* and *Female Figure*. The stone head is reminiscent of Hindu types but it is also sculpturally akin to the earliest Buddhist statues of China. (See page 277.)

The full-length figures are similarly reminiscent of Indian sculpture, but by the seventh century Khmer craftsmen had become masters in their own right. There is a liveliness here, an aesthetic vitality, that brings the figures into line with the simple, timeless art of Old Kingdom Egypt and of China in the Wei Period. It is worth noting how delicately yet fully each garment and hair arrangement is indicated, without detracting from the massiveness and unity of the figure: how minor enrichment is added without sacrificing the integrity of the block.

Head of Buddha. Clay. Mon type, 6th–7th centuries. Prapatom. *National Museum, Bangkok*

The *Buddha* now at Seattle indicates the progress made in the seventh and eighth centuries toward a national, classic type. No less simple than the preceding figures, it bears, especially in the head, the marks of certain crystallizing idioms. The line of the eyebrows approaches the horizontal and the lips are wide and full. Above all, it possesses a serenity of spirit.

In the fragmentary *Head of Buddha* from the Sachs Collection, which dates from the height of the classic period, there is a wonderful expression of peace of soul. Here again is a fixing of the spirit of Buddhism, a statement in terms of art, of the felicity of inundation in Nirvana.

The Khmers, like the Indians, developed both a Hindu and a Buddhist art, but it was to the Hindu gods that the greatest monuments were erected, not without concessions to Buddhist iconography. The magnificent ruins of Angkor Thom and Angkor Vat (meaning "capital city" and "capital temple") comprise one of the most impressive landmarks in the advance of Eastern sculpture. They are rivaled in opulence and the prevalence of masterpieces only among the Javan, Sinhalese, and Indian temple areas.

At Angkor there is a complex of gateways, bridges, palaces, temples, and terraces, and there are miles of walls ornamented with figures or carved in abstract or floral themes.

Female Figure. Stone. 7th century. Cambodia. *Musée Guimet*. (*Giraudon photo*)

Harihara. Stone. Early 7th century. *Phnom Penh Museum*. (*Photo Musée Guimet, courtesy Tel*)

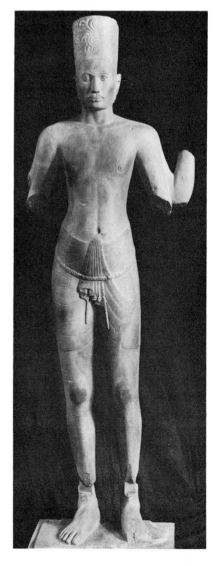

While the profounder relics of Indo-Khmer culture show affinity with the austere type of Indian image, there is ample evidence at Angkor Vat that the Khmers had also fallen heir to the mastery of the abundant decorative mode. The impression is less turbulent, and the piled-up figures are less fecund and illogical, than at Ellora and Elephanta; but at Angkor there are relief scenes and surrounding ornamentation which occupy acres. Some appear in the details illustrated. The entire display is at an extraordinarily high level of narrative representation and decorative embellishment.

The subject-matter is nominally religious, but the sculptors devote considerable attention to the apsaras or dancing nymphs, who combine ample physical loveliness with their saintly function. As they appear at both Angkor Vat and Angkor Thom, they are captivating creatures, and sometimes they are frozen into superb rhythmic friezes. There is every degree of low relief and high relief among the murals, and every variation from a single, half-emergent, dominating figure to vast battle scenes—which are, indeed, among the most animated in the history of plastic art.

The superbly sculptured heads, from statues at the original temple sites, have been brought to distant art museums, and they have become identified especially as examples of the Khmer style. The calm, the serenity, the sweetness are to be found in a multitude of examples. The lithic quality is consistently maintained, and the fineness of the cutting is remarkable. It is true that these heads comprise a type, with standardized characteristics, but each one has come alive in the sculptor's hands. Each is a sculptural entity and reflects the Buddhist ideal of peace of mind on earth and rest in the bliss of

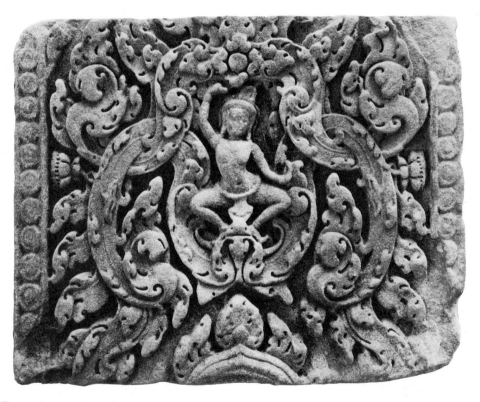

Decorative mural panel with Apsara. Stone. Khmer, 11th century. Angkor Thom. *Musée Guimet*

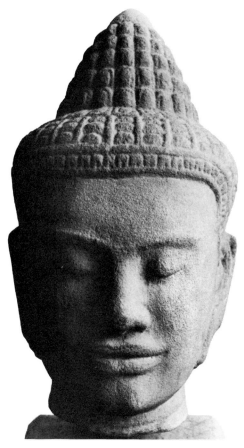

Head of Buddha. Stone. Khmer. Lopburi, Siam. Collection of Reginald Le May, Tunbridge Wells

Head of Buddha. Stone. Khmer, 12th century.
Collection of C. T. Loo

Head of Buddha. Stone. 12th century.
Prah-Khan Temple, East Cambodia.
Musée Guimet. (Giraudon photo)

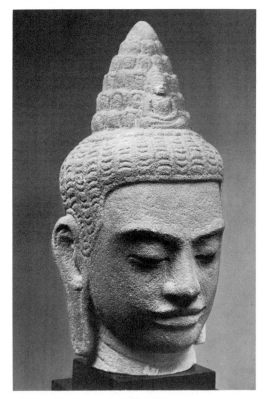

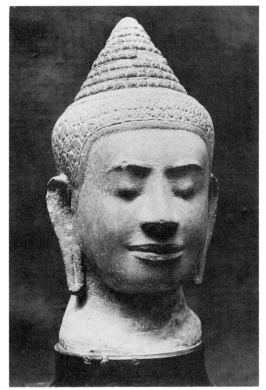

Nirvana. The example in the Le May collection, shown opposite, is a masterpiece in every sense.

The *Head of a Bodhisattva* from the Musée Guimet, below, marks a return to a primitive simplicity. The *Head of Buddha* beside it is of a later type, interesting for its fluent cutting and for a new mannerism of sharp ridging. The *Head of Buddha* at the Fogg Museum (page 282) is exceptional among Khmer relics, being in wood. It is one of the most beautiful surviving pieces.

The Mon-Gupta stone head from Lopburi has Indian attributes, is in direct descent from Gupta art, and is an example of the Mon style of Siamese art. The *Mask of Buddha* in stucco and *Head of Buddha* in clay (page 275) are rare early examples of the Mon style, one characterized by exceptional subtlety, the other a work in which Khmer influence has been slight.

As an example of the Pala style from northern India, counted Siamese but apparently little affected by Khmer or Mon influence, there is the unusual statue of *Buddha Expounding the Law* now at the Metropolitan Museum of Art. It is in bronze.

The *Buddha Seated on a Serpent* of the adjoining illustration, a figure timelessly still, epitomizes the ideal of serenity characteristic of so much Buddhist sculpture.

At Lopburi in south Siam, particularly, the Mon workers, mixing with the Khmer, produced art that was little more than a variation of the contemporary Cambodian. Heads of Buddha ascribed to the eleventh and twelfth centuries are barely distinguishable from the examples uncovered at Angkor Vat. The two are different only in that one seems like pure Khmer, while the other is substantially Khmer, with some racial modification: the eyebrows definitely meet, the mouth is less wide, the cheeks are often puffed to give the face a more oval outline. Again the Buddhist sweetness and peace are apparent.

Head of a Bodhisattva. Stone. Khmer, 12th–13th centuries. *Musée Guimet*

Head of Buddha. Stone. Khmer, 12th–13th centuries. *Musée Guimet*

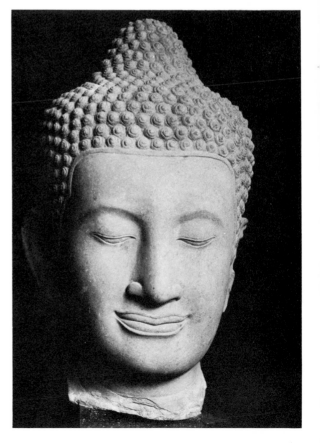

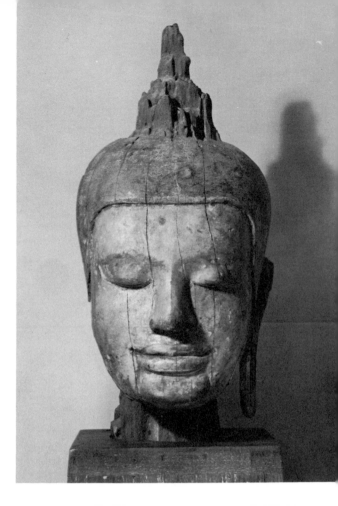

Head of Buddha.
Wood with traces of gilt.
12th–13th centuries.
Fogg Museum of Art

Head of Buddha. Stone.
Mon-Gupta type. Lopburi, Siam.
Collection of Reginald Le May

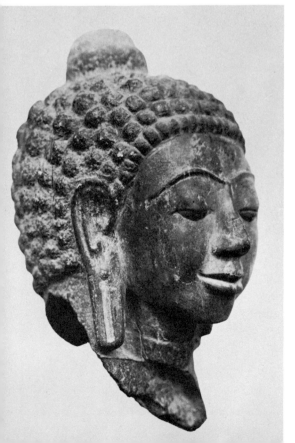

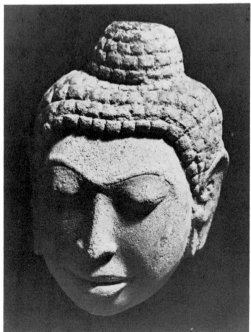

Mask of Buddha. Stucco. Mon,
6th–7th centuries. Prapatom.
Collection of Reginald Le May

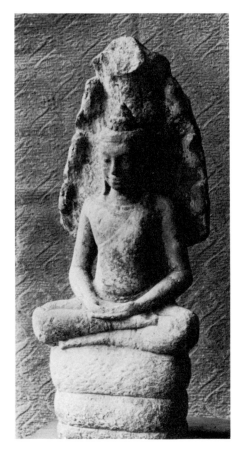

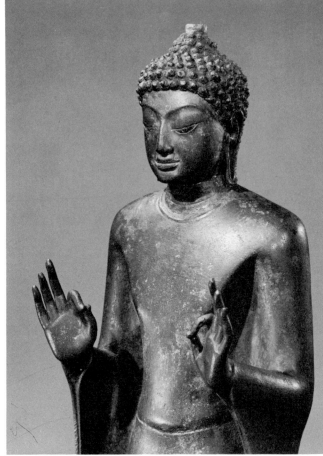

Buddha Expounding the Law. Bronze.
Mon-Gupta, 9th–10th centuries. Devaravati.
Metropolitan Museum of Art, Fletcher Fund

Upper left:
Buddha Seated on a Serpent. Stone.
Khmer style.
Collection of Reginald Le May

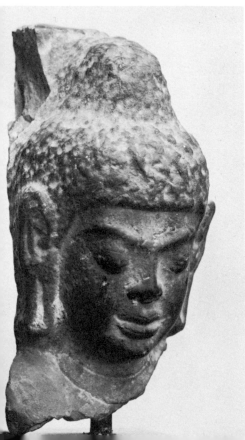

Head of Buddha. Stone.
Mon. Siam. *British Museum*

It is sometimes claimed that the name Siam should not be applied before the invasion from the north, which gathered force in the eleventh and twelfth centuries and reached its peak in the thirteenth. Only late in this period was a thoroughly typical Siamese style first marked. It then presents a facial type considerably different from the Khmer. For example, in the bronze *Head of Buddha* (below, right) the nose has become long and thin, the eyebrows are arched, the mouth is more delicate and the head ovoid. The squared face, leveled brows, and full lips of the Cambodian heads are gone.

The bronzes, in particular, now attain a refinement seldom equaled in the history of sculpture, an elegance sustained with great subtlety. The small figures are graceful, with very careful attention to attitude. It is not unusual to find a detached hand displayed in a museum as a masterpiece of sculptural expressiveness.

Head of Buddha. Stone. 14th century. Lopburi. *Detroit Institute of Arts*

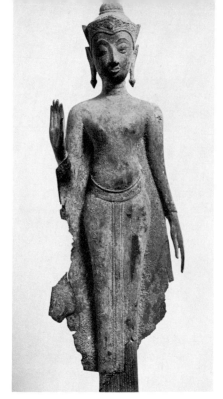

Buddha. Bronze. Sukotai Period, 13th–14th centuries. *Museum of Fine Arts, Boston*

Head of Buddha. Bronze, gilded. Ayrudhya type, 15th–16th centuries. *Collection of Reginald Le May*

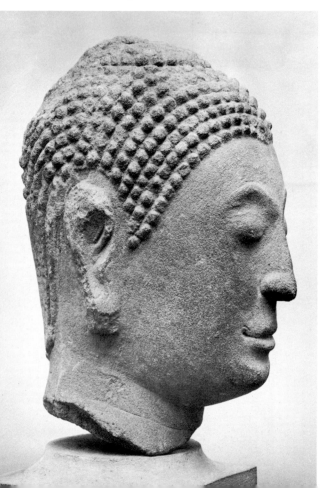

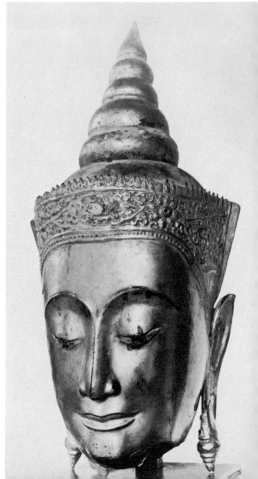

A characteristic Siamese type of head in stone has protruding eyes, long turned-down nose, and lips noticeably upturned at the corners. The monumental lithic element is beautifully displayed in the example at the Detroit Institute of Arts (on facing page), which is one of many surviving heads in museums and private collections. Other variations are illustrated in a series of three heads, two in the Le May collection, one at Montreal. The two in bronze display again the refinement and elegance: one superlatively, in a smooth, suave stylization; the other in a decorative composition. The flame-top idiom goes back to the Khmer period and to India. The stone head at Montreal is monumental and commanding and is a late variation of the Buddha type. Here again the artist seems to draw upon spiritual philosophy for aid in his craftsmanship.

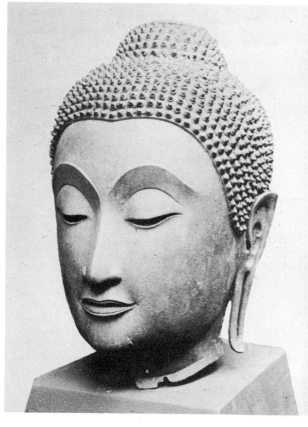

Below and upper right:
Heads of Buddha. Bronze. Thai.
Collection of Reginald Le May

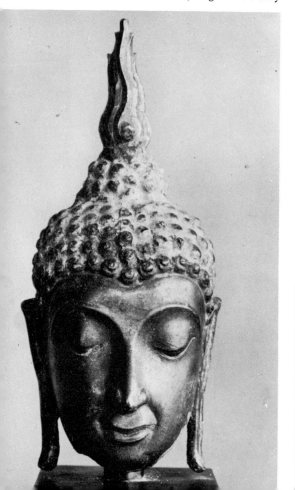

Head of Buddha. Stone. Thai-Lopburi type,
14th century. *Art Association of Montreal*

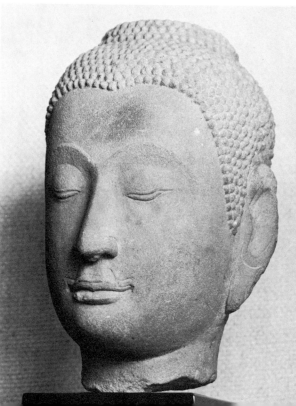

The final illustrations from Siam are of statuettes. The one in the Hanoi Museum is dated by authorities as late as the seventeenth or possibly the eighteenth century. Though unmistakably Thai, it reverts in feeling to the art of India of the classic or Gupta period.

The *Siva Seated* is from Champa and is typical of the heavy conventionalization and of the characteristic device of playing minor areas of rich ornament against simplified and bold masses.

One other flowering of the Indian style of sculpture occurred during the medieval centuries. In the island of Java the simplified, austere image of the Buddha lived again, and the narrative relief art arrived at an unprecedented lavishness of display. The lines of early development are vague, but the

evidence indicates direct importation of the sculptural art with settlers from India. As the Hindus amalgamated with other peoples, with substantial Mongolian elements from the north but with a possible admixture of Polynesians, the Indian religions, Hinduism and Buddhism, along with Indian religious art, were unreservedly adopted.

Almost the oldest—and certainly the greatest—Javanese monument is the temple-complex of Borobudur, which is Buddhist, where earlier relics had been Sivaist. The dynasty under which Borobudur was erected had pushed in from Sumatra, and some authorities count the true Javanese art a later type, softer, more sensuous, and therefore more Indonesian and akin to the Polynesian. But Borobudur is so overwhelming in its extent and its wealth of sculpture that later develop-

Siva Seated. Stone. 9th century.
Champa. *Collection of Baron
Eduard von der Heydt, Switzerland*

Buddha, statuettes. Bronze.
Left: 14th–15th centuries. *Victoria and Albert
Museum. Right:* 17th century. *Hanoi Museum.*
(*Musée Guimet photo*)

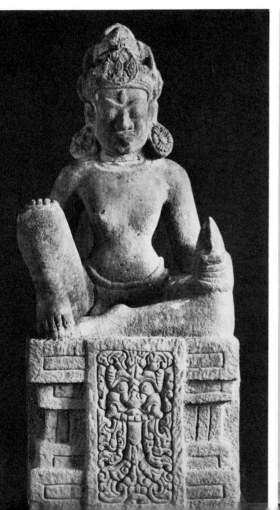

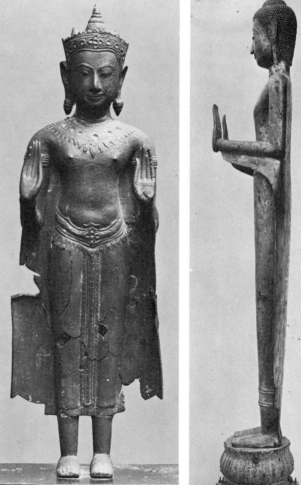

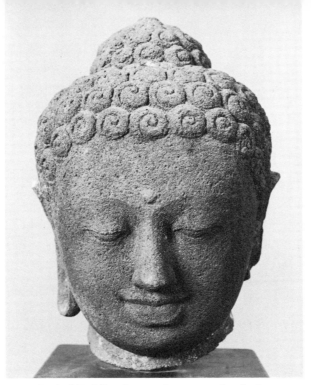

Head of Buddha. Stone. 8th century. Borobudur.
Museum of Asiatic Art, Amsterdam, Van der Mandele Gift

ments in the island, even though more truly native, sink into comparative insignificance.

The temple at Borobudur is not strictly a building, but a coating of terraced pavements and walls over an artificially shaped hill, with an almost unbelievable number of turreted shrines disposed geometrically around a crowning stupa. There are gateways, platforms, niches, and mural carving, with at least three miles devoted to panels crammed with narrative sculpture.

The large seated *Buddhas,* of which detached heads are frequently displayed in Western museums (often as the only examples of Javanese sculpture), probably numbered 505. The generally high standard attained in cutting the statues is attested in the examples shown. The stone figures are

Seated Buddha. Stone. 9th century.
Borobudur, Central Java

Head of Buddha. Stone. 8th or 9th century.
Borobudur. *British Museum*

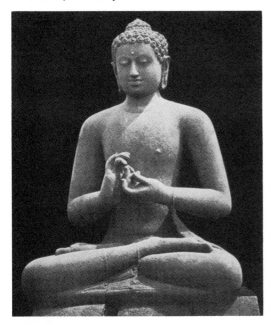

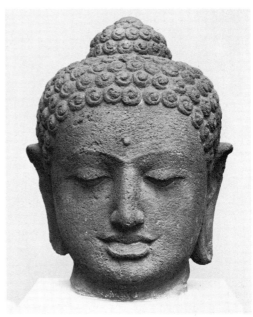

Borobudur Temple. Total height 100 feet. 8th–9th centuries.
(*Official photo, Republic of Indonesia*)

at this time less subtly modeled, and the Buddha face generally lacks the reflection of inner bliss so superbly displayed in the Cambodian examples; but they are impressive models of religious iconography. All the figures are in the traditional attitudes of the Buddha, such as in meditation or preaching.

The marvel of marvels at Borobudur is the superb series of mural illustrations of stories from the Buddhist classics. Nowhere else has a narrative been displayed with quite so much ambition and mastery. The Egyptian tomb walls are pale and unsculptural in comparison; the Indian temple murals and sculptured cliffs are perhaps as extensive and as elaborate, but at Borobudur there is unique sculptural discipline and unity of impression. The panels appear on the walls flanking the terraces, and if laid out in sequence would form a storybook several miles in length, with nearly two thousand "leaves."

The episodes shown are representative and illustrate some of the happy groupings of protagonists and minor characters. The first shows the Buddha in meditation under the tree, like a rock amid the allurements of the temptresses of Mara. The second is a panel

equally well composed, with its central female figure, flanking figures, and trees, elephant, and horses. In both cases the balanced secondary figures are notable. For a freer treatment, more graphic and detailed and a little less sculptural, the next panels are outstanding. The ship is in itself a tour-de-force in rock-carved illustration. (Page 290.)

The first two illustrations are more typical of the style. The human figures have an almost voluptuous grace, and the flora of Java, as well as the customs and costumes of the people are represented in conventionalized detail.

The Java of Borobudur (and of one earlier important temple, Candi Mendut) was a part of a Sumatran-Javanese empire, that of the Sailendra kings. The *Buddha* in bronze (at Worcester) is a single example to represent the sculpture of Sumatra, and may serve to remind us of the widespread heritage of sculptural art embraced in the relices from Indochina and Indonesia and the several other lands which were influenced by Hindu culture. The lingering beauty of Gupta art is recaptured in this statuette, but in a manifestation shaped by a local culture.

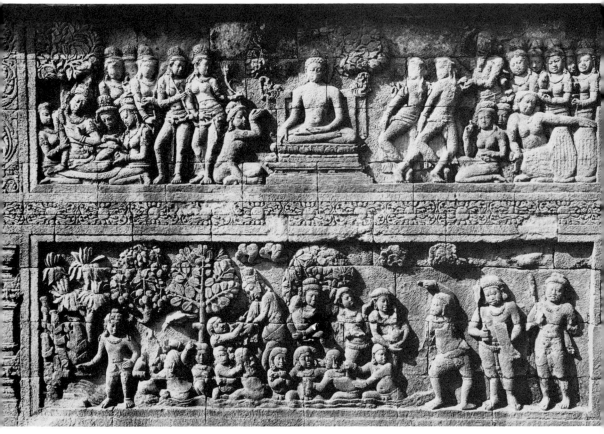

Stories of the Buddha, relief panels. Stone. Borobudur. (*Courtesy Musée Guimet*)

Buddhist Story, relief panel. Stone. Borobudur. (*Photo Victoria and Albert Museum*)

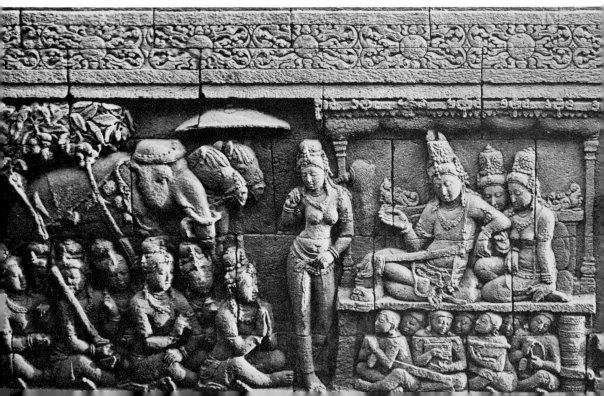

The first reproduction from the temple of Siva at Prambanan in Java shows the incident of Rama drawing the bow of Djanaka to gain the hand of Sita, and it would be difficult to conceive of a happier illustration of this story from the *Ramayana*. The second, with a battered central stone showing Vishnu on the serpent, is notable for the compositions on the side stones: Garuda, the sun-bird, and a cluster of attending gods. Next is an incident of the monkeys and the sea creatures, to illustrate a somewhat amusing relief method, in an exceptional sculptor-draftsman's technique. The final scene, though vital and dynamic, tending toward sculpture in the round, marks a step toward the melodramatic action and the crowded *mise-en-scène* that were to characterize Javanese sculpture in the period of decadence. It was this excessively vigorous and crowded style that prevailed from the tenth century onward.

Gradually the reliefs take on the flat and angular ornamentalism of the Wayang

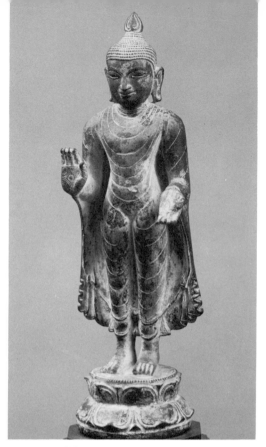

Buddha. Bronze. Sumatran, 9th century. Negapatam. *Worcester Art Museum*

Stories of the Buddha, relief panels. Stone. Borobudur. (*Official photo, Republic of Indonesia*)

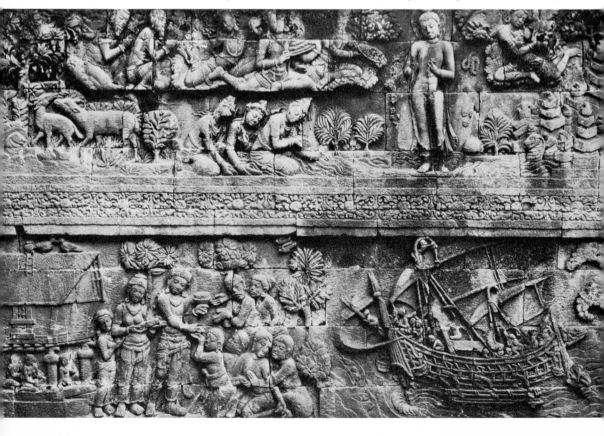

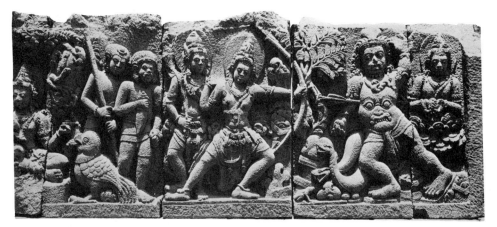

Panels from the Siva Temple, Prambanan. Stone. (*Courtesy Musée Guimet*).
Top: *Story of Rama and Sita,* detail. Center: *Story from "Ramayana,"* detail.
Bottom: *Scene from the "Ramayana,"* detail

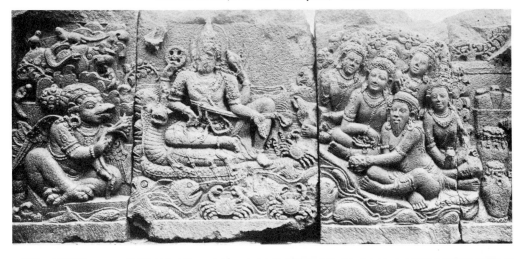

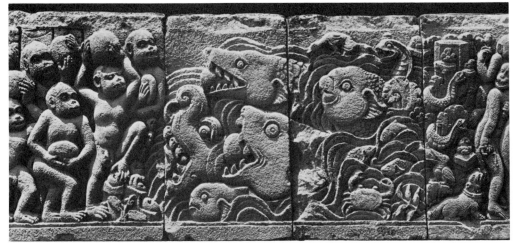

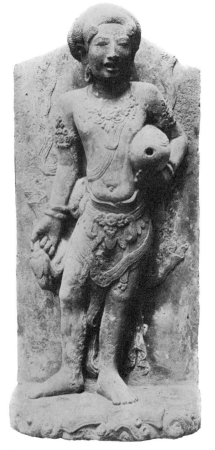

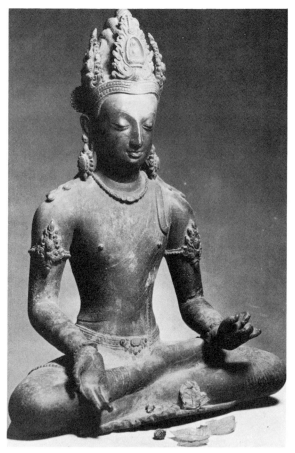

Fountain or downspout. Majapahit Period,
14th century. East Java.
Majakerta Museum (Courtesy Musée Guimet)

Avalokitesvara. Bronze. C. 14th century.
Golden Monastery, Patan, Nepal.
(Courtesy Asia House, New York)

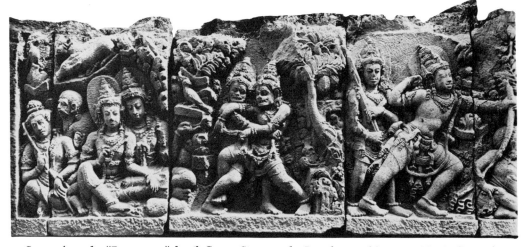

Scenes from the "Ramayana," detail. Stone. Siva temple, Prambanan. (Courtesy Musée Guimet)

puppets, but without the rich expressiveness of those uniquely spirited actors. Occasionally there is an example of figure-modeling in which the garlands and traceries enhance the sculptural effect, as in the fountain piece or gargoyle illustrated.

Even at that late date, however, there were sculptors in Further India who were masters of the art (as the illustrations from Siam show). A graphic lesson can be read in the reproductions here of a subtly beautiful *Avalokitesvara*, a product of Nepal of the fourteenth century, and, the *Head of a Buddhist Monk*, a typical work of the East Javanese school. The two exhibits, in confrontation, emphasize two underlying facts: first, that the sculpture of Central and Southeastern Asia is fundamentally alike, so that examples from India and Nepal, or from the Golden Lands, whether Burma, Cambodia, or Java, cannot be mistaken as creations from any other part of the world; and second, that within this unity the differences are so marked, the originality is so inherent, that this *Head of a Monk*, for instance, could not be guessed as other than Javanese.

Head of a Buddhist Monk. Stone. Candi Sewu. (*Courtesy Musée Guimet*)

12: Early Christian Sculpture:

Coptic, Byzantine

I

THE beginnings of Christian art developed within the tottering framework of the Roman Empire, but in sculpture there is nothing as early as the frescoes and scratchings in the catacombs of Rome, which were hidden from official eyes. On the later Roman sarcophagi, however, the Christian initiate could read a religious significance, such as the parable of the strayed sheep in the figure of a shepherd carrying a sheep on his shoulders. It was not until the Emperor Constantine legalized the Christian religion in A.D. 313, after three centuries of persecution, that the Bible stories could be safely incorporated into the sarcophagus compositions. Then the favorite incidents, such as Daniel in the lions' den, the stories of Jonah, of David and Goliath, and the gospel stories of Christ and the saints, became standard, whether the tombs were designed in Rome, Gaul, or centers in the East.

Two distinctive developments in early Christian art were the Coptic style in Egypt and the Byzantine style, which became focused under the emperor's influence at Constantinople. Egypt, as represented by its cultural center, Alexandria, had been fully Hellenized, but it was Oriental mysticism rather than Greek logic that afforded early Christianity its essential character and determined aesthetic expression. The provincial Coptic style developed in Egypt, close to the spiritual sources of Christian monasticism, but elements similar to the Coptic were to appear later in Byzantine works.

Peacocks Drinking, building stone. Byzantine, 7th century. Venice.
State Museum, Berlin. (Giraudon photo)

The Miracle at Cana. Ivory. Coptic, 6th century. *Victoria and Albert Museum*

The Byzantine style was brought into being through the fusion of its Roman, Near Eastern, and Hellenic elements. The reflowering, in Oriental terms, of the Greek spirit was allied to the burgeoning aesthetic life of the Christian religious communities in Egypt, Palestine, and Syria, and in Constantinople when it became the capital of the Christian world. A minor influence was the art of the northern or barbarian people, which was to be more fully integrated much later, in the Romanesque style.

Sculpture was not a foremost art in early Christian times. Indeed, nothing in the entire range of Coptic or Byzantine art in stone matched the glories of Byzantine architecture, mosaics, and frescoes. As the ancient Roman Empire became a slackly organized Christian empire, sculpture deteriorated to a secondary and hardly more than auxiliary art. Apart from a few exceptional works, monumental expression was lacking from the second to the ninth centuries. The surviving relics consist of ivory plaques or marble coffins in the Roman and then the Near Eastern tradition. There were reliefs in metals, such as plaques for book covers, or ritual platters, and a multitude of architectural details such as decorated capitals. Slabs of various types were carved in low relief in ivory, wood, or stone, and were common in Greece and Constantinople. But the church or palace of monumental proportions was sheathed with colorful mosaics or frescoes, and sculpture enriched the buildings at only a few points. The influence of Persia

and Mesopotamia, where building art leaned but lightly upon sculpture for embellishment, is seen in the architecture of Santa Sophia church in Constantinople, constructed in A.D. 532–537.

There were one or two major monuments, such as the fourteen-foot bronze figure of Valentinian I, now at Barletta in southern Italy, which illustrates the survival of Roman portraiture into the latter half of the fourth century. It is, however, nondescript and sculpturally clumsy. The arms and legs were once melted for use in bells and were awkwardly replaced in the Renaissance period. There is also a group of four figures in stone, set into a corner of the Treasury of St. Mark's Cathedral in Venice. It is of great interest to historians of art because it is ascribed to the end of the third century and yet already exhibits the essential characteristics of the Byzantine style: a total lack of Greek (or Roman) naturalness, an attempt at rhythmic composition, and addition of rich patterning in every available area. Portrait busts in the Roman tradition soon sink to an almost unbelievable ineptness. A very few heads, showing signs of a more truly Eastern approach, such as the one at Dumbarton Oaks (page 303), are attractive and vivid. The only consistent triumph of portraiture in these times is on the coins, and occasionally on the ivory plaques, either in idealized heads and faces or in the historical portraits of the late compositions.

By the time Rome fell to barbarian invaders in 410, a vast part of the empire had been ruled (or wasted in wars) under mixed barbarian and Roman elements for many years. Theodoric the Goth became ruler of Rome in 493, but barbarians as well as Romans had been Christianized long since. Egyptian Christian monasticism was introduced into Italy by St. Benedict (480–544) at Subiaco and Monte Cassino, and a network of Benedictine monasteries began to spread over Europe under a rule encouraging the arts.

The early Byzantine style prevailed from the third to the fifth centuries. The sixth century is the period of the great masterpieces and the climax, as seen in the church of Santa Sophia in Constantinople and the group of buildings at Ravenna. In sculpture the famous throne of Maximian at Ravenna, sheathed with ivory plaques, belongs to this period. After three centuries of lesser activity, during which the iconoclast wars stopped production for a time, there was a renaissance in the mid-ninth century. Many of the finest ivories were carved during this period of wealth and prosperity. There was a further renaissance in the twelfth century.

When the period of decadence came in the Near East, many of the characteristics of Eastern art, as seen in the Byzantine masterpieces, fused with the Romanesque art of the West. Many Byzantine objects such as plaques, book covers, and the circular box or pyx, were portable and were circulated in countries from the eastern Mediterranean to the British Isles, and in turn they affected Western Christian art. The Byzantine Empire lasted technically until Constantinople fell to the Turks in 1453.

II

THE ivory with *Scenes from the New Testament* is an Early Christian piece, with Roman affinities. While the story-telling compositions suggest a legacy from the classic narrative panels, there are a new vividness and vigor that can be counted only as Eastern. As in so many ivories of the early period, there are touches of Oriental pattern-ing and the over-all design is rhythmic and opulent. The two parts of the plaque (matched here from two museums) show also the typical fullness and roundness of each figure, against generally uncluttered backgrounds.

The two plaques *Miracles of Christ* and *The Story of Joseph*, also labeled Early

Scenes from the New Testament. Ivory. Italian, 5th century.
State Museum, Berlin; Louvre. (Giraudon photo)

Christian or Latin, show even more Eastern influence. The first places the rounded figures against backgrounds entirely traced over with patterning. In the other, although the workmanship is somewhat clumsy, there is again exceptional feeling for surface enrichment. The animals and the foliation, deeply pierced to produce sparkling light-and-shade, are Oriental in feeling. Here the classic West and the plastically inventive East have met in a new fusion, in the style called Byzantine.

As Byzantine architecture developed, the columns in the Christian churches were often capped with sculptured compositions.

Miracles of Christ. Ivory. C. 5th century.
Victoria and Albert Museum

The Story of Joseph. Ivory. C. 5th century.
Treasury of Sens Cathedral. (*Giraudon photo*)

These range from the abstract (very like Islamic designs, in the later periods) through semi-abstract compositions based on floriation, and on to fully figurative types with knotted animals or conventionalized biblical figures. Illustrated are a near-abstract capital, now in the museum at Ravenna, and, in contrast, a capital with animals, still in place in the Church of San Michele in Pavia, Italy. There is in the latter composition more than a hint of the Romanesque style that was to succeed the Byzantine in Italy and France.

Late classic mastery in sculpture had been best expressed in the sarcophagi of the first and second centuries. But in the third and fourth centuries the progression was completed from purely Roman motives to Christian icon and Christian genre piece. In one of the panels (page 301) it is possible to find both Jonah and the Good Shepherd. By the fifth century Oriental decoration and Oriental rhythmic composition had all but overwhelmed classic realism of statement.

The little pyx at Florence reveals the transition in a slightly different way. It is wholly Eastern in its exuberance and its wealth of detail. If it lacks logical order it nevertheless is wonderfully alive and vibrant.

There are ivories that juxtapose a story-

Pyx. Ivory. 5th century.
National Museum, Florence. (Giraudon photo)

Capitals. Stone. Byzantine. 6th–7th centuries.
Above: Museum, Ravenna. (Anderson photo).
Below: Church of S. Michele, Pavia. (Alinari photo)

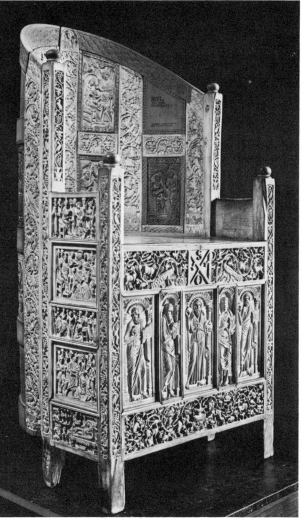

Throne of Maximian. Ivory over wood.
6th century. *Archepiscopal Palace, Ravenna.*
(Anderson photo)

telling composition and a decorative panel, and the two traditions can be detected, still not quite fused. The didactic figures in the ivory at Liverpool have been composed into a rhythmic group. In the figures of the top panel, and also the animals of the scene below, there is the special rounding of forms which was to persist as a hallmark of the Byzantine style.

One of the most instructive examples is the famous bishop's throne of Maximian at Ravenna, sheathed with representational panels and running borders of ornament. Though the figure panels have didactic Roman traits, all else has the new freedom and the aesthetic sensibility of the East. Like most of the accomplished ivory of so early a time (the sixth century), it was until recently credited to the studios of Alexandria. Later attributions are to other centers. The Byzantine style was in full tide over a vast territory by the mid-sixth century. A new way of design had evolved, and centers of manufacture existed on three continents.

The Coptic composition in the Louvre showing a god, a horse, and a crocodile, has hardly more than a heavy manner, a lithic beauty, and direct statement to link it with earlier Egyptian work. It is transformed, by workmen imbued with Eastern feeling, into a decorative entity. No Greek in the classic tradition, and certainly no Roman, could have rendered the two animals at once so unreal and so alive, or the whole composition so compact and so decorative.

Early Christian sarcophagus. Stone. 3rd–4th centuries. *Vatican Museum, Rome. (Brogi photo)*

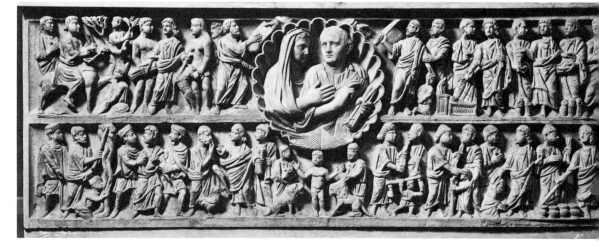

Battle with Stags in an Arena, panel. Ivory. 5th century. *Liverpool Museum.* (*Giraudon photo*)

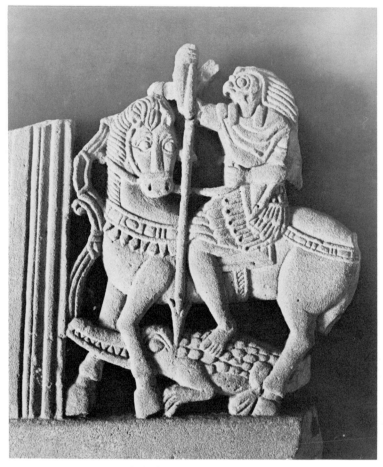

A God on a Horse. Stone. Coptic. Egypt. *Louvre.* (*Giraudon photo*)

Early Christian sarcophagus. Stone. 3rd–4th centuries. *Church of S. Maria Antiqua, Rome.* (*Brogi photo*)

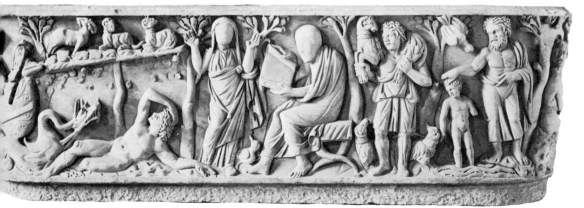

It is the frank decorativeness of Coptic art that sets it off from earlier developments on Egyptian soil; and indeed the majority of the Coptic sculptures in the museums are abstractly decorative and not figurative at all. They comprise floriated capitals, rich friezes, and all-over-patterned panels. But the Copts could treat figure compositions without losing the play of light and shadow upon patterned areas, producing luxuriant designs. The stone relief from Greece, with animals and birds, shows how this ornamentalism expressed itself somewhat later in the course of Byzantine art. It represents the florid aspect of the Byzantine style.

Relief. Stone. Byzantine. 9th or 10th century. Greece. *Louvre.* (*Giraudon photo*)

In the ivory panel illustrating the Miracle at Cana (page 295) there are the full and fluent figures of the Byzantine style. The drapery ends are composed into ornamental counterpoint, and the hair is frankly ornamentalized—not in the late Roman manner, but in patterning that heightens by contrast the smooth modeling of face and figure. Even the wine jars are disposed for rhythmic counterplay. Yet the Christian story-theme is served.

The silver plate, a part of the Treasure of Cyprus, is a further reminder of the mixed nature of the sculptural art during the formative centuries of the Byzantine style. The story of David and Goliath is told explicitly in three scenes, in the manner of Hellenistic Rome rather than in the sumptuous Persian manner. But there is enough ornamentalism in the treatment of the draperies, and especially in the patterning on the shields, echoed in the stippling of the towers, to indicate the meeting of the two traditions.

The Story of David and Goliath. Silver. 6th century. From the Treasure of Cyprus. *Metropolitan Museum of Art*

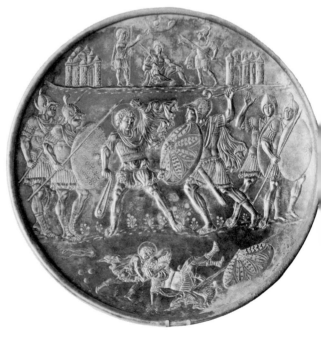

Portrait head. Stone.
Dumbarton Oaks Collection

Portrait head. Stone. Coptic,
6th–7th centuries. *Louvre*

The art of portraiture in stone never fully developed at Byzantium. Roman portraiture had so degenerated that there could be no strong influence from that direction, and by the eighth century the iconoclast movement within the Eastern Church had put a serious check upon all figurative art. The few portrait heads that survive are marked by incomplete understanding of anatomy—not necessarily a grave fault, but a fault for which one seldom finds compensation in superior plastic sensibility or striking sculptural aliveness.

The head in the Dumbarton Oaks Collection is something of an exception; the striated treatment of beard and hair is novel, though the contrast of unbroken surfaces with beard and hair so heavily ridged is typically Eastern. The head in the Louvre is of indeterminate date, is thought to be from Phoenicia, and has some affinity with Roman art.

By the end of the eighth century Greco-Byzantine artists were working in Rome. In Ravenna, Byzantine art had predominated for three centuries, as witnessed especially by the architectural monuments and mosaics. There was no notable sculpture other than the beautifully carved capitals with interlaced ornament, comparable to those of Coptic Egypt and of Byzantium itself. Just after A.D. 800 there occurred a minor renaissance, associated with the religious and cultural advance in Europe under Charlemagne's patronage, and there are groups of illuminations and ivories of the period, catalogued by scholars as "Ada" (from the name of Charlemagne's sister), "School of Reims," and so on. In the early tenth and the eleventh centuries, at a time when a new wave of Orientalism had swept over the Eastern studios, there was a more determining renaissance in the West known as the Ottonian (or Orthonian), which led on to Romanesque and is considered by some to belong to that style.

In both periods of revival the general expression is Byzantine or Byzantesque. (Ireland alone then clung to Celtic and was accomplishing the chief flowering of the Barbarian style in sculpture.) Theodoric and Justinian imported architects and artisans from the East to design and build churches and palaces at Ravenna in the sixth century, and Charlemagne's architects sent to Ravenna for models and materials for the new capital at Aachen in the eighth and ninth centuries, while the Ottonian kings simply revivified the style closest at hand. The early Ottonian ivories are especially spirited and dramatic.

Objects in ivory in a wide range of design and subject are shown on this and the following pages. They are probably of the tenth and eleventh centuries, except those marked Carolingian, and the panel of the Veroli Casket, which, on its several faces, shows lively treatment of Christian and pagan themes, strangely mixed together. It is of exquisite workmanship and it affords an instance of the way in which artists full of enthusiasm for their medium, with superb technical mastery, often misunderstood the written texts and the painted miniatures which were their chief sources of inspiration. In one panel Europa and the Bull usurp the place of Achan amid the Israelites hurling stones.

As the Church had been the only force to shape any sort of unity from the confused national and racial elements, so art became now an appanage of the ecclesiastic ruling power. The thematic materials were taken from the life of Jesus or of Mary, or from Old Testament stories. The *Crucifixion*, with Christ in majesty and other scenes, in the Cluny Museum, is a particularly beautiful example of the story-telling type. It is of Charlemagne's time.

The central leaf of a triptych illustrating Christ crowning the Emperor Romanus IV

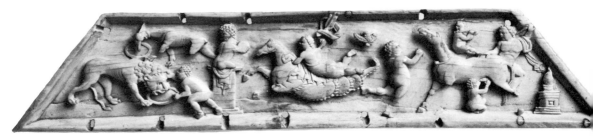

Panel with fantastic subjects. Ivory. Byzantine, 9th–10th centuries.
Formerly Collection de Vasselot, Paris. (Giraudon photo)

Veroli Casket. Ivory over wood. Byzantine, 9th century. *Victoria and Albert Museum*

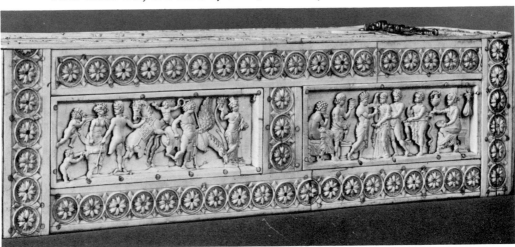

and Empress Eudocia is of special interest in indicating the union of Church and state. It is equally an index to the artistic methods of the Byzantine craftsmen. The *Madonna and Child with Saints* in the Dumbarton Oaks Collection is a work in the mature Byzantine manner, showing slenderized figures though without losing the idiomatic rounding of forms.

The *Christ in Majesty* is a distinctive German variation. That the Orient was again asserting itself in the Western studios is attested by the spirited symbolic animals at the base of the design, these being the symbols of Mark and Luke. The *Crucifixion* at the British Museum, which borders on ex-

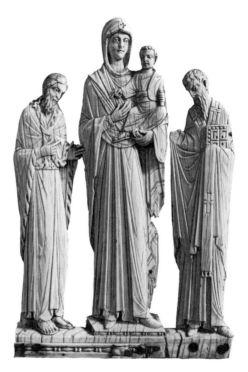

Madonna and Child with Saints. Ivory. *Dumbarton Oaks Collection*

Crucifixion from book cover. Ivory. French, Carolingian. *Cluny Museum.* (*Giraudon photo*)

Christ Crowning Romanus IV and Eudocia. Ivory. Byzantine, 11th century. *Bibliothèque Nationale, Paris.* (*Giraudon photo*)

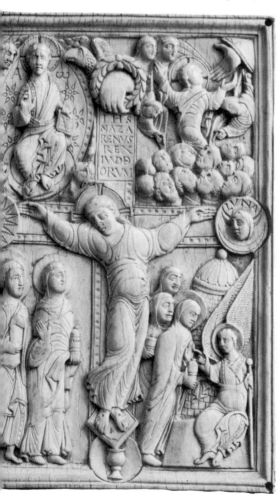

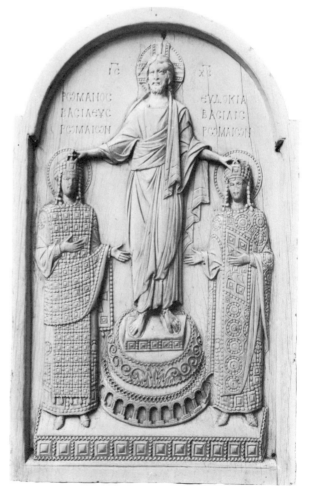

pressionistic distortion, nevertheless exhibits an expert sense of space design and a pleasing counterpoint. It illustrates the Ottonian vigor in process of transformation into Romanesque dynamism.

The freedom and variety of treatment in Byzantine ivories can be explained by the great territory over which the style had spread, from Africa and Asia to northern France and western Germany, so lately barbarian. The *Crucifixion* with other scenes, under a typically ornate dome or canopy supported by pierced columns, is so frankly Oriental in its general richness of effect that it is surprising to find each figure, in what might easily be a cluttered and confused composition, set out with decision and clarity.

In contrast, there are reliefs that pile scene

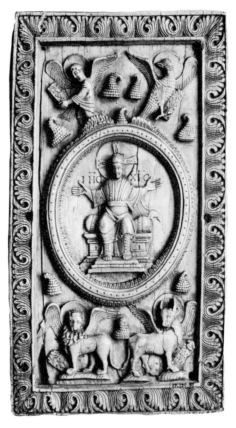

Christ in Majesty. Ivory. Ottonian.
Metropolitan Museum of Art

Crucifixion. Ivory. *British Museum*

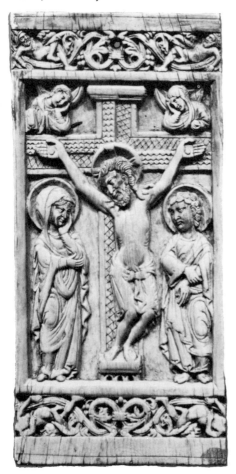

Crucifixion. Ivory. 10th–11th centuries.
Metropolitan Museum of Art

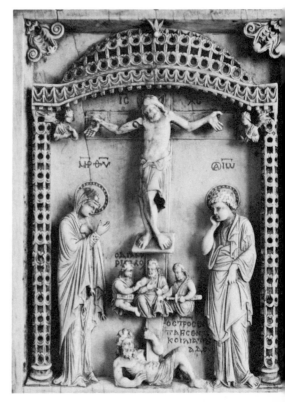

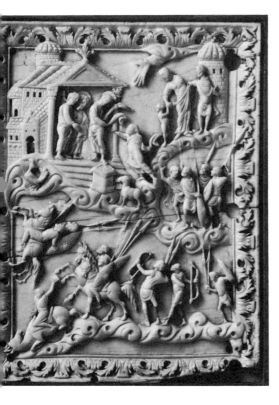

upon scene, employing, at times, scores of supernumeraries, depending not upon a figure or two to dominate the design, but rather upon a tapestry-like distribution of elements, with a flowing rhythm which unobtrusively holds the composition together. The panel from a bookbinding at Munich is a pleasing if unconventional example. The panel illustrating Psalm XXVII, now at the National Museum in Zurich, is at once explicit and fluid, and indeed a masterpiece.

The ivory leaf at Zurich showing the *Crucifixion and Deposition* is a more sober and conventional work. The upper panel illustrates beautifully the art of space-filling, in

Illustration for Psalm XXVII. Ivory. French, Carolingian, 9th century. National Museum, Zurich

Crucifixion and Related Scenes, panel from a bookbinding. Ivory. 10th–11th centuries. *State Library, Munich. (Courtesy Archiv für Kunst und Geschichte, Berlin)*

Crucifixion and Deposition. Ivory. 10th century. National Museum, Zurich. (Giraudon photo)

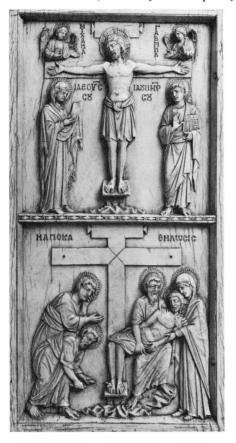

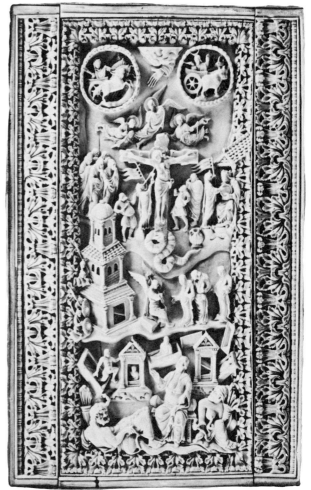

which the Byzantine carvers incomparably surpassed the Classical Greeks. The relative sizes of the figures are interesting, as is the function served by the two little inward-turned, winged half-figures.

It is hardly necessary to stress the devotion and the religious emotion expressed in the Carolingian and Ottonian ivory panels. They were produced during one of the supreme periods of Christian mysticism and worship, and something of the divine awareness and the reverence of the spiritual pilgrim breathes from these miniature devotional works. They were often made as portable altars or as insets for the bindings of Bibles or psalters, or for adorning reliquaries.

Notable religious works were made in metal too. The relief of *Christ Enthroned* is from southern Italy and is one leaf of a portable diptych. The important Frankish-Byzantine or Germano-Byzantine examples were more often plates adorning bookbindings. While Barbarian and Irish influences played their part in forming the impulse that led to the metal-casting at Hildesheim, there were potent currents from Italy too. There the Lombards had already developed a variation which pointed toward the Romanesque style.

A panel treating the old theme of animal-combat, below, is typically Byzantine. The *Adoration of the Kings,* an English piece, demonstrates how fully the Oriental manner had penetrated even westward of the European continent. Coptic and Byzantine art had developed within the Church. There was a third source of medieval Christian sculpture, seemingly alien: the barbarian works of the itinerant peoples. At the beginning of a new chapter we turn to the art of the successive waves of Wanderers.

Gladiators and Lions. Ivory. Byzantine. *Hermitage, Leningrad. (Giraudon Photo)*

Adoration of the Kings. Ivory. English, 11th century. *Victoria and Albert Museum*

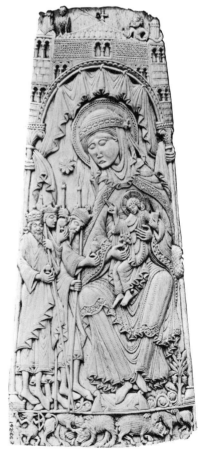

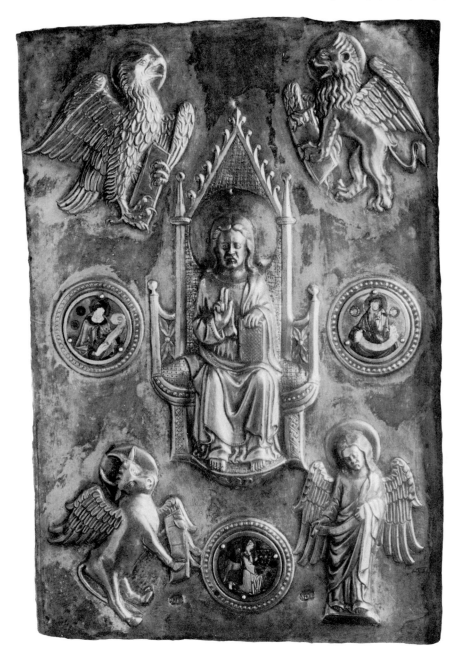

Christ Enthroned, with Symbols of the Evangelists, leaf of diptych. Metal.
Treasure of Cathedral of Lucera, Apulia, Italy. (Alinari photo)

13 : European Christian Sculpture:

Barbarian, Romanesque, Gothic

I

MIGRATORY tribes had no cities and built no churches or palaces, and so the Barbarian sculpture of the North achieved even less monumental expression than did Byzantine sculpture. The typical invention was in jewelry, weapons, and horse trappings; especially in metalwork studded with enamels or traced over with enriching graved designs. Like the Scyths, the Celts and the Gauls, the Franks and the Goths and the Lombards concentrated on miniature craftsmanship, but they produced objects that are marvels of spirited design.

Through more than a millennium the barbarians opposed their Indo-Germanic way of art to the flourishing, then the waning, Greco-Roman tradition. In the end they were overcome, just as, after sacking Rome again and again, they were absorbed into a new empire which was Christian and most dependent upon Byzantium for its culture. From the centuries of opposition there re-

Gargoyles. **Stone. 12th century.** *Notre Dame de Paris.* (*ND photo*)

main rich remnants of Barbarian art; and in the end it was the spirited free design and ornamental richness in the Northern style that transformed Roman and Byzantine arts into the glorious expression of Romanesque.

The Romans had pushed their way northward, spreading Roman civilization throughout Western Europe. Paris of the third century was Gallic-Roman, but the coming of the Franks in the fourth and fifth centuries added to the Germanic element. The suc-

cessive barbarian invasions modified Roman art almost beyond recognition.

Christianity was the great catalyst in the Dark Ages and Middle Ages. The barbarians who arrived in Central and Western Europe were anti-Christian as well as anti-Roman. But as minority groups, with shrewd and opportunistic leaders, they sometimes drifted into acceptance of, and sometimes fervently espoused, the new religion. It marked a turning-point in history when Clovis, King

Fibulae and ornaments. Bronze. Art of the wandering peoples.
Albania, Austria, Switzerland, etc. *St. Germain Museum; Cernuschi Museum; National Museum, Zurich*

of the Franks, the first truly French king, who had been converted to Christianity, bowed his head in the Church of St. Etienne in Paris.

By the late eleventh century, Celtic, Gallic, and Frankish art had been absorbed into the expressionistic Romanesque style. It was in the Romanesque centuries and the early decades of Gothic that the Christian spirit most richly and most truly inspired art. The story of Christian architecture is at no other time so glorious. The cathedrals of Chartres, Amiens, Reims, and Paris are among the most inspired buildings erected by men; the English cathedrals are hardly less noble. In spite of seven or eight centuries of wars and vandalism, the sculpture in the cathedrals and churches of the Middle Ages remains the one supreme exhibit in the West to compare with the art that flourished in Persia, India, and China.

The story of the building of the cathedrals is well known, and especially the emergence of artisan guilds that worked to produce the immensely complex fabric of the cathedrals. The extraordinary production of sculpture, a more personal art, is more difficult to account for. With a few exceptions, even the names of the sculptors are unrecorded. Most notably Gislebertus signed his name at Autun and has been credited with much of the work there between 1125 and 1135. Three centuries later Nicolas Gerhaert of Leyden was chiseling sculptures for Strasbourg Cathedral and left a unique signature in a stone self-portrait. But the artists who created the St. Peter at Moissac, the St. James at Compostela, and the Old Testament figures of the Royal Portal at Chartres, who covered with statues the portal recesses and façades of practically all the great cathedrals, and often their choirs and other areas within

The Royal Portal, Cathedral of Notre Dame, Chartres. Mid-12th century. (*ND photo*)

The Last Judgment, detail. Stone. 12th century.
Tympanum of Cathedral of St. Lazare, Autun. (Giraudon photo)

as well, at Paris and Reims, Strasbourg and Salisbury, Burgos and León, to name but a few—these are anonymous.

Barbarian art is known through the minor sculpture the migrants brought with them, such as safety pins for their clothing, and harness ornaments and sword-guards. Their style of curling, twisting shapes was preserved in its pure form in the Irish and the Scandinavian national expressions.

But in France the style was absorbed into the Romanesque. Thousands of capitals on columns in the Romanesque churches of Europe exhibit in their sculpture the spirit of the Indo-Germanic invaders—especially in the portrayal of animals. The expressionistic or distorting element in the larger sculptural investiture at Vézelay, Moissac, or the early doorways at Chartres has a similar origin.

When the Romanesque style became fully developed, the prodigious feats of medieval architecture and sculpture were accomplished. The churchmen, architects, and artists, whether working in stained glass or stone, had a single vision of the unified cathedral, awe-inspiringly simple in its engineering, amazingly adorned on its surfaces. All worked for their God to provide a vast storybook of religious legend and instruction.

Whether one today reads Christian history as the unfolding of man's understanding of the revelations of Christ, or takes account of the sources upon which the early Christian Fathers drew, such as the mystery-religions of Greece, of Asia, of Egypt, the old Palestinian learning, Platonism, and Mithraism, the trend was from classic intellectualism and materialism toward the spiritual life.

Spiritual art discounts the body. The spiritual artist turns away from nature except as a means of communication, to an image formed as a result of spiritual and aesthetic contemplation. Nature is discounted as far as exact measurements and lines and masses are concerned. Romanesque marks the supreme instance in the West of emotional or spiritual attainment in sculpture.

Classically trained historians in the nineteenth century found no excuse for the deformations of surface realism, and especially the unnaturalness of human and animal figures, in Romanesque works at such centers as Moissac, Vézelay, and Autun. They glorified the Gothic as the supreme art of the medieval centuries. In twentieth-century opinion, however, the art of the eleventh

and twelfth centuries is considered more creative.

It remains only to add dates for the events of this period. Barbarian art was being carried into Western Europe over a period of 1300 years. The Gauls had spread over France in the fourth and third centuries B.C. Although Gallic France was put under Roman rule by Julius Caesar in 58–51 B.C., the barbarian incursions continued for centuries after and culminated in the Frankish invasion of the third and fourth centuries. Celtic culture had pushed as far as Ireland in 400 B.C. The old Celtic art lived on for another twelve hundred years, in its purest form, in the Irish goldwork, stone sculptured crosses, and manuscripts (as in the famous *Book of Kells*, of the eighth century).

Romanesque architecture developed over an indeterminate period. Romanesque sculpture, however, matured only in the early eleventh century and was dominant for the following two hundred years. It was transformed into Gothic about the year 1200.

The architectural metamorphosis can be ascribed to approximately the mid-twelfth century, for the earliest combination of Romanesque vaulting with the pointed arch is commemorated in accounts of the building of the Cathedral of St. Denis. Eleanor of Aquitaine, then Queen of France, was shown the "new" style in the cathedral choir by Suger in 1144. The great cathedrals, except that of Paris, were in process of building. At Amiens, Chartres, Reims, Sens, they had been started in the Romanesque style but became Gothic in the course of construction. Notre Dame de Paris was a little later, begun in 1160, a date sometimes given for the emergence of the Gothic style.

This was the time of the decay of feudalism and the rise of town communes and the powerful state; of the beginnings of capitalism and the first emergence of a bourgeoisie. The Church, without seeming to relax control over men's minds, was admitting into everyday life new disruptive and divisive forces, was permitting changes in civil organization, education, and even ecclesiastical philosophy that were to lead to separation of Church and state, and to post-medieval intellectualism and materialism. The universities became centers of learning in a new sense. The transformation of Romanesque art into Gothic has its perfect parallel within the Church polity and the Church teaching, in the triumph of the Scholastics over the proponents of early Christian mysticism and faith. The logic and clarity of St. Thomas Aquinas and the science of Roger Bacon were replacing the mystic self-giving and the revelatory outpouring of St. Bernard. Emotional and spiritual expression retreated before a new confidence in reality, a new devotion to the non-abstract.

But the sculptors remained Romanesque-minded until well into the thirteenth century. As Gothic realism and Gothic grace took over in sculpture, the old expressionism died in France. It survived fitfully in Spain and the Spanish colonies until some centuries later. Broadly speaking, the years between about 1200 and 1500 in European sculptural history were substantially Gothic.

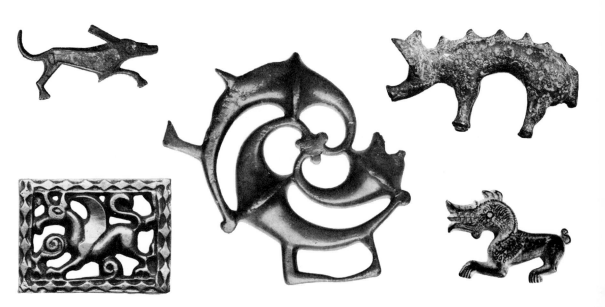

II

BARBARIAN art, which takes its name from its rivalry with Greco-Roman classic art ("barbarian" meaning "foreign"), flourished before the centuries of the organization of the Christian Church. It precedes and parallels the Early Christian art of the foregoing chapter. Its spirit and drive mark it as the chief creative forerunner of the monuments of Romanesque art. Except for the monumental Celtic crosses and some of the Viking figureheads, its works are small: usable jewelry such as fibulae, and harness accessories, sword guards, and coins.

The illustrations showing fibulae, ornaments, and animals indicate both the wide diffusion of the Barbarian style and the nature of Iron Age art as a continuation of an Asian tradition. The animals, and the fibulae and ornaments that suggest animals without recognizably depicting the head, body, or legs, are from districts as far separated as Macedonia and Ireland, the Baltic Sea and Iberia. Here is visual evidence of lines of descent, among people known as Celts, Franks, Goths, and Anglo-Saxons, from remote ancestors in the steppe country, where the animal art had developed a thousand or more years before Christ.

The style or expression is limited, as is the means: laboriously worked metal, quite commonly inset with enamel or colored stone, and embossed or engraved. Geometric or vaguely zoomorphic ornament is standard over the entire territory. The total design, in outline and mass, suggests a Scythian connection or perhaps connection with a late development of Scythian such as Sarmatian.

The fish and the birds and the ornamental fibula of the first group of illustrations, with depressions once filled with enamels (page 311), and formalized animals, mostly from Central Europe, above and opposite, are

Animals and *Animal Abstraction*. Bronze; gold. Celtic, Avaric, 9th century B.C.–6th century A.D. Switzerland; England; France; Albania. *Metropolitan Museum of Art (above, left and center)*; *British Museum (above, top right)*; *Art Museum, Princeton University (above, lower right, and facing page, left)*; *National Museum, Zurich (facing page, right)*

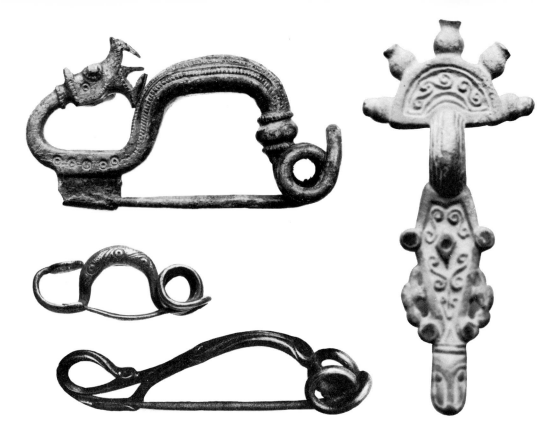

reminiscent indeed of the old steppe-country art. (The bird with wings spread *is* from Asia.) The bordered griffin in gold is a perfect example. In the European fibulae and brooches the animal form is implied rather than stated. The spirit of the beast survives in decorative rather than figurative compositions.

The *Boar* (page 315, top right) is a British work of the first century A.D., at the time when the Emperor Claudius was initiating the first successful invasion of the islands; and the sparse ornamental ridgings along the back and the concave ears are idioms in many ornaments of the time. The brooch or safety pin of bronze wire is an Irish variation of the pin type, but the general form of it can be traced back through the La Tene Periods

Brooches and fibulae. Bronze; silvered bronze. Celtic, various dates.
Tessin, Switzerland; Ireland; England; France.
National Museum, Zurich; British Museum; Louvre; Victoria and Albert Museum

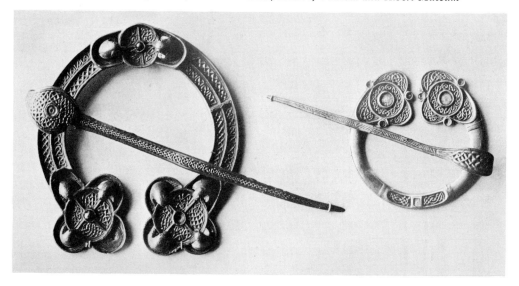

and through Hallstatt to the Bronze Age civilizations of Eastern Europe and north-western Asia. The brooch (in silvered bronze), with animal heads all but lost in the geometric pattern, is typical Celtic, of the penannular type best known in Irish art, but closely related to British and Scandi-navian design. (At bottom of facing page.)

The animals on a pair of beak-flagons in the British Museum, so directly suggesting their steppe-art ancestry, illustrate a rarer phase of Celtic and are said to be of the fourth century. The beak-flagon form itself can be traced back over the territory and the centuries of the wandering peoples, to the racial reservoir in upper Eurasia and back to Altai-Iran. (An early example will be found among the illustrations of Luristan bronzes.) The Celtic animals, when they are free of ornament, are uncommonly graceful and even elegant.

Indeed, despite miles of exhibits uncouth and fumbling as works of art, in natural-history museums, the best of Gallic-Celtic

sculpture comprises a style brilliant and vital. It leads on to the phase of Frankish art known as Merovingian, from the legendary figure of Merovech, king of the Salian Franks and grandfather of King Clovis, a type of Barbarian art best known in panels of Oriental-looking interlaced ornament set into architecture.

The most important phase of Christian art in a purely Barbarian style produced the towering Celtic stone crosses of Ireland and the borderland of Scotland and Northumber-land. Elsewhere the barbarian rulers, when converted to Christianity, had called in late Roman and especially Byzantine craftsmen to adorn their persons, their palaces, and their churches, as Theodoric had done at Ravenna, and as Charlemagne was doing at about the time when the Irish monastic art was at its peak.

During the darkest period of the struggles of barbarians and Romans, the Irish had be-

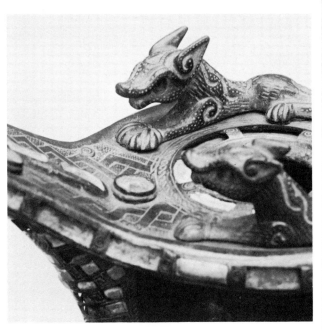

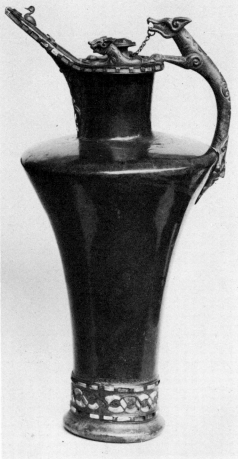

Beak-flagon, with detail. Bronze. Celtic, 4th century. *British Museum*

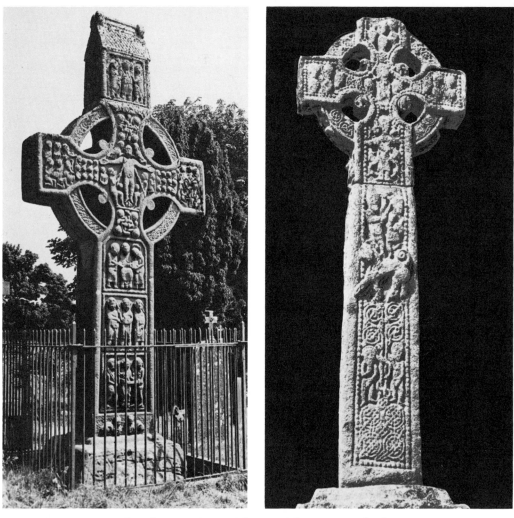

Burial crosses. Stone. Celtic, c. 10th century. Ireland

come the foremost conservators of Christian learning and of the arts of the scriptoria. They founded famous monasteries as far away as Fulda in Germany and St. Gall in Switzerland, and were known at St. Denis in France, and, of course, in Scotland and England. They jealously guarded their traditional style and they emerged with this distinctive sculptural expression.

The crosses, surviving still in numberless cemeteries, are generally in the form of a Celtic cross, with a ring encircling the intersection of arms and shaft. Each face of the monument is divided into panels and ornamented with figure groups or other compositions. The figures are those of the Old Testament or Christian tradition and some-

times of St. Patrick. The ornamental panels portray the beasts of the earlier Celtic tradition and represent them in one of the boldest approximations of the Scythian style; or else they luxuriate in the fascinating patterns of abstract ornament built on endless spirals and interlacings, as better known in the Irish illuminated manuscripts.

The Norsemen were also from the great Eastern reservoir to which the creators of Celtic art can be traced. The Vikings had become unfavorably known as marauders and conquerors down the coasts of the British Isles and along the rivers of France, and through the European-Mediterranean waterway as far as Sicily. To the Irish they were sometimes neighbors, but as pirates and in-

vaders they carried away great quantities of booty, including many examples of Irish art. How far the imported pieces affected native Scandinavian industry can only be guessed. In any case, there emerged in Scandinavia a type of sculpture, dated from the seventh to the eleventh centuries, that is patently a sister art to the geometric and zoomorphic sculpture of Eire and Saxon England.

The prows of the Viking ships were

Stern-post of a Viking ship. Wood. C. 800. The Oseberg Find. *Historical Museum, Oslo*

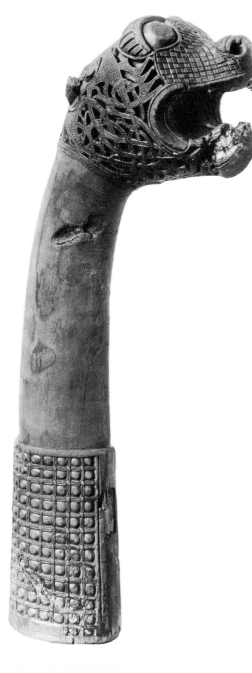

adorned with figureheads, though these were mostly patterned over until the vital play of light and shade became more important than the beasts portrayed. The near-geometric patterns yield upon study the interlacings, the endless spirals, and the abstract leaf motives of Irish Celtic decoration. The wood carving on the door of a church at Urnes in Norway, mixing vaguely animalesque motives with abstraction, is one of the few surviving masterpieces in the style. It is beautiful and vital, and, though recut in modern times, it apparently has lost none of the original élan. The artist-craftsmen of Iceland contributed handsomely to the Northern style. The illustrated bronze clasp below is typical.

The legions of Rome brought civil organization and Roman luxuries and arts to the new territories of Gaul and Britain. Such architectural masterpieces as the Pont du Gard and the temple known as the Maison Carrée at Nîmes were produced, but, on the whole, provincial Roman art in Western Europe was mediocre. As Roman power collapsed, the Roman style somewhat influenced the barbarians of France in a variation known as Gallo-Roman. Rare examples of architectural sculpture uncovered on walls of early churches in southwest France represent the best of the style, which is heavy and more

Clasp. Bronze. Icelandic, 10th–11th centuries. *National Museum, Reykjavik*

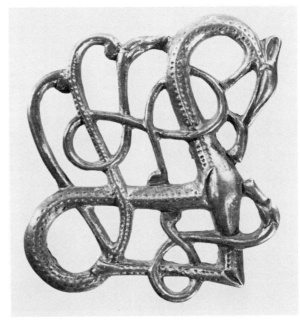

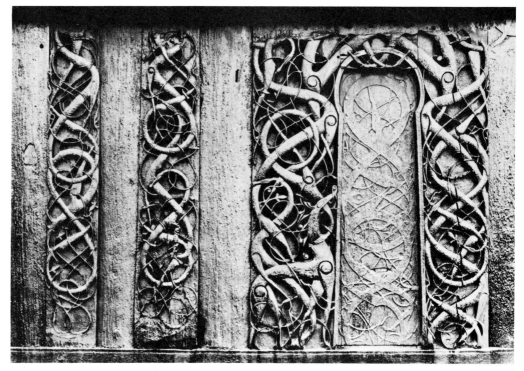

Norse woodcarving. Possibly 10th century. Doorway of church at Urnes, Norway,
transferred from earlier building

massive than Byzantine or the Romanesque that was to follow later. The figure panel shown is thought to have been transferred to a niche on a church at St. Astier, in the Dordogne, from an earlier building. Scholars believe it illustrates a local transformation of insensitive Roman imaging into a distinctive, frankly decorative native mode. Perhaps ten centuries later, Breton folk art embodied a style which looks like a late but direct survival of the Gallo-Roman, unlike the late Gothic expression of its own time, about the seventeenth century. (Facing page, above.)

Some authorities would mark certain capitals and other details in the early French churches as purest Barbarian, possible only to descendants of the creators of the Asian animal style. The beasts are at once dynamic and decorative, originally Scythian or Indo-Iranian, known alike to the Lurs and to the Sassanian Persians and to the mature artists of Byzantium. They were inherited through another line by the Celts, the Gauls, and the Vikings, and had gone through tortuous and confusing permutations. These are animals transmitted, by one road or another, from Altai-Iran, without loss of spiritedness or significant change of emphasis. In the West they are encountered oftenest in the churches of Provence and of Southwest and Central France.

Those who named the Romanesque style thought of it as a reflowering, in the Romance countries, of qualities inherent in Roman and classic culture. But now there seems to be more reason to identify the character of it as rising from barbarian and Byzantine sources. The mysticism of it is Eastern and Northern, and the outward expressionism, with frequent reliance upon exaggeration and distortion, is totally foreign to Roman ideals.

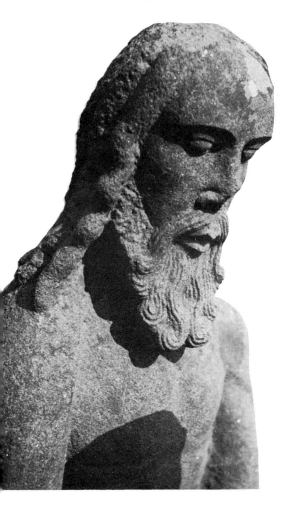

Yet classical ornaments are embedded in the decorative complexes at St. Gilles in Gard and upon St. Trophîme in Arles, and essentially Roman arches are superimposed on the façades at Poitiers and at Angoulême. The figures on these churches, nevertheless, could not by any stretch of imagination be linked with the classic, and the added patterning is richest Oriental. The truth may be that the *architectural* mode of Romanesque design grew logically out of experiment with Roman forms, but that the builders sought their sculptural adornment from other sources.

Whatever the roots, the flowering of Romanesque sculpture is one of the most magnificent in the records of the art. The crossing of currents from Rome and from the East is vividly illustrated in the tapestry-like façade of Notre Dame la Grande at Poitiers. The complex figures and opulent foliage in the capital from Angoulême Cathedral sufficiently emphasize the non-classical

Head of Christ, detail of Calvaire. 16th–17th centuries. *Pleyben, Brittany.* (*Photo by Jean Roubier*)

Figure panel. Stone. Gallo-Roman.
Church of St. Astier, Dordogne

Capital with animals. Stone.
Romanesque. France. (*Bulloz photo*)

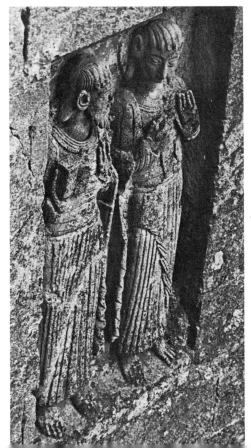

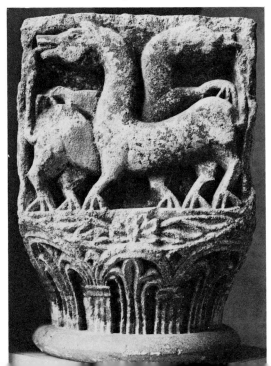

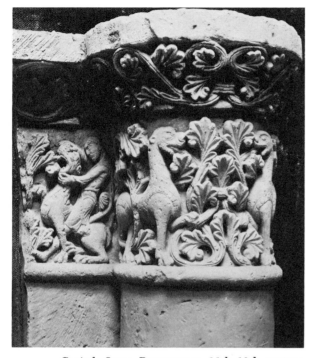

Capital. Stone. Romanesque, 11th–12th century. *Cathedral of Angoulême. (Archives Roget-Viollet)*

nature of certain of the sculptural detail set into the architectural fabric of early Romanesque design.

The appearance of the Romanesque style marks the great revival of the building arts in France, which had known little of monumental expression since the Romans completed the last provincial temples, theaters, and arenas. As was to be expected, some of the influence crept up from Italy, where Roman architecture had been followed by early Christian basilicas and by such monuments as the Byzantine churches at Ravenna and some related monuments in Sicily. In northern Italy, too, the Lombards, by the eleventh century, had created a first tentative version of Romanesque.

If there is not the magnificent show of Romanesque sculpture in the cities of Lombardy and Tuscany (despite fascinating works at Pistoia and Parma and elsewhere),

Façade of Church of Notre Dame la Grande, Poitiers. 11th–12th century. (*Archives Roget-Viollet*)

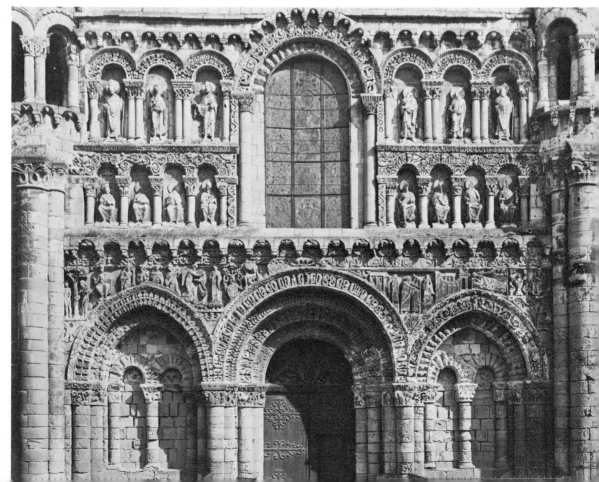

the Italian Germans are yet to be credited with one of the earliest contributions to the new style. The stone reliefs on cathedrals at Modena, Verona, and Ferrara, and the relief panels on the bronze doors (of later date) of Pisa Cathedral and Benevento Cathedral, present sometimes competent and often beautifully crisp relief scenes, more sculptural and nearer the full round than similar Byzantine reliefs had been. (Benevento, in southern Italy, had been a Lombard duchy from the sixth to the eleventh centuries.)

The Frankish Germans at the same time, as mentioned in an earlier chapter, had created or fostered fresh idioms as the Ottonian School matured, especially at Hildesheim, where the style of the cathedral doors is reminiscent of the Byzantine-Romanesque found in Italy. In the ivory reliefs the late Ottonian sculptural changes, the slenderer figures, the asymmetrical compositions, the more dramatic presentation of the story element, and a certain twisting, even tortured

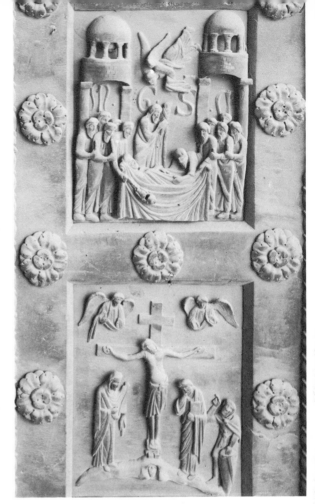

Detail of door of Pisa Cathedral. Bronze. Bonanno Pisano. 12th century. (*Alinari photo*)

Detail of door of Benevento Cathedral. Bronze. 12th century. (*Alinari photo*)

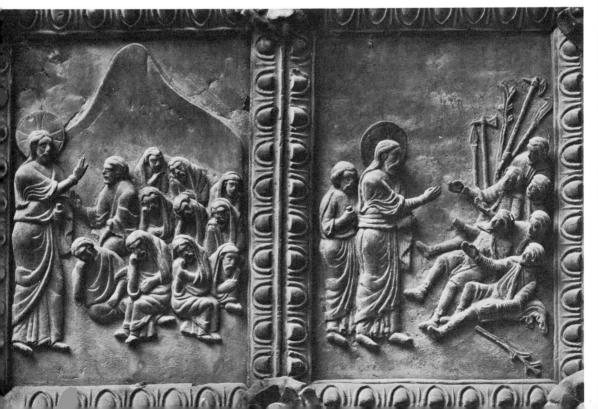

quality entering into the drawing, mark the transition from Byzantine into a more aspiring and vital language of art. There is a new relish for drama, for exaggerated action.

The carvers of portable ivories carried on their trade throughout the eleventh and twelfth centuries, the approximate period of Romanesque ascendancy. The leaf of a Spanish diptych, showing *Biblical Scenes,* at the Metropolitan Museum combines Byzantine rhythmic design and ornamentalism with the new dramatic statement by means of exaggerated gesture, forced action, and a degree of distortion not to recur in Europe before twentieth-century expressionism.

The workers in metal also reflected the transition, especially the enamelers. In the little *Crucifixion* on a bookbinding at the Metropolitan Museum, the Byzantine rounding of forms survives but is modified by exaggerations that give alertness and fuller plastic life to the figures. The eleventh-century medallion (which is still attached to a battered reliquary at Conques) likewise illustrates the artist's training in Byzantine disciplined craftsmanship, and his attempt to find a more emotional and dynamic mode of expression.

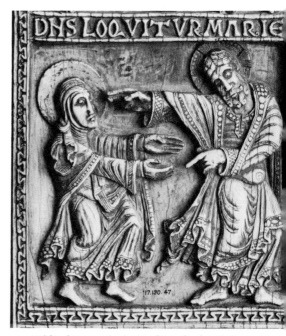

Biblical Scene, leaf of a diptych, detail. Ivory. Romanesque, 11th–12th centuries. Spain. *Metropolitan Museum of Art*

Crucifixion, on a book cover. Ivory, metals, and jewels. Romanesque, 11th century. Spain. *Metropolitan Museum of Art*

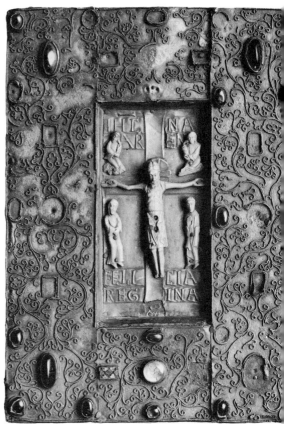

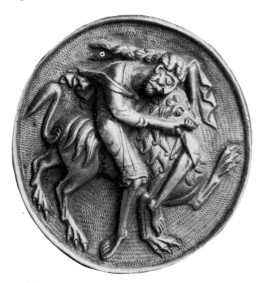

Medallion on Reliquary of Begon. 11th century. *Treasure of Church of Sainte-Foy, Conques, France. (Giraudon photo)*

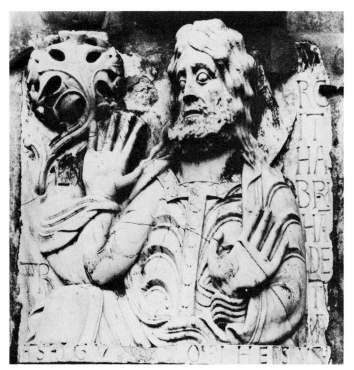

St. James, relief. Stone. Romanesque, 11th–12th centuries. Spain.
Cathedral of Santiago de Compostela

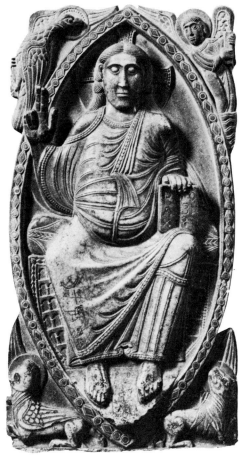

But to return to the mainstream, the Christian religion enjoyed one of its most glorious revivals in the eleventh century. There occurred then an unparalleled outpouring of works of aesthetic creation, that left its record on innumerable portals and in the tympanums of Vézelay, Moissac, and Chartres, and on the façades and naves of so many lesser cathedrals and churches of France.

The figure of Christ in the ambulatory of St. Sernin at Toulouse, at right, too solidly monumental and too roundly chiseled to be called Romanesque, is yet a focal point in a church architecturally in the later style. The aspect of the figure is Oriental and Byzantine.

In Spain the Oriental tradition was even stronger, reinforced by the contribution of the Moors. The Church of St. James at Compostela disputes with St. Sernin the honor of being the earliest outstanding monument of Romanesque building, and it is adorned with a greater wealth of transitional sculpture. The relief of St. James at the moment of the Transfiguration, above, is in-

deed more magnificent than any contemporary French piece. This early Romanesque masterpiece is of the final decade of the eleventh century or the early twelfth.

There are innumerable capitals in the Spanish churches that show inspired sculptural invention, and at Compostela many figures in high relief are worthy companion pieces to the St. James. But it was in France that the new style swept over the land and found expression in an amazing number of cathedrals and churches; that the dynamic expressionist mode of design crystallized as an unmistakable style. In the Church of St. Madeleine at Vézelay it is clear that Byzantium has made its contribution but its influence has largely passed. There are patterned areas and borders of enchanting medallions and beast-and-flower capitals, but these are incidental to an exhibit of figure sculpture of sheerest creativeness, consistent stylization, and extraordinary plastic sensibility.

This is the morning of European Christian art, the time of vision and aspiration and inspired craftsmanship. Sustained by the Christian philosophy, by an inspiring mysticism, and by a wholehearted dedication to work in the service of God, the sculptors produced masterpieces of devotional art. As growth of the spirit of Christianity marked a revolt against the violence and materialism into which the Roman world had sunk, so Christian art might be read as a reaction from the

Central portal of Church of S. Madeleine, Vézelay. 11th–12th centuries. (*ND photo*)

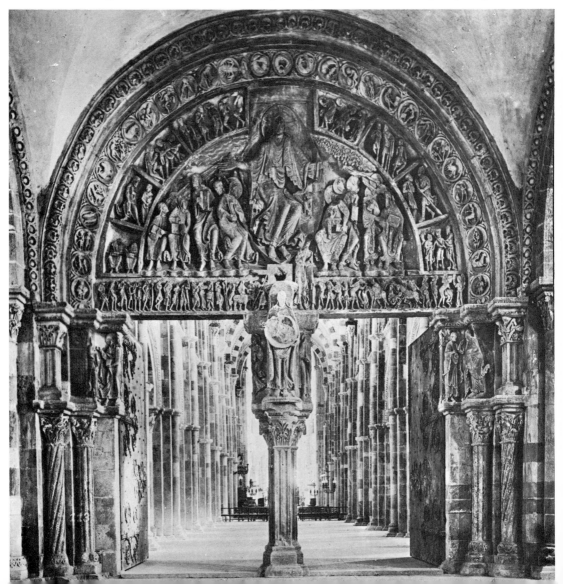

naturalism and materialism of late Greek and Roman art.

At Vézelay, Autun, and Moissac the "unnatural" phase of Christian sculptural art is supremely illustrated. Despite the complicated arrangement of the tympanum, the composition at Vézelay holds together perfectly, constituting, as may be seen from the illustration, a fitting portal to the impressive nave.

The detailed scene from the *Last Judgment* on the tympanum at Autun (page 313) is an example of the most exaggerated stylization. It indicates both likenesses to and variations in the style in neighboring communities, both near Cluny. At Cluny itself the abbey church, which was largely destroyed in the First Empire, was known as the richest monument of Romanesque design in France.

In its tympanum, its porches with story scenes, its isolated relief figures, and its cloister capitals, the Church of St. Peter at Moissac affords as near a complete range of Romanesque sculpture as can be found (see below). The French Revolution and the Puritan movement in England let loose iconoclasts who did a stupendous job of smashing "idols" and denuding churches of their sculptural and painted wealth. Moissac is far to the southwest, but on the Burgundian "pilgrim road" to Spanish shrines. Here the extreme stylization is evident, but the exaggerations, even the deformities, are less striking.

Biblical Scenes, detail. **Porch of Church of St. Peter, Moissac.** (*Photo by Jean Roubier*)

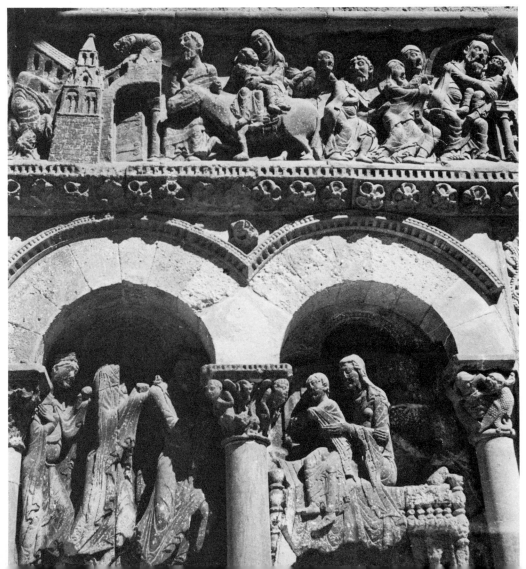

One of the characteristics which separate Romanesque from Gothic sculpture is the respect shown by the earlier artists for the whole architectonic composition. They seldom obscured a structural line or impaired a boundary. They could however, introduce a relief figure on a pillar or a jamb with extraordinary effectiveness. At Moissac the jamb figures are among the most notable isolated reliefs known to Romanesque sculpture. The *St. Peter* illustrated is in the main channel of the style—elongated and forced into an extreme gesturing pose, carved in the purest manner (with lightly repeated folds accentuating the long lines, and relieved by rich but restricted patterning), with special intentness displayed in the face, above hands no less expressive. Even the key is decorative.

Mention has been made of the eccentricities, not to say the wild distortions, at Autun. These ran not only to stylistic deformations but to the depiction of abnormal creatures such as human-headed monsters and monster-headed humans, or two beasts with one head. To create horror was one of the purposes of the sculptors of the time; Gislebertus added to his signature on the *Last Judgment* at Autun the admonition, "Let these terrors frighten those who live their lives on earth in sin." St. Bernard of

St. Peter. Stone. *Church of St. Peter, Moissac.* (*Giraudon photo*)

Angel. Stone. 12th century. *Within a porch at St. Gilles du Gard.* (*Photo by Noel le Boyer*)

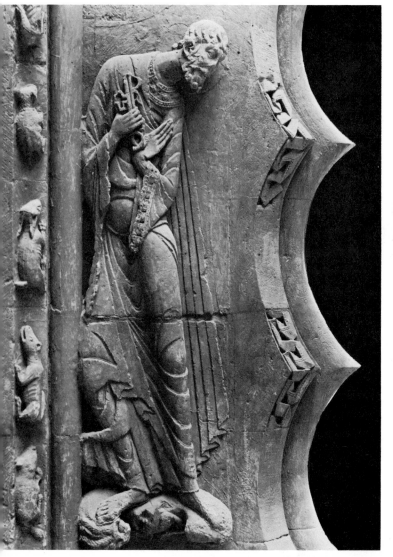

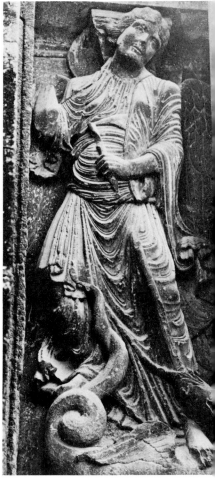

Clairvaux, the greatest churchman of the age, whose one purpose was to bring men into consciousness of God's presence, abhorred the sculptured horrors and protested against them as pagan and alien disturbances of Christian calm. (See page 313.)

To the north the church-builders borrowed the unnatural animals but portrayed them without so much distortion. At Aulnay, where the north portal of the transept is a model of restrained but rich Romanesque design, the arch over the outermost columns bears thirty-four of the monstrous carvings, which seem here to have little more than a decorative purpose. Each capital and each semicircular panel is vital, as is the horizontal frieze of the doorway. In the central part of France, Auvergne and westward, such adaptations of the Romanesque style developed.

The school of the south, sometimes called the School of Languedoc, with the Cluniac or Burgundian School, had provided the truer pattern of Romanesque sculpture (though not so fully of Romanesque architecture); while Auvergne and the central-west country and Provence drew upon methods

and even subject-matter standard along the pilgrim road. In Provence the style became more exuberant, and this may be attributed to the continual traffic and influence along the littoral from Italy and by sea from the Orient through Marseilles.

At Arles and in St. Gilles-du-Gard the architects and sculptors composed scenes in which the Apostles and Church Fathers, with traces of Roman, Byzantesque, and Romanesque ways of imaging, consort with unreal Oriental beasts, Lombard variety, amid panels of patterning that strangely oscillate between the Byzantine and Roman styles. Corinthian capitals and acanthus borders, the lions of the Lombard porches, friezes crowded with figures in the southwest Romanesque style—all were incorporated into a rich, if not very well-integrated, local language of sculpture. Some of the single figures at St. Gilles, moreover, like some of the capitals in the cloisters at Arles, indicate a mature sense of the monumental along with feeling for decorative effect. The *Angel* at left, not to be identified stylistically, is arrestingly handsome.

By the mid-twelfth century the Roman-

Doorway of Church of St. Peter, Aulnay. (*Photo Roget-Viollet*)

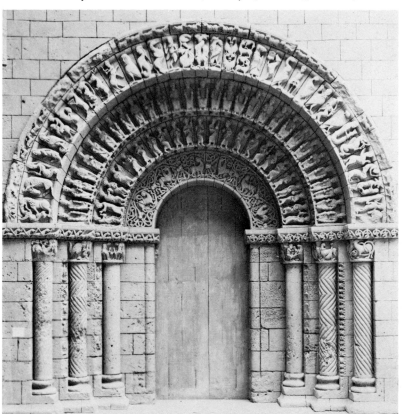

esque style had spread over a great deal of France and notable monuments were being erected in Brittany, in Normandy (where the builders had been among the inventors of Romanesque rib vaulting), and in the Ile de France. The more eccentric and angular of the peculiarities evident at Moissac and Vézelay were modified in the north, so that at Chartres there is little to distress the eye of the realist; though the typical Romanesque vigor and dynamism survive, together with enough of the stylization, as seen in the slenderized figures and the schematic treatment of draperies and hair, to mark parts of the decoration as pre-Gothic.

The way in which the late Romanesque sculptors utilized the slender figures to decorate columns or pilasters, without dis-turbing architectural lines, is especially well illustrated by the *Christ* on the trumeau at the church of St. Loup de Naud. Here the Romanesque heritage from Byzantium is still evident in the patches of rich ornamentation, soon to be suppressed by sculptors devoted to naturalism, and the gesture and the alert pose are typical.

The cathedral at Chartres most nobly illustrates the whole transition from Romanesque to Gothic (with some unfortunate post-Gothic "improvements"). The sculpture of the west façade must be dated close to 1150, while other parts of the church and decorations belong to the late twelfth century and the thirteenth. The typical Romanesque respect for the architectural line is observed in the west or Royal Portal, as seen in the

Detail of the main portal of the Church of St. Trophîme, Arles. Southern Romanesque. (*Giraudon photo*)

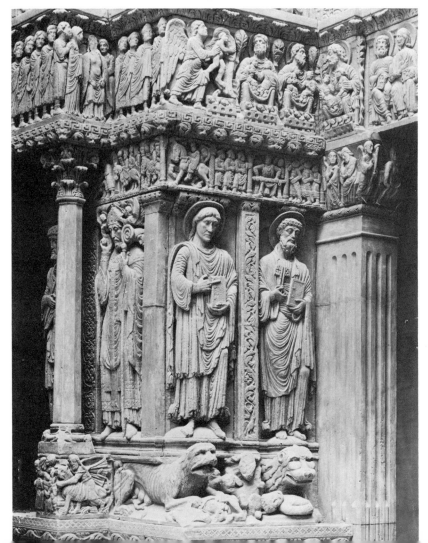

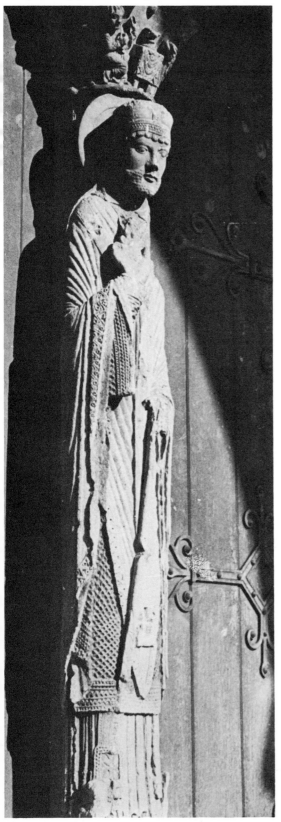

Christ, on trumeau. *Church of St. Loup de Naud.* (*Photo by Jean Roubier*)

photograph on page 312. (It is necessary only to look at page 340 in order to realize how the later sculptors spilled their figures beyond the implied architectonic limits, making a statue a display in itself rather than a motive in a preconceived and controlled fabric.) The figures flanking the Royal Portal, each carved on a pillar-stone, are among the most impressive in the late Romanesque restrained style. The utterly stylized figures seen in close-up (in the photograph on the following page), with folded draperies in the old Burgundian tradition, mark a high point in sculpture serving and intensifying architectural appeal.

At the time of the Norman invasion the Romanesque builders carried their art to England. The new rulers were inspired to erect churches as large and majestic as those of France. They took with them religious leaders, engineers, and masons; and thus Romanesque became the standard style for such monuments as the cathedrals at Canterbury, Durham, and Ely. The Romanesque name has generally been discarded in England in favor of "Norman."

Architecturally, there was little change at first from the style as known in France. At Durham the structure has generally heavy columns in the nave, round arches, and—first step toward the Gothic—rib vaulting over the nave and aisles. Ely Cathedral outwardly retains more of the Romanesque appearance. At many of the cathedrals—Salisbury, York, Canterbury, Lincoln, Worcester, Wells—the outward aspect is Gothic, owing to change to the pointed style during construction, or to later additions.

In the English cathedrals the art of sculpture was less well served than at Arles or Moissac or Chartres. Romanesque carving as known in France is surprisingly scarce and incidental in the magnificent cathedrals and abbey churches. English Norman sculpture, nevertheless, is interesting and appealing by reason of elements surviving from an antecedent native style.

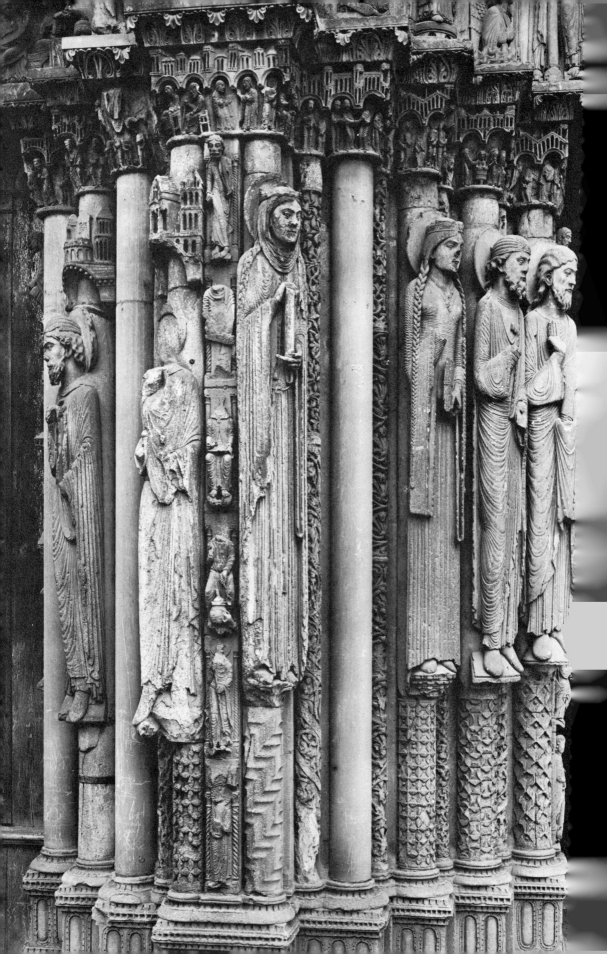

The Celtic crosses, best known in Ireland, are found occasionally in the counties of the West and North of England. After the Celts there had been the Saxons, bringing an art closely related to that of earlier Wandering Peoples. (The next invasion, that of the Danes, had little effect upon Anglo-Saxon art.)

In a church at Kilpeck in Herefordshire there are figures and panels of ornament that seem to be descended directly from the old Celtic and Anglo-Saxon art, and other figures that recall the Romanesque expressionist tradition of the French pilgrimage churches. The detail illustrated, a section of a double column or shaft flanking the church doorway, suggests an origin in the interlacing orna-

Facing page:
Detail of Royal Portal, Chartres.
(*ND photo*)

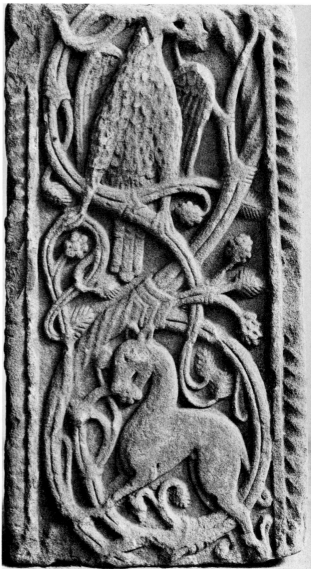

Decorative panel.
Stone. 8th century.
Easby Abbey, Yorkshire.
Victoria and Albert Museum

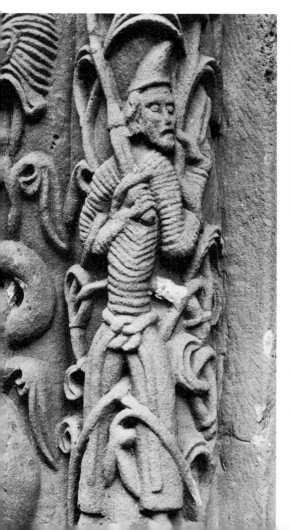

Warrior, detail from door shaft. Stone.
12th century. *Church of St. Mary and St. David,*
Kilpeck, Herefordshire.
(*Photo by Jean Roubier*)

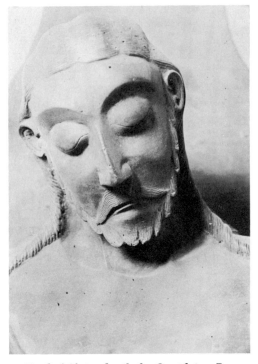

Head of Christ, detail of a *Crucifixion*. Bronze. German, 11th century. *Abbey Church, Werden an der Ruhr. (Archiv für Kunst and Geschichte, Berlin)*

The Lion of Brunswick. Bronze. 1166. Burgplatz, Brunswick, Germany. *(Archiv für Kunst und Geschichte, Berlin)*

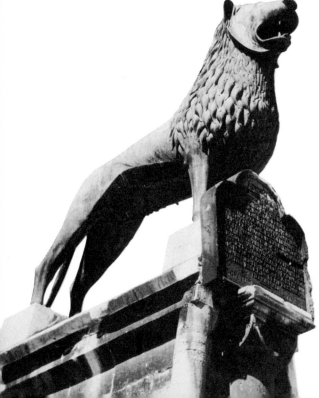

ment and the attenuated figuring familiar in Irish and Scandinavian sculpture of the preceding centuries. Dated c. 1160, it is an exceptional example of English Norman sculpture enlivened by lingering Iro-Celtic spirit. A detailed illustration from Easby Abbey in Yorkshire shows a fragment of a decorative panel of earlier date than the imported Norman, but with the vigorous carving, rich patterning, and carelessness of nature that characterize the Romanesque style. It is a sort of sculpture rooted in the Celtic style but modified in the following Germanic or Anglo-Saxon centuries, and perfectly fitted for fusion with twelfth-century Norman.

In the Norman cathedrals of England a number of monumental sculptural designs are known. At Chichester in the choir aisle are two large panels of patched-together stones bearing scenes picturing Christ meeting with Mary and Martha and the Raising of Lazarus. These ambitious and rather crowded reliefs

Head of Christ, detail of *Crucifix* at top of facing page. *National Museum, Nuremberg. (Archiv für Kunst und Geschichte, Berlin)*

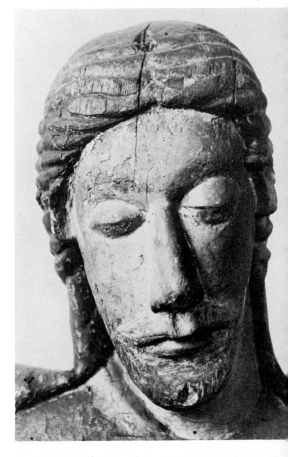

Crucifix. Wood. German, 11th century.
National Museum, Nuremberg

suffer, however, from a certain clumsiness in the carving. Salisbury Cathedral and Wells Cathedral are but two of several having western façades richly embellished with sculptured figures—350 at Wells; but the arrangement is generally unimaginative, in mechanically repeated niches, and the quality of the individual carvings is not at the top Romanesque (or Gothic) level. Occasional Norman doorways survive, such as the handsome Prior's Portal at Ely, with a tympanum seemingly in direct line from the early Romanesque of Southern France. But it is true that the Norman builders, whether in pre-Conquest Normandy or in England, put less stress on sculptural adornment and more on purely architectural invention. And in England the Reformation iconoclasts destroyed or defaced most of the "idols" they could reach. What is left is hardly more than the few monuments and portals mentioned. The real treasures, Romanesque or Gothic, consist of fonts, tomb figures, capitals, and what would be beam-ends if we were talking of wooden buildings. The capital illustrated from Canterbury Cathedral, with its spirited composition of a griffin and a serpent, is characteristic.

There are prime monuments in Germany, especially of early Romanesque architecture; and crucifixes in wood and a multitude of metal works have survived that are fully in the pre-Gothic expressionist vein. One of the most distinctive works of the eleventh century, marking the early morning of post-Byzantine sculptural art, is the bronze *Crucifixion* in the abbey church at Werden an der Ruhr. (The head is illustrated on page 334.) This striking and, to some eyes, distressingly stylized interpretation of Christ on the Tree

Capital. Stone. Early 12th century.
Canterbury Cathedral. (Photo by Jean Roubier)

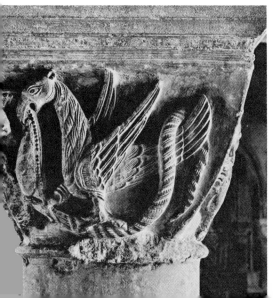

is a product of the Saxon School, which was responsible for some of the finest bronze-casting of the Middle Ages. The *Lion of Brunswick* is another example from this accomplished school. Hardly since Etruscan art faded into Roman had such a spirited beast been cast in Europe; it is the only free-standing Romanesque survival in monumental size.

Among the Romanesque relics in wood, the German crucifixes are particularly fine, and they are marked with an expressiveness wholly different from the Byzantine on one hand and the Gothic on the other. The *Crucifix* at Nuremberg is especially notable. The body is characteristic of a school of woodcutters of upper Germany. The statue is perhaps the outstanding masterpiece of the German expressionist school of the late eleventh and the early twelfth centuries.

The head, shown separately, marks a trend of the Romanesque woodcarvers of Germany toward lifelike statement. The face is surprisingly natural, with just the change from formalization and generalization that spells the transition from Romanesque to Gothic sculpture.

A painted wooden crucifix at the Metropolitan Museum illustrates a common Spanish type. Again it is a late example of the style: although the body is hardly less summary and symbolic than the extreme German examples of a century earlier, the face is livingly dramatic. (The head is on this page, far left.) The Romanesque style lived on in Spain long after the transition to Gothic in France, and Spanish colonial art in Mexico and in South America yields examples to the nineteenth century. The *Prophet* shown is a Spanish work of the fifteenth century, and the treatment of the eyes and brows, and the general heavy ridging for dramatic light-and-shade are Romanesque mannerisms.

The bronze work of the transitional period was even more varied, and even after 1200 the candlesticks, and especially the aquamanili, were apt to exhibit all the vigor, the frank distortion, and the fancifulness belonging to Romanesque invention, with some Byzantine ornamentalism. This development occurred first in Germany, and later in Northern Italy, France, England, and Flanders.

The illustration of the horseman and two candleholders shows three examples in the Louvre and exhibits strikingly different modes of formalization. The style was still distorted, and it is clear from each example that the artist's intention was not to represent nature

Head of Christ. Wood, painted. Spanish, 12th century. *Metropolitan Museum of Art*

Prophet, detail. Wood. Spanish, 15th century. *Ridgeway Collection, Paris. (Giraudon photo)*

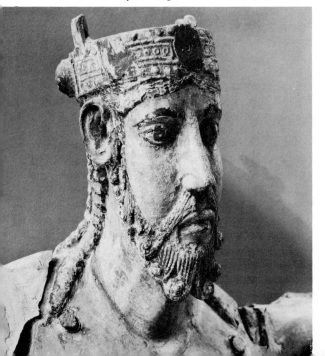

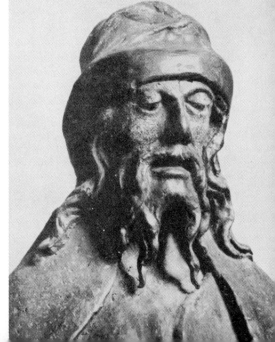

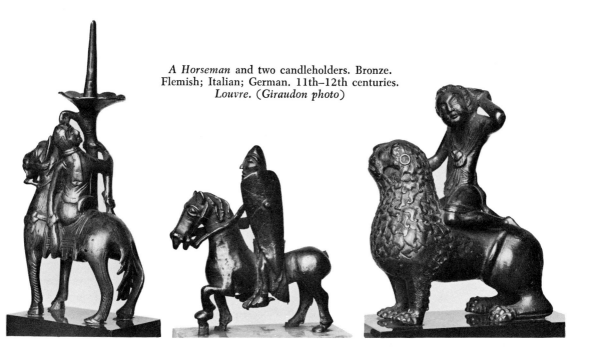

A Horseman and two candleholders. Bronze.
Flemish; Italian; German. 11th–12th centuries.
Louvre. (*Giraudon photo*)

but to create self-sufficient artistic entities. The statuette of a knight on horseback is oldest and is supposedly Italian. The rather lumpy primitivism of the sculptural method is extraordinarily effective. The candleholder on the left is a commoner type, probably Flemish. The frank conventionalization, as seen especially in the horse's haunches and tail and in the virile, curving lines, survived in the metalworkers' studios as late as the fifteenth century. The candleholder on the right might be of a time when Byzantine art was first giving way before the more dramatic Romanesque, but it has also been accorded a considerably later date.

The aquamanile in polished bronze, below, a fauceted vessel representing a *Horse,* now at the Cluny Museum, suggests a connection with the style of the Celtic beak-flagons; and from the Scythians survives the art of imposing one animal, in the handle, upon another of a totally different kind.

Horse. Aquamanile. Bronze. Flemish, 15th century. *Cluny Museum, Paris.* (*Alinari photo*)

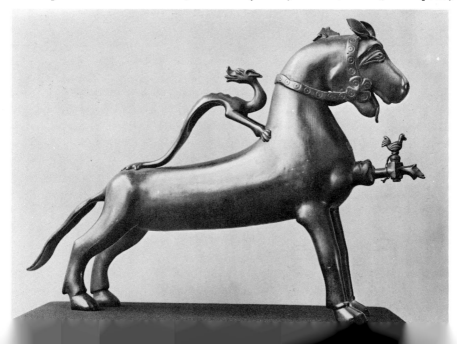

Naturalism began to take over Christian art, and for a time the new realism was conditioned by imagination and by a lingering idealism. But late Gothic sculpture was to illustrate a melancholy descent from fitting architectural carving, from architectonic integrity and disciplined group expression, to a parade of occasional pieces, each effectively "real" or sentimentally engaging or clever, but without framework.

With the first outpouring of the new spirit, Gothic sculpture bounds forward on a grand and disciplined scale, lit up with a new and perceptive interest in the phenomenal world. The logic that renders the cathedrals of Paris, Amiens, and Reims three of the most superbly knit buildings of the ages transforms Romanesque carving without destroying the emotional richness and the sense of architectural fitness. At Chartres the north and the south porches are glorious displays of the blending of architectural and sculptural fabrication. The strict limitation of the column statues to the column width no longer holds, as in the beautifully stylized figures of the west portal, and there is a tendency to various excrescences that dull the edges of the structural courses. But at this stage these may be taken as merely signs of the exuberance of artists intoxicated with a newly gained freedom and ease. The tendency to realism, too, is in keeping and laudable when it gives us the sensitive faces and the dignified figures seen in the illustrations of Chartres. (Facing and page 341.)

In the best of these figures there is still the boldness and telling dramatic posing of Romanesque design, but the expressionistic deformations are gone. The treatment of hair and beards, halfway between the old heavy and formalized ridging and the careful fourteenth-century curls, is a typical transitional method (though naturalism in representing the hair, as understood by the Florentine sculptors of the mid-Renaissance, never did interest the Gothic carvers). Naturalism as

Figures in North Portal, Cathedral of Notre Dame, Chartres. 12th century. (*ND photo*)

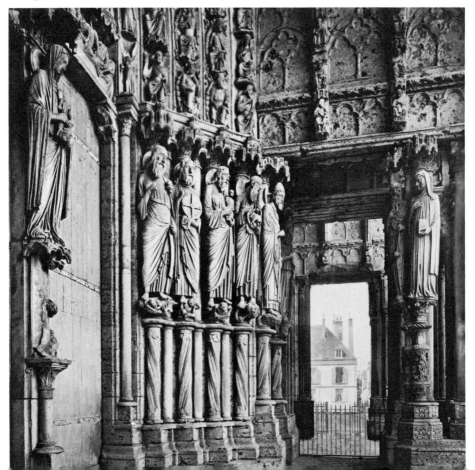

a pervading interest in the surrounding world as it looks claims the artist increasingly, so that the flora and fauna of France begin to be documented in stone, and little human-interest touches, and even anecdotal or biographical trivia, are introduced among the impressive representations of God, Christ, the prophets, and the angels.

Chief of the technical changes was the lifting of the figure from the background. While relief-carving did not disappear, figures were oftener worked in the round, whether left slightly engaged or set out in total independence of column or wall. At first the Thomist passion for order and clarity, still operative at the level of architect and master-builder, restrained the sculptor who wished to make a showpiece of his statue. Indeed, the group spirit, and specifically the guild spirit, operated to harmonize the sculptures and stained glass with the cathedral's architecture.

Each of the rigidly upright, attenuated figures on the pillars of the Royal Portal at Chartres (page 332) bespeaks care for the integrity of the architectural member. In the illustration one may see how at Sens Cathedral the statue of St. Stephen on the

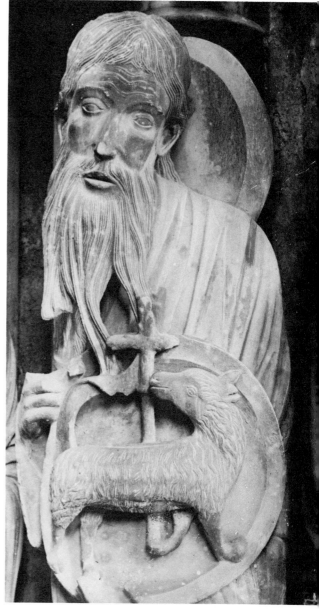

St. John the Baptist. Stone.
12th century. *North Portal, Chartres.*
(Houvet photo)

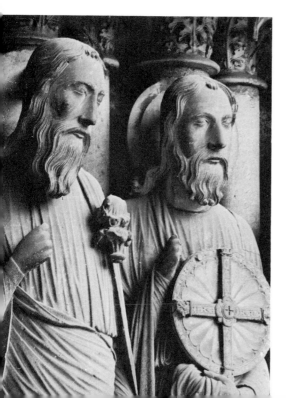

Isaiah and Jeremiah. Stone.
North Portal, Chartres.
(Photo by Jean Roubier)

trumeau of the central doorway accords with the architect's intention but indulges in a little more spread than was permitted at Chartres. The *Madonna* on the portal of the north transept of Notre Dame in Paris has become a work of art in her own right: the pillar lines are obscured, and the structural integrity is no longer served.

Some observers consider this the point at which medieval sculpture came of age, and they praise the increased freedom of grouping, the greater naturalness of the individual figure, and the free disposal of draperies, wings, and other accessories without regard to a cramping framework. Others feel certain that the loss to the magnificent cathedral structure is greater than the gain: that the architectonic fabric is rent. After A.D. 1200 the single face or figure held the interest. Notre Dame in Paris was built early enough (1160–1225) so that its west façade remains classically simple, and the portal sculpture (comparatively dull as restored in the nineteenth century) is laid into the fabric per-

Madonna, trumeau figure. Late 13th century. North Portal, *Notre Dame de Paris*

St. Stephen, trumeau figure. Stone. 12th century. Central portal of Cathedral of Sens. (*Photo by Jean Roubier*)

Apostles. Stone. *South Portal; Cha* (*Giraudon p*

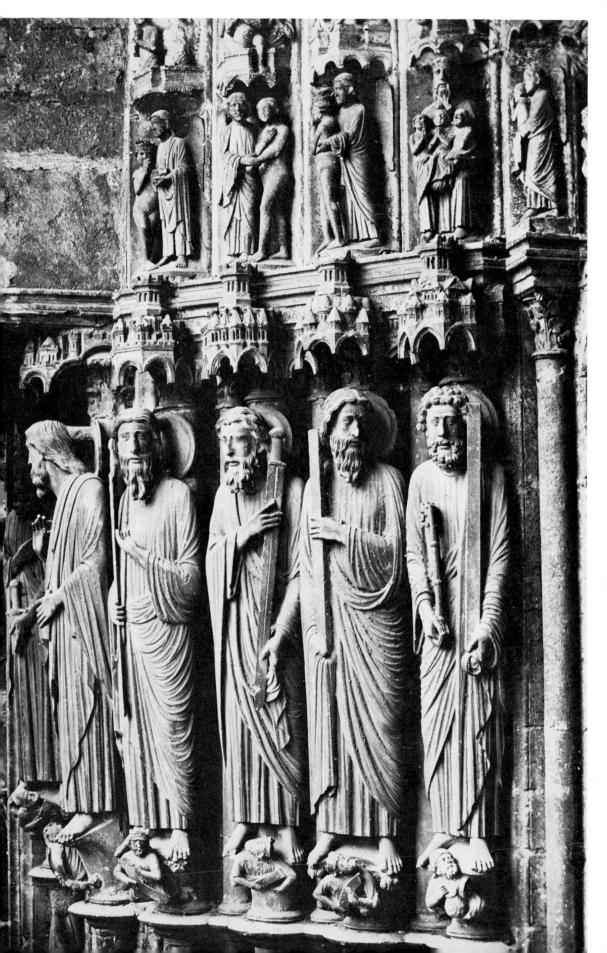

fectly. The gargoyles are an added feature, and are the best of the sculptural exhibit, vigorous, fanciful, and essentially lithic. (Shown on page 310.) Exceptional too is some of the later story-telling sculpture, in realistic vein but cut with notable feeling for stonelike effect and sensitive modeling. It has, however, little Gothic character. (See below, left.)

But at Amiens it is the *Gilded Madonna* (page 347) or the *Beau Dieu,* and at Reims the *Smiling Angel* or the *Virgin of the Visitation* which attract the eye. At Reims the sculpture serves two main purposes. It adds a

sense of profuse life and a rich play of light and shadow to the façade. Second, the individual statues and certain groups present the Christian lessons. The sculpture on each cathedral is still, of course, a picturebook of religious story and instruction, in a systematic pageant ordained by the theologians. Occasionally the artist's mastery lifts a face or figure or a group above the inevitable routine average of design and cutting; so that within a porch at Reims one comes upon such a row of masterpieces of the new realism as the four figures of the *Purification.* Each superb statue is set out to be studied and enjoyed for

Adam and an Angel. Stone. Notre Dame de Paris.
(Giraudon photo, Archives Roget-Viollet)

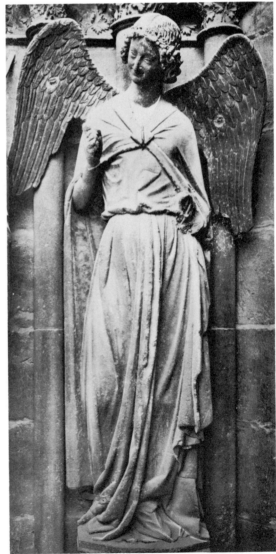

Smiling Angel. Stone. 13th century.
Portal of Cathedral of Reims

its patent virtues. What was begun at Chartres, in the period between the adornment of the west portal and the adornment of the north portal (or perhaps earlier at St. Denis, in compositions destroyed during the Revolution), ended in these high Gothic masterpieces. (Page 344.)

The profusion of sculpture at Reims is almost equaled in the porches at Chartres; but Reims and Amiens illustrate the Gothic architect's dream of a building grandly composed, simple, and richly adorned. These great monuments of the West might conceivably be placed beside the lushest Indian temples or the ruins of Angkor Vat and Borobudur and not seem sculpturally meager.

The evolution of medieval architecture, Byzantine and Lombard into Romanesque, and Romanesque into Gothic, was primarily dependent on the development of methods

Small portal, detail. 13th century. *Cathedral of Reims.* (*ND photo*)

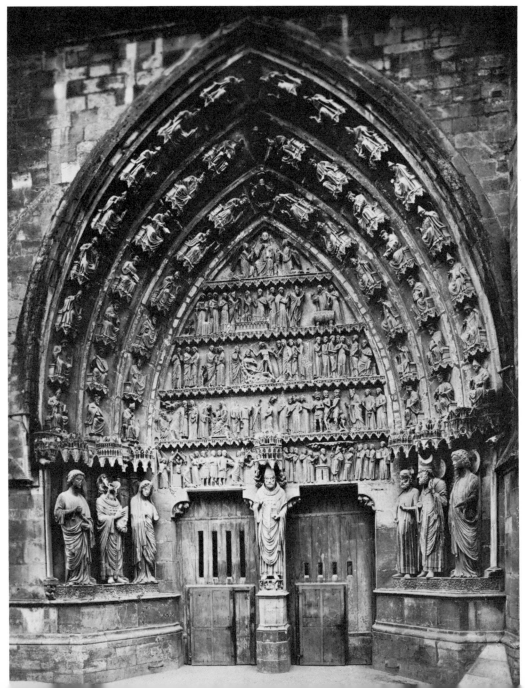

of arching, vaulting, and buttressing. The pointed arch, the ribbed vault, the flying buttress are basic to the Gothic style. There is further evolution, without basic structural change, after the high Gothic of Amiens and Reims, say, after the year 1300. The daring which had raised the organism to unprecedented heights and to a marvelous structural perfection gave way to pretty inventions in the nature of lacelike screens and walls lost in forests of beautiful tracery.

Beneath, the structure remained as logical, as rightly adjusted, as ever. But the decorative elements, even the decorative sheathing, took on increased importance—as can be seen in the illustration of the façade at Strasbourg. What interests us here is the use of inset sculpture to enrich and accent the pointed arches, pinnacles, and traceries. At Strasbourg and Rouen there is hardly as much figurative sculpture as at Amiens and Reims, but the impression is sculpturally richer,

The Purification. Portal of Cathedral of Reims

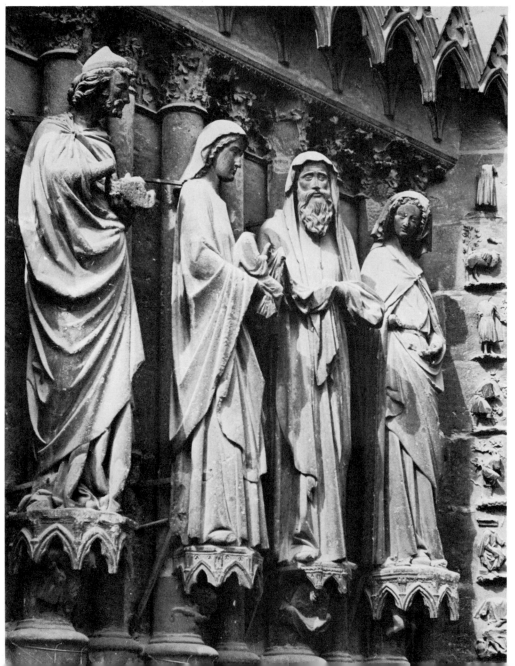

because the statues are bedded in a delicate fabric of shaped architectural elements, which themselves constitute a species of abstract art in stone. Beyond the middle portal in the west façade of Strasbourg Cathedral, figurative sculpture and architectural detail are barely distinguishable from each other.

This is, of course, a lighter form of Gothic art, yet only an extreme purist would be likely to call it decadent or overstrained. There is ample evidence at Strasbourg that very great sculptors were employed during the cathedral building, as the vigorous and forthright heads of St. Philip and St. Stephen witness. These should be labeled perhaps as German or Alsatian Gothic works rather than French.

There are signs of decadence in certain of the pretentious story scenes at Bourges Cathedral, where a tympanum contains rows of lively, even boisterous figures. In activeness

Façade of Cathedral of Strasbourg, detail. C. 1300. (*ND photo, Archives Roget-Viollet*)

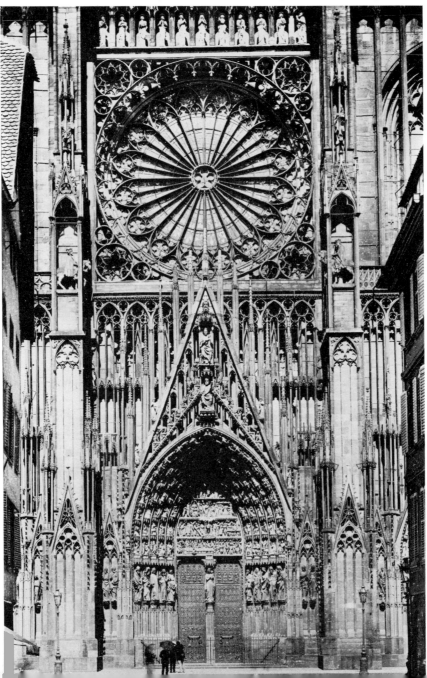

St. Philip. Stone.
Cathedral of Strasbourg.
(Photo by Jean Roubier)

Lower left:
Virtue. Stone.
13th–14th centuries.
Cathedral of Strasbourg.
Musée de l'Oeuvre, Notre Dame,
Strasbourg. (Tel photo)

St. Stephen. Stone.
Cathedral of Strasbourg.
(Photo by Jean Roubier)

The Gilded Madonna. Mid-13th century. *South Portal, Cathedral of Amiens.* (*Archives Photographiques*)

and eccentricity they are reminiscent of Vézelay and Autun, but they lack the disciplined grouping and the engaging stylization of the Romanesque masters.

A contrasting phase of Gothic which is more vigorous, a trifle heavy, perhaps, and earlier in feeling if not in date, is to be seen at the Church of Notre Dame in Semur. Semur is in Burgundy, and the style of the Burgundian school differs from that of the school of the Ile de France; here it has entered a flamboyant phase.

Both Strasbourg and Rouen are sometimes classed as monuments of flamboyant Gothic, but the incidental sculpture hardly deserves the description. The smiling angels that became so popular were copied from cathedral to cathedral, even during the thirteenth century, but generally they lack dignity and restraint. Though they have an irresistible surface charm, as works of art they are inferior to the Romanesque angels. The Rouen façade is not as solemn and impressive as Notre Dame or Chartres, but it is a tour-de-force of graceful architectural draping.

The course of the Gothic style in general was marked by growing realism, but from

Detail of tympanum. 14th century. *Church of Notre Dame, Semur.* (*ND photo*)

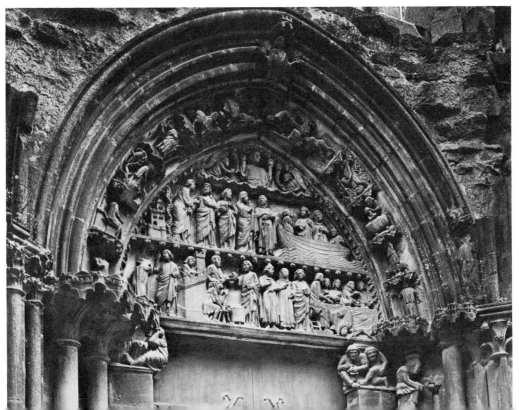

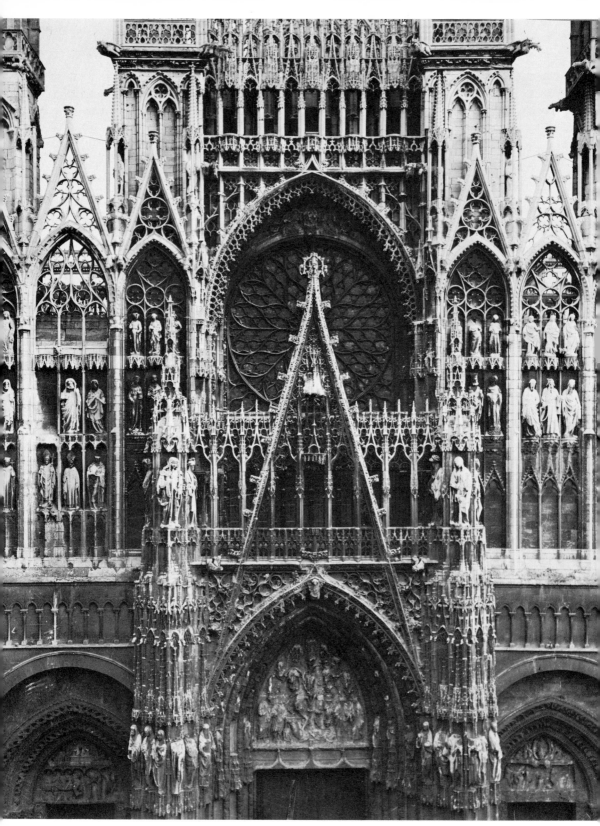

Detail of façade. Flamboyant Gothic, 14th century. *Cathedral of Rouen.* (*Photo by Jean Roubier*)

the mid-thirteenth century there followed some four hundred years of French sculpture that is hardly more than transiently appealing. Basically the trouble was that devotion to naturalism destroyed the feeling for the sculptural block. The new individualism superseded the old guild spirit and the opportunities for disciplined cooperative expression.

The lacelike façades of Strasbourg and Rouen are reflected on the late Gothic ivory plaques; and indeed the whole history of the change from Romanesque to early vigorous Gothic, to a more lifelike middle phase, and on to the glittering flamboyant, can be traced in the marvelously carved French ivory panels of the thirteenth and fourteenth centuries.

The leaf of an ivory diptych at the Cluny Museum is representative of the way in which religious stories were presented. A balance is maintained between design of the illustrative scene for its own sake and composition in which figures and their setting are arranged to produce a flat, tapestry-like effect.

The two leaves of a diptych at Providence tend to sacrifice flatness, and compartmentalization, for the sake of presenting the story more fully in a larger space. There is a suggestion of perspective. (Page 350.)

Single leaves could still be designed in a firm, clear, and architectural style, as is evident in the little *Crucifixion* of the Cluny Museum. Though the accessories mark it as Gothic, the vigor of it, and a certain frank distortion, suggest the Romanesque style. Vividly contrasting is a set of eight panels of the *Life of Christ* now in the Victoria and Albert Museum. The lacy ornamentalism is obtained by the use of architectural tracery and by the sharpening of the figures so that

Biblical Scenes, leaf of diptych.
Ivory. Gothic, French, 14th century.
Cluny Museum, Paris. (Giraudon photo)

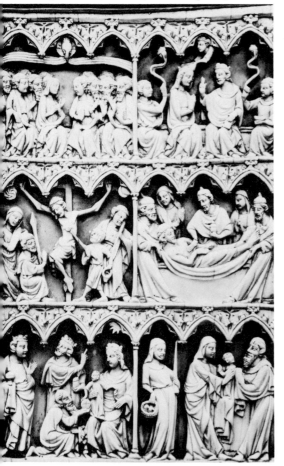

Scenes from the Life of Christ, leaf of diptych.
Ivory. Italian, Milanese School, 15th century.
National Gallery of Art, Washington

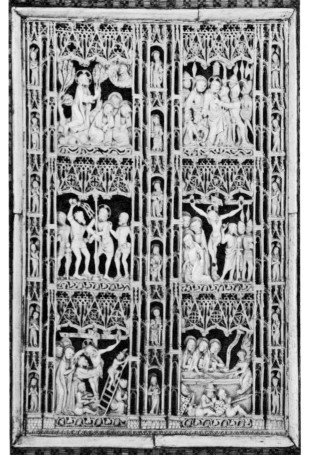

Crucifixion. Ivory.
French, 14th–15th centuries.
Cluny Museum. (*Giraudon photo*)

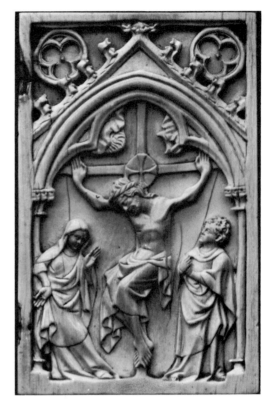

they fill each panel without permitting the eye to escape to the background. The miniature craftsmanship here is marvelous, displaying the heights to which Gothic artistry attained in the fifteenth century, in the flamboyant style. (Page 351.)

Two further phases can be seen: a group of ivories containing some graceful but not very important plaques devoted to pagan or lay themes, especially love-making, jousting, and hunting, and examples of religious picturing even more attenuated and filmy than the panels just shown. The *Scenes from the Life of Christ* on a leaf of a diptych at the National Gallery, Washington, are characteristically lacy and ornate, and, like the preceding example, are in a pierced technique which lends peculiar prominence to the figures. This is an Italian work of the Milanese School of the fifteenth century. (Page 349.)

After this technical virtuosity, a simple,

Biblical Scenes, diptych. Ivory. Gothic, French, 13th–14th centuries.
Museum of Art, Rhode Island School of Design, Providence

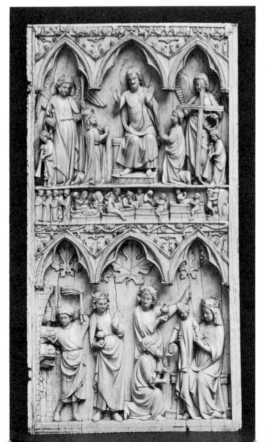
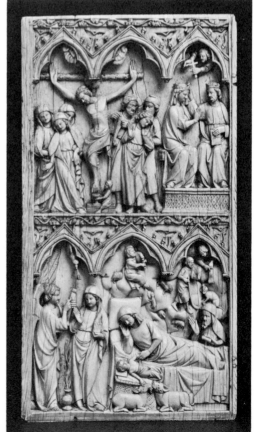

vigorous, and utterly genuine development of sculpture occurred on French soil, in Brittany, in the same century. A folk art arose, important especially for its religious monuments or "Calvaires" in stone. The two details shown, and one illustrated earlier with an example of Gallo-Roman art, suggest an affinity of method and perhaps a direct line of descent, and show the strength and sculptural soundness of this Breton art. The figures are parts of groups which unfortunately are more masterly in detail than as integrated compositions; but seldom are reverent attention and utter piety so perfectly expressed.

Christ of the Resurrection, detail of Calvaire. Stone. Breton, 16th–17th centuries. Pleyben, Brittany. (*Photo by Jean Roubier*)

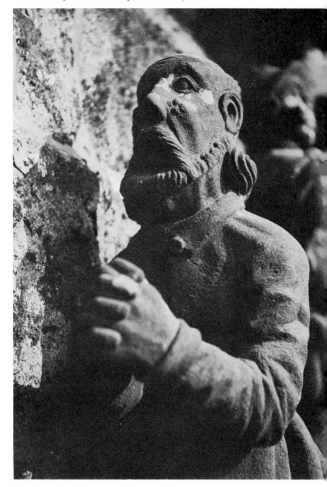

Life of Christ. Ivory.
French, 14th–15th centuries.
Victoria and Albert Museum

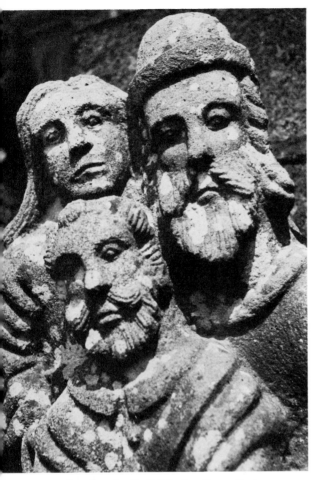

Apostles, detail of Calvaire. Stone. Breton, 16th–17th centuries. Guimiliau, Brittany. (*Photo by Jean Roubier*)

Passion, the life of the Virgin, such incidents as the martyrdom of Thomas Becket, and so on. Since the alabaster reliefs were much prized by devout Christians throughout the breadth of Europe, a great many were transported from England, and enough have survived to prove the quality and the originality of the products of the Nottingham school.

Although alabaster, like jade, is prized partly for its texture and the translucent character of the stone, the English panels were freely gilded and painted. Time, perhaps fortunately, has worn off most of the color. The reliefs are sculpturally notable for a sound sense of space-composition, for dramatic disposition of the figures, and for a cutting method especially suited to the softish stone. Two examples, a beautifully realized *Christ on the Cross* and the surprisingly stylized *St. Jude*, indicate a real mastery in the medium.

The heads at Strasbourg have already been noted as German, and there are equally impressive statues at Bamberg, Naumberg, and elsewhere. More of Romanesque expressionism survives in German carving than in French, and the Gothic style is more rugged and often touched with distortion. The *Head of King Stephen* at Bamberg (part of an equestrian figure) is one of the most expressive carvings of the fourteenth century, and a prime example of German workmanship.

Other heads at Bamberg, such as the *Head of Elizabeth,* are remarkable for their extraordinary portrayal of Teutonic types that have persisted recognizably into a period six centuries later, but the vigorous designing and the fluent cutting are perhaps the more significant achievement.

It has been said that German sculpture of this period is more emotional than the French. This is perhaps true in the sense that more feeling appears in the faces, as in the *Prophet Joel* in St. Peter's Church at Hamburg (page 354), but the word "emotion" demands some delimiting: German emotion is more homely and more poignant—and often more exaggerated. In France, too, the tone of

In England, where the cathedrals are second only to those of France in architectural splendor, the iconoclasts destroyed almost the whole body of important religious sculpture. Fragmentary evidence indicates an original rich investiture of stonecarving in many Gothic buildings or parts of buildings. But today the great English cathedrals stand almost denuded of their sculptural treasures.

During the fourteenth and fifteenth centuries there arose a school of carvers in Nottingham which specialized in producing portable panels and portable altars in alabaster, dealing with the usual subjects of the

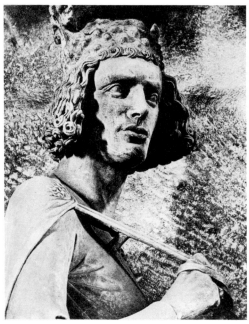

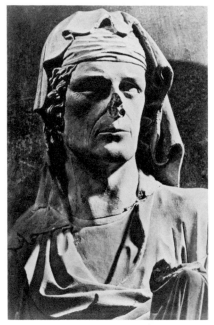

Head of King Stephen, detail of an equestrian statue. Stone. German, 14th century. *Bamberg Cathedral, Bavaria. (Archiv für Kunst und Geschichte, Berlin)*

Head of Elizabeth. Stone. German, 13th century. *Bamberg Cathedral, Bavaria. (Archiv für Kunst und Geschichte, Berlin)*

St. Jude. Alabaster. English, Nottingham School, 14th–15th centuries. *Victoria and Albert Museum*

Christ on the Cross. Alabaster. English, Nottingham School, 14th–15th centuries. *Victoria and Albert Museum*

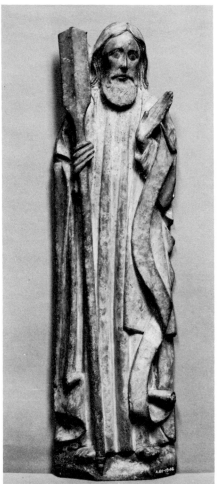

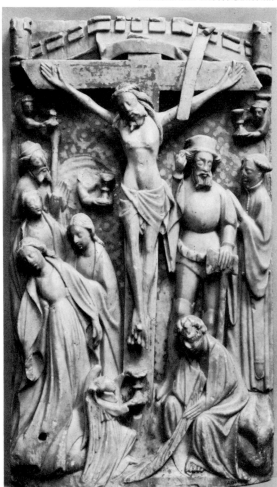

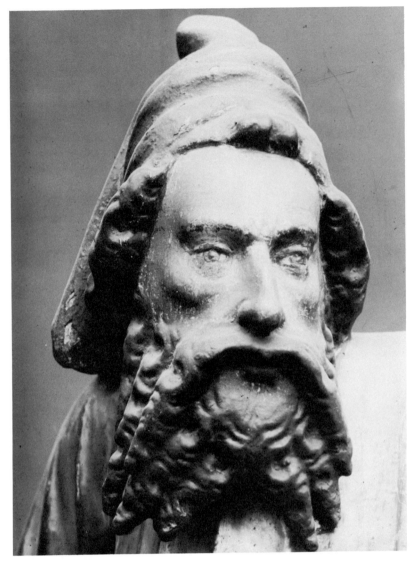

Head of the Prophet Joel. Master Bertram. German, 1379.
Altar, Church of St. Peter, Hamburg. (Archiv für Kunst und Geschichte, Berlin)

Christian iconography had changed in the early Gothic centuries. Dignity and awe had given place to sentimental interest and personal identification with the Virgin or the suffering Christ. Where Christ in Majesty might have been the central motive of a tympanum or a diptych panel before, the tragedy and the pathos of the Crucifixion were later dwelt upon.

The Germans succeeded the French as the leading religious sculptors in late Gothic times. Then naïveté blossomed again. Gothic sophistication fades, though there is no other style to which the woodcarving of the Rhine valley, Bavaria, and the Tirol can be linked. The statuettes of Christ and John in which the sleeping John rests his head on the Savior's shoulder, his hand in Christ's hand, form a beautiful image even if sentimental.

The German folk artists had, in general, an

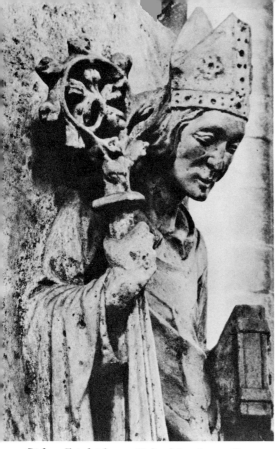

Bishop Friedrich von Hohenlohe. Stone. German, Wurzburger school, c. 1352. *Bamberg Cathedral, Bavaria.* (Archiv für Kunst und Geschichte, Berlin)

innate talent for carving in wood. They remembered the block and indulged a passion for rhythmic massing before trying to imitate natural effects. There are examples of folk sculpture that are a lasting delight, for their near-primitive directness of statement, their naïvely emotional approach, and their sound sculptural composition. They were produced from the sixteenth century on, until, by the end of the eighteenth century, a tide of realism had swept through and left a plethora of weak naturalistic groups and figures, from such centers as Nuremberg, Oberammergau, and the Tirolean towns. But the detail from a *Madonna* and the *Mary Kneeling* (two centuries later in date) are typical of a style of sculpture too often overlooked in the histories because it is a people's art and a people's expression.

The German folk feeling entered into much of the church sculpture too, so that naïve story-scenes and quaint decorative figures may be encountered in the churches, especially the crèches at Christmastime. The illustrated figure of *Christ Riding the*

Madonna, detail. Wood. German-Swiss, Rhineland school. *Historical Museum, Basel*

Mary Kneeling. Wood. German-Swiss, Rhineland school. *Historical Museum, Basel*

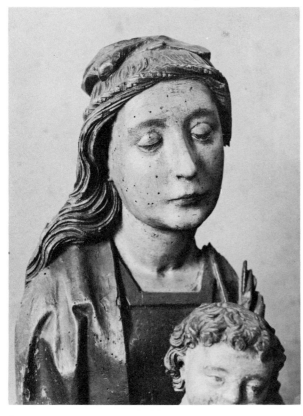

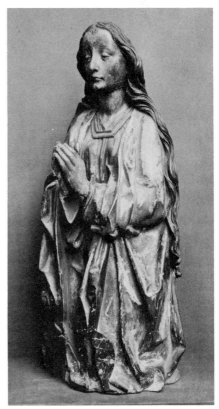

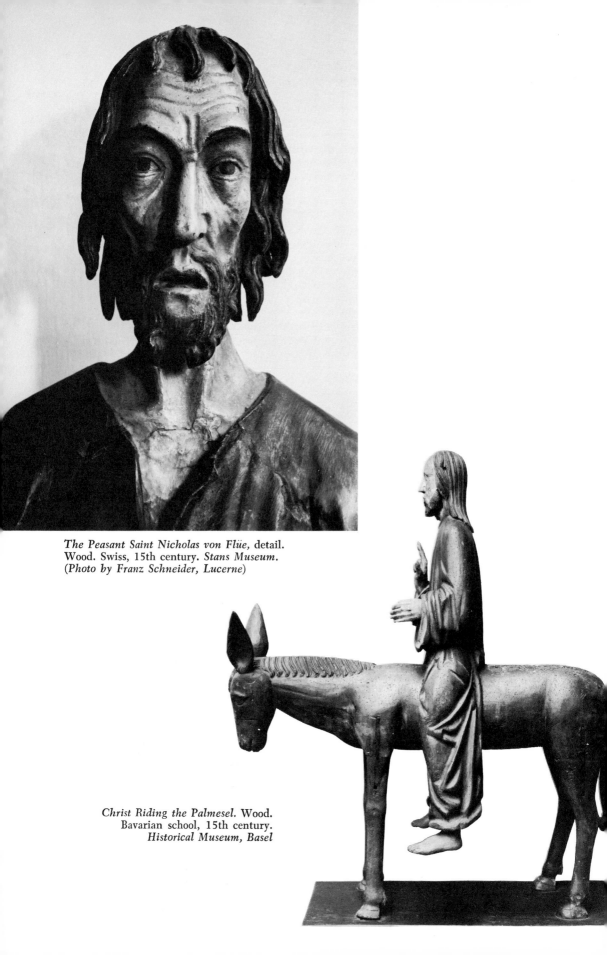

The Peasant Saint Nicholas von Flüe, detail.
Wood. Swiss, 15th century. *Stans Museum.*
(*Photo by Franz Schneider, Lucerne*)

Christ Riding the Palmesel. Wood.
Bavarian school, 15th century.
Historical Museum, Basel

Palmesel (the ceremonial ass of the Palm Sunday ritual) is a Bavarian piece.

Switzerland also has a long folk-art history. The portrait of Nicholas von Flüe, who died in 1487, is an extraordinary example of homely, truthful carving by an anonymous sculptor, apparently from the Swiss Unterwalden or the neighboring canton of Lucerne. The subject, known also as Brother Claus, was born a peasant, became an inarticulate mystic and ascetic, and a hermit. But such was his innate honesty and his clear seeing that he gave counsel to his fellow peasants and later to the canton officials, high churchmen, and foreign noblemen who sought out his hut and chapel in an Alpine gorge.

Monumental, official German art had, of course, felt the influence of the Italian Renaissance. Veit Stoss was but one of a group of German sculptors who inherited from the Gothic but were well aware of new ideals and fresh impulses from the south. To a large extent their work is outside the commonly named styles, and there is confusion over it because it comes closer to an incipient baroque style than to Gothic.

In Flanders the power of Burgundy was for a time supreme, and the Gothic development followed closely that in France. Many Flemish sculptors worked at the French centers of art. Most of the monuments of late Gothic sculpture in the Low Countries reflect French grace and realism. There are, however, some vigorous and strikingly stylized figures in wood. The illustrated Flemish image of St. James is an upstanding, elongated type, quite different from French

St. Paul. Wood. French, 15th century. Toulouse Museum. (Giraudon photo)

St. James. Wood. Flemish. 16th century. Formerly Collection of Peers de Nieuberg, Brussels

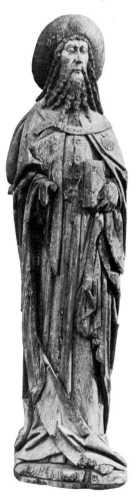

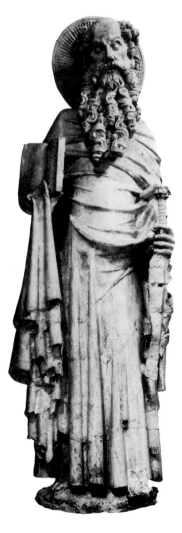

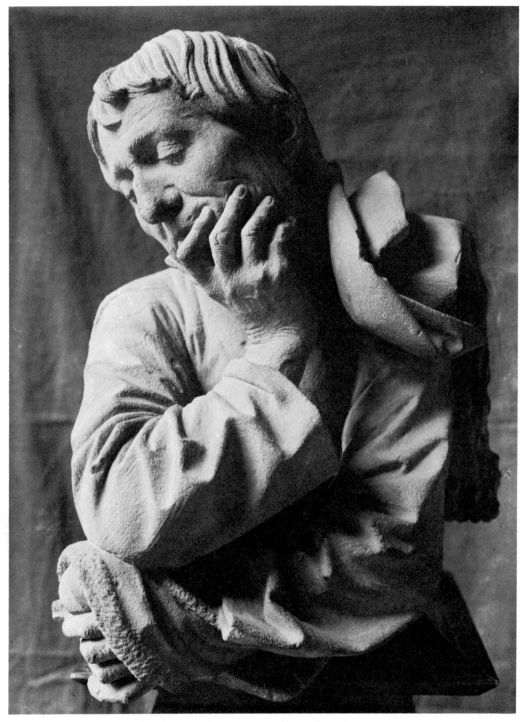

Presumed self-portrait by Nicolas Gerhaert of Leyden. Stone. 1467.
Musée de l'Oeuvre, Notre Dame, Strasbourg

models. Some likeness of method may be seen in the *St. Paul* at Toulouse.

Nicholas Gerhaert of Leyden was a Low Country sculptor who had gained experience in the Burgundian school and went as a master to Strasbourg. The unique self-portrait shown was recovered from the rubble left by the iconoclast mobs when they desecrated the cathedral during the French Revolution.

Spain, where Byzantine, Moorish, and French Romanesque currents had crossed, was influenced also by Gothic art. The French churchmen who went into Spain as the Saracens withdrew included architects and sculptors. While there is no outstanding monument of Gothic design—as there is of the Romanesque in St. James of Compostela—the cathedrals at Burgos and León are interesting examples of the style, with some modifications in the features such as tympanums and the flanking figures of the portals.

The mural-like art of sculptured altar screens and choir screens is the most distinctive of the Hispanic developments in the style. The altar backing at Neustra Señora de Pilar at Saragossa, with Gothic tracery and Gothic niche figures, produces a dazzling effect. The better-known reredos of the Cathedral of Seville is inferior (as a whole) because the figure groups are less well submerged in the decorative screen. Flemish sculptors also specialized in devising intricately carved altar screens in wood, and they developed a tradition in carving tiny scenes of the Passion or the life of the Virgin, cut in wooden shells hardly larger than walnuts.

The Italians started their adventure in Renaissance classicism long before the northern Gothic style had run its course. There are many statues of Gothic aspect on the decorated façades of Milan Cathedral, but the effort to cover the cathedrals with pictorial storybooks of Christianity extended only to a

The Last Judgment, detail. Stone. *Façade of Cathedral of Orvieto, Italy*

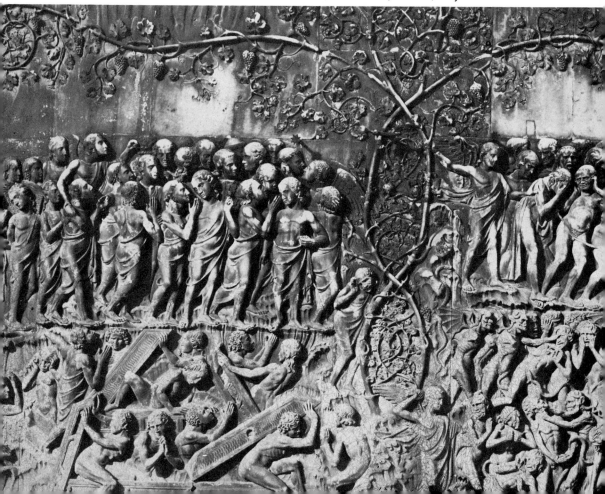

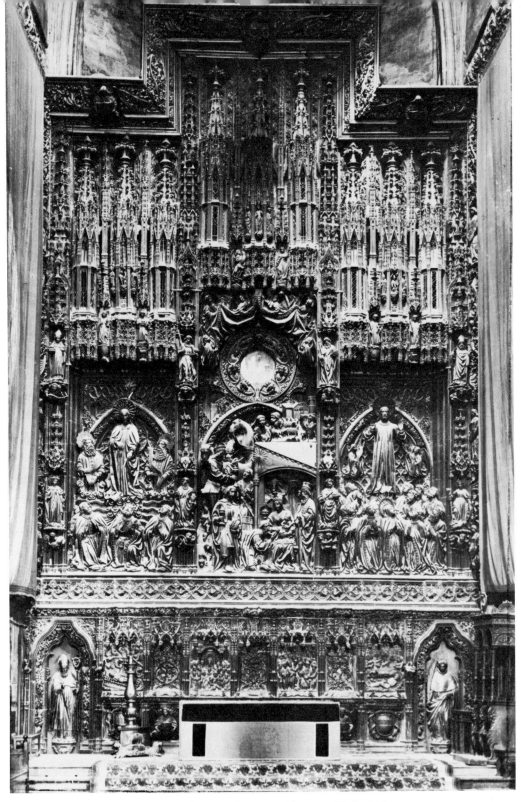

Altar area and reredos. Wood. Damian Forment. Early 16th century.
Church of Nuestra Señora de Pilar, Saragossa, Spain.
(Photo courtesy Department of Photographs, Princeton University)

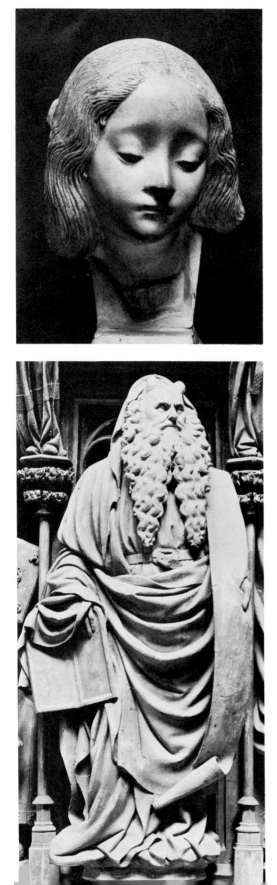

St. Fortunata. Stone. French, 15th century. Church of St. Fortunade, Corrèze. (*Giraudon photo*)

few Italian cities. The illustration from Italy showing a part of the front of the cathedral at Orvieto exhibits many of the characteristics of late Gothic art in France: a relish for naturalism in the accessories, shown here in the vine that grows from the base, branching to divide the figure groups; and the sense of loosened composition in the grouping of the figures. The classicists, however, condemn the treatment of the Last Judgment here as ugly and northern; in Italy the theme had generally been treated with restrained emotion if not sunny confidence. It is known that a Sienese architect-sculptor, Lorenzo Maitani, was called to Orvieto in 1310 to supervise the planning of the cathedral, and then to work for ten years on the sculptural adornments. But innumerable other sculptors came and went in the first half of the century.

In Touraine the chapel façade at the Château of Amboise where the Italian Leonardo da Vinci died in 1519, has the fragile grace of late flamboyant Gothic, and the sculpture is charming though a trifle playful. The separation of sculpture from architecture, as seen here, marks the end of the period of great mural sculpture in central and northern Europe. Leonardo's unmarked tomb is thought to be in this Chapel of St. Hubert, now restored. The story of Hubert's miraculous conversion is told graphically in the sculptured panel over the doors.

Claus Sluter of the school of Burgundy is considered a leader in the reforms that briefly stemmed the currents of mannerism and sophistication. The late Burgundian school was known for vigorous facial expression and heavily folded and deeply undercut draperies. The finest of the surviving monuments is the Fountain of the Prophets at the Carthusian Monastery at Champmol near Dijon. Though it fails to integrate the sculpture with the architecture, it is notable for the massive and expressive figures of the six prophets. The *Moses* is most effective and is generally con-

Moses, detail of Fountain of the Prophets. Claus Sluter. Burgundian School, 15th century. *Champmol Monastery, near Dijon.* (*Giraudon photo*)

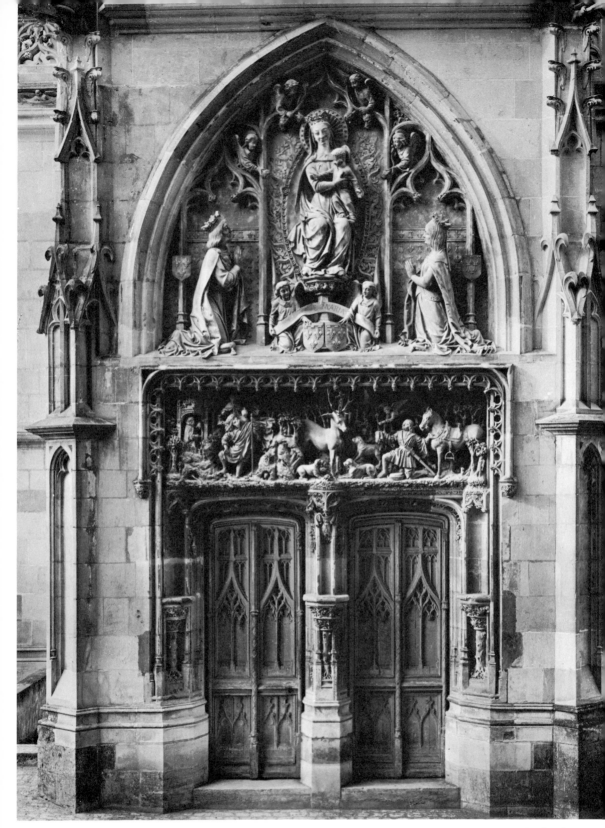

Portal of the chapel, Château of Amboise, Touraine, France. Late Gothic, 16th century. (*ND photo*)

sidered the peak figure in the Burgundian style, which after this date—about 1405—was more successfully followed in Flanders and Holland than in France.

The charming fifteenth-century head of St. Fortunata was at one time counted as Gothic. It surmounts a reliquary in the Church of St. Fortunade in the town of that name in the Rhône Valley. The sweetness of the face is no less remarkable than the sensitive and fluent cutting. It is an isolated work, though it might have been produced at one of the ateliers of the French sculptors of the *détente* or relaxed school.

The Gothic spirit persisted more definitely in connection with animal sculpture and with grotesques. Upon late churches or châteaux, even when the rest of the sculpture is routine and dull and often ill-placed, one may dis-cover picturesque gargoyles which retain the robust realism of the early examples of the style. Here, as a final illustration from pre-Renaissance France, is another Burgundian work, a winged *Ox of St. Luke*. Decorative and solidly sculptural, it is somewhat in the spirit of Claus Sluter, and although it escapes the unnaturalness of Romanesque expressionism and the distortion of the Celtic or Barbarian animals of early medieval European sculpture, it recaptures something of the strength, ruggedness, and spiritedness of the traditional animal art of northern peoples. Gothic was a northern art. The next flowering of sculpture had already begun in Italy. And France and England showed almost the same lack of interest in the Renaissance spirit, in the formative years, as Italy had shown in the Gothic.

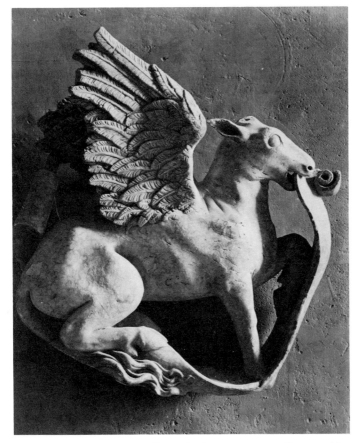

Ox of St. Luke. Stone. French, Burgundian school, 15th century. *Louvre.* (*Giraudon photo*)

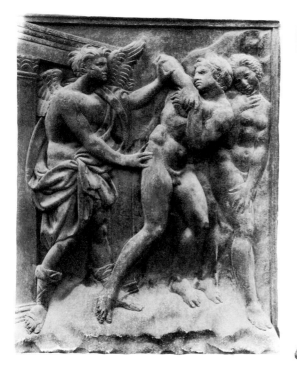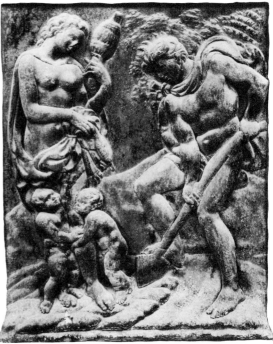

14: The Renaissance:

From the Pisanos to Michelangelo

I

IN each visual art there is a difference, if not opposition, between two kinds of communication, one embodying expression of the inner spirit, the other the visible appearances of the world. Never was the transformation of the arts, from the spiritually true to the physically true, more completely accomplished than during the Italian Renaissance. From the formalized Italo-Byzantine and Romanesque styles, and especially from the Sienese painters who so beautifully adapted the "unreal" medieval style, to the Florentines of the generation of Masaccio, Brunelleschi, and Donatello, practicing hardly more than one hundred years later, there is a full turn of the circle, from expression of inner, mystical meaning to a reasoned and "natural" depiction of the world.

In the earlier phases of the Renaissance, however, the two styles existed side by side. Nicola Pisano revitalized the Italian medieval style with Roman idioms and Roman natural-

The Expulsion; Adam and Eve at Work. Stone. Jacopo della Quercia. 15th century.
Church of San Petronio, Bologna. (*Anderson photos*)

ism in his pulpit bas-reliefs; while his son Giovanni Pisano looked northward to introduce Gothic sensitivity and Gothic second meaning, and was abetted by Arnolfo di Cambio and echoed by Orcagna and Nanni di Banco. Even after Brunelleschi and Donatello had directed the course of art back to the classical—by a stroke epochal and heroic, as it seemed—an inspired Sienese, Jacopo della Quercia, continued to produce works of such grandeur and such plastic sensibility that they attach perfectly to the northern and anti-classic tradition. But in such works as the baptistry doors of Ghiberti, and in the neo-Grecian figures of Donatello, Roman pictorialism and classic lifelikeness prevailed, and Europe was committed to a revival of art conforming to the appearances of the actual world.

Italy had never given in fully to the Gothic style. Romanesque relics, hardly to be distinguished from Byzantine at times, are to be found at Parma, Florence, and Pistoia, in all the Lombard cities, and as far south as the Apulian and Calabrian towns. Truly Gothic expression is rarer, and it breathes uneasily from the Italian churches; though Milan Cathedral is an exception, its innumerable statues including many by sculptors from France and Germany and by local masters converted late to the northern style. But, exceptions aside, the transformation to reasonable, clear, graceful sculpture in the classic tradition is the great historic fact of early Renaissance times.

The change might in some minds imply a transfer from religious imaging to portrayal of secular scene and figure. It is true that portraiture of lay men and women became fashionable during the mid-period of the Renaissance. But sculpture remained primarily religious in subject and intent. Donatello, a key figure, is known almost entirely for his religious monuments. (The famed bust of Nicola da Uzzano in the Roman manner is al-

Pulpit. Stone. Nicola Pisano. 1266–68. *Cathedral of Siena. (Anderson photo)*

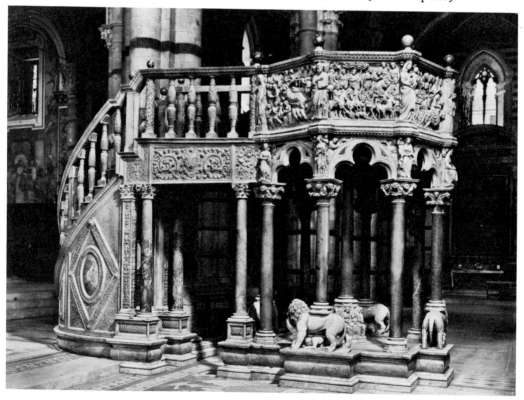

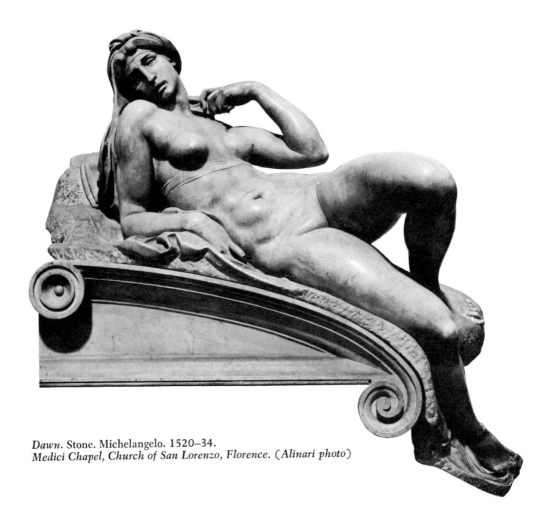

Dawn. Stone. Michelangelo. 1520–34.
Medici Chapel, Church of San Lorenzo, Florence. (*Alinari photo*)

most the sole exception. The appealing *putti* are scarcely to be distinguished from angels and cherubs.) Even the fabulously popular works of the della Robbias are religious in subject-matter. When there comes, in the closing years of the Renaissance, the one transcending genius of the era, Michelangelo, he is first of all a worker in churches and chapels. From the lovely *Pietà* of his youthful years to the stark *Deposition* of his old age, in which he depicted himself as a stricken mourner over the crucified Christ, Michelangelo is religious and Christian. The Renaissance freed men's minds and opened the way to new forms of intellectual enlightenment, but religion still was the crucial motivating force in artistic creation.

There is a third fundamental fact about the Renaissance in relation to the art of sculp-ture. It is that Michelangelo appeared not as a crowning figure in the progression toward "truth" in the art, but as a creator rising above all that had been exalted by the outstanding sculptors from Nicola Pisano, Ghiberti, and Donatello to the later della Robbias. Sculpture had become veracious, illustrational, and graceful. Against these outward virtues, Michelangelo pitted a passionate devotion to the inner central elements that constitute sculptural art, devotion to the integrity of the stone block, to the living qualities of massive-ness and majesty and power. He wrote—he was the greatest of the writing sculptors—that a work of true sculpture, that is, one cut, not modeled, should retain so much of the form of the stone block, should so avoid projections and separation of parts, that it would roll downhill of its own weight. There one hears

the voice of the lover of the quarried block, the giant cutter of stone, who felt that in no other way could the artist endow his work with the grandeur and the hint of eternity that are its most precious assets. Michelangelo is a sculptor apart, mystical, contemplative, in love with the stone. Through his feeling for the basic, profound sculptural process, he is one with the archaic Greeks and the Indian, Chinese, and Mayan masters.

The Renaissance in the sense of the rebirth of Latin literature and the revival of the classical style in art was essentially Italian in spirit. It developed out of the special nature and the rivalries of the Italian city-states, and out of dominance by a ruling class which enormously expanded economic power and commerce—and patronized the arts. Nevertheless in the northern countries the Renaissance spirit changed the course of sculpture, if tardily. In France the vitality of the Gothic style did not fade until the end of the fifteenth century, and there was no great French sculptor in the time of Donatello, Luca della Robbia, and Michelangelo. In Ger-

many the extension of the Italian spirit was marked, especially in woodcarving, and in Spain the classic movement modified the intense religious realism surviving from late Gothic times.

In Italy the end of the Renaissance period saw the perfecting of the virtues of the goldsmith Cellini, in unparalleled numbers of pretty mantelpiece bronzes. It was also a time when the Michelangelesque virtues were transformed into the rather empty dramatics of the mannerists, and the accomplishments of a few scholar-sculptors who carried on the tradition initiated by Donatello or hopelessly tried to imitate Michelangelo. Sansovino, who died in 1570, was the most successful, retaining a sense of the monumental while avoiding the bizarre effects of the mannerists. Of those who gained from the freedoms introduced by mannerism, Giambologna, who survived into the early years of the seventeenth century, was most notable. His was, indeed, the last world-famous name in the era between Michelangelo and the initiator of the Baroque style, Bernini.

Death of the Virgin. Stone. Tilman Riemenschneider. German, 16th century. *Cathedral of Würzburg.* (*Archiv für Kunst und Geschichte, Berlin*)

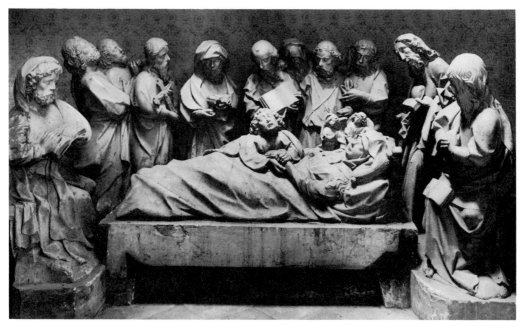

II

IF the Renaissance style in sculpture is realistic, clear, and harmonious, there are nevertheless forerunners who speak with an inherited Gothic or Romanesque accent.

Three illustrations show stages of the transformation from Lombard Romanesque, as seen in the bronze door at Pisa, through the Gothic reliefs on the cathedral façade at Orvieto, and on to that landmark of sculptural progress, the pulpit designed by Nicola Pisano for the baptistry at Pisa. Three of its columns rise from the backs of lions in the Lombard Romanesque manner, and the arches retain suggestions of the northern pointed style; but the major panels are filled with picture compositions resembling the bas-reliefs of ancient Roman sarcophagi. Historically this is an epochal revival of classic realism and pictorialism. Nicola, though known as Pisano, had come from Apulia,

where he must have examined at first hand the exhumed classical relics. He was the first to introduce Roman naturalism into what had been till then Italian medieval art; the painters were still Italo-Byzantine, or Sienese "Primitives."

Between 1266 and 1268 Nicola Pisano and his pupils produced another famous pulpit, for the Cathedral of Siena. Romanesque lions were used as supports, but again the relief panels showed the sculptors' masterly ability in adapting Roman idioms to decorative and pictorial uses. (Illustrated on page 365.)

Giovanni Pisano, son of Nicola, tempered the over-literal Roman expression with a picturesqueness and a sensitivity learned from contemporary Gothic practice. His panels on the pulpit at Pistoia are lively and dramatic and naturally composed. Single figures of his are among the finest sculptures of the time.

Detail of door, Cathedral of Pisa. Bronze. Romanesque, 12th century. (*Alinari photo*). (See also page 323)

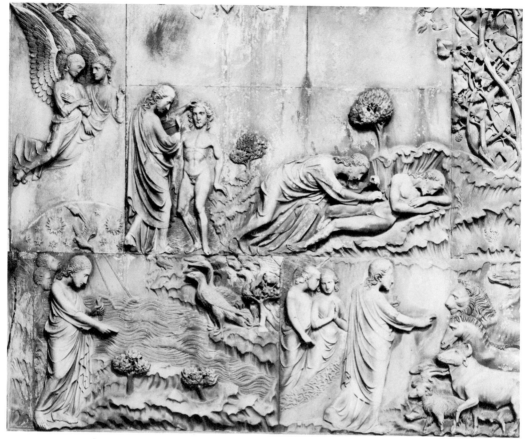

Creation of Man and other scenes. Stone. Italian Gothic, 14th century.
Cathedral of Orvieto. (*Anderson photo*)

Pulpit. Stone. Nicola Pisano. Italian, 1260. *Baptistry, Cathedral of Pisa.* (*Anderson photo*)

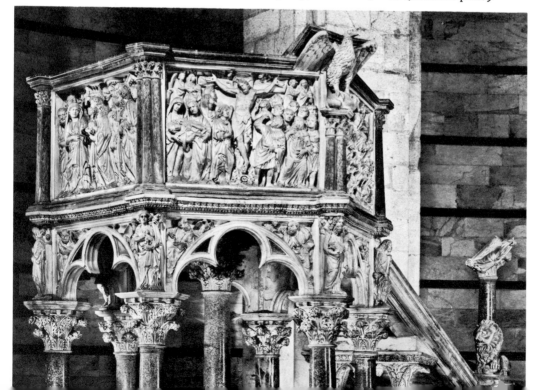

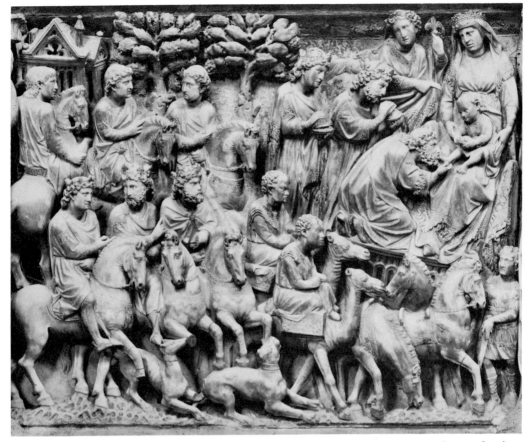

Adoration of the Magi, relief panel. Stone. Nicola Pisano. *Cathedral of Siena. (Anderson photo)*

Birth of Christ, relief panel. Stone. Giovanni Pisano. *Church of San Andrea, Pistoia.*
(Alinari photo)

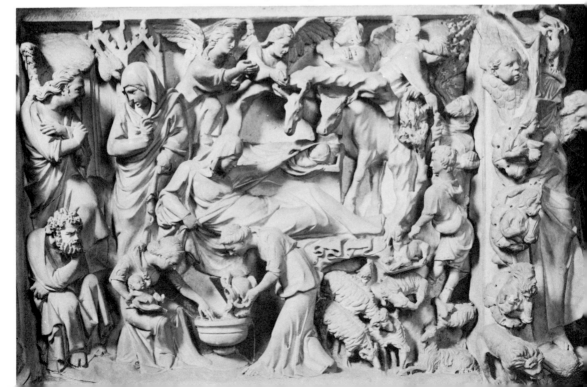

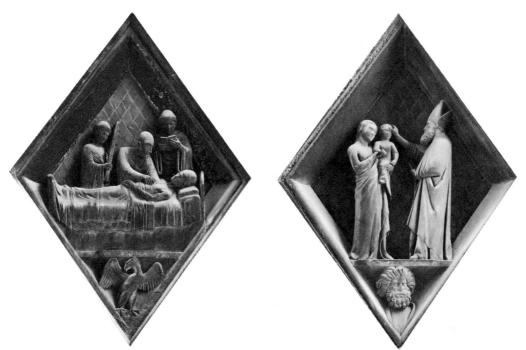

Extreme Unction; Baptism.
Stone. Andrea Pisano. 13th–14th centuries. *Campanile, Cathedral of Florence.* (*Alinari photos*)

Giovanni's pupil, Andrea Pisano, with Arnolfo di Cambio and Andrea Orcagna, stayed for a while the tide toward classicism. Andrea Pisano's little diamond-shaped panels set into the cathedral campanile (Giotto's Tower) at Florence have more the feeling of vigorous Romanesque expression; but a larger set after Giotto's designs, from Andrea Pisano's studio, borrowed from Gothic realistic composition.

Arnolfo di Cambio is better known for his architecture, but Andrea Orcagna, who also excelled in both arts, retained Andrea Pisano's Gothicism in the main features of the famous tabernacle within the Church of Or San Michele, Florence. The architectural forms of the tabernacle are Italianate Gothic, in the light and lacy manner of Milan Cathedral, and the sculptural picturing is what an artist who knew the northern style but looked forward to the triumph of neo-classicism might be expected to produce.

Nanni di Banco was a sculptor who re-

Creation of Woman; Horse and Rider. Stone. Andrea Pisano and Giotto.
13th–14th centuries. *Campanile, Cathedral of Florence.* (*Alinari photos*)

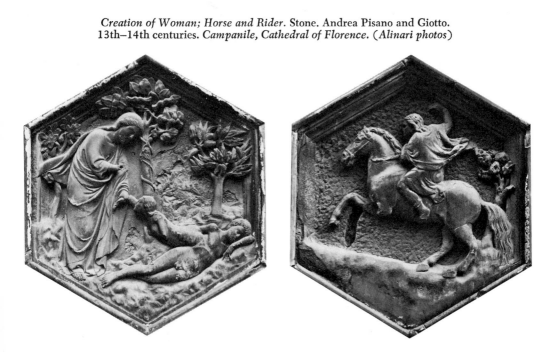

verted even more fully to late Gothic mannerisms in the prettily designed marble relief over the Porta della Mandorla of the Florentine cathedral. The lightness of touch, the vivacity, the sinuous grace of limbs and draperies are attributes of sculpture during the late medieval period rather than during the full Renaissance. (Facing page.)

The Sienese sculptor Jacopo della Quercia rose above all schools and all influences. He was the very antithesis of a neo-Roman. Through his emotional force, his dramatic composing, and his sense of rhythmical plastic order he came closer to the anonymous Romanesque masters. His versions of the Madonna and Child suggest an influence from Byzantine hieratic formalism. Except for the products of the overwhelming genius of Michelangelo, the works from della Quercia are almost the last ones with lithic grandeur produced in Renaissance Europe.

The genius of Jacopo della Quercia is best transmitted to us in a series of reliefs on the portal of the Church of San Petronio in Bologna. These are compositions so powerful, so beautifully ordered within three-dimensional space, so plastically alive, that the youthful Michelangelo is reported to have been inspired by them. (Pages 364 and 373.)

Brunelleschi and Ghiberti, born in 1377 and 1378, assiduously studied the remains of ancient architecture and believed that they were reviving the spirit of the golden age of Greece, though instead they adapted the more pedestrian style of Rome. They were followed in their researches by Donatello, who sometimes copied Roman forms and mannerisms but possessed sufficient imagination and native plastic sense to triumph brilliantly with a clearly seen and humanly felt sculpture that was his personal interpretation of the Hellenic ideal.

By the first decade of the *quattrocento* Florence had taken the lead, artistically, po-

Madonna and Child. Stone. Jacopo della Quercia. Sienese school, 14th–15th centuries.
Louvre; Church of San Petronio, Bologna. (Giraudon, Alinari photos)

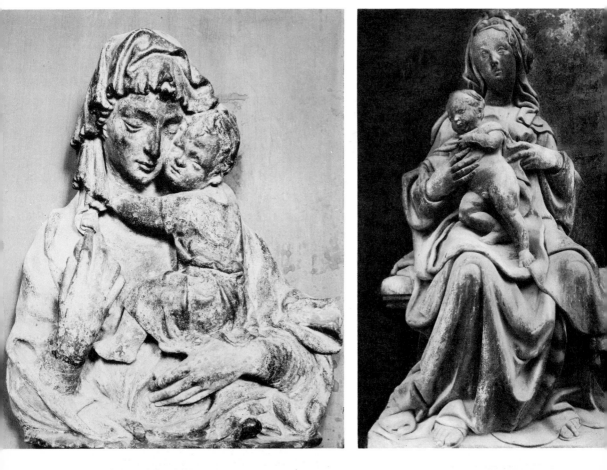

litically, and financially, among Italian city-states. There were great projects for the glorification of the city, and none created more stir than a competition for the design of new bronze doors for the cathedral baptistry. In a trial piece each of seven sculptors showed how he would fill one of the twenty-eight panels of the doors. Today Brunelleschi's design, preserved still at the Bargello, may be considered superior to that of Ghiberti; the sacrifice of Isaac is pictured realistically, readably, and with shrewd regard to the filling of architectural space. Ghiberti, on the other hand, produced a somewhat confused and lumpy, but episodically dramatic and sentimental panel and won the commission to design the portals. There is no further record of sculpture by Brunelleschi, who be-

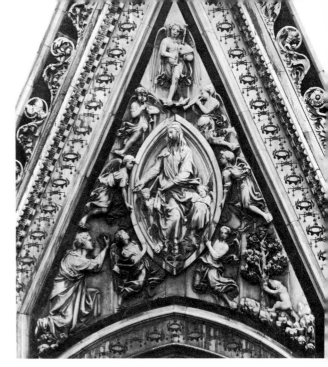

Madonna in a Mandorla, relief. Stone. Nanni di Banco. *Over Porta della Mandorla, Cathedral of Florence.* (*Alinari photo*)

Creation of Man. Stone. Jacopo della Quercia. 15th century. *Church of San Petronio, Bologna.* (*Anderson photo*)

Doors of the baptistry, Cathedral of Florence. Bronze. Lorenzo Ghiberti.
15th century. (*Alinari photo*)

came the first leader in the transformation of Italian architecture from a lingering and mixed medievalism to a clear and harmonious neo-classic style.

The first pair of baptistry doors was set in place in 1424, and the second, known as the Gates of Paradise, was completed in 1452. Lorenzo Ghiberti outgrew some of the deficiencies revealed in the sketch-panel of Abraham and Isaac, and certain of the twenty-eight compositions are clear and harmoniously composed, within the limits of illustrational bas-relief. But the "Paradise" series is more mature and more interesting because it marks the highest point reached in the West in the effort to make sculpture do the work of painting, legibly and engagingly. Ghiberti gave up the idea of dividing the door surface into many small panels, a device that had imparted to the first doors (and an earlier pair by Andrea Pisano) an effect of all-over ornamentalism. He limited himself to ten major panels and set out to make each a masterpiece of miniature sculptural picturing. He greatly pleased his patrons, and his bronze

panels have delighted millions of casual observers.

The truth is that these pictorial compositions, designed in a technique learned from the painters of the era, with landscape vistas, perspective effects, foreshortening, and other attributes of the new realism, are essentially unsculptural. Each design is a masterpiece of relief sculpture masquerading as painting. According to modern opinion, in the ten pictures on the "Gates of Paradise" Ghiberti proved himself a painter in bronze, without elementary feeling for plastic relationships or the effects appropriate to his material.

Up to 1400 the Pisans, the Sienese, and others had served the Florentines and had taught them, but then Florence became a center for locally born sculptors, many of whom became world-famous. Donatello (1386–1466) was the first of the very great Florentine sculptors, rising above his contemporaries and every later Italian sculptor except Michelangelo. He developed a clearly stated, idealized, and gracious figuring, and left a dozen statues that sweetly embody his vision—as well as

The Story of Abraham *Solomon Receiving the Queen of Sheba*

Panels on the baptistry doors, Cathedral of Florence. (*Anderson, Alinari photos*)

Nicola da Uzzano. Clay, painted. Donatello. 1428–30. *National Museum, Bargello, Florence*

masterpiece of natural movement, of camera-eye observation and casual depiction.

Some of the early works of Donatello are among his best. The series of statues in the round, including a *St. John* in the Florence Cathedral and a *St. Mark* and a *St. George* executed for Or San Michele, retain a massive simplicity later lost. The *St. George*, of 1416, is one of the most appealing works of the *quattrocento*, a perfect revelation of the sculptor's vision of youthful determination and chivalry. The *Zuccone*, or "Pumpkin-head," in a niche on Giotto's Tower, is an equally striking creation, expressing a rugged realism at a moment when the art was in danger of descending to a pretty surface naturalism.

The masterly modeling and clean chiseling that characterize Donatello's early works can be seen also in the *Youthful St. John*, a study such experiments as the bust of Nicola da Uzzano, which is interesting as a perfect re-creation of Roman naturalistic, cruelly candid portraiture; and the great equestrian *Gattamelata Monument* at Padua, on which the nobly conceived and finely modeled head of the rider is one of the notable features.

He produced many reliefs in the excessively painterly technique of the followers of Ghiberti; those representing scenes from the Passion on the pulpits of San Lorenzo, begun in his old age and completed by his assistants, Bertoldo di Giovanni and Bartolommeo Bellano, are typically graphic, delicate, crowded, and washy. He played with oversweet Madonnas and cherubs and *putti* in the manner that led to the sentimental art of the della Robbias and the superficially graceful reliefs of Desiderio and of Agostino di Duccio. In panels such as the famous *Annunciation* at Santa Croce and the equally beloved frieze of the Cantoria in the Museum of the Florentine cathedral, he related the figures without adequate sense of plastic order. The frieze, with its jolly babes, is nevertheless a

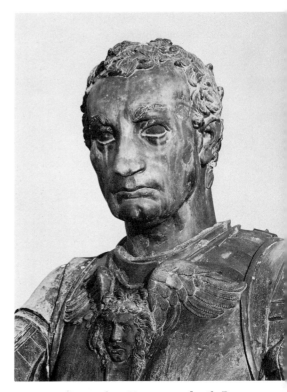

Gattamelata Monument, detail. Bronze. Donatello. 1444–50. Before Church of Sant' Antonio, Padua. (*Anderson photo*)

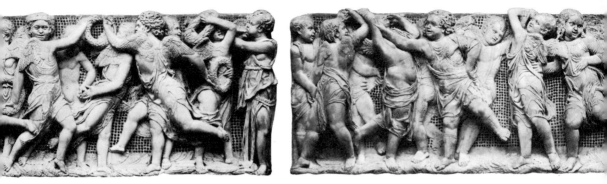

Details from frieze of the Cantoria. Stone. Donatello, 1433–38.
Museum of the Cathedral of Florence. (*Brogi photo*)

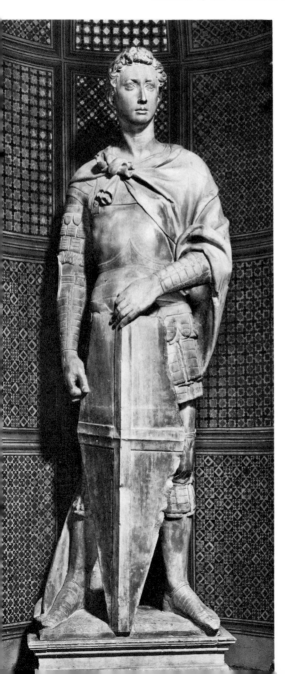

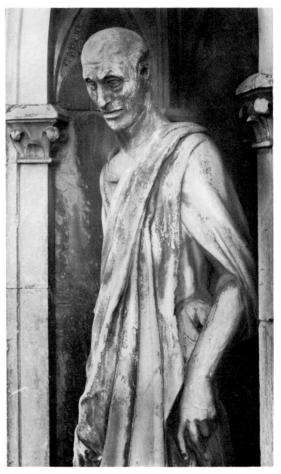

Zuccone (*A Prophet*). Stone. Donatello.
1435–36. *Campanile, Florence.* (*Alinari photo*)

St. George. Stone. Donatello. 1416. *National
Museum, Bargello, Florence.* (*Anderson photo*)

realistic in every detail but so clearly the embodiment of a personal and noble conception that it transcends nature.

Though sculptural grandeur and the basic "feeling for the stone" were going out of the art during the fifteenth century, Donatello and his followers still carved directly in the marble and maintained the autographic virtues that were lost when "sculptors" began to be content with making clay models for transfer to the stone by masons with pointing machines. For works in bronze the artist necessarily modeled in clay (or wax).

Some authorities prefer Donatello's *David* to all his other works. Despite the beautiful modeling and the perfectly caught pose, it is too pretty a work to stand comparison with the *St. George* or the *Youthful St. John.* Verrochio's *David,* matched with Donatello's here, suffers from some of the same faults, though it escapes the over-prettification of the boy.

Andrea del Verrocchio produced few masterpieces, but in the final seven years of his life, 1481–1488, he designed the monument to Bartolommeo Colleoni in Venice, which surpassed his rival's equestrian work. Verrocchio's statue is consistent, well set, and imbued with the feeling of the *condottiere* on parade. It breathes strength, power, and human mastery. The excessive amount of detail—goldsmith's work, for most of these Florentine sculptors were trained to goldsmithing as well as architecture, painting, stone-carving, modeling, and casting—fails to detract from the effect of vigor and largeness.

Bernardo and Antonio Rossellino, Desiderio da Settignano, Mino da Fiesole, Francesco Laurana, the della Robbias, and other lesser imitators of Donatello's pretty works formed within the Florentine school a group concerned with the smaller sculptural virtues. The statues of the late *quattrocento,* and of the 1500s, cannot be judged by the standards applied to della Quercia or Michelangelo; any test shows up most of them as rather sweet and sentimental. No body of works has been more extravagantly praised.

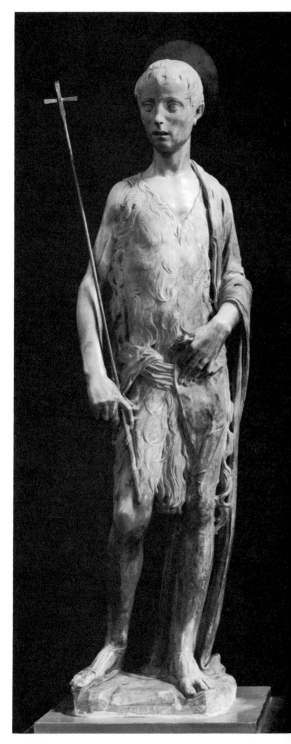

Youthful St. John. Stone. Donatello. 1434–40. *National Museum, Bargello, Florence.* (*Brogi photo*)

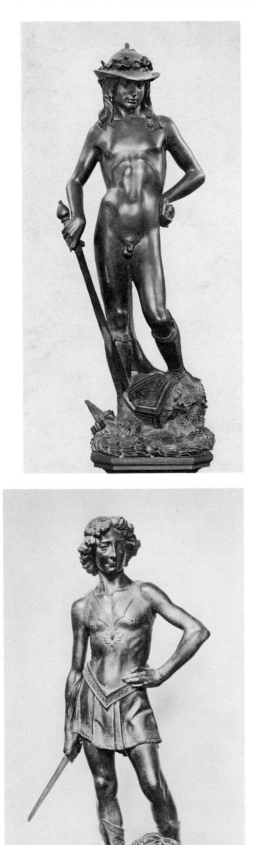

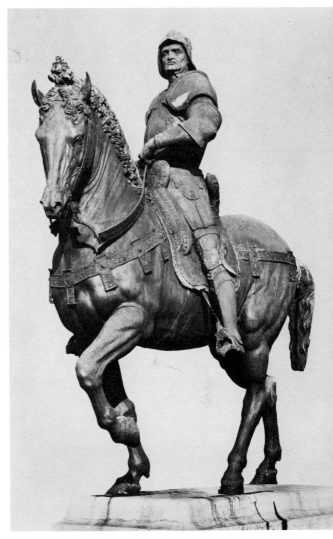

David. Bronze. Donatello. *National Museum, Bargello, Florence. (Alinari photo)*

Bartolommeo Colleoni. Bronze. Verrocchio. 1481–88. Piazza SS. Giovanni e Paoli, Venice. *(Anderson photo)*

David. Bronze. Verrocchio. *National Museum, Bargello, Florence. (Brogi photo)*

Desiderio da Settignano is perhaps the best of this school of delineators of the sweet and the charming. He specialized in cherubs, young mothers, and pretty boys. But much can be forgiven him—even the frozen smiles of the children—when one sees the grace and the delicate restraint of the *Bust of a Young Woman* at the Bargello. Here sculptural suavity has done everything possible to represent to the observer the natural charm of an aristocratic girl. Desiderio's fault of a too scrupulous detailing is here curbed. Inner character is revealed, and a sensitive feeling for flowing contour, even for proportion and mass.

The *Bust of a Little Boy* in the National Gallery in Washington is a chubby, perky, irresistible child immortalized. But when Desiderio decorated tombs he was likely to destroy the architecture by the unrelated collection of reliefs and figures in the round.

Indeed at this time the feeling for the statue as other than a display piece had passed. Agostino di Duccio learned to keep his graceful relief figures flat to the wall, and sometimes, as at Perugia, he disciplined his sinuous angels trailing fluttering draperies into pleasing mural decorations.

Bust of a Little Boy. Stone.
Desiderio da Settignano. *Mellon Collection, National Gallery of Art, Washington*

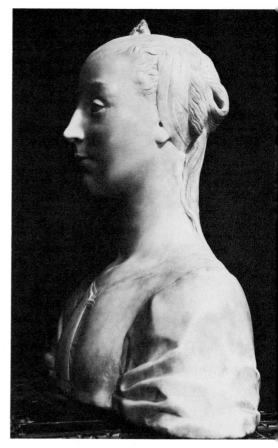

Bust of a Young Woman. Stone. Desiderio da Settignano. Mid-15th century. *National Museum, Bargello, Florence. (Alinari photo)*

Saint Bernardino in Glory, detail. Stone. Agostino di Duccio. C. 1460. *Façade of Church of S. Bernardino, Perugia. (Anderson photo)*

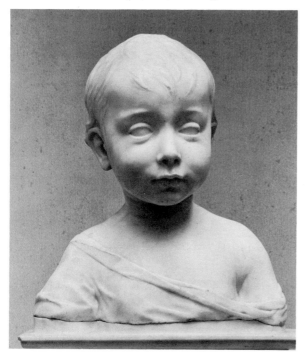

Francesco Laurana, born in Dalmatia, was a roving sculptor who almost equaled Desiderio in suave portraiture, as may be seen in the appealing *A Princess of the House of Aragon* at Washington. Another exquisite portrait, *Bust of a Woman*, is ascribed to the Neapolitan school, with which Laurana's name has been associated. Benedetto da Maiano, sculptor of a famous pulpit at the Santa Croce Church, Florence, is held by some critics to be superior to Laurana, Desiderio, and others of the Florentine school by reason of his portraiture and his reliefs in the pictorial style of Ghiberti.

Antonio Pollaiuolo introduced melodramatic action into painting, and tried to do the same for sculpture. In general he destroyed whatever traces of massiveness and quietude were left in the art. The once-famed statuettes of Bertoldo di Giovanni today seem overactive and rather insensitive. He had been a student of Donatello's and was an early teacher of Michelangelo. Il Vecchietta—Lorenzo di Pietro of Siena—more successfully added a sort of nervous energy to his modeling and preserved a total unity while enlivening the surface appeal.

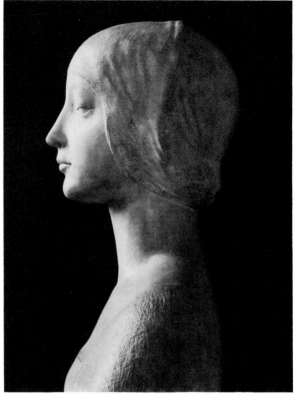

Bust of a Woman. Stone. Neapolitan school, 15th century. *Louvre.* (*Alinari photo*)

The Risen Christ. Bronze. Lorenzo Vecchietta. 15th century. *Church of Santa Maria della Scala, Siena.* (*Alinari photo*)

A Princess of the House of Aragon. Stone. Francesco Laurana. Venetian school, 15th century. *Mellon Collection, National Gallery of Art, Washington*

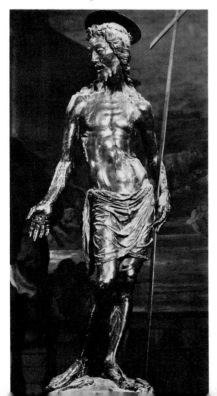

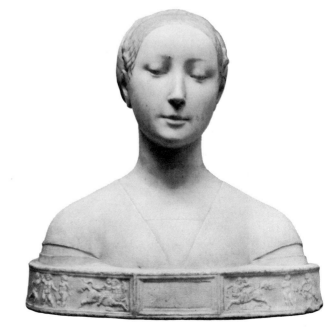

Since Luca della Robbia founded a family business for producing brightly colored glazed terra-cotta plaques, so many of these have appeared in and on the buildings of Florence that they have constituted a kind of folk art. In the time of Donatello's triumphs, Luca began to experiment in clay modeling in high relief. The figures were painted white against a background painted blue, and the whole was glazed and fired. Shortly after, the common polychromed garlands of flowers and fruits appeared as borders, and there were experiments in less simple color schemes in the medallions, lunettes, tabernacle panels, and free-standing busts that streamed from his studios. Luca, the first della Robbia, was a true sculptor of his time, versatile and skilled. His marble panels of singing cherubs made for the cantoria of the cathedral have been hardly less praised than Donatello's more riotous, though less distressingly cute, singing children.

Luca had a sensitive feeling for surface composition, and he designed panels filled with the most popular devotional subjects, the *Virgin in Adoration,* the *Annunciation,* the *Resurrection, Angels, Cherubs,* and *Bambini,* in a pretty, rounded, and highly colored style which is purely pictorial.

The *Virgin in Adoration,* now at Philadelphia, is a perfect example, in its sentiment, naturalism, and beautiful surface composition. The details of flying angels from the predella of the Altar of the Holy Cross in the Church of the Madonna dell' Impruneta near Florence are among the best-known works of Luca della Robbia. There are also a few independent glazed figures and free-standing groups from his hand.

Andrea, Luca's nephew, was brought into partnership at the age of twenty-five, succeeded as head of the studio at forty-seven, and lived to be ninety. He thus was able to turn out countless "della Robbias"—to the confusion of historians trying to separate Luca's designs from later and generally less competent works. Andrea too pleased an immense public, but in general his compositions were a little more crowded and elaborate.

The altarpiece with the *Coronation of the Virgin* at Siena is one of the most successful of his designs. The predella panels are characteristic of the best period of full pictorialism, achieved with a shrewd sense of composition and a graceful naturalism. The other members of the della Robbia family continued with the manufacture of colored

Virgin in Adoration. Faïence. Luca della Robbia. Florentine, 15th century.
Philadelphia Museum of Art. (*Giraudon photo*)

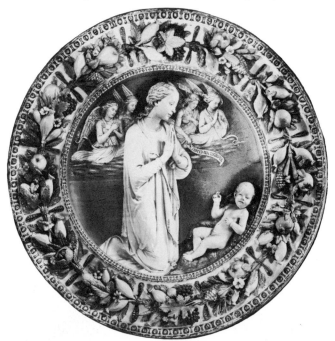

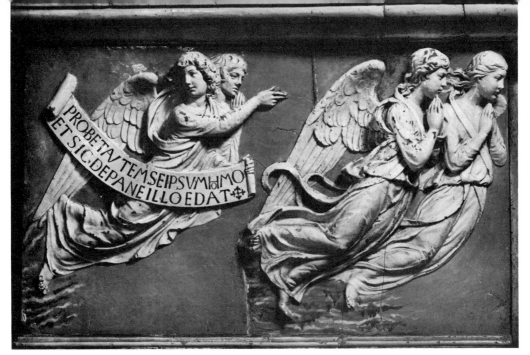

Angels, detail. Faïence. Luca della Robbia. *Chapel of the Holy Cross,*
Church of the Madonna dell' Impruneta, near Florence. (*Alinari photo*)

Coronation of the Virgin. Faïence. Andrea della Robbia.
Church of the Convento dell' Osservanza, Siena. (*Brogi photo*)

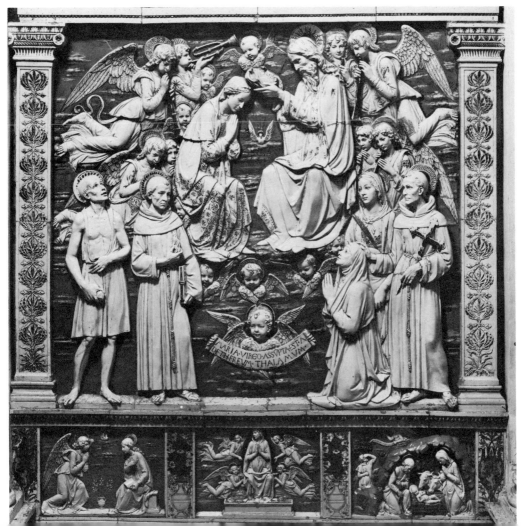

ware through many decades, but the plaques made after Luca and Andrea died were inferior.

Instead of the score of world-famous and important sculptors produced by Italy, and especially Florence, during the *quattrocento,* the *cinquecento* produced but one. Not only is Michelangelo the outstanding sculptural creator of Italy's High Renaissance, but he also transcends any other figure in the history of the art in post-medieval times. He was a stormy individual, and his sculpture and painting are elemental, overpowering, and sometimes turbulent. But in all that is basic and profound in the art, in lithic grandeur, in stonelike quietude, in the implication of spiritual meaning and four-dimensional order, he is supreme.

It is difficult to understand why the giant of the Renaissance should have appeared at the time when Florentine sculpture itself was weakest. Michelangelo was born nine years after Donatello died. His work matured long after Verrocchio, Desiderio, Agostino di Duccio, Laurana, and the other secondary masters had disappeared from the scene. Luca della Robbia had gone, and his nephew Andrea was filling orders for "della Robbias" with diminishing invention and taste. Michelangelo was engaged as an apprentice sculptor for four years to the great Medicean patron of the arts, Lorenzo the Magnificent. Then he spent a season in Bologna, where he had leisure to study the sculptures of Jacopo della Quercia, the only Italian (except for the anonymous Romanesque masters) fitted to influence profoundly so gifted a sculptor.

Battle of the Lapiths and the Centaurs, high relief panel. Stone. Michelangelo. 1490–92. *Casa Buonarroti, Florence. (Brogi photo)*

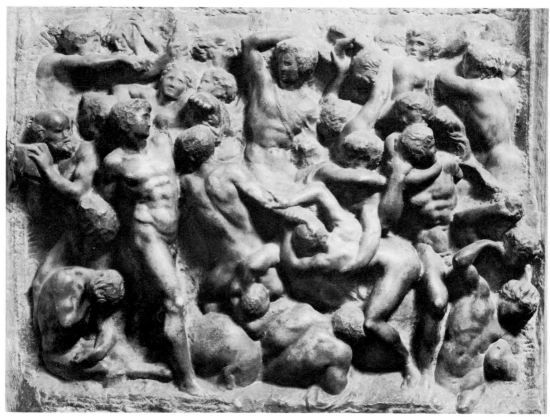

Certain of the very early works of Michelangelo exhibit those attributes of powerful contained movement and monumental impressiveness so patent in the late figures. Even a trial piece, the relief of the *Battle of the Lapiths and the Centaurs*, carved when he was eighteen years old, is imbued with elemental movement and plastic order. In two

early single figures, a *Bacchus* chiseled when he was no more than a youth, and the *David* at San Miniato, the profounder feeling for plastic rhythms and monumental order is tempered by an apparent desire to conform to the tradition of Florentine neo-classic naturalism. The early *David* is shown here beside the unfinished (and much later) *David*

David. Stone. Michelangelo. 1504. *Academy, Florence. (Alinari photo)*

David. Stone. Michelangelo. 1529. *National Gallery, Bargello, Florence. (Brogi photo)*

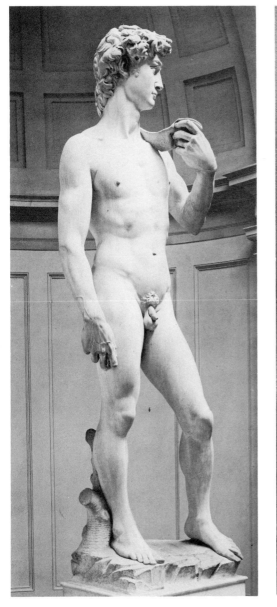

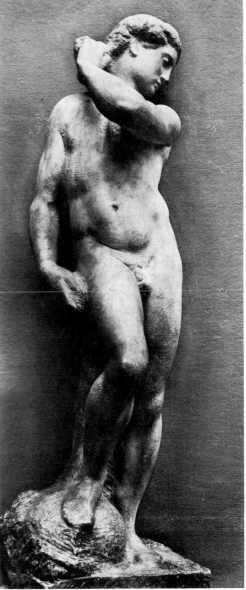

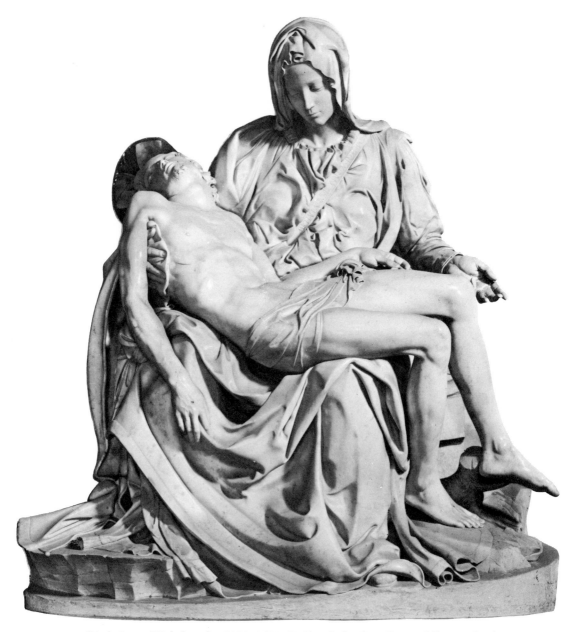

Pietà. Stone. Michelangelo. 1499–1500. *St. Peter's Basilica, Rome.* (*Alinari photo*)

of the Bargello. The *Pietà* at St. Peter's in Rome was carved before the artist was twenty-five years old, and is one of the great religious monuments of the Western world. Its realism is so far transcended by the sculptural ordering of masses and the symphonic interplay of line, of thrust and counterthrust

and containing contour, that one's eye reads the composition easily and agreeably, in a melodious language perfectly suited to the spiritual and tragic message of the monument.

The special dignity with which the sculptor endowed even the smallest piece of mar-

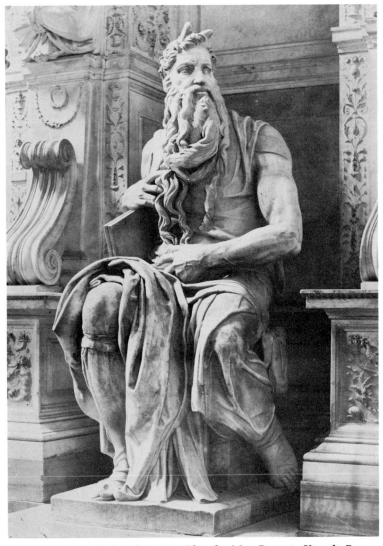

Moses. Stone. Michelangelo. 1515. *Church of San Pietro in Vincoli, Rome*

ble is inherent in the *Moses,* the central feature of the tomb of Pope Julius II in the Church of San Pietro in Vincoli, Rome. The whole monument was to have been from the hand of the master, but after heartbreaking delays, during which he was forced to paint the incomparable frescoes of the Sistine Chapel, which he regretted as an interruption of his more beloved labors in sculpture, Michelangelo gave over the scheme to lesser artists. Two *Slaves* which he originally cut for the tomb of Julius II are in the galleries of the Louvre, where they seem to dwarf other Renaissance sculpture. The *Moses* is an individualistic conception of the Lawgiver, rocklike yet vibrating with movement, specific in detail yet held within a unity. The man is sternly the instrument of God, majestically portrayed.

From 1520 to 1534 Michelangelo labored intermittently to put into effect the elaborate architectural and sculptural scheme of the Medici Chapel in the Church of San Lorenzo in Florence. The one part nearest

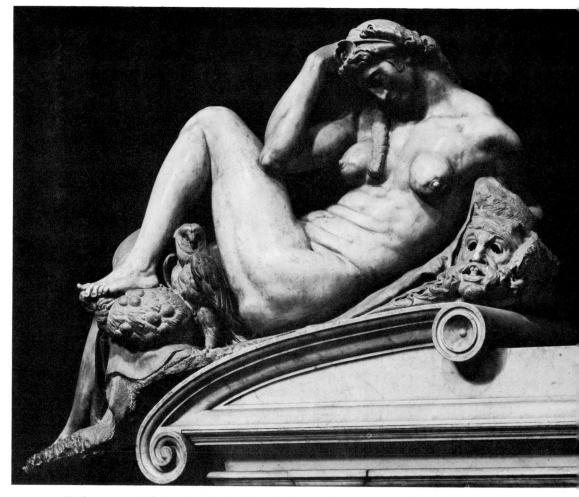

Night. Stone. Michelangelo. *Medici Chapel, Church of San Lorenzo, Florence.* (*Brogi photo*)

completion, the tomb of Lorenzo de' Medici, shows the figure of Lorenzo, known as *The Thinker,* over two figures symbolizing twilight and dawn. The three statues link well together, and the unfortunate location of the group in an overbare room fails to dim the sense of spiritual power and elemental grandeur flowing from these essentially living figures. The *Dawn* is illustrated on page 366 (and the *Twilight* in the Introduction). On the tomb of Giuliano de' Medici, the matching figures are of *Night* and *Day* (the latter with the head not fully chiseled out of the marble block). The four symbolic figures are generally considered the most masterly sculptures inherited by mankind from the

period of the Renaissance. These, like Jacopo della Quercia's works, are of a certain magnitude. They have a sheer physical largeness and an appearance of contained, concentrated power that make a comparison with the marbles of the Athenian Parthenon inevitable.

The figure of *Night* has been counted by many authorities the incomparably great statue of the series. But the *Day* appears no less magnificent, in spite of being unfinished. It conveys a sense of grandeur hardly surpassed in the history of art. *Dawn* might be compared with the *Goddesses,* the *Ilissos,* and the other elemental figures of the Parthenon pediment.

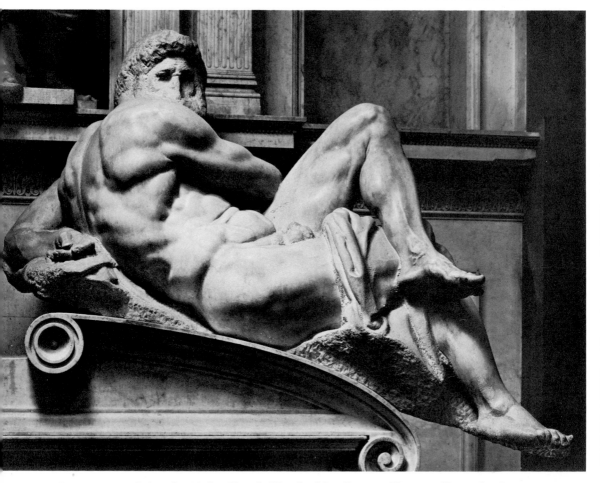

Day. Stone. Michelangelo. *Medici Chapel, Church of San Lorenzo, Florence.* (*Brogi photo*)
(See illustrations on pages 5 and 366)

In the chapel there is a statue of the *Madonna and Child,* endowed with the human tenderness and the tragic pity so beautifully carved into the *Pietà.* Apart from these great works, there are a fragmentary *Fiume,* and a final work, a *Deposition,* in the Cathedral at Florence, in which Michelangelo, nearing ninety years of age, survivor of one on the stormiest lives in the annals of art, portrayed himself as a mourner helping to release Christ from the Cross, thus affirming his final mystical and passionate devotion to the Christ.

From various periods in his career there are statues left half finished when, for example, unstable patrons changed their minds, or died. The group of the four *Prisoners* at Florence was hardly more than half worked from the block and was intended for the tomb of Julius II. Just as the immediate successors of Michelangelo, the Florentine mannerists, were to imitate certain surface characteristics of his art—his large masses and emphatic movement—without his sense of symphonic order, so, nearly four hundred years later, a great individualist, Rodin, was to see the enormous creative possibilities in a partially worked marble block, though he never quite achieved the magnificent power of the *Prisoners.*

Raphael was stirred by the ambition to equal the one rival whose stature had over-

Prisoner. Stone. Michelangelo.
National Museum, Bargello, Florence.
(Mannelli photo)

Prisoner. Stone. Michelangelo.
National Museum, Bargello, Florence.
(Mannelli photo)

shadowed his own, and he set out in sculpture, as in painting, to create Michelangelesque masterpieces. He could not carve in stone, but he made sketches or models for heroic figures of the prophets, which Lorenzetto executed for the Chigi Chapel of Santa Maria del Popolo, Rome. At first glance the *Jonah* and the *Elias* seem like works of the master, being massive and superficially rhythmic. But the synthetic nature of the pieces soon becomes clear in the softening of the forms and a violation of feeling for the block.

Other imitators fared less well, as the huge malformations, not to say monstrosities, in the Piazza della Signoria in Florence especially testify. Baccio Bandinelli—more successful in lesser works—erected the huge, tasteless Hercules and Cacus there and proved how easily sculptural largeness and power could be turned to uses of sensationalism and melodrama; while Bartolommeo Ammanati, with collaborators who included the very talented Giambologna, contributed a distressing Fountain of Neptune that stands nearby.

Andrea del Verrocchio had been Leonardo da Vinci's master, and the equestrian monument to Francesco Sforza over which Leonardo labored so many years, only to see the final model destroyed before it could be cast in bronze, was an attempt to rival Verrocchio's *Colleoni Monument*. The colossal mock-up constructed by Leonardo and his assistants at the Sforza *castello* in Milan was extravagantly praised. There are several spirited small bronzes approximating to the surviving sketches made by Leonardo for the Sforza statue and for a planned monument to Trivulzio; and each is claimed to be, in miniature, *the* Horse of Leonardo. One of these may well be cast from a sketch model, and others may be free copies, for several are outstandingly strong and rhythmic in comparison with the hundreds of weakly realistic statuettes of the period 1450–1600. The bronze at Budapest, with a tiny rider mounted on a spirited stallion, is perhaps the finest of

these da Vinci models. A very similar horse (without a rider) is at the Metropolitan Museum in New York.

One other name should be included in the list of sculptors influenced by Michelangelo: Jacopo Sansovino, who had been a pupil of

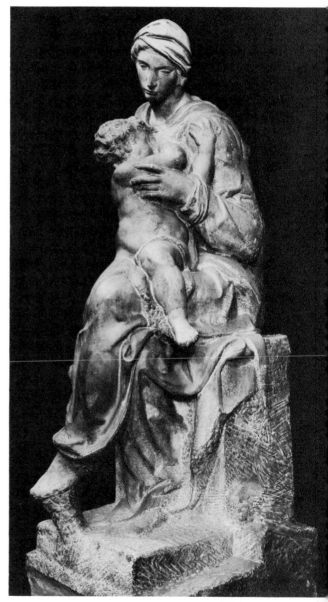

Madonna and Child. Stone. Michelangelo. *Medici Chapel, Church of San Lorenzo, Florence.* (*Brogi photo*)

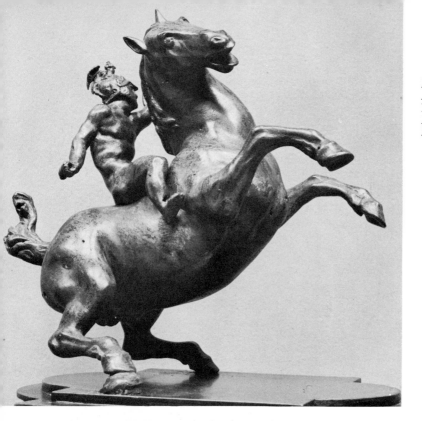

Horse and Rider. Bronze.
After Leonardo da Vinci.
Early 16th century.
*Museum of Fine Arts,
Budapest*

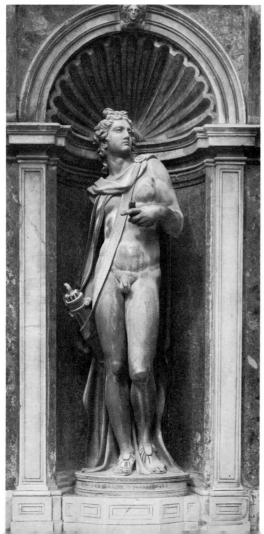

Apollo. Stone. Jacopo Sansovino. C. 1540.
Logetta at the Base of the Campanile,
Piazza San Marco, Venice. (*Alinari photo*)

Andrea Sansovino and took his surname.
A good Sansovino may be an echo of the
largeness and vigor of Michelangelo or a
nearly successful attempt to revive a har-
monious neo-classicism, as in the pleasing
figures of the loggetta of the campanile of San
Marco, Venice.

Baccio de Montelupo was older than
Michelangelo but had been his student, as had
Alessandro Vittoria, both of whom are men-
tioned in the histories and are creditably repre-
sented in the churches. Baccio de Montelupo's
St. Damian, beside Michelangelo's *Madonna
and Child* in the Medici Chapel, does not too
badly suffer in such stupendous company,
though there might have been collaborative
help from the teacher.

The specialists in small bronzes were to the
forefront in sculptural history during the fol-
lowing half-century. It was Benvenuto
Cellini's ambition to equal the greatest, but
his talents remained only those of the skillful
goldsmith. There is too much detail, and too

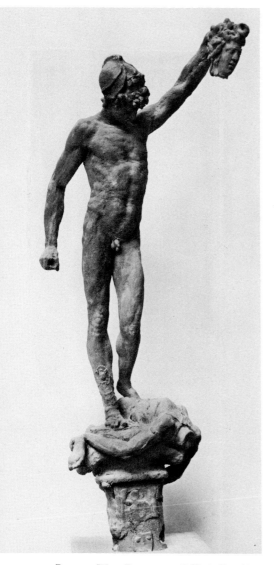

Perseus. Wax. Benvenuto Cellini. C. 1550.
Bargello, Florence. (*Brogi photo*)

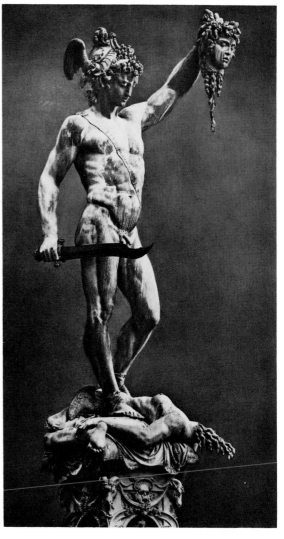

Perseus. Bronze. Benvenuto Cellini. C. 1550.
*Loggia dei Lanzi, Piazza della Signoria,
Florence.* (*Alinari photo*)

much ornament, in almost every one of his statues. The work generally accepted as his masterpiece, the bronze *Perseus* in the Loggia dei Lanzi, Florence, shows this overelaboration, but Cellini left a sketch-model in wax, and this early version has the grace and vitality of the larger figure without the distracting accessories, as can be seen when the two versions are pictured together.

The schools of bronze-workers were many: Florentine, Paduan, Venetian. Untold thou-

sands of statuettes were turned out, as original pieces, very realistic and softened and trivial, in general; as imitations of the antique (for devotion to Greece and Rome had not in the least diminished); and as echoes of the recent Florentine masters, from the powerful Michelangelo to the graceful Donatello and the pretty della Robbia pictorialists.

Giambologna, or John of Boulogne, who was born in 1524, when Michelangelo was at the height of his powers, and lived into the

seventeenth century, is the best-known of the producers of bronze mantelpiece art. He was a prolific sculptor in the large, too, but his heroic-sized statues in emulation of Michelangelo and Ammannati are less successful. There are untold thousands of miniature replicas of his *Flying Mercury*. It is smooth in technique and naturalistic down to the last detail. The *Bather* is perhaps a better work of art, and certainly it is superior to hundreds of the genre pieces surrounding it at the Bargello.

The small bronze was, of course, the natural medium of Benvenuto Cellini. Il Riccio (Andrea Briosco), of the Paduan School; Pier Jacopo Alari Bonacolsi, who is better known as l'Antico; Francesco da Sant'Agata; and Pietro Francavilla, who, like Giambologna, was an Italian only by adoption, were other successful producers.

Some of the finest bronzes of the Renaissance period are medals. Restricted to a small space within a geometrical outline, certain sculptors disciplined their talents and created appropriate formal designs. The ablest and most original medalists date back to the generation of Donatello and Ghiberti. The medallion-bust of Ninfa is proof enough that Donatello (if the attribution is correct) could manage a graceful and pleasing bas-relief portrait within a constricted outline. It was his contemporary, Il Pisanello, or Vittore (also known as Antonio) Pisano, of Verona, who became the greatest of the medalists. Better known as one of the most original painters of the time, Pisanello specialized, as a sideline, in the commemorative medals. He is superior to many who followed in his steps because he kept his designs simple, formalized, and bold, within the small space at his disposal. The examples shown (page 396), made for the Estes and for Nicolo Picininno, are typical.

Matteo de' Pasti of Verona and, later, Benvenuto Cellini were outstanding in the field.

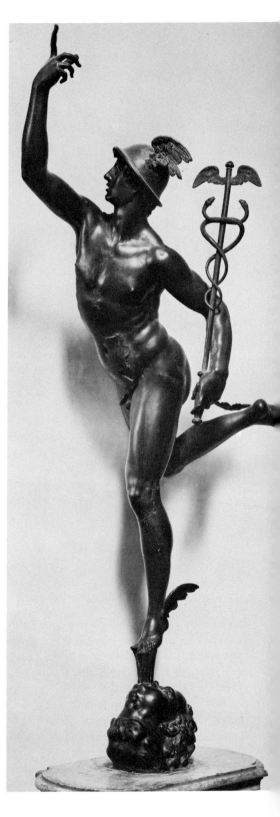

Flying Mercury. Bronze.
Giambologna. 16th century.
Bargello, Florence. (Alinari photo)

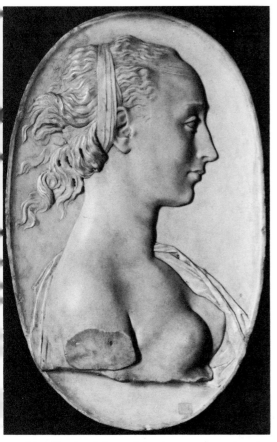

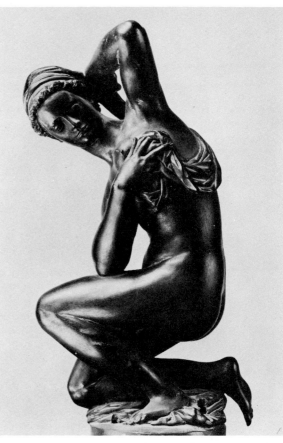

Medallion with bust of Ninfa. Stone. Attributed to Donatello. *Archaeological Museum, Milan.* (*Brogi photo*)

Bather. Bronze. Giambologna. 16th century. *Bargello, Florence.* (*Brogi photo*)

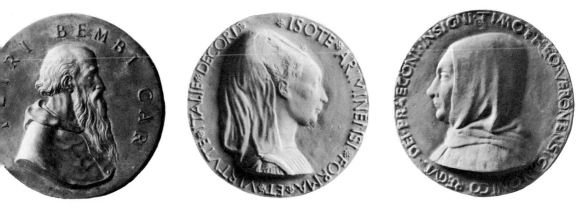

Medals. Bronze. Benvenuto Cellini (left); Matteo de' Pasti (center and right). 15th–16th centuries. *Bargello, Florence; Brera Gallery, Milan; Bibliothèque Nationale, Paris.* (*Alinari photos*)

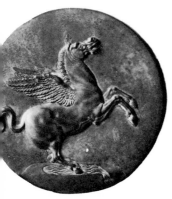
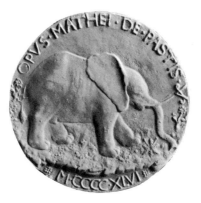
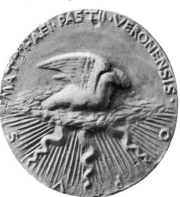

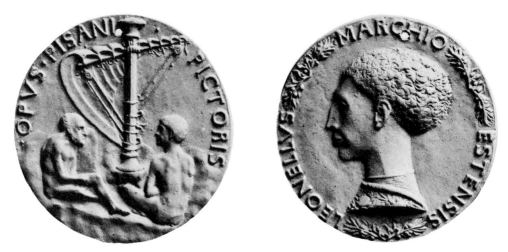

Medals. Bronze. Pisanello. 15th century. *British Museum*

The most original and accomplished German sculptor of the period was Tilman Riemenschneider. The group scenes, such as the *Death of the Virgin* at Würzburg Cathedral (page 367), and notably the altar panels, are well composed, and do not strain after the perspective vistas and other graphic effects in the Italian manner. Single figures are carved (in wood) with an instinct for the ordering of masses and the rhythmic play of contours. Some of the heads taken alone, out of the context of the surrounding figures, are among the most pleasing sculptural works of the time—about the end of the fifteenth century.

Because Riemenschneider avoided the literalism and sentimentalism typical in Italian neo-classic sculpture after 1450, many historians consider him a pre-Renaissance figure who ended the Gothic line rather than initiated the new. A transitional figure, he is perhaps the greatest North European sculptor of the period.

Certain works, not very important intrinsically, become interesting as turning-points in art. *Eve* by Peter Vischer the Younger is a sign of the triumph of Italian ideals north of the Alps in the early 1500s. The nude subject and the realistic representation show that the full current of Renaissance neo-classicism had flowed over parts of Germany. Peter Vischer

the Younger here proved himself the equal of his Italian contemporaries in the art of the small bronze. The plastic integrity of the figure, and the avoidance of self-conscious sentimentalism, make it preferable to thousands of statuettes of the kind. In perhaps the best-known Vischer work, the *King Arthur* at Innsbruck—a collaboration between father and son—overdetailing was allowed to destroy the unity of the statue. But Peter Vischer the younger remains a key figure in the transformation of German art in the short time between medieval practice and the entry of the baroque style. The bronze foundry of the Vischers at Nuremberg remained perhaps the most notable in Europe for twenty years after the deaths of the two Peters in 1528 and 1529.

From the end of the fifteenth century the French kings and their courtiers dreamed of transforming their castles and lodges into Italian Renaissance palaces, at first in the château country of Touraine, then at Fontainebleau, and finally at Versailles and Paris.

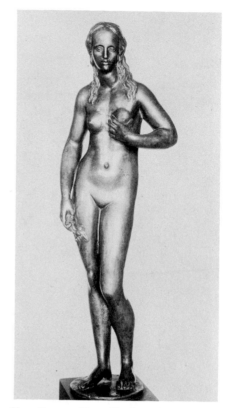

Eve. Bronze. Peter Vischer the Younger. German, c. 1500. *Museum of Art, Rhode Island School of Design*

St. Bernard of Würzburg. Wood. Riemenschneider. 16th century. *Kress Collection, National Gallery of Art, Washington*

St. John, detail. Wood. Riemenschneider. Early 16th century. *Church of St. Nicolas, Kalkar.* (*Archives Roget-Viollet*)

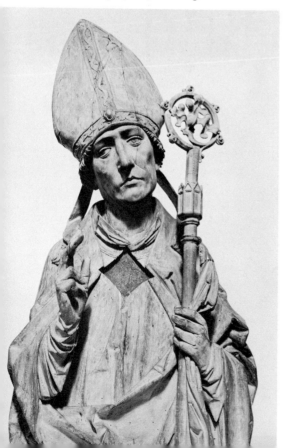

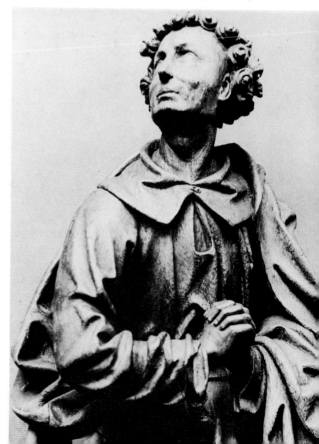

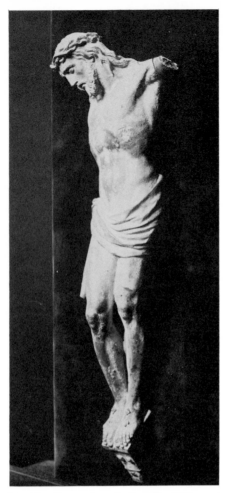

Crucifix. Iron, silvered. French, 17th century. *Curtis Collection. (Giraudon photo)*

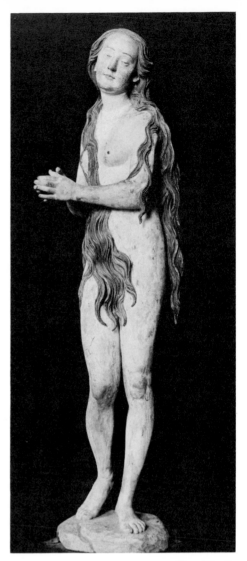

Eve. Wood. Attributed to Riemenschneider. 16th century. *Louvre. (Giraudon photo)*

Tomb figure of René de Birague. Bronze. Germain Pilon. French, 16th century. Church of St. Catherine, Paris. *Louvre. (Alinari photo)*

They imported leading Italian artists, including Francesco Laurana, Leonardo da Vinci, and Benvenuto Cellini; and a host of minor artists in painting, sculpture, music, and the arts of the theater.

Among the French, Michel Colombe, who died about 1515, left no works comparable to those of the secondary Italian masters. It was rather Jean Goujon who, by midcentury, established the native Renaissance style as the typical court art of France. His one famous work consists of the relief panels of the Fountain of the Innocents, Paris. Each panel represents symbolically, in pretty Italianate manner, one of the rivers of France.

A more original and forceful sculptor was Germain Pilon, whose career fell within the latter half of the sixteenth century. The effigy of the Chancellor René de Birague, in bronze, now in the Louvre, has both originality and a certain massive integrity.

Innumerable sensitive and beautiful crucifixes would suggest that even in the seventeenth century the Gothic style remained predominant in French, German, and Flemish practice, retaining Gothic tenderness and even touches of Romanesque expressionism. Their treatment is more affecting, both ideologically and aesthetically, than the Italian realism seen in Donatello's famous *Christ upon the Cross* at Padua.

The fact that French Renaissance sculpture was not superlative did not prevent influence from Fontainebleau and Versailles reaching most of the courts of Europe. From the late seventeenth century every country north of the Alps emulated French styles and mannerisms. Spain fortunately had both Italian and French tutors in the earlier period, and the greatest of the Spanish transitional sculptors, Alonso Berruguete, had received his training in Italy. His tomb of Cardinal Tavera at Toledo, even though too decorative, possesses a hint of power reminiscent of Michelangelo.

Spanish Renaissance sculpture developed into a forced style congruous with the overencrusted architecture known as Churrigueresque, which inspired much of the Colonial Spanish architecture of Mexico and South America. Some sculpture, however, became

Tomb of Cardinal Tavera.
Stone. Alonso Berruguete. Spanish, 16th century. *Hospital de Afuera, Toledo*

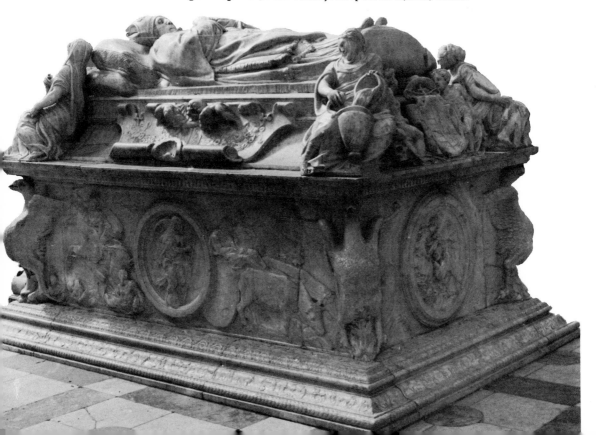

intensely realistic, like that of Pedro de Mena
in the middle of the seventeenth century. The
painted wooden statues of the Spanish carvers
of this time gained unity through the swathing
of head and figure in cowl and cassock, and
touched a high point in sensitive naturalistic
representation. Intense spiritual feeling is re-
vealed in the faces. The smallness of the head
as well as the idealized, almost Christlike
features in the figure of St. Francis in the
Toledo Cathedral suggests unworldliness,
even asceticism. The extreme delicacy of de-
lineation is notable also in the *Madonna of
Sorrows* in the Victoria and Albert Museum,
by Juan Martínez Montañes.

In the new world of Spain's American
colonies this art of tender feeling and devo-
tional dedication crossed with native Amerin-
dian and Mayan strains and produced some of
the most original and attractive of the known
types of folk sculpture, as well as a great deal
of disagreeably realistic treatment of the
tragic aspects of the Christ story. Gruesome
sculpture was common in Spain, too, in the
Counter-Reformation period.

But the serious and appealing *San Bruno*
may remind us that extraordinarily fine de-
tails may be found in the altar screens, deco-
rated portals and incidental adornments of
churches and monasteries. This masterly head
is at the Carthusian convent of Miraflores
near Burgos.

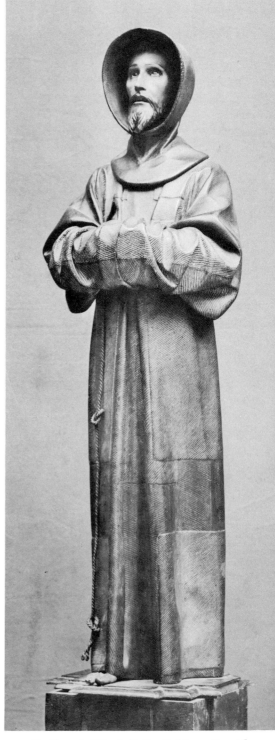

St. Francis. Wood. Pedro de Mena. Spanish,
17th century. *Cathedral of Toledo.* (L. L. *photo*)

Madonna of Sorrows. Wood, painted. Juan Martinez Montañes. Spanish, 17th century.
Victoria and Albert Museum

San Bruno, detail. Wood, painted. Manuel Pereira. Spanish, 17th century.
Cartuja de Miraflores, Burgos

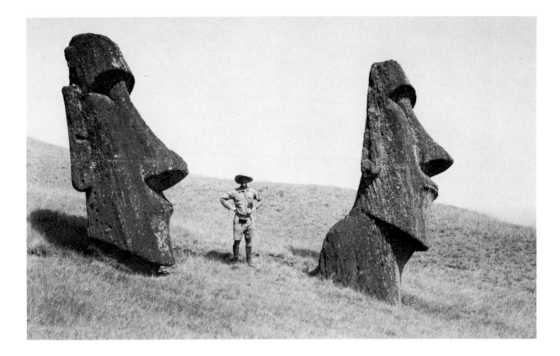

15: The South Seas and Negro Africa:
"Exotic" Sculpture

I

THE carvings of the primitive peoples of the South Sea Islands and of Negro Africa have revealed profound sculptural values and unique decorative stylization. They were discovered by the ethnographic museums in the nineteenth century, were hailed as consummate art by the French and German artist-revolutionaries of the early twentieth century, and are now included in histories of sculpture. Open-minded observers, trained to respond to the values of form-organization and abstract creation, have penetrated beyond the strange-

ness to enjoyable manifestations of basic sculptural emotion.

In the Pacific Ocean there are a thousand islands that appear as no more than pinpoints on our maps. Some that are north of the equator and not geographically in the South Seas have yielded objects commonly included with South Seas art, most notably the Hawaiian Islands. South from the equator are dotted the great number of inhabited islands, including such fabled places as the Marquesas, Fiji, Tahiti, Samoa, and Easter Island. There are

Heads. Stone. Polynesian. Easter Island. (*Photo courtesy American Museum of Natural History*)

also the great island masses of New Guinea, north of Australia, of which the eastern and northeastern coasts are in Melanesia, and the New Zealand islands southeast of Australia, which are in Polynesia. The Maori art of New Zealand is well known, since the native style has been encouraged by the white settlers after earlier suppression. The art of Easter Island, an eastern outpost of Polynesia, has also been celebrated by writers and widely displayed in museums.

The territory of the Pacific tribes or nations, called Oceania, comprises three main areas— Micronesia, Polynesia, and Melanesia—although Australia and Tasmania are also in this geographical region. The Micronesian area lies northward of the hypothetical Oceanic Center, up toward Japan; Melanesia is southwestward, stretching from New Guinea to Fiji; and Polynesia occupies the rest of the islanded space, being a vast territory reaching eastward to Easter Island off the South American coast and northward to include the Hawaiian Islands. The western boundary of Polynesia is roughly on a line drawn from the Hawaiian Islands through the Fiji Islands to New Zealand.

In Africa there are many Negro tribal cultures which have produced strikingly stylized and appealingly human carvings. The vast area of the differing cultures yields no norm by which objects can be readily classified, but native African statuettes, masks, or utensils can be distinguished immediately from the products of American Indians or South Sea Islanders. The impulse to beautify everyday utensils by means of carving is notable in many districts in Africa. Spoons, cups, bobbins, weapons, and weights are but a few of the objects commonly enriched with figurative sculpture.

Within the African style are outstanding tribal expressions of imaginative skill, such as the Baluba, the Ashanti, and the Benin. Two divisions of Negro non-utilitarian art are the ancestral, or devotional, and the ceremonial. African sculptured figures are not idols, in the sense of gods to be worshiped. Many of the masks represent spirits and are ceremonial and ritual properties used in religious dances, puberty rites, etc., by such tribal organizations as the men's secret societies.

The sculpture from the South Sea Islands and from tribal Africa is technically called primitive, for there was no written culture. The carvings show an intuitive grasp of sculptural fundamentals and are innocent of pursuit of natural imitation on its own account, as can be seen in the following illustrations.

Secret-society mask. Ivory. Warega. Congo.
Museum of Primitive Art

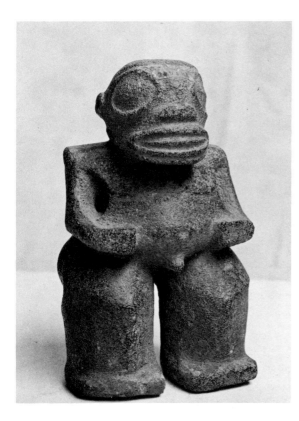 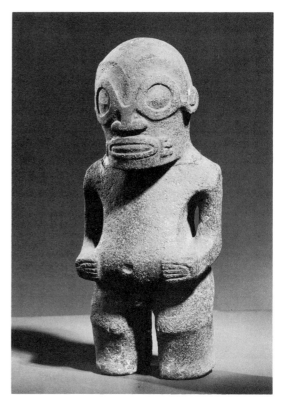

II

ALTHOUGH it may be said that sculptures from the South Seas are "light," often being made from pith or bark or the lighter woods, or from grasses, cloth, feathers, basketry, hair, and shells, the fundamental basis of the art is in stone and the denser woods. Amid the intricately carved and beautifully decorative things there are important examples of instinctively lithic rock sculpture.

There is nothing light or fantastic in the primitively simple stone figures on page 402. The idols of the Polynesians are in general monumental. They are heavier and closer to basic sculpture than are those of the Melanesians. Whether the small stone *tiki* of the Marquesans or the five-ton images carved by the Easter Islanders, the Polynesian statues are characterized by an intuitive feeling for masses in formal relationship and for simple melodic rhythms. The two large-eyed, squat-figured images shown above are variations of a type recognizable as Marquesan. They indicate survival of primitive feeling—direct, vigorous statement and instinctive squaring of forms, relieved by only the barest detailing and ornamentation.

In the colossal stone idol from Easter Is-

Statuette. Stone. Polynesian. Marquesas Islands. *Musée de l'Homme, Paris*
Statuette. Stone. Polynesian. Marquesas Islands. *University Museum, Philadelphia*

land—where surviving statues range up to ten times human size and to a weight of thirty tons—the main masses are hardly less compact, though the edges are cut more sharply and the rhythms are linear in effect. One of the wonders of Polynesian art is that stonecutting was accomplished with stone instead of metal tools. (In smaller work, tools of shell, or tools incorporating a boar's tusk or a shark's tooth, or even a rat's tooth, were sometimes used.)

The Easter Islanders occupy a remote and almost barren fragment of the earth, but they developed a surprising range of sculptural expression. Besides the elemental and rather crude colossi in stone, there are many beautifully polished stylized images, fashioned in wood with an almost sophisticated regard for melodic line and flowing contour. A distinctive type is illustrated in the ancestral figure with its masklike head, excrescent ribs, and elliptical limbs (below).

Within Polynesia, excepting New Zealand, the art of sculpture is best represented thus by three-dimensional statues and statuettes. Many relief carvings in wood from the Cook Islands and Samoa are interesting for their

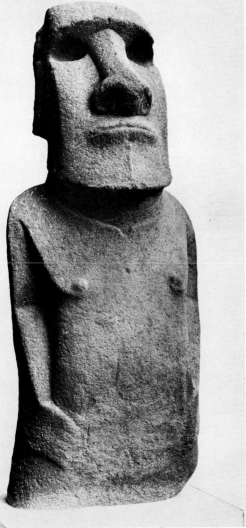

Idol. Stone, colossal. Polynesian.
Easter Island. *British Museum*

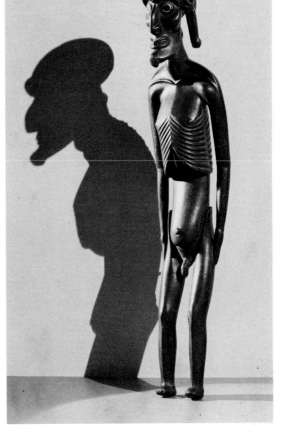

Ancestral figure. Wood. Easter Island.
University Museum, Philadelphia

rich patterning, and there are hair ornaments carved in bone from the Marquesas Islands. But the art of relief-cutting, and of decorative elaboration in the combined media of bas-relief and painting, will best be illustrated by work of the natives of New Guinea and of the Maoris.

Idols, ancestral images, and fetishistic figures found in the smaller Polynesian islands indicate a common racial ancestry, with characteristic idioms that spell local tradition. The illustrated larger-than-life wooden figure with a frightening mask is Hawaiian and represents a war-god. The peaceful little *Woman* is Fijian, from an island on the fringe of the Melanesian culture. The oracle figure is from the island of New Guinea in Melanesia. Here the characterful face and the sheerly carved body contrast effectively with the ornamental screen. (The piece is twelve inches high.)

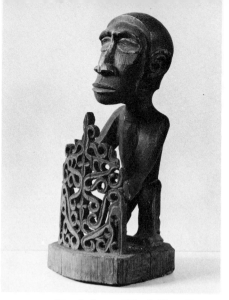

Oracle figure. Wood. New Guinea.
University Museum, Philadelphia

Woman. Wood. Fiji Islands.
National Museum, Washington.
(Courtesy Museum of Modern Art, New York)

War-God. Wood. Hawaii.
Peabody Museum, Salem, Massachusetts

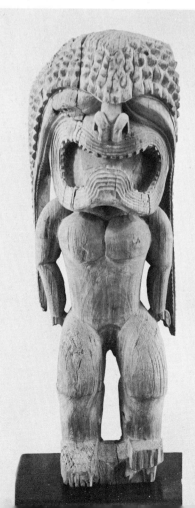

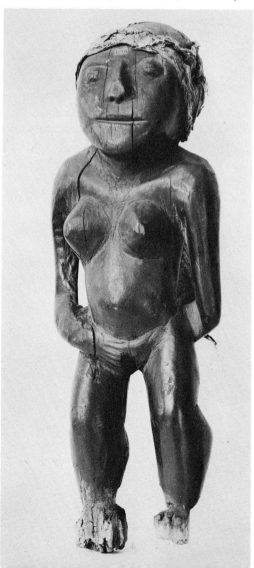

The sculptors among the Maoris of New Zealand had a distinctive native style and seldom concerned themselves with free-standing figures. The best of their art consisted of richly carved relief patterns with incidental human forms, embellishing the prows and stern-boards of canoes, and the pillars, beams, lintels, and window-frames of the great assembly-houses. These communal buildings functioned as combined men's clubhouses and holy arcana. The decorated weapons also are very fine, and minor objects in jade, especially the *Hei-tiki,* are exquisitely cut and polished, often with bold yet sensitive sculptural feeling.

The distinctive curvilinear style of design is illustrated in the two house lintels and the canoe prows. The art of the Maoris indicates a strong feeling for the contrast of main motive and richly embellished but subdued relief,

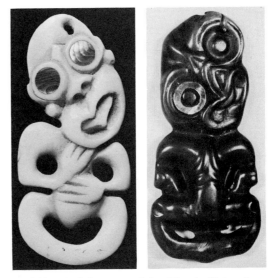

Hei-Tikis. Whale ivory; jade. Maori. *University Museum, Philadelphia; Brooklyn Museum*

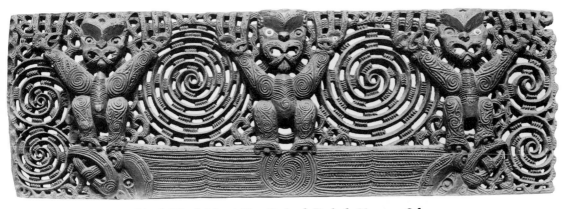

Lintel. Wood. Maori. New Zealand. *Peabody Museum, Salem.* (*Courtesy Museum of Modern Art, New York*)

Canoe prow. Wood. Maori. New Zealand. *American Museum of Natural History*

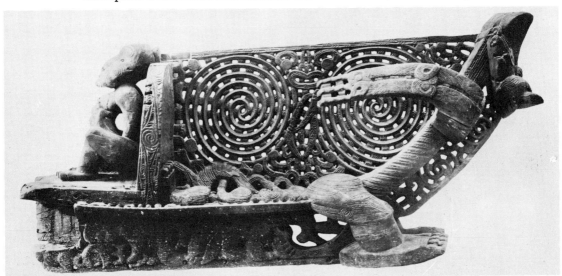

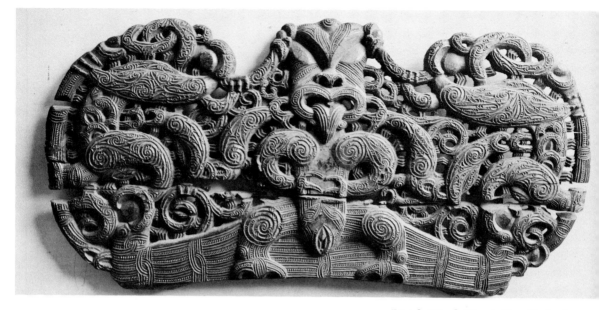

Lintel. Wood. Maori. New Zealand.
British Museum

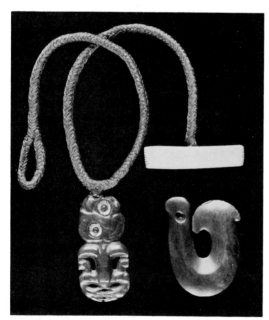

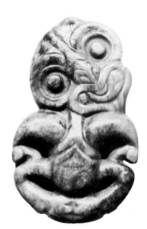

Hei-Tikis. Greenstone. Maori.
University Museum, Philadelphia; British Museum

Canoe prow. Wood. Maori. New Zealand.
American Museum of Natural History

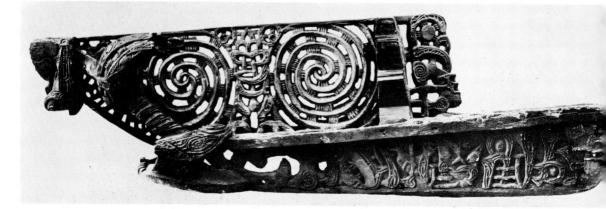

whereas, in general, South Sea decorative carving was rich in aimless patterning. The figures that stand out are, of course, strictly conventionalized, if not geometrized, in harmony with the mathematically conceived all-over design.

A Maori flute or paddle, or food bowl or toilet box, lovingly carved with traditionally significant and patently attractive designs, is the fruit of an instinctive urge to create and to be surrounded with beautiful objects.

The best of the arts of Melanesia are to be found on the immense island of New Guinea and the nearby archipelagoes known as the Admiralty Islands, New Ireland and New Britain, the Solomon Islands, the New Hebrides, and New Caledonia. The gaudily exotic and colorfully fanciful, even grotesque nature of the designs, often in combined sculpture and painting, is matched occasionally by pieces that are simple, sober, and dignified. The departure from natural forms, the expressionistic distortion, does not preclude the carving of heads and masks as nearly realistic as the wooden one from New Britain. (Page 410.) Among masks the bark-cloth one below is gorgeously decorative and inhumanly grotesque, and is the more typical example. It is a property used by dramatic dancers at the cli-

max of socio-religious ceremonies, and it doubtless had spiritual and totemic meanings. For elaboration and ultimate fantasy the South Sea Islanders are rivaled in the rest of the world only among the distantly related Malayan peoples, or those of Borneo, Bali, and Java.

The Melanesian style has affinity with elements in Indian and Sinhalese art, which lends credence to the theory that the Pacific tribes made their way as immigrants from the Indo-Chinese and Malayan peninsulas. Their ethnic background of Indo-European, Dravidian, and Mongolian strains was further modified with a Negroid element.

The less elaborate masks of the Melanesians include types nearer to basic sculpture and extraordinarily interesting and imaginative approximations of the human visage. They are sometimes near-abstract. The sculptor began with the elements of the face but allowed his aesthetic fancy to lead him off into visionary design and decorative improvisation. That his imagination sometimes produced masks which are incomprehensible to us need not blind us to his amazing virtuosity in creating such effective analogues (at once suggesting and denying the human visage) as the elongated one on the following page.

Mask. Bark cloth. Melanesian. New Britain. *American Museum of Natural History*

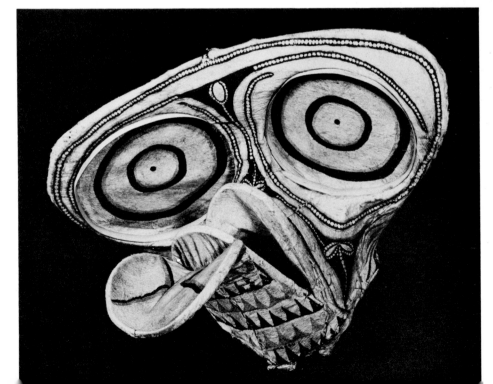

A conventionalization which featured a long hook nose curved in to meet the chin or the breast is considered by some ethnologists as representing a bird beak. To others it is a survival of an elephant's trunk, in direct line from the well-known elephant-faced idols of the Hindus and the Indonesians. In the illustration a highly stylized figure, with the proboscis very exaggerated and prominent, is shown. The fourth illustration here is an utterly different kind of carving, on a fan handle, similar to the squat, large-eyed Polynesian idols. The totem-pole form of this minor carving suggests a racial link to a different continent: to the "native" races of North America.

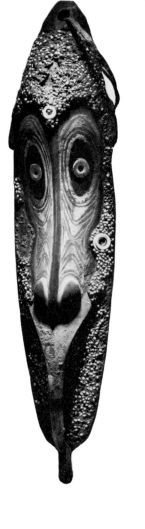

Ancestor mask. Wood, clay, shell, and seeds, painted. Iatmul, recent. Sepik River area, New Guinea. *Lowie Museum of Anthropology, University of California, Berkeley*

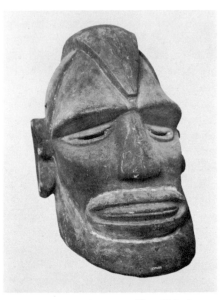

Mask. Wood. Melanesian. New Britain. *Chicago Museum of Natural History*

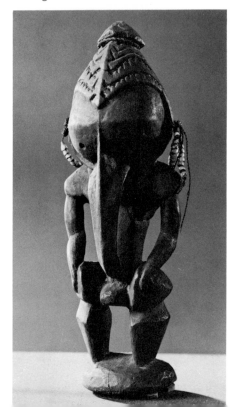

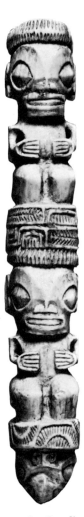

Totemic carving, ivory fan handle. Polynesian. Marquesas Islands. *University Museum, Philadelphia*

Figure with a proboscis or trunk. Wood. Melanesian. New Guinea. *University Museum, Philadelphia*

Decorative compositions such as the dance shield and the prow ornament from the Trobriand Islands illustrate a particularly beautiful type of low-relief carving, with perforations and painting. The bird motive, especially the beak, is conventionalized almost beyond recognition.

It is necessary to understand something of the religious impulses, the social objectives and taboos, and the emotions and the sexual codes of the dark-skinned races in order to enjoy many of the sculptured figures and much of the carved ornamentation. However, after some exposure to the strange and sometimes repellent effigies, masks, and utensils, even Western-trained perceptions respond to aesthetic values of a remarkable purity and a compelling intensity. The Negro, especially, reveals himself as instinc-

tive master of fundamental sculptural design, creating plastic works of an amazingly direct expressiveness. He seldom succumbed to the easy lure of naturalistic appeal. The virtues of his art are the basic ones of formal significance and lyric invention.

African sculpture is essentially an art of massive and three-dimensional solids. In primitive examples the stone is implicit in the effect. When wood became the medium, the sense of the trunk as cylinder pervaded the design.

Only a small number of major stone relics from ancient times or ancient cultures remains, and the primitively heavy things resemble those found at comparable levels in Sumer or Egypt, or the Amerindian lands. Of the two figurines shown from French Guinea, only the second exhibits mannerisms, or accomplishments, uniquely belonging to the Negro artist. (Page 412, center and right.)

Woodcarvings, on the other hand, display a full mastery of plastic expressiveness. The

Canoe prow ornament. Wood. Trobriand Islands, New Guinea. *Chicago Museum of Natural History*

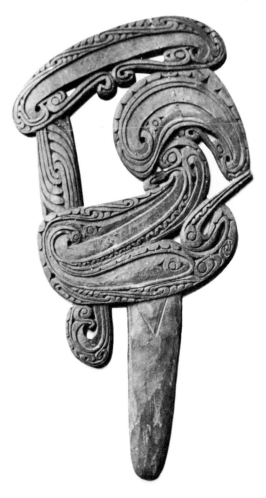

Ceremonial dance shield. Melanesian. Trobriand Islands. *Newark Museum, Newark, New Jersey*

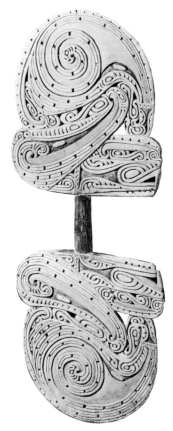

Ritual Figure, with arms raised in supplication, is a supremely simple work in which the meaning is conveyed directly and instantaneously. Sculptural form is manipulated to enforce one impression. Sculptors of older, intellectually knowing civilizations were often unable to express emotion thus directly. Here body measurements have little relationship to human anatomy, but the one gesture, the essential meaning, is profoundly intensified. The *Standing Woman,* also on the facing page, a Bambara piece, is no less summary and expressive. It and the *Figure Holding a Bag* (below, left), from the Bahuana, show a considerable advance as transcriptions of human dimensions and singularities; and the *Rhythm Pounder* (page 414) shows conspicuous mastery of human anatomy, with a marvelous study of facial expression. The headdress of wood with a hide covering returns us to the simplest primitive expression, superbly direct and packed with feeling. The expressionist means are not obtrusive. In spite of the unrealistic features, the whole visage is understandable and soundly sculptural.

A familiar subject in African sculpture is the woman holding a bowl. In this group one commonly finds the primitive directness and solidity, the carelessness of nature, the intensification of a single idea or emotion, and the intuitive playing up of the material, wood, for its fullest sculptural appeal. The example in the British Museum is twenty inches high and representative of all these

Figure Holding a Bag. Wood. Bahuana. Gabon. *Pierre Matisse Gallery, New York*

Figurines. Stone. African, Kissi. French Guinea. *Musée de l'Homme, Paris*

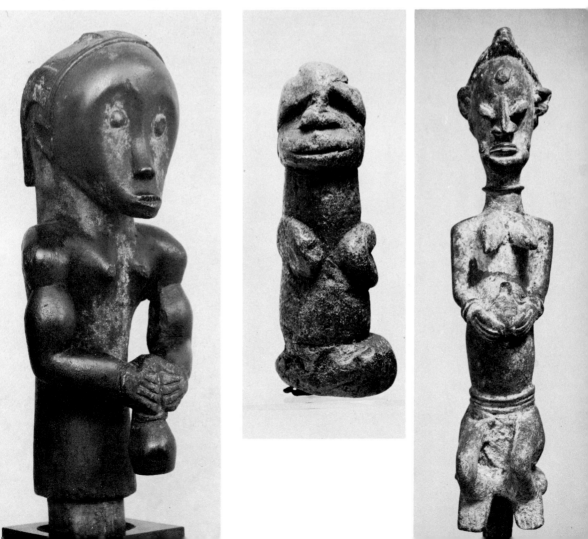

Ritual Figure. Wood. Warega. Congo.
Collection of John P. Anderson,
Red Wing, Minnesota

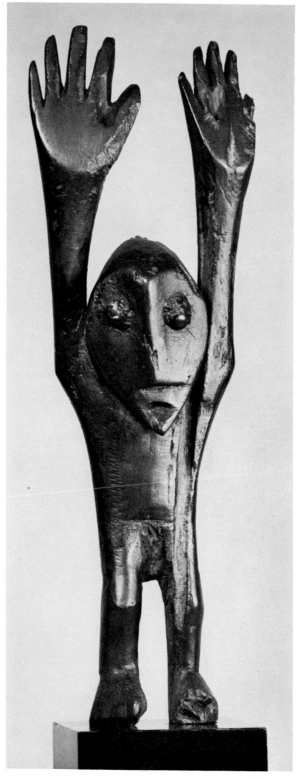

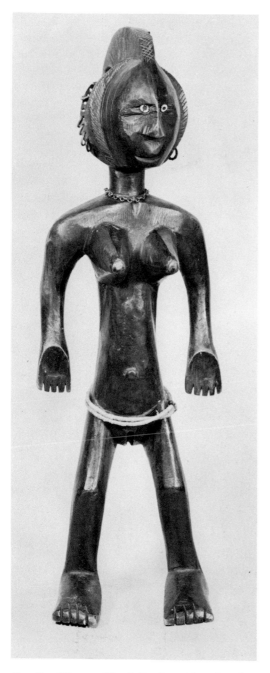

Standing Woman. Wood. Bambara. French Sudan.
Brooklyn Museum

Man (Rhythm Pounder). Wood.
Senufo. Ivory Coast. *Museum of Primitive Art*

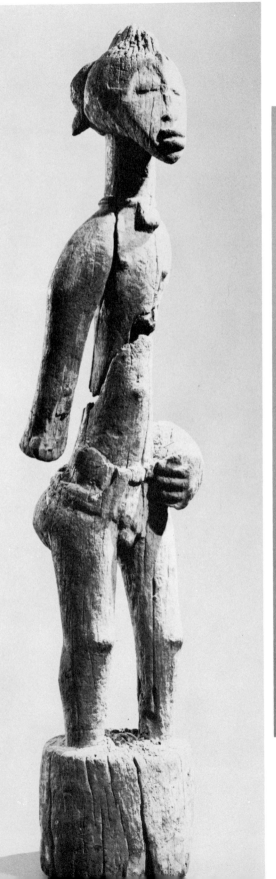

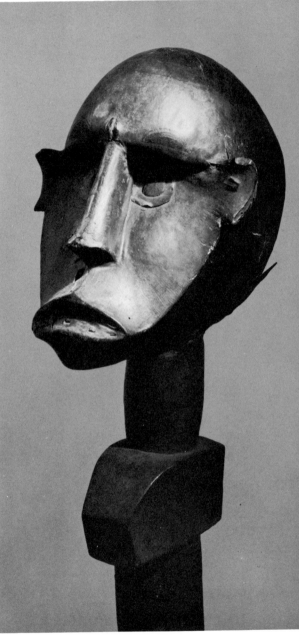

Headdress for dance. Wood, with hide.
Ibibio. Nigeria. *Museum of Primitive Art*

qualities. The relatively long arms, the torso reduced to the same thickness as the neck, and the skimped and arbitrarily curved-in legs are details in a process of shaping the figure to a vigorous and weighty rhythmic scheme. To be noted also is the one touch of ornamentation, scar patterns on the trunk. Some authorities believe that the many compositions in which a woman holds a bowl constitute no more than a sort of genre art; but others regard them as offering figures, designed to be placed before the dwellings of women unable to work and dependent upon charity.

From the Baluba tribe in the Congo there are many carved stools, following a few generalized patterns, in which the seat is held up by a single figure or grouped figures. The same loving care is given to the cutting and polishing of the figures in these utilitarian pieces as is evident in the religious or semi-religious masks and ancestral figures. A likeness in the faces of large numbers of the stool-figures suggests continuing repetition of a standard face. Yet, as may be seen from the single-figure composition and the double-figure stool illustrated, there is a wealth of interest in each separate object.

Woman with a Bowl. Wood. Baluba. Congo. *British Museum*

Woman Supporting Seat. Wood. Baluba. Congo. *Collection of Congregation des Orphelins d'Auteuil, Paris. (Courtesy Musée de l'Homme)*

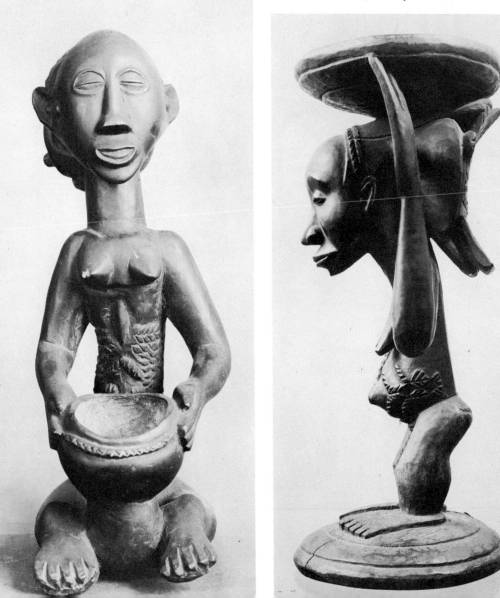

The predominant quality in the figures, as in the three heads here, is the feeling for the medium; the anonymous artists have known intuitively the susceptibility of wood to fluent cutting and high polish, appealing to the touch.

A variation from the standard figure in wood is found in the ivory fetishes of the Baluba and Bapende tribes in the Congo. Miniature masks as well as miniature figures were carved as little pocket-pieces or pendants and are said to have been carried in memory of important ancestors. An amazing amount of character has been infused into many of the fetishes, as may be seen from the illustrations. If some of the depictions seem to non-native eyes to border on caricature, the purely sculptural virtues are nevertheless serious and expert.

Through the wide range of masks the expression is conventional and impersonal. The types and the materials are as varied as

Figures Supporting Seat. Wood. Warua. Congo. *Museum für Volkerkunde, Berlin*

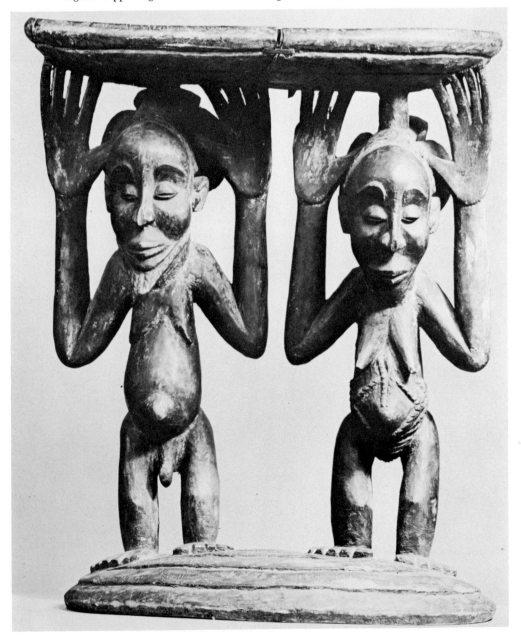

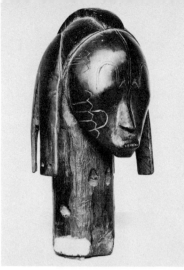

Head. Congo.
University Museum, Philadelphia

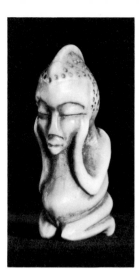

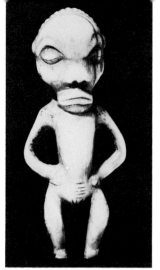

Heads and figures: fetishes. Ivory. Baluba and
Bapende. Congo. *Museum of Science, Buffalo;*
Museum of Primitive Art

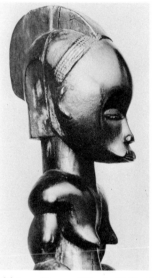

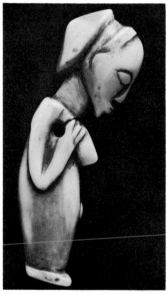

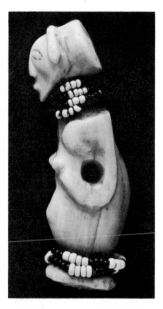

African Venus. Wood. *Collection*
of Louis Carré, Paris. (*Courtesy*
Museum of Modern Art, New York)

Head. Wood with metal. Fang.
Gabon. *Museum of Primitive Art*

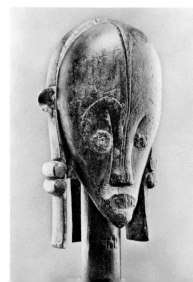

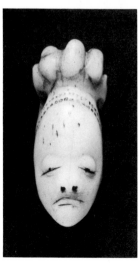

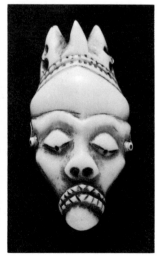

among the American Indians, and in general there is an "abstraction" of the face, which approaches the nonobjective. Deity is impersonal and cannot be thought of naturalistically. But a mask symbol of divinity, to endow the wearer with deity during a dramatic dance or ceremony, recalls the only real countenance known to the audience, the human.

There is no show element in the masks. In the carving, the creator follows a tradition or custom and endeavors to please the gods or spirits. Yet the aesthetic values are real and pure. The grasp of the basic elements of design, the relieving of symmetry by a slight asymmetry, the knowing use of geometrical equivalents for the individualized human features, the effective reversal of positive and negative, or protuberance and hollow; above all, the rhythmic organization of the sculptural masses—these are matters for wonder and delight. (See also page 403.)

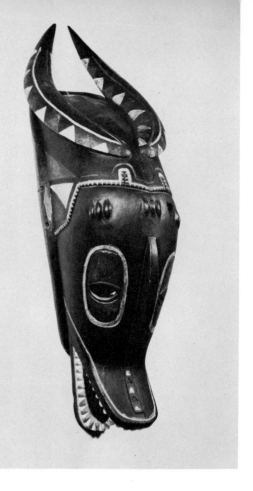

Antelope mask. Wood, painted. Guro. Ivory Coast. *Lowie Museum of Anthropology, University of California, Berkeley*

Mask. Wood. Guro. Ivory Coast. *University Museum, Philadelphia*

Mask. Wood. Baule. Ivory Coast. *University Museum, Philadelphia*

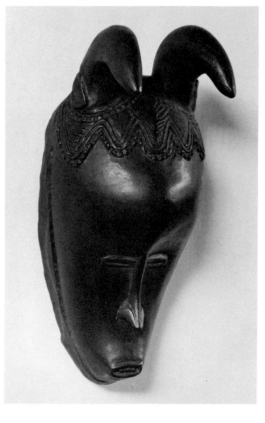

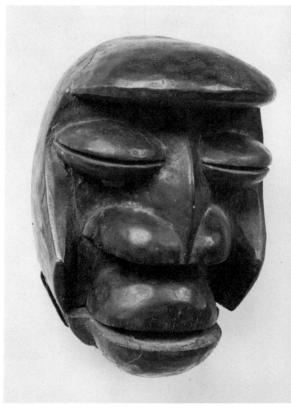

The objects next illustrated are for practical use, bobbins originating among the Ivory Coast tribes. The rhythmic contours and, in the woman's head, the counterplay of ornamental ridgings are admirable. The gazelle and the antelope head are examples of fanciful design, not uncommon in the French Sudan. Streamlining, as in the *Tjiwara* head, is a fully mastered mannerism noticeable in much primitive art.

In the fifteenth century Portuguese explorers and traders brought back reports of the remarkable civilization of Benin, the kingdom of the Bini people, in what is now Nigeria. The Bini were sufficiently advanced to have a capital with broad avenues and sumptuously decorated public buildings. The remains of their art, including innumerable bronze heads, figures, and reliefs produced by the difficult *cire-perdue* process, are mostly scattered in European and American museums and private collections.

Bobbins: animal; human. Baule. Ivory Coast.
Collection Louis Carré, Paris; Musée de l'Homme

Tjiwara, bobbin. Wood. Bambara. French Sudan.
University Museum, Philadelphia

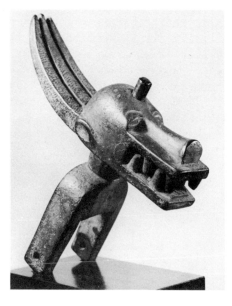

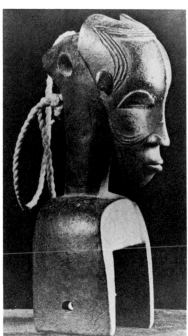

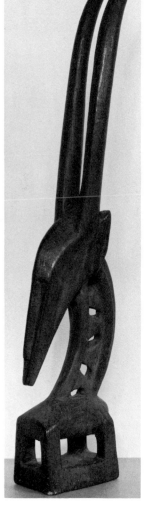

Antelope. Wood. French Sudan.
Collection Louis Carré, Paris

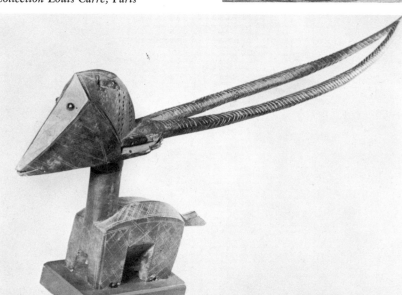

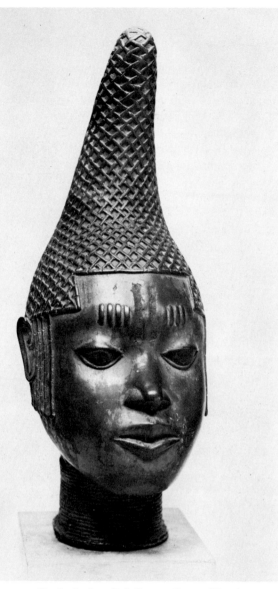

The two bronze heads illustrated are of common types. The *Head of a Bini Girl* indicates a departure of the Bini artists from the extreme expressionism that is standard over most of Negro Africa; though, aside from the face, realism gives way before a strictly conventionalized stylization. The second *Head,* in the Museum für Völkerkunde in Berlin, is typical of an archaic period of Benin art. It may date back to the fifteenth century. The so-called classical period that followed seems to have been terminated late in the seventeenth century during terrible civil wars.

During the centuries of the greatest prosperity of Benin there was a school of ivory-carvers that turned out some of the most intricate and elaborate pieces known to the art, and many other crafts were practiced efficiently. The *Leopard* shown is an ivory piece studded with copper. The *Lion,* a work of the Dahomans, who lived to the west of the Bini in what is now a state in its own right, has achieved a considerable fame. It was fabricated in territory where metal casting was hardly known, and has the appearance of a solid or hollow silver piece, whereas actually it is shaped in wood with patches of silver sheathing nailed on with silver nails. It is one of the rare African sculptures suggesting Oriental influences, possibly from the Chad district to the northeast, where the population was mixed Negro and Arab. In

Head of a Bini Girl. Bronze. Benin. Nigeria. *British Museum*

Lion. Silver over wood. Dahomey. *Formerly Ratton Collection. (Courtesy Musée de l'Homme)*

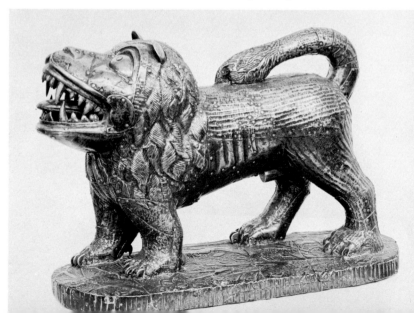

Head. Bronze. Nigeria.
Museum für Völkerkunde, Berlin.
(*Courtesy Musée de l'Homme*)

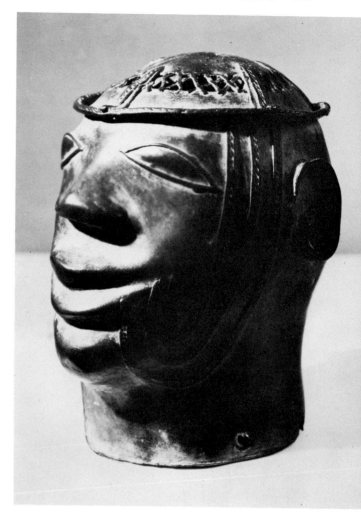

Leopard. Ivory and copper. Benin. Nigeria.
British Museum

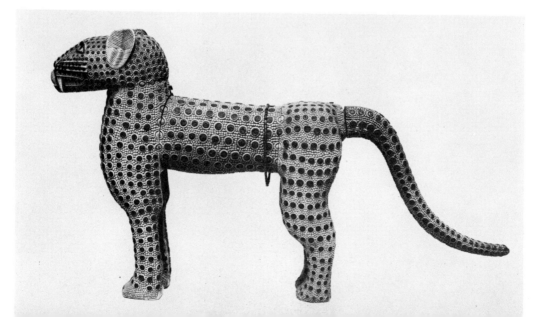

Ethiopia and through a considerable area southward, true Arabs, from Saudi Arabia, had infiltrated and intermarried with Negroes. The Arabs who had infiltrated the Chad district were rather the product of centuries-old blending of several races, in Libya, Algeria, Morocco, and other regions.

Between Dahomey and Benin lies the territory of Yoruba, and it is there that the most recent and some of the most renowned finds of African sculptural treasures have been made. Extraordinarily accomplished heads in terra cotta were unearthed at Ife, and a collection of related heads in bronze has been found.

The examples shown, of both terra-cottas and bronzes, indicate how near these Ifan works are to the standard realistic portraiture of Europe. Their lifelikeness reveals inner character as well as outer appearance. Some of the heads belong to the psychological portrait type, as known many centuries before at El Amarna in Egypt. How a similar mastery passed to or was developed by the sub-tribe Ife is a mystery.

Formerly it was suggested that the Benin bronzes had been made possible because a European explorer had taught the Negroes the *cire-perdue* or lost-wax process of casting. Now it seems more likely that centuries ago the Bini inherited the process from an older culture in Ife. The bronzes from Benin and the bronzes and terra-cottas from Ife add greatly to the sculptural prestige of the Negro race.

After the razing of Benin City by the

Heads. Clay. Ife. Nigeria.
(*Photos courtesy Musée de l'Homme*)

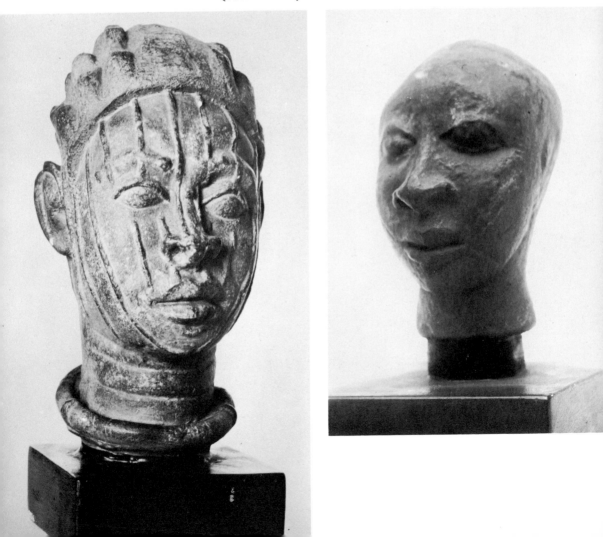

whites in 1897, research revealed much about the history of the sculptural art of the Bini. There is a local legend that a king of Benin begged a metal-caster from the nearby Ife tribe and set up a guild of metalworkers. The Bini artists quickly excelled in the art, which flowered about 1500, the period of the bronze heads. In bronze also there were human fig-

ures and animals and a notable series of reliefs which sumptuously decorated the palace walls of baked mud.

In some tribal areas the sculpture of the people, mostly in woodcarving, remained creative up to the nineteenth or even the twentieth century. Now, in spite of continuous crumbling of tribal traditions and extraordinary political changes, African sculptors are continuing to send out trade pieces of good quality, higher in aesthetic value than most folk exports.

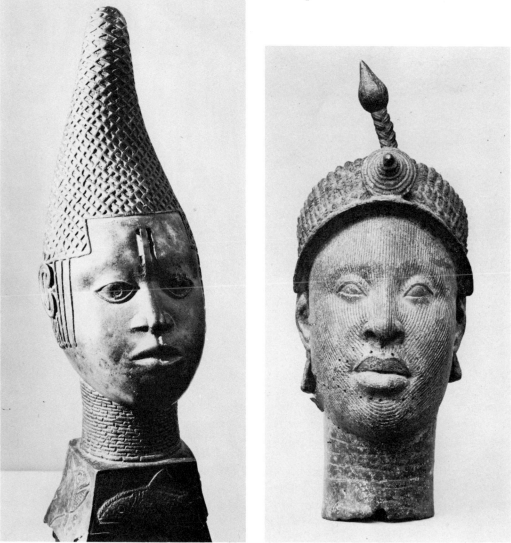

Heads. Bronze. Benin; Ife. Nigeria.
British Museum; Museum für Völkerkunde, Berlin. (*Courtesy Musée de l'Homme*)

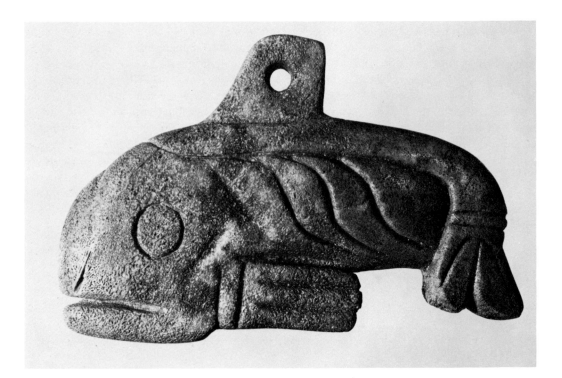

16: Amerindian Sculpture

and the Mexican–Mayan Masters

I

SINCE the Amerindians who occupied North America before the white man arrived never rose out of a near-primitive status, there is an appearance of Stone Age monumentality, of primitive heaviness, about the earlier sculpture found throughout the territory. This particular attribute of basic sculptural expressiveness survived in a few cultures, particularly those on the northwest coast, even down to the time when white men invaded the area; the monumental totem poles are evidence of this, and the ceremonial masks were generally elaborate and often over life size, whether cut by the Tlingit of Alaska, the Kwakiutl of British Columbia, or the Iroquois of the East Coast woodlands.

On the whole, the relics from Canada and the United States are mostly minor or miniature manifestations, or are restricted to a narrow kind of stylization. The aboriginal North

Killer Whale. Shaman's charm. Whalebone. Tlingit. Sitka, Alaska.
Portland Art Museum, Portland, Oregon

American continent has yielded such diverse relics as the carved tobacco pipes of the Mound Builders of the Middle West and South, the bird stones and banner stones of the East, the Eskimo bone and ivory carvings, and the groups of miniature effigies of animals, such as the whales of the Channel Islands of California, the sheep of the Zuñis, and the turtles of the Lenni Lenape on the East Coast.

The most productive tribes were situated along the northwest coast from the Columbia River Valley north to Alaska, where the cultures of the Kwakiutl, Haida, and Tlingit flourished. The range here, from heavy stone figure and elaborate totem to expressive mask and opulently decorated chest and domestic utensil, is not surpassed in any part of the United States or Canada.

Next in importance was the Mound Builder culture of the Midwestern states, especially Ohio, and the middle Southern states, where the small stone sculptures are best known and the larger pieces rare. There are some indications, especially in clay vessels with figures, of contact with and influence from Mexican cultures. The Mound Builders were Stone Age men, and their mounds were tumuli and enclosures in varying shapes. The effigy mounds, in the shapes of animals and birds, approached sculpture in conception. Statuettes in stone and clay are fairly common, but the carved pipes comprise the most remarkable realistic figurative sculpture in the Amerindian collections.

The prehistoric arts among the Eskimos of the Arctic preceded the coming of the white man and possibly date back one thousand years or more. The Arctic Eskimos are now believed to be a part of the largely Mongolian people who once ringed the vast polar sea. In Greenland and on the north Canadian shores and in Alaska the Eskimos developed their separate culture, quite different from that of the Eurasian shore-lands which formed a half-circle opposite, from the present Bering Strait through the frozen northern areas of Siberia and Russia to Lapland.

Another complex of tribes, those of the Southwest, including the Pueblos, the Zuñi (originally a Pueblo community), the Hopi, and the Navajos, were, and still are, very accomplished in the arts, but sculpture was one of the least practiced forms.

The advanced civilization of the Mayas in Mexico and Central America is traced back to Mongolian or Mongoloid racial stock represented by the Amerindians north of the Rio Grande. There is little information as to what happened to these southern cousins of the Eskimos from the time when the parent tribes migrated from Asia, by way of the Aleutian bridge, to the time well before the life of Christ, when the founders of the Mayan empire emerged with a culture of a level higher than any other on the continent. Their amazingly proficient sculpture in stone was accomplished with tools of hard stone—obsidian and flint. The cities of the Mayan Classic began to be deserted in the seventh century. The people migrated north into what is now Yucatán, and there a new Mayan empire prospered from about 1000 onward, though in sculpture its achievements were less notable than those of the old or Classic empire.

The beginnings of Middle American art are hidden, but there were two main areas of

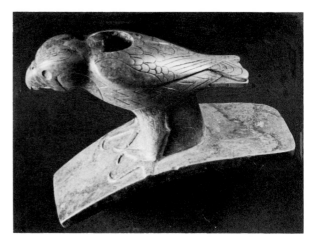

Hawk. Platform pipe. Stone. Hopewell Culture. Tremper Mound, Ohio. *Ohio State Museum.* (*Photo courtesy Museum of Modern Art, New York*)

development, one in the Valley of Mexico (the present Mexico City district), the other comprising southern Yucatán and parts of Honduras and Guatemala. Apart from the central cultures there were less civilized but artistically productive peoples such as the Olmecs (predating the Mayas) and the Zapotecs.

Relics from the Valley of Mexico civilization can be roughly grouped as archaic, Toltec, and Aztec, in chronological order. The architectural ruins of Teotihuacán, which extend over six square miles not far from the present Mexico City, are witness to the native originality and artistic genius of the ancient valley people. Their large sculpture was, in general, barbaric and frightening. The Toltecs were an invading tribe with no known background, who ruled from the tenth century until in the fourteenth century their power was weakened by other invading peoples. Toltec sculpture, based on that of the Teotihuacán culture, was interesting and varied, especially in the stone masks and in products in jade and in clay. The Toltecs gave way before the next empire-building tribe, the Aztecs. They established Tenochtitlán or Mexico City in 1325 and eventually subjugated not only the Toltecs but the other surrounding nations so that when the Spaniards arrived they ruled most of Mexico.

The Olmecs lived east of the Valley of Mexico, near the city of Veracruz. The range of their sculpture is remarkable, from colossal stone heads, apparently related to Central American primitive work, to exquisite jade carvings and little clay figures fantastically elaborated.

The Totonacs were also long established on the Gulf coast, to the north of the Olmecs. The culture is famous for its vast buildings, a full range of clay sculpture, and some special types of stonecarving, such as yoke-shaped stones, richly carved with decorative and symbolic designs.

Yet another culture, of the Mezcalas in Guerrero, a generally mountainous state south and west of the Valley of Mexico, produced works of heavy stone, a near-primitive Stone Age art. The region has not yet been systematically explored for archaeological remains.

The dating of pre-Columbian art has been a great puzzle to American archaeologists. The first firm structure of dates was devised in connection with the Pueblo civilization of the Southwest. By an ingenious method of counting tree-rings in wood found in old pueblos, the foundation date of any pueblo could be ascertained. New carbon-dating and argon-dating systems are now widely used. It is known that man has inhabited the continent since the Pleistocene era, and migration into America may have begun as early as forty thousand years ago, as unearthed weapons indicate. It is believed that from about the beginning of the Upper Paleolithic period wave after wave of migrants entered North America by a route across the Bering Strait.

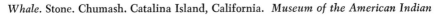

Whale. Stone. Chumash. Catalina Island, California. *Museum of the American Indian*

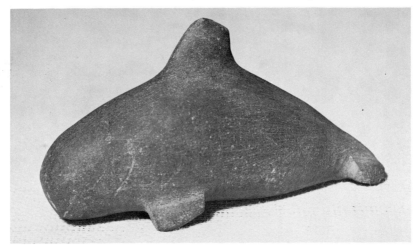

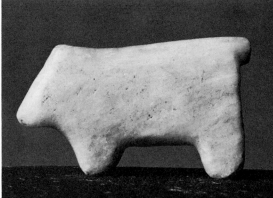

II

THE animal figures pictured here are physically small but illustrate a common aspect of massiveness. There are some stone figures up to one-half life size and over, and the totem poles of the Northwest are monumental in a restricted, conventionalized mode. There are, too, the masks, face-size and over, from tribes east and west; the one on page 428 is a superb example. Nevertheless Indian sculpture in the United States and Canada is oftenest in miniature form, though primitively heavy.

The *Mountain Sheep* from Arizona, really a mortar (illustrated on page 428), indicates studied observation. Simple, stylized objects, however, are at the heart of the Amerindian achievement. They may be roughly formalized, even crude images, such as appear in both useful and fetishistic objects from the Antilles. The virtues of the pestles carved with human heads, as shown at page 28 of the "Primitive Sculpture" chapter, are simple and close to the native rock, as are those of

the "triangular stone," illustrated on page 428. Seldom nearer to naturalism than the example shown, the pointed or "mountain" stones exhibit an intuitive feeling for near-abstract sculptural massing. Sculpturally stonelike, too, with a tendency toward abstract alteration of the human features, is the Caribbean mask at the Museum of Primitive Art, New York. (Illustrated on page 429.)

The stylization may appear in more refined forms, as in the thousands of banner stones and bird stones of the Northeastern and Central Indians, or the woodcarvings of the Northwest Indians. The bird stones and the banner stones reveal a difference between two kinds of abstract art: the bird stones are semi-abstract compositions, each stone taking character from the subject. The banner stones, on the other hand, are fully nonobjective.

As miniature sculpture of symmetrical design, the banner stones (probably used as added weights on spear-throwers) are outstanding. There are variations known as cres-

Seal. Charm. Stone. Tlingit. Alaska. *Portland Art Museum, Portland, Oregon*

Sheep. Stone. Zuñi. New Mexico. *University Museum, Philadelphia*

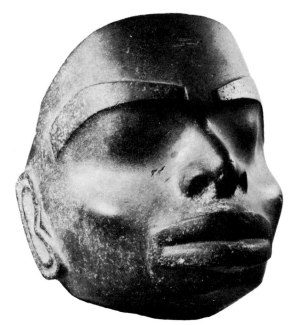

Mask. Stone, painted. Tsimshian. British Columbia. *National Museum of Canada, Ottawa.*
(Courtesy Lowie Museum, University of California, Berkeley)

Mountain stone. Arawak culture.
Dominican Republic. *Musée de l'Homme*

Mountain Sheep. Mortar. Stone. 700–900 A.D.
Arizona. *Museum of the American Indian*

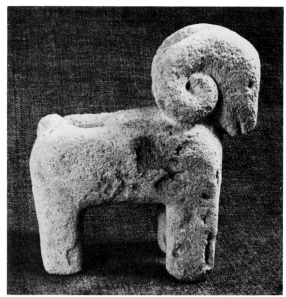

Bird stones. Georgia; Michigan; Illinois.
Philadelphia Museum of Art, Arensberg Collection;
Collection of A. Bradley Martin,
courtesy Brooklyn Museum;
Museum of the American Indian

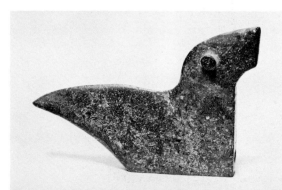

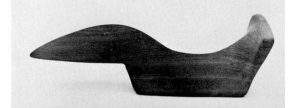

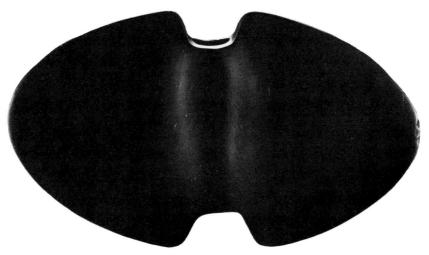

Banner stone. Mound Builders Culture. Possibly A.D. 500. Ohio.
André Emmerich Gallery, New York

Mask. Stone. Arawak. Puerto Rico.
Museum of Primitive Art, New York

cent stones, lunar stones, spade stones, etc., and these are thought to have been ceremonial objects or amulets, or mere ornaments.

The abstract or semi-abstract "stones" are found over a considerable part of the United States, from the central Mississippi Valley eastward and in nearby parts of Canada. Many of the fine specimens have been collected from the country of the Iroquois and the Algonquins.

Stone tobacco pipes were chiefly the product of the Mound Builders, who flourished probably for some centuries before A.D. 1500. The culture had disappeared when the white men pushed into the territory west of the Appalachians. There are undecorated pipes and non-figurative designs, but the pipe with a carved animal is standard. Sometimes an otter crouches in the angle between bowl and stem, or a squirrel decorates the front of the bowl. Oftener the bowl rises up from the back of a crow or a dog, or is hollowed in it. Fairly soft stones were used. The two platform

Double Goose. Pipe. Stone. Hopewell Mound.
Ohio State Museum

Hawk; Otter with Fish. Pipes. Stone. Mound Builders Culture. Tennessee; Ohio. *Museum of the American Indian; Ohio State Museum. (Photos courtesy Museum of Modern Art, New York)*

pipes, one with a hawk (page 425) and the other showing an otter with a fish, are examples of observant realism and have notable sculptural quality. The pipe in the form of a standing human figure, from the Adena Mound in Ohio, is unusual. This type of formalization is rare among the Indians of the Eastern and Central States. There is unmistakable stylistic evidence of a connection with the art of Mexico and Central America.

The totem poles, usually great trees carved with the heraldic insignia of family or clan, are a most spectacular exhibit, but they should be seen in their native setting. A miniature example, in stone, illustrates the curiously effective method of squaring the main forms, then carving as if in relief, without deep incisions and with fluent rounding of the minor forms. The totemic motives and significance are present also in carved wooden masks, charms and rattles, wooden boxes with panels in relief, and even in such minor objects as sucking tubes, spoons, and dishes. The carving is of a distinctive style, vigorous yet intricate and subtle, as indicated in the ivory shaman's charm and the composition of bird and frog.

The commoner types of ceremonial masks are fanciful or grotesque, or constitute geometric abstractions of the human countenance. The Kwakiutl mask (page 432) is a direct expression in the heavy, highly decorative style of carving to be seen in the totem poles. The Cowichan mask, while sculpture in the truest sense, illustrates the way in which the Indians of the Northwest utilized paints and stains to enrich their carvings. The

Human effigy pipes. Stone. Mound Builders Culture. Tennessee; Ohio. *University of Tennessee; Ohio State Museum*

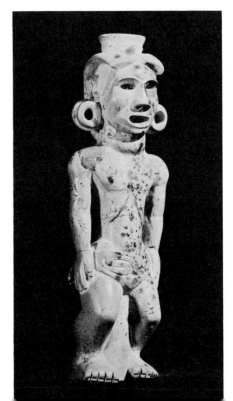

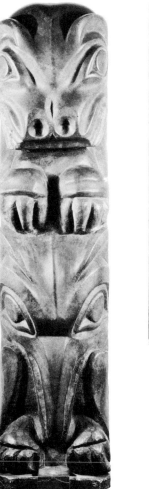

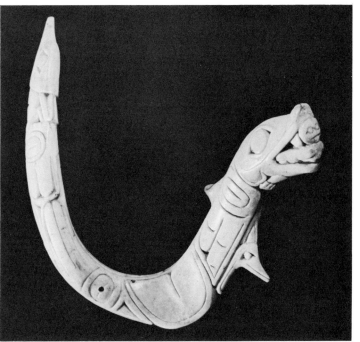

Shaman's charm. Ivory. Haida. Queen Charlotte
Island. *Chicago Natural History Museum*

Totemic composition of bird and frog. Wood.
Völkerkundemuseum, Munich.
(Archiv für Kunst und Geschichte)

Totem pole. Stone. Vancouver.
Royal Ontario Museum, Toronto

Rattle. Wood, leather, etc. Tlingit.
University Museum, Philadelphia

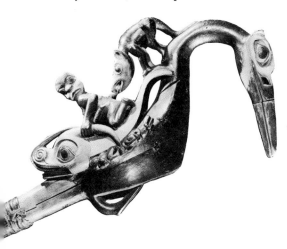

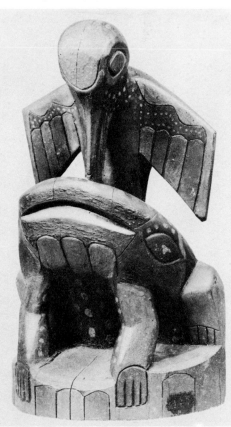

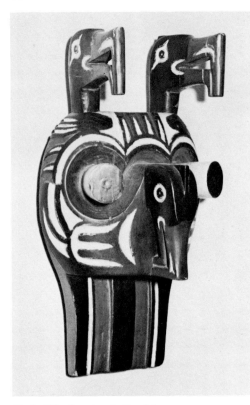

Mask. Wood, painted. Cowichan.
Denver Art Museum

Mask. Wood, painted. Kwakiutl.
American Museum of Natural History

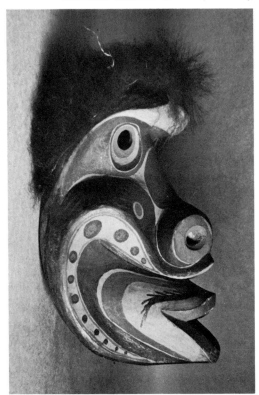

masks are ritualistic objects, and in general they represent famed ancestors or spirits, or the animal that is the totemic ancestor or protector of family or clan.

The Kwakiutl mask at right, an articulated dance mask, consists of two compositions, a bird's head and the man-mask. It is enriched with a great deal of painting and with patches of cedar bark. The lower jaw of the bird, like that of the man, is movable by strings, and the painted flaps can be drawn in over the carved face. The whole is an impressive and original expression of Indian religious custom and native skills.

In contrast a pair of carvings in the simple sculptural tradition is shown. The ancestral mask is a traditional one and depicts the soul of a dead man. The eagle head is a superb carving from the Haida tribe, whose territory was in southern Alaska and the Queen Charlotte Islands off British Columbia. The Tlingits were essentially an Alaskan tribe.

Spirit of Dead Man. Mask. Wood. Tlingit. Wrangell, Alaska. *Portland Art Museum*

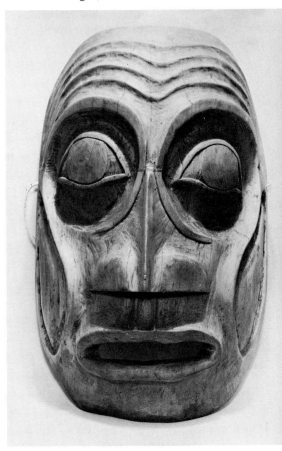

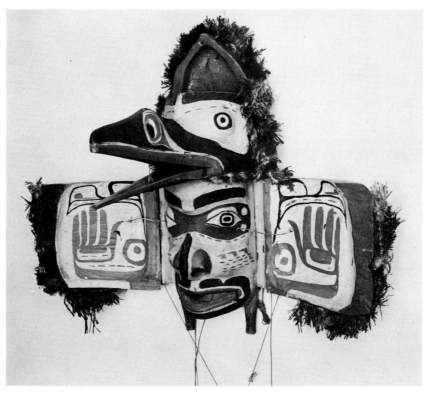

Articulated dance mask. Wood, bark, paint. Probably Kwakiutl. *Portland Art Museum*

Head of Eagle. Mask. Wood. Haida. Prince of Wales Island. *Portland Art Museum*

Head. Mortar. Stone. Columbia River culture. Sauvies Island. *Portland Art Museum*

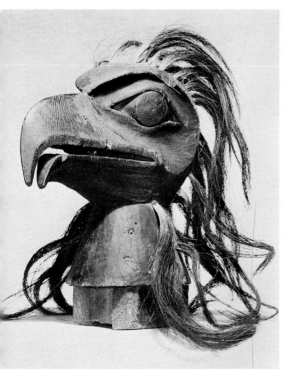

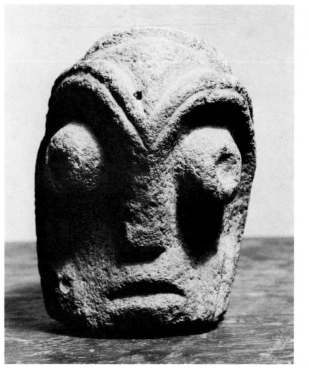

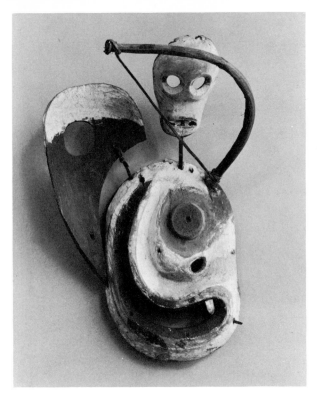

Mask. Wood. Eskimo. Southwest Alaska. *Lowie Museum, University of California, Berkeley.*
(*Photo courtesy Museum of Modern Art, New York*)

There was interchange of style between these tribes and the southern Eskimos, especially in masks. The Eskimo ceremonial masks were on the whole less ostentatious. The strange mask-with-appurtenances from southwest Alaska is an Eskimo product, probably of the nineteenth century, and is prophetic of the twentieth century experiments in constructivism in Europe. The southern Eskimos are generally included in the culture known as Northwest Indian.

Most of the Northwest art is primitive expression of a comparatively recent time. But at the lowest border of the territory, in the Columbia River Valley, relics of a prehistoric culture have been found. The *Head* (page 433) is a mortar from Sauvies Island on the Columbia River, where many of the sometimes utilitarian, sometimes free pieces have been found. It suggests how close the development is to Stone Age cultures in other parts of the world. It is a typically primitive piece, vital, direct in expression, unadorned, and intuitively sculptural. There are evidences of

an extension of the culture or style northward to Puget Sound and the Fraser River.

In the nineteenth and twentieth centuries Eskimo sculpture has tended toward the realistic and the graphic, and nowhere is it monumental. Some centuries earlier, however, there had been an Eskimo culture, centered in the Bering Sea area, which produced designs richer in decorative values, and sculpture in the round with more serious implications. The *Seal* is one of the rare pieces surviving from the Old Bering Sea civilization. It is remarkably vital both as representation and as sculptural creation. Its markings are patently like the linear tracings on the near-abstract winged object shown with it. In their style marks the old Eskimo artifacts are not too unlike those of the Gilyaks of Eastern Siberia, a Neolithic people supposed to have an unbroken history of thirty thousand years from a cave-man beginning. (The cave men of Europe lived at the edges of icefields, as do the Eskimos, and were similarly hunters of the reindeer.)

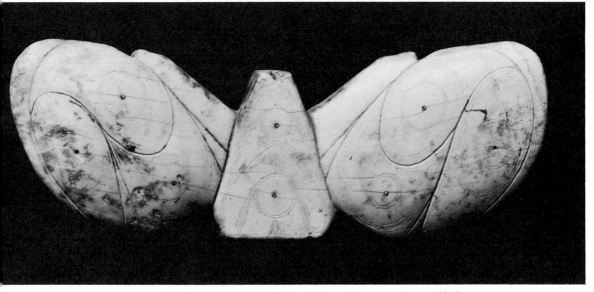

Man with Wings, back. Ivory. Old Bering Sea culture, Northwest Alaska.
University Museum, Philadelphia

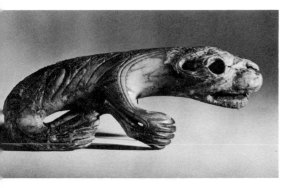

Effigy jar. Clay. Arkansas. *Museum of the*
American Indian

Seal. Ivory. Old Bering Sea culture. Northwest
Alaska. *American Museum of Natural History*

There are many clay vessels from the
Lower Mississippi Valley and from the south
Appalachian area which were modeled as
both pot and statue. The motives and meth-
ods suggest a link with the ancient Mexican
cultures, but no evidence of direct contact
has been established. The tendency of this
phase of Amerindian art toward realism sug-
gests the existence, several centuries ago, of
an art culture far advanced in the skills of
representation, extending across the southern
states from Missouri, Arkansas, and Louisiana
to Georgia and Florida, with a northern ex-
tension in Ohio.

The pipes of the Mound Builders, adorned
with near-realistic animals, and such frankly
realistic clay jars as the one illustrated here,
as well as the wooden masks dredged at Key
Marco, imply a widespread talent for sensi-
tively representational carving. The *Deer's
Head* is one of the most lifelike things to be
discovered in the range of Amerindian art,
which, like the Asian art from which it re-
motely descended, is usually unreal, formal,
and decorative.

Deer's Head. Mask. Wood. Key Marco, Florida. *University Museum, Philadelphia.*
(Photo courtesy Museum of Modern Art, New York)

The first of the Middle American speci-
mens of sculpture illustrated is typically heavy
and massive. This man seated on a bench (a
difficult subject to compose in stone, in any
style) is shaped into a near-geometrical ap-
proximation, except for the lifelike, if sum-
mary, treatment of the face.

The greater body of known Mayan work
is in relief, or exists in fragments broken away
from combinations of low and high relief,
like the two heads from the ruins of the city
of Copán in Honduras. They were attached

parts of architectural relief sculptures, beauti-
fully expressive of the Mayan purpose of im-
personal and hieratic representation. They are
both sensitive and soundly lithic.

The grotesque head, facing at top right,
is of a frightening subject common to Middle
American art. Human sacrifice and terrifying,
implacable deities were often depicted on the
stone temples; but the range of pre-Colum-
bian sculpture includes pretty and even frivo-
lous ornaments in gold, and representations of
animals, common folk, and smiling girls.

Effigy jars. Clay. Mound Builders Culture. Arkansas. *Museum of the American Indian;*
Peabody Museum, Harvard University

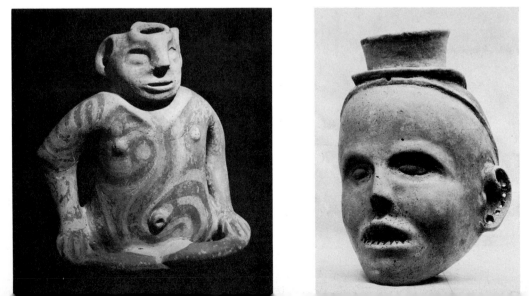

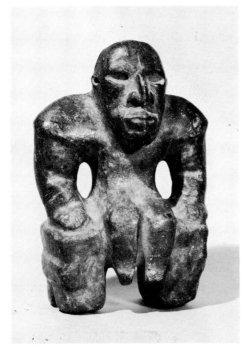

Seated Figure. Stone. Mayan. Guatemala.
American Museum of Natural History

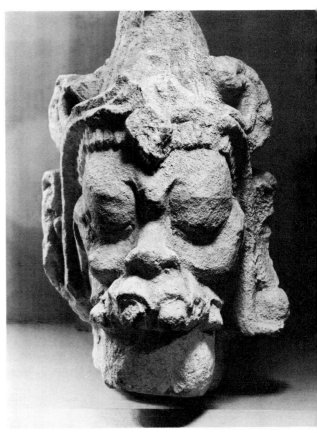

Head of Maize God. Stone. Mayan. Copán,
Honduras. *American Museum of Natural History*

Above and below:
Heads. Stone. Mayan. Copán.
American Museum of Natural History

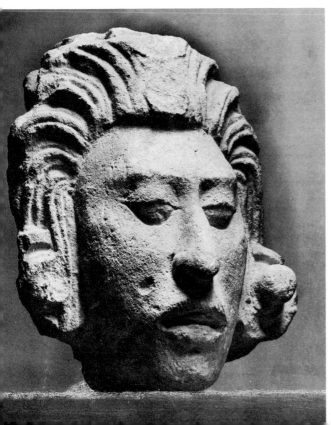

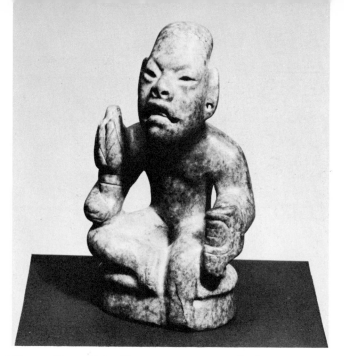

Seated Human Figure. Jade. Olmec. A.D. 100–400. *Cleveland Museum of Art*

The miniature jade *Seated Human Figure* above is directly in line with Mayan monumental art of the early Classic period. This and related pieces are among the finest jades of the realistically figurative type known to any civilization. There are in jade also the more usual relief plaques and masks.

The Mayan pottery of early times was varied and expert. It reached a climax of opulence in cylindrical jars brightly painted with pictorial and hieroglyphic scenes paralleling the reliefs on stelae and walls. Mayan monumental sculpture was freely painted, but all trace of the color has long since been washed away. The stelae and the panels and agglomerations on early Classic Mayan tem-

ple walls are difficult to read, for both subject-matter and aesthetic impression, but one can hardly escape the decorative impact and the sheer design value in such a minor relief as the marker for a ball court at Copán. It is from a stone ball court of about A.D. 600 and probably depicts a ceremonial meeting of priests and player. The ornament in shell is an extraordinary piece of sophisticated miniature carving. A few Mayan heads or masks rank among the supreme examples of "psychological realism," with the Amarna masks. The very fine stucco mask (facing) has the appearance of exact portraiture, with the aim of revealing the inner character, as against the usual Mayan style of conventionalization.

Ball-court marker. Stone. Mayan. C. A.D. 600. Copán. *Copán Museum.* (Photo by E. Z. Kelemen)

Bird and God's Head. Ornament. Shell. Mayan. Chiapas, Mexico. *Museum of Primitive Art*

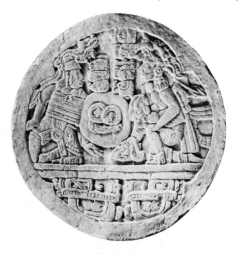

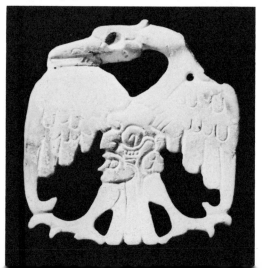

Certain cultures apparently once allied to the old empire still exist among Mayan remnant tribes in the Guatemalan and Honduran highlands. The many relics from the Central American region are difficult to date, and primitive idioms may have persisted through a dozen centuries. Many stone figures are found in Nicaragua and Costa Rica. The strangely geometrized effigy from the American Museum of Natural History is the familiar prehistoric "idol" as uncovered in mid-Asia, the South Seas, or North America; it is crude but formalized in an angular, rhythmic way that renders the piece appealing. The figure on the ceremonial slab represents facile, less expressionistic sculptural expression.

The variation by means of areas of pattern playing against sheer surfaces is characteristic of one phase of Central American design. It is at its best, perhaps, in the many *metates,* or tables for grinding corn, from the coastal region between Guatemala and Panama. These may be simple and utilitarian, or elaborate and therefore probably ceremonial. The orna-

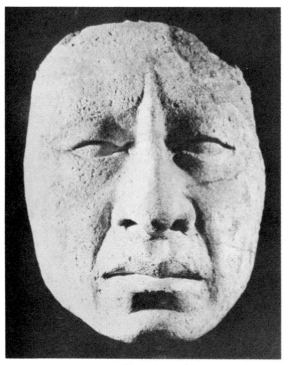

Mask. Stucco. Mayan. Palenque.
National Museum, Mexico City

Ceremonial stele, detail. Stone. Costa Rica.
American Museum of Natural History

Figure. Stone. Nicaragua.
American Museum of Natural History

Ceremonial corn grinders. Stone. Guatemala; Panama.
University Museum, Philadelphia; American Museum of Natural History

mentation of edges, and sometimes of legs, lends a richness, even an elegance, to the composition. Those shown here are of an exceptional reticence of design except in the contrasting heads, which are formalized and imaginative. Such idiomatic expression suggests a link between the Central American cultures and the Classic Mayans.

A group of Mayan carved marble vessels was found exclusively in the valley of the Ulua River in Honduras. The beauty of these is due partly to the milky texture of the stone. In the largest example shown, the low-relief, mask-and-spiral design contrasts with the round handles, each formed as an animal holding a smaller animal upside down. These Mayan vessels were fashioned with stone tools and are unsurpassed even by the alabaster vases of Europe and Asia.

The Zapotec was one of the greatest of the older cultures of Mexico and is best known through the excavations at Monte Albán and Mitla. The Zapotecs, near neighbors of the Mayans to the westward, had their monumental palaces and temples, but they are famous rather for clay wares, especially some elaborated incense-burners, of which the one shown is typical. (Facing page, lower left.)

Mayans and Zapotecs and, in general, the Mexicans of the successive Amerindian cultures worked with an especial sense of the fitness of the stone or clay or gold for effects of mass and texture and surface interest. The Middle American sculpture in clay surpasses that of any other culture except the Chinese. The stony heaviness of the ancient Olmec Mexican mask is instrumental in evoking a sculptural emotion. The effect of the handling of the clay and the suitability of terra cotta for modeling surface variations are expertly

Sculptured cups. Stone. Mayan. Honduras. *University Museum, Philadelphia*

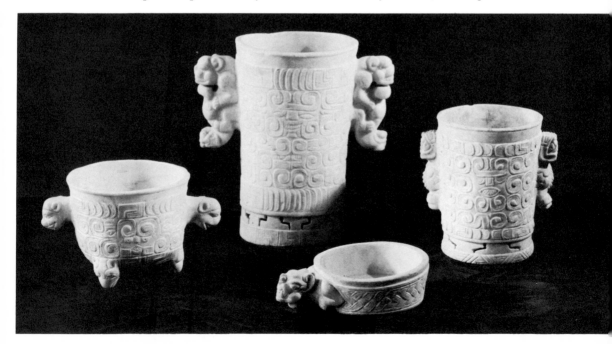

brought out in the contrasting piece, a Toltec head.

The extensive ruins of the city of Teotihuacán illustrate the early culture of the Valley of Mexico, which paralleled the Mayan civilization of the south, though the best-known sculpture from Teotihuacán is a profusion of stone masks. When the warlike Toltecs overran the valley, they modified the earlier culture. The culture spread not only to a new capital city at Tula but to many distant centers, including Chichén-Itzá in Yucatán, a creation of the Mayans of the Late Classic period. The pictured buildings are of the time when Mayan architecture and sculpture had been altered under Toltec pressure.

The coming of the Aztecs from the north soon overshadowed all else. They seem to have had only a tenuous hold upon the arts, and took over the methods and the style of the country they invaded, but their sculpture of the fourteenth and fifteenth centuries achieved a solid realism. It lacked, however, the grandeur of the Mayan and its controlled barbaric exuberance. The five Aztec stone

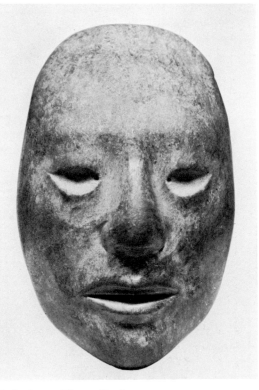

Mask. Stone. Olmec. Mexico.
British Museum

Xipe. Incense-burner. Clay. Zapotec. Monte Alban, Oaxaca. *National Museum, Mexico City*. (*Photo courtesy Museum of Modern Art, New York*)

Head. Clay. Toltec. Mexico.
Musée de l'Homme

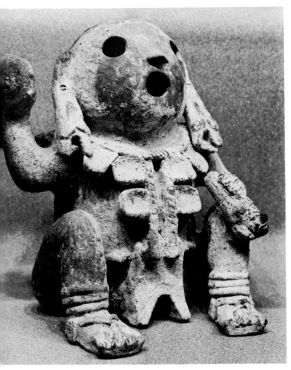

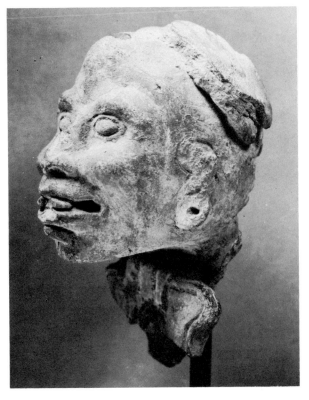

carvings illustrated are witness to the exist-
ence of great and subtle sculptors. The
two statues of a man standing and a man sit-
ting are typical pieces. In one a certain blunt
conventionalization persists, with considerable
squaring of forms for massive effect. The
other is more alive and the rhythms are freer.

The mask of Xipe, the god of the flayed
skin, is a reminder of the sacrifice of human
beings in the name of religion. At this period
the suffering face was common in masks, and
monumental sculpture was overpowering and
awe-inspiring. The mask here, an example on
the moderate side, is beautifully carved with
reliefs at the back.

Animal sculpture seems to have been a spe-
cialty of the Aztecs. Subjects ranged from al-
ligators and snakes to turkeys, frogs, and
grasshoppers. Though the treatment may ap-
proach the realistic, as in the *Dog*, a heavy
formalization was more usual. The massive-

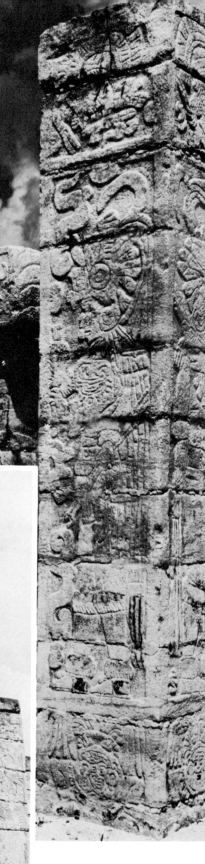

Remains of sculptured pillars.
Temple of the Warriors, Chichén-Itzá, Yucatan

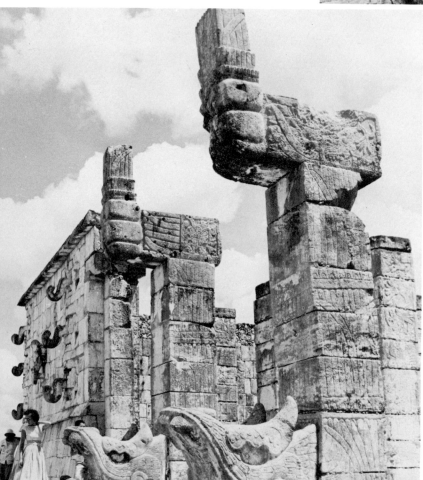

Man. Stone. Aztec.
Musée de l'Homme, Paris

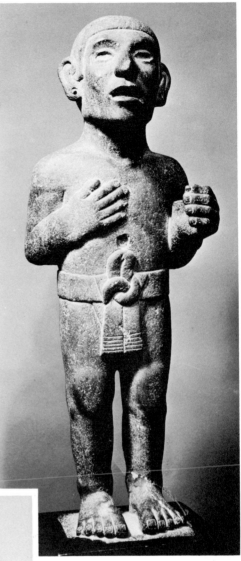

Young God. Stone. Aztec.
National Museum, Mèxico City. (*Photo
courtesy Museum of Modern Art, New York*)

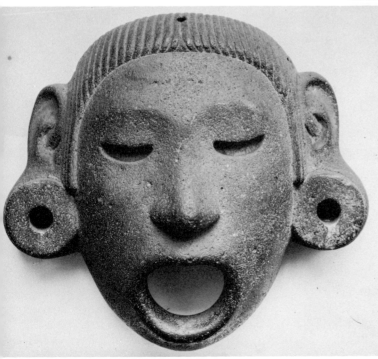

Xipe. Mask.
Stone. Aztec.
British Museum

ness and density of the stone are expressed, as well as animal character.

The coiled snake provoked the artist's imagination, and many versions of the rattlesnake are superb sculptural compositions: compact, massive, symphonic. The serpent head, carried to the most unrealistic point of conventionalization, was one of the commonest motives in decoration of Mexican temples.

The Olmecs, to the east of the valley of Mexico, did not lack realism but their genius was especially suited to expressionistic or exaggerated effects.

There are strikingly simple unadorned masks to be seen in abundance in the museums of Paris, New York, and Mexico City. Collectively the stone masks and heads of ancient Mexico constitute one of the most conspicuously mature achievements within

the range of lithic art. The age of the Olmec masks cannot be estimated. The civilization probably goes back to a time before the Mayan beginnings. The distinctive decorated mask from Oaxaca (facing page) is typical. Its facial elements are schematized and fitted into a preconceived plastic pattern. The linear tracings add to the non-realistic effect. It is a variation of the tiger-mouth deity, a young god with partially jaguar features.

The fine *Head* in black stone in the American Museum of Natural History has a facial cast similar to that of the tiger-face mask, and the upper lip is pushed forward like an animal's muzzle. The creative handling of the masses, and the essential form-organization, are at a high level.

Dog. Stone. Aztec. *Pueblo Museum.*
(*Photo by E. Z. Kelemen*)

Head. Stone. Probably from Vera Cruz.
American Museum of Natural History

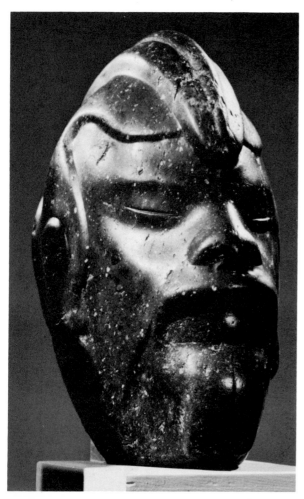

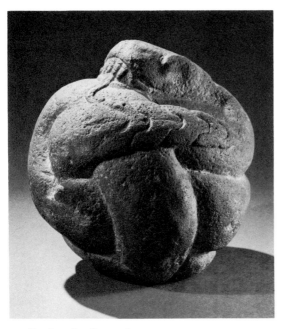

Rattlesnake. Stone. Aztec.
Museum of Primitive Art, New York

The Totonacs, to the north of the Olmecs, were carvers of yoke stones and other distinctive types of sculpture. In line with their ceremonial use, many of the yokes were as intricately cut and as highly polished as the jewel-like jade carvings of the Olmecs.

One of the most extraordinary in a series of heads sculptured to approximate to the shape of a ceremonial ax is the example at Providence. (Following page.) Despite its bug eyes, bulging cheeks, and flattened nose, it somehow has the aspect of a portrait—as do many of the specimens in the group of flattened heads. The piece shown with it finely preserves the feel of the stone and is a good illustration of consistent heavy formalization. It is noticeably ax-head shaped. The nonobjective ax from Tajin illustrates beautifully the type form to which the heads were approximated. The Totonac heads were supposedly

Hacha. Stone. Tajin. Vera Cruz.
Museum of Primitive Art

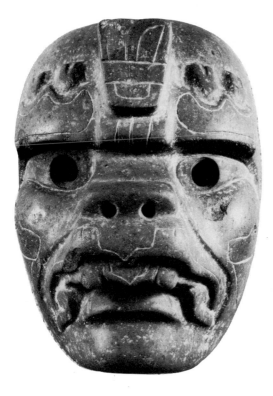

Mask. Stone. Olmec. Oaxaca.
Peabody Museum, Harvard University

worn as body gear in the ball games forming part of human-sacrifice rituals. The Totonac *palmas* had a related ritual purpose. The palmate stones are like stelae with flattish relief designs on back and front, and flaring, rounded tops, usually with concave bases. They are generally fashioned from volcanic stone and are left with a rough grain surface. Those carved with near-abstract designs are among the most pleasing, though the transition from the low-relief, nonobjective mode to figurative elements almost in the full round is gracefully accomplished, as in the second example here.

Throughout Middle America minor sculptures in clay abound. The usual method was modeling of individual pieces by hand, but at times great numbers of figurines were made in molds. The Tarascans were not especially known for monumental or other sculpture in stone, though they created some of the most fascinating genre types in clay. There are well-known warriors with clubs, very like modern baseball players. The seated *Woman* illustrated is more subtle and rhythmic. Beside this is a small Totonac or Tarascan head, which is very lifelike, despite a general simplification. How far the Tarascans went in exact delineation is illustrated on page 30 of the "Primitive Art" chapter, where a child and a dog, actually jars, are realistically rendered.

Heads. Stone. Totonac. *Museum of Art, Rhode Island School of Design, Providence; Robert Woods Bliss Collection, Dumbarton Oaks, courtesy National Gallery of Art, Washington*

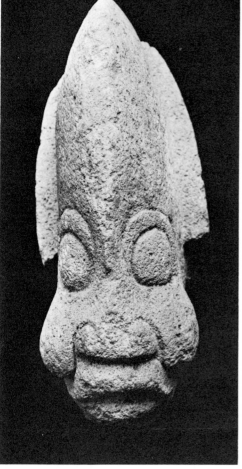
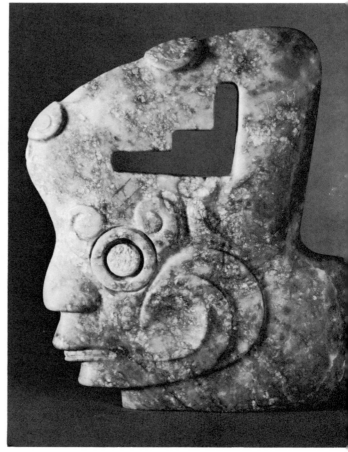

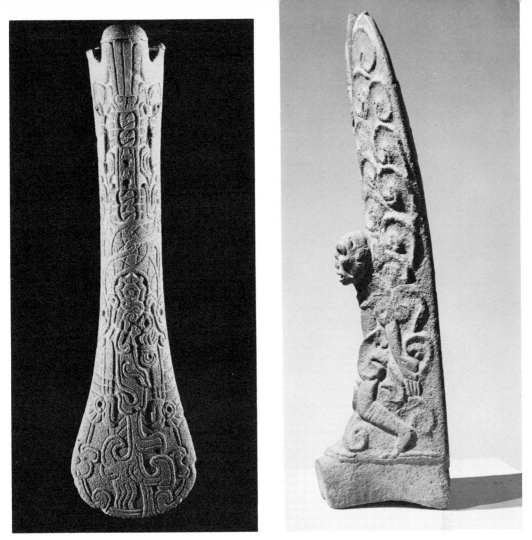

Palmas. Stone. Totonac. *American Museum of Natural History; Museum of Primitive Art*

Woman. Clay. Tarascan.
Brooklyn Museum

Head. Clay. Totonac. Central Vera Cruz.
American Museum of Natural History

All the way down through Central America and in the Andean country of South America small clay sculptures are found in great quantities in a bewildering range of styles. The pre-Incan painted vases of Peru are famous, but there were amazingly beautiful wares also from Coclé in Panama; and the pottery of Colombia, Ecuador, and Bolivia is unusually varied.

The famed Nazca wares and those of Tiahuanaco, representing two of the pre-Incan cultures, are most beautiful and colorful, but depend upon painting rather than modeling for their appeal. But the early Chimu or Mochica effigy jars are among the world's most diverting minor clay sculptures. The Mochican potters were especially concerned with human and animal figurative designs, naturalistically depicted. Outstanding examples of the so-called portrait vessels are illustrated here.

The stone sculpture of South America is rare and in most categories is inferior to Mayan and Mexican examples. Some stone bowls in animal form are, however, outstanding. The *Puma*, thought to be of the Chavin culture of the high Andean country, indicates a stylistic bond with the Olmec. A more typically Peruvian expression is instanced in a series of miniature llamas, almost jewel-like in workmanship and endowed with a pleasing sculptural simplicity and rhythm.

Portrait jars. Clay. Chimu. Peru. *Linden Museum, Stuttgart. (Archiv für Kunst und Geschichte, Berlin)*

Llama. Lamp. Stone. Inca. Peru. *Philadelphia Museum of Art, Arensberg Collection*

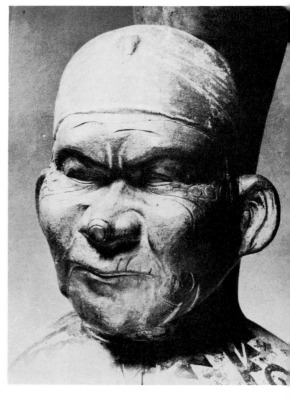

There are fabulous stories of the treasure in sculptured gold taken from Panama, Costa Rica, and Peru by the Spanish and British fortune-hunters, to be melted down. The museums have saved enough from later finds to prove that the artisans of Central and South America surpassed all others in the ability to fashion living little statues and strikingly beautiful ornaments in precious metals. The gold and silver animals include crocodile, alligator, llama, bird, shark, and monkey, and occasionally a man or woman is depicted. Examples illustrate the vitality and the aspect of believable reality attained when the sculptors curbed their decorative aims.

The conventionalized or decorative mode was, however, more common. An animal or a

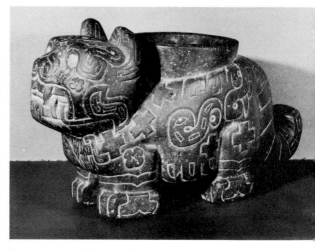

Puma. Stone. Chavin culture. Peru or Bolivia. *University Museum, Philadelphia*

Llamas. Stone. Inca. Peru. *University Museum, Philadelphia*

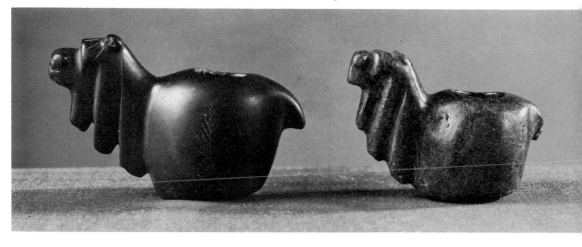

Llamas. Silver. Inca. Peru. *Art Association of Montreal; American Museum of Natural History*

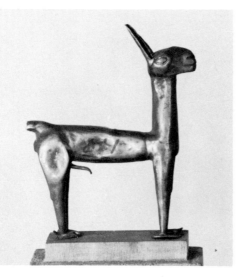

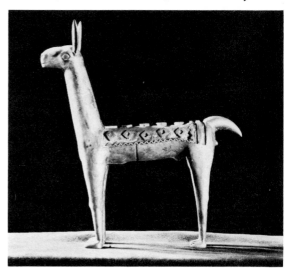

serpent's head or a human figure was taken as a starting point. The object as cast or hammered out became an approximation of the subject, but often only an archaeologist can ascertain what inspired the composition. It is easy to identify the bird in gold on a bronze knife; but it will be seen that the human and animal motives have strangely changed in the group of pendants following. In the literally thousands of examples in public and private collections the wonder of the composition is its bold ornamentalism and the consistency with which the sculptor carried through his decorative conception.

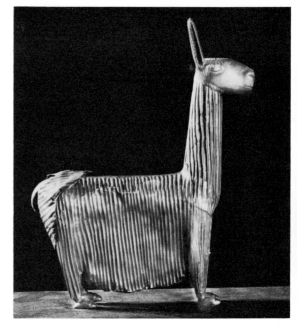

Alpaca. Silver. Inca. Peru.
American Museum of Natural History

Knife. Bronze and gold. Inca. Peru.
University Museum, Philadelphia

Man. Hollow silver.
Robert Woods Bliss Collection, Courtesy
National Gallery of Art, Washington

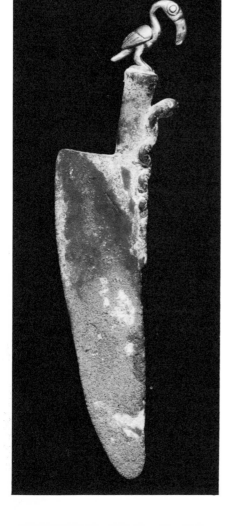

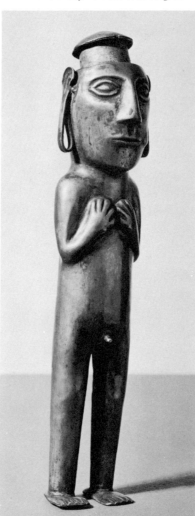

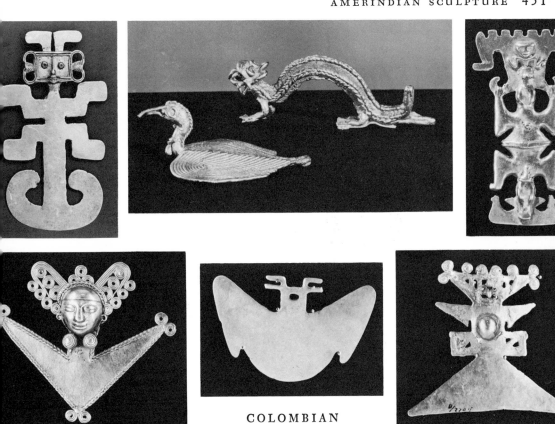

<div align="center">

COLOMBIAN

Pendants, ornaments, bell. Gold. Quimbaya, Chibcha, and other cultures.
*Museum of Primitive Art; Robert Woods Bliss Collection, Dumbarton Oaks,
courtesy of National Gallery of Art, Washington; American Museum of Natural
History; Philadelphia Museum of Art, Arensberg Collection*

PANAMANIAN

</div>

The chapter is best concluded with a return to primitive or near-primitive Stone Age art. In Guerrero, a generally mountainous state south and west of the Plain of Mexico, there was the Mezcala culture, of which the chief known relics are works of heavy stone. The most notable finds have been comparatively recent. There may have been thirty centuries of production of stone sculptures in the area, and they show a lingering Neolithic tendency toward abstraction. The *Standing Man* in black stone, with typical high polish and an aspect of monumentality, is only five and a half inches high. The superb stone mask shows that influences from the better-known cultures, Mayan, Olmec, and Teotihuacán, had seeped into Guerrero State and into the Mezcala Valley at one time or another. Mezcala adds one more vivid chapter to the history of Amerindian sculpture in Middle America.

Mask. Stone. Mezcala Culture. Guerrero.
André Emmerich Gallery, New York.
(*Photo by Lee Boltin*)

Standing Man. Stone. Mezcala Culture. Guerrero.
André Emmerich Gallery, New York.
(*Photo by Lee Boltin*)

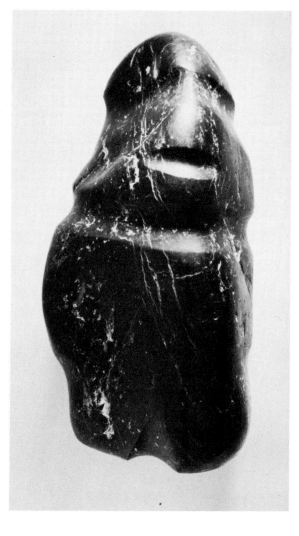

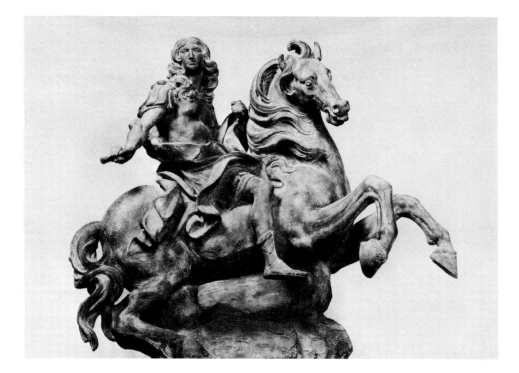

17: Western Sculpture

From the Baroque to Rodin

I

BY the year 1620, in Italy and France, the two great art-producing countries of Europe, the output of sculpture had become routine and trivial. The smaller pieces were naturalistic fragments or sentimental and fanciful. Monumental sculpture, approached more seriously, nevertheless suffered from a pictorial obsession, and compositionally it was disunified and mannered. The best of the post-Michelangelesque producers of mantelpiece art and of busts—most notably Giambologna and Alessandro Vittoria—were long since dead. The art was in the hands of dilettanti and pedants.

Italy, however, produced one last sculptor genius, Giovanni Lorenzo Bernini. He had originality and vision and created a style, the baroque, which swept over Europe and dominated Italian, German, Austrian, and Spanish design through the period of the Counter-Reformation. To many historians baroque marks a prolongation of Italian Renaissance realism and pictorialism, though classic calm and purity are not evident in Bernini's major works.

Model for a monument to Louis XIV. Bernini. *Galleria Borghese.* (*Anderson photo*)

From about 1620 to 1920 styles shifted fit-fully from baroque to neo-classic, to photo-graphically realistic, to impressionistic; and then, by a revolutionary leap, to an expression-ism unknown since the Romanesque masters. Baroque and its French variation, rococo, lived on especially in Spain, Portugal, and the Span-ish American colonial cities long after the sculptors of Italy and Germany had been won over to neo-classicism. In France the Renais-sance spirit had never quite faded, and in French sculpture baroque and neo-classic were hardly more than minor interruptions in the flow from late Renaissance realism to the native graceful realism of Clodion and Houdon. Realism continued to be pre-eminent during the nineteenth century. From the full-blooded form practiced by Rude, tinged with roman-ticism or melodrama, through Carpeaux's still slightly poetic style, and on to the unashamed naturalism of Barye, it all seemed to be leading up to Rodin. In his works all aspects of realism were expressed. His early naturalistic figures surpassed those of Barye; his portraits were more substantial and more lifelike than Houdon's; the modeled pieces that gained from impressionistic attributes had a new exactitude but at the same time a luminous gloss beyond any known to the figures by Falconet and Clodion. At the end, before the break into formalism and expressionism, there was a period of honest reappraisal, typified in the work of Maillol, whose return to direct cutting in stone and to a general weightiness marked a reversal historic and beneficial.

There will always be confusion at this point in history because the last renowned realists—Rodin, Maillol, Bourdelle, Despiau, Kolbe—practiced at a time when expressionism was being widely introduced. Rodin, anticipating post-impressionist modernism, produced at least one major monument, the *Balzac,* and some minor modeled pieces (*Iris,* etc.) By the time of his death in 1917 the leaders of the expressionist school were active in Germany and England as well as in France.

A simple listing of styles, leaders, and dates, 1620–1917, follows:

The baroque style, brought to focus by Giovanni Lorenzo Bernini, who lived from 1598 to 1680, is generally dated from the first half of the seventeenth century to the late eighteenth century. It is the style of the Coun-ter-Reformation and flourished especially in the Catholic countries, Italy, Austria, Ger-many, and parts of Switzerland, and for a longer period in Spain and the Spanish Ameri-can colonies.

Pierre Puget (1622–1694), a disciple of Bernini in Italy, took the baroque style to France, but France was slow to accept the theatricality and extravagance of it.

Rococo, a refined version of baroque, was developed in France under Louis XV in the eighteenth century.

Houdon (1741–1828), the greatest French sculptor of the six centuries between the fourteenth century and Rodin, resisted the baroque influence and favored classicism or a slightly idealized realism.

Neo-classicism as a school was founded by Antonio Canova (1727–1822) in Italy; he was followed by a Dane, Bertel Thorvaldsen (1770–1844). The school's vogue lasted from 1790 to about 1840 and was international.

Romanticism returned European sculpture from the classic path about 1830; but this art never knew revolutionaries of the stature of such painters as Delacroix and Géricault. The French sculptor François Rude (1784–1855) is pre-eminent.

Realism became the ideal of the sculptors of Europe and America in the 1850s especially, though the move toward verisimilitude had been going on for a long time. The final degra-dation of realism, its most superficial product, naturalism, occurred later in the century.

The impressionist school flourished from the mid-1870s on.

Rodin (1870–1917) was a master of natural-ism, became the greatest of modern realists, and later turned to expressionism.

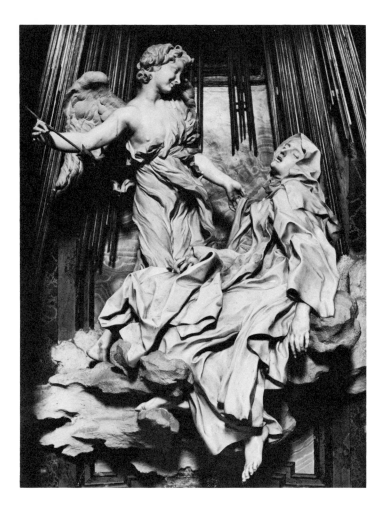

II

IN an early work, an *Apollo and Daphne* of 1623–1624, Bernini had developed attributes of baroque. Swiftly he capitalized upon his innovations—fluttery movement, emphatic gesture, and naturalistic depiction. His father had been a sculptor, and the son possessed exceptional knowledge of the technique of the art and an aptitude for striking composition. The model for the monument to Louis XIV of France (illustrated at the beginning of this chapter) is a perfect example of his genius in harmonizing movement and accessories within a sound sculptural unity.

Classicists view all baroque as an appeal to the sensual side of man. Bernini's most famous statue, *St. Theresa in Ecstasy* with its marble figures in marble clouds and a background of gilded rays, has been mercilessly criticized for realistic and melodramatic treatment of a subject which should be pictured only reticently

Saint Theresa in Ecstasy. Stone. Bernini. 1644. *Santa Maria della Vittoria, Rome.* (*Anderson photo*)

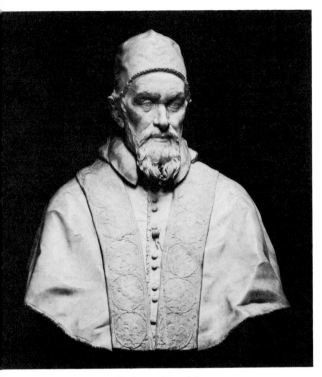

Innocent X. Stone. Bernini.
Palazzo Doria, Rome. (Anderson photo)

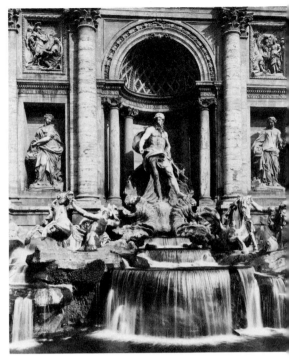

Fountain of Trevi. Design attributed to Bernini,
executed by others. Mid-18th century. Rome.
(*Anderson photo*)

and purely. The apologists for Counter-Reformation art, on the other hand, have found the statue reverent, emotionally true, and moving.

Certainly Bernini ran to excess at times. Purists feel that the baldaquin sheltering the high altar in St. Peter's in Rome is a sculptural aberration and an affront to both eye and spirit. And there are other failures and trumpery half-victories. At the far extreme from these are the comparatively restrained portrait busts, as illustrated in the *Innocent X* at the Doria Palace.

The photograph of the Trevi Fountain illustrates a work projected by Bernini but executed by others long after his death. It is superior to two similar fountain complexes which the artist designed and executed. Beyond its patent attractiveness, it is important as a model for innumerable works in the category of "exposition sculpture." It had its imitators in the grounds of every ostentatious palace in Europe.

Bernini had a host of imitators but only one

rival, Alessandro Algardi, who was only slightly inferior in both monumental work and portraiture. He tried to moderate the intensity of feeling and the reliance upon swirl implied in Bernini's approach, but he never succeeded in endowing his pieces with the unity and the surface appeal of Bernini's soberer works. Algardi had studied under the three Carracci in Bologna and was well fitted to practice in a school glorifying violent action. But perhaps the Carracci tendency to rhetoric and loose composition spelled the measure of his failure in rivalry with the creative Bernini. There was a host of local imitators, but no other Italians appear in the list of sculptors of world-wide importance until a century after Bernini's death in 1680.

At the time when baroque art was flourishing in Italy, armies were marching back and forth through the German principalities, and the Thirty Years' War (1618–1648) almost put an end to art practice. Nevertheless, in Bavaria and in the Rhine cities, and in the Austrian and

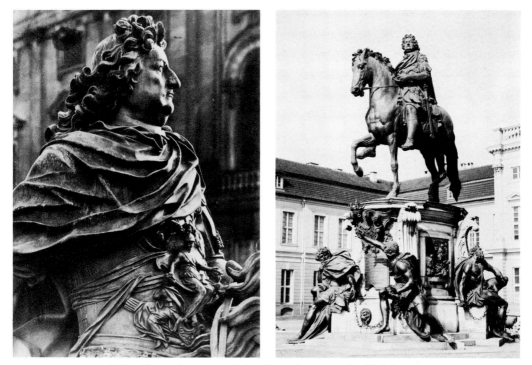

Right: Equestrian statue of the Great Elector, with added figures.
Left: Detail. Bronze. Andreas Schlüter. 1701.
Court of Charlottenburg Castle, Berlin. (Archiv für Kunst und Geschichte)

Swiss lands closely tied to German culture, the baroque style spread in its pure form as nowhere else outside Italy. A late practitioner, Andreas Schlüter, designed the monument of the Great Elector in Berlin, which is considered the finest of baroque equestrian statues, though the figures and panels of the base are inferior.

While in northern Germany the impetus was partly from an earlier native tendency to activate and elaborate sculpture, baroque was accepted as a valid expression of the Counter-Reformation, as it was in Austria. In Munich, Salzburg, and Vienna, and in many a village church or isolated mountain monastery in the German, Austrian, or Swiss Alps, the altars are decorated with swirling groups of figures and opulent canopies of carved wood or stone. The theatrical but not unpleasing group in the church at Rohr in Lower Bavaria is typical. Hardly less restrained is the sculpture in the monastic church at Stams in the Austrian Tirol. The photograph indicates how sculptors,

architects, and painters worked together to create a dazzling baroque effect. (Page 458.)

Pierre Puget had been among the numerous assistants of Bernini in Rome, and he took the new style back to France. He was considered the most truly baroque of the Frenchmen, who were then becoming leaders in the European art world; but his most enjoyable works are, for most people, not the overactive, even tortured reliefs and groups, but his portrait busts. (See page 459.) France held stubbornly to the classical tradition, which had been watered down to a prettified realism, and the violence of Italian baroque was never to be fully accepted. Rather, the late Renaissance manner, as exemplified especially in the two Italicized northern artists Giovanni da Bologna and Francavilla, persisted and was gradually given some impetus by the impact of Puget and other baroque enthusiasts.

Whatever elements of the new Italian style were adapted soon took on grace and feminin-

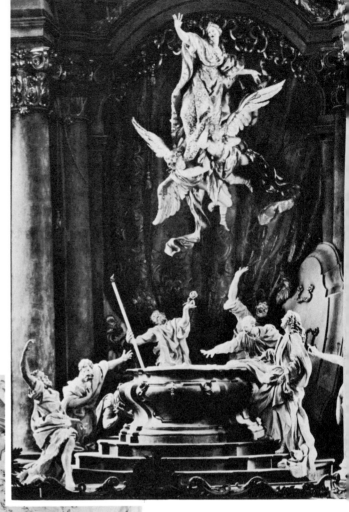

The Assumption of Mary. Stucco.
1717–19. Cosmas and Egid Asam.
*High Altar of the Pfarrkirche,
Rohr, Lower Bavaria*

Interior of monastic church
at Stams, Austrian Tyrol.
C. 1730

ity. But certainly the productions of Antoine
Coysevox, Guillaume Coustou the Elder, and
François Girardon for the brilliant French
court of Louis XIV lack the spontaneity of
Italian baroque, as well as classic reposeful
beauty. Girardon, who made a famous eques-
trian statue of the king, typically half natural,
half artificial, also contributed a work which
was utterly symbolic of the court spirit, and
a landmark in the French drift toward graceful
pictorialism and sensitive naturalism, in the
lead reliefs of *Bathing Nymphs* decorating a
pool in the Versailles gardens. Of its kind,
nothing could be more graceful but at the
same time more trivial from the point of view
of the lover of profound sculptural art.

Robert Le Lorrain, who was a pupil of
Girardon's, went a step further in feminizing
sculpture and rendering it painty when he
cut the *Horses of the Sun* on the wall of the
Hôtel de Rohan, now the Imprimerie Nation-
ale, in Paris. Here every implication of basic
sculpture, of the method itself, is negated.
The composition represents a pretty and
graphic wash-drawing transferred to the stone
and, like the baptistry doors at Florence, marks
a high point in diverting but unsculptural
sculpture.

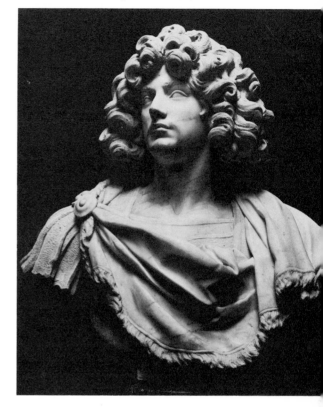

Louis XIV. Stone.
Pierre Puget. *Musée, Aix.*
(*Giraudon photo*)

Horses of the Sun. Stone. Robert Le Lorrain. *Hôtel de Rohan, Paris,* (*Giraudon photo*)

The sculptors of the late eighteenth century, Lemoyne, Bouchardon, Pigalle, Pajou, were still appreciated in the Victorian era, but their works now seem lifeless and cold. One type of statue did maintain its popularity and seems to justify the once transcending reputation of two other late-eighteenth-century practitioners, Etienne-Maurice Falconet and Clodion. This is the immemorially popular bathroom nude. The charming creatures, represented in the prettiest poses, register the farthest point reached by realism in re-creating physically the miracle of feminine loveliness. As seen here, Falconet's *Bathing Girl* escapes the coldness of the goddesses and nymphs about to be introduced by the neo-classicists; and certainly it is superior as a work of art to the wholly unidealized naked women of Carpeaux in the following period of avowed realism.

Clodion (Claude Michel) sometimes disguised his bathers as ancient goddesses and nymphs and agreeably fulfilled the frankly sensual aims of the courtly sculptors. He was baroque in his devotion to movement and momentary gesture but in accessories he sometimes lapsed into the excesses of rococo.

Spanish sculpture tends more than any other to be over-ornate. In Spain and in the Spanish colonies the style that was considered peculiarly the expression of the Catholic reaction became standard. However, no Spaniards could compare with Bernini, and if there are masterpieces at all, they are on the sensational side. The Catholic churches of Middle America and South America are filled with generally debased examples of the baroque style.

Sooner or later in art, excess of violence, of ornament, and of the playful virtues brings reaction toward soberer methods. The reaction against the tidal wave of baroque came not in France but in Italy. Rome, with its revived interest in the exhumed monuments of Greek and Roman art, became an international center of study—the story of American sculpture, for example, may be said to have begun there.

It was painters, led by Mengs and Winckelmann, who expressed the principles of neo-classicism and began a retreat toward

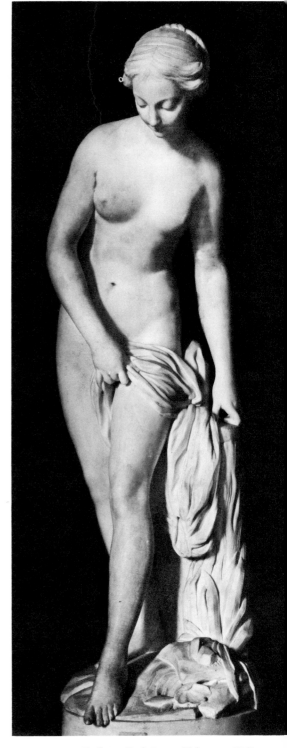

Bathing Girl. Stone. Falconet. 1757. *Louvre.* (*Alinari photo*)

classical purity, repose, and coldness. Sculptors reproduced figures of the Greek gods and the heroes and heroines of the Greek myths. Often the versions were scarcely more than paraphrases of the *Aphrodites, Apollos,* and *Marble Fauns* of Greco-Roman times. Even contemporary portrait pieces were accoutered in togas or peplums, or bordered on nudity. Unfortunately Greek idealization was interpreted as a smoothing-down process which largely removed character from the face and beauty of modulation from the body.

In 1787, at the age of thirty, Antonio Canova was the leader of the neo-classicists. He was a Venetian in early training, but resident in Rome from his twenty-third year. The coldly graceful statue of the Princess Pauline Borghese, sister of Napoleon Bonaparte, as Venus reposing, is typically half natural and half Greek, pleasing in its lines but really more notable as a sculptural curiosity. It has a woodenness, a lack of sensitivity, that characterizes practically all sculpture intentionally smoothed down to approximate Greek effects.

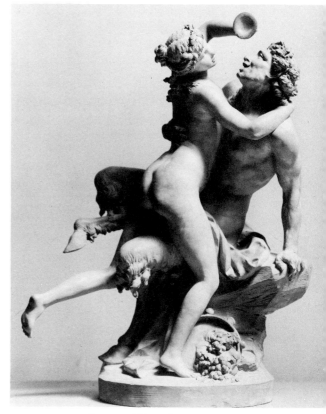

Satyr and Nymph. Stone. Clodion.
Metropolitan Museum of Art

Pauline Bonaparte as Venus Reposing. Stone. Antonio Canova.
Villa Borghese, Rome. (*Alinari photo*)

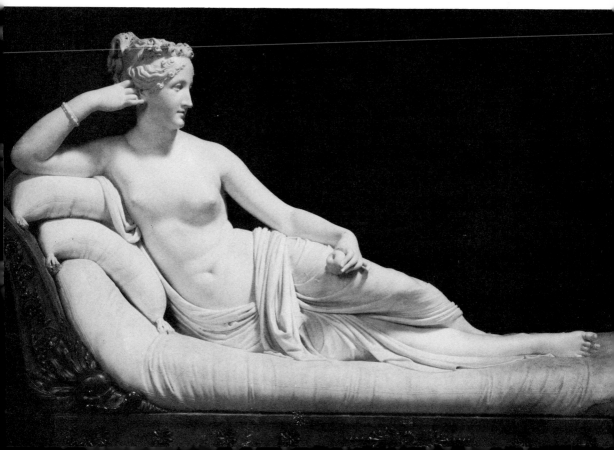

Self-Portrait. Johann von Danneker. Stone.
Landesmuseum, Stuttgart.
(*Archiv für Kunst und Geschichte*)

The sculptors of the modern neo-classic school, which can be dated 1790–1840, were still thinking of Praxiteles and Lysippus and later artists as the Greek masters. The Parthenon marbles and the earlier schools then seemed less pure. Canova was born with a sense of rhythm, and his statues escape the stiffness which most of his fellows considered part of the classic endowment.

Compositionally his *Cupid and Psyche,* his *Venus,* and his *Hebe* are pleasing, and there is a seductive prettiness that is generally not achieved by his rivals. The pleasing composition is a surface one, for all neo-classic sculptors seem to have lost the basic feeling for the block, the architectonic, sculptural integrity of Michelangelo or della Quercia.

Bertel Thorvaldsen, the Danish expatriate to Rome, was so popular that at Canova's death he succeeded to leadership of the classic school. In Copenhagen there is a Thorvaldsen Museum where some hundreds of his works are on permanent exhibition, but his reputation has diminished. It is seen that his devotion to classicism bound him to a sunless formula.

Diana. Bronze. Jean Antoine Houdon.
Louvre. (*Bulloz photo*)

His inheritors became the emotionless and correct academic sculptors during the latter half of the nineteenth century. In England John Flaxman and John Gibson made local reputations, though some of Flaxman's designs in Wedgwood pottery achieved a wider acclaim.

Among the Germans, Johann von Danneker's best-known work was an *Ariadne,* of which there were innumerable replicas. He tempered classicism with a sturdy naturalism, as illustrated here by the bust, a self-portrait, draped in the antique fashion. His contemporary, Johann Gottfried Schadow, was even less bound by Thorvaldsen's strict rules, though he profited by study of classic grace.

Of Americans in Rome, several became

routine sculptors in the neo-classic manner. Hiram Powers achieved wide popularity. Best known were two simple nude figures of *The Greek Slave* and *California*.

In France baroque had never quite won over either the sculptors or the court patrons of art. A fairly straight line can be traced from the realism and pictorialism of Ghiberti and Donatello to Falconet and Clodion, with only occasional bending to baroque pressure. By the time of Jean Antoine Houdon, born in 1741 and a worker for ten years in Rome, there was a marked current toward simplification and toward a revival of classic conventions.

Houdon was the most original and the most talented French sculptor between the late Gothic masters and Rodin, and he helped to hasten the establishment of naturalism as the standard sculptural style of the early nineteenth century, in advanced circles where neo-classicism was already challenged as lifeless and as the echo of the echo of an art. Houdon's *Voltaire* at the Comédie Française, and many other portraits, including the charming bust of Louise Brogniard shown on the title page, despite an occasional diadem or toga, mark steps toward the realism of Carpeaux, Rodin, and Despiau. Houdon said once to his pupils, "Copy, keep on copying, and above all, copy exactly."

In the history of sculpture the nineteenth century is one of the weakest, and the artists who were only recently considered masters are now generally seen to be second-rate. In France, which produced more sculptors than any other country at the time, the forceful but melodramatic François Rude, who designed the *Marseillaise* group on the Arc de Triomphe in Paris, is sometimes considered the sculptural representative of the romantic school. This challenged neo-classicism in the third decade of the century.

The reaction in which Courbet and Manet led revolutionary painters, in the movement known as "realism," produced Antoine-Louis Barye, a sincere nature-lover who had a camera eye and a talent for forceful modeling. Another sculptor, Jules Dalou, was a vivid

Le Bailli de Suffren. Houdon. *Musée, Aix. (Giraudon photo)*

picturer but without the instinct for sculptural integrity, and Jean Baptiste Carpeaux combined the new realism with some of the lingering spirit of rococo. Barye's *Lion* (page 465) is patently naturalism for its own sake, without deviation toward the sculptural inventiveness which renders the animals of the Chou and Han sculptors superbly alive aesthetically, although "unreal."

Verisimilitude is expressed somewhat differently in Carpeaux's opulent art. His masterpiece is the rhythmic group entitled *The Dance* on a wall of the Paris Opera House. It has a certain swollen grace, but the subject, as interpreted by the artist, is more suited to painting than to sculpture. As to its realism, one may note that the dancing figures are perfectly transcribed naked women. Even the coldly idealized nymphs of the neo-classicists seem superior to the realistic nudes from innumerable sculptors' studios after 1850.

Paris had displaced Rome as the world center for art study. And although some of the finest realism of the period was produced by

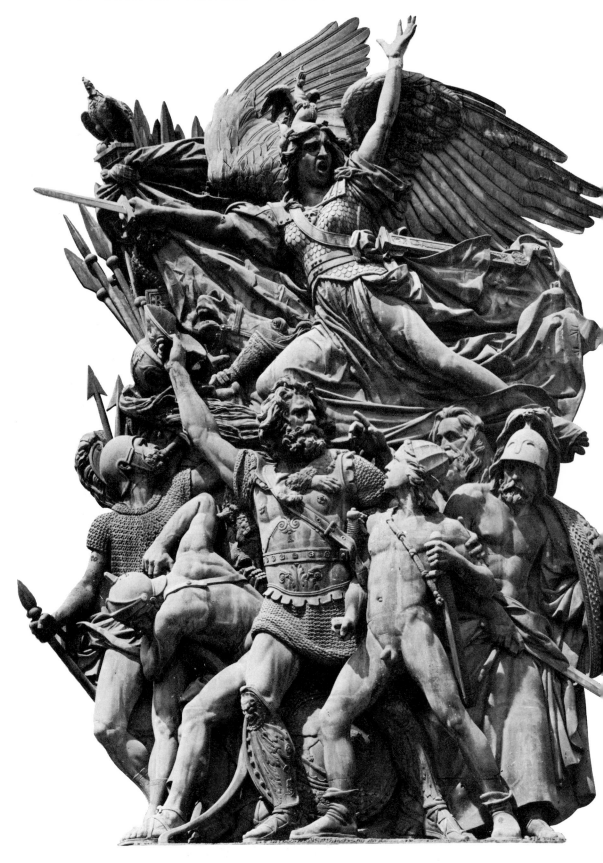

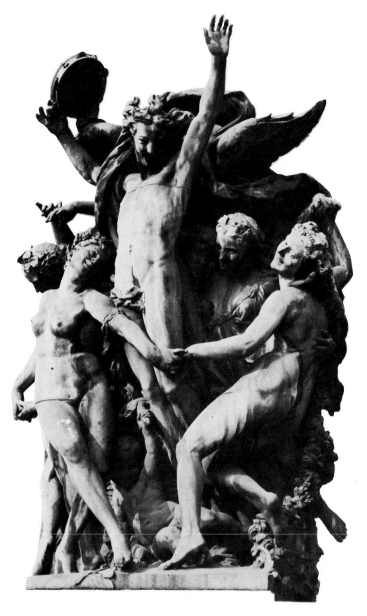

The Dance. Stone.
Jean Baptiste Carpeaux. 1869.
Exterior of Paris Opera House

On facing page:
The Marseillaise. Stone.
François Rude.
1837. *Arch of Triumph, Paris.*
(*Giraudon photo*)

Lion. Stone. Antoine-Louis Barye.
Ministry of the Colonies, Paris.
(*Roget-Viollet photo*)

Russians, Germans, and Americans, they were mostly pupils of the French school. The half-Russian, half-American Paul Troubetzkoi received training in Italy and France. He specialized, along with other Parisian sculptors of the late nineteenth century, in a sketchy realism bordering on impressionism. The attractive spontaneity and healthy freedom of a small bronze such as the *Tolstoi on a Horse* are hardly to be denied.

The transfer of thumb-marked clay effects into bronze is faintly disturbing, since a part of the task of the sculptor is to express the values inherent in his materials. Later moderns, especially Brancusi and Archipenko, were to search for direct expressiveness in bronze and copper. Troubetzkoi, however, was but one of hundreds of *fin-de-siècle* sculptors who believed that the dash and sparkle of a sketchy impressionism would enliven plastic art. Their statuettes remain, often, appealing and persuasive products, although one may rate higher the bronze replicas of the divert-

ing clay sketches of dancing figures modeled by the painter Degas, and Renoir's occasional genre pieces. The spontaneity and earthiness of the original clay compositions often seem to give way to an air of agitation and confusion after the transformation into metal.

In the nineteenth century practically none of the great monumental sculptors was trained to cut stone. The artist made a clay model, and expert stone carvers made the final product mechanically, reproducing the model by means of a pointing machine. This explains the lack of basic feeling for the stone. The softer virtues of the talented clay-modeler became standard, whether expressive of academic classicism or of realism.

Augustus St. Gaudens, an American born in Ireland and schooled in Paris, escaped to

Dancer. Bronze, with hair ribbon, vest, and tulle skirt. Edgar Degas. *Metropolitan Museum of Art, H. O. Havemeyer Collection*

Tolstoi on a Horse. Bronze. Paul Troubetzkoi. *Formerly Luxembourg Palace, Paris. (Giraudon photo)*

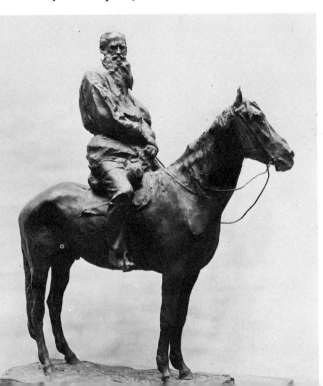

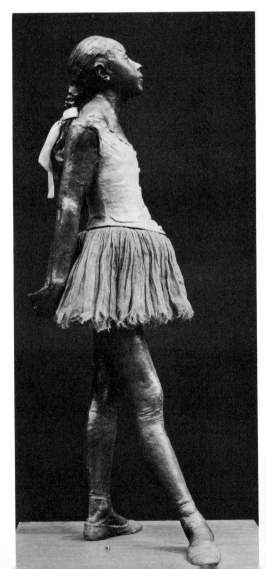

some extent from the soft and glittering style encouraged by the Ecole des Beaux-Arts at that time, and he inestimably raised the standard of sculptural achievement in the United States. A realist and, in certain elaborate monuments, a pictorialist, he succeeded in endowing public statuary with dignity and a rather sincere sentiment, though he lacked the sense of sculpture as a massive art, as proceeding from the block by direct cutting. His *Abraham Lincoln* in Chicago, impressively simple (considering the extravagant tendencies of the era), lifelike, and embodying a popular conception of the humane Lincoln, marks a high point touched by the century-end sculptors who adapted camera-eye realism to sentimental and idealistic ends.

Medardo Rosso, who was ten years younger than St. Gaudens, escaped the limitations of a too-binding realism. The most daring Italian innovator of his time, a rebel against all types of classicism and academism, he shared with Rodin the credit for bringing the free modeling and the luminous surfaces of impressionism to sculpture. He did not possess the profound vision and the grand schemes of his French contemporary, but his insight into human nature made his "soft-focus" works appealing and revelatory. His understanding of children is beautifully externalized in the several versions of *Ecce Puer*. Perhaps the most beautiful is the one illustrated here.

Ecce Puer. Wax over plaster. Medardo Rosso. 1906.
Collection of Mr. and Mrs. Harry Lewis Winston, Birmingham, Michigan

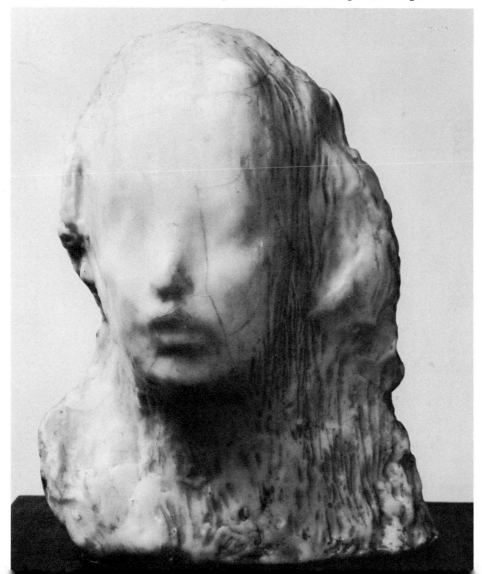

The story of nineteenth-century sculpture culminated in the work of one towering figure, Auguste Rodin, who practiced every type of "natural" sculpture, beginning with the camera exactitude of *The Age of Bronze* and *St. John the Baptist,* moved on to smoothed-

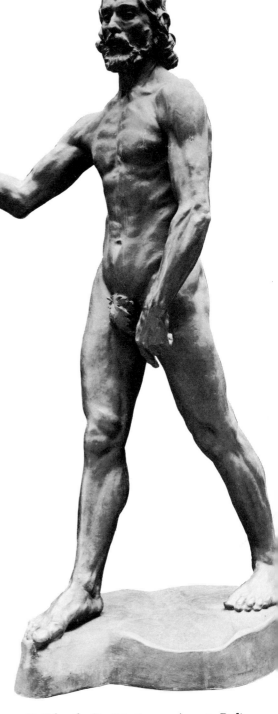

down, summary, and impressionistic variations, and finally created the extraordinarily real but distorted *Balzac,* a post-impressionist triumph.

Rodin fortunately escaped the standard Beaux-Arts training in art. His schooling came largely from elsewhere: an early course under Barye; later a visit to Italy, where he admired Donatello and studied Michelangelo's masterpieces; experience under the mediocre sculptors to whom he was assistant, before becoming an independent artist in Paris in his mid-thirties.

The first of many skirmishes with the authorities occurred when *The Age of Bronze* was submitted to the Salon in 1877. So transcendingly natural was the piece that Rodin was accused of making direct plaster casts from a human body. He eventually disproved the charge by taking casts from his model and showing that these differed in some details from the statue.

To carry the naturalness to an even higher degree, Rodin gave up the universal custom of posing the models on a throne in preconceived attitudes; instead they could wander freely about his studio. He thus ruled out the artificially set and awkward posing that rendered so much Salon statuary static and unnatural. The *St. John the Baptist,* a work of the years 1876–1878, stands beside the *Age of Bronze* as a masterpiece of Rodin's studiedly spontaneous naturalism.

St. John the Baptist. Bronze. Auguste Rodin. 1876–78. *Rodin Museum, Paris*

The transcribing of the caught attitude, suggesting the possibility of movement, is but one side of Rodin's devotion to impressionism. From the concept of the single, fleeting aspect —the impression—the impressionist painters had gone on to achieve a sparkling surface liveliness. They made their canvases brilliant by means of broken color or controlled light-vibration. Rodin saw the opportunity to render sculpture more "colorful" than ever before by modeling his statue's surfaces with minutest variations of boss and hollow. He gave a new meaning to an old saying that the trick in sculpture is to create interesting arrangements of mass and shadow. The larger play of light and shade in *The Thinker*, and many related works, and the sensuous minor play of surface contours and textures are remarkable.

Rodin and his *praticiens* and finishers achieved a tactile quality in sculpture as had no one before them. The statues in marble are luminous, ingratiatingly soft, even silky. Some of the portraits are, indeed, oversweet and over-facile. Basic sculpture was lost under the atmospheric finish. Nevertheless, such beloved groups as *The Kiss* (see illustration in Introduction), *The Eternal Idol,* and *Pygmalion and Galatea* constitute the most original and, many would say, the most beautiful body of stone sculpture achieved in Europe after Michelangelo.

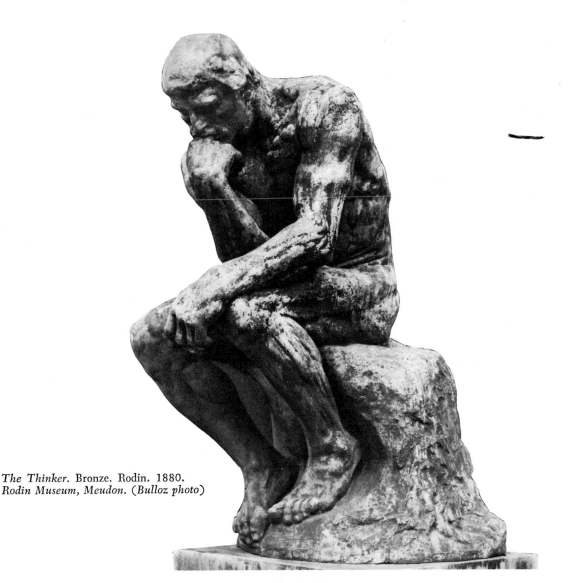

The Thinker. Bronze. Rodin. 1880.
Rodin Museum, Meudon. (Bulloz photo)

A great individualist, Rodin excelled also in vigorous composition that by contrast showed up the weakness and impotence of routine contemporary sculpture. *The Thinker*, originally conceived as a Dante surveying the tides of human misery, in the sculptor's unfinished *Gates of Hell*—but widely interpreted as symbolizing primitive man brought to pause by thought—is almost brutally vigorous. The pugilist's body and the small head, the huge fist pushed against the jaw, and, above all, the savagely forceful modeling, endow the figure with a feeling of bursting physical power. There had been no such innately powerful figure since Michelangelo, though Rodin generally failed to achieve expression in that fourth dimension which was Michelangelo's element. The Frenchman is here the great, the incomparable realist; the Italian is the creator of vast melodies from some other world.

The *Adam* and the *Eve* (studies for the *Gates of Hell* composition), the controversial *Old Courtesan*, and numerous fragmentary torsos, hands, even portrait heads, of which the bronze portrait of Hanako the Japanese dancer is typical, possess a vigor which Rodin alone seemed able to impart. Among the bronze and marble heads and the plaster and wax masks there is every intermediate type of realistic portrayal between the rugged likenesses and the silkily finished, prettified things.

This very great master of modeling seldom touched stone or metal. He made small clay originals, or a full-size clay or plaster model. From these his assistants made replicas or casts, generally in mechanically enlarged size. There is no doubt that Rodin was the

Head of Hanako. Bronze. Rodin.
California Palace of the Legion of Honor,
San Francisco, Alma de Bretteville Spreckels Gift

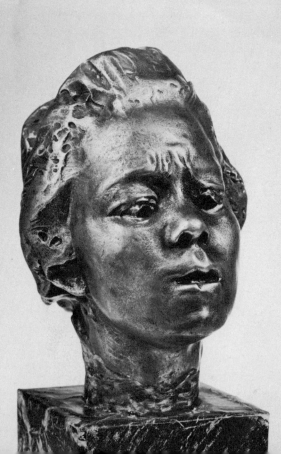

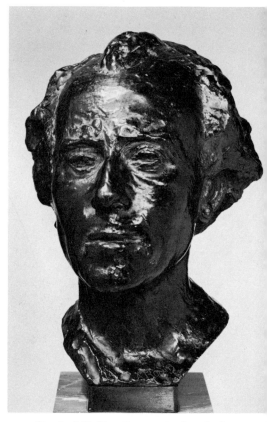

Head of Mahler. Bronze. Rodin. Rodin Museu
Philadelphia. (Photo by A. J. Wy

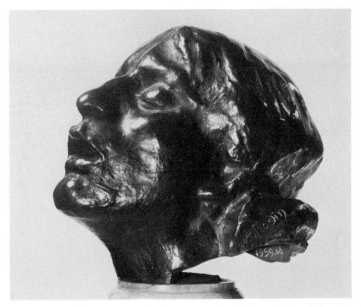

Head of Sorrow. Bronze. Rodin. 1882. *Yale University Art Gallery, Gift of Mrs. Patrick Dinehart*

genius; his works are too genuinely touched with his individualistic magic to admit distrust of his vision or his ability. But the one criticism that can be leveled at his work as a whole is that he had no instinctive feeling for the virtues of stone. He is at the opposite pole from the primitive sculptors, who were so close to the materials, moved by a passion for expression in those materials, instinctively capitalizing upon the virtues of stone or wood.

The exhibits in museums are in many cases replicas. This need not diminish appreciation of *Despair* or *The Thinker* or *The Kiss,* but the lack of basic sculptural emotion prevents Rodin's works from ranking with those of Michelangelo or the Chinese or Egyptian masters. The fact is that the School of Paris, the leading nineteenth-century school, admitted no allegiance to the stone.

It was against unsculptural sculpture and against naturalism that the revolutionaries of 1905–1930 dissented most strongly. In his monument to Balzac, Rodin did transcend naturalism and grasped the key resource of the expressionists—distortion in the service of emotional and formal intensification. Though the material was clay or plaster, the artist at last reached an ultimate secret of his art and rendered the Balzac figure into a menhir-like column. There are both grandeur and depth of emotion in the piece. Official Paris rejected it. The incomparable realist-impressionist, nevertheless, had proven his position as forerunner of the twentieth-century insurgents, with a vision beyond realism. His path can

Despair. Stone. Rodin. *City Art Museum, St. Louis*

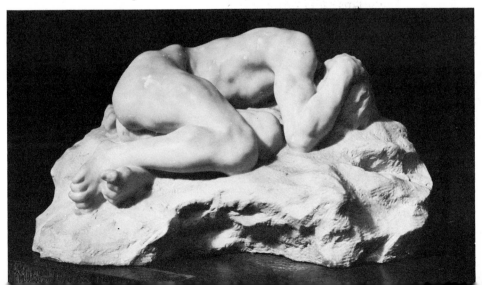

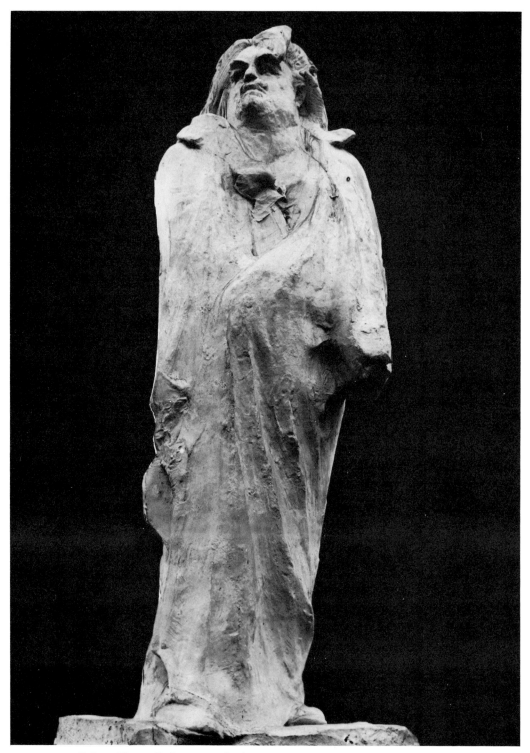

Balzac. Plaster. Rodin. 1897. *Rodin Museum, Meudon.* (*Giraudon photo*)

be charted from the point where realism is an exact replica of nature to realism that is an intensified expression of a momentary impression, and later, to a single monumental example of the art that goes beyond impressionism. Many smaller pieces are expressionistic in method, with free use of nature-distortion— summary, untidy, and sometimes savagely slashed. These emotionally powerful works were dismissed by critics and public in the artist's lifetime as studies and "unfinished work," though now they are prized possessions of museums and private collectors, and are valued as products of an extreme sensitivity and creative vision.

Rodin was the most subtle and successful modeler in Western history, and his method proved to be an overwhelming influence upon the younger sculptors. His sweetly modulated surfaces inspired new study of the nuances of modeling and challenged the dicta of the still-lingering neo-classicists and the mere naturalists. Most potent, however, was the example of his vigorous figures such as *The Thinker*. He had, of course, countless imitators.

The eminent men among his contemporaries had sufficient individuality to rise above schools and above imitation. Aristide Maillol was a great transitional and independent sculptor, whose role was to restore the ancient simplicity and massiveness of the art before the twentieth-century moderns could begin their explorations in cubism, expressionism, constructivism, and the various modes of abstraction.

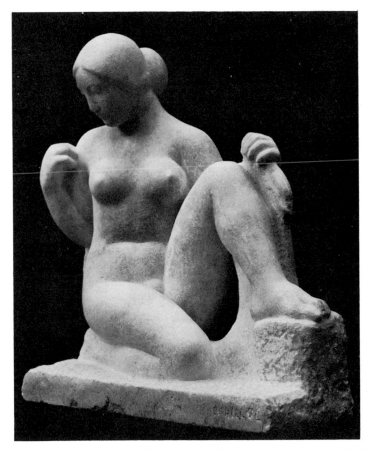

Seated Nude. Stone. Aristide Maillol. 1931. *Collection of Pierre Matisse, New York*

Maillol beautifully demonstrated sculptural simplification and devotion to the block. He was not truly post-impressionist, but branched off before impressionism became a creed and a method. He simply felt sculpture as a voluminous art, and he returned to the problem of endowing simple, and generally heavy, works with rhythmic plastic life. He achieved largeness and repose. He was the negation of all that had happened in the art since Michelangelo, having rejected baroque ostenta-

Head of Mme. Derain. Plaster. Charles Despiau. 1922. *The Phillips Collection, Washington*

tion and flourish, neo-classic wooden conventionalism, and overdetailed, camera-eye naturalism. He was a realist returning to the basic expressive means of the art, and he rose above the ruck of realists by his instinctive compositional sense and genius for capturing the character of the model in the life and character of the sculptural piece.

A less substantial forerunner of the moderns, but certainly the second great creative figure of the period in France, was Antoine Bourdelle (1861–1929). He was one of Rodin's pupils who added a personal note, even a personal force, in application of the master's precepts. His sculpture is impressionistic and suffers from being patently the art of a modeler. But it has a certain largeness and breadth. In many portraits the sculptor's marvelous naturalism veered slightly toward post-impressionist distortion. *Hercules the Archer* is typical of Bourdelle's vigorous and graphic figure compositions. It is the best of its sort, though a modeler's piece, and somewhat removed from the substantiality and the repose that characterize the greatest sculpture.

Next to Rodin, the most popular sculptor of the century-end was Constantin Meunier, a Belgian, an honest and talented artist who chose his subjects from the ranks of manual laborers. The vogue for his bronzes has later been recognized as being due to the novelty in his choice of themes, and perhaps to sentimentalism, rather than to his sculptural treatment.

In the main, portraiture continued to be naturalistic after Rodin and Bourdelle. Wonderfully exact likenesses from clay modelings were produced in all the Western countries. The amazingly factual heads by two American sculptors, Jo Davidson and Charles Grafly, failed in revealing inner character in the way of Benno Elkan of Germany, a master of sensitive realism. He was surpassed only by the Parisian Charles Despiau. Discerning portraiture, with regard to both the outward look of the sitter and the animating personal character, could hardly go further than in Despiau's works.

Georg Kolbe, a German, was one of the most sensitive of the early-century realists, partly by reason of a group of revealing portrait heads, but more especially for a long series of tenderly realized figure pieces. These are so exact in pose and so sensitively modeled—and so personal in presentation—that Kolbe enjoys a place in history as distinctive as that of Despiau, or that of the Italian Medardo Rosso. In the *Dancer,* illustrated, the outstretched arms violate some fundamental tenets of the moderns, being dangerously "away from the block"; but the melodic modeling of the piece and the associative rhythmic emotion are appealing.

Jan Stursa of Czechoslovakia followed closely in the Rodin tradition and perhaps came closest to him as a sensitive impressionist.

Hercules the Archer. Bronze, gilded.
Antoine Bourdelle. 1909.
Metropolitan Museum of Art

Anatole France. Bronze. Bourdelle. (*Bulloz photo*)

During the Victorian era Alfred Stevens had been the most original and interesting British sculptor. The influence of Rodin was less pronounced in England than on the Continent. The first modern to emerge was Frank Dobson, who was indebted rather to Maillol. After a period of working in the most sober kinds of realism, Dobson accepted the formalism and expressionism that were to animate an extraordinary group of creative English sculptors working from 1925 to the present.

Dancer. Bronze. Georg Kolbe. 1912. *Formerly National Gallery, Berlin*

18: Modern Sculpture:

Formalism, Expressionism, Abstraction

I

A modern sculptor, Etienne Hajdu, has told how he went to Paris from his native Rumania in 1927, when cubism was twenty years old and surrealism was the current fad. He met a great number of students and became acquainted with leaders of the avant-garde. He relates that he arrived at "a state of the most absolute confusion" and abandoned sculpture for two years, returning to practice only after a period of reading and subjecting himself to influences: the primitives, the Egyptians, the Cycladics, and many another. The sculpture of pre-Columbian America, of Africa, of Romanesque France, and of Renais-

sance Italy influenced him. He learned from Rodin, and finally came to understand the foremost rebels of his own time, Brancusi, Arp, Giacometti, and Moore. His work began with simple forms, "as the first signs of a future language," and ended in a distinctive style, rocklike, abstract, suave, and appealing. In the 1960s he has been recognized as a master original and in the truest sense modern.

The story of Etienne Hajdu points up several truths about modern sculptors. They did indeed flock to Paris from all the countries of the world. But they did not go on to great achievement because they learned the ele-

Red G, mobile. Metal. Alexander Calder. 1963. *Perls Galleries, New York*

ments of cubism or surrealism, or because they were influenced by Picasso, who "cubed" a portrait head in 1909, or because the advanced painters of the *fauves* school discovered the effectiveness of African tribal masks. A hundred influences came to bear upon the students in Paris rather than one dominating idea. Rodin had opened the way for the post-realistic style a full decade before Braque and Picasso developed cubism. Even earlier the German moderns had turned to formalism as a revolt against Rodin's dominating realistic style. The expressionists had followed with nonrealistic works from 1906 on, and arrived at theoretical abstraction by 1910. They, like the *fauves* in Paris, were drawn to sculptures from the primitive cultures, African, Oceanic, Amerindian.

A few youthful sculptors went to Paris already equipped for original achievement: Gonzalez with a knowledge of metal forging, which led him to pioneer work in welded metals; Calder with a knack for invention with wire which culminated in creation of a new world of mobiles, stabiles, and animated sculptures. Nevertheless, the total "modern movement" gained impetus from the hundred sources. Even the greatest creators acknowledge debts to rediscovered historic cultures: Henry Moore equating a miner's love of the stone with a deep study of ancient Mexican images; Brancusi simplifying forms until they comport perfectly with Cycladic idols, but with an immediacy of material and method learned from modern architecture and modern industrial design.

Up to about 1915 post-impressionist art was shaped mostly by painters. The revolutionary schools, from neo-impressionism to cubism and surrealism, were painter-inspired. The sculptor members followed, absorbing into their techniques the neo-impressionist surface lighting, a "fauvish" carelessness toward nature, a squaring of forms and an inclination toward a study of planes from the cubists. But after the war years of 1914 to 1918 the sculptors took over leadership and provided most of the world-famous artist figures.

The School of Paris remained supreme, as a study center, until the beginning of the next war; but after Despiau there were no Frenchmen among the foremost creators. The leaders, as opinion in the mid-1960s might rank them, were Brancusi (Rumanian), Lehmbruck (German), Gonzalez (Spanish), Archipenko, Gabo, and Lipchitz (Russian), and Giacometti (Swiss); all these had close ties to Paris. Without Parisian training, and perhaps the greatest sculptor of the mid-century, was the Englishman Henry Moore. Many historians would include Jacob Epstein, originally American, French-trained, but a giant figure in English modern art from 1905.

These sculptors, and a host of carvers in the second rank, had been freed from the realist's obsession with copying natural appearances. From the time of Lehmbruck and Brancusi on, distortion, in one sense or another, was at the heart of modern practice. Whether the purified art of Brancusi and Arp, the monumental approximations by Henry Moore and Barbara Hepworth, or the roughly modeled portraits by Epstein and Giacometti, all modern sculpture entailed a rejection of man as he is superficially seen in a mirror or photographic lens. Sculptors were now preoccupied with interpretation, essences, and inner vision.

"Expressionism" is the term most often used today in writing about the international art that is patently post-realistic. Expressionism was at first a name applied by the Germans to describe the work of their radicals. Therefore in Paris the term was opposed as alien, and it was widely thought that "post-impressionism" or perhaps just "modernism" would serve. But historians early found analogies in the expressionistic art of primitive peoples, in a great deal of Chinese sculpture, in the "distorted" figures of French Romanesque religious art. As a rule artists and historians speak of French and all other modern sculpture since about 1910 as a part of expressionism.

Some of the most recent and unorthodox innovations—constructions and assemblages—

are probably best considered as experiment. But the most widespread current work, that of the sculptor-welders, seems to mark the beginning of an activity that extends the boundaries of the sculptor's art.

A listing of schools or styles, with the names of leaders and dates, follows.

Formalism. Not a well-defined movement; preceded the more spectacular French schools and provided a first challenge to the realists. Beginning in Germany in the earliest years of the century, it was known through the theorist Adolph Hildebrand (1847–1921) and in the works of Franz Metzner (1870–1919), leading on to the more radical insurgency of Wilhelm Lehmbruck (1881–1919) and Ernst Barlach (1870–1938). In France the movement was not unrelated to the art of the symbolists; Joseph Bernard (1866–1931) was the most notable French practitioner. From Paris the influence spread to George Minne of Belgium and to Carl Milles of Sweden. Paul Manship was a leader in a large group of formalist sculptors in the United States.

Fauvism. The Fauves, or "wild men," were a group of painters who came to notice in Paris in 1905, bringing into focus the ideas of the individual revolutionaries of post-impressionism, most notably Cézanne, Van Gogh, and Gauguin. The Fauvist leaders were Matisse, Rouault, and Derain. In 1907 Braque joined the group, which was the first to bear the name "School of Paris." The Fauves practically revolutionized the art of painting. But no leader among sculptors was involved.

Expressionism. The first school of expressionists was organized in 1905 in Dresden, under the name *Die Brücke*. More central to German expressionism was the *Blaue Reiter* group, which set up a secessionist exhibition in Munich in 1911. Its leaders were the German painter Franz Marc and the Russian painter Vasily Kandinsky. Both groups were devoted primarily to painting, but as the word "expressionism" took on meaning as a label for all Western anti-realism in art, it spread over to include creative sculpture as well.

Cubism. A development in painting by two fauvists, Braque and Pablo Picasso, in 1907 and 1908. The cubists squared forms and they disassembled and reassembled planes, and these activities attracted, generally after 1909, a number of sculptors, among whom the most creative were Jacques Lipchitz, Henri Laurens, and Raymond Duchamp-Villon.

Futurism. Originally the invention of a group of Italian painters who talked much of dynamism, futurism created a minor sensation in Paris in 1909. But it was soon recognized as advocating a return to illustrational art. Umberto Boccioni, one of the founders, was sculptor as well as painter, but his futuristic innovations proved not to be along the main way of progress in plastic art.

Vorticism. This was an English movement inspired directly by the futurist rebels. Unimportant except that the young French sculptor Henri Gaudier-Brzeska enlisted in its ranks and produced exceptionally fine compositions in stone, marked by a high degree of distortion. His *oeuvre* was recognized later as expressionist.

Constructivism. At first a school formed in Russia in 1917 by a varied and loosely organized group of "constructors" that included Vladimir Tatlin, Antoine Pevsner, and Naum Gabo. Its impetus was international, and an important kind of modern sculpture, anti-imitational and concerned with machine imagery, was widely developed. In Paris constructivism was accepted as a further territory, just beyond cubism, in which a typical machine-age plastic art could be invented. A second group of artists, Dutch in origin, who called themselves neo-plasticists (though more generally known as the *De Stijl* group, from the name of a magazine they published), merged easily with the constructivists; both groups tended to geometrical designing and to an ideal of abstraction. The Belgian Georges Vantongerloo from the Dutch group and the Russian Gabo were outstanding pioneer sculptors. Much of contemporary

welded sculpture is in a direct line from Russian constructivism.

Purism. In painting this minor school was descended from flat-plane cubism and was created by Amédée Ozenfant and the architect Le Corbusier in 1920. But the word "purist" is often used in describing the near-abstract sculpture of Brancusi and the fully abstract work of Jean Arp.

Surrealism. The founders of this school in 1924 tried to throw a veil of "dream reality" over subject-art. But the principles were more easily realized in painting than in sculpture. Arp and Giacometti were claimed as members of the school, but outgrew its limitations, the one as a leading abstractionist, the other because he turned to a very personal type of expressionism.

Abstractionism. Not a school or a movement, abstractionism has been a worldwide development in the arts since about 1900. The main aim has been to achieve, even to isolate, the formal element in art, the form structure. After the late Cubist work, in about 1909 and 1910, and the paintings and pronouncements of the *Blaue Reiter* group in 1910 and 1911, abstraction in sculpture was achieved by Brancusi, by Arp, by Hajdu and Viani, and after 1930, by the forgers and welders of metals in a dozen countries. Where absolute abstraction has not prevailed, emphasis has been thrown on the essential form values, with subject values secondary. Treated in many histories as abstract expressionism, it includes nonobjective pieces—as seen in certain sculptures of Arp, Gabo and Hajdu —and the slightly objective compositions by the foremost sculptors of the mid-nineteen-sixties, such as Henry Moore and Jacques Lipchitz, or those of the less well-known Fritz Wotruba of Austria, Kenneth Armitage of England, and David Smith of America. Abstraction, too, fathered the invention of Alexander Calder's mobiles and stabiles.

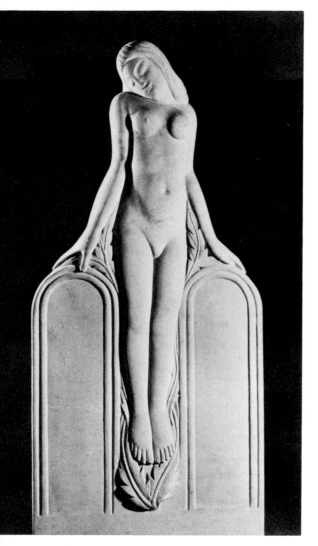

Stele. Stone. Eric Gill. *Tate Gallery, London.*
(Photo by Roland Federn)

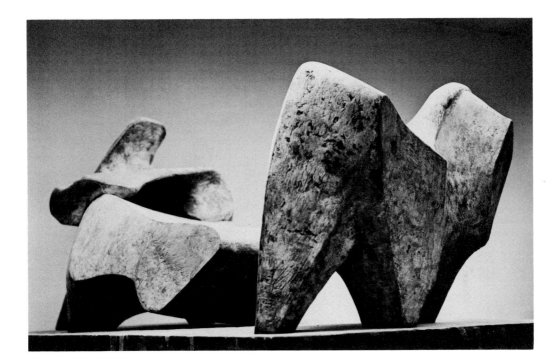

II

THE first widespread reaction from realism occurred even while Rodin was at the height of his power and influence. In the beginning it took shape not as a wildly revolutionary and expressionist movement, but as a trend toward formalized sculpture. Natural aspect became less important than a consistent and pleasing stylistic artistry. The movement was toward the formal and decorative ideals of the Orient. It was most marked in Germany, where Franz Metzner stylized his figures with a smooth decorativeness and a heavy "bluntness" found in his work and that of Hugo Lederer. A German artist who was not primarily a sculptor, Franz von Stuck, achieved a minor masterpiece in the

Amazon. It is typical in its prettily smoothed surfaces, linear rhythms, and the frankly decorative conventionalization of the helmet and the horse's mane.

The formalized treatment lends itself to pretty rather than profound effects. As seen in certain figures by the Frenchman Joseph Bernard, it became a pleasing simplification, whereas in the hands of certain talented mannerists it became a borrowed artistry, consciously manipulated to create charming and fanciful decorative effects, without deep sense of plastic rhythm or plastic order. Paul Manship, an American, was a leader in the formalist group. Another sculptor, with a lighter touch, was the Dane Kay Nielsen.

Reclining Figure, three-piece ("Bridge Prop"). Bronze. Henry Moore. 1963.
City Art Gallery and Museum, Leeds

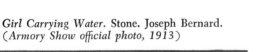

Girl Carrying Water. Stone. Joseph Bernard.
(*Armory Show official photo, 1913*)

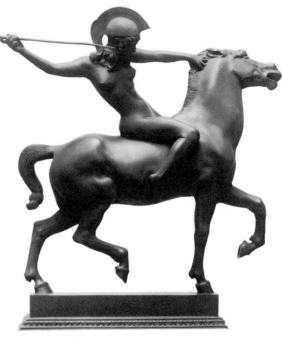

Amazon. Bronze. Franz von Stuck. *Art Institute of Chicago, Fritz von Frantzius Collection*

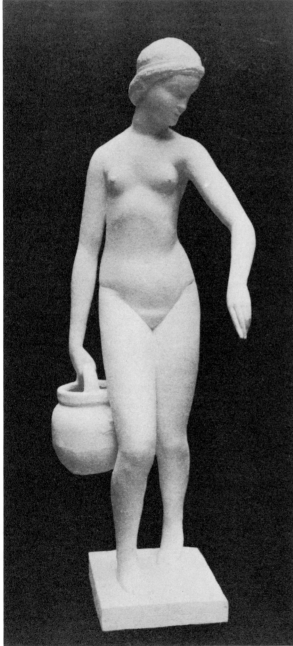

The formalizing trend has continued through more than a half-century, along with the more turbulent movement initiated by the avowed expressionists. Both movements opposed realism, and especially naturalism. Carl Milles, a Swedish sculptor who lived in the United States after 1929, began as a formalizer and became a leading sculptor because he combined a feeling for essential sculptural traits with his flair for charming decorative effects. His monumental work has largeness and dignity and considerable feeling for the special massiveness which is, the moderns of the thirties believed, the basic test of the art. The solidity of his designs and a characteristic preciseness in fixing gesture or pose are illustrated in the Folkunga Fountain at Linkoping, Sweden. The illustration here is a version in bronze of the dominating figure.

Ivan Meštrović developed from a moderate formalization to a heavier expression without hesitating to distort nature when aesthetic aims could be served. An elemental note appeared in all his work, as was natural, per-

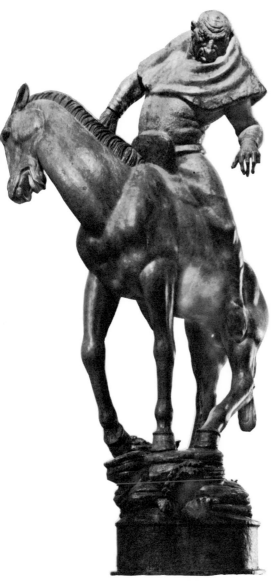

Figure from Folkunga Fountain. Bronze. Carl Milles. *City Art Museum, St. Louis*

haps, since he began his career by carving directly in wood and stone when he was a shepherd boy in the mountains of Serbia. By 1912 Meštrović was an internationally known artist, the first giant modern sculptor who gained such renown independent of Paris. His powerful, often heroic statues, touched with the somber and sometimes pathetic appeal natural to themes from Serbian history,

marked the first emergence of sculpture totally unaffected by the Italian Renaissance and the post-Renaissance schools of realism. If there are influences in Meštrović's work, they are archaic and Byzantine.

He was a fervent Christian and mystic, and one of the very few modern artists capable of creating religious sculpture. The era of realism had been an era of growing paganism and devotion to profane beauty. Meštrović restored the impersonal grandeur and the reverent sentiment that are inseparable from spiritual expression in sculpture.

Eric Gill was a less profound sculptor, but his prettily formalized reliefs and his half-round and round figures for church walls are very attractive. His earliest training had been as cutter of stone lettering, and he preferred to be called a workman rather than an artist. He disapproved of artists who owed their reputations to anonymous workers' replicas, and deplored the machine's inroads upon hand craftsmanship. A helpful patron managed to persuade him to go to Paris for training, but one day in the great art metropolis sufficed, and he decided upon an immediate return to England. The example illustrated is typical of his clean-cut, sensitively felt, but sturdy art. (Page 485.)

The sculpture of the impressionists and of the devotees of the utterly natural had been most often showpieces, expressive in their own right. It was no longer produced as an integral part of a building. Its virtues had become photographic, impressionistic, declamatory, so that it could not easily be held within a frame. The modern movement, post-impressionism, restored architecturally conceived sculpture. Often the compositions of Meštrović and Gill were destined for specific places on buildings. Their works fitted perfectly with simple walls and doors and windows.

One product of modernism is an architecturally conceived monument, a structure built to afford fullest validity to the sculpture, while the figures fit into the architectural scheme as a focal point. The Reformation monument at Geneva, while hardly more

than good sculpture in the formalist vein if the figures are examined separately, becomes majestic as an architectural whole.

Brancusi, Gill, and Gaudier were the modern sculptors who most effectively and most passionately emphasized that stone is the key material of the art. Feeling for the stone was basic to their creations. Each one of them visualized the complete figure in the uncut block. Eric Gill condemned the French and French-trained sculptors who modeled in clay;

he considered the finished work a stone imitation of a clay model.

Expressionism as a name for the main revolutionary movement in twentieth-century post-realistic art is justified by the transfer of emphasis from representation to expression. Intensification of the expressiveness is both emotional and formal. The subject or content value is intensified by dwelling upon the essential or inner attributes of the subject, often to the extent of noticeable distortion of out-

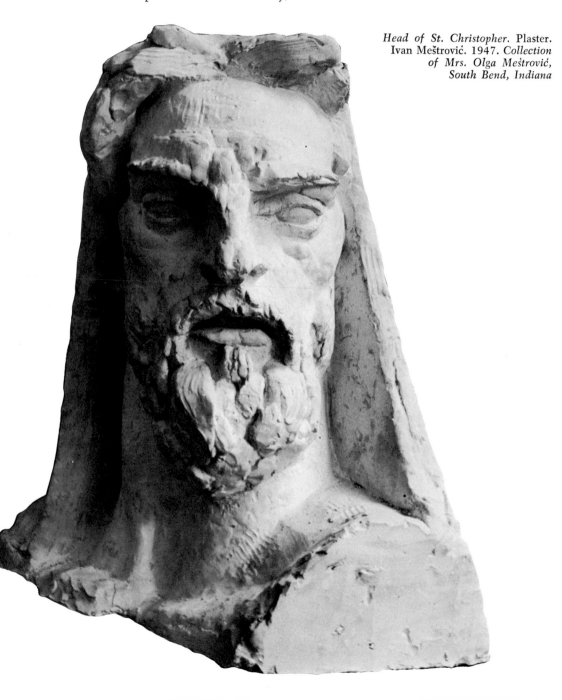

Head of St. Christopher. Plaster. Ivan Meštrović. 1947. *Collection of Mrs. Olga Meštrović, South Bend, Indiana*

Tobias and Sara. Stone. Eric Gill. 1926.
(*From* Eric Gill *by Joseph Thorp,
courtesy Jonathan Cape
and Harrison Smith*)

Monument of the Reformation. Stone. Henri Bouchard and Paul Maximilian Landowsky. Geneva

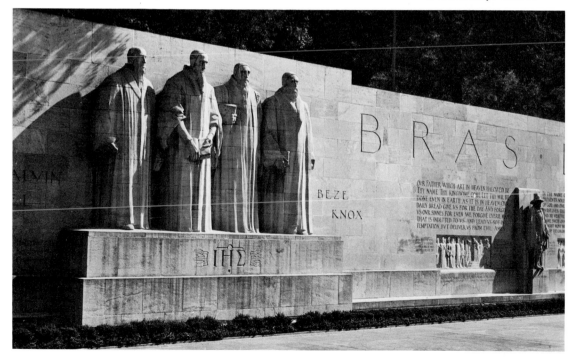

ward aspects, and by communication of the artist's passion over the subject. Inseparable from that expressiveness is intensification of the character of the materials, of the feeling for the stone, as so beautifully demonstrated by Gill, Brancusi, and Gaudier.

Henri Gaudier, later Gaudier-Brzeska, was a French sculptor who spent his few creative years in England but was killed in the First World War at the age of twenty-three. He was author of almost the first consistent series of sculptures which could be called expressionist. Naturally there survives a certain amount of his experimental and student work; but the few statues, such as the *Seated Figure,* indicate how far he had gone in achieving simplification, a primitive massiveness, a rhythmic formalization, and concentrated feeling. Gaudier's definition is often quoted to explain modern sculpture: "Sculptural energy is the mountain. Sculptural feeling is the appreciation of masses in relation. Sculptural ability is the defining of these masses and planes."

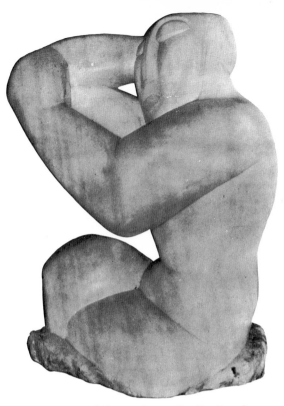

Seated Figure. Stone. Gaudier-Brzeska. *Formerly John Quinn Collection*

After the prolonged epoch of clay modelers there came, among other influences, a study of primitive and exotic sculpture exhibited in natural-history museums. There the lesson of adapting design to the material, of formal beauty arising in part from the shapes, texture, and hardness of stone or wood, was relearned. Just as certain of the revolutionaries were inspired by the emotion of the stone block, so others were inspired to cut directly in wood; and they found special pleasure in Negro sculpture, with its exquisite craftsmanship and loving care for the beauty of the wood manifested in each ancestral figure or mask or instrument.

A few of the pioneers of expressionism executed pieces in imitation of the Negro figures. But the real rebirth of wood sculpture came when other artists went back far enough to regain by experience the values special to cutting in wood. Ernst Barlach of Germany gave the modern Western world almost its first demonstration of a considerable *oeuvre* cut directly in wood. He preserved the forms natural to the wood block as opposed to the stone

Old Woman with a Cane. Ernst Barlach. (*Photo courtesy Paul Cassirer, Berlin*)

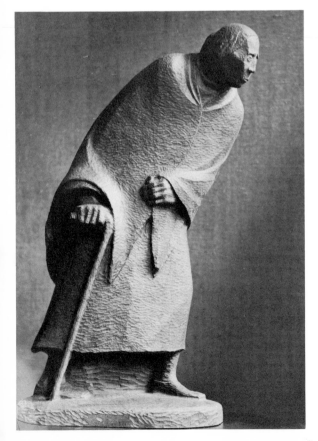

block, rendered the masses fluently, with easy undercutting, and gained surface values, of variation and texture, out of the marks of the cutting tool.

With Constantin Brancusi, a Rumanian artist who spent the greater part of his life in Paris, it was the direct expression of the values in metals or polished marble that became an obsession. He was one of the most radical of the expressionists and veered toward abstraction. He simplified natural forms almost beyond recognition to convey his own inner emotion regarding the subject. A portrait head appeared as hardly more than a highly polished egg-shaped mass of bronze or brass or stone, with only the barest indication of facial features. (Nothing could be more

unlike the then standard bronze busts made as transfers from clay models.) A torso became a frank geometrization, hardly more than a cylinder of brass. A bird became a tapered shaft, so mounted that its movement and balance afford vaguely (or perhaps quintessentially) the feeling of a bird, whether perched or in flight.

Brancusi's, among all the near-abstract moderns, was the most independent and the

Bird in Space. Polished bronze. Brancusi. 1925. *Philadelphia Museum of Art*

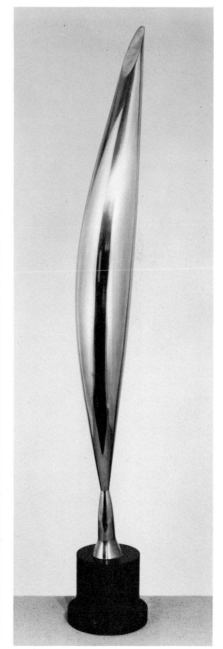

Mlle. Pogany. Stone. Constantin Brancusi. 1913. *Philadelphia Museum of Art.* (*Photo by A. J. Wyatt*)

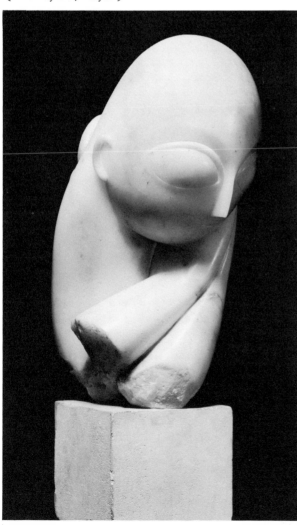

most subtle achievement of intrinsic sculptural values. His handling of the polished metals gave new meaning to the idea of enhancing aesthetic effect through creative use of materials. His works, whether symbols, abstractions, or formal creations only faintly related to life and the phenomenal world, convey the spirit rather than the natural shape. He served as an example to all contemporary sculptors, in his return to elementary relating of masses and to a meticulous care for sensuous surface appeal.

The second great adventurer in the field of abstraction was Alexander Archipenko, a Russian-born artist who was prominent in the art life of Central Europe before the First World War, and after 1923 resided in the United States. He was the most extreme of the pioneer workers in near-abstraction and through his experiments in nonobjective, geometrically simplified, and "reversed" forms—where, for instance, hollows suggest projections—he exerted tremendous influence upon international practice. The two statuettes illustrated are indicative of the harmonies he sought, the one an early simplified *Torso,* the other a late "modeling of space," as the artist termed it.

Flat Torso. Bronze. Alexander Archipenko. 1914. *Perls Galleries, New York*

Empire. Bronze. Archipenko. 1956.

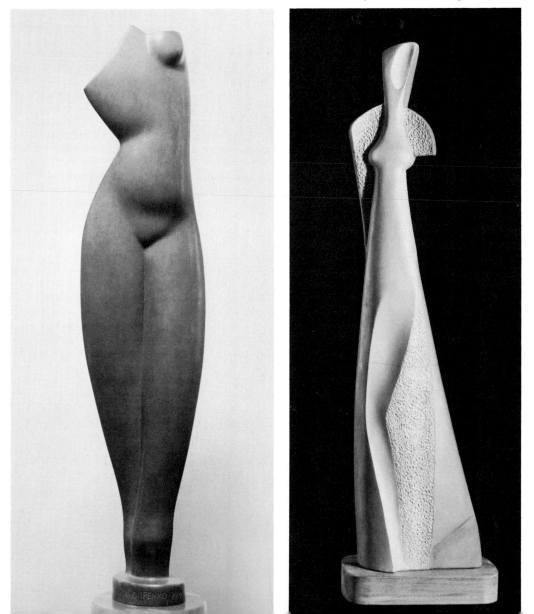

Sculptors made less progress than painters in rendering abstraction acceptable and pleasing. Nevertheless the overemphasis during the nineteenth century upon literary content, or upon mere naturalness, led to a determined search for the values of abstract formal order, or absolute sculptural beauty. Purely nonobjective compositions and partial abstractions became common in the avant-garde galleries. But in modern sculpture there was no artist to match the achievement of Kandinsky in abstract painting.

What was gained, through Archipenko and Brancusi and such lesser pioneers as Jean (originally Hans) Arp, was a general conviction that without the abstract values and the creative formal rhythm or the expressive sculptural form that lies at the heart of the art, sculpture tends to become mere illustration. Today content remains, but the giants of modern art in stone are those who endow each statue with a sculptural life of its own, over and above representational or associative value.

Arp, like Brancusi, sought to penetrate to the heart of sculptural emotion and to escape from the tyranny of worldly appearances. His compositions such as *Growth* (page 12) suggest rather than define aspects of the phenomenal world. His is near-abstract sculpture with a sure surface appeal. Two sculptors who in individual creative ways have produced not very dissimilar abstractions are Etienne Hajdu and the Italian Alberto Viani.

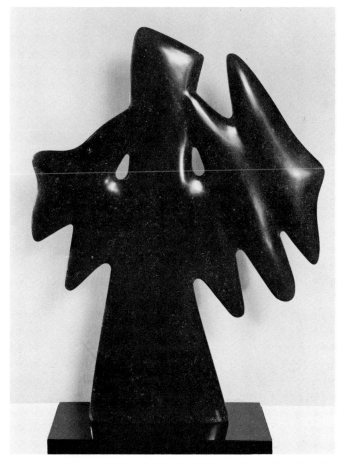

Fern. Bronze. Etienne Hajdu. 1959–60. *M. Knoedler & Co., New York*

More profound and more disturbing is the sculpture of the Englishman Henry Moore. His work ranges from composition of mere forms, seldom nonobjective in the total sense but certainly extreme, to presentation of the human figure in altered and oblique approximations that achieve melodic and often profound sculptural order.

Moore gets back to a primitive solidity. His work is elemental in the sense of creative power. He is close to the beginnings of things, with unfailing expression of those forms

Glenkiln Cross. Bronze. Henry Moore. 1955–56. (*Courtesy M. Knoedler & Co., New York*)

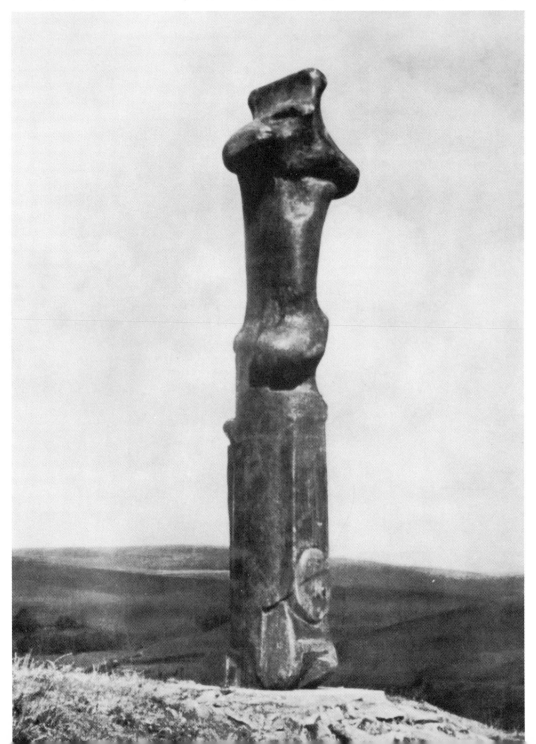

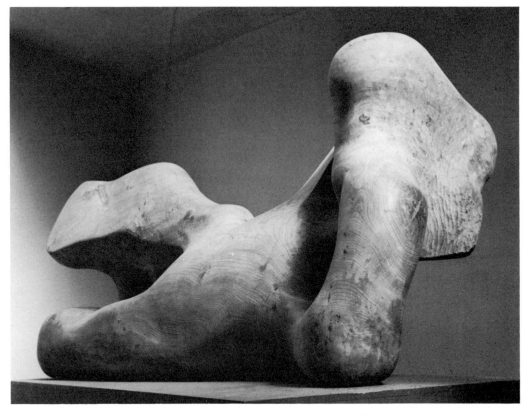

Reclining Figure. Wood. Henry Moore. 1959–64. (*Courtesy of the artist*)

which man subconsciously relates to earth and creation. He has repeated some of his simple figures in various sizes from a few inches in length or height to over life size; but the sense of weight, of mass, is never lost.

The *Reclining Figure* illustrated in the Introduction is only six inches in length. At the Tate Gallery in London there is a version in stone that is four and a half feet long. Through the years from the mid-twenties to the sixties this was Moore's most frequent subject, in variations from merely moderate expressionistic carving to near-abstraction. But in the 1950s the artist began to create in a very different vein, and he was as successful in his "upright motives" as in the horizontal series, and as fundamentally sculptural. The motives were nearly architectural abstractions at times, and became suggestive of human figures, and then unmistakably *were* figures; and at one point he sculptured a cross inevi-

tably suggesting Calvary. The near-abstract *Glenkiln Cross* is one of the most impressive of the sculptor's uprights, and it may bear for some observers vague connotations of some of the profoundest truths of existence.

Moore went on to two- and three-piece compositions, as variations on the *Reclining Figure* theme (page 481); or sometimes two upright figures related to a wall. But the most imposing multiple works are those in great size, immense, boulder-like masses, still bearing distant likeness to human forms, arranged in craglike conjunction. They are perhaps the most stately—most mysterious—works in twentieth-century sculpture up to this time.

England, though long hostile to modernism in art, became in the 1930s one of the world's foremost centers for experimental effort in sculpture. Frank Dobson is a less radical artist than Moore and a follower in Maillol's path, but honestly expressive in any chosen ma-

terial. Barbara Hepworth is a pioneer in di-
rect carving and in devotion to abstraction.
She has been second only to Henry Moore in
achieving monumental effects. The *Figure for
Landscape* illustrated is impressively massive.
Richard Bedford is known for his engaging
rhythmic compositions from flower and ani-
mal forms. But until Moore's triumphs, Jacob
Epstein, an American expatriate, was the most
famous modern sculptor in England.

In his early years Epstein experimented in
all the varieties of expressionism, and he was
an advocate of direct carving and full capi-
talization of the values inherent in the chosen
material. His most impressive monuments, in-
cluding the heavy *Night* and *Day* on the St.
James's Building of the London Under-
ground, were cut in stone. But Epstein re-

turned to modeling, and the most numerous
and characteristic of his later works were
bronze casts after clay originals.

No contemporary artist surpassed him in
portraiture. Despiau was not more sensitive to
nuances of outward expression, and to
Despiau's subtlety and precision Epstein
added some slight distortion in the expression-
ist manner. His was a supreme psychological
portraiture, with the outward aspect deformed
and re-formed for intensification of character.
But even the most devoted admirer of his
amazingly revelatory and always interesting
portraits must note uneasily the lumpy sur-
face and the general looseness and muddiness
evident in the bronze replicas. Unfailingly
the work has the air of authenticity, of a
unique mastery of the clay medium; but some

Figure for Landscape. Barbara Hepworth. 1960. *Marlborough-Gerson Gallery, New York*

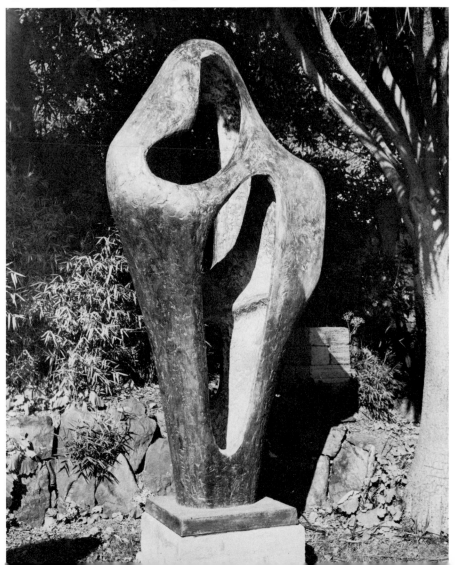

of this is lost in the transfer to bronze. This one inconsistency removes Epstein's work from the company of the world's great masterpieces of the art.

German artists were at the forefront of modern experimentation in sculpture until the Nazi dictatorship's suppression of liberty in the arts. Lederer and Metzner had been background rebels; Adolph Hildebrand, not himself one of the greatest sculptors of his time, was the formulator of a theory of form-organization; Ernst Barlach was the pioneer carver in wood; Hermann Hahn went far toward realizing Hildebrand's aims of simplification and rendering the sculptured figure a living entity in its own right. Others were Ernesto de Fiori (of Latin origin), Gerhard Marcks, and Georg Kolbe.

But Wilhelm Lehmbruck was the greatest of the Germans, and perhaps the most gifted of modern sculptors up to mid-century. He

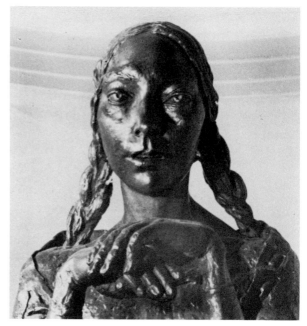

Visitation, detail. Bronze. Jacob Epstein. 1926. *Tate Gallery, London*

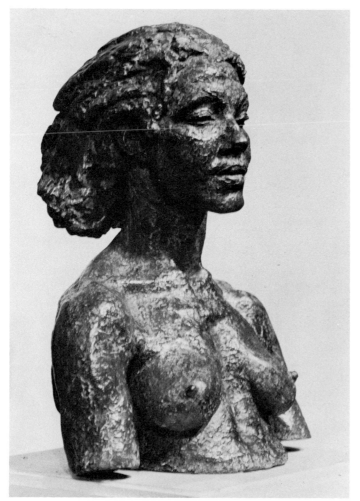

Senegalese Girl.
Bronze. Epstein. 1921.
Weintraub Gallery,
New York

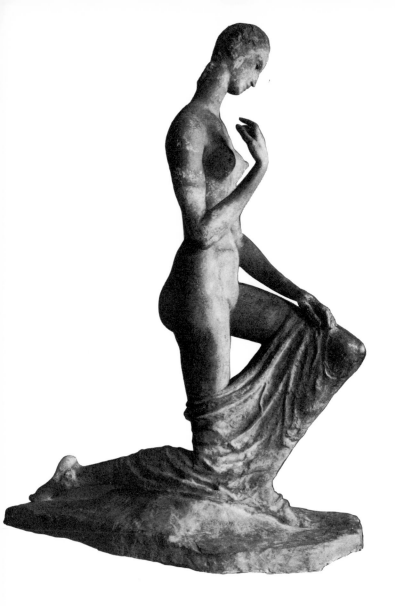

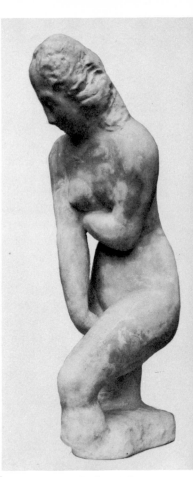

Bathing Woman.
Cast stone. Lehmbruck.
Private Collection

Kneeling Woman. Cast stone.
Wilhelm Lehmbruck. 1911.
Museum of Modern Art, New York

died by his own hand at the age of thirty-eight. Lehmbruck rose above the limitations of the routine sculptor's training in naturalism. He worked in Germany and in Paris but found no instructor capable of lastingly influencing him. By 1908 he was experimenting with subtle distortions for greater rhythmic effect. A period of heavy simplification and formalization, which might be noted as not greatly unlike Maillol's on one hand and Metzner's on the other, was followed by that period of utterly original stylization, with distortedly slender forms, which culminated in the famous *Kneeling Woman,* the *Dying Soldier,* and other characteristic masterpieces.

Lehmbruck's sculpture has been termed romantic on account of its affinity with medieval sculpture, but nothing could be further from the French or German romanticism of 1830. He was a pioneer who returned to pure and essential expression. His work had movement within a contained structure, vitality with utter stillness, elegance and monumentality. Many of his smaller works are in terra cotta. Most of the larger statues were cast in artificial stone and then worked over by the artist. The carefully controlled compositions of elongated forms and the sensitive surface expressiveness are well served in this new medium.

Between 1910 and 1940 Paris was still the center of study, but native sculptors were overshadowed (except for Despiau) by Brancusi, Arp, Lehmbruck, Zadkine, and Lipchitz. There were also the painters of the fauvist and cubist schools, most notably Pablo Picasso, who made brief excursions into the field of sculpture. Between 1926 and 1940 Picasso's fellow countryman Julio Gonzalez did revolutionary groundwork in forged, hammered, and welded metals in Paris and inspired the international school of welders.

The Russian Ossip Zadkine, like Brancusi and Gonzalez, remained in Paris and was a chief experimentalist among the post-cubist expressionists. He produced a wide range of original pieces, nonobjective as well as figurative, the latter with marked distortion of nature. Jacques Lipchitz, born in Lithuania in 1891, went to Paris to study in 1909. He adopted a series of styles and techniques be-fore he developed an individual, rather heavy and vigorous style of his own. Forced out of France by the German occupation, he went to New York in 1941 and since then has been a modeler of elemental form-organizations and one of the most powerful of modern sculptors.

Other French sculptors came to the forefront at this time, including Henri Laurens, who made cubist and expressionist works. Germaine Richier insisted upon using strange new and broken forms in metal and enjoyed a vogue when ultra-modern collectors began to value especially the imaging of degraded, dehumanized, and twisted man. At the far extreme, François Pompon delighted the public with statues, especially of animals, smoothed down to the point of slickness. The marble *White Bear* at the Musée d'Art Moderne in Paris has solid sculptural virtues and a touch of true modern short-cutting.

Prometheus Strangling the Vulture. Plaster. Jacques Lipchitz. 1944. Owned by the artist. (*Courtesy Philadelphia Museum of Art*)

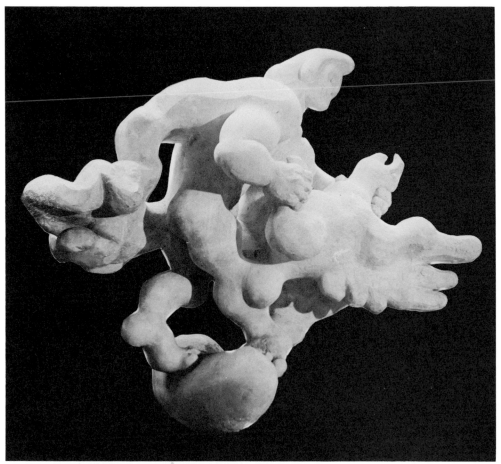

In this second group of School of Paris sculptors, the Russian Chana Orloff, the Spanish Pablo Gargallo, and the Rumanian-born Etienne Hajdu, adopted members of the Paris school, were among the more creative artists. By 1926 the now internationally famous Swiss Alberto Giacometti had become a provocative experimental figure in Paris.

Gaston Lachaise emigrated to America in 1906 at the age of twenty-three and became the acknowledged leader of the modern sculptors in the United States. Lachaise cut directly in stone. The sculptural head illustrated here is typically neo-primitive and quite unlike other American or French portraits of its time. He also created a series of statues and statuettes of the female figure in which he showed an obsession with the idea of fecundity. Using distortion of nature freely, he achieved his purpose, a statue at once massively sculptural and emotionally expressive of womanliness; but his finely lithic portrait heads are held in greater esteem.

In the years between the death of Lachaise, in 1935, and 1950 the American studios seethed with sculptural experimentation, but no native sculptor grew to the stature of a Maillol or a Lehmbruck. Fortunate in attracting artists already successful in Europe—Lipchitz and Meštrović, Archipenko and Milles—Americans had yet to see any of their own sculptors rise to a position of world celebrity. All the following would certainly have been named in any list of the dozen most original and creative sculptors in what may be termed loosely the New York school: Alfeo Faggi, Polygnotos Vagis, José de Creeft (who was by exception a well-known artist when he arrived in America), Heinz Warneke, Oronzio Maldarelli, Ahron Ben Schmuel, Chaim Gross, Isamu Noguchi, Concetta Scaravaglione, and Robert Laurent. The national ori-

Head. **Stone. Gaston Lachaise.** *Roland P. Murdock Art Collection, Wichita Art Museum*

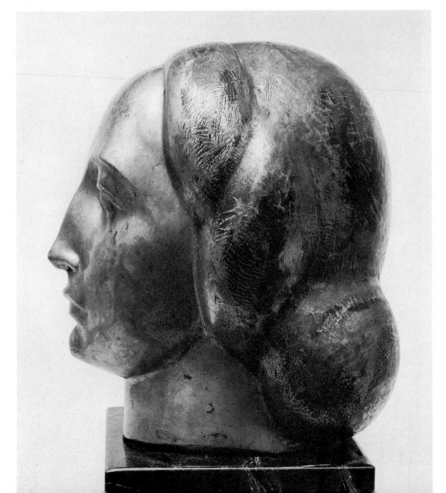

gins of this rather remarkable group, Italian, Greek, Spanish, German, Austrian, Japanese, and French, were hardly more varied than the types of experiment or style they practiced. The primitive integrity and solidity of Vagis, the sensitive lyricism, with a spiritual overtone, of Faggi, the essential stone feeling of Warneke's figures, and the overwhelming power of Ben Schmuel's compositions are all traits within the modern movement, though none perhaps could be identified as typifying America. Rather there is evidence of a new internationalism here.

Traditionalists in the group found in William Zorach (born in Lithuania) a leader who created a considerable body of advanced work and went on to aid his fellow artists by promoting government encouragement of the visual arts, writing, and lecturing to urge the younger men to practice direct carving in

stone and wood. His work and that of Maldarelli and de Creeft stayed generally within the movement that might be termed the first phase of twentieth-century modernism: the movement that brought about restoration of a stonelike massiveness as the basis of the art, and a need to work directly in the final material, a reaction to the almost universal nineteenth-century lapse into modeling.

José de Creeft was, in the *oeuvre* he created between 1930 and 1960, the surest in his creative touch. The two illustrations are representative of two phases of a widely varied output. The piece entitled *Cloud* is eloquent of all that has been said about return to the stone: a primitively compact and sculpturally alive creation. More on the sensitive side, but still notably blocklike, is the head in beaten lead over plaster, called *Himalaya*. Its expressionistic distortions are evident but not distracting.

The two men who carried the love of stone for its own sake to the ultimate conclusion were Polygnotos Vagis and John B. Flannagan. Both affirmed that the block of stone itself dictated the subject and the form of the sculptured piece. There is a boulder-like

St. Francis. Bronze.
Alfeo Faggi

Cloud. Stone. José de Creeft. 1939.
Whitney Museum of American Art, New York

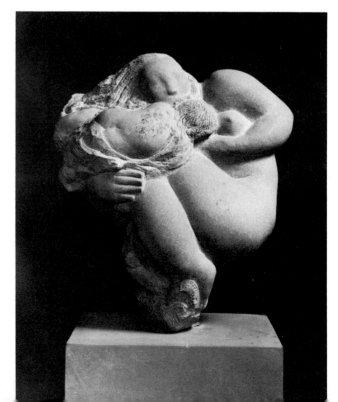

Himalaya. Beaten lead. De Creeft. 1942.
Whitney Museum of American Art, New York

aspect in many of Vagis's later compositions, though he patently draws upon a respect for for the dignity and worth of the human being —or animal. The two illustrations indicate two quite different ways in which the feel of stone is used: one almost a natural boulder, only slightly shaped; the other a completed composition but still rocklike and elemental.

The work of Flannagan, who was, like Lehmbruck, a suicide in a world often not kind to sculptors, has generally the immemorial lithic look, out of "the eternal nature of the stone itself," as he phrased it. His *Goat* is illustrated in the Introduction.

In the early 1960s the American sculptors were typical of the new internationalism, with the artists sharply divided into two groups: one within the historical tradition, the other branching out into fields hitherto unknown, such as the aerial sculpture invented by Alexander Calder; the forged or welded linear sculpture of a hundred "far-out" shapers of metal; compositions in strange materials, derivative from the Russian school of constructivists; the found-object or "junk" school; and so on into avenues of confusion so far distant from basic bulk-in-space art that the word "sculpture" hardly applies.

Revelation. Stone. Polygnotos Vagis. 1951.
Museum of Modern Art, New York,
Gift of Mr. and Mrs. John de Menil

Bear and Cub. Stone. Vagis.
(Courtesy of the artist)

An American within the historical tradition, one who came to the fore only in the early sixties, was Leonard Baskin. Obsessed by the negative and shameful aspects of man's progress through the ages, with an eye to death and the corruptions of the flesh, he at first alienated observers; but as his mastery of his materials and the sincerity and depth of his feeling became recognized he was accepted by a growing audience. There is, for instance, a figure entitled *The Great Dead Man,* which invites long and thoughtful scrutiny for its rigid, deathlike stillness and for a certain dignity and suggested repose of the spirit expressed in the face. In many other figures the bloated flesh is strangely at variance with the intellectual or aspiring look of the heads. The first illustration is a satirical interpretation of this theme, because we are apt to think that a poet should not be grossly fat. The large statue of Thomas Aquinas is outside the satirical group and can be read as a humanized portrait of a saint. It is at the same time a very fine sculptural composition.

Baskin spoke for a considerable group of

Head. Stone. John B. Flannagan.
Weyhe Gallery, New York

Poet Laureate. Bronze. Leonard Baskin. 1956.
Collection of Mr. and Mrs. Roy R. Neuberger.
(Courtesy Grace R. Borgenicht Gallery, New York)

modern artists. "Our human frame, our gutted mansion, our enveloping sack of beef and ash is yet a glory." And: "Man . . . has charted the earth and befouled the heavens more wantonly than ever before. He has made of Arden a landscape of death. In this garden I dwell, and . . . I hold the cracked mirror up to man. All previous art makes this course inevitable."

Baskin's course was not particularly American. Germaine Richier in France had worked in this pessimistic vein; and in England no phenomenon was more talked about than the "kitchen sink school" of painting and the Angry Young Men of the theater. England's young and revolutionary sculptors joined the effort to create a new and fuller image of

man, his tensions, frustrations, and sexual corruptions included. Foremost perhaps was Reg Butler, followed closely by Lynn Chadwick and (in a somewhat soberer vein) Kenneth Armitage. All are welders or forgers, and Butler and Chadwick first became known for metal figures on the abstract and somewhat spidery side, but progressed to greater bulk and solidity. In 1953 Butler won the historic international competition in which 2500 sculptors submitted models for a monument to the Unknown Political Prisoner. Superficially his model might be described as three incidental figures, a cagelike structure in the new metal technique, and a nonexistent prisoner.

St. Thomas Aquinas. Wood. Baskin.
St. John's Abbey, Collegeville, Minnesota.
(*Photo by Walter Rosenblum*)

Maquette for *The Unknown Political Prisoner.*
Bronze, wire, stone base. Reg Butler. 1952.
(*Courtesy of the artist*)

Horse and Rider. Bronze.
Marino Marini. 1947–48.
*Museum of Modern Art,
New York,
Lillie P. Bliss Bequest*

The most pleasing artist, revolutionary like these others, but holding to the historical tradition in the matter of sculptural volume—even with a touch of archaism—is Italy's foremost modern, Marino Marini. He is best known by a series of statues of horses, some with riders, a series that grew while the artist observed the bewildered animals and men under attack by bombers in wartime. Although not afraid of expressionistic distortion, he held to the general form of the beast and man. Without comment, without anger, the artist has made each piece in the series a reminder of mankind's as yet ineradicable penchant for war. Marini is known, too, as a portraitist, in which field he is hardly surpassed.

Late in the 1950s Alberto Giacometti emerged as the most popular sculptor of the School of Paris. He had been born a Swiss and had received his early training in Switzerland. In 1922 he went to Paris to study, and survived association with the surrealists, then the constructivists. In the 1940s he developed a sheerly original style of expressionistic image-making and produced ever more attenuated figures, remote from reality. His method approaches caricature, but the sensitivity of his touch ensures a spiritual completeness for each image; for Giacometti first of all reveals imaginative aspects of life in sculptural terms. The *Large Head* illustrated is at a peak of modern expressionistic modeling. The *Man Pointing* is typical of the many utterly slenderized pieces which have done most to win the artist international recognition.

The School of Paris, the world's most influential producer of revolutionary painting, had few French members among internationally known sculptors after Bourdelle, Maillol, and Despiau. Raymond Duchamp-Villon created a few monuments within the idiom of cubism, but he died at the early age of forty-two during World War I. Some of the painters of the School of Paris also left notable sculptural

Head. Stone. Amedeo Modigliani.
Victoria and Albert Museum

On facing page:
Left: *Large Head.* Bronze. Alberto Giacometti.
1960. *The Phillips Collection, Washington*

Right: *Man Pointing.* Bronze. Giacometti. 1947.
Museum of Modern Art, New York,
Gift of Abby Aldrich Rockefeller

works. Matisse produced some small figures obviously influenced by Rodin; later he reverted to modeling, but his sculpture does not compare with his magnificent decorative paintings. Modigliani also practiced sculpture for a time but was forced to give up the art because of the effect of stone dust upon his lungs. His sculptural works, cut directly in stone, are solidly blocklike, with an individual, expressionistic deformation of nature. But again there is very little to compare with the artist's strangely appealing paintings. The little bronze figures from Renoir's clay studies are intriguing, but possibly the artist only indicated their form and substance, since a cooperating professional modeler put them into final shape. Gauguin carved in wood a very few compositions, but his mastery of the medium was evident and the several pieces are very appealing.

Pablo Picasso took over the leadership of the School of Paris when the fauvist Matisse did not embrace cubism, and there were critics who in the early 1960s termed him the greatest living sculptor. But his *oeuvre* is so scattered—clay, wax, plaster, wood, tin, iron; old-fashioned modeling, cubism, constructions, pottery—that he can hardly be said to have found a style or to have affected the world current of sculpture. In most pieces there is a formal aliveness, and occasionally there is a creative and satisfying attainment, but there are also willful perversities and lapses of taste. Beside Moore, Picasso seems hardly more than a dabbler in sculpture; beside Lehmbruck he seems insensitive. Yet his diverse sculptures are part of a stupendous personal achievement in the arts, and of an unprecedented triumph.

Practically all the artists whose work has been described so far in this brief outline of twentieth-century modernism remained within the tradition of massive sculpture. That tradition has lasted for at least 30,000 years, and its essential appeal and its variations form substantially the history of the art. In the present era there are many kinds of so-called sculpture that negate massiveness,

that began as offshoots of the tree of sculptural creation but pushed so far into new expression and new appeal that they are still experimental. The labels given them, "mobiles," "constructions," "found objects," indicate the directions of experiment and a certain withdrawal from tradition.

The most noted innovator was Alexander Calder, an American. Born in 1898, son of a respected traditional sculptor, he was educated in engineering, then painting. Before 1930 he was known in America and in France for his wire compositions. The virtues of these pieces were novelty, humor, and not a little sound sculptural artistry. From near-abstract works in wire—a famous one, dated 1931, was entitled *Kiki's Nose*—he went on to his most characteristic and inventive constructions, the mobiles. They are hanging contrivances of heavy wire rods supporting complexes of metal stems terminating in sheet-metal leaves, the whole adjusted and weighted so that the slightest movement of air keeps the several parts in gentle motion. There is a fascination in the drift and flow of the terminal elements, a pattern of motion foreseen by the artist which clearly brings the invention into the realm of art. (See page 477.)

It is, of course, the element of movement that marks this as a new departure. Repose, stillness, has been a basic quality of historic sculpture. Calder's mobiles have inspired many kinds of moving constructions, some with clockwork agitators, some powered with electric motors; and soon, no doubt there will be contrivances kept in motion by atomic energy.

Calder has had international influence. The United States, England, France, and Japan are but four countries where younger artists have become his disciples, and where mobiles are constructed and give pleasure. George Rickey was born in America but educated in Scotland and England in his formative years, and he most successfully widened the scope of mobile or kinetic composition. He explained the basis of the new art in these words in 1961: "I study the motions which

Nature's laws permit. . . . I embody this aspect of Nature in freely composed 'kinetic' sculptures. The designs behave like machines but echo and suggest living forms. The forces which come to bear and the shapes and movements they engender do not imitate Nature. But their performance is analogous to organic life and may appear to be associated with it."

Another nontraditional activity was carried on by the constructivists from about 1917. They looked forward to an art purified of natural appearances and material representation, an art of new or overlooked materials such as glass, celluloid, the plastics, and the new metals. Their constructions generally had a light and airy look. Although they pursued a kinetic or dynamic ideal, they early dropped the element of movement from their contrivances. They spoke against sculpture's obsession with volume; but their leaders, most notably Antoine Pevsner and Naum Gabo, fell back at times into creation of substantial if not bulky compositions, even to Arp-like concretions or figures futuristically assembled. These two artists, both Russian, through their airy improvised abstractions have exercised a wide influence in many lands. (See page 506.)

An individual vision and a strict adherence to a single constructivist principle were characteristic of an American, Richard Lippold. His hanging constructions, complex and dependent upon precise mathematical calculation, are of wires or rods in pleasing formation and gleaming with light.

One path of modern experiment led to what is called "assemblages," or sometimes "found objects." Artists discovered in some picked-up object a quality or attribute which could be used to form part of a sculpture, such as a rusted pitchfork or a bent automobile fender, a detached mannequin's leg or a seashell. The inventive artist could build on this beginning a structure or medley of harmonious objects. Most exhibitions of assemblages show the bizarre, the quaint, and the amazing aspects of creation. Certainly no great sculptor became known primarily through association with the movement. But

Variation within a Sphere, No. 10: The Sun.
Gold-filled wire. Richard Lippold. 1953–56.
Metropolitan Museum of Art, Fletcher Fund

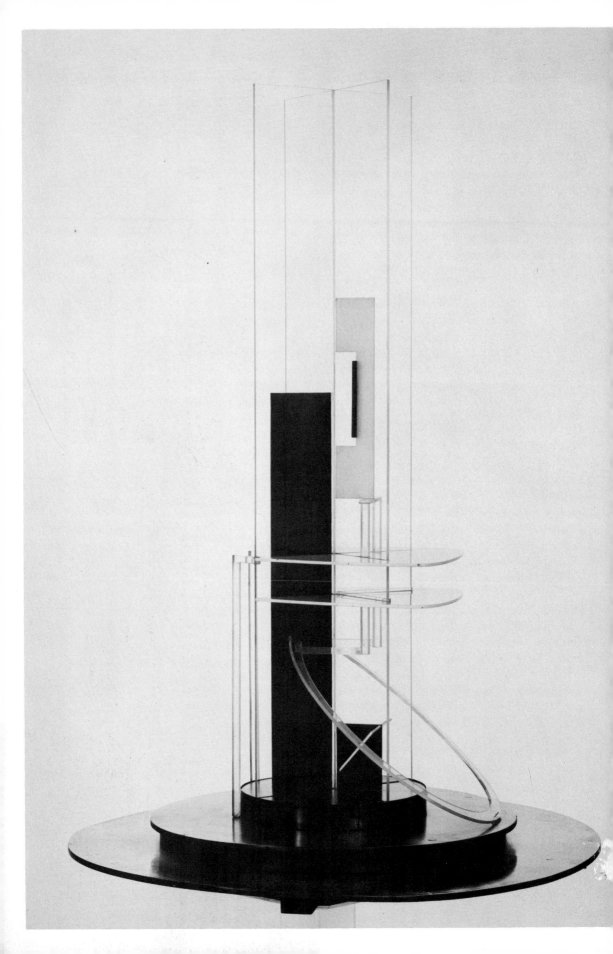

the activity was connected with that of the constructivists and with that of the new school of metal welders.

It is the welders, among modern groups, who bring us back to true sculpture, to an attenuated but creative metal composition. The tools are new—especially the acetylene torch—but the aims are those of plastic artists down the ages. A retreat from stone and wood was inevitable with the coming of the Space Age. Metals, in the form of machines, surround the human being in everyday life. Metals, no less, condition the consciousness (or the subconscious) of man. To the contemporary artists the accessibility of metals has been a challenge.

It is remarkable how much of the achievement of the modern school of direct workers in metal was foreshadowed in the *oeuvre* of Julio Gonzalez, the Spanish Parisian who died in 1942. His exceptionally voluminous *Montserrat* is illustrated in the Introduction. It is a work in sheet iron, composed as a monument to human dignity and defiance in face of the atrocities of the Spanish Civil War. But he was as skilled as any of the later welders or forgers in the more linear and tenuous style that is most practiced today.

The Danish artist Robert Jacobsen has become internationally known for his originality, as shown in works which combine sturdiness with grace. The English practitioners, especially Reg Butler, Eduardo Paolozzi, and Lynn Chadwick, have added individualistic contributions within the style. The Americans have shown striking imagination: David Smith with his signlike and totem-like standards raised against the sky; David Hare; Mary Callery with her distinctive, rhythmic, continuous figures; Herbert Ferber; Ibram Lassaw, who was preeminent in elaboration of the metal structure and in color; Theodore Roszak, inventor of strange metal-inspired flowers and stranger birds; Seymour Lipton, somewhat simpler in vision and more a purist—all these are in the full tide of a sculptural art unlike any other in history since the Renaissance.

Column. Glass, plastic, metal, and wood. Naum Gabo. 1923. *The Solomon R. Guggenheim Museum, New York*

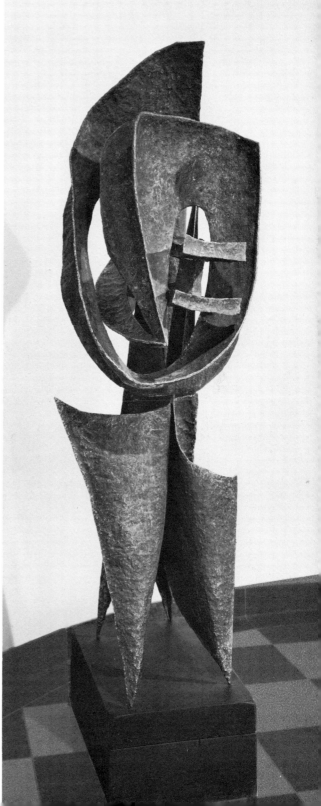

Ancestor. Nickel-silver on monel metal. Seymour Lipton. 1958. Height: 87 inches. *The Phillips Collection, Washington*

It may be that modern sculpture, like modern architecture, is as yet in its primitive stage. After the pale sweetness of the neoclassic age, and the ensuing degeneration of routine sculpture into a marvelously true but uncreative naturalism, a new start, embodying a return to the primitive virtues, was necessary. So far the world has seen, in post-impressionism or expressionism—which is the main movement of the twentieth

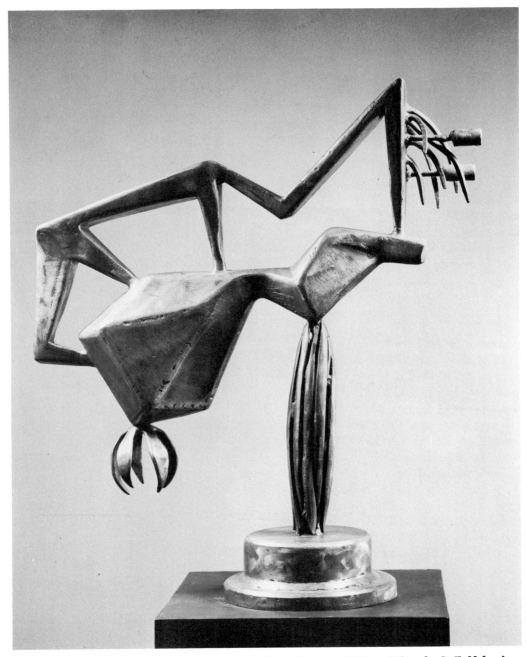

Insect. Burnished steel. David Smith. 1948. *Marlborough-Gerson Gallery. (Photo by O. E. Nelson)*

Menand VII. Painted steel. David Smith. 1963. *Marlborough-Gerson Gallery*

Sitting Figure VI. Bronze. Lynn Chadwick. 1962. *Marlborough-Gerson Gallery.* (Photo by O. E. Nelson)

century—chiefly the impulsive, powerful beginnings. Only a rare artist such as Lehmbruck or Moore has been able to add sensitivity to basic sculptural grandeur, an effective personal emotion to architectonic form-organization. But Gonzalez and his followers have afforded glimpses into new and exciting areas of invention.

The workers in metal have been leaders in the twentieth-century march toward abstraction. Many had their early training under the realistic modelers of 1900–1930. Fritz Wotruba, an Austrian artist, born in 1907, began with fully figurative modeled sculpture, then made an international reputation with heavy stonecut pieces. His style was born of vigor and consciousness of the block. But in mid-career, without ever quite forgetting the human form, he declared for an image nearer the abstract and, as he thought, nearer the essence of sculpture. One of his late pieces, in metal, is, perhaps appropriately, placed on this final page of a history of the art. On page 508 is an *Insect* by David Smith, also leaning to the abstract, but also reminiscent of a "real" subject. A different sort of achievement is seen in Lynn Chadwick's *Sitting Figure*.

If today there are more creative sculptors at work in the world than ever before—the idea is defensible—it is partly because a multitude of only partially recognized experimenters, not yet ready for history, exists in the background. The object-makers, the stringers of wires, the constructors of monumental box forms, the builders of shaped walls, the adventurers in moving sculpture: these all contribute to an atmosphere of unbounded invention and creation. Among the obscure workers are doubtless geniuses who will be part of tomorrow's history. At the moment it seems fairer to end with the creations of Lipton and Gabo, Smith, Chadwick, and Wotruba. Explorers and adventurers in their day, they now seem to be safely within history.

Reclining Figure. Bronze. Fritz Wotruba. 1960. *Marlborough-Gerson Gallery*. (*Photo by O. E. Nelson*)

For Further Reading

Acknowledgments

Index

PHOTOGRAPHS FOLLOWING THE TEXT

For Further Reading heading:
Interior wall of tomb, bas-relief, detail. Stone. Dynasty VI. Sakkara. *Cairo Museum*

Acknowledgments heading:
Dionysus, Pan, and a Bacchante. Relief, stone. Greco-Roman. *National Museum, Naples. (Alinari photo)*

Index heading:
Ceremonial corn grinder, detail. Stone. Panama. *American Museum of Natural History.*
Text reference on pages 439–40

For Further Reading

Beyond the usual bare listing of title, author, place of publication, and date, I have added brief notes of three kinds: 1) indicating the number of illustrations, because pictures add so greatly to enjoyment in this field; 2) indicating which books are paperbacks and therefore less expensive; 3) inserting occasionally the name of publisher or series—as "Phaidon monograph" or "Pelican History of Art"—as indication of excellence. Infrequently a title fails to identify the civilizations under discussion; I have then added a few words indicating coverage. Only books in English are listed.

PERIODS, PEOPLES, STYLES

Prehistoric and Primitive Man, by Andreas Lommel. (Landmarks of the World's Art series; 210 illustrations.) London, New York, and Toronto, 1966.

Prehistoric Art, by T. G. E. Powell. (263 illustrations; paperback.) London and New York, 1966.

Prehistoric Art: Paleolithic Painting and Sculpture, by P. M. Grand. (Pallas Library of Art series; 115 illustrations; de luxe format.) Greenwich, Connecticut, 1967.

The Art of the Cave Dweller: A Study of the Earliest Artistic Activities of Man, by G. Baldwin Brown. (166 illustrations.) London, 1928.

In the Beginnings: Early Man and His Gods, by H. R. Hays. (Worldwide coverage; 116 illustrations, maps.) New York and Toronto, 1963.

The Dawn of Civilization: Human Cultures in Early Times, edited by Stuart Piggott, with essays by thirteen authorities. (Covers prehistoric arts and earliest cultures in Asia, Europe, Egypt, the Americas; de luxe format; 940 illustrations.) London, New York, and Toronto, 1961.

Egyptian Art, by Werner and Bedrich Forman and Milada Vilimkova. (118 large plates.) London, 1962.

The Art of Ancient Egypt. (A Phaidon monograph; brief text, 341 illustrations.) Vienna, London, and New York, 1936; London and Toronto, 1937.

Eternal Egypt, by Pierre Montet, translated by Doreen Weightman. (110 photographic illustrations, textcuts, maps.) London, 1964; New York, 1965.

The Art and Architecture of Ancient Egypt, by W. Stevenson Smith. (Pelican History of Art; 308 photographic illustrations, textcuts.) Harmondsworth and Baltimore, 1958.

The Ancient World, by Giovanni Garbini. (Landmarks of the World's Art series; 227 illustrations; covers Mesopotamian, Egyptian, and early Persian civilizations.) New York and Toronto, 1966.

The Art and Architecture of the Ancient Orient, by Henri Frankfort. (Pelican History of Art; covers Mesopotamian, Hittite, and early Persian sculpture; 192 photographic plates, 117 textcuts.) Harmondsworth and Baltimore, 1954–55.

Mesopotamia and the Middle East, by Leonard Woolley. (60 photographic illustrations, 73 text figures.) London, 1961.

Cylinder Seals of Western Asia, by D. J. Wiseman, with photographs by W. and B. Forman. (118 plates showing each seal in actual size and greatly enlarged; covers British Museum collection only.) London, n.d., recent.

Scythian Art, by Gregory Borovka. (74 plates.) London and New York, 1928.

Scythians and Greeks, by Ellis H. Minns. (9 plates, 351 textcuts.) Cambridge, England, 1913.

Art of the Steppes, by Karl Jettmar. (Art of the World series; 195 illustrations.) New York, 1967.

Four Thousand Years Ago: A World Panorama of Life in the Second Millennium B.C., by Geoffrey Bibby. (38 photographic illustrations, textcuts, maps.) London and New York, 1962.

The Classical World, by Donald E. Strong. (Landmarks of the World's Art series; 220 illustrations.) London, New York, and Toronto, 1965.

Greek Art, by John Boardman. (251 illustrations.) London and New York, 1964.

The Civilization of Greece, by François Chamoux. (229 illustrations, maps.) London and New York, 1965.

The Art of Classical Greece, by Karl Schefold. (120 photographic illustrations, 77 textcuts.) London and New York, 1967.

Etruscan Sculpture, by Ludwig Goldscheider. (Phaidon monograph; brief text, 169 illustrations.) London and New York, 1941.

Etruscan Art, A Study, by Raymond Bloch. (101 illustrations; de luxe format.) London, 1959.

The Etruscans, by M. Pallottino, translated from the Italian by J. Cremona. (51 illustrations; paperback.) Harmondsworth and Baltimore, 1955.

The Art of the Romans, by J. M. C. Toynbee. (Ancient Peoples and Places series; 90 illustrations.) London and New York, 1965.

Roman Portraits. (Phaidon monograph; brief text, 135 illustrations.) London and New York, n.d.

Ancient Iran: The Art of Pre-Islamic Times, by Edith Perada. (60 photographic plates, 125 textcuts.) London, 1963.

Masterpieces of Persian Art, by Arthur Upham Pope. (206 illustrations.) New York, 1945.

The Heritage of Persia, by Richard N. Frye. (126 illustrations, maps.) London, Cleveland, and New York, 1963.

The World of Islam, by Ernest J. Grube. (Landmarks of the World's Art series; 211 illustrations.) London, New York, and Toronto, 1966.

Art of China, Korea, and Japan, by Peter C. Swann. (261 illustrations.) London and New York, 1963.

A History of Far Eastern Art, by Sherman E. Lee. (Covers India and Southeast Asia, China, Japan; de luxe format; 716 illustrations.) New York, 1964.

Chinese Monumental Art, by Peter C. Swann, with photographs by Claude Arthaud and François Hébert-Stevens. (157 plates, maps; de luxe format.) London and New York, 1963.

Pageant of Japanese Art: Sculpture, edited by staff members of the Tokyo National Museum. (Popular edition; boards, 119 illustrations.) Tokyo and Rutland, Vermont, 1958. (There is a de luxe edition, Tokyo, 1954.)

The Enduring Art of Japan, by Langdon Warner. (92 illustrations; paperback.) New York and Toronto, 1952.

Sculpture of Japan, from the Fifth to the Fifteenth Century, by William Watson. (129 illustrations.) London and New York, 1929.

The Craft of the Japanese Sculptor, by Langdon Warner. (89 illustrations.) New York, 1936.

Handbook of Japanese Art, by Noritake Tsuda. (355 illustrations.) Tokyo, New York, and Toronto, 1936.

The Art of India: Traditions of Indian Sculpture, Painting and Architecture, by Stella Kramrisch. (196 illustrations.) London, 1955.

The Art and Architecture of India: Buddhist, Hindu, Jain, by Benjamin Rowland. (Pelican History of Art; 289 photographic illustrations, textcuts.) Harmondsworth and Baltimore, 1953.

Indian Sculpture: Masterpieces of Indian, Khmer and Cham Art, photographs by W. and B. Forman, text by M. M. Deneck. (Almost exclusively a picture book, 264 illustrations.) London, 1962.

The Art of Nepal, by Stella Kramrisch. (Catalogue of an exhibition at Asia House, New York; 127 illustrations.) New York, 1964.

The Culture of South-East Asia: The Heritage of India, by Reginald Le May. (215 illustrations, maps.) London, 1954.

A Concise History of Buddhist Art in Siam, by Reginald Le May. (206 illustrations, maps.) Cambridge, England, and New York, 1938.

The Art of Thailand: A Handbook of the Architecture, Sculpture and Painting of Thailand (Siam), and a Catalogue of the Exhibition in the United States in 1960–61–62. Includes "The Art and Sculpture of Siam," by A. B. Griswold. (163 illustrations; paperback.) Published by 9 American Museums under direction of Indiana University Art Museum, Bloomington, 1960.

Byzantine Art, by D. Talbot Rice. (Revised edition, paperback; 80 photographic illustrations, textcuts, maps.) London, Melbourne, and Baltimore, 1954.

Byzantine Aesthetics, by Gervase Mathew. (25 illustrations.) London and New York, 1963–1964.

Arts of the Migration Period in the Walters Art Gallery: Hunnish, Gothic, Ostrogothic, Frankish, Burgundian, Langobard, Visigothic, Avaric, Irish and Viking, by Marvin Chauncey Ross. (61 illustrations.) Baltimore, 1961.

Early German Art and Its Origins, from the Beginnings to about 1050, by Harold Picton. (Covers Germanic "barbarian" sculpture in and out of Germany; 101 plates bearing 434 illustrations.) London, 1939.

Pattern and Purpose: A Survey of Early Celtic Art in Britain, by Sir Cyril Fox. (81 plates, textcuts.) Cardiff, 1958.

Irish Art in the Early Christian Period to 800 A.D., by Françoise Henry. (160 illustrations.) London, 1963; Ithaca, New York, 1965.

Viking Art, by David M. Wilson and Ole Klindt-Jensen. (80 plates, 69 textcuts.) London, 1963; Ithaca, New York, 1966.

Romanesque Sculpture, by Hans Weigert, edited by Harald Busch and Bernd Lohse. (181 plates.) London, 1962.

French Sculpture of the Romanesque Period: Eleventh and Twelfth Centuries, by Paul Deschamps. (96 plates.) Florence and New York, 1930.

European Sculpture from Romanesque to Neoclassic, by H. D. Molesworth and P. Cannon Brookes. (276 illustrations; paperback.) London and New York, 1965.

Architecture and Sculpture in Early Britain: Celtic, Saxon, Norman, by Robert Stoll, with photographs by Jean Roubier. (254 illus-trations.) London and New York, 1967.

Sculpture in England in the Middle Ages, by Lawrence Stone. (Pelican History of Art; 305 photographic illustrations.) Harmondsworth and Baltimore, 1955.

English Sculpture of the Twelfth Century, by F. Saxl. (100 plates, 50 textcuts.) London, 1954.

Gothic Art from the 12th to the 15th Centuries, by Andrew Martindale. (207 illustrations.) London and New York, 1967.

Gothic Sculpture, by Hans Weigert, edited by Harald Busch and Bernd Lohse. (201 plates, minimum text.) London and New York, 1963.

Gothic Sculpture: The Intimate Carvings, by Max H. von Freeden. (35 large plates.) London, 1962; New York, 1963.

Sculpture in the Netherlands, Germany, France and Spain, 1400 to 1500, by Theodor Müller. (Pelican History of Art; 192 illustrations.) Harmondsworth and Baltimore, 1966.

Renaissance Sculpture, by Hans Weigert, edited by Harald Busch and Bernd Lohse. (225 illustrations, minimum text.) London and New York, 1964.

Larousse Encyclopedia of Renaissance and Baroque Art, edited by René Huyghe. (Arts and Mankind series; 1211 illustrations.) New York, 1964.

Man and the Renaissance, by Andrew Martindale. (Landmarks of the World's Art series; .204 illustrations.) London, New York, and Toronto, 1966.

Primitive Art: Its Traditions and Styles, by Paul S. Wingert. (Covers Oceanic, African tribal, and Amerindian sculpture; 126 illustrations.) London and New York, 1962.

Polynesian Art, by Edward Dodd. (341 illustrations.) New York, 1967.

Oceanic Sculpture: Sculpture of Melanesia, by Carl A. Schmitz, photographed by F. L. Kenett. (35 large plates; de luxe format.) Greenwich, Connecticut, 1962.

Tribes and Forms in African Art, by William Fagg. (122 large plates.) London and New York, 1965.

African Sculpture: An Anthology, by William Fagg and Margaret Plass. (176 illustrations.) London and New York, 1964.

The Sculpture of Africa, by Eliot Elisofon, with text by William Fagg. (405 exceptional photographs.) London and New York, 1958.

Indian Art in America, by Frederick J. Dock-

stader. (250 illustrations.) London, New York, and Toronto, 1961.

North American Indian Art, by Erna Siebert and Werner Forman. (Covers Northwest Coast sculpture only, in two little-known collections in Leningrad and Moscow; 107 extraordinarily fine plates in color, 35 black-and-white illustrations.) London, 1967.

North American Indian Mythology, by Cottie Burland. (176 illustrations.) London, 1965.

Art before Columbus: The Art of Ancient Mexico—from the Archaic Villages of the Second Millennium B.C. *to the Splendor of the Aztecs,* by André Emmerich, with photographs by Lee Boltin. (172 illustrations, maps.) New York, 1963.

Mediaeval American Art: A Survey, by Pal Kelemen. (2 volumes, 306 plates, bearing 980 illustrations.) New York, 1946. (Popular reprint, 1 volume, New York, 1956.)

The Ancient Maya, by Sylvanus Griswold Morley, revised by George W. Brainerd. (226 photographic illustrations, textcuts, maps.) Stanford, California, 1963.

Ancient Arts of the Andes, by Wendell C. Bennett. (Museum of Modern Art monograph; 209 illustrations, maps.) New York, 1954.

Baroque Sculpture, by Werner Hager and Eva-Maria Wagner, edited by Harald Busch and Bernd Lohse. (216 illustrations, minimum text.) New York, 1965.

Larousse Encyclopedia of Modern Art, from 1800 to the Present Day, edited by René Huyghe. (Covers from 18th century neo-classicism through romanticism and realism to 20th century experimental modernism; 1228 illustrations.) London and New York, 1965.

A Concise History of Modern Sculpture, by Herbert Read. (339 illustrations; paperback.) London, New York, and Toronto, 1964.

The Sculpture of this Century, by Michel Seuphor. (414 illustrations.) Neuchâtel, Switzerland, 1959; London and New York, 1960.

Modern Sculpture: Origins and Evolution, by Jean Selz. (233 illustrations.) London and New York, 1963.

Form and Space: Sculpture of the Twentieth Century, by Eduard Trier. (213 illustrations.) London and New York, 1961–62.

Modern English Sculpture, by A. M. Hammacher. (128 illustrations; de luxe format.) London, 1967.

MONOGRAPHS: INDIVIDUAL ARTISTS

Donatello. (Phaidon monograph; 319 illustrations.) London and New York, 1941.

The Sculptures of Michelangelo. (Phaidon monograph; 200 illustrations.) London and New York, 1940.

The Art and Thought of Michelangelo, by Charles de Tolnay. (48 plates.) New York and Toronto, 1964.

Rodin, by Albert E. Elsen. (Museum of Modern Art monograph; 161 illustrations.) New York, 1963.

Auguste Rodin, by Robert Descharnes and Jean-François Chabrun. (388 illustrations; de luxe format.) London, New York, and Toronto, 1967.

Maillol, by John Rewald. (Hyperion Press monograph; 165 illustrations.) London, Paris, and New York, 1939.

Constantin Brancusi, by Carola Giedion-Welcker. (157 illustrations.) New York and London, 1959.

Alexander Calder, by James Johnson Sweeney. (Museum of Modern Art monograph; 56 illustrations; paperback.) New York, 1943.

Jacob Epstein, Sculptor, by Richard Buckle. (667 illustrations.) London, 1963.

The Art of Henry Moore, by Will Grohmann. (239 illustrations.) London, 1960.

Henry Moore: A Study of His Life and Work, by Herbert Read. (245 illustrations; paperback.) London, 1965; New York, 1966.

Gonzalez, by Leon Degand. (Universe Sculpture Series; paperback; 32 illustrations.) London, New York, and Toronto, 1959.

The Sculpture of Picasso, by Roland Penrose. (Sumptuous paperback; Museum of Modern Art monograph; 284 illustrations.) New York, 1967.

Ivan Meštrović: Sculptor and Patriot, by Laurence Schmeckebier. (201 illustrations.) Syracuse, New York, 1959.

Arp, edited by James Thrall Soby. (Museum of Modern Art monograph; 117 illustrations.) New York and Toronto, 1958.

The Sculpture of Jacques Lipchitz, by Henry R. Hope. (Museum of Modern Art monograph; 102 illustrations; boards.) New York and Toronto, 1954.

Alberto Giacometti, with an introduction by Peter Selz. (Museum of Modern Art monograph; 112 illustrations.) New York, 1965.

GENERAL

About these books of theory, historical background, and reference, I am adding a few words of evaluation, for guidance of the reader who may be unfamiliar with the literature of the subject.

The Art of Sculpture, by Herbert Read. (225 illustrations.) New York, 2nd edition, 1961. This is the number-one book on the theory of sculpture. Well chosen illustrations from many cultures, primitive and Oriental as well as European. Comprehensive, sound, modern.

The Observer's Book of Sculpture, by William Gaunt. (Boards; 64 illustrations.) London and New York, 1966. Of the histories of sculpture in English, this very small volume—128 pages of text, in miniature pocket size—is outstanding. The illustrations, so far as they go, are well chosen, though the Far East is poorly represented; there are no illustrations from China and Japan. Readable, modern.

Henry Moore on Sculpture: A Collection of the Sculptor's Writings and Spoken Words, edited by Philip James. (128 illustrations.) London and New York, 1967. The best book by a sculptor about sculpture. The illustrations include, beside Moore's own works, outstanding examples from many periods. A revealing human story, combined with more wisdom about the art than can be found in any other volume.

The Metamorphosis of the Gods, by André Malraux. (184 illustrations.) London, New York, and Toronto, 1960. A trip through history with the sculptured gods. Perceptive, stimulating.

The Concise Encyclopedia of Archaeology, edited by Leonard Cottrell. (Text by 48 eminent scholars; 166 illustrations, maps.) London, New York, and Toronto, 1960. A very useful, though incomplete, one-volume reference work.

Artists on Art, from the XIV to the XX Century, compiled and edited by Robert Goldwater and Marco Treves. (100 illustrations.) New York, 1945; London, 1947. An anthology devoted mainly to painters, but including statements about their art by many sculptors. Convenient collection of first-hand theories.

Dictionary of Modern Sculpture, edited by Robert Maillard. (453 illustrations.) New York, 1962. Remarkable coverage of 412 sculptors, alphabetically from Achiam to Zwobada, in time from Rodin and Hildebrand to the latest experimenters in metal contrivances.

Encyclopedia of World Art, 15 volumes, New York, 1959–1968. Generally excellent coverage of all art topics, with thousands of illustrations. The standard reference work; but awkward to use because plates are banked at the end of each volume, away from the text entries. Authoritative, modern, comprehensive.

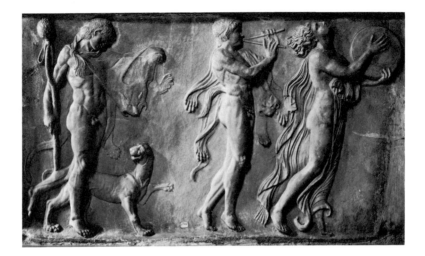

Acknowledgments

In this book the names of museums and of photographers are included in the captions with the pictures. Therefore the usually appended lists of owners and of photograph-sources are omitted. Instead I have set down notes about individuals who have helped me in my search for illustrations, and about certain museums that have responded with exceptional generosity. Added are acknowledgments to international institutions and to archives, in cases where names could not, for reasons of space, appear in the captions.

Over a period of twenty years I received friendly help from a number of internationally known archaeologists and anthropologists. The first was the late Dr. George C. Vaillant, Director of the University Museum in Philadelphia and an honorary Curator at the American Museum of Natural History in New York. He had written a pioneer book, *Indian Arts in North America*. Interested because I was planning to afford primitive sculpture full coverage in a world history of the art, he contrived that I should have free access to the photographs from which his volume had been illustrated. At the Musée Guimet in Paris I had the good fortune to obtain the cooperation of Jeannine Auboyer, Curator of the National Museums and a distinguished scholar in the field of Asian arts. To her and to the staff at the Musée Guimet I owe a debt beyond estima-

tion, for the many photographs made from the museum's negatives. Similar gratitude must go to the American scholars Arthur Upham Pope and Phyllis Ackerman. When they mounted in 1940 the extraordinary Exhibition of Persian Art for the Iranian Institute in New York, I was able to obtain from their negatives many photographs of important Persian sculptures which until then had been little known. In addition to the illustrations of objects in museums and private collections, it will be noted that there are two Islamic subjects from photographs taken by Dr. Pope in Persia.

At the Metropolitan Museum of Art in New York I enjoyed the friendship and aid of the late Francis Henry Taylor, then director. My gratitude also goes to Alan Priest, Curator of the Department of Far Eastern Art. Richard E. Fuller, Director of the Seattle Museum of Art, noted collector of Far Eastern sculpture, has been particularly helpful. At the Philadelphia Museum of Art, Stella Kramrisch, Curator of Indian Art and author of the Phaidon monograph *The Art of India through the Ages,* has answered my queries patiently and graciously. To these individual specialists I record my thanks. I hasten to add that not one of them is responsible for any opinion expressed in my text.

My debt to one other scholar is unique. Dr.

Reginald Le May of Tunbridge Wells has permitted me to reproduce in my book photographs of Siamese and Cambodian works in his unrivaled collection of Southeast Asian sculpture. From his friendly letters and from the books he has written—see my list "For Further Reading" —I gained in knowledge and enjoyment of the arts of "Further India." Thanks are due to several other collectors: to Baron Eduard von der Heydt of Ascona, Switzerland, for information about his collection and for photographs; to Dagny Carter, who provided photographs of outstanding pieces in her collection of Ordos bronzes; to Mr. and Mrs. Harry Lewis Winston for the photograph of Rosso's *Ecce Puer;* to Mr. and Mrs. Edward M. M. Warburg for the photograph of their spirited Luristan *Leaping Lion;* and to John P. Anderson for the photograph of the Warega ritual figure in his collection. A long, long time ago I was permitted by Adolph Stoclet to see the extraordinary collection of Chinese sculpture in his home at Brussels. Recently his daughter, Mme. L. Feron-Stoclet, has provided two photographs of objects in the collection for reproduction in this book. Asia House in New York, under the enlightened direction of Gordon B. Washburn, has let me have certain photographs otherwise unavailable.

Because I started my search for illustrations in the troubled days following World War II, special problems arose in connection with the photographs needed for the chapter on Japanese and Korean sculpture. In Japan the Kokusai Bunka Shinkokai or Society for International Cultural Relations cooperated by having twenty-one subjects specially photographed. More than one-half of the chapter's illustrations are from that group, and I am grateful to the society and to its Managing Director, Kikuji Yonezawa, for this friendly service. I must record my thanks also to Chewon Kim, Director of the National Museum of Korea at Seoul, for forwarding photographs and answering questions at a difficult time.

More than a score of photographs of sculpture at various sites in Germany, or in lesser-known museums there, were provided by the Archiv für Kunst und Geschichte in Berlin. I am grateful to the Director, Dr. Wilfried Göpel, and to Miss Marie L. Gericke of the German Information Office in New York, who acted as intermediary.

Over the years I have enjoyed a friendly relationship with many gallery owners, from Paris and London to New York and San Francisco. For aid in gathering the pictures for this book I am especially indebted to André Emmerich, a noted writer as well as dealer. Photographs of objects seen first at his gallery in New York will be found especially in the Primitive and Amerindian chapters. An equal debt is owing to Pierre Matisse, who has traced down a number of photographs in the modern field as well as a wanted African figure. Thanks are due also to M. Knoedler and Company, to Bertha Schaefer, and to Klaus Perls, all proprietors of galleries in New York. By a coincidence four of the final five illustrations are from photographs from the files of the Marlborough-Gerson Gallery in New York or their London affiliate, Marlborough Fine Art, Ltd. Thanks are owing also to the Grace Borgenicht Gallery in New York for illustrations; to Spink and Son in London; and to Louis Carré in Paris. That prince of dealers, C. T. Loo, from his treasure-house galleries in Paris and New York, was consistently friendly and helpful.

In a few cases the photographs have come directly from the artists. Among American sculptors, Gaston Lachaise and Polygnotos Vagis especially were friends and helped with prints. I have had friendly response from artists abroad when writing to request photographs. Particularly gracious were two English sculptors, Henry Moore and Reg Butler. Mrs. Olga Meštrović kindly provided the photograph of the *Head of St. Christopher* by Ivan Meštrović.

Although the names of photographers (in general) appear in the captions, it would be less than courteous to omit acknowledgment of indebtedness to certain ones here. Perhaps the best-known "artist-photographer" in the field of sculpture is Jean Roubier of Paris. He gave me freely of his specialized knowledge when I was in Europe gathering illustrations some years ago. In this country the extraordinarily fine photographs of Lee Boltin have put us all in his debt. It is likely that his contribution to this book is greater than the captions indicate, since he has photographed extensively for the American Museum of Natural History, which issues its prints without photographer-identification. Elisabeth Z. Kelemen was good enough to send me two prints of Mayan and Aztec subjects from negatives made for her husband's book, *Mediaeval American Art.* Claude Arthaud and François Hébert-Stevens kindly provided prints of two subjects photographed for

their sumptuous volume *Chinese Monumental Art* (with text by Peter C. Swann). The thanks here should go also to the original publisher, B. Arthaud of Paris, and to Thames and Hudson of London, first publishers of the translation into English. In a few cases the names of noted photographers have not been placed in the captions because the material supplied by the museums omitted them. Occasionally space limitations—especially in cases of group illustrations: of seals, medals, coins, etc.—determined that photographic credits should be withheld. A special word of thanks should go to Soichi Sunami, who has photographed so many sculptural exhibits at the Museum of Modern Art in New York. I am grateful also to George W. Bailey of New Hope, who has done skilled work in rephotographing borrowed prints, printing from old negatives, and so forth, besides contributing one original photograph to the book. I owe an inestimable debt to the Department of Photography and Slides at Princeton University, which provided a score of illustrations.

A very few illustrations are taken from books. The Phaidon Press in London, through its director, Dr. B. Horowitz, has permitted reproduction of three plates from *Etruscan Sculpture* by Ludwig Goldscheider, and one from *Roman Portraits*. These were cases in which Phaidon's own photographer, I. Schneider-Lengyel, had made prints patently superior to any others available. Thanks are due also to Ernst Benn, Ltd., London, for three reproductions from their publication *Scythian Art* by Gregory Borovka. One illustration is from *La Sculpture Irlandaise* by Françoise Henry. Two illustrations are, by the author's courteous permission, from Osvald Sirén's *A History of Early Chinese Art*.

Finally I must make some accounting to the great museums. My gratitude to the Metropolitan Museum of Art is well nigh overwhelming. There are in this book photographs of more than sixty objects owned by the institution; in addition the directors have permitted reproduction of a number of photographs taken by their staff members in the phenomenally rich Cairo Museum. All the illustrations have come from the Metropolitan's own photographic department, where the staff has been patient and helpful to me over a period of twenty years. I found the same sort of aid at the British Museum in London, which is represented by sixty-two illustrations in these pages.

Uniformly, from the museum's director, Sir Frank Francis, to the workers in the museum's Photographic Service, I found sympathetic interest in my problems and immediate cooperation. There are forty illustrations from subjects in the Victoria and Albert Museum, where I was especially aided by Mr. Charles Harvard Gibbs-Smith. In the case of the Louvre in Paris, my photographs, about fifty in all, were obtained from commercial photographic firms or agencies: in largest number from Giraudon, but also from Alinari, the Tel agency, and Bulloz. Thanks are due to Archives Photographiques, a department of the National Museums of France, but for photographs of historic sculpture still *in situ* rather than from museum exhibits. At the Hermitage in Leningrad I was accorded the rare privilege of examining piece by piece many masterpieces in the museum's unrivaled collection of Scythian and related bronzes; though I had to look elsewhere for photographs of them, particularly to the Iranian Institute in New York.

For material in the field of primitive art, the collections of the American Museum of Natural History have yielded many outstanding illustrations. These include not only a score of objects owned by the museum but photographs of sculpture in out-of-the-way places such as Easter Island. My thanks go to many staff members, and especially to those in the Division of Photography. In this field I am deeply indebted also to the Museum of Primitive Art in New York. The Musée de l'Homme in Paris has provided photographs from objects in its own collections and a number of wanted prints from other sources. Finally, among the anthropological museums, I am indebted to the Museum of the American Indian, Heye Foundation, New York, and especially to its director, Dr. Frederick J. Dockstader; to the Peabody Museum at Harvard University, the Lowie Museum of Anthropology at the University of California, Berkeley, the Museum of Science, Buffalo, and the Chicago Natural History Museum.

The Museum of Modern Art in New York has courteously supplied illustrations in the modern field, but even more notably many photographs from exhibits in its Amerindian, South Seas, and other primitive exhibitions. I have many friends there but can name, gratefully, only two who have cooperated in this connection: Alfred H. Barr, Jr., director of the collections at the

museum, and Pearl L. Moeller, supervisor of photographic reproductions. The Philadelphia Museum of Art has been generous in answering my requests for photographs in many fields, from the primitive to such moderns as Rodin and Brancusi. Hardly less varied, and as valued, are the illustrations from the Boston Museum of Fine Arts, which number thirty-five. The Cleveland Museum of Art, the Art Institute of Chicago, the City Museum at St. Louis, and the Nelson Gallery–Atkins Museum at Kansas City are represented by large groups of illustrations. The Art Association of Montreal kindly provided five photographs of Scythian and Middle American works. The Walters Gallery at Baltimore has cooperated with me generously, as has the Museum of Art of the Rhode Island School of Design at Providence. The chapter on Chinese sculpture was enriched especially with photographs from the Freer Gallery of Art in Washington, a part of the Smithsonian Institution, as was the Persian chapter. Another large group of illustrations for the Oriental section of the book came from the Royal Ontario Museum in Toronto, with also a number of primitive illustrations. For smaller groups of illustrations I am grateful to the Toledo Museum of Art, the Minneapolis Institute of Arts, the Detroit Institute of Arts, and the California Palace of the Legion of Honor in San Francisco.

For years I have found especially helpful the museums at universities. The Fogg Art Museum at Harvard University has permitted illustration of many objects in its rich collections, and members of the staff have helped me to obtain photographs from other sources. The Dumbarton Oaks Collection in Washington is a specialized branch of the Fogg Museum, and there I have found additional exhibits for my illustrations set. The University Museum at Philadelphia—more fully the Museum of the University of Pennsylvania—has aided with many photographs not otherwise available, especially for the primitive, Mesopotamian, and Oriental chapters, to the extent of more than thirty pieces. The staff at the Yale University Art Gallery has been generously helpful. I owe thanks also to the Yale University Library for impressions of Babylonian seals. The Art Museum of Princeton University is represented in the Greek and Persian chapters. My debt to the Oriental Institute of the University of Chicago is especially heavy, not only for illustrations from objects in the collections at Chicago but for "field" photographs taken during the institute's expeditions in the Orient. In England I owe gratitude to the staff of the Ashmolean Museum at Oxford University for courteous aid.

To the Portland Art Museum, Portland, Oregon, I am deeply indebted for unique exhibits in the field of Amerindian sculpture. To the Worcester Art Museum and to its successive directors, Francis Henry Taylor and Daniel Catton Rich, I must record special thanks. The National Gallery of Art, Washington, through its director, John Walker, and Charles C. Stotler of the library staff, has been cooperative and helpful. The debt is for outstanding exhibits from the gallery's collection and also for photographs of many objects in the Robert Woods Bliss collection of pre-Columbian American art, now permanently housed at Dumbarton Oaks. The National Museum of India at New Delhi has been generous. In addition to photographs I have had important information from the director, Dr. Grace Morley. Of the larger national museums, that at Athens cooperated generously, as did that at Mexico City. I dealt less with the phenomenally rich museums in Italy than with commercial photographers. In pursuit of certain prints we have gone further afield: to the National Museum at Reykjavik, where the director, Kristján Eldjárn, provided a wanted Icelandic photograph; and to the National Museum at Phnom Penh, where the conservatrice, Madeleine Giteau, made arrangements for us to receive photographs of certain of the museum's treasures.

But it is impossible to set down the full list of those who have contributed to the book in one way or another; in the case of those museum officials, collectors, and photographers who are represented by only one or two illustrations, I can only ask that they be content with the inscribing of their names in the captions under the pictures—though I add a general and sincere "thank you" here.

A number of museums especially photographed exhibits for this book. Among them were the American Museum of Natural History; the Metropolitan Museum of Art; the Walters Art Gallery at Baltimore; the Royal Ontario Museum at Toronto; the University Museum, Philadelphia; the Ohio State Museum; and the Oriental Institute of the University of Chicago. My gratitude goes in special measure to these museums.

Not given credit in the captions are the government agencies and the tourist bureaus in New York which supplied photographs from their files or (in some cases) obtained prints from their governments abroad. In this category I had valued aid from the French Information Center, the Greek Press and Information Service, the Government of India Tourist Office, the Swiss National Tourist Office, the Indonesian Information Office, The Italian Tourist Information Office, the Spanish Tourist Office, the Austrian State Tourist Department, the United Arab Republic Information Office, and the Mexican Government Tourism Department. To these should be added the Irish Tourist Association in Dublin. I have already noted my debt to the German Information Center, which made arrangements for my alliance with the very helpful Archiv für Kunst und Geschichte in Berlin; for the other major contribution from a foreign institution, that of the Society for International Cultural Relations in Tokyo, I have to thank both the Japanese Consulate in New York and the Japan Society of America.

Finally I acknowledge aid from friends who helped in two directions: the first group by going out of their way to make fugitive prints available; and second, the commercial photographers who sold me photographs by the dozen or score, or even by the hundred. Of the personal friends I may cite Miss Elisabeth Lawrie, who took down from her living-room wall a rare photograph and lent it long enough for rephotographing; and Miss Elisabeth Naramore, who long ago sought out certain photographs which I had been told were unavailable. Of the commercial photographers, I remember best, with friendly regard, A. Giraudon. After one of the wars I spent several days in his unheated office in Paris while he combed his files for the hun-

dred or so prints I needed. My debt to him is great, as the captions will show. The Alinari prints were more easily obtained, a few here, a dozen there, before I arrived at Florence and the main offices of Fratelli Alinari. The salesroom staff was uniformly courteous and helpful, as the firm's sixty-two photographs in these pages will indicate. A second fruitful source in Paris was the "photographic document center" administered by H. Roger-Viollet. My debt there is twofold: in addition to a number of photographs by Roger-Viollet, I found fugitive prints, even from other countries, for reproduction in chapters beyond the French. In Italy the gallery bearing the name Francesco Pineider provided the many Anderson photographs of classical subjects that I have used; Mr. Giuseppe Kaiser of the staff was particularly helpful. Giacomo Brogi of Florence provided twenty-seven photographs of historic sculptures.

If certain minor inconsistencies appear in these acknowledgments, and possibly in the wording of the captions, these are the reasons: Attribution of certain works to the Persian Institute in New York indicates only that the photographs came into my hands before the institution changed its name to Iranian Institute. (The words "Persia" and "Iran" are used as synonyms throughout the book.) Certain museums have changed their names during the period of the book's production. Occasionally photographs were obtained while a sculpture was in earlier ownership; an example is a group of photographs from the Joseph Brummer collection, from which objects were sold to the Metropolitan Museum of Art and other institutions, some of them not easily traceable. I am grateful to Mr. Brummer, and I am sorry if any museum or collector finds, for these reasons, that some piece of sculpture in his collection is not properly attributed.

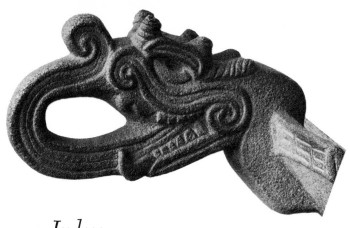

Index

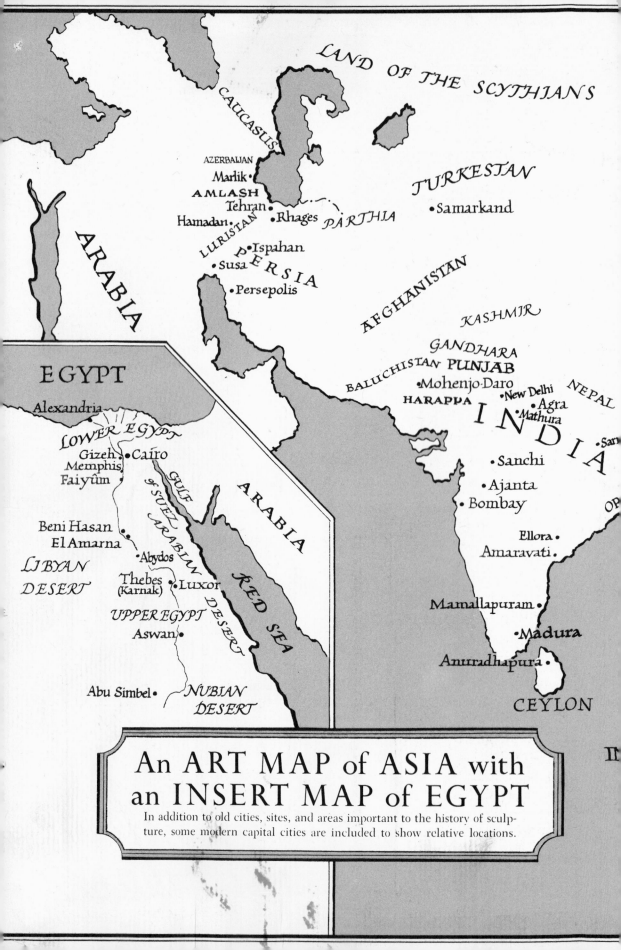

LAND OF THE SCYTHIANS

CAUCASUS

TURKESTAN

AZERBAIJAN
Marlik •
AMLASH
Tehran •
Hamadan • • Rhages PARTHIA • Samarkand
LURISTAN
• Ispahan
PERSIA
• Susa
AFGHANISTAN
• Persepolis

KASHMIR

GANDHARA
BALUCHISTAN PUNJAB
• Mohenjo-Daro
HARAPPA • New Delhi NEPAL
• Agra
Mathura • Sar

ARABIA

EGYPT

Alexandria •

LOWER EGYPT
Gizeh • • Cairo
Memphis
Faiyûm

ARABIA

INDIA

• Sanchi

• Ajanta
• Bombay

OR

Beni Hasan
El Amarna

LIBYAN
DESERT

GULF OF SUEZ

ARABIAN DESERT

• Abydos
Thebes • Luxor
(Karnak)

RED SEA

Ellora •
Amaravati •

UPPER EGYPT

Mamallapuram •

Aswan •

• Madura

Abu Simbel • NUBIAN
DESERT

Anuradhapura •

CEYLON

II

An ART MAP of ASIA with
an INSERT MAP of EGYPT

In addition to old cities, sites, and areas important to the history of sculp-
ture, some modern capital cities are included to show relative locations.